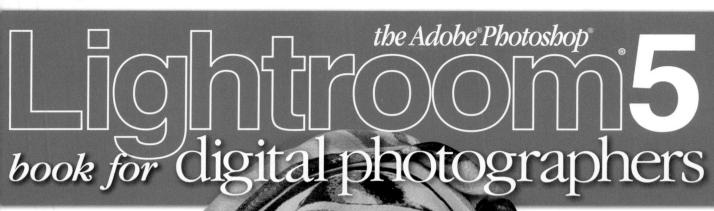

Scott Kelby

The Adobe Photoshop Lightroom 5 Book for Digital Photographers Team

CREATIVE DIRECTOR
Felix Nelson

TECHNICAL EDITORS
Cindy Snyder
Kim Doty

PRODUCTION MANAGER **Dave Damstra**

ART DIRECTOR

Jessica Maldonado

COVER PHOTO BY **Scott Kelby**

Published by New Riders

Copyright ©2014 by Scott Kelby

All rights reserved. No part of this book may be reproduced or transmitted in any form, by any means, electronic or mechanical, including photocopying, recording, or by any information storage and retrieval system, without written permission from the publisher, except for the inclusion of brief quotations in a review.

Composed in Myriad Pro, Helvetica, and Blair ITC by Kelby Media Group, Inc.

Trademarks

All terms mentioned in this book that are known to be trademarks or service marks have been appropriately capitalized. New Riders cannot attest to the accuracy of this information. Use of a term in the book should not be regarded as affecting the validity of any trademark or service mark.

Photoshop, Photoshop Lightroom, and Photoshop Elements are registered trademarks of Adobe Systems, Inc.

Macintosh, Mac, and Mac OS X Leopard and Snow Leopard are registered trademarks of Apple Inc.

Windows is a registered trademark of Microsoft Corporation.

Warning and Disclaimer

This book is designed to provide information about Adobe Photoshop Lightroom for digital photographers. Every effort has been made to make this book as complete and as accurate as possible, but no warranty of fitness is implied.

The information is provided on an as-is basis. The author and New Riders shall have neither liability nor responsibility to any person or entity with respect to any loss or damages arising from the information contained in this book or from the use of the discs, electronic files, or programs that may accompany it.

THIS PRODUCT IS NOT ENDORSED OR SPONSORED BY ADOBE SYSTEMS INCORPORATED, PUBLISHER OF ADOBE PHOTOSHOP LIGHTROOM 5.

ISBN13: 978-0-321-93431-4 ISBN10: 0-321-93431-8

9876543

http://kelbytraining.com www.newriders.com

This book is for my amazing wife Kalebra. I just so dig you!

ACKNOWLEDGMENTS

start the acknowledgments for every book I've ever written the same way—by thanking my amazing wife, Kalebra. If you knew what an incredible woman she is, you'd totally understand why.

This is going to sound silly, but if we go grocery shopping together, and she sends me off to a different aisle to get milk, when I return with the milk and she sees me coming back down the aisle, she gives me the warmest, most wonderful smile. It's not because she's happy that I found the milk; I get that same smile every time I see her, even if we've only been apart for 60 seconds. It's a smile that says, "There's the man I love."

If you got that smile, dozens of times a day, for nearly 24 years of marriage, you'd feel like the luckiest guy in the world, and believe me—I do. To this day, just seeing her puts a song in my heart and makes it skip a beat. When you go through life like this, it makes you one incredibly happy and grateful guy, and I truly am.

So, thank you, my love. Thanks for your kindness, your hugs, your understanding, your advice, your patience, your generosity, and for being such a caring and compassionate mother and wife. I love you.

Secondly, a big thanks to my son, Jordan. I wrote my first book when my wife was pregnant with him (16 years ago), and he has literally grown up around my writing. Maybe that's why he's so patient as he waits for me to finish a page or two so we can go play *Call of Duty: Black Ops 2* with all his friends, and my buddies Matt, RC, Brad, Hans, and Jeff. He's such a great "little buddy" to me, and it has been a blast watching him grow up into such a wonderful young man, with his mother's tender and loving heart. (You're the greatest, little buddy!)

Thanks to our wonderful daughter, Kira, for being the answer to our prayers, for being such a blessing to your older brother, and for proving once again that miracles happen every day. You are a little clone of your mother, and believe me, there is no greater compliment I could give you. You're my little sweetie!

A special thanks to my big brother, Jeff. I have so much to be thankful for in my life, and having you as such a positive role model while I was growing up is one thing I'm particularly thankful for. You're the best brother any guy could ever have, and I've said it a million times before, but one more surely wouldn't hurt—I love you, man!

My heartfelt thanks go to my entire team at Kelby Media Group. I know everybody thinks their team is really special, but this one time—I'm right. I'm so proud to get to work with you all, and I'm still amazed at what you're able to accomplish day in, day out, and I'm constantly impressed with how much passion and pride you put into everything you do.

A warm word of thanks goes to my in-house Editor Kim Doty. It's her amazing attitude, passion, poise, and attention to detail that has kept me writing books. When you're writing a book like this, sometimes you can really feel like you're all alone, but she really makes me feel that I'm not alone—that we're a team. It often is her encouraging words or helpful ideas that keep me going when I've hit a wall, and I just can't thank her enough. Kim, you are "the best!"

I'm equally as lucky to have the immensely talented Jessica Maldonado (a.k.a. "Photoshop Girl") working on the design of my books. I just love the way Jessica designs, and all the clever little things she adds to her layouts and cover designs. She's not just incredibly talented and a joy to work with, she's a very smart designer and thinks five steps ahead in every layout she builds. I feel very, very fortunate to have her on my team.

http://kelbytraining.com

Also, a big thanks to my in-house tech editor Cindy Snyder, who helps test all the techniques in the book (and makes sure I didn't leave out that one little step that would take the train off the tracks), and she catches lots of little things others would have missed.

Thanks to "Big Dave" Damstra and his team, who do the layout work once the text and graphics start coming in, and they do such a great job, on such a tight deadline, yet still turn out books with a tight, clean layout that people love. You rock!

The guy leading this crew of creative superstars is none other than my friend (and Creative Director), Felix Nelson, whose limitless talent, creativity, input, and flat-out great ideas make every book we do that much better.

To my best buddy and book-publishing powerhouse, Dave Moser (also known as "the guiding light, force of nature, miracle birth, etc."), for always insisting that we raise the bar and make everything we do better than anything we've done before.

Thanks to my friend and business partner, Jean A. Kendra, for her support and friendship all these years. You mean a lot to me, to Kalebra, and to our company.

A huge, huge thanks to my Executive Assistant, Susan Hageanon, for all her hard work and for handling so many things so well that I have time to write books.

Thanks to my Editor Ted Waitt at Peachpit Press. Like Kim Doty does in-house, you do outside by helping me feel connected to "the mothership." Thanks for all your hard work and dedication to making the kind of books that make a difference. Also, thanks to my Publisher Nancy Aldrich-Ruenzel, and her team, including Sara Jane Todd and Scott Cowlin. (Lest we forget Gary-Paul.)

Thanks to Lightroom Product Manager Tom Hogarty for answering all my late-night emails, and to Bryan O'Neil Hughes for helping out in such an impactful way throughout the original development of this book.

I owe a special debt of gratitude to my buddy, Matt Kloskowski, for being such an excellent sounding board (and sometimes tech editor) during the development of this latest version of the book. Your input made this book better than it would have been.

Thanks to my friends at Adobe Systems: Terry White, Cari Gushiken, Bryan Lamkin, Julieanne Kost, and Russell Preston Brown. Gone but not forgotten: Barbara Rice, Rye Livingston, John Loiacono, Kevin Connor, Addy Roff, and Karen Gauthier.

I want to thank all the talented and gifted photographers who've taught me so much over the years, including: Moose Peterson, Joe McNally, Bill Fortney, George Lepp, Anne Cahill, Vincent Versace, David Ziser, Jim DiVitale, Cliff Mautner, Dave Black, Helene Glassman, and Monte Zucker.

Thanks to my mentors, whose wisdom and whip-cracking have helped me immeasurably, including John Graden, Jack Lee, Dave Gales, Judy Farmer, and Douglas Poole.

Most importantly, I want to thank God, and His Son Jesus Christ, for leading me to the woman of my dreams, for blessing us with two amazing children, for allowing me to make a living doing something I truly love, for always being there when I need Him, for blessing me with a wonderful, fulfilling, and happy life, and such a warm, loving family to share it with.

OTHER BOOKS BY SCOTT KELBY

Professional Portrait Retouching Techniques for Photographers Using Photoshop

The Digital Photography Book, parts 1, 2, 3 & 4

Light It, Shoot It, Retouch It: Learn Step by Step How to Go from Empty Studio to Finished Image

The Adobe Photoshop Book for Digital Photographers

The Photoshop Elements Book for Digital Photographers

The iPhone Book

Photoshop Down & Dirty Tricks

Photo Recipes Live: Behind the Scenes: Your Guide to Today's Most Popular Lighting Techniques, parts 1 & 2

ABOUT THE AUTHOR

Scott Kelby

Scott is Editor, Publisher, and co-founder of *Photoshop User* magazine, Executive Editor and Publisher of *Lightroom* magazine, and host of *The Grid*, the weekly, live, webcast talk show for photographers, as well as the top-rated weekly video webcast *Photoshop User TV*.

He is President of the National Association of Photoshop Professionals (NAPP), the trade association for Adobe® Photoshop® users, and he's President of the training, education, and publishing firm, Kelby Media Group, Inc.

Scott is a photographer, designer, and award-winning author of more than 50 books, including The Adobe Photoshop Book for Digital Photographers, Professional Portrait Retouching Techniques for Photographers Using Photoshop, Light It, Shoot It, Retouch It: Learn Step by Step How to Go from Empty Studio to Finished Image, Photoshop Classic Effects, The Photoshop Elements Book for Digital Photographers, and The Digital Photography Book, parts 1, 2, 3 & 4.

For the past three years, Scott has been honored with the distinction of being the world's #1 best-selling author of photography books. His book, *The Digital Photography Book*, part 1, is now the best-selling book on digital photography in history.

His books have been translated into dozens of different languages, including Chinese, Russian, Spanish, Korean, Polish, Taiwanese, French, German, Italian, Japanese, Dutch, Swedish, Turkish, and Portuguese, among others, and he is a recipient of the prestigious ASP International Award, presented annually by the American Society of Photographers for "...contributions in a special or significant way to the ideals of Professional Photography as an art and a science."

Scott is Training Director for the official Adobe Photoshop Seminar Tour and Conference Technical Chair for the Photoshop World Conference & Expo. He's featured in a series of Adobe Photoshop training DVDs and online courses at KelbyTraining.com and has been training Adobe Photoshop users since 1993.

For more information on Scott, visit him at:

His daily blog: http://scottkelby.com

Twitter: @scottkelby

Facebook: www.facebook.com/skelby

Google+: Scottaplus.com

TABLE OF CONTENTS

	CHAPTER 1	1	
•	Importing GETTING YOUR PHOTOS INTO LIGHTROOM		
Be ^s	fore You Do Anything, Choose Where Store Your Photos		. 2
Ne (It'	ext, Do This: Set Up Your Folder Organization 's Really Important)		. 3
	etting Photos from Your Camera Into Lightroom		
Usi Ext	ing Smart Previews to Work Without an ternal Hard Drive Attached		16
lm	porting Photos Already on Your Computer		18
Sav (an	ve Time Importing Using Import Presets nd a Compact View)		.20
lm	porting Video from Your DSLR		22
She	ooting Tethered (Go Straight from Your Camera, ght Into Lightroom)		24
	ing Image Overlay to See if Your Images Your Layout		28
Cre	eating Your Own Custom File Naming Templates		32
Ch	oosing Your Preferences for Importing Photos		36
Th	e Adobe DNG File Format Advantage		39
Cre (Cc	eating Your Own Custom Metadata opyright) Templates		40
Fo	ur Things You'll Want to Know Now About etting Around Lightroom		42
Vie	ewing Your Imported Photos		44
Usi	ing Lights Dim, Lights Out, and her Viewing Modes		46
-	eing a Real Full-Screen View		48
Usi	ing Guides and the Resizable id Overlays		49
	htroom Killer Tips	-	

CHAPTER 2	55
▼ Library HOW TO ORGANIZE YOUR PHOTOS	
Folders and Why I Don't Mess with Them (This Is Really Important!)	56
Sorting Your Photos Using Collections	
Organizing Multiple Shoots Using Collection Sets	72
Using Smart Collections for Automatic Organization	
Keeping Things Tidy Using Stacks	76
When to Use a Quick Collection Instead	
Using Target Collections (and Why They're So Handy)	82
Adding Specific Keywords for Advanced Searching	
Renaming Photos Already in Lightroom	
Adding Copyright Info, Captions, and Other Metadata	
If Your Camera Supports GPS, Prepare to Amaze Your Friends	
Organizing Your Photos on a World Map	
Finding Photos Fast!	100
Creating and Using Multiple Catalogs	
From Laptop to Desktop: Syncing Catalogs on Two Computers	
Backing Up Your Catalog (This Is VERY Important)	
Relinking Missing Photos	
Dealing with Disasters	
Lightroom Killer Tips	

Library Develop Мар Book Print Web

http://kelbytraining.com

CHAPTER 3 119
▼ Customizing
HOW TO SET THINGS UP YOUR WAY
Choosing What You See in Loupe View
Choosing What You See in Grid View
Make Working with Panels Faster & Easier
Using Two Monitors with Lightroom
Choosing What the Filmstrip Displays
Adding Your Studio's Name or Logo for a Custom Look
Lightroom Killer Tips
CHAPTER 4 139
▼ Editing Essentials
HOW TO DEVELOP YOUR PHOTOS
Are You Seeing Different Sliders? Read This First!
Setting the White Balance
Setting Your White Balance Live While Shooting Tethered
My Editing Your Images Cheat Sheet
How to Set Your Overall Exposure
60 Seconds on the Histogram (& Which Slider Controls Which Part)
Auto Tone (Having Lightroom Do the Work for You)
Dealing With Exposure Problems (the Highlights and Shadows Sliders)
Setting Your White Point and Black Point
Adding "Punch" to Your Images Using Clarity 159
Making Your Colors More Vibrant
Using the Tone Curve to Add Contrast
Two Really Handy Uses for RGB Curves 166
Adjusting Individual Colors Using HSL 168

How to Add Vignette Effects					170
Getting That Trendy High-Contrast Look .					173
Creating Black-and-White Images					176
Getting Great Duotones (and Split Tones)					180
ightroom Killer Tips					182

CHAPTER 5	185
▼ DJ Develop (Part Deux) MORE WAYS TO TWEAK YOUR IMAGES	
Making Your RAW Photos Look More Like JPEGs .	186
Seeing Befores and Afters	188
Applying Changes Made to One Photo to Other Photos	189
Virtual Copies—The "No Risk" Way to Experiment	191
Editing a Bunch of Photos at Once Using Auto Syn	ıc 193
Using One-Click Presets (and Making Your Own!).	194
Using the Library Module's Quick Develop Panel .	198
Using Soft Proofing to Make Your Images Look Good in Print and on the Web	200
The "Previous" Button (and Why It Rocks!)	204
Lightroom Killer Tips	206

CHAPTER 6	209
▼ Local Adjustments HOW TO EDIT JUST PART OF YOUR IMAGES	
Dodging, Burning, and Adjusting Individual Areas of Your Photo	210
Five More Things You Should Know About Lightroom's Adjustment Brush	217
Selectively Fixing White Balance, Dark Shadows, and Noise Issues	218
Getting Creative Effects Using the Adjustment Brush	220
Retouching Portraits	222

TABLE OF CONTENTS

Using the Radial Filter	228
Lightroom Killer Tips	
CHAPTER 7 2	35
▼ Problem Photos FIXING COMMON PROBLEMS	
Fixing Backlit Photos	236
Reducing Noise	238
Undoing Changes Made in Lightroom	240
Cropping Photos	242
Lights Out Cropping Rocks!	245
Straightening Crooked Photos	246
Finding Spots and Specks the Easy Way	248
Oh Hallelujah, It's a Regular Healing Brush! (Finally!)	251
Removing Red Eye	254
Fixing Lens Distortion Problems	255
Auto Correcting Perspective and Other Lens Problems Using Upright	260
Fixing Edge Vignetting	266

Fixing Skies (and Other Stuff) with a Gradient Filter 226

	CHAPTER 8	279
•	Exporting Images SAVING JPEGS, TIFFS, AND MORE	
Sav	ving Your Photos as JPEGs	280

Adding a Watermark to Your Images 288

Emailing Photos from Lightroom .								292
Exporting Your Original RAW Photo)							294
Publish Your Images with Just Two	CI	icl	ζS.					296
ightroom Killer Tips								302

CHAPTER 9				2	3 0	5	
▼ Jumping to Photoshop HOW AND WHEN TO DO IT							
Choosing How Your Files Are Sent to Photoshop							306
How to Jump Over to Photoshop, and How to Jump Back							307
Adding Photoshop Automation to Your Lightroom Workflow							318
Stitching Panoramas Using Photoshop							324
Creating HDR Images in Photoshop							329
Lightroom Killer Tips							335

	337
▼ Book of Love CREATING PHOTO BOOKS	
Before You Make Your First Book	338
Building Your First Book from Scratch	340
Adding Text and Captions to Your Photo Book	352
Adding and Customizing Page Numbers	356
Four Things You'll Want to Know About Layout Templates	358
Creating & Saving Your Own Custom Layouts	360
Creating Cover Text	363
Custom Template Workaround	366
Lightroom Killer Tips	368

Fixing Chromatic Aberrations

Library Develop Мар Book Slideshow Print Web

http://kelbytraining.com

CHAPTER 11	371
▼ Slideshow	
CREATING PRESENTATIONS OF YOUR WORK	
Creating a Quick, Basic Slide Show	372
Customizing the Look of Your Slide Show	376
Adding Video To Your Slide Show	382
Getting Creative with Photo Backgrounds	384
Working with Drop Shadows and Strokes	390
Adding Additional Lines of Text	
and Watermarking	391
Adding Opening and Closing Title Slides	392
Adding Background Music	394
Choosing Your Slide Duration and Fade Length	396
Sharing Your Slide Show	397
Lightroom Killer Tips	399
CHAPTER 12	401
▼ DSLR: The Movie	
WORKING WITH VIDEO SHOT ON YOUR DSLR	
Working with Videos	402
CHAPTER 13	413
The Rig Print	

WORKING WITH VIDEO SHOT ON YOU	R	DS	5L	R					
Working with Videos									402
					AAAAAA				
CHAPTER 13							41	13	
▼ The Big Print PRINTING YOUR PHOTOS									
Printing Individual Photos									414
Creating Multi-Photo Contact Sheets									418
Creating Custom Layouts Any Way You Want Them									426
Adding Text to Your Print Layouts									430
Printing Multiple Photos on One Page									432
Saving Your Custom Layouts as Templates									437
Having Lightroom Remember Your Printing Layouts									438

Creating Backscreened Prints				•		. 439
The Final Print and Color Management Settings						. 442
Saving Your Page Layout as a JPEG						. 453
Adding Custom Borders to Your Prints						. 455
ightroom Killer Tips						. 458

CHAPTER 14	461
▼ The Layout CREATING COOL LAYOUTS FOR WEB 8	& PRINT
Here Are Some of My Layouts for You to Use	462
Bonus: 24 Cool Lightroom 5 Develop Module Presets	476

CHAPTER IS	
■ My Portrait Workflow MY STEP-BY-STEP PROCESS FROM THE SHOOT TO THE FINAL PRINT	
Workflow Step One: It All Starts with the Shoot	90
Workflow Step Two: Right After the Shoot, Do This First	91
Workflow Step Three: Finding Your Picks & Making a Collection	92
Workflow Step Four: A Quick Retouch for Your Selects	95
Workflow Step Five: Emailing Your Clients the Proofs	97
Workflow Step Six: Making the Final Tweaks & Working with Photoshop 49	99
Workflow Step Seven: Delivering the Finished Image(s)	04
10 Important Bits of Advice for New Lightroom Users	06
Want to Learn More?	12
Index	15

Seven (or So) Things You'll Wish You Had Known Before Reading This Book

I really want to make sure you get the absolute most out of reading this book, and if you take two minutes and read these seven (or so) things now, I promise it will make a big difference in your success with Lightroom 5, and with this book (plus, it will keep you from sending me an email asking something that everyone who skips this part will wind up doing). By the way, the captures shown below are just for looks. Hey, we're photographers—how things look really matters.

- (1) If you don't want to read this, then go right now to http://kelbytraining.com/books/LR5 and watch the short video I made to explain these seven (or so) things in more detail. It's short, it's quick, and it will help you read this book in half the time (okay, the "half the time" thing is marketing hype, but you'll get a lot out of the video, so head over there first. I'll make it worth your while).
- (2) You can download many of the key photos used here in the book, so you can follow along using many of the same images that I used, at http://kel-bytraining.com/books/LR5. See, this is one of those things I was talking about that you'd miss if you skipped over this and jumped right to Chapter 1. Then you'd send me an angry email about how I didn't tell you where to download the photos. You wouldn't be the first.
- (3) If you've read my other books, you know they're usually "jump in anywhere" books, but with Lightroom, I wrote the book in the order you'll probably wind up using the program, so if you're new to Lightroom, I would really recommend you start with Chapter 1 and go through the book in order. But hey—it's your book—if you decide to just hollow out the insides and store your valuables in there, I'll never know. Also, make sure you read the opening to each project, up at the top of the page. Those actually have information you'll want to know, so don't skip over them.

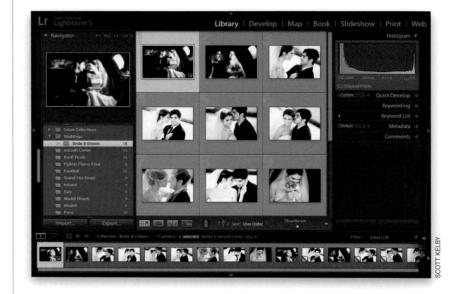

- (4) The official name of the software is "Adobe Photoshop Lightroom 5" because it's part of the Photoshop family, but if every time I referred to it throughout the book, I called it "Adobe Photoshop Lightroom 5," you'd eventually want to strangle me (or the person sitting nearest you), so from here on out, I usually just refer to it as "Lightroom" or "Lightroom 5" Just so you know.
- (5) The intro page at the beginning of each chapter is designed to give you a quick mental break, and honestly, they have little to do with the chapter. In fact, they have little to do with anything, but writing these quirky chapter intros is kind of a tradition of mine (I do this in all my books), but if you're one of those really "serious" types, you can skip them, because they'll just get on your nerves.
- (6) At the end of the book is a special bonus chapter, where I share my own startto-finish workflow. However, don't read it until you've read the entire book first, or you might not know how to do certain things that I'll be telling you to do (that's why I put it at the end of the book).
- (7) Where's the chapter on the Web module? It's on the web (you'll find it at the address in #7.5 below). I put it there because Adobe has...well...they've kind of abandoned it (not officially mind you, but come on—they haven't really added any new features in the past three versions, so I can't [with a straight face] recommend that you use it at all). But, just in case, I still updated it and posted the chapter on the web, so just think of it as a bonus you won't ever use.
- (7.5) I created a short bonus video. It shows you step by step how to create Identity Plate graphics with transparency (which you'll learn about in Chapters 11 and 13). You can find it at http://kelbytraining.com/books/LR5. Okay, now turn the page and let's get to work.

The Adobe Photoshop Lightroom 5 Book for Digital Photographers

IMPORTING getting your photos into lightroom

Okay, if you're reading this chapter intro, then it's safe to assume that you read my brief warning (given just a page earlier), that these chapter intros have little, if anything, to do with what's actually in the chapter ahead. These are here strictly to give you a quick mental break from all the learning. Of course where it kind of falls apart is right here at the beginning of the book, because...well...you haven't really learned anything at this point, so you probably don't need a mental break quite yet. Of course, this concerns me, but clearly not enough to actually skip having a chapter intro for Chapter One, because then this page would be blank, and if there's one thing I've learned—people don't like blank pages. That's why in some books when you see a blank page, it says, "This page intentionally left blank." This fascinates me, partly because they never tell you why

it's intentionally left blank and partly because, since they've printed the sentence "This page intentionally left blank," the page isn't actually blank anymore. So really, the whole thing's a big blank page scam, but if you call them on it, they start talking about "printers' spreads" and "pagination for press" and "propaganda spread by subversive anti-government organizations" and a dozen other technical reasons why sometimes a page has to be left blank. Well, I don't want you to think that this page was a part of their larger conspiracy, so even though you didn't actually need a mental break at this point (but probably do now), you're still getting one. In the publishing world, this is called "paying it forward." By the way, that's not what it's really called, but what it's really called can only be included on pages that were intentionally left blank. (Hey, I warned you these intros would be like this.)

Before You Do Anything, Choose Where to Store Your Photos

Before you dive into Lightroom and start importing photos, you need to make a decision about where you're going to store your photo library. This isn't as easy a decision as you might think, because you have to consider how many photos you've taken so far (and want to manage with Lightroom), and how many you think you might take in the next few years, and you need to make sure you have enough room to store thousands of photos, wherever you decide to store them—on your computer or on an external hard drive. Here's where to start:

For Desktop Computer Users:

Lightroom assumes you're going to store your photos on your computer's internal hard disk, so by default, it automatically chooses your Mac's or PC's Pictures folder to store all your photos. So, unless you choose differently (in Lightroom's Import window, which you'll learn about in just a few minutes), it's going to always choose to save your photos in this folder. As long as you've got a lot of free hard disk space available on your computer (and I mean a lot!), then you're all set. (Note: If you're wondering how much is "a lot," consider this: if you shoot just once a week, and fill up nothing more than a single 4-GB card with each shoot, in one year alone, you'll eat up more than 200 GB of drive space. So when it comes to hard drive storage space, think big!) If you don't have enough free hard disk space on your computer, then you'll need to buy an external hard drive to store all your photos (don't worry, Lightroom will still manage all your images, you're just storing them on a separate hard drive. You'll learn how to set this all up in the next few pages).

For Laptop Users:

If you primarily use a laptop computer for editing your images, then I would definitely recommend using an external hard drive to store your photo library because of the limited hard disk space on most laptops. Think about it. You're going to need to manage literally thousands (or tens of thousands) of images, and your laptop is going to get really full, really fast (believe me, it gets there faster than you'd think), so using an external drive (they're surprisingly inexpensive these days) has become the choice for many photographers using Lightroom. (You can find 500-GB external hard drives for around \$50 these days, but if you can spend just a little more [around \$70], go for the now popular 1-TB [terabyte] drives, which hold 1,000 GB.)

Lightroom can do a brilliant job of keeping you organized, as long as you start out being organized, and that means sticking to this one simple, but critical, rule: keep all your photos inside one main folder. It doesn't matter how many other folders you have inside that main folder, just make sure all your photos reside within it. This is the key ingredient to making everything work smoothly. If, instead, you import photos from folders in different locations all over your computer, you're headed for trouble. Here's how to set things up right from the start:

Next, Do This: Set Up Your Folder Organization (It's Really Important)

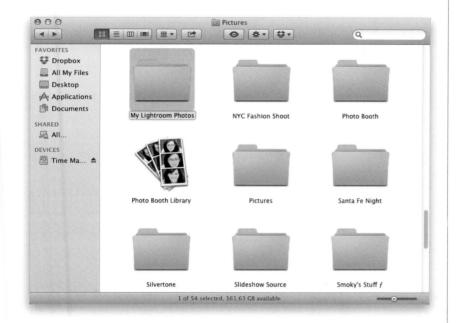

Step One:

As you read above, our goal is to get all our photos inside one main folder, right? Well, if you decided to store all your photos on your computer, then the rest is pretty easy. By default, Lightroom automatically chooses your Pictures (or My Pictures) folder as your main photo folder, and when you go to import photos from a memory card, it will automatically choose that folder for you. However, I'm going to recommend doing one extra thing now to make your life much easier: go inside your Pictures folder, create a new empty folder, and name it "My Lightroom Photos" (you don't have to name it that exactly, but just to make things consistent here in the book, that's what I've named my main folder). That way, when that day comes when you run out of hard disk space (and it will come way sooner than you might imagine), you can move, copy, or back up your entire photo library by simply moving one folder—your My Lightroom Photos folder. This is one of those things that if you do it now, there will come a day when it will save you not just hours, but literally days, worth of work.

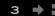

Step Two:

If you already have folders full of photos on your computer, before you start importing them into Lightroom, you'll want to drag-and-drop those folders inside your My Lightroom Photos folder. That way, all your photos reside inside that one My Lightroom Photos folder before you import them into Lightroom. Although it doesn't seem like it now, again, it's amazing how this one little bit of organization will make your life that much easier down the road. If you choose to store your photos on an external hard drive, then you'll set things up pretty much the same way (that's in the next step).

Step Three:

On your external hard drive, just create a new folder, name it My Lightroom Photos (or whatever you'd like), then drag-anddrop any photos on your computer that you want managed by Lightroom into that My Lightroom Photos folder on your external drive. Of course, keep them in their original folders when you drag-anddrop them over into your My Lightroom Photos folder (after all, you don't want to just drag-and-drop thousands of photos into one big empty folder). Do all this before you start importing them into Lightroom (which we'll talk about in detail starting on the next page, along with how to tell Lightroom how to use that new folder you created to store all your imported photos).

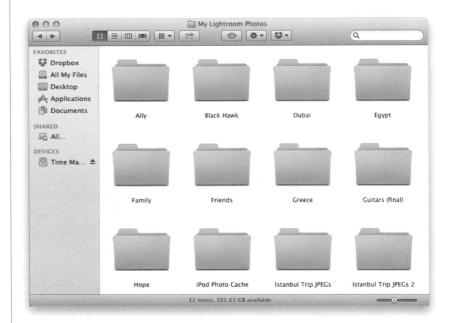

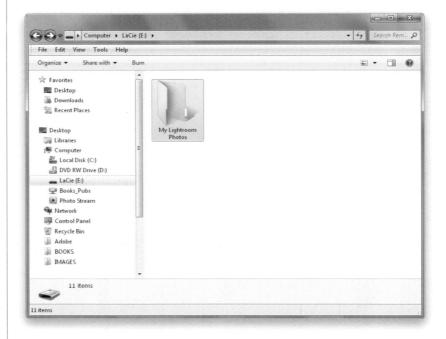

The photos you bring into Lightroom are probably coming from either your camera (well, your camera's memory card), or they're already on your computer (everybody's got a bunch of photos already on their computer, right?). We'll start here with importing photos from your camera's memory card (importing photos already on your computer is on page 18).

Getting Photos from Your Camera Into Lightroom

Web

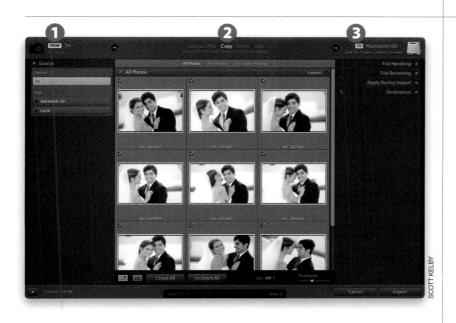

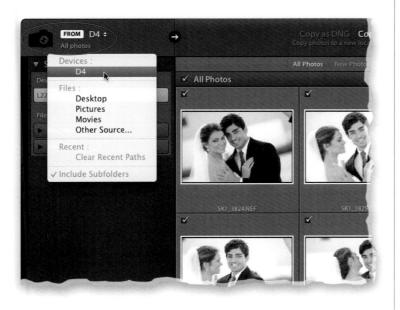

Step One:

If you have Lightroom open, and connect your camera or memory card reader to your computer, the Import window you see here appears over your Lightroom window. The top section of this Import window is important because it shows you what's about to happen. From left to right: (1) it shows where the photos are coming from (in this case, a camera); (2) what's going to happen to these images (in this case, they're getting copied from the camera); and (3) where they're going to (in this case, onto your computer, into your Pictures folder). If you don't want to import the photos from your camera or memory card right now, just click the Cancel button and this window goes away. If you do this, you can always get back to the Import window by clicking on the Import button (at the bottom of the left side Panels area in the Library module).

Step Two:

If your camera or memory card reader is connected, Lightroom assumes you want to import photos from that card, and you'll see it listed next to "From" in the top-left corner of the window (circled here). If you want to import from a different card (you could have two card readers connected to your computer), click on the From button, and a pop-up menu will appear (seen here) where you can choose the other card reader, or you can choose to import photos from somewhere else, like your desktop, or Pictures folder, or any recent folders you've imported from.

Continued

Step Three:

There is a Thumbnails size slider below the bottom-right corner of the center Preview area that controls the size of the thumbnail previews, so if you want to see them larger, just drag that slider to the right.

TIP: See a Photo Larger

If you want to see any photo you're about to import at a large, full-screen size, just double-click on it to zoom in, or click on it, then press the letter **E**. Double-click to zoom back out, or press the letter **G**.

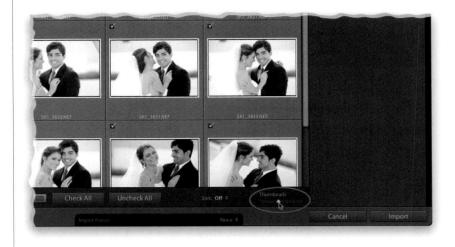

Step Four:

The big advantage of getting to see the thumbnail previews of the photos you're about to import is that you get to choose which ones actually get imported (after all, if you accidentally took a photo of the ground while you were walking, which for some inexplicable reason I seem to do on nearly every location shoot, there's no reason to even import that photo at all, right?). By default, all the photos have a checkmark beside them (meaning they are all marked to be imported). If you see one or more photos you don't want imported, just turn off their checkboxes.

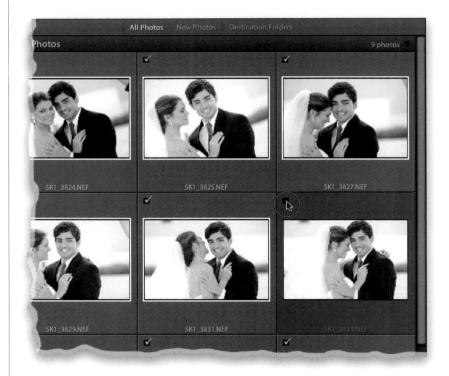

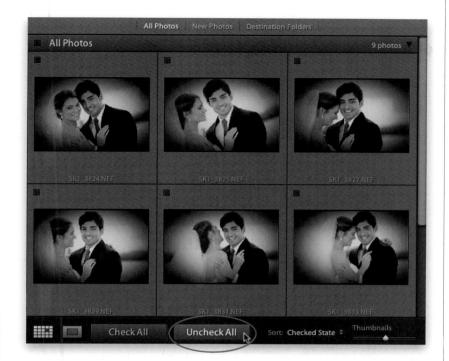

Step Five:

Now, what if you have 300+ photos on your memory card, but you only want a handful of them imported? Then vou'd click the Uncheck All button at the bottom left of the Preview area (which unchecks every photo), and Commandclick (PC: Ctrl-click) on just the photos you want to import. Then, turn on the checkbox for any of these selected photos, and all the selected photos become checked and will be imported. Also, if you choose Checked State from the Sort pop-up menu (beneath the Preview area), all of the images you checked will appear together at the top of the Preview area.

TIP: Selecting Multiple Photos If the photos you want are contiguous, then click on the first photo, press-andhold the Shift key, scroll down to the last photo, and click on it to select all the photos in between at once.

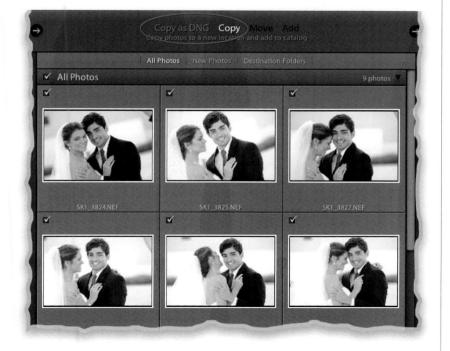

Step Six:

At the top center of the Import window, you get to choose whether you want to copy the files "as is" (Copy) or Copy as DNG to convert them to Adobe's DNG format as they're being imported (if you're not familiar with the advantages of Adobe's DNG [digital negative] file format, turn to page 39). Luckily, there's no wrong answer here, so if at this point you're unsure of what to do, for now just choose the default setting of Copy, which copies the images off the card onto your computer (or external drive) and imports them into Lightroom. Neither choice moves your originals off the card (you'll notice Move is grayed out), it only copies them, so if there's a serious problem during import (hey, it happens), you still have the originals on your memory card.

Step Seven:

Below the Copy as DNG and Copy buttons are three handy view options. By default, it displays all the photos on your card, but if you shoot to a card, then download those photos, pop the card back into the camera, shoot some more, then download again (which is pretty common), you can click New Photos, and now it only shows the photos on the card that you haven't imported yet, and hides the rest from view (sweet-I know). There's also a Destination Folders view, which hides any photos with the same name as photos that are already in the folder you're importing into. These last two buttons are just there to clear up the clutter and make it easier for you to see what's going on as you move files from one place to another, so you don't have to use them at all if you don't need them.

Step Eight:

Now we've come to the part where you tell Lightroom where to store the photos you're importing. If you look in the topright corner of the window, you'll see the To section, which shows where they'll be stored on your computer (in my case here, on the left, they're going into my Pictures folder on my hard drive). If you click-and-hold on To, a menu pops up (as seen far right) that lets you choose your default Pictures folder, or you can choose another location, plus you can choose any recent folders you've saved into. Whatever you choose, if you look in the Destination panel below, it now displays the path to that folder on your computer, just so you can see where your photos are going. So now, at this point, you know three things: (1) the photos are coming from your memory card; (2) they're being copied from that card, not just moved; and (3) they're going into a folder you just chose in the To section. So far, so good.

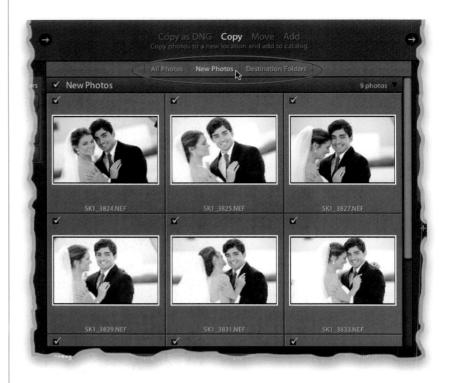

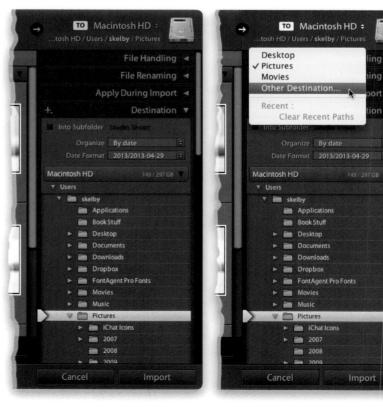

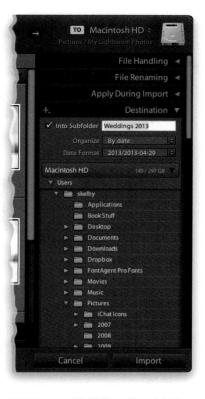

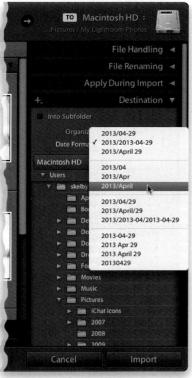

Step Nine:

Now, if you choose the My Lightroom Photos folder we created earlier as the place to store your photos—don't worry it's not just going to toss your images in there scattered all over the place. Instead, it will either put them in a folder organized by date, or you can have it create a folder for you, and name it whatever you like (which is what I do, so we'll start with that). Go to the Destination panel on the right side of the window, turn on the Into Subfolder checkbox (shown here), and a text field appears to the right where you can type in whatever name you want for your folder. So, in my case, I'd be importing my photos into a folder called "Weddings 2013" inside My Lightroom Photos. Personally, it makes it easy for me to keep track of my images by just naming my shoots exactly what they are, but some folks prefer to have everything sorted by year, or by month, and that's cool, too (and we'll cover that option in the next step).

Step 10:

To have Lightroom organize your photos into folders by date, first make sure the Into Subfolder checkbox is turned off, set the Organize pop-up menu to By Date, then click on the Date Format pop-up menu, and choose which date format you like best (they all start with the year first, because that is the main subfolder. What appears after the slash [/] is what the folder inside the 2013 folder will be named). So, if I chose the date format shown here, then my photos would be stored inside My Lightroom Photos, where I'd find a 2013 folder, and inside of that there would be another folder named "April." So, what you're really choosing from this list is the name of the folder that appears inside your new 2013 folder. By the way, if you choose a date option with no slash, it doesn't create a 2013 folder with another folder inside. Instead, it just creates one folder with that exact name (automatically using today's date, of course).

Step 11:

Okay, so now that you know where your files are coming from and going to, you can make a few important choices about what happens along the way in the File Handling panel (at the top right of the Import window). You choose, from the Render Previews pop-up menu, just how fast larger previews (larger sizes than just your thumbnails) will appear when you zoom in on a photo once it's in Lightroom. There are four choices:

(1) Minimal

Minimal doesn't worry about rendering previews of your images, it just puts 'em in Lightroom as quickly as it can, and if you double-click on a photo to zoom in to Fit in Window view, it builds the preview right then, which is why you'll have to wait just a few moments before this larger, higher-quality preview appears onscreen (you'll literally see a message appear onscreen that says "Loading"). If you zoom in even closer, to a 100% view (called a 1:1 view), you'll have to wait a few moments more (the message will read "Loading" again). That's because it doesn't create a higher-quality preview until you try to zoom in.

(2) Embedded & Sidecar

This method grabs the low-res JPEG thumbnails that are embedded in the files you're importing, too (the same ones you see on the back of your camera on the LCD screen), and once they load, it starts to load higher-resolution thumbnails that look more like what the higher-quality zoomed-in view will look like (even though the preview is still small).

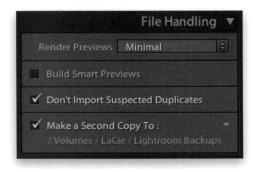

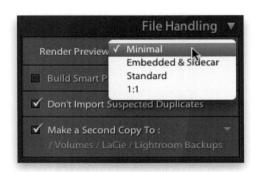

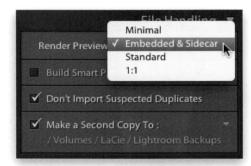

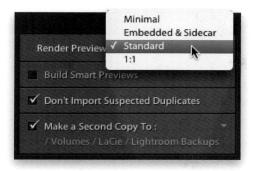

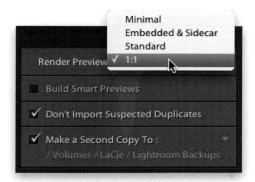

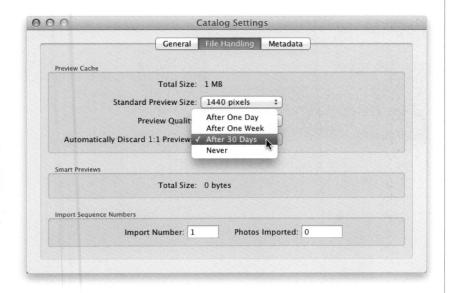

(3) Standard

The Standard preview takes quite a bit longer, because it renders a higher-resolution preview as soon as the low-res JPEG previews are imported, so you don't have to wait for it to render the Fit in Window preview (if you double-click on one in the Grid view, it zooms up to a Fit in Window view without having to wait for rendering). However, if you zoom in even closer, to a 1:1 view or higher, you'll get that same rendering message, and you'll have to wait a few seconds more.

(4) 1:1

The 1:1 (one-to-one) preview displays the low-res thumbnails, then starts rendering the highest-quality previews, so you can zoom in as much as you want with no waiting. However, there are two downsides: (1) It's notoriously slow. Basically, you need to click the Import button, then get a cup of coffee (maybe two), but you can zoom in on any photo and never see a rendering message. (2) These large, high-quality previews get stored in your Lightroom database, so that file is going to get very large. So large that Lightroom lets you automatically delete these 1:1 previews after a period of time (up to 30 days). If you haven't looked at a particular set of photos for 30 days, you probably don't need the high-res previews, right? You set this in Lightroom by going under the Lightroom (PC: Edit) menu and choosing Catalog Settings, then clicking on the File Handling tab and choosing when to discard (as shown here).

Note: Which one do I use? Minimal. I don't mind waiting a couple of seconds when I zoom in on an image. Besides, it only draws previews for the ones I double-click on, and I only double-click on the ones I think might be good (an ideal workflow for people who want instant gratification, like me). However, if you charge by the hour, choose 1:1 previews—it will increase your billable hours. (You know I'm joking, right?)

Step 12:

Below the Render Previews pop-up menu (and below Build Smart Previews; more on this coming up next) is a checkbox you should turn on to keep you from accidentally importing duplicates (files with the same name), but right below that is a checkbox that I feel is the most important one: Make a Second Copy To, which makes a backup copy of the photos you're importing on a separate hard drive. That way, you have a working set of photos on your computer (or external drive) that you can experiment with, change, and edit, knowing that you have the untouched originals (the digital negatives) backed up on a separate drive. I just can't tell you how important it is to have more than one copy of your photos. In fact, I won't erase my camera's memory card until I have at least two copies of my photos (one on my computer/external drive and one on my backup drive). Once you turn on the checkbox, click right below it and choose where you want your backup copies saved (or click the down-facing arrow on the right to choose a recent location).

Step 13:

The next panel down is File Renaming, which you use if you want to have your photos renamed automatically as they're imported. I always do this, giving my files a name that makes sense (in this case, something like Andrews Wedding, which makes more sense to me than _DSC0399. NEF, especially if I have to search for them). If you turn on the Rename Files checkbox, there's a pop-up menu with lots of different choices. I like to give my files a name, followed by a sequence of numbers (like Andrews Wedding 001, Andrews Wedding 002, etc.), so I choose Custom Name -**Sequence**, as seen here. Just by looking at the list, you can see how it will rename your files, so choose whichever one you like best, or create your own by choosing **Edit** at the bottom of the menu (I take you through that whole process on page 32).

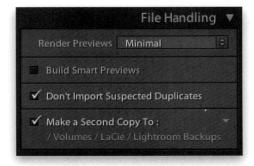

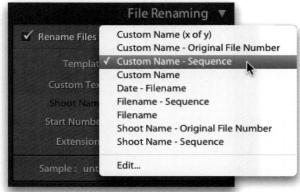

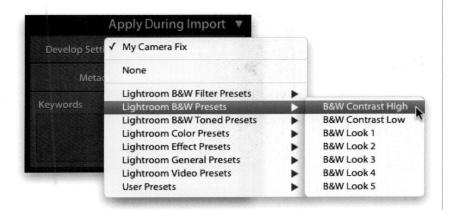

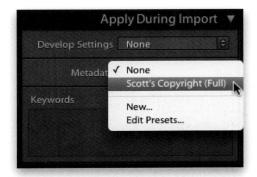

Step 14:

Right below that is a panel called Apply During Import, which is where you can apply three things to your images as they're imported. Let's start at the top. The Develop Settings pop-up menu lets you apply special effects or corrections automatically as your photos are imported. For example, you could have all your photos appear in Lightroom already converted to black and white, or they could all already be adjusted to be more red, or blue, or... whatever. If you click on the Develop Settings pop-up menu, you'll see a list of built-in presets that come with Lightroom and if you choose one, that look gets applied to your images as they're imported (you'll learn more about these, along with how to create your own custom Develop presets in Chapter 5, so for now, just leave the Develop Settings set to None, but at least you know what it does).

Step 15:

The next pop-up menu, Metadata, is where you can embed your own personal copyright and contact info, usage rights, captions, and loads of other information right into each file as it's imported. You do this by first entering all your info into a template (called a metadata template), and then when you save your template, it appears in the Metadata pop-up menu (as shown here). You're not limited to just one template—you can have different ones for different reasons if you like (like one of just your copyright info, and another with all your contact info, as well). I show you, step by step, how to create a metadata template on page 40 of this chapter, so go ahead and jump over there now and create your first metadata template, then come right back here and choose your copyright template from this pop-up menu. Go ahead. I'll wait for you. Really, it's no bother. (Note: I embed my copyright info into every photo [well, at least the ones I actually shot] using a metadata template like this while importing.)

Step 16:

At the bottom of the Apply During Import panel is a field where you can type in keywords, which is just a fancy name for search terms (words you'd type in if, months later, you were searching for the photos you're now importing). Lightroom embeds these keywords right into your photos as they're imported, so later you can search for (and actually find) them by using any one of these keywords. At this stage of the game, you'll want to use very generic keywords—words that apply to every photo you're importing. For example, for these wedding photos, I clicked in the Keywords field, and typed in generic keywords like Wedding, Bride, Groom, Outdoors, and St. Petersburg (where the wedding was held). Put a comma between each search word or phrase, and just make sure the words you choose are generic enough to cover all the photos (in other words, don't use Kiss, because they're not kissing in every photo).

Step 17:

I mentioned this earlier, but at the bottom right of the Import window is the Destination panel, which just shows again exactly where your photos are going to be stored once they're imported from your memory card. At the top left of this panel is a + (plus sign) button and if you click on it, there's a pop-up menu (shown here) where you can choose to Create New Folder, which actually creates a new folder on your computer at whatever location you choose (you can click on any folder you see to jump there). While you're in that menu, try the Affected Folders Only command to see a much simpler view of the path to the folder you've chosen (as seen here—this is the view I use, since I always store my photos within the My Lightroom Photos folder. I don't like to see all those other folders all the time, so this just hides them from view until I choose otherwise).

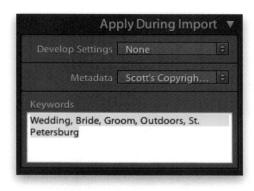

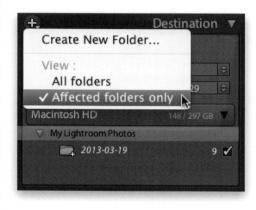

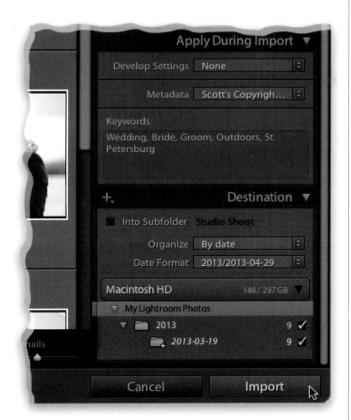

Step 18:

Now you're set—you've chosen where the images are coming from and where they're going, and how fast you'll be able to view larger previews when they appear in Lightroom. You've added your own custom name to the images, embedded your copyright info, and added some search terms. All that's left to do is click the Import button in the bottom-right corner of the Import window (as shown here) to get the images into Lightroom. If this seems like a lot of work to go through, don't worry—you've created custom file naming and metadata presets (templates), remember? (You'll be surprised at how many presets you can create in Lightroom to make your workflow faster and more efficient. You'll see as we go on. Presets rule! As a matter of fact, you can turn to page 20 before you click Import to learn how to save this as an Import preset.)

Using Smart Previews to Work Without an External Hard Drive Attached

In the past, if you stored your images on an external hard drive (which is pretty common since internal hard drives tend to get filled up pretty fast these days), and you disconnected that drive, you couldn't edit your images any longer. Sure, you could still see their thumbnails, and move them around into different collections and stuff, but you couldn't edit them in the Develop module—changing things like Exposure or White Balance, and so on. Well, that's no longer the case with the new Smart Previews feature in Lightroom 5. Here's how it works:

Step One:

To be able to still edit your images when they're "offline" (the external hard drive with your images is not currently attached to your computer or laptop), you need to turn this feature on in the Import window. Just turn on the Build Smart Previews checkbox in the top-right corner (in the File Handling panel; it's shown circled here in red).

Step Two:

Once your images are imported, click on one of your images, then look right underneath the histogram at the top right and you'll see "Original + Smart Preview," which lets you know that you're seeing the real original image (since the hard drive with the real original file is connected—look over in the left side Panels area here, in the Folders panel, and you'll see "Scott's Ext Drive 2" listed as one of my mounted drives), but that the image also has a smart preview.

TIP: Smart Previews After Importing If you forgot to turn on the Build Smart Previews checkbox on import, no sweat. In the grid, just select the photos you want to have smart previews, then go under the Library menu, under Previews, and choose **Build Smart Previews.**

Step Three:

Now let's put this Smart Previews feature to work: Go ahead and eject your external drive (the one with these photos on it). You'll notice that over in the Folders panel, your external hard drive is now grayed out (since it has been ejected, it's no longer available, right?), and you'll see a gray rectangle above the top-right corner of each thumbnail (instead of the question mark icon that used to appear there in previous versions of Lightroom when your image was unavailable, although if you don't create smart previews, you'll now see an exclamation point icon). That rectangle is letting you know that what you're seeing is a smart preview. Also, take a look under the histogram now. It no longer reads Original + Smart Preview because the original image has been ejected. Now, it just reads "Smart Preview."

Step Four:

Press **D** to jump over to the Develop module, and now you can edit the photo any way you'd like (adjust the Exposure, White Balance, use the Adjustment Brush—you name it), just as if the original was connected (how handy is that?!). No more carrying a bunch of drives with you when you go on the road. The nice thing is that when you do plug that external drive back into your computer, it automatically updates the real files with your changes. So, what's the downside to this? Why would you ever not make smart previews? Well, it stores those previews in your catalog, so it makes your catalog's file size a lot bigger. For example, by importing these 12 images with smart previews, it added 4 megabytes to my catalog (and to my hard drive). That doesn't sound like that much, but remember—that's just 12 images.

TIP: Deleting Smart Previews
If you don't need the smart previews for a particular group of images, just select them and then go under the Library menu, under Previews, and choose
Discard Smart Previews.

Importing Photos Already on Your Computer

Importing photos that are already on your computer is a breeze compared to importing them from a memory card, because so many decisions have already been made (after all, they're already on your computer, so you don't have to worry about where to store them, they're already named, etc.). Plus, since your computer's hard drive is much faster than even the fastest memory card, they zoom into Lightroom faster than a greased pig (I've been waiting for a legitimate way to work "greased pig" into a sentence for quite some time now).

Step One:

If the images are already on your computer, just go under Lightroom's File menu and choose Import Photos and Video or press Command-Shift-I (PC: Ctrl-Shift-I) to bring up the Import window. In the Source list on the left side, find the folder on your computer that has the photos you want to import. When you click on that folder, you'll see thumbnails of the images in that folder (if you see a much smaller version of the window shown here, just click the arrow in the bottom-left corner to expand it to what you see here, complete with thumbnails). To change the size of the thumbnails, drag the Thumbnails slider at the bottom right of the Preview area. By default, all the photos in that folder will be imported, but if there are any you don't want imported, just turn off the checkbox at the top left of each of those photos.

Step Two:

Since you're just adding these photos to Lightroom, you can leave them right where they currently are on your computer and just import them by clicking on Add at the top of the Import window (as shown here). Now, back at the beginning of this chapter, I talked about how important it was to have your images all within one main folder. So, if for some reason, these photos are somewhere else on your computer, click on Move instead, and then over in the Destination panel on the right side of the window, choose your My Lightroom Photos folder.

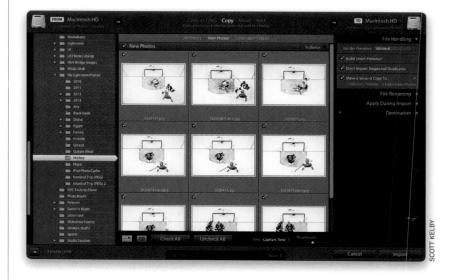

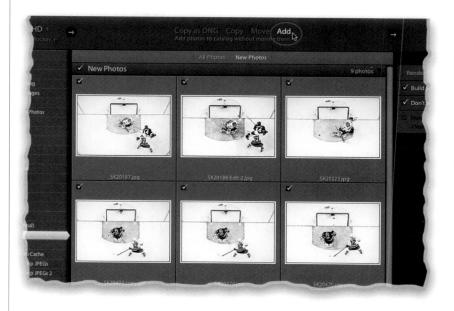

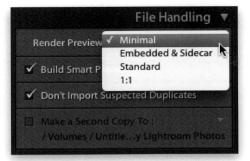

Apply During Import ▼ Develop Settings None Metadata Scott's Copyrigh... Keywords Hockey, NHL, Tampa Bay Lightning, Carolina Hurricanes, Tampa Bay Times Forum

Step Three:

Since the photos are already on your computer, there's very little you have to do in the rest of the Import window (in fact, most of the other stuff you'd have to do when importing from your camera's memory card is hidden). However, you should go to the File Handling panel on the right and decide how quickly you want your images to appear once they're in Lightroom and you zoom in on them. You do this in the Render Previews pop-up menu. If you jump back to page 10, Step 11, I describe what these four Render Previews choices do, and how to choose the one that's right for you. Also, I recommend leaving the checkbox turned on for Don't Import Suspected Duplicates, just so you don't import two copies of the same image.

Step Four:

There's one other set of options you need to know about: the Apply During Import panel settings (also on the right side of the window). I explain these on page 13, starting in Step 14, so jump back there, check those out, make your choices, and that's about it—you're ready to hit the Import button and bring those photos into Lightroom faster than a....well...ya know.

Save Time Importing Using Import Presets (and a Compact View)

If you find yourself using the same settings when importing images, you're probably wondering, "Why do I have to enter this same info every time I import?" Luckily, you don't. You can just enter it once, and then turn those settings into an Import preset that remembers all that stuff. Then, you can choose the preset, add a few keywords, maybe choose a different name for the subfolder they're being saved into, and you're all set. In fact, once you create a few presets, you can skip the full-sized Import window altogether and save time by using a compact version instead. Here's how:

Step One:

We'll start by setting up your import settings, just like always. For this example, we'll assume you're importing images from a memory card attached to your computer, and you're going to copy them into a subfolder inside your Pictures folder, and then have it make a backup copy of the images to an external hard drive (a pretty common import setup, by the way). We'll have your copyright info added as they're imported, and we'll choose Minimal Render Previews, so the thumbnails show up fast. Go ahead and set that up now (or just set it up the way you actually would for your own workflow).

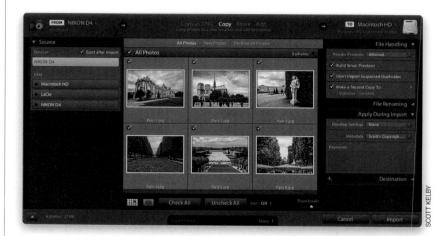

Step Two:

Now go to the bottom center of the Import window, where you'll see a thin black bar, and the words "Import Preset" on the far left. On the far right, click-and-hold on None and, from the pop-up menu that appears, choose **Save Current Settings as New Preset** (as shown here). You might want to save a second preset for importing images that are already on your hard drive, too. Okay, that's the hard part. Now let's put it to work.

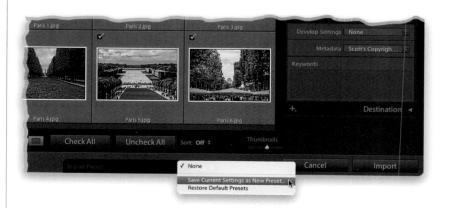

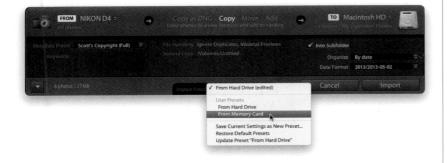

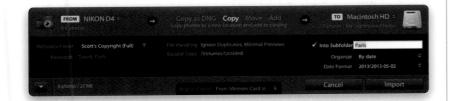

Step Three:

Click the Show Fewer Options button (it's the up-facing arrow) in the bottomleft corner of the Import window, and it switches to the compact view (as seen here). The beauty of this smaller window is: you don't need to see all those panels, the grid, and all that other stuff, because you've already saved most of the info you'll need to import your photos as a preset. So, from now on, your Import window will appear like this (in the compact view), and all you have to do is choose your preset from the pop-up menu at the bottom (as shown here, where I'm choosing my From Memory Card preset), and then enter just the few bits of info that do change when you import a new set of photos (see the next step). Note: You can return to the fullsize Import window anytime by clicking the Show More Options button (the downfacing arrow) in the bottom-left corner.

Step Four:

Across the top of the Minimal Import window, you can see that same visual 1-2-3 roadmap we saw in the full-size Import window on page 5 of where your images are coming from, what's going to happen to them, and where they're going, complete with arrows leading you from left to right. The images here are (1) coming from your card reader, (2) then they are being copied, and (3) these copies are being stored in a folder on your hard drive. In the middle section, you can add any keywords that would be specific to these images (which is why I leave this field blank when I save my Import presets. Otherwise, I'd see keywords here from the previous import). Then, it shows your preferences for file handing and backing up a second copy of your images. On the right, you can name the subfolder these images are going to be saved into. So, how does this save you time? Well, now you only have to type in a few keywords, give your subfolder a name, and click the Import button. That's fast and easy!

Importing Video from Your DSLR

You can hardly find a new DSLR these days that doesn't include the ability to shoot high-definition video, so we're lucky that Lightroom 5 lets you import this video. Besides adding metadata, sorting them in collections, adding ratings, labels, Pick flags, and so on, you really can't do much video editing per se (see Chapter 12 for more on what you can do with them), but at least now these are no longer invisible files in our workflow (plus you can easily preview them). Here's how it works:

Step One:

When you're in the Import window, you'll know which files are video files because they'll have a little movie camera icon in the bottom-left corner of the thumbnail (shown circled here in red). When you click the Import button, these video clips will import into Lightroom and appear right alongside your still images (of course, if you don't want these videos imported, turn off their checkboxes in the top-left corner of their thumbnail cell).

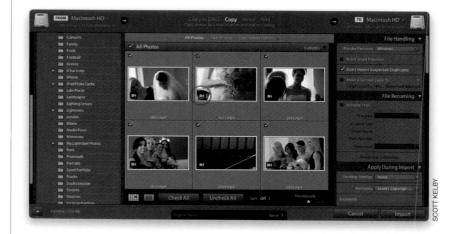

Step Two:

Once the video clip has been imported into Lightroom, in the Grid view, you'll no longer see the movie camera icon, but you'll see the length of the clip in the bottom-left corner of it. You can see a larger view of the first frame by just selecting the video, then pressing the **Spacebar** on your computer or clicking on that time stamp.

If you want to see a preview of the video, once you're in Loupe view, click the Play button beneath the video (it turns into a Pause button) and it plays the video clip. Also, you can export your video clips from Lightroom (just be sure to turn on the Include Video Files checkbox in the Video section of the Export dialog).

TIP: Program for Editing DSLR Video Adobe's latest version of Premiere Pro has built-in support for editing DSLR video, so if you're really into this stuff, at least go download the free 30-day trial from www.adobe.com.

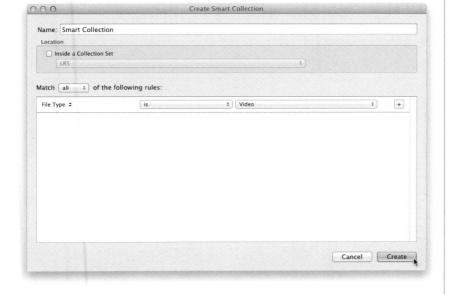

Step Four:

If you want to organize all your video clips into one central location, create a smart collection to do it for you. In the Collections panel, click on the + (plus sign) button on the right side of the panel header and choose Create Smart Collection from the pop-up menu. When the dialog appears, from the first pop-up menu on the left, under File Name/Type, choose File Type, from the second menu choose Is, and from the third choose Video. Name your smart collection and click the Create button, and it gathers all your video clips and puts them in a smart collection, but best of all, this collection updates live anytime you import a video clip, it's also added to your new smart collection of video clips.

Shooting Tethered (Go Straight from Your Camera, Right Into Lightroom)

One of my favorite features in Lightroom is the built-in ability to shoot tethered (shooting directly from your camera into Lightroom), without using third-party software, which is what we used to do. The advantages are: (1) you can see your images much bigger on your computer's screen than on that tiny LCD on the back of the camera, so you'll make better images; and (2) you don't have to import after the shoot—the images are already there. Warning: Once you try this, you'll never want to shoot any other way.

Step One:

The first step is to connect your camera to your computer using that little USB cable that came with your camera. (Don't worry, it's probably still in the box your camera came in, along with your manual and some other weird cables that come with digital cameras. So, go look there for it.) Go ahead and connect your camera now. In the studio, and on location, I use the tethered setup you see here (which I learned about from world-famous photographer Joe McNally). The bar is the Manfrotto 131DDB Tripod Accessory Arm, with a TetherTools Aero Traveler Tether Table attached.

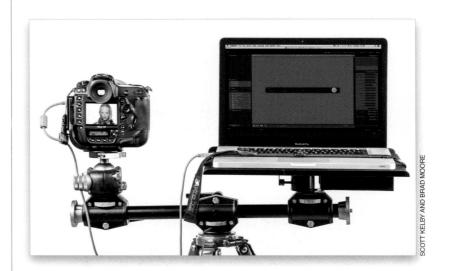

Step Two:

Now go under Lightroom's File menu, under Tethered Capture, and choose **Start Tethered Capture**. This brings up the dialog you see here, where you enter pretty much the same info as you would in the Import window (you type in the name of your shoot at the top in the Session Name field, and you choose whether you want the images to have a custom name or not. You also choose where on your hard drive you want these images saved to, and if you want any metadata or keywords added—just like usual). However, there is one important feature here that's different—the Segment Photos By Shots checkbox (shown circled in red here) which can be incredibly handy when you're shooting tethered (as you'll see).

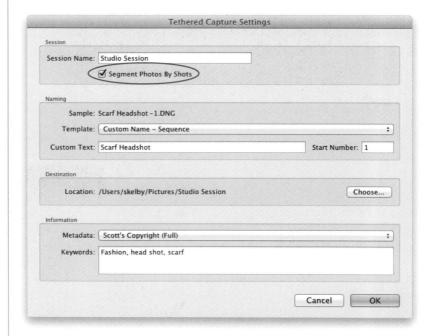

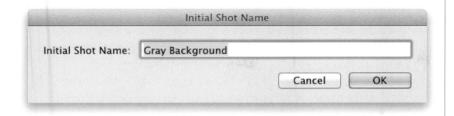

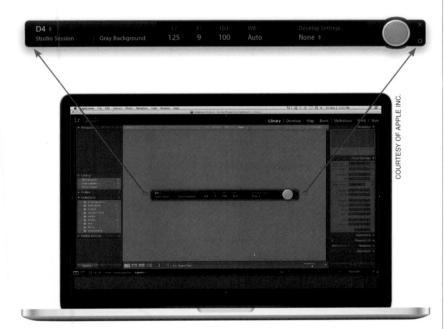

The Segment Photos By Shots feature lets you organize your tethered shots as you go. So, let's say you're doing a fashion shoot, and you're using two different lighting setups—one where your background is gray and one where it's white. You can separate each of these different looks into different folders by clicking the Shot Name (this will make more sense in a moment). Try it out by turning on the Segment Photos By Shot checkbox and clicking OK. When you do this, a naming dialog appears (shown here), where you can type in a descriptive name for the first shoot of your session.

Step Four:

When you click OK, the Tethered Capture window appears (seen here), and if Lightroom sees your camera, your camera model's name will appear on the left (if you have more than one camera connected, you can choose which one you want to use by clicking on the camera's name and choosing from the pop-up menu). If Lightroom doesn't see your camera, it'll read "No Camera Detected," in which case you need to make sure your USB cable is connected correctly, and that Lightroom supports your camera's make and model. To the right of the camera's model, you'll see the camera's current settings, including shutter speed, f-stop, and ISO. To the right of that, you can apply a Develop module preset (see Chapter 5 for more on those, but for now, leave it set at None).

TIP: Hiding or Shrinking the Tethered Capture Window

Press **Command-T** (**PC: Ctrl-T**) to show/ hide it. If you want to keep it onscreen, but you want it smaller (so you can tuck it to the side of your screen), press-and-hold the Option (PC: Alt) key and the little X in the top right that you'd click on to close the window changes into a – (minus sign). Click on that and the window shrinks down to just the shutter button. To bring it back full size, Option-click (PC: Alt-click) in the top right again.

Step Five:

The round button on the right side of the Tethered Capture window is actually a shutter button, and if you click on it, it'll take a photo just as if you were pressing the shutter button on the camera itself (pretty slick). When you take a shot now, in just a few moments, the image will appear in Lightroom. The image doesn't appear quite as fast in Lightroom as it does on the back of the camera, because you're transferring the entire file from the camera to the computer over that USB cable (or wireless transmitter, if you have one connected to your camera), so it takes a second or two. Also, if you shoot in JPEG mode, the file sizes are much smaller, so your images appear in Lightroom much faster than RAW images. Here's a set of images taken during a tethered shoot. The problem is if you view them in the Library module's Grid view like this, they're not much bigger than the LCD on the back of your camera. Note: Canon and Nikon react to tethering differently. For example, if you shoot Canon, and you have a memory card in the camera while shooting tethered, it writes the images to your hard drive and the memory card, but Nikons write only to your hard drive.

Step Six:

Of course, the big advantage of shooting tethered is seeing your images really large (you can check the lighting, focus, and overall result much easier at these larger sizes, and clients love it when you shoot tethered when they're in the studio, because they can see how it's going without looking over your shoulder and squinting to see a tiny screen). So, double-click on any of the images to jump up to Loupe view (as shown here), where you get a much bigger view as your images appear in Lightroom. (Note: If you do want to shoot in Grid view, and just make your thumbnails really big, then you'll probably want to go to the toolbar and, to the left of Sort Order, click on the A-Z button, so your most recent shot always appears at the top of the grid.

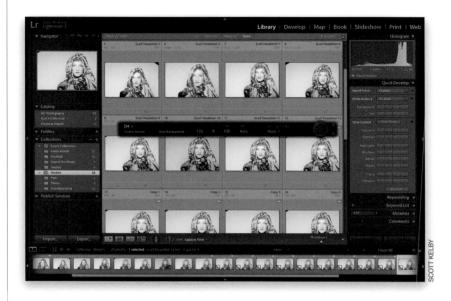

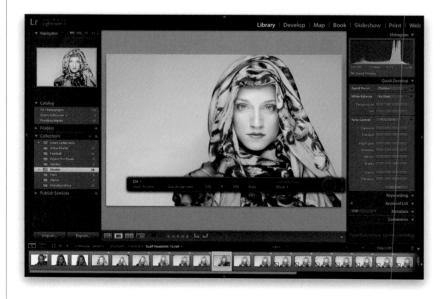

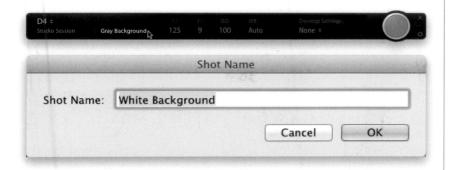

Step Seven:

Now let's put that Segment Photos By Shot feature to use. Let's say you finish this round of shots with your subject in the first lighting setup (the gray background) and now you want to switch to the other. Just click directly on the words "Gray Background" in the Tethered Capture window (or press Command-Shift-T [PC: Ctrl-Shift-T]) and the Shot Name dialog appears. Give this new set of shots a name (I named mine "White Background") and then go back to shooting. Now these images will appear in their own separate folder, but all within my main Studio Session folder.

TIP: Shortcut for Triggering **Tethered Capture**

They added this in Lightroom 5 and as somebody who uses tethering a lot, I was happy to see that you can now trigger a tethered capture by pressing F12 on your keyboard.

Step Eight:

When I'm shooting tethered (which I always do when I'm in the studio, and as often as I can on location), rather than looking at the Library module's Loupe view, I switch to the Develop module, so if I need to make a quick tweak to anything, I'm already in the right place. Also, when shooting tethered, my goal is to make the image as big as possible onscreen, so I hide Lightroom's panels by pressing **Shift-Tab**, which enlarges the size of your image to take up nearly the whole screen. Then lastly, I press the letter L twice to enter Lights Out mode, so all I see is the full-screen-sized image centered on a black background, with no distractions (as shown here). If I want to adjust something, I press L twice, then Shift-Tab to get the panels back.

Using Image Overlay to See if Your Images Fit Your Layout

This is one of those features that once you try it, you fall in love with it, because it gives you the opportunity to make sure an image you're shooting for a specific project (like a magazine cover, brochure cover, inside layout, wedding book, etc.) looks and fits the way you want it to, because you get to see the artwork as an overlay in front of your image as you're shooting tethered. This is a big time and frustration saver, and it's simple to use (you just need a little tweaking in Photoshop to set up your artwork).

Step One:

You'll need to start in Photoshop by opening the layered version of the cover (or other artwork) you want to use as an overlay in Lightroom. The reason is this: you need to make the background for the entire file transparent, leaving just the type and graphics visible. In the cover mock-up we have here, the cover has a solid gray background (of course, once you drag an image in there inside of Photoshop, it would simply cover that gray background). We need to prep this file for use in Lightroom, which means: (a) we need to keep all our layers intact, and (b) we need to get rid of that solid gray background (more likely, you'll have a solid white background, but that looked weird with all this white type, so I filled it with gray so it was easier to see).

Step Two:

Luckily, prepping this for Lightroom couldn't be simpler: (1) Go to the Background layer (the solid gray layer in this case), and delete that layer by dragging it onto the Trash icon at the bottom of the Layers panel (as shown here). Now, (2) all you have to do is go under the File menu, choose Save As, and when the Save As dialog appears, from the Format pop-up menu (where you choose the file type to save it in), choose PNG. This format lets you keep the layers intact and, since you deleted the solid gray background layer, it makes the background transparent (as seen here). By the way, in the Save As dialog, it will tell you that it has to save a copy to save in PNG format, and that's fine by us, so don't sweat it.

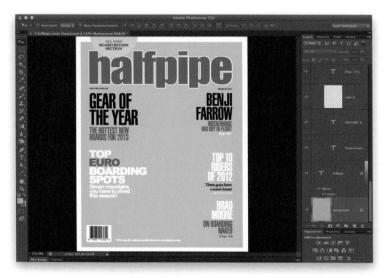

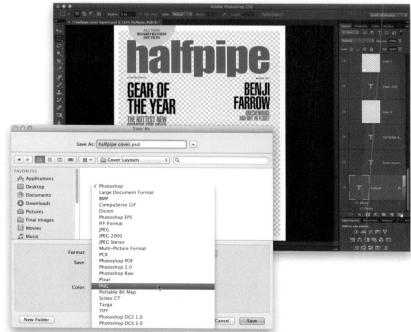

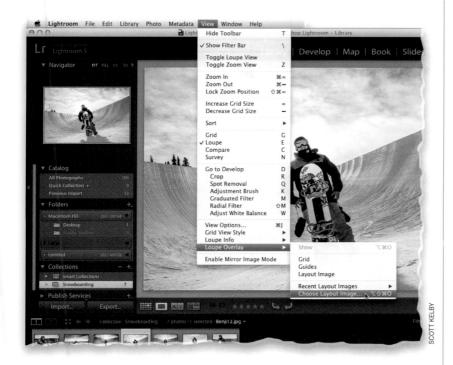

That's all you have to do in Photoshop, so head back over to Lightroom and go to the Library module. Now, go under the View menu, under Loupe Overlay, and select **Choose Layout Image** (as shown here). Then, find that layered PNG file you just created in Photoshop and choose it.

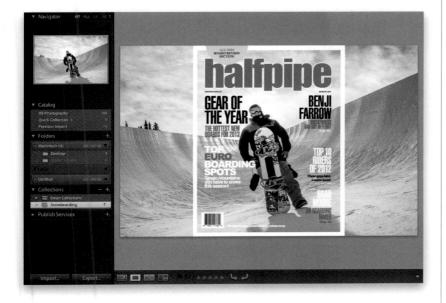

Step Four:

Once you select Choose Layout Image, your cover appears over whichever image you currently have onscreen (as shown here). To hide the cover, go under the same Loupe Overlay menu, and you'll see that Layout Image has a checkmark by it, letting you know it's visible. Just choose Layout Image to hide it from view. To see it again, choose it again. Or press Command-Option-O (PC: Ctrl-Alt-O) to show/hide it. Remember, if you hadn't deleted the Background layer, what you'd be seeing here is a bunch of text over a gray background (and your image would be hidden). That's why it's so important to delete that background layer and save in PNG format. Okay, let's roll on, because there are a few more features here you'll want to know about.

Step Five:

Now that your Image Overlay is in place, you can use the Left/Right Arrow keys on your keyboard to try different images on your cover (or whatever file you used). Here's what it would look like with a different shot.

Step Six:

When you look at the image in the previous step, did you notice that he's positioned off to the right a little bit? Luckily, you can reposition the cover to see what it would look like with him right in the center. Just press-and-hold the Command (PC: Ctrl) key and your cursor changes into the grabber hand (shown circled here in red). Now, just click-and-drag on the cover and it moves left/right and up/down. What's kind of weird at first is that it doesn't move your image inside the cover. It actually moves the cover. It takes a little getting used to at first, but then it becomes second nature.

Step Seven:

You can control the Opacity level of your Overlay Image, as well (I switched to a different image here). When you pressand-hold the Command (PC: Ctrl) key, two little controls appear near the bottom of the Overlay Image. On the left is Opacity, and you just click-and-drag to the left directly on the word "Opacity" to lower the setting (as seen here, where I've lowered our cover image to 46%). To raise the Opacity back up, drag back to the right.

Web

Step Eight:

The other control I actually think is more useful, which is the Matte control. You see, in the previous step, how the area surrounding the cover is solid black? Well, if you lower the Matte amount, it lets you see through that black background, so you can see the rest of your image that doesn't appear inside the overlay area. Take a look at the image here. See how you can see the background outside the cover? Now I know that this image has room for me to move him either left or right, and parts of him are still there. Pretty handy, and it works the same as the Opacity control—pressand-hold the Command key and clickand-drag right on the word "Matte."

Creating Your Own Custom File Naming Templates

Staying organized is critical when you have thousands of photos, and because digital cameras generate the same set of names over and over, it's really important that you rename your photos with a unique name right during import. A popular strategy is to include the date of the shoot as part of the new name. Unfortunately, only one of Lightroom's import naming presets includes the date, and it makes you keep the camera's original filename along with it. Luckily, you can create your own custom file naming template just the way you want it. Here's how:

Step One:

Start in the Library module, and click on the Import button on the bottom-left side of the window (or use the keyboard shortcut Command-Shift-I [PC: Ctrl-Shift-I]). When the Import window appears, click on Copy as DNG or Copy at the top center, and the File Renaming panel will appear on the right side. In that panel, turn on the Rename Files checkbox, then click on the Template pop-up menu and choose Edit (as shown here) to bring up the Filename Template Editor (shown below in Step Two).

Step Two:

At the top of the dialog, there is a pop-up menu where you can choose any of the built-in naming presets as a starting place. For example, if you choose Custom Name -Sequence, the field below shows two blue tokens (that's what Adobe calls them; on a PC, the info appears within braces) that make up that preset: the first represents the text, the second represents the auto numbering. To remove either token, click on it, then press the Delete (PC: Backspace) key on your keyboard. If you want to just start from scratch (as I'm going to do), delete both tokens, choose the options you want from the pop-up menus below, then click the Insert buttons to add them to the field.

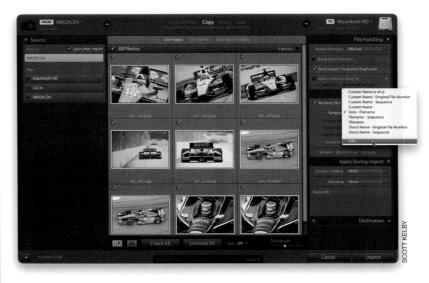

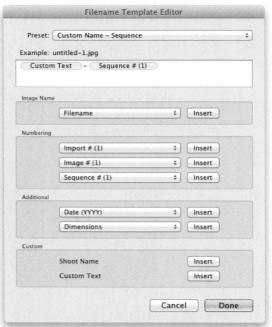

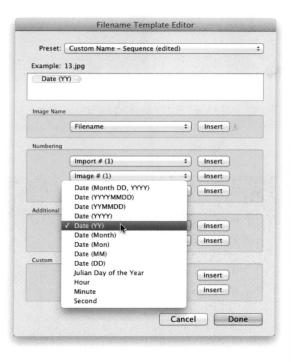

Filename Template Editor Preset: Custom Name - Sequence (edited) + Example: 1305.jpg Date (YY) Date (MM) Image Name Filename Insert Date (Month DD, YYYY) Insert Date (YYYYMMDD) Insert Date (YYMMDD) Date (YYYY) Insert Date (YY) Date (Month) Additional Date (Mon) ✓ Date (MM) Insert Date (DD) Insert Julian Day of the Year Hour Custom Minute Second Insert **Custom Text** Insert Done Cancel

Step Three:

I'm going to show you the setup for a popular file naming system for photographers, but this is only an example you can create a custom template later that fits your studio's needs. We'll start by adding the year first (this helps keep your filenames together when sorted by name). To keep your filenames from getting too long, I recommend using just the last two digits of the year. So go to the Additional section of the dialog, click on the pop-up menu, and choose Date (YY), as shown here (the Y lets you know this is a year entry, the YY lets you know it's only going to display two digits). The Date (YY) token will appear in the naming field and if you look above the top-left side of it, you'll see a live example of the name template you're creating. At this point, my new filename is 13.jpg, as seen here.

Step Four:

After the two-digit year, we add the two-digit month the photo was taken by going to the same pop-up menu, but this time choosing **Date (MM)**, as shown here. (Both of these dates are drawn automatically from the metadata embedded into your photo by your digital camera at the moment the shot was taken.) By the way, if you had chosen Date (Month), it would display the entire month name, so your filename would have looked like this: 13May, rather than what we want, which is 1305.

Step Five:

Before we go any further, you should know there's a rule for file naming, and that's no spaces between words. However, if everything just runs together, it's really hard to read. So, after the date, you're going to add a visual separator—a thin flat line called an underscore. To add one, just click your cursor right after the Date (MM) token, then press the Shift key and the Hyphen key to add an underscore (seen here). Now, here's where I differ from some of the other naming conventions: after the date, I include a custom name that describes what's in each shoot. This differs because some people choose to have the original camera-assigned filename appear there instead (personally, I like to have a name in there that makes sense to me without having to open the photo). So to do that, go to the Custom section of the dialog and to the right of Custom Text, click the Insert button (as shown here) to add a Custom Text token after your underscore (this lets you type in a one-word text description later), then add another underscore (so it looks like Custom Text . In your example up top, though, it will say "untitled" until you add your custom text).

Step Six:

Now you're going to have Lightroom automatically number these photos sequentially. To do that, go to the Numbering section and choose your numbering sequence from the third pop-up menu down. Here I chose the Sequence # (001) token, which adds three-digit autonumbering to the end of your filename (you can see the example above the naming field).

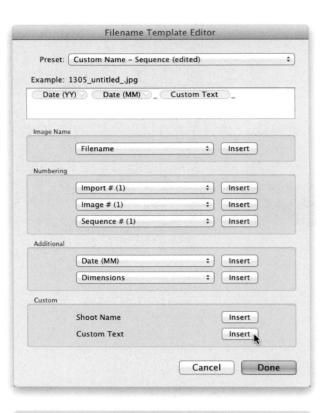

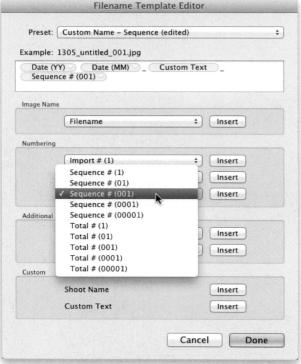

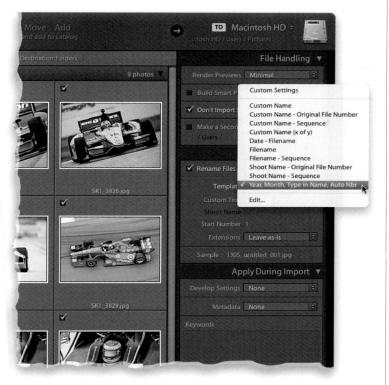

Make a Second Copy To: File Renaming ▼ Template Year, Month, Ty... + Custom Text GrandPrixFinals Apply During Import ▼ Metadata Scott's Copyrigh... + Organize By date Sort: Off \$

Step Seven:

Once the little naming example looks right to you, go under the Preset pop-up menu, and choose Save Current Settings as New Preset. A dialog will appear where you can name your preset. Type in a descriptive name (so you'll know what it will do the next time you want to apply it—I chose "Year, Month, Type in Name, Auto Nbr"), click Create, and then click Done in the Filename Template Editor. Now, when you go to the Import window and click on the File Renaming panel's Template pop-up menu, you'll see your custom template as one of the preset choices (as shown here).

Web

Step Eight:

After you choose this new naming template from the Template pop-up menu, click below it in the Custom Text field (this is where that Custom Text token we added earlier comes into play) and type in the descriptive part of the name (in this case, I typed in "GrandPrixFinals," all one word—no spaces between words). That custom text will appear between two underscores, giving you a visual separator so everything doesn't all run together (see, it all makes sense now). Once you type it in, if you look at the Sample at the bottom of the File Renaming panel, you'll see a preview of how the photos will be renamed. Once you've chosen all your Apply During Import and Destination panel settings, you can click the Import button.

Choosing Your Preferences for Importing Photos

I put the import preferences toward the end of the Importing chapter because I figured that, by now, you've imported some photos and you know enough about the importing process to know what you wish was different. That's what preferences are all about (and Lightroom has preference controls because it gives you lots of control over the way you want to work).

Step One:

The preferences for importing photos are found in a couple different places. First, to get to the Preferences dialog, go under the Lightroom menu on a Mac or the Edit menu on a PC, and choose **Preferences** (as shown here).

Step Two:

When the Preferences dialog appears, first click on the General tab up top (shown highlighted here). Under Import Options in the middle, the first preference lets you tell Lightroom how to react when you connect a memory card from your camera to your computer. By default, it opens the Import window. However, if you'd prefer it didn't automatically open that window each time you plug in a camera or card reader, just turn off its checkbox (as shown here). The second preference here is new in Lightroom 5. In all previous versions, if you used the keyboard shortcut to start importing photos while in another module, Lightroom left whatever you were working on and jumped over to the Library module to show you the images as they were importing (basically, it assumed you wanted to stop working on whatever you were doing, and start working on these currently importing images). Now, you can choose to stay in the folder or collection you are in and just have those images import in the background by turning off the Select the "Current/Previous Import" Collection During Import checkbox.

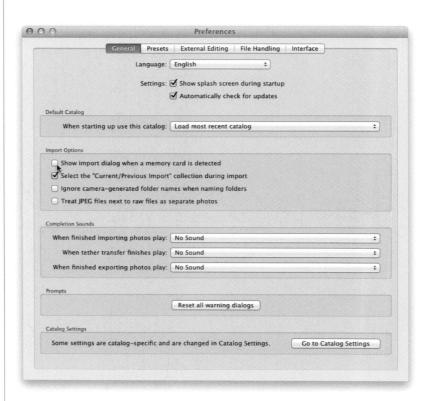

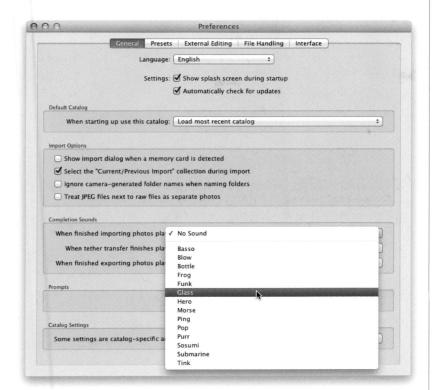

There are two other importing preference settings I'd like to mention that are also found on the General tab. In the Completion Sounds section, you not only get to choose whether or not Lightroom plays an audible sound when it's done importing your photos, you also get to choose which sound (from the pop-up menu of system alert sounds already in your computer, as seen here).

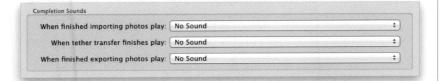

Step Four:

While you're right there, directly below the menu for choosing an "importing's done" sound are two other pop-up menus for choosing a sound for when your tether transfer finishes and for when your exporting is done. I know, the second one isn't an importing preference, but since we're right there, I thought...what the heck. I'll talk more about some of the other preferences later in the book, but since this chapter is on importing, I thought I'd better tackle these here.

Step Five:

Now, at the bottom of the General tab, click the Go to Catalog Settings button (also found under the Lightroom [PC: Edit] menu). In the Catalog Settings dialog, click on the Metadata tab. Here you can determine whether you want to take the metadata you add to your RAW photos (copyright, keywords, etc.) and have it written to a totally separate file, so then for each photo you'll have two files—one that contains the photo itself and a separate file (called an XMP sidecar) that contains that photo's metadata. You do this by turning on the Automatically Write Changes into XMP checkbox, but why would you ever want to do this? Well, normally Lightroom keeps track of all this metadata you add in its database file—it doesn't actually embed the info until your photo leaves Lightroom (by exporting a copy over to Photoshop, or exporting the file as a JPEG, TIFF, or PSD—all of which support having this metadata embedded right into the photo itself). However, some programs can't read embedded metadata, so they need a separate XMP sidecar file.

Step Six:

Now that I've shown you that Automatically Write Changes into XMP checkbox, I don't actually recommend you turn it on, because writing all those XMP sidecars takes time, which slows Lightroom down. Instead, if you want to send a file to a friend or client and you want the metadata written to an XMP sidecar file, first go to the Library module and click on an image to select it, then press Command-S (PC: Ctrl-S), which is the shortcut for Save Metadata to File (which is found under the Metadata menu). This writes any existing metadata to a separate XMP file (so you'll need to send both the photo and the XMP sidecar together).

I mentioned that you have the option of having your photos converted to DNG (Digital Negative) format as they're imported. DNG was created by Adobe because today each camera manufacturer has its own proprietary RAW file format, and Adobe is concerned that, one day, one or more manufacturers might abandon an older format for something new. With DNG, it's not proprietary—Adobe made it an open format, so anyone can write to that specification. While ensuring that your negatives could be opened in the future was the main goal, DNG brings other advantages, as well.

The Adobe DNG File **Format Advantage**

	General Presets	External Editing File Handling In	terface
mport DNG Creation			
	File Extension:	dng ÷	
	Compatibility:	Camera Raw 6.6 and later \$	
	JPEG Preview:	Medium Size ‡	
	(♂ Embed Fast Load Data	
	(Embed Original Raw File	
Reading Metadata			
	a keyword separator	During import or when reading metadata Lightro	oom can recognize
	a keyword separator	dot, forward slash, and backslash separated key hierarchies instead of flat keywords. The vertical	words as keyword bar is automatically
		recognized as a hierarchy separator.	
ile Name Generatio	1		
Treat the follo	owing characters as illeg	gal: (/: +)	
Replace illegal	file name characters wi	ith: Dashes (-) 💠	
Whe	en a file name has a spa	ce: Leave As-Is 💠	
Camera Raw Cache S	ettings		
Location	: /Users/skelby/Library	/Caches/Adobe Camera Raw	Choose
	: 1.0 GB		Purge Cache
Maniana Cina	. 1.0 GB		Turge cache
Maximum Size			
Maximum Size			
		Maximum Size: 3.0	GB Purge Cache

Setting Your DNG Preferences: Press Command-, (comma; PC: Ctrl-,) to bring up Lightroom's Preferences dialog, then click on the File Handling tab (as shown here). In the Import DNG Creation section at the top here, you can see the settings I use for DNG conversion. Although you can embed the original proprietary RAW file, I don't (it adds to the file size, and pretty much kills Advantage #1 below). By the way, you choose Copy as DNG at the top center of the Import window (as shown below).

Advantage #1: DNG files are smaller RAW files usually have a pretty large file size, so they eat up hard disk space pretty quickly, but when you convert a file to DNG, it's generally about 20% smaller.

Advantage #2: DNG files don't need a separate sidecar

When you edit a RAW file, that metadata is actually stored in a separate file called an XMP sidecar file. If you want to give someone your RAW file and have it include the metadata and changes you applied to it in Lightroom, you'd have to give them two files: (1) the RAW file itself, and (2) the XMP sidecar file, which holds the metadata and edit info. But with a DNG, if you press Command-S (PC: Ctrl-S), that info is embedded right into the DNG file itself. So, before you give somebody your DNG file, just remember to use that shortcut so it writes the metadata to the file first.

Creating Your Own Custom Metadata (Copyright) Templates

At the beginning of this chapter, I mentioned that you'll want to set up your own custom metadata template, so you can easily and automatically embed your own copyright and contact information right into your photos as they're imported into Lightroom. Well, here's how to do just that. Keep in mind that you can create more than one template, so if you create one with your full contact info (including your phone number), you might want to create one with just basic info, or one for when you're exporting images to be sent to a stock photo agency, etc.

Step One:

You can create a metadata template from right within the Import window, so press Command-Shift-I (PC: Ctrl-Shift-I) to bring it up. Once the Import window appears, go to the Apply During Import panel, and from the Metadata pop-up menu, choose New (as shown here).

Step Two:

A blank New Metadata Preset dialog will appear. First, click the Check None button at the bottom of the dialog, as shown here (so no blank fields will appear when you view this metadata in Lightroom—only fields with data will be displayed).

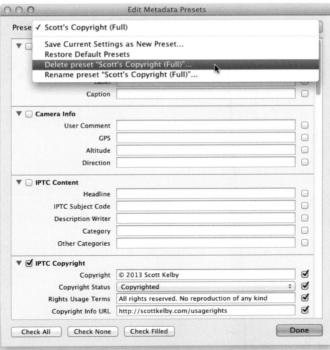

In the IPTC Copyright section, type in your copyright information (as shown here). Next, go to the IPTC Creator section and enter your contact info (after all, if someone goes by your website and downloads some of your images, you might want them to be able to contact you to arrange to license your photo). Now, you may feel that the Copyright Info URL (web address) that you added in the previous section is enough contact info, and if that's the case, you can skip filling out the IPTC Creator info (after all, this metadata preset is to help make potential clients aware that your work is copyrighted, and tell them how to get in contact with you). Once all the metadata info you want embedded in your photos is complete, go up to the top of the dialog, give your preset a name— I chose "Scott's Copyright (Full)"—and then click the Create button.

Step Four:

As easy as it is to create a metadata template, deleting one isn't much harder. Go back to the Apply During Import panel and, from the Metadata pop-up menu, choose **Edit Presets**. That brings up the Edit Metadata Presets dialog (which looks just like the New Metadata Preset dialog). From the Preset pop-up menu at the top, choose the preset you want to delete. Once all the metadata appears in the dialog, go back to that Preset pop-up menu, and now choose **Delete Preset** [Name of Preset]. A warning dialog will pop up, asking if you're sure you want to delete this preset. Click Delete, and it is gone forever.

Four Things You'll Want to Know Now About Getting Around Lightroom

Now that your images have been imported, there are some tips about working with Lightroom's interface you're going to want to know about right up front that will make working in it much easier.

Step One:

There are seven different modules in Lightroom, and each does a different thing. When your imported photos appear in Lightroom, they always appear in the center of the Library module, which is where we do all our sorting, searching, keywording, etc. The Develop module is where you go to do your photo editing (like changing the exposure, white balance, tweaking colors, etc.), and it's pretty obvious what the other five do (I'll spare you). You move from module to module by clicking on the module's name up in the taskbar across the top, or you can use the shortcuts Command-Option-1 for Library, Command-Option-2 for Develop, and so on (on a PC, it would be Ctrl-Alt-1, Ctrl-Alt-2, and so on).

Step Two:

There are five areas in the Lightroom interface overall: that taskbar on the top, the left and right side Panels areas, a Filmstrip across the bottom, and your photos always appear in the center Preview area. You can hide any panel (which makes the Preview area, where your photos are displayed, larger) by clicking on the little gray triangle in the center edge of the panel. For example, go ahead and click on the little gray triangle at the top center of the interface, and you'll see it hides the taskbar. Click it again; it comes back.

The #1 complaint I hear from Lightroom users about working with panels is they hate the Auto Hide & Show feature (which is on by default). The idea behind it sounds great: if you've hidden a panel, and need it visible again to make an adjustment, you move your cursor over where the panel used to be, and it pops out. When you're done, you move your cursor away, and it automatically tucks back out of sight. Sounds great, right? The problem is one pops out anytime you move your cursor to the far right, left, top, or bottom of your screen. It really drives them nuts, and I've had people literally beg me to show them how to turn it off. You can turn Auto Hide & Show off by Right-clicking on the little gray triangle for any panel. A pop-up menu will appear (shown here) where vou'll choose Manual, which turns the feature off. This works on a per-panel basis, so you'll have to do it to each of the four panels.

Step Four:

I use the Manual mode, so I can just open and close panels as I need them. You can also use the keyboard shortcuts: **F5** closes/ opens the top taskbar, F6 hides the Filmstrip, F7 hides the left side Panels area, and **F8** hides the right side (on a newer Mac keyboard or a laptop, you may have to press the Fn key with these). You can hide both side Panels areas by pressing the **Tab key**, but the one shortcut I probably use the most is **Shift-Tab**, because it hides everything—all the panels—and leaves just your photos visible (as shown here). Also, here's an insight into what is found where: the left side Panels area is used primarily for applying presets and templates, and showing you a preview of the photo, preset, or template you're working with. Everything else (all adjustments) is found on the right side. Okay, on the next page: tips on viewing.

Viewing Your Imported Photos

Before we get to sorting our photos and separating the winners from the losers (which we cover in the next chapter), taking a minute just to learn the ins and outs of how Lightroom lets you view your imported photos is important. Learning these viewing options now will really help you make the most informed decisions possible about which photos make it (and which ones don't).

Step One:

When your imported photos appear in Lightroom, they are displayed as small thumbnails in the center Preview area (as seen here). You can change the size of these thumbnails using the Thumbnails slider that appears in the right side of toolbar (the dark gray horizontal bar that appears directly below the center Preview area). Drag it to the right, and they get bigger; drag to the left, and they get smaller (the slider is circled here).

Navigator | Naviga

Step Two:

To see any thumbnail at a larger size, just double-click on it, press the letter **E** on your keyboard, or press the **Spacebar**. This larger size is called Loupe view (as if you were looking at the photo through a loupe), and by default it zooms in so you can see your entire photo in the Preview area. This is called a Fit in Window view, but if you'd prefer that it zoomed in tighter, you can go up to the Navigator panel at the top left, and click on a different size, like Fill, and now when you double-click, it will zoom in until your photo literally fills the Preview area. Choosing 1:1 will zoom your photo in to a 100% actual size view when it's double-clicked, but I have to tell you, it's kind of awkward to go from a tiny thumbnail to a huge, tight zoom like that.

The default cell view is called Expanded and gives you the most info

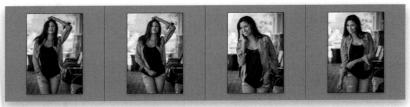

Press J to switch to Compact view, which shrinks the size of the cell, hides all the info, and just shows the photos

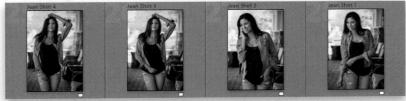

Press J one more time and it adds back some info and numbers to each cell

I leave my Navigator panel setting at Fit, so when I double-click I can see the entire photo fitting in the center Preview area, but if you want to get in closer to check sharpness, you'll notice that when you're in Loupe view, your cursor has changed into a magnifying glass. If you click it once on your photo, it jumps to a 1:2 view of the area where you clicked. To zoom back out, just click it again. To return to the thumbnail view (called Grid view), just press the letter **G** on your keyboard. This is one of the most important keyboard shortcuts to memorize (so far, the ones you really need to know are: Shift-Tab to hide all the panels, and now G to return to Grid view). This is a particularly handy shortcut, because when you're in any other module, pressing G brings you right back here to the Library module and your thumbnail grid.

Step Four:

The area that surrounds your thumbnail is called a cell, and each cell displays information about the photo from the filename, to the file format, dimensions, etc.—you get to customize how much or how little it displays, as you'll see in Chapter 3. But in the meantime, here's another keyboard shortcut you'll want to know about: press the letter J. Each time you press it, it toggles you through the three different cell views, each of which displays different groups of info—an expanded cell with lots of info, a compact cell with just a little info, and one that hides all that distracting stuff altogether (great for when you're showing thumbnails to clients). Also, you can hide (or show) the toolbar by pressing **T**. If you press-andhold T, it only hides it for as long as you have the T key held down.

Using Lights Dim, Lights Out, and Other **Viewing Modes**

One of the things I love best about Lightroom is how it gets out of your way and lets your photos be the focus. That's why I love the Shift-Tab shortcut that hides all the panels. But if you want to really take things to the next level, after you hide those panels, you can dim everything around your photo, or literally "turn the lights out," so everything is blacked out but your photos. Here's how:

Step One:

Press the letter **L** on your keyboard to enter Lights Dim mode, in which everything but your photo(s) in the center Preview area is dimmed (kind of like you turned down a lighting dimmer). Perhaps the coolest thing about this dimmed mode is the fact that the Panels areas, taskbar, and Filmstrip all still work—you can still make adjustments, change photos, etc., just like when the "lights" are all on.

Step Two:

The next viewing mode is Lights Out (you get Lights Out by pressing L a second time), and this one really makes your photos the star of the show because everything else is totally blacked out, so there's nothing (and I mean nothing) but your photos onscreen (to return to regular Lights On mode, just press L again). To get your image as big onscreen as possible, right before you enter Lights Out mode, press Shift-Tab to hide all the panels on the sides, top, and bottom—that way you get the big image view you see here. Without the Shift-Tab, you'd have the smaller size image you see in Step One, with lots and lots of empty black space around it.

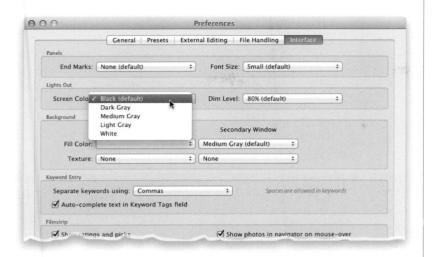

TIP: Controlling Lights Out Mode You have more control over Lightroom's Lights Out mode than you might think: just go to Lightroom's preferences (under the Lightroom menu on a Mac or the Edit menu on a PC), click on the Interface tab, and you'll find pop-up menus that control both the Dim Level and the Screen Color when you're in full Lights Out mode.

Web

Step Three:

If you want to view your grid of photos without distractions in the Lightroom window, press **Shift-F** on your keyboard twice. The first time you press Shift-F, it makes the Lightroom window fill your screen and hides the window's title bar (directly above the taskbar in Lightroom's interface). The second Shift-F actually hides the menu bar at the very top of your screen, so if you combine this with Shift-Tab to hide your panels, taskbar, and Filmstrip, and **T** to hide the toolbar (and \ [backslash] if your Filter bar is showing), you'll see just your photos on a solid top-to-bottom gray background. I know you might be thinking, "I don't know if I find those two thin bars at the top really that distracting." So, try hiding them once and see what you think. Luckily, there's an easy shortcut to jump to the "super-clean, distraction-free nirvana view" you see here: you press Command-Shift-F (PC: Ctrl-Shift-F), \, then T. To return to regular view, use the same shortcut. The image on top is the gray layout you just learned, and on bottom, I pressed L twice to enter Lights Out mode.

Seeing a Real **Full-Screen View**

In previous versions of Lightroom, you could technically do what they called a "full-screen view," but sadly, your image never really filled the full screen—it filled most of it, but there were black bars around all four sides of your image. It was dramatic for sure, but it lacked the impact of a real full-screen view (and it took about four clicks to get to that "almost-full-screen" view and four clicks to get back out. Well, finally, in Lightroom 5, we have the real deal, and it's just one key away.

Step One:

Back in previous versions of Lightroom, getting to "almost-full-screen" was a pain. You had to (1) press Shift-Tab to hide all the panels, (2) press F to switch to Full Screen mode, then (3) press L twice to enter Lights Out mode. When you were done, you had to undo all that, so basically it was an 8-click move. Now, to see your current image at full screen, you just press the letter F on your keyboard.

Step Two:

If you look at the image above, you'll see that it fills the screen top-to-bottom, but it does leave a tiny little black bar on the left and right side of your image. It's really small, but it's there. If you want to zoom in a tiny bit to fill that area (and every inch of your entire screen), just press Command-+ (plus sign; PC: Ctrl-+). To return to regular view mode, just press F again (or the Esc key). Also, it's nice to note that if you use this "zoom-to-fill-that-tiny-space-on-the-sides" trick, it remembers that full-screen setting for the rest of your session (meaning, until you restart Lightroom again). I actually wish this was a preference setting, because I would always have it set at "zoom to fill" for full screen.

In Lightroom 5, Adobe added moveable non-printing guides (like Photoshop's guides, only these may be better). Also, they added the ability to have a resizable, non-printing grid over your image, as well (helpful for lining things up or for straightening a part of your image), but it's not just a static grid, and it's not just resizable. We'll start with the guides.

Using Guides and the Resizable Grid Overlays

Step One:

To make the non-printing guides visible, go under the View menu, under Loupe Overlay, and choose Guides. Two white guides will appear centered on your screen. To move either the horizontal or vertical guide by itself, press-and-hold the Command (PC: Ctrl) key, then move your cursor right over either guide, and your cursor will change to a double-sided arrow cursor. Just click-and-drag that guide where you want it. To move the two guides together (like they're one unit), press-and-hold the Command (PC: Ctrl) key, then click directly on the black circle where they intersect and drag. To clear the guides, press Command-Option-O (PC: Ctrl-Alt-O).

Step Two:

You also have a grid that pretty much works the same. Go under the View menu, under Loupe Overlay, and choose Grid. This puts a non-printing grid over your image, which you can use for alignment (or anything else you want). If you press-andhold the Command (PC: Ctrl) key, a control bar appears at the top of the screen. Click directly on the word Opacity to change how visible the grid is (here, I cranked it up to 100%, so the lines are solid). Click directly on the word "Size," to change the size of the grid blocks themselves—drag left to make the grid smaller or right to make it larger. To clear the grid, press Command-Option-O (PC: Ctrl-Alt-O). Note: You can have more than one overlay, so you can have both the guides and grid visible at the same time.

Lightroom Killer Tips > >

▼ Drag-and-Drop Straight Into Lightroom (It's Smarter Than You'd Think)

You can drag-and-drop an image (or a number of images for that matter) from your desktop, or from a folder on your computer, right onto the Lightroom icon

(or the Dock icon if you're using a Mac) and it not only brings up the Import window, but it selects the folder (or desktop) where those images appear. And it's even smarter: if you have 20 or 30 images on your desktop (or in your folder), only the images you dragged onto that icon will have checkmarks by them for importing. That way, it ignores the other images on the desktop (or in that folder) and only imports the ones you selected.

▼ Lightroom Won't Let You Import Duplicates

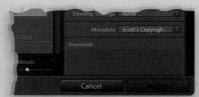

If you go to import some photos, and some (or all) of them are already found in your Lightroom catalog (in other words, these are duplicates), and the Don't Import Suspected Duplicates checkbox is turned on, any images already in Lightroom will be grayed out in the Import window. If all the images are duplicate, the Import button will also be grayed out, so you can't import them.

▼ Using Separate Catalogs to Make Lightroom Faster

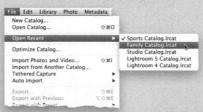

Although I keep one single catalog for all the photos on my laptop, and just three catalogs for my entire collection in the studio, I have a friend who's a fulltime wedding photographer who uses a different Lightroom catalog strategy that freaked me out when I first heard it, but really makes perfect sense (in fact, it may be just what you need). He creates a separate Lightroom catalog (go under the File menu and choose New Catalog) for every single wedding. At each wedding, he shoots more than a thousand shots, and often he has one to two other photographers shooting with him. His way, Lightroom really screams, because each catalog has only a thousand or so photos (where for many folks, it's not unusual to have 30,000 or 40,000 images, which tends to slow Lightroom down a bit). Hey, if you're a high-volume shooter, it's worth considering.

▼ When the Import Window Doesn't Appear Automatically

If you connect a memory card reader to your computer, Lightroom's Import window should appear automatically.

If for some reason it doesn't, press **Command-**, (comma; **PC: Ctrl-**,) to bring up Lightroom's Preferences, then click the General tab up top, and make sure the checkbox is turned on for Show Import Dialog When a Memory Card Is Detected.

▼ Why You Might Want to Wait to Rename Your Files

As you saw in this chapter, you can rename your files as you import them into Lightroom (and I definitely think you should give your files descriptive names), but you might want to wait until after you've sorted your photos (and deleted any out-of-focus shots, or shots where the flash didn't fire, etc.), because Lightroom auto-numbers the files for you. Well, if you delete some of these files, then your numbering will be out of sequence (there will be numbers missing). This doesn't bother me at all, but I've learned that it drives some people crazy (you know who you are), so it's definitely something to consider.

▼ Getting Back to Your Last Imported Images

Lightroom keeps track of the last set of images you imported, and you can get back to those images anytime by going to the Catalog panel (in the Library module's left side Panels area) and clicking on Previous Import. However, I think it's faster (and more convenient) to go down to the Filmstrip, and on the left side, where you see the current image's name, click-and-hold, and from the pop-up menu that appears, choose **Previous Import**.

Develop

Lightroom Killer Tips > >

Organize Multiple Shoots by Date

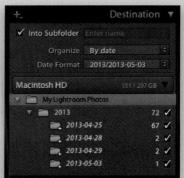

If you're like me, you probably wind up having multiple shoots on the same memory card (for example, I often shoot one day and then shoot a few days later with the same memory card in my camera). If that's the case, then there's an advantage to using the Organize By Date feature in the Import window's Destination panel, and that is it shows each of the shoots on your memory card by their date. The folders will vary slightly, depending on the Date Format you choose, but you will have a folder for each day you shot. Only the shoots with a checkmark beside them will be imported into Lightroom, so if you only want to import shots from a particular date, you can turn off the checkbox beside the dates you don't want imported.

▼ Multiple Cards from One Shoot If you shot two or three memory cards of the same subject, you'll want to choose Custom Name - Sequence from the File Renaming panel's Template pop-up menu, which adds a Start Number field, where you can type in which number you want to start with as you import each card (rather than always starting with the number 1, like the Custom Name template). For example, if you imported 236 photos from your first card, you'd

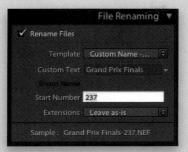

want the second card to start numbering with 237, so these shots of the same subject stay sequential. Once that card is imported (let's say you had 244 shots on that card), then you'd want the start number for the third card's photos to be 481. (By the way, I don't do the math, I just look at the file number of the last photo I imported, and then add one to it in the Start Number field.)

▼ Your Elements Library

If you're moving to Lightroom 5 from Elements 5 or later, you can have Lightroom import your Elements catalog. Just go under Lightroom's File menu, choose Upgrade Photoshop Elements Catalog, and then choose your Elements catalog from the dialog's pop-up menu. You may need to upgrade your Elements catalog for Lightroom, so just click Upgrade if prompted to. Lightroom will close and then reopen with your Elements catalog imported.

▼ Back Up to an External Drive

For the Make a Second Copy To feature to work properly, you've got to save those copies onto a separate external hard drive. You can't just back up your photos to a different folder on the same computer (or the external hard drive you are storing your photos on), because if your computer's hard drive (or your storage hard

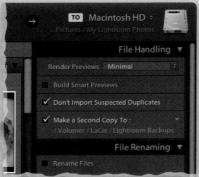

drive) crashes, then you lose both your working copies and the backup copies, too. That's why you've got to make sure the backups go to a completely separate external hard drive.

▼ Using Two External Hard Drives

If you're already storing your original photos on an external hard drive, it means you now have two external hard drives one for your working photos, and one for your backups. A lot of photographers buy two small, stackable external hard drives (small hard drives that can stack one on top of the other), and then connect one with a FireWire cable (called an IEEE 1394 on a PC), and the other with a USB 2 cable (hey, I never said this was going to be cheap, but think of it this way: if, one day, you lost all your photos, you'd pay anything to get them back, right?

Instead, just pay a fraction now for a

backup hard drive—believe me, you'll

sleep better at night).

Lightroom Killer Tips > >

▼ Hard Drive Space an Issue? Convert to DNG on Import

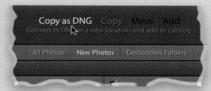

If you're working on a laptop, and you'd like to save between 15% and 20% (in most cases) of your hard drive space when importing RAW files, click on Copy as DNG at the top center of the Import window.

Changing Your Grid View Thumbnail Size

You don't have to have the toolbar at the bottom of the center Preview area visible to change your thumbnail size in the Library module's Grid view—just use the + (plus sign) and - (minus sign) keys on your keyboard to change sizes. The cool thing is that this works in the Import window, too.

Save Time Importing into **Existing Folders**

If you're going to import some photos into a folder you've already created, just go to the Folders panel in the Library module, Right-click on the folder, and choose Import to this Folder from the pop-up menu. This brings up the Import window with this folder already chosen as the destination for your imported photos.

▼ Converting Photos to DNG

If you didn't choose Copy as DNG at the top center of the Import window, and you want your imported photos saved in this file format, you can always convert any photo you've imported into Lightroom into a DNG by just clicking on the photo(s), going to Lightroom's Library menu, and choosing Convert Photo to DNG (although, technically, you can convert JPEGs and TIFFs into

DNG format, converting them into DNG doesn't really offer any advantages, so I only convert RAW photos to DNG). This DNG replaces the RAW file you see in Lightroom, and the RAW file remains in the same folder on your computer (Lightroom, though, gives you the option of deleting the original RAW file when you make the conversion. This is what I choose, since the DNG can include the RAW photo within it).

Organizing Images in Folders

You get to choose how your images are organized, as they're imported, in the Destination panel. If you don't turn on the Into Subfolder checkbox and you choose Into One Folder from the Organize pop-up menu, Lightroom tosses the loose photos into whichever folder you chose in the To section at the top right of the Import window, and they're not organized within their own separate folder. So, if you choose the Into One Folder option, I recommend that you turn on the Into Subfolder checkbox and then name the folder. That way, it imports them into their own separate folder inside

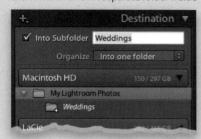

your Pictures or My Lightroom Photos folder. Otherwise, things will get very messy, very quickly.

▼ Lightroom 5 Handles Your Backup Better

In earlier versions of Lightroom, when you copied images to a backup hard drive, it didn't include any custom file names, or metadata, or keywords that you added—it just made an exact copy of what was on the memory card. Now. it renames these second copies, includes your metadata, and keeps your file structure, as well.

▼ Using Smart Previews If You've Lost the Original File

The smaller version of your image created as a smart preview is actually pretty large (it's 2,540 px on the long edge), so if you get in a bind and lose the original image (hey, it happens), at least you can export the smart preview as a DNG file so you'll have a physical file—it just won't have the full resolution of the original.

▼ You Can Import and Edit PSDs and More!

In earlier versions of Lightroom, you could only import and edit RAW images, TIFFs, and JPEGs, but in Lightroom 3, Adobe added the ability to import PSDs (Photoshop's native file format), along with images in CMYK mode or Grayscale mode. Develop

Lightroom Killer Tips > >

▼ Ejecting Your Memory Card

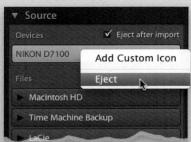

If you decide not to import anything and want to eject your camera's memory card, just Right-click directly on it in the Import window's Source panel, then choose **Eject** from the pop-up menu that appears. If you pop in a new card, click on the From button at the top left of the window, and choose it from the pop-up menu that appears.

▼ See How Many Images and How Much Room They'll Take

If you look in the bottom-left corner of the Import window, you'll see the total number of images you have checked to import, along with how much space they will take up on your hard drive.

Choosing Your Preview Rendering

I ran a Lightroom preview time trial, importing just 14 RAW images off a memory card onto a laptop. Here's how long it took to import them and render their previews:

Embedded & Sidecar: 19 seconds

Minimal: 21 seconds

Standard: 1 minute, 15 seconds

1:1: 2 minutes, 14 seconds

You can see that the 1:1 preview took seven times as long as Embedded & Sidecar. That may not seem that bad with 14 photos, but what about 140 or 340

photos? Yikes! So, armed with that info, you can make a decision that fits your workflow. If you're the type of photographer that likes to zoom in tight on each and every photo to check focus and detail, then it might be worth it for you to wait for the 1:1 previews to render before working on your images. If you're like me, and want to quickly search through them, and just zoom in tight on the most likely keepers (maybe 15 or 20 images from an import), then Embedded & Sidecar makes sense. If you look at them mostly in full-screen view (but don't zoom in really tight that often), then Standard might work, and if you want thumbnails that more closely represent what your photo will look like when it is rendered at high quality, choose Minimal instead.

■ Hiding Folders You Don't Need If you're importing photos that are already on your computer, that long list of folders in the Source panel can get really long and distracting, but now you can hide all those extra folders you don't

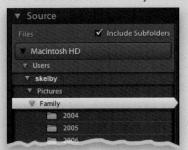

need to see. Once you find the folder you're importing from, just double-click on it, and everything else tucks away leaving just that folder visible. Try this once and you'll use it all the time.

▼ If Your Nikon Won't Tether

If your Nikon camera is supported for tethered shooting in Lightroom (like the D90, D5200, D7000, D300, D300s, D600, D700, D3, and D3x), but it doesn't work, chances are your camera's USB settings aren't set up to work with tethering. Go to your camera's Setup menu, click on USB, and change the setting to MTP/PTP. (*Note*: Newer cameras, like Nikon's D4 and D7100, are set to this mode by default.)

▼ Seeing Just Your Video Clips

First choose **All Photographs** from the path pop-up menu at the top-left side of the Filmstrip. Then, in the Library module go up to the Library Filter at the top of the window (if it's not visible, press the \ [backslash] key), and click on Attribute. Over on the far-right side, to the right of Kind, click on the Videos button (its icon is a filmstrip and it's the third icon from the left) and now it displays nothing but all the video clips you have in Lightroom (pretty handy if you want to make a regular collection of just your video clips).

▼ To Advance or Not to Advance

When I'm shooting tethered, as each new image comes in, I like to see it onscreen at full size. If you'd prefer to control which image appears onscreen, and for how long (remember, if you see one onscreen you like, it may only stay there a moment or two until the next shot comes in), go

under the File menu, under Tethered Capture, and turn off **Auto Advance Selection.** Now, you'll use the Left/Right Arrow keys on your keyboard to move through your images, rather than always seeing the image you just took onscreen.

LIBRARY how to organize your photos

It's been a tradition in all my books to name each chapter with either a song title, TV show title, or movie title. For example, in one of my books on Photoshop, I have a chapter on sharpening, and I called it "Sharp Dressed Man" (a nod to the 1983 hit of the same name from the Texas-based rock band ZZ Top). Under the chapter name, I would put a subhead that explains what the chapter is actually about, because sometimes from the name it wasn't guite as obvious. For example, in another book, I have a chapter called "Super Size Me" (from the movie of the same name), about how to resize your images. But for the previous editions of this book, I dispensed with those titles and just gave each chapter a regular boring ol' name, and now that I'm writing the Lightroom 5 version, I'm kinda wishing I hadn't done away with it (even though I guess this way does make it easier). See, I was thinking

that people who buy books on Lightroom are photographers, and that means they're creative people, which to me means that if I named the chapters after things that in themselves are creative (like songs, TV shows, and movies...well...songs and movies anyway), they'd totally dig it. Well, as luck would have it, I just checked on the iTunes Store and there actually is a song named "Library" by a band called Final Fantasy from their album Has a Good Home. Anyway, I listened to the song and I have to say, it was mind numbingly bad—bad on a level I haven't heard in years, yet the album has 12 five-star reviews, so either these people are criminally insane, or they were basing their review on their general love of one of Final Fantasy's other songs, titled "He Poos Clouds." Man, I wish I could have used that name for a chapter. My 16-year-old son would still be giggling.

Folders and Why I Don't Mess with Them (This Is Really Important!)

When you import photos, you have to choose a folder in which to store them on your hard drive. This is the only time I really do anything with folders because I think of them as where my negatives are stored, and like with traditional film negatives, I store them someplace safe, and I really don't touch them again. I use the same type of thinking in Lightroom. I don't really use the Folders panel (I use something safer—collections, which is covered next). So, here I'm only going to briefly explain folders, and show one instance where you might use them.

Step One:

If you quit Lightroom and on your computer look inside your Pictures folder, you'll see all the subfolders containing the files of your actual photos. Of course, you can move photos from folder to folder (as seen here), add photos, or delete photos, and so on, right? Well, you don't actually have to leave Lightroom to do stuff like that—you can do those things from within the Folders panel in Lightroom. You can see all those same folders, and move and delete real files just like you do on your computer.

Step Two:

Go to the Library module, and you'll find the Folders panel (shown here) in the left side Panels area. What you're seeing here are all the folders of photos that you imported into Lightroom (by the way, they're not actually in Lightroom itself—Lightroom is just managing those photos—they're still sitting in the same folders you imported them into from your memory card).

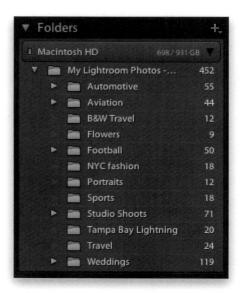

Develop

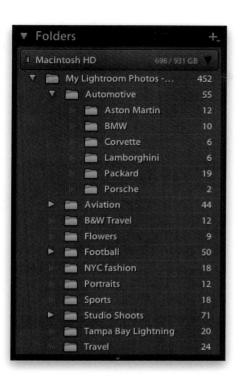

Step Three:

There's a little triangle to the left of each folder's name. If the triangle is solid gray, it means there are subfolders inside that folder, and you can just click on that triangle to see them. If it's not solid gray, it just means there are no subfolders inside. (*Note:* These little triangles are officially called "disclosure triangles," but the only people who actually use that term are...well...let's just say these people probably didn't have a date for the prom.)

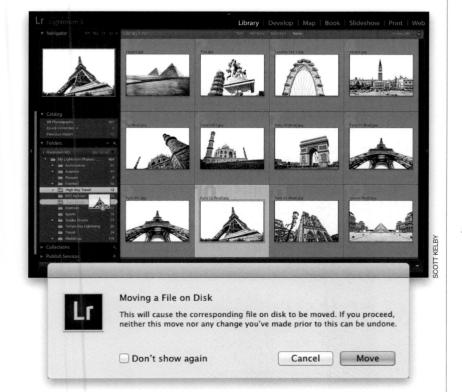

Step Four:

When you click on a folder, it shows you the photos in that folder that have been imported into Lightroom. If you click on a thumbnail and drag it into another folder (like I'm doing here), it physically moves that photo on your computer from one folder to another, just as if you moved the file on your computer outside of Lightroom. Because you're actually moving the real file here, you get a "Hey, you're about to move the real file" warning from Lightroom (see here below). The warning sounds scarier than it is—especially the "This cannot be undone" part. What that means is, you can't just press Command-Z (PC: Ctrl-Z) to instantly undo the move if you change your mind. However, you could just click on the folder you moved it to (in this case, the Paris Finals folder), find the photo you just moved, and drag it right back to the original folder (here, it's the High Key Travel folder), so the dialog's bark is worse than its bite.

Continued

Step Five:

If you see a grayed-out folder in the Folders panel with a question mark on it, that's Lightroom's way of letting you know it can't find this folder of photos (you either just moved them somewhere else on your computer, or you have them stored on an external hard drive, and that drive isn't connected to your computer right now). So, if it's the external drive thing, just reconnect your external drive and it will find that folder. If it's the old "moved them somewhere else" problem, then Right-click on the grayed-out folder and choose Find Missing Folder from the pop-up menu. This brings up a standard Open dialog, so you can show Lightroom where you moved the folder. When you click on the moved folder and click Choose, it relinks all the photos inside for you.

TIP: Moving Multiple Folders In previous versions of Lightroom, you could only move one folder at a time, but in Lightroom 5 you can Commandclick (PC: Ctrl-click) on multiple folders to select them, and then drag them all at the same time. A little time saver.

Step Six:

Now, there's one particular thing I sometimes use the Folders panel for, and that's when I add images to a folder on my computer after I've imported. For example, let's say I imported some photos from a trip to Paris and then, later, my brother emails me some shots he took. If I drag his photos into my Paris Finals folder on my computer, Lightroom doesn't automatically suck them right in. In fact, it ignores them unless I go to the Folders panel, Right-click on my Paris Finals folder, and choose Synchronize Folder.

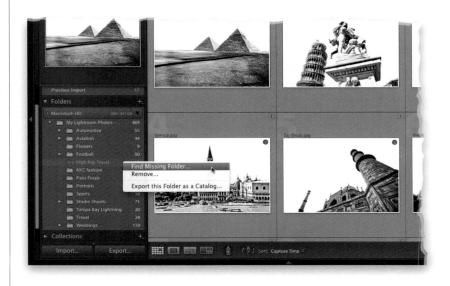

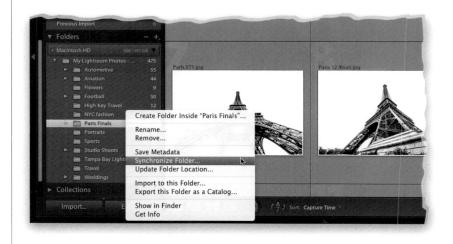

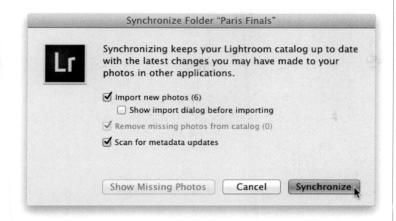

Step Seven:

Choosing Sychronize Folder brings up the Synchronize Folder dialog for that folder. I dragged the six new photos my brother sent me into my Paris Finals folder, and you can see it's ready to import six new photos. There is a checkbox to have Lightroom bring up the standard Import window before you import the photos (so you can add your copyright, and metadata, and stuff like that if you like), or you just bring them in by clicking Synchronize and adding that stuff once the images are in Lightroom (if you even want to. Since my brother took these, I won't be adding my copyright info to them. At least, not while he's looking). So, that's pretty much the main instance where I use folders when I drag new images into an existing folder. Other than that, I just leave that panel closed pretty much all the time, and just work in the Collections panel (as you'll learn about in the next tutorial).

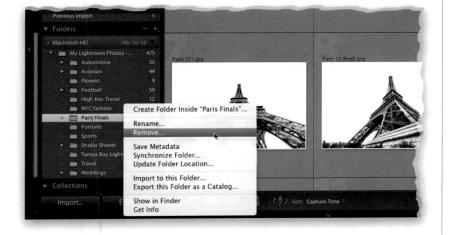

TIP: Other Folder Options
When you Right-click on a folder, and the pop-up menu appears, you can choose to do other things like rename your folder, create subfolders, etc. There's also a Remove option, but in Lightroom, choosing Remove just means "remove this folder of photos from Lightroom." However, this folder (and the photos inside it) will still be right there in your Pictures folder on your computer. Just so you know.

Sorting Your Photos Using Collections

Sorting your images can be one of the most fun, or one of the most frustrating, parts of the editing process—it just depends on how you go about it. Personally, this is one of the parts I enjoy the most, but I have to admit that I enjoy it more now than I used to, and that's mostly because I've come up with a workflow that's fast and efficient, and helps me get to the real goal of sorting, which is finding the best shots from your shoot—the "keepers"—the ones you'll actually show your client, or add to your portfolio, or print. Here's how I do it:

Step One:

When you boil it down, our real goal is to find the best photos from our shoot, but we also want to find the worst photos (those photos where the subject is totally out of focus, or you pressed the shutter by accident, or the flash didn't fire, etc.), because there's no sense in having photos that you'll never use taking up hard drive space, right? Lightroom gives you three ways to rate (or rank) your photos, the most popular being the 1-to-5-star rating system. To mark a photo with a star rating, just click on it and type the number on your keyboard. So, to mark a photo with a 3-star rating, you'd press the number 3, and you'd see three stars appear under the photo (shown here at the top). To change a star rating, type in a new number. To remove it altogether, press 0 (zero). The idea is that once you've got your 5-star photos marked, you can turn on a filter that displays only your 5-star photos. You can also use that filter to see just your 4-star, 3-star, etc., photos. Besides stars, you can also use color labels, so you could mark the worst photos with a Red label, slightly better ones with Yellow, and so on. Or, you could use these in conjunction with the stars to mark your best 5-star photo with a Green label (as shown here at the bottom).

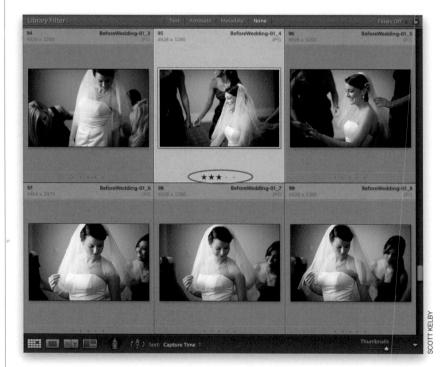

Step Two:

Now that I've mentioned star ratings and labels, I want to talk you out of using them. Here's why: they're way too slow. Think about it—your 5-star photos would be your very best shots, right? The only ones you'll show anybody. So your 4-star ones are good, but not good enough. Your 3-star ones are just so-so (nobody will ever see these). Your 2-star ones are bad shots—not so bad that you'll delete them, but bad—and your 1-star shots are out-of-focus, blurry, totally messed up shots you're going to delete. So what are you going to do with your 2- and 3-star photos? Nothing. What about your 4-star photos? Nothing. The 5-stars you keep, the 1-stars you delete, the rest you pretty much do nothing with, right? So, all we really care about are the best shots and the worst shots, right? The rest we ignore.

Step Three:

So instead, I hope you'll try flags. You mark the best shots as Picks and the really bad ones (the ones to be deleted) as Rejects. Lightroom will delete the Rejects for you when you're ready, leaving you with just your best shots and the ones you don't care about, but you don't waste time trying to decide if a particular photo you don't care about is a 3-star or a 2-star. I can't tell you how many times I've seen people sitting there saying out loud, "Now, is this a 2-star or a 3-star?" Who cares? It's not a 5-star; move on! To mark a photo as a Pick, just press the letter P. To mark a photo as a Reject, press the letter X. A little message will appear onscreen to tell you which flag you assigned to the photo, and a tiny flag icon will appear in that photo's grid cell. A white flag means it's marked as a Pick. A black flag means it's a Reject.

Step Four:

So here's how I go about the process: Once my photos have been imported into Lightroom, and they appear in the Library module's Grid view, I double-click on the first photo to jump to Loupe view so I can get a closer look. I look at the photo, and if I think it's one of the better shots from the shoot, I press the letter P to flag it as a Pick. If it's so bad that I want to delete it, I press the letter X instead. If it's just okay, I don't do anything; I just move on to the next photo by pressing the Right Arrow key on my keyboard. If I make a mistake and misflag a photo (for example, if I accidentally mark a photo as a Reject when I didn't mean to), I just press the letter **U** to unflag it. That's it—that's the process. You'll be amazed at how quickly you can move through a few hundred photos and mark the keepers and rejects. But you've still got some other things to do once you've done this first essential part.

Step Five:

Once you've got your Picks and Rejects flagged, let's get rid of the Rejects and delete them from your hard drive. Go under the Photo menu and choose **Delete Rejected Photos.** This displays just the photos you've marked as Rejects, and a dialog appears asking if you want to delete them from your disk or just remove them from Lightroom. I always choose Delete from Disk, because if they were bad enough for me to mark them as Rejects, why would I want to keep them? What could I possibly use them for? So, if you feel the same way, click the Delete from Disk button and it returns you to the Grid view, and the rest of your photos. (Note: Because we just imported the photos into Lightroom, and they're not in a collection yet, it gives you the option to delete the images from the disk. Once they're actually in a collection, doing this just removes the photos from the collection, and not from your hard disk.)

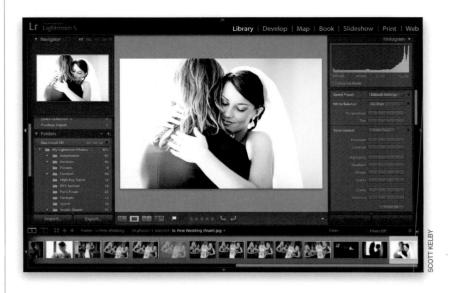

Step Six:

Now to see just your Picks, click on the word **Attribute** up in the Library Filter bar that appears at the top of the center Preview area (if you don't see it, just press the \ [backslash] key on your keyboard), and a little Attribute bar pops down. Click on the white Pick flag (shown circled here), and now just your Picks are visible.

TIP: Use the Other Library Filter
You can also choose to see just your Picks,
Rejects, or your unflagged photos from
down on the top-right side of the Filmstrip. There's a Library filter there too, but
just for attributes like flags and star ratings,
and some metadata.

Step Seven:

What I do next is put these Picks into a collection. Collections are the key organizational tool we use, not just here in the sorting phase, but throughout the Lightroom workflow. You can think of a collection as an album of your favorite photos from a shoot, and once you put your Picks into their own collection, you'll always be just one click away from your keepers from the shoot. To get your Picks into a collection, press Command-A (PC: **Ctrl-A)** to select all the currently visible photos (your Picks), then go over to the Collections panel (in the left side Panels area), and click on the little + (plus sign) button on the right side of the panel header. A pop-up menu will appear, and from this menu, choose **Create** Collection (as shown here).

Continued

Step Eight:

This brings up the Create Collection dialog you see here, where you type in a name for this collection, and below that you can assign it to a set (we haven't talked about sets yet, or created any sets, or even admitted that they exist. So for now, leave this checkbox turned off, but don't worry, sets are coming soon enough). In the Options section, you want your collection to include the photos you selected (your Picks) in the previous step, and because you made a selection first, this checkbox is already turned on for you. For now, leave the Make New Virtual Copies and Set as Target Collection checkboxes turned off, then click the Create button.

Step Nine:

Now you've got a collection of just your keepers from that shoot, and anytime you want to see these keepers, just go to the Collections panel and click on the collection named St Pete Wedding Picks (as seen here). Just in case you were wondering, collections don't affect the actual photos on your computer—these are just "working collections" for our convenience—so we can delete photos from our collections and it doesn't affect the real photos (they're still in their folder on your computer, except for the Rejects we deleted earlier, before we created this collection).

Note: If you're an Apple iPod, iPad, or iPhone owner, then you're familiar with Apple's iTunes software and how you create playlists of your favorite songs (like big hair bands of the '80s, or party music, or classic rock, etc.). When you remove a song from a playlist, it doesn't delete it from your hard disk (or your main iTunes Music Library), it just removes it from that particular playlist, right? Well, you can think of collections in Lightroom as kind of the same thing, but instead of songs, they're photos.

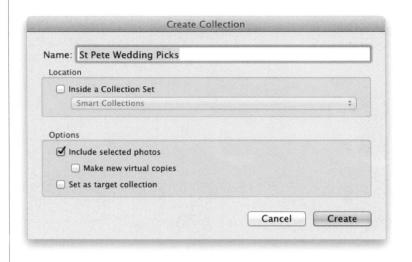

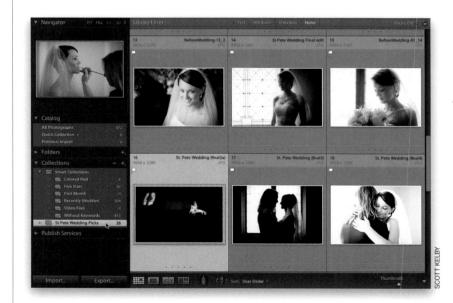

Step 10:

Now, from this point on, we'll just be working with the photos in our collection. Out of the 298 bridal shots that were taken that day, only 26 of them were flagged as good shots, and that's how many wound up in our Picks collection. But here are some questions: Are you going to print all 26 of these keepers? Are all 26 going in your portfolio, or are you going to email 26 shots of this one bridal shoot to the bride? Probably not, right? So, within our collection of keepers, there are some shots that really stand out—the best of the best, the ones you actually will want to email to the client, or print, or add to your portfolio. So, we need to refine our sorting process a little more to find our best shots from this group of keepers our "Selects."

Step 11:

At this stage, there are three ways to go about viewing your photos to narrow things down. You already know the first method, which is the whole Pick flag thing, and you can do that same process again here in your collection, but first you'll need to remove the existing Pick flags (in earlier versions of Lightroom, when you added photos to a collection, it automatically removed the flags, but in Lightroom 5, it remembers them). To remove them press Command-A (PC: Ctrl-A) to select all of the photos in your collection, then press the letter **U** on your keyboard to remove all the Pick flags, so we can add new ones. The second view that you might find helpful is called Survey view, and I use this view quite a bit when I have a number of shots that are very similar (like a number of shots of the same pose) and I'm trying to find the best ones from that group. You enter this view by first selecting the similar photos, as seen here (click on one, then press-and-hold the Command [PC: Ctrl] key and click on the others).

Step 12:

Now press the letter **N** to jump to Survey view (I don't know which is worse, this view being named Survey or using the letter N as its shortcut. Don't get me started). This puts your selected photos all onscreen, side by side, so you can easily compare them (as shown here). Also, anytime I enter Survey view, I immediately press **Shift-Tab** to hide all the panels, which makes the photos as large as possible on my screen.

TIP: Try Lights Out Mode

Survey view is a perfect place to use the Lights Out feature that blacks out everything but your photos. Just press the letter L on your keyboard twice to enter Lights Out mode and you'll see what I mean. To return to the regular view, press L again.

Step 13:

Now that my photos are displayed in Survey view, I start the process of elimination: I look for the weakest photo of the bunch and get rid of it first, then the next weakest, and the next, until I'm left with just the best couple shots of that pose. To eliminate a photo, move your cursor over the photo you want to remove from contention (the weakest of the bunch) and click on the small X that appears in the bottom-right corner of the image (as seen here), and it's hidden from view. It isn't removed from your collection, it's just hidden to help with your process of elimination. Here, I removed one photo and the others automatically readjusted to fill in the free space. As you continue to eliminate images, the remaining images get larger and larger as they expand to take up the free space.

TIP: Changing Your Survey Order While you're in Survey view, you can change the order of the images displayed onscreen by just dragging-and-dropping them into the order you want.

Step 14:

Once you narrow things down to just the ones you want to keep of this pose, press **G** to return to the thumbnail Grid view and those photos that were left onscreen will automatically be the only ones selected (see the two final photos I wound up leaving onscreen—they're the only ones selected). Now, just press the letter P to flag those as Picks. Once they're flagged, press Command-D (PC: **Ctrl-D)** to deselect those photos, then go and select another group of photos that are similar, press N to jump to Survey view, and start the process of elimination on that group. You can do this as many times as you need, until you've got the best shots from each set of similar shots or poses tagged as Picks.

Note: Remember, when you first made your collection from flagged Picks, we selected all the photos and removed the Pick flags by pressing the letter U. That's why you're able to use them again here.

Step 15:

Now that you've gone through and marked the very best shots from your Picks collection, let's put just those "best of the best" in their own separate collection (this will make more sense in just a minute). At the top of the center Preview area, in the Library Filter bar, click on Attribute, and when the Attribute bar pops down, click on the white Pick flag to display just the Picks from your Picks collection (as seen here).

Continued

The Adobe Photoshop Lightroom 5 Book for Digital Photographers

Step 16:

Now press Command-A (PC: Ctrl-A) to select all the Picks displayed onscreen. and then press Command-N (PC: Ctrl-N) to bring up the Create Collection dialog. Here's a tip: name this collection by starting with the name of your keepers collection, then add the word "Selects" (so in my case, I would name my new collection "St Pete Wedding Selects"). Collections appear listed in alphabetical order, so if you start with the same names, both collections will wind up together, which makes things easier for you in the next step (besides, you can always change the name later if you like).

ame: St Pete Wedding Selects	
ocation	
☐ Inside a Collection Set	
	*
Options	
✓ Include selected photos	
☐ Make new virtual copies	
Set as target collection	

Step 17:

Just to recap, now you have two collections: one with your keepers from the shoot (the Picks), and a Selects collection with only the very best images from the shoot. When you look in the Collections panel, you'll see your keepers collection with the Selects one right below (as shown here).

Note: We still have one more method to cover for narrowing things down, but just so you know, after that you'll learn how to use collection sets, which make things easy when you have multiple collections from the same shoot—like we do here with a Picks collection and Selects collection.

Step 18:

There's a third view you can use to view your images that can help you in situations where you need to find the one single, solitary, best shot from a shoot (for example, let's say you want to post one single shot from your bridal shoot on your studio's blog, so you need to find that one perfect shot to run with your post). That's when you use Compare view—it's designed to let you go through your photos and find that one, single, best shot. Here's how it works: First, select the first two photos in your Selects collection (click on the first photo, then Commandclick [PC: Ctrl-click] on the second image, so they're both selected). Now, press the letter **C** to enter Compare view, where the two photos will appear side by side (as shown here), then press Shift-Tab to hide the panels and make the photos as large as possible. Also, you can enter Lights Out mode now, if you like (press the letter L twice).

Step 19:

So, here's how this works, and this is a battle where only one photo can win: On the left is the current champion (called the Select), and on the right is the contender (called the Candidate). All you have to do is look at both photos, and then decide if the photo on the right is better than the photo on the left (in other words, does the photo on the right "beat the current champ?"). If it doesn't, then press the **Right Arrow key** on your keyboard and the next photo in your collection (the new contender) appears on the right to challenge the current champ on the left (as seen here, where a new photo has appeared on the right side).

Step 20:

If you press the Right Arrow key to bring up a new Candidate, and this new photo on the right actually does look better than the Select photo on the left, then click the Make Select button (the X|Y button with a single arrow, on the right side of the toolbar below the center Preview area, shown circled here in red). This makes the Candidate image become the Select image (it moves to the left side), and the battle starts again. So, to recap the process: You select two photos and press C to enter Compare view, then ask yourself the question, "Is the photo on the right better than the one on the left?" If it's not better, press the Right Arrow key on your keyboard. If it is better, click the Make Select button and continue the process. Once you've gone through all the photos in your Selects collection, whichever photo remains on the left (as the Select photo) is the best image from the shoot. When you're done, click the Done button on the right side of the toolbar.

Although I always use the Arrow keys on my keyboard to "do battle" in Compare view, you can also use the Previous and Next buttons in the toolbar. To the left of the Make Select button is the Swap button, which just swaps the two photos (making the Candidate the Select, and vice versa), but I haven't found a good reason to use this Swap button, and just stick to the Make Select button. So, which of the three views do you use when? Here's what I do: (1) the Loupe view is my main view when making Picks, (2) I use Survey view only when comparing a number of shots of a similar pose or scene, and (3) I use Compare view when I'm trying to find a single "best" image.

Develop

Step 22:

One last thing about Compare view: once I've determined which photo is the single best photo from the shoot (which should be the image on the left side when I get through all the images in my Selects collection—what I call "the last photo standing"), I don't make a whole new Selects collection for just this one photo. Instead, I mark this one photo on the left as the winner by pressing the number 6 on my keyboard. This assigns a Red label to this photo (as shown here).

Step 23:

Now anytime I want to find the single best photo out of this shoot, I can go to the Library module's Grid view (G), click on Attribute in the Library Filter bar, and then in the Attribute bar below it, I can click the Red label (as shown circled here), and bang—there's my "Best of Show." So, in this tutorial, you've just learned a key part of the organization process—creating collections—and using collections puts both "your keepers" and your very best photos from each shoot just one click away. Next, we'll look at how to organize related shoots that will have multiple collections (like a wedding or vacation).

Organizing Multiple Shoots Using Collection Sets

If you spent a week in New York and went out shooting every day, once you got all your shoots into Lightroom, you'd probably have collections with names like Times Square, Central Park, 5th Avenue, The Village, and so on. Because Lightroom automatically alphabetizes collections, these related shoots (they're all in New York, taken during the same trip) would be spread out throughout your list of collections. This is just one place where collection sets come in handy, because you could put all those shoots under one collection set: New York.

Step One:

To create a collection set (which just acts like a folder to keep related collections organized together), click on the little + (plus sign) button on the right side of the Collections panel header (in the left side Panels area), and choose **Create Collection Set**, as shown here. This brings up the Create Collection Set dialog where you can name your set. In this example, we're going to use it to organize all the different shoots from a wedding, so name it "Moore Wedding" and click the Create button.

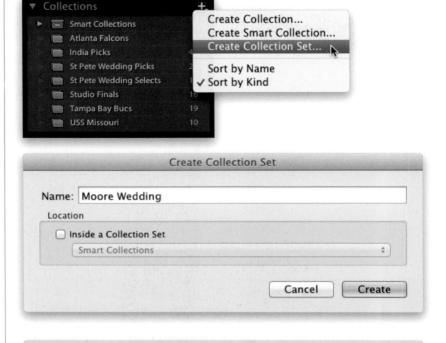

Step Two:

This empty collection set now appears in the Collections panel. When you go to create a new collection of shots from this wedding, Command-click (PC: Ctrlclick) on the images you want in the collection, then choose **Create Collection** from the little + (plus sign) button's pop-up menu. In the Create Collection dialog, name your new collection, then turn on the Inside a Collection Set checkbox, choose Moore Wedding from the pop-up menu, and click Create.

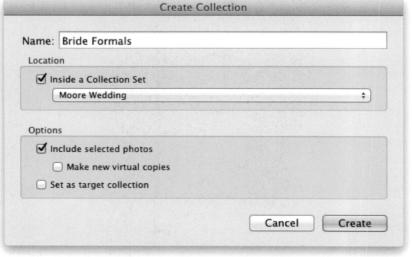

Develop

Here's the collection set expanded, so you can see all the collections you saved inside it

Moore Wedding Smart Collections India Picks St Pete Wedding Picks St Pete Wedding Selects Studio Finals Tampa Bay Bucs USS Missouri

Here's the same collection set collapsed, and you can see how much shorter this makes your list of collections

Collections Smart Collections **Weddings** Barker Wedding Collins Wedding Concepcion Wedding Grimes Wedding Kloskowski Wedding Mautner Wedding Moore Wedding Bride Formals Bridesmaids &... Ceremony First Dance **Groom Portraits** Leaving the C... Pre-Wedding S. Rehearsal Dinner Wedding Band

Here, all your weddings are contained within one main Weddings collection set. If you want to see the individual collections inside a particular wedding, then you click on the triangle that appears before its name to reveal its contents

Step Three:

When you look in the Collections panel, you'll see the collections you've added to the Moore Wedding collection set appearing directly under it (well, they actually are grouped with it). With something like a wedding, where you might wind up creating a lot of separate collections for different parts of the wedding, you can see how keeping everything organized under one header like this really makes sense. Also, here we created the collection set first, but you don't have toyou can create one whenever you want, and then just drag-and-drop existing collections right onto that set in the Collections panel.

Step Four:

If you want to take things a step further, you can even create a collection set inside another collection set (that's why, back in Step One, when you created your first collection set, the Inside a Collection Set pop-up menu appeared in that dialog so you could put this new collection set inside an existing collection set). An example of why you might want to do this is so you can keep all your wedding shoots together. So, you'd have one collection set called Weddings (as shown here), and then inside of that you'd have separate collection sets for individual weddings. That way, anytime you want to see, or search through, all your wedding photos from all your weddings, you can click on that one Weddings collection set.

Using Smart Collections for Automatic Organization

Say you wanted to create a collection of your 5-star bridal portraits from the past three years. You could search through all your collections, or you could have smart collections find them all for you, and put them in a collection automatically. Just choose the criteria and Lightroom will do the gathering, and in seconds, it's done. Best of all, smart collections update live, so if you create one of just your red-labeled images, any time you rate a photo with a red label, it's automatically added to that smart collection. You can create as many of these as you'd like.

Step One:

To understand the power of smart collections, let's build one that creates a collection of all your best travel photos. In the collections panel, click on the + (plus sign) button on the right side of the panel header, and choose Create Smart Collection from the pop-up menu. This brings up the Create Smart Collection dialog. In the Name field at the top, name your smart collection and from the Match pop-up menu, choose All. Then, from the pop-up menu beneath that, under Other Metadata, choose Keywords, choose Contains from the pop-up menu to the right, and in the text field, type "Travel." Now, if you iust want vour latest work included, create another line of criteria, by clicking on the little + (plus sign) button to the right of the text field, and another line of criteria appears. Under Date, choose Capture Date from the first pop-up menu, Is in the Last from the second, type "12" in the text field, and then choose Months from the last pop-up menu.

Step Two:

Now, let's narrow things down. Pressand-hold the Option (PC: Alt) key and the + buttons will turn into # (number sign) buttons. Click on the one to the right of your last line of criteria to get additional criteria choices. Leave the first pop-up menu set to Any of the Following Are True, then under Source, choose Collection from the first pop-up menu below, choose Contains from the one to the right, and in the text field, type "Selects." It's now set to gather all the photos in all your Selects collections.

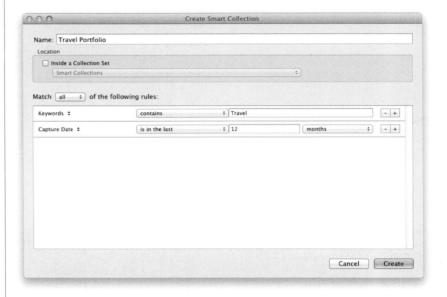

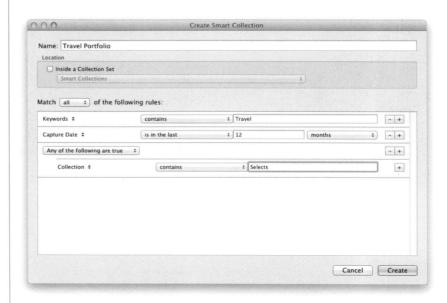

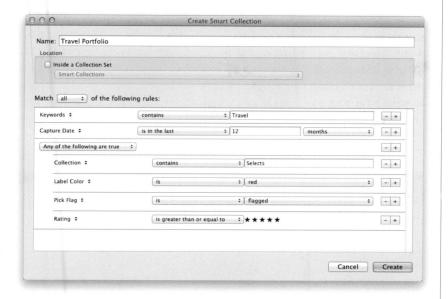

Step Three:

Let's add another criterion in case you labeled one Select photo red, rather than just putting that one photo in a collection. From the first pop-up menu, choose Label Color, from the second choose Is, and choose Red from the third. If you clicked the Create button now, it would make a smart collection of all the photos in any Selects collection, along with any photos labeled red that have the keyword "Travel" and were taken in the last 12 months. If you've been using Pick flags or the 1-to-5-star rating system, you can also add additional lines of criteria for these, as well, to pick up any Picks or 5-star rated photos that you have. (Note: Here are some new choices in Smart Collections: you can now create one based on image size, or color profile, or a particular bit depth, or number of color channels, or if the file type is PNG, or an image's Smart Preview status.)

Step Four:

Now when you hit the Create button, it compiles all of this for you and best of all, it will constantly be updated. New photos with the Travel keyword in any Selects collection, or labeled red, or 5-star, or flagged with a Pick flag, will automatically be added to this collection and any images older than 12 months will automatically be removed. Also, say you remove the red label from a recent travel photo that wasn't in a Selects collection and didn't have a Pick flag or a star rating, it gets removed from this smart collection without you having to do anything, because it no longer matches the criteria. You can edit the criteria for any existing smart collection anytime by just double-clicking directly on it in the Collections panel. This brings up the Edit Smart Collection dialog with all your current criteria in place, where you can add additional criteria (by clicking the + button), delete criteria (by clicking the - [minus sign] button), or change the criteria in the pop-up menus.

Keeping Things Tidy Using Stacks

Stacking images (which had been a feature in folders) has finally made its way to collections. With stacking, now we can group similar-looking images together within our collections, so we have less scrolling through the grid with big shoots. It works like this: Say you had 22 shots of the bride in pretty much the same pose. Do you really need to see those 22 shots all the time? Probably not. With stacks, you can tuck those 22 thumbnails behind just one thumbnail, which represents the rest. That way, you don't have to scroll through 22 nearly identical thumbnails to get to your other images.

Step One:

Here, we've imported images from a seminar shoot, and you can see what I was talking about above, where there are several shots that include the same pose. Seeing all these photos at once just adds clutter and makes finding your "keepers" that much more of a task. So, we're going to group similar poses into a stack with just one thumbnail showing. The rest of the photos are collapsed behind that photo. Start by clicking on the first photo of a similar pose (as seen highlighted here), then press-and-hold the Shift key and click on the last photo that has the same pose (as shown here) to select them all (you can also select photos in the Filmstrip, if you prefer).

Step Two:

Now press Command-G (PC: Ctrl-G) to put all your selected photos into a stack (this keyboard shortcut is easy to remember, if you think of G for Group). If you look in the grid now, you can see there's just one thumbnail visible with that pose. It didn't delete or remove those other photos they stacked behind that one thumbnail (in a computery, technical, you'll-just-haveto-trust-that's-what's-happening kind of way). Look how much more manageable things are now that those four photos are collapsed down to one.

Develop

Step Three:

In the zoomed-in view here, you can see the number 4 in a rectangle in the top left of the thumbnail. That's to let you know two things: (1) this isn't just one photo, it's a stack of photos, and (2) how many photos are in this stack. The view you're seeing here is the stack's collapsed view (where three similar photos are collapsed behind the first one). To expand your stack and see all the photos in it, just click directly on that little number 4 (the expanded view is shown in the next step), press **S** on your keyboard, or click on one of the two little thin bars that appear on either side of the thumbnail. (To collapse the stack, just do any of these again.) By the way, to add a photo to an existing stack, just drag-anddrop the photo you want to add right onto the existing collapsed stack.

Step Four:

Here are a few things that will help you in managing your stacks. The first photo you select when creating a stack (the top photo) will be the one that remains visible when the stack is collapsed. If that's not the photo you want to represent your stack, you can make any photo in your stack the top photo. First, expand the stack, then Right-click directly on the little rectangle with the photo number in it, and choose **Move to Top of Stack** (as shown here).

Step Five:

To remove a photo from a stack, first expand the stack, then Right-click directly on that photo's photo number, and choose Remove from Stack from the pop-up menu (as shown here). This doesn't delete it, or remove it from a collection, etc., it just takes it out of this stack. So, for example, if you removed just one photo, when you collapsed the stack again, you'd see two thumbnails in the grid—one representing the three photos still stacked, and a second thumbnail of just that individual photo you removed. Note: If you want to remove more than one photo from your stack at the same time, Command-click (PC: Ctrl-click) on the ones you want removed to select them, Right-click on the photo number on one of them, and then choose Remove from Stack from the pop-up menu.

Step Six:

Before we move on, there's one more thing on the topic of removing photos from your stack. If you do want to actually delete a photo in your stack (not just remove it from your stack), just expand the stack, then click on the photo and press the Delete (PC: Backspace) key on your keyboard. Okay, here's another tip: if you want all your stacks expanded at once (so every thumbnail from the shoot is visible again), just Right-click on any thumbnail (not just a stack—any thumbnail), choose Stacking, and then choose **Expand All** Stacks (or Right-click on any stack's photo number rectangle and choose Expand All Stacks). If you want to collapse all your stacks, instead choose Collapse All Stacks, and now you'll see just one photo representing each pose.

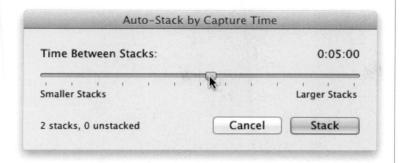

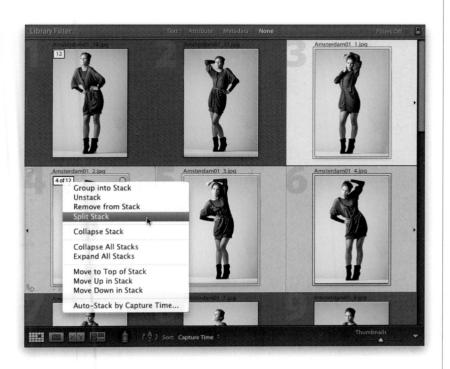

Step Seven:

Lightroom can automatically stack similar photos together based on how much time passed between shots. Let's say you're shooting in the studio where you're firing off shots pretty regularly, but when it's time for your subject to change outfits (or for you to change the lighting setup), it probably takes at least five minutes. So, you'd set the Auto-Stack feature to five minutes, and that way, when you stop shooting for five minutes or more, it takes everything you just shot and puts it in a stack for you (this works better than it sounds). To turn on this Auto-Stack feature. Right-click on any thumbnail, then from the pop-up menu, under Stacking, choose Auto-Stack by Capture Time. The dialog shown here appears, and as you drag the slider to the left or right, you'll see photos start jumping into stacks in real time. This is one of those you just have to try to see that it usually works pretty darn well.

Step Eight:

By the way, if you use the Auto-Stack feature, it might stack some photos together that don't actually belong together. If that happens, it's easy to split a stack and have those other photos separated into their own stack. To split a stack, expand it, then just select the photos you want to split out into their own stack, Right-click on the photo number rectangle on any one of them, and in the pop-up menu that appears, choose **Split Stack** (as shown here). Now, you'll have two stacks—in our case, one with eight photos, and one with four. One last thing about stacks: once photos are in a stack, any edits you apply to your stack while it's collapsed are actually only applied to the top photo, not to the rest of the photos in the stack. Quick Develop settings, keywords, and any other edits can be applied to the entire stack if you expand the stack and select them all before you change your setting or add your keyword.

When to Use a Ouick Collection Instead

When you create collections, they're a more permanent way of keeping your photos organized into separate albums (by permanent, I mean that when you relaunch Lightroom months later, your collections are still there but of course, you can also choose to delete a collection, so they're never really that permanent). However, sometimes you want to just group a few photos temporarily, and you don't actually want to save these groupings long term. That's where Ouick Collections can come in handv.

Step One:

There are a lot of reasons why you might want a temporary collection, but most of the time I use Ouick Collections when I need to throw a quick slide show together, especially if I need to use images from a number of different collections. For example, let's say I get a call from a potential client, and they want to see some examples of football games I've shot. I'd go to a recent football game shoot, click on its Selects collection, and then double-click on an image to look at them in Loupe view. When I see one I want in my slide show, I just press the letter **B** to add it to my Quick Collection (you get a message onscreen to show you that it has been added).

Step Two:

Now I go to another football game collection and do the same thing—each time I see an image that I want in my slide show, I press B and it's added, so in no time I can whip through 10 or 15 "Best of" collections and mark the ones I want in my slide show as I go. (You can also add photos to your Quick Collection by clicking on the little circle that appears in the top-right corner of each thumbnail in the Grid view when you move your cursor over the thumbnail—it'll turn gray with a thick black line around it when you click on it. You can hide the gray dot by pressing **Command-J** [PC: Ctrl-J], clicking on the Grid View tab up top, then turning off the checkbox for Quick Collection Markers, as shown on the right here.)

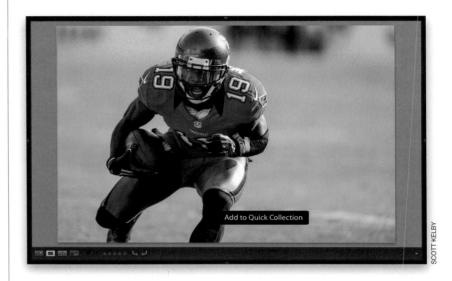

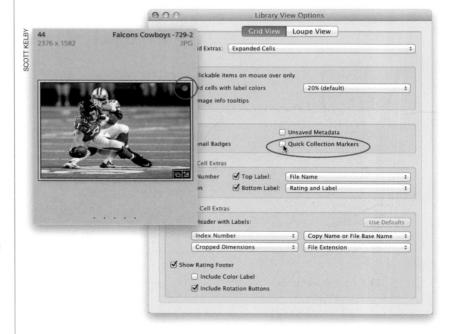

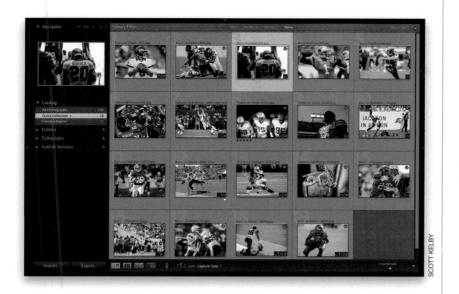

Step Three:

To see the photos you put in a Quick Collection, go to the Catalog panel (in the left side Panels area), click on Quick Collection (shown here), and now just those photos are visible. To remove a photo from your Quick Collection, just click on it and press the **Delete (PC:** Backspace) key on your keyboard (it doesn't delete the original, it just removes it from this temporary Quick Collection).

Web

Step Four:

Now that your photos from all those different collections are in a Quick Collection, you can press Command-Return (PC: Ctrl-Enter) to start Lightroom's Impromptu Slideshow feature, which plays a full-screen slide show (as shown here) of the photos in your Quick Collection, using the Default preset in Lightroom's Slideshow module. To stop the slide show, just press the Esc key.

TIP: Saving Your Quick Collection If you decide you want your Quick Collection to be saved as a regular collection, just go to the Catalog panel, Right-click on Quick Collection, choose Save Quick **Collection** from the pop-up menu, and a dialog appears where you can give your new collection a name.

Using Target Collections (and Why They're So Handy)

We just talked about Quick Collections and how you can temporarily toss things in there for an impromptu slide show, or until you figure out if you actually want to create a collection of those images, but something you might find more useful is to replace the Quick Collection with a target collection. You use the same keyboard shortcut, but instead of sending things to the Quick Collection, now they go to an existing collection. So, why would you want to do that? Read these two pages and you'll totally see why these are so handy (you are soooo going to dig this!).

Step One:

Let's say during the year you shoot a lot of photos of motorcycles. Well, wouldn't it be handy to have one collection of all your favorite motorcycle shots, so they're all just one click away? If that sounds handy to you (it sure does to me), then create a new collection and name it "Motorcycles." Once it appears, Right-click on it and, from the pop-up menu that appears, choose **Set as Target Collection** (as shown here). This adds a + (plus sign) to the end of the collection's name, so you know at a glance it's your target collection (as seen here).

Step Two:

Now that you've created your target collection, adding images to it is easy just click on any image, press the letter **B** on your keyboard (the same shortcut you used to use for Quick Collection), and that image is added to your Motorcycles target collection. For example, here we're looking at the finals from a studio shoot I did of a Big Dog chopper. I have them in a regular collection called, "Red Chopper Finals." I also want these final images added to my Motorcycles target collection, so I selected them all and simply pressed B. I get a confirmation onscreen that reads, "Add to Target Collection 'Motorcycles," so I know they were added. It doesn't remove them from my Red Chopper Finals collection; it just also adds them to the Motorcycles target collection.

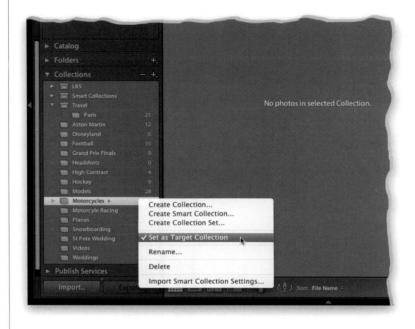

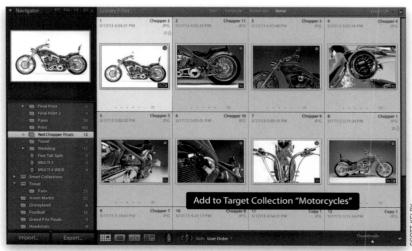

SCOTT KELBY

Step Three:

Now, if I click on that Motorcycles target collection, I see those red chopper images, plus images from other motorcycle shoots, as well, because now all my motorcycle shoot finals are in one place (I told you this was pretty handy, right?).

ame: Ducati Diavel Carbon	
ocation	
☐ Inside a Collection Set	

Options Include selected photos	
Make new virtual copies	
Set as target collection	

Step Four:

In Lightroom 5, Adobe made the process of creating target collections a little more convenient, because now when you create a collection, there's a checkbox in the Create Collection dialog that will make this new collection a target collection (just turn on the Set as Target Collection checkbox and this new collection is your new target collection). By the way, you can only have one target collection at a time, so when you choose a different collection to become the target collection, it removes the target from the previously selected collection (the collection is still there—it doesn't delete it. But, pressing B doesn't send images to that collection anymore—it sends them to the new collection you just designated as the target collection). Also, just keep in mind that if you want to go back to creating a Quick Collection (using the B keyboard shortcut), you'll need to turn off your target collection, by just Right-clicking on it and choosing Set as Target Collection.

Adding Specific Keywords for Advanced Searching

Most of the time, finding images you want in Lightroom will be easy. Want to look at photos from your vacation to New York? Just click on your New York collection. If you want to see all your photos from all your New York trips, then you could search by the keyword New York (remember those generic keywords you added when you first imported your photos?). But what if you want just photos of the Empire State Building, and just photos of it at night? If that sounds like something you'd wind up doing fairly regularly, then this is for you.

Step One:

Before we go into all this, I just want to say up front that most folks won't need to do the level of keywording I'm about to go into. But if you're a commercial photographer, or if you work with a stock photo agency, keywording all your images is pretty much what you have to do. Luckily, Lightroom makes the process fairly painless. There are a few ways to add specific keywords, and there are different reasons why you might choose one way over another. We'll start with the Keywording panel in the right side Panels area. When you click on a photo, it will list any keywords already assigned to that photo near the top of the Keywording panel (as shown here). By the way, we don't really use the word "assigned," we say a photo's been "tagged" with a keyword, as in, "It's tagged with the keyword NFL."

Step Two:

I tagged all the photos here with 12 kinda generic keywords when I imported them, like Bucs, Football, NFL, and Patriots. To add another keyword, you'll see a text field below the keyword field where it literally reads, "Click here to add keywords." Just click in that field, and type in the keyword you want to add (if you want to add more than one keyword, just put a comma between them), then press the Return (PC: Enter) key. For the selected photo in Step One, I added the keyword "Tom Brady." Easy enough.

Keywording Enter Keywords Keyword Tags Bucs, Conference, Football, League, National, New England, NFC, NFL, Patriots, Preseason, Raymond James Stadium, Tampa Bay Tom Brady **Keyword Suggestions** National Football League Conference Bucs Preseason NFC Raymond Ja.

Step Three:

The Keywording panel is also ideal if you want to add the same keywords to a bunch of photos at once. For example, let's say that 71 photos from your full shoot were taken in the first quarter. You'd select those 71 photos first (click on the first one, press-and-hold the Shift key, then scroll down to the last one, and click on it—it'll select all the photos in between), then in the Keywording panel, add your keywords in the Keyword Tags text field. For example, here I typed "First Quarter" and it added "First Quarter" to all 71 selected photos. So, the Keywording panel is my first choice when I need to tag a number of photos from a shoot with the same keywords.

TIP: Choosing Keywords

Here's how I choose my keywords: I ask myself, "If, months from now, I was trying to find these same photos, what words would I most likely type in the Find field?" Then I use those words. It works better than you'd think.

Step Four:

Say you wanted to add some specific keywords to just certain photos, like those of one particular player. If it's just three or four photos kind of near each other, you can use the Keywording panel technique I just showed you. But if it's 20 or 30 spread throughout a shoot, then try the Painter tool (in Grid view, it's found down in the toolbar—it looks like a spray paint can), which lets you "paint" on keywords as you scroll through your images. First, click on the Painter tool, then to the right, make sure Keywords appears after Paint, then in the field to the right, type in "Ronde Barber" or any other specific keywords that relate to just those photos.

Step Five:

Scroll through your images and any time you see a Ronde Barber photo, just click once on it and it "paints" that keyword onto your photo (you can add as many as you want—just remember to put a comma between them). As you click the Painter tool, a white highlight border will appear around the tagged photo, and a dark rectangular box appears with the keyword(s) you've just assigned (as seen here). If you see multiple photos in a row you want to tag, just press-and-hold your mouse button and paint right across them, and they'll all be tagged. When you're done with the Painter tool, just click back where you found it in the toolbar. The Painter tool is what I use when I have a lot of photos in a shoot, but just need to tag some individual photos with a particular keyword.

TIP: Create Keyword Sets

If you use the same keywords often, you can save them as a Keyword Set, so they're just one click away. To create a set, just type the keywords in the Keyword Tags text field, then click on the Keyword Set pop-up menu at the bottom of the panel. Choose **Save Current Settings as New Preset** and they're added to the list, along with built-in sets like Wedding, Portrait, etc.

Step Six:

The next panel down, Keyword List, lists all the keywords you've created or that were already embedded into the photos you've imported. The number to the right of each keyword tells you how many photos are tagged with that keyword. If you hover your cursor over a keyword in the list, a white arrow appears on the far right. Click on it and it displays just the photos with that keyword (in the example shown here, I clicked on the arrow for Ronde Barber, and it brought up the only four photos in my entire catalog tagged with that keyword). This is why specific keywords are so powerful.

Step Seven:

Now, it doesn't take very long for your list of keywords to get really long. So, to keep things organized, you can create a keyword that has sub-keywords (like Football as the main keyword, then inside that is NFL, Patriots, Bucs, and so on). Besides having a shorter keyword list, it also gives you more sorting power. For example, if you click on Football (the toplevel keyword) in the Keyword List panel, it will show you every file in your catalog tagged with Patriots, Bucs, etc. But, if you click on Patriots, it will show you only the photos tagged with Patriots. This is a huge time saver and I'll show you how to set this up in the next step.

TIP: Drag-and-Drop and Delete Keywords

You can drag-and-drop keywords in the Keyword List panel right onto photos to tag them and vice-versa—you can drag-and-drop photos right onto keywords. To remove a keyword from a photo, in the Keywording panel, just delete it from the Keyword Tags field. To delete a keyword entirely (from all photos and the Keyword List panel itself), scroll down to the Keyword List panel, click on the keyword, then click the – (minus sign) button on the left side of the panel header.

Step Eight:

To make a keyword into a top-level one, just drag-and-drop other keywords directly onto it. That's all you have to do. If you haven't added the keywords you want as sub-keywords yet, do this instead: Right-click on the keyword you want as a top-level keyword, then from the pop-up menu, choose **Create Keyword Tag Inside** (as shown here) to bring up a dialog where you can create your new sub-keyword. Click the Create button, and this new keyword will appear under your main keyword. To hide the sub-keywords, click the triangle to the left of your main keyword.

Renaming Photos Already in Lightroom

In Chapter 1, you learned how to rename photos as they're imported from your camera's memory card, but if you're importing photos that are already on your computer, they keep the same names they had (because you're just adding them to Lightroom). So, if they're still named with those cryptic names assigned by your digital camera, like "_DSC0035.jpg," here's how to rename them to something that makes sense.

Step One:

Click on the collection of photos you want to rename, then press **Command-A** (**PC: Ctrl-A**) to select all of the photos in this collection. Go under the Library menu and choose **Rename Photos**, or press **F2** on your keyboard to bring up the Rename Photos dialog (shown here). Here, it gives you the same File Naming presets as the Import window does. Choose whichever File Naming preset you want to use. In this case, I chose the Custom Name – Sequence preset, which lets you enter a custom name, and then it starts the automatic numbering at 1.

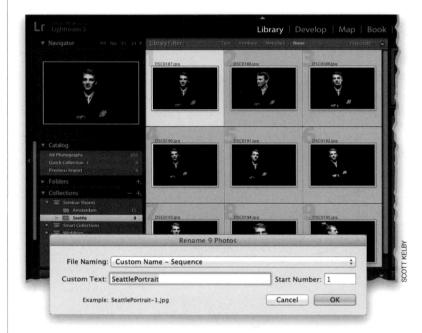

Step Two:

Now just click OK, and all the photos are renamed in an instant. This whole process takes just seconds, but makes a big difference when you're searching for photos—not only here in Lightroom, but especially outside of Lightroom in folders, in emails, etc., plus it's easier for clients to find photos you've sent them for approval.

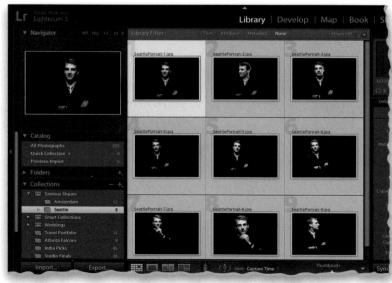

Your digital camera automatically embeds all kinds of info right into the photo itself, including everything from the make and model of the camera it was taken with, to the type of lens you used, and even whether your flash fired or not. Lightroom can search for photos based on this embedded information, called EXIF data. Beyond that, you can embed your own info into the file, like your copyright info, or photo captions for uploading to news services.

Adding Copyright Info, Captions, and Other Metadata

Step One:

You can see the info embedded in a photo (called metadata) by going to the Metadata panel in the right side Panels area in the Library module. By default, it shows you some of the different kinds of data embedded in your photo, so you see a little bit of the stuff your camera embedded (called EXIF data—stuff like the make and model of camera you took the photo with, which kind of lens you used, etc.), and you see the photo's dimensions, any ratings or labels you've added in Lightroom, and so on, but again, this is just a small portion of what's there. To see all of just what your camera embedded into your photo, choose **EXIF** from the pop-up menu in the left side of the panel header (as shown here), or to see all the metadata fields (including where to add captions and your copyright info), choose **EXIF** and IPTC.

TIP: Get More Info or Search
While in Grid view, if you see an arrow
to the right of any metadata field, that's
a link to either more information or an
instant search. For example, scroll down
to the EXIF metadata (the info embedded
by your camera). Now, hover your cursor
over the arrow that appears to the right of
ISO Speed Rating for a few seconds and a
little message will appear telling you what
that arrow does (in this case, clicking that
arrow would show you all the photos in
your catalog taken at 200 ISO).

Step Two:

Although you can't change the EXIF data embedded by your camera, there are fields where you can add your own info. For example, if you need to add captions (maybe you're going to be uploading photos to a wire service), just go to the Caption field in the IPTC metadata, click your cursor inside the field, and start typing (as shown here). When you're done, just press the **Return (PC: Enter)** key. You can also add a star rating or label here in the Metadata panel, as well (though I usually don't do that here).

Step Three:

If you created a Copyright Metadata preset (see Chapter 1), but didn't apply it when you imported these photos, you can apply that now from the Preset menu at the top of the Metadata panel. Or if you didn't create a copyright template at all, you can add your copyright info manually. Scroll down to the bottom of the Metadata panel to the Copyright section, and just type in your copyright info (and make sure you choose Copyrighted from the Copyright Status pop-up menu). By the way, you can do this for more than one photo at a time. First, Command-click (PC: Ctrl-click) to select all the photos you want to add this copyright info to, then when you add the information in the Metadata panel, it's instantly added to every selected photo.

Note: This metadata you're adding is stored in Lightroom's database, and when you export your photos from Lightroom as either JPEGs, PSDs, or TIFFs, this metadata (along with all your color correction and image editing) gets embedded into the file itself at that moment. However, it's different when working with RAW photos (as you'll see in the next step).

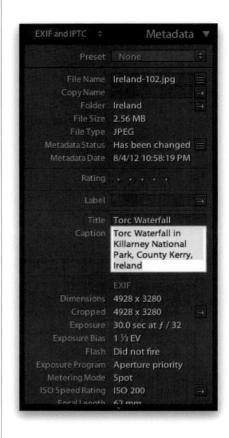

Step Four:

If you want to give someone your original RAW file (maybe a client or co-worker) or if you want to use your original RAW file in another application that processes RAW images, the metadata you've added in Lightroom (including copyright info, keywords, and even color correction edits to your photo) won't be visible because you can't embed info directly into a RAW file. To get around that, all this information gets written into a separate file called an XMP sidecar file. These XMP sidecar files aren't created automatically—you create them by pressing Command-S (PC: Ctrl-**S)** before you give someone your RAW file. After you press this, if you look in the photo's folder on your computer, you'll see your RAW file, then next to it an XMP sidecar file with the same name, but with the .xmp file extension (the two files are circled here in red). These two files need to stay together, so if you move it, or give the RAW file to a co-worker or client, be sure to grab both files.

Ceneral | File Handling | Metadata | Editing | Include Develop settings in metadata inside JPEG, TIFF, PNG, and PSD files | Automatically write changes into XMP | Warning: Changes made in Lightroom will not automatically be visible in other applications. Reverse Geocoding | Enable reverse geocoding of GPS coordinates to provide address suggestions | Export reverse geocoding suggestions whenever address fields are empty | EXIF | Write date or time changes into proprietary raw files.

Step Five:

Now, if you converted your RAW file into a DNG file when you imported it, then when you press Command-S, it does embed the info into the single DNG file (a big advantage of DNG—see Chapter 1), so there will be no separate XMP file. There actually is a Lightroom catalog preference (choose Catalog Settings from the Lightroom menu on a Mac, or the Edit menu on a PC, then click on the Metadata tab, shown here) that automatically writes every change you make to a RAW file to the XMP sidecar, but the downside is a speed issue. Each time you make a change to a RAW file, Lightroom has to write that change into XMP, which slows things down a bit, so I leave the Automatically Write Changes into XMP checkbox turned off.

If Your Camera Supports GPS, Prepare to Amaze Your Friends

This is more of a "Wow, that's cool!" feature than an incredibly useful one, but if your camera has built-in GPS (which embeds the exact latitude and longitude of where the photo was shot), or if you bought one of the GPS units now available for digital cameras, then gather your friends around Lightroom and prepare to blow them away, because it not only displays this GPS information, but one click will actually bring up a map pinpointing the location where you took the photo. Amazing! Next thing you know they'll put a man on the moon.

Step One:

Import a photo into Lightroom that was taken with a digital camera that has the built-in (or add-on) ability to record GPS data (camera companies like Ricoh, Canon, and Nikon make GPS-enabled digital cameras, and many Nikon and Canon DSLRs have a GPS-compatible connector port, which can make use of add-ons like Nikon's GP-1 unit, with a street price of around \$200 [at the time of writing] or Canon's GP-EP2 unit, with a street price of around \$300).

Step Two:

In the Library module, go to the Metadata panel in the right side Panels area. Near the bottom of the EXIF section, if your photo has GPS info encoded, you'll see a metadata field labeled GPS with the exact coordinates of where that shot was taken (shown circled here in red).

Step Three:

Just seeing that GPS info is amazing enough, but it's what comes next that always drops jaws whenever I show this feature live in front of a class. Click on the little arrow that appears to the far right of the GPS field (it's shown circled here in red).

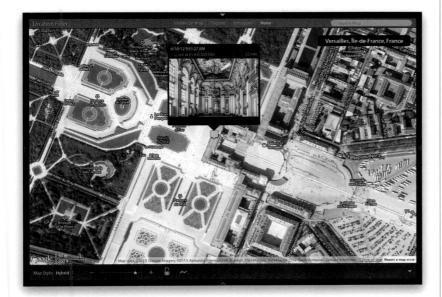

Step Four:

When you click on that little arrow, if you're connected to the Internet, Lightroom will automatically switch to the Map module and display a full-color photographic satellite image with the exact location the shot was taken pinpointed on the map (as shown here). Seriously, how cool is that!? Now, in all honesty, I've never had even a semi-legitimate use for this feature, but I've found that despite that fact, I still think it's just so darn cool. All guys do. We just can't explain why. If you want to learn more about the Map module, turn the page.

Organizing Your Photos on a World Map

This is another feature in Lightroom 5 that is yet another way to organize your images—a very visual one at that. Even if this doesn't sound like something you'd like to do, you've just gotta try it once, because it's so well done, it might surprise you. By the way, although this uses the Map module, I thought it belonged here in the Library chapter because it's really just another way to organize your images, which is what the Library is all about.

Step One:

There are two ways to organize your images using Lightroom's Map feature: (1) If you have photos that have embedded GPS coordinates in them, Lightroom will automatically take those photos and add them to its world map. If you're thinking you don't have any of these, you actually probably do—in your cell phone. Most smartphones (like the iPhone and most Android-based smartphones) automatically embed the GPS info from where the photo was taken right into the image file itself, and if you have those in Lightroom, they're "on the map." If you don't have any GPS info in your images, you're not out of luck, because (2) you can search the map and place them on it yourself (it's simple). Note: To use the Map module, you'll need to be connected to the Internet, since it uses a version of Google Maps.

Step Two:

We'll look at the automated method first (which assumes that you have at least a few GPS-embedded images already in Lightroom. If you know you don't, import a few from your cell phone, so you can at least try this out). Now, click on the Map module up top, and then click on the collection of images you want to see plotted on the map (or if you want it to show all the GPS-embedded photos in your entire library, go to the Catalog panel and click on All Photographs). On the map, you'll see an orange pin marking where each photo was taken (it'll often look like one pin until you zoom in farther), and you'll see the number of photos taken right on the pin (as seen here).

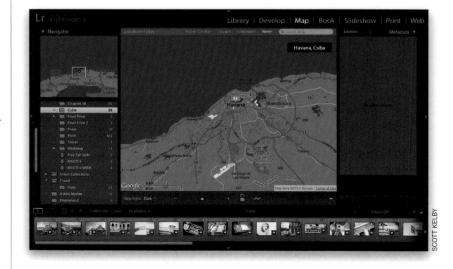

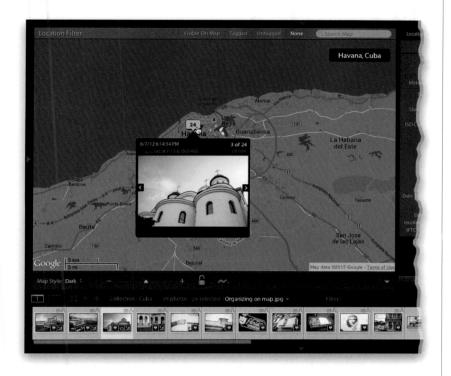

Step Three:

To see the photos represented by that little orange pin, just hover your cursor over it and a little preview window pops up that shows you a thumbnail of the first image. (By the way, if you double-click on the orange pin, the preview window pops up and stays.) To see more photos, just click the left and right arrows on the sides of the preview window (or you can use the **Left/Right Arrow keys** on your keyboard). Double-click on any one of the image previews to open it in Loupe view in the Library module. If you click on the orange map pin, it turns gold and selects all the photos. This is why this makes a pretty cool, very visual way to organize your photos.

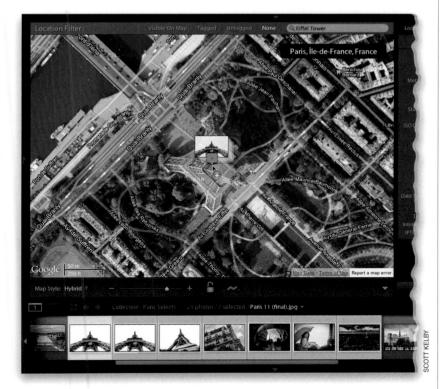

Step Four:

But, what if you don't have GPS data embedded into your photos? You can still add photos to the map—you just do it manually by searching for the location (this is easier than it sounds), and then dragging the images you want assigned to that location to the location on the map. For example, here is a set of photos taken in Paris, France, but without any GPS data. All you do is go up to the Search field above the top-right corner of the map itself (if you don't see it, press Command-F [PC: Ctrl-F]), and type in "Paris, France" and it locates Paris on the map for you. Now all you do is select all those photos from Paris in the Filmstrip, and drag-and-drop them right on the pin that represents Paris. Also, if you have images from a well-known monument, like the Eiffel Tower or the Taj Mahal, you can just type "Eiffel Tower" (as I did here) or "Taj Mahal" and it will find it for you.

Step Five:

So, this is cool, but you might be thinking "Where's the organization part of all this?" Well, that comes once you've found a pin on the map that you might want to go back to. For example, let's say you added those photos from Paris, and you want to be able to see them anytime, without having to search the world (so to speak). Well, once you've found your Paris shots, save them as a Saved Location (kind of your "favorite shots on the map"). You do this over in the Saved Locations panel in the left side Panels area. First, click on the orange pin for Paris, then click the + (plus sign) button on the right side of the panel header to bring up the dialog you see here.

Step Six:

First, give your location a name, then use the Radius slider below it to determine how far out (in miles or kilometers) you want other nearby photos tagged to that same location. So, for example, if you shot around Paris for a week on vacation, but you took day trips to nearby areas, you could include photos taken in those other areas by setting a radius that includes them (so, if you know you stayed within 25 miles of Paris, set it at 25, and all your day trips would appear under the one pin). As you drag the slider, it visually shows the radius as a white circle on the map, kind of like a radar beacon, so you can see what's being covered (if you need to zoom in closer, use the Zoom slider in the toolbar below the map). Lastly, there's a Private checkbox, and turning this on tells Lightroom to automatically strip out your GPS data if you save these files outside of Lightroom (that way, nobody knows you were in Paris, except of course for people who see your images of Paris and say, "Hey, isn't that a shot from Paris?"). Click Create, and this location is added to your Saved Locations panel.

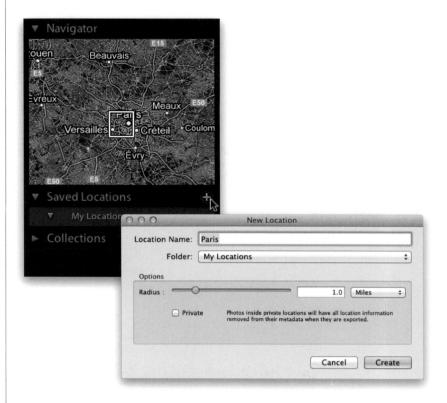

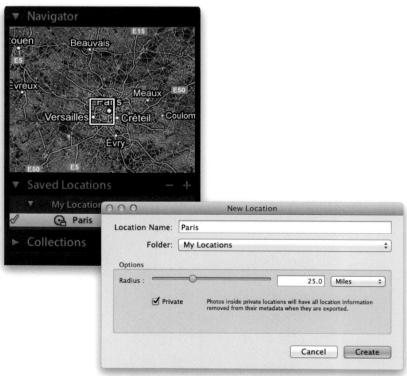

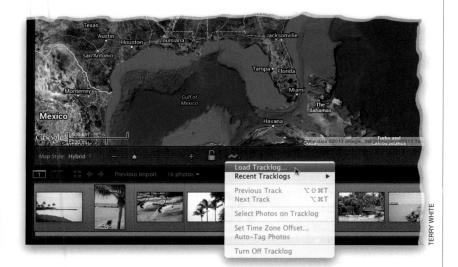

Step Seven:

There are a few other important Map module features you should know about. For example, if you have a GPS unit for your camera that, instead of embedding the GPS data directly into the images themselves, creates a tracklog (basically, it creates a text file with a list of everywhere you've been while your GPS was on) to be matched up to the images afterward, Lightroom lets you import that tracklog by clicking on the little chart (GPS Tracklog) icon in the toolbar below the map, which brings up a pop-up menu where you choose **Load Tracklog** (as shown here).

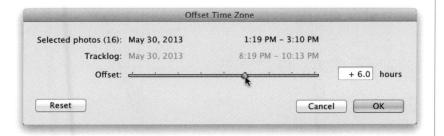

Step Eight:

If you travel with a GPS unit that uses a tracklog, you'll need to remember to change the time to match the current time zone you're in when you're using the tracklog, because the tracklog matches up your images by comparing the time in the tracklog to the time embedded into each photo by your camera. If you don't remember to do that, when you import the tracklog into Lightroom, your time will be off by at least an hour (or more, depending on how far you strayed from home). Luckily, Lightroom figures you're like me, and that you forget to change your camera's time for the time zone that you're in, so what you do is select all the photos from your trip, then from that GPS Tracklog pop-up menu in the toolbar, choose **Set Time Zone Offset**, to bring up the dialog you see here, which lets you add (or subtract) hours to adjust for the time zone, so your time in your images and your tracklog are now in sync, and it can now match up the images and place them on the map. However, you're not done yet.

Step Nine:

So far, all you've done is change the time of the photos, but to actually have those photos move to the map, you need to select them, then go back to that same GPS Tracklog pop-up menu and choose Auto-Tag Selected Photos, as shown here, and now those images get added to the map.

TIP: Zooming In

To zoom in closer on a location on the map, you can just double-click on that area and it will zoom in one level tighter. You can use the Zoom slider in the toolbar, or the + (plus sign) and - (minus sign) keys on your keyboard. You can also press-and-hold the Option (PC: Alt) key, and click-and-drag out a selection around the area you want to zoom in tight on. Lastly, if your mouse has a scroll wheel, that works for zooming in/out, too.

Step 10:

At the top of the map is a Location Filter, which is handy for helping you find which images in your library have been tagged on the map, or not. So, if you want to instantly see all the photos that do have embedded GPS info, go to the Library module, click on All Photographs in the Catalog panel, then go back to the Map module, and click the Tagged button (as I did here). All your tagged photos will be highlighted in the Filmstrip. To see the ones missing that data (so you can make sure they get added to the map), click the Untagged button and all the images that aren't tagged on the map appear highlighted down in the Filmstrip. To see all the images that are visible on your current map, just click the Visible On Map button. I won't insult you by explaining what None does. :-)

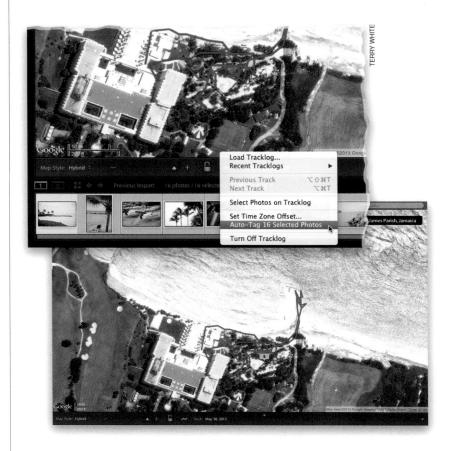

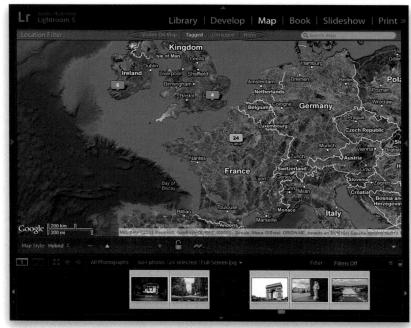

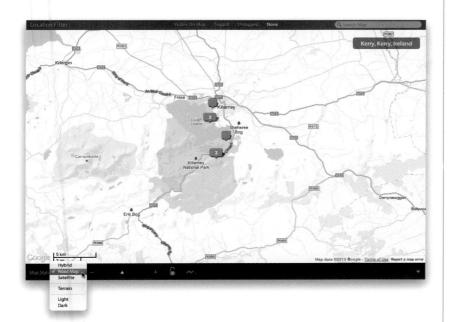

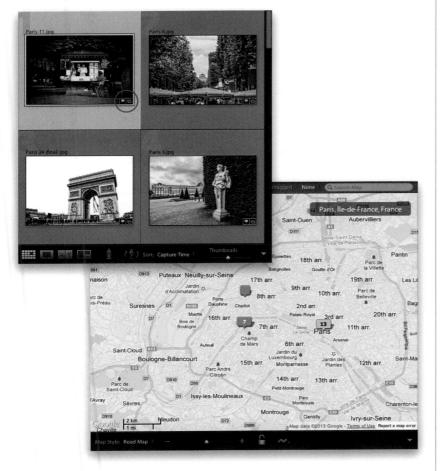

Step 11:

We haven't really talked too much about the map itself, but you'll probably find it helpful to know a few options you have here. First, the default map view is Hybrid, which puts street names and other standard map data over a satellite view of the map, but you can switch to other views (like Road Map, or just the Satellite view, or Terrain) with the Map Style popup menu at the left end of the toolbar (as shown here, where I've chosen the Road Map view).

TIP: You Can Drag Pin Locations If you're adding a pin, you can drag it anywhere you'd like. However, if you want to lock down your pins (so you don't accidentally drag one while you're moving around the map), just click the Lock Markers icon in the toolbar beneath the map.

Step 12:

I've been saving this for last, but there's actually another quick way to access your images on the map. You know those little badges that appear along the bottom of your thumbnail in the Library module's Grid view that show whether your photo has been cropped, or edited, and such? Well, there's a GPS badge, as well (it looks like a pin, as shown circled in red here), and if you click on the pin badge, it takes you to that photo's position on the map.

TIP: Seeing Your GPS Location If you want to see the actual GPS data for your location (the longitude and latitude numbers), look over on the right side in the Metadata panel and it displays your GPS data there.

Finding Photos Fast!

Okay, so to make finding our photos easier, we gave them names that make sense when we imported them, and we applied a few keywords to help make searching easier, and now we finally get the payoff: we can put our hands on exactly the photo (or photos) we need, in just seconds. This has been our goal from the very start—to set things up the right way from the beginning, so we have a fast, organized, streamlined catalog of our entire photo collection, and now we're ready to take 'er out for a spin.

Step One:

Before you start searching, first you need to tell Lightroom where you want it to search. If you want to search just within a particular collection, go to the Collections panel and click on that collection. If you want to search your entire photo catalog, then look down on the top-left side of the Filmstrip and you'll see the path to the current location of photos you're viewing. Click-and-hold on that path and, from the pop-up menu that appears, choose **All Photographs** (other choices here are to search the photos in your Quick Collection, your last import of photos, or any of your recent folders or collections).

Step Two:

Now that you've chosen where to search, the easiest way to start a search is to use a familiar keyboard shortcut: Command-F (PC: Ctrl-F). This brings up the Library Filter bar across the top of the Library module's Grid view. Chances are you're going to search by text, so just type in the word you're searching for in the search field, and by default it searches for that word everywhere it can—in the photo's name, in any keywords, captions, embedded EXIF data, you name it. If it finds a match, those photos are displayed (here, I searched for the word "Naval"). You can narrow your search using the two pop-up menus to the left of the search field. For example, to limit your search to just captions, or just keywords, choose those from the first pop-up menu.

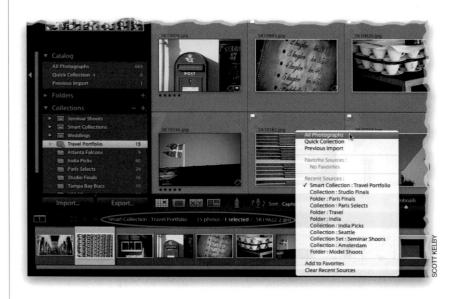

Develop

Step Three:

Another way to search is by attribute, so click on the word Attribute in the Library Filter and those options appear. Earlier in this chapter, we used the Attribute options to narrow things down to where just our Picks were showing (you clicked on the white Pick flag), so you're already kind of familiar with this, but I do want to mention a few other things: As for the star ratings, if you click on the fourth star, it filters things so you just see any photos that are rated four stars or higher (so you'd see both your 4-star and 5-star images). If you want to see your 4-star rated images only, then click-and-hold on the ≥ (greater than or egual to) sign that appears to the immediate right of the word Rating, and from the pop-up menu that appears, choose Rating Is Equal to, as shown here.

Step Four:

Besides searching by text and attributes, you can also find the photos you're looking for by their embedded metadata (so you could search for shots based on which kind of lens you used, or what your ISO was set to, or what your f-stop was, or a dozen other settings). Just click on Metadata in the Library Filter, and a series of columns will pop down where you can search by date, camera make and model, lenses, or labels (as shown here). However, I have to tell you, if the only hope you have of finding a photo is trying to remember which lens you used the day you took the shot, you've done a really lame job of naming and/or keywording your shots (that's all I'm sayin'). This should truly be your "search of last resort."

Step Five:

Again, there are four default ways to search using the Metadata options:

By Date: If you think you can remember which year the photo you're looking for was taken, in the Date column, click on that year, and you'll see just those photos appear. If you want to narrow it down further, click the right-facing arrow to the left of the year, and you'll find each month, and then you can drill down to the individual days (as shown here).

By Camera Body: If you don't remember the year you took the photo, but you know which camera body you took the shot with, then just go straight to the Camera column and click directly on the camera (you'll see how many photos you took with that camera listed to the right of the camera body). Click on the body, and those photos appear.

By Lens: If the shot you took was a wide angle, then go right to the Lens column, click on the lens you think it was taken with, and those images will appear. This helps if you know the photo was taken with a speciality lens, like a fisheye—you can just click right on that lens (as shown here), and you'll probably find the shot you're looking for pretty quickly. By the way, you don't have to start with the Date column, then Camera, then Lens. You can click on any column you'd like, in any order, as all of these columns are always "live."

By Label: The last column seems somewhat redundant to the Attribute search options, but it actually is helpful here if you've found 47 photos taken with a fisheye, and you know you have the best ones marked with a label. This will narrow things down even further.

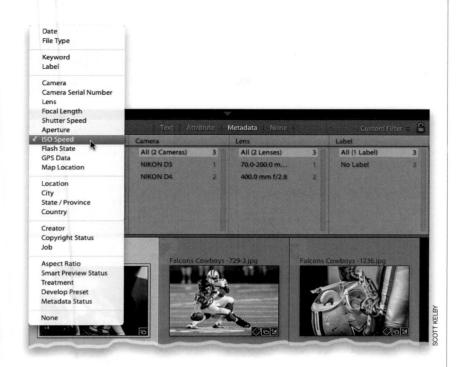

Step Six:

Let's say you don't really ever need to search by date, but you do a lot of low-light shooting, so instead, searching by ISO might be more helpful. Luckily, you can customize each column, so it searches for the type of metadata you want, by clicking on the column header and choosing a new option from the pop-up menu (as shown here, where I've chosen ISO Speed for the first column). Now, all my ISOs will be listed in the first column, so I know to click on 800, 1600, or higher to find my low-light shots. Another helpful choice (for me anyway) is to set one column to Creator (the copyright info), so I can quickly find shots in my catalog taken by other people with just one click.

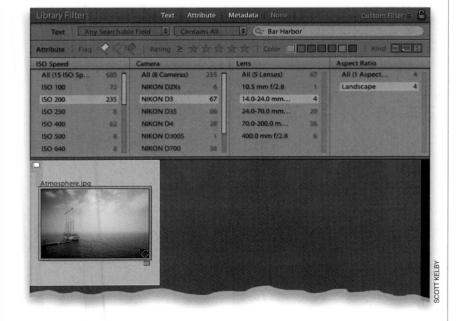

Step Seven:

Want to take things up one last notch? (Sure ya do!) If you Command-click (PC: Ctrl-click) on more than one of the three search options in the Library Filter, they're additive (go ahead, Command-click on Text, then Attribute, then Metadata, and they just pop down one after another). Now you can search for a photo with a specific keyword (in this case, "Bar Harbor") that's marked as a Pick, with a Red label, that was taken at ISO 200, with a Nikon D3, using a 14-24mm lens, and is in Landscape (wide) orientation (the result of that search is shown here). Ya know what else is cool? You can even save these criteria as a preset. You have to admit, although you shouldn't have to resort to this type of metadata search in the first place, it's still really amazing.

Creating and Using Multiple Catalogs

Lightroom is designed for managing a library of literally tens of thousands of images—I know photographers who have well over 100,000 images in their catalog, and Lightroom can handle it, no sweat. However, once your catalog gets that large, Lightroom can start to take a performance hit, so you might want to think about creating a second catalog (you can create more than one catalog and switch between them any time you like), so you can keep your catalog sizes manageable and Lightroom running at full speed.

Step One:

So far, we've been working with a catalog of photos that was created for you when you launched Lightroom for the first time. However, if you wanted to, for example, create a separate catalog for managing all your travel photos, family photos, or sports photos, then you'd go under Lightroom's File menu and choose New Catalog (as shown here). This brings up the Create Folder with New Catalog dialog. Give your catalog a simple name (like "Wedding Catalog") and pick a place to save it to (just to keep things straight, I save all of my catalogs in my Lightroom folder, so I always know where they are).

Step Two:

Once you click the Create button, Lightroom closes your database, then Lightroom itself quits and automatically relaunches with your brand new, totally empty catalog, with no photos in it whatsoever (as seen here). So, click on the Import button (near the bottom-left corner), and let's bring in some wedding photos to get the ball rolling.

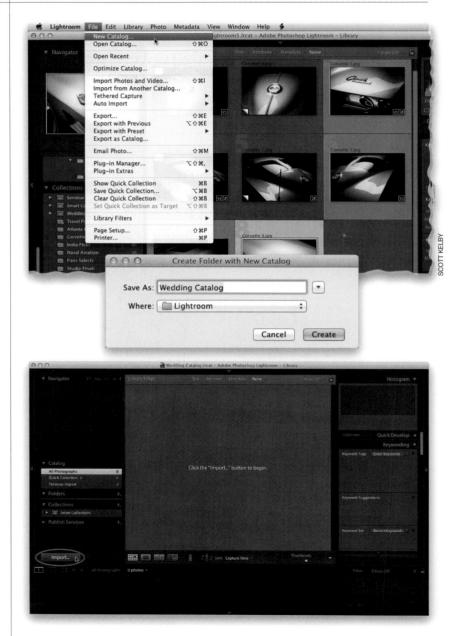

Ti Lightroom5.lrcat	/Users/skelby/Pictures/Lightro	oom/Lightroom5	
₩edding Catalog.lrcat	/Users/skelby/Pictures/Lightro	/Users/skelby/Pictures/Lightroom/Wedding Catalog	
d Lightroom 4 Catalog.lrcat	/Users/skelby/Pictures/Lightro	/Users/skelby/Pictures/Lightroom	
Always load this catalog on startu	p	Test integrity of this catalog	
		in read-only folders.	
Always load this catalog on startu			

Step Three:

You know what to do from here, as far as building a catalog of images (import more photos, add keywords, make your collections, etc., just like always). When you're done working with this new Wedding catalog, and you want to return to your original main catalog, just go under the File menu, under Open Recent, and choose your original catalog, as shown here. Click Relaunch in the Open Catalog dialog and Lightroom will save your wedding photos catalog, and once again, quit, and relaunch with your main catalog. I know it's kinda weird that it has to guit and relaunch, but luckily it's pretty darn quick about it.

Step Four:

You can actually choose which catalog you want to work with when you launch Lightroom. Just press-and-hold the Option (PC: Alt) key while you launch Lightroom, and it will bring up the Select Catalog dialog you see here, where you can choose which catalog you want it to open. Note: If you want to open a Lightroom catalog you created, but it doesn't appear in the Select a Recent Catalog to Open section (maybe you didn't save it in your Lightroom folder when you created it or you haven't opened it recently), then you can click the Choose a Different Catalog button at the bottom left of the dialog and locate the catalog using a standard Open (PC: Browse) dialog. Also, I know I probably don't have to say this, but if you want to create a brand new empty catalog, just click the Create a New Catalog button.

TIP: Always Launch the Same Catalog If you always want to launch Lightroom with a particular catalog, click on the catalog in the Select Catalog dialog, then turn on the Always Load This Catalog on Startup checkbox (which appears beneath your catalog list).

From Laptop to Desktop: Syncing Catalogs on Two Computers

If you're running Lightroom on a laptop during your location shoots, you might want to take all the edits, keywords, metadata, and of course the photos themselves, and add them to the Lightroom catalog on your studio computer. It's easier than it sounds: basically, you choose which catalog to export from your laptop, then you take the folder it creates over to your studio computer and import it—Lightroom does all the hard work for you, you just have to make a few choices about how Lightroom handles the process.

Step One:

Using the scenario described above, we'll start on the laptop. The first step is to decide whether you want to export a folder (all the imported photos from your shoot), or a collection (just your Picks from the shoot). In this case, we'll go with a collection, so go to the Collections panel and click on the collection you want to merge with your main catalog back in your studio. (If you had chosen a folder, the only difference would be you'd go to the Folders panel and click on the folder from that shoot instead. Either way, all the metadata you added, and any edits you made in Lightroom, will still be transferred over to the other machine.)

Step Two:

Now go under Lighroom's File menu and choose **Export as Catalog** (as shown here).

Step Three:

When you choose Export as Catalog, it brings up the Export as Catalog dialog (shown here), where you type in the name you want for your exported catalog at the top, but there are some very important choices you need to make at the bottom. By default, it assumes that you want to include the previews that Lightroom created when you imported the photos into Lightroom, and I always leave this option turned on (I don't want to wait for them to render all over again when I import them into my studio computer). You can also choose to have it build and include Smart Previews. If you turn on the top Export Selected Photos Only checkbox, then it will only export photos in that collection that you had selected before you chose Export as Catalog. But perhaps the most important choice is the second checkbox—Export Negative Files. With this off, it only exports previews and metadata, it doesn't really export the actual photos themselves, so if you do indeed want to export the actual photos (I always do), then turn the second checkbox on.

Step Four:

When you click the Export Catalog button, it exports your catalog (it usually doesn't take very long, but of course the more photos in your collection or folder, the longer it will take), and when it's done exporting, you'll see the folder on your computer that you exported (as seen here). I usually save this file to my desktop, because the next step is to copy it onto an external hard drive, so you can move this folder full of images over to your studio computer. So, go ahead and copy this folder onto an external hard drive now.

Continued

The Adobe Photoshop Lightroom 5 Book for Digital Photographers

Step Five:

When you get to your studio, connect your hard drive to your studio computer, and copy that folder to the location where you store all your photos (which should be that My Lightroom Photos folder we created in Chapter 1). Now, on your studio computer, go under Lightroom's File menu and choose Import from Another Catalog to bring up the dialog you see here. Navigate to that folder you copied onto your studio computer, and then inside that folder, click on the file that ends with the file extension LRCAT (as shown here), and click the Choose button. By the way, if you look at the capture shown here, you can see that Lightroom created four items inside this folder: (1) a file that includes the previews, (2) a file that includes the Smart Previews, (3) the catalog file itself, and (4) a folder with the actual photos.

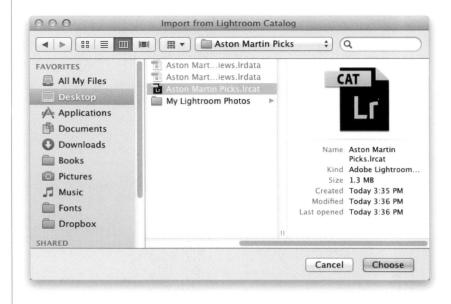

Step Six:

When you click the Choose button, it brings up the Import from Catalog dialog (seen here). Any photos in the Preview section on the right that have a checkbox turned on beside them will be imported (I always leave all of these turned on). In the New Photos section on the left is a File Handling pop-up menu. Since we already copied the photos into the proper folder on our studio computer, I'm using the default setting which is Add New Photos to Catalog Without Moving (as shown here), but if you want to copy them directly from your hard drive into a folder on your computer, you could choose the Copy option instead. There's a third option, but I have no idea why at this point you'd choose to not import the photos. Just click Import, and these photos will appear as a collection, with all the edits, keywords, etc., you applied on your laptop.

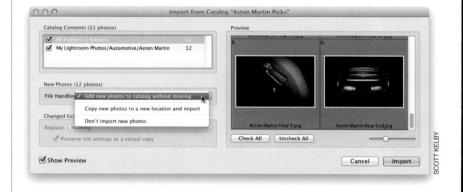

All the changes, edits, keywords, etc., you add to your photos in Lightroom are stored in your Lightroom catalog file, so as you might imagine, this is one incredibly important file. Which is also why you absolutely need to back up this catalog on a regular basis, because if for some reason or another your catalog database gets corrupted—you're completely hosed. (Of course, unless you backed up your catalog, in which case you're not hosed at all.) The good news is Lightroom will back up this catalog database for you, but you have to tell it to. Here's how:

Backing Up Your Catalog (This Is VERY Important)

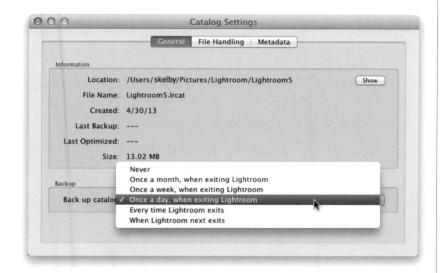

Step One:

Start by going under the Lightroom (PC: Edit) menu and choosing Catalog Settings. When the Catalog Settings dialog appears, click on the General tab up top (shown highlighted here). At the bottom of this dialog is a Backup section, and a Back Up Catalog pop-up menu with a list of options (shown here) for having Lightroom automatically back up your current catalog. Choose how often you want that to be, but I recommend that you choose Once a Day, When Exiting Lightroom. That way, it backs up each time you're done using Lightroom, so if for some reason the catalog database becomes corrupt, you'd only lose a maximum of

Step Two:

one day's editing.

The next time you quit Lightroom, a dialog will appear reminding you to back up your catalog database. Click the Back Up button (as shown here), and it does its thing. It doesn't take long at all, so don't be tempted to click Skip Until Tomorrow or Skip This Time (those are sucker bets). By default, these catalog backups are stored in separate subfolders inside the Backup folder, which lives inside your Lightroom folder. To be safe, in case your computer crashes, you should really store your backups on an external hard drive, so click the Choose button, navigate to your external drive, then click Choose (PC: OK).

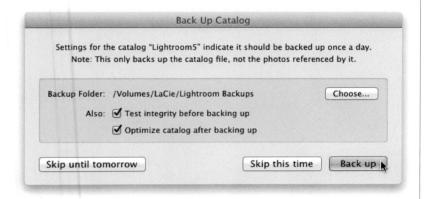

The Adobe Photoshop Lightroom 5 Book for Digital Photographers

Step Three:

So now that you've got a backup of your catalog, what happens if your catalog gets corrupted or your computer crashes? How do you restore your catalog? First you launch Lightroom, then you go under the File menu and choose Open Catalog. In the Open dialog, navigate to your Backups folder (wherever you chose to save it in Step Two), and you'll see all your backups listed in folders by date and 24-hour time. Click on the folder for the date you want, then inside, click on the LRCAT file (that's your backup), click the Open button, and you're back in business.

TIP: Optimizing Your Catalog If

Things Start to Get Kinda Slow Once you accumulate a lot of images in Lightroom (and I'm talking tens of thousands here), things can eventually start to get a little slow. If you notice this happening, go under the File menu and choose Optimize Catalog. This optimizes the performance of the currently open catalog, and while it might take a few minutes now, you'll get that time back really quickly with much faster performance. Even if you don't have tens of thousands of images in Lightroom, it's a good idea to optimize your catalog every couple of months or so to keep everything running at full speed. You can also do this when you back up your catalog by turning on the Optimize Catalog After Backing Up checkbox.

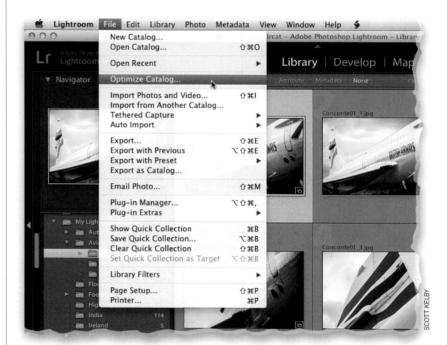

If you work for any amount of time in Lightroom, at some point you're going to see a little exclamation point icon appear above the top right of a thumbnail, which means Lightroom can't find the original photo. You'll still be able to see the photo's thumbnail and even zoom in closer to see it in Loupe view, but you won't be able to do any serious editing (like color correction, changing the white balance, etc.), because Lightroom needs the original photo file to do those things, so you'll need to know how to relink the photo to the original.

Relinking Missing Photos

Step One:

In the thumbnails shown here, you can see one of them has a little exclamation point icon, letting you know it has lost its link to the original photo. There are two main reasons why this probably happened: (1) The original photo is stored on an external hard drive and that hard drive isn't connected to your computer right now, so Lightroom can't find it. So, just reconnect the hard drive, and Lightroom will see that drive is connected, instantly relink everything, and all goes back to normal. But if you didn't store your photos on an external hard drive, then there's a different problem: (2) You moved or deleted the original photo, and now you've got to go and find it.

Step Two:

To find out where the missing photo was last seen, click on that little exclamation point icon and a dialog will pop up telling you it can't find the original file (which you already knew), but more importantly, under the scary warning it shows you its previous location (so you'll instantly be able to see if it was indeed on a removable hard drive, flash drive, etc.). So, if you moved the file (or the whole folder), you just have to tell Lightroom where you moved it to (which you'll do in the next step).

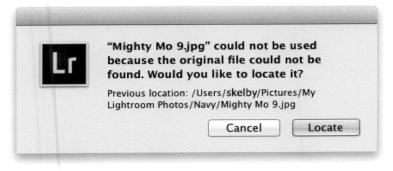

Continued

The Adobe Photoshop Lightroom 5 Book for Digital Photographers

Step Three:

Click on the Locate button, and when the Locate dialog appears (shown here), navigate your way to where that photo is now located. (I know you're thinking to yourself, "Hey, I didn't move that file!" but come on—files just don't get up and walk around your hard drive. You moved it—you just probably forgot you moved it, which is what makes this process so tricky.) Once you find it, click on it, then click the Select button, and it relinks the photo. If you moved an entire folder, then make sure you leave the Find Nearby Missing Photos checkbox turned on, so that way when you find any one of your missing photos, it will automatically relink all the missing photos in that entire folder at once.

TIP: Keeping Everything Linked If you want to make sure that all your photos are linked to the actual files (so you never see the dreaded exclamation point icon), go to the Library module, under the Library menu up top, and choose Find All Missing Photos. This will bring up any photos that have a broken link in Grid view, so you can relink them using the technique we just learned here.

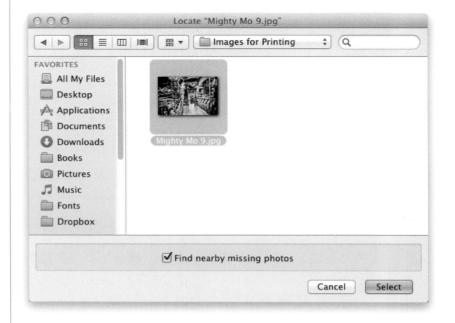

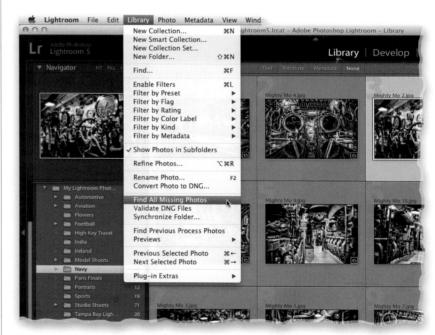

It's pretty unlikely that you'll have a major problem with your Lightroom catalog (after all these years of using Lightroom, it's only happened to me once), and if it does happen, chances are Lightroom can repair itself (which is pretty handy). However, the chances of your hard drive crashing, or your computer dying, or getting stolen (with the only copy of your catalog on it) are much higher. Here's how to deal with both of these potential disasters in advance, and what to do if the big potty hits the air circulation device:

Dealing with Disasters

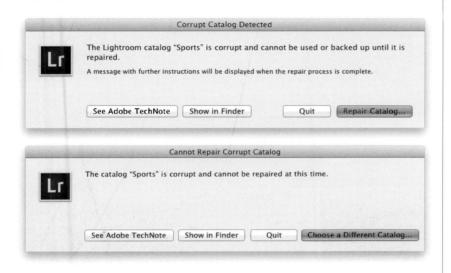

Step One:

If you launch Lightroom and you get a warning dialog like you see here (at top), then go ahead and give Lightroom a chance to fix itself by clicking the Repair Catalog button. Chances are pretty likely it'll fix the catalog and then you're all set. However, if Lightroom can't fix the catalog, you'll see the bottom warning dialog instead, letting you know that your catalog is so corrupt it can't fix it. If that's the case, it's time to go get your backup copy of your catalog (ya know, the one we talked about a couple pages ago).

Step Two:

Now, as long as you've backed up your catalog, you can just go restore that backup catalog, and you're back in business (just understand that if the last time you backed up your catalog was three weeks ago, everything you've done in Lightroom since then will be gone. That's why it's so important to back up your catalog fairly often, and if you're doing client work, you should back up daily). Luckily, restoring from a backup catalog is easy. First, go to your backup hard drive (remember, your backup catalog should be saved to a separate hard drive. That way, if your computer crashes, your backup doesn't crash along with it), and locate the folder where you save your Lightroom catalog backups (they're saved in folders by date, so double-click on the folder with the most current date), and inside you'll see your backup catalog (as seen here).

Continued

Step Three:

Next, go and find the corrupt Lightroom 5 catalog on your computer (on my computer, it's in my Lightroom folder that's in my Pictures folder), and delete that file (drag it into the Trash on a Mac, or into the Recycle Bin on a PC). Now, drag-and-drop your backup catalog file into the folder on your computer where your corrupt file used to be (before you deleted it).

TIP: Finding Your Catalog

If you don't remember where you chose to store your Lightroom catalogs—don't worry—Lightroom can tell you. Go under the Lightroom (PC: Edit) menu and choose **Catalog Settings**. Click on the General tab, then under Location it will show the path to your catalog.

Step Four:

The final step is simply to open this new catalog in Lightroom 5 by going under the File menu and choosing **Open Catalog**. Now, go to where you placed that backup copy of your catalog (on your computer), find that backup file, click on it, then click OK, and everything is back the way it was (again, provided you backed up your catalog recently. If not, it's back to what your catalog looked like the last time you backed it up). By the way, it even remembers where your photos are stored (but if for some strange reason it doesn't, go back to the last project to relink them).

TIP: If Your Computer Crashed...

If, instead of a corrupt catalog, your computer crashed (or your hard drive died, or your laptop got stolen, etc.), then it's pretty much the same process—you just don't have to find and delete the old catalog first, because it's already gone. So, you'll start by just dragging your backup copy of the catalog into your new, empty Lightroom folder (which is created the first time you launch Lightroom on your new computer, or new hard drive, etc.).

Lightroom Killer Tips > >

▼ Deleting a Collection

If you want to delete a collection, just click on it in the Collections panel and then click the - (minus sign) button on the right side of the panel header. This deletes just the collection, not the real photos themselves.

Adding Photos to an **Existing Collection**

You can add photos to any existing collection by just dragging a photo from the grid (or Filmstrip) and dropping it onto your collection in the Collections panel.

▼ Renaming a Collection

To rename a collection, Right-click on the collection and choose Rename from the pop-up menu.

▼ How to Share Smart Collections Settings

If you Right-click on a smart collection, you can choose Export Smart Collection Settings from the pop-up menu to save the smart collection's criteria, so you can share it with a friend. After you send it to them, they can import it using the Import Smart Collection Settings command from the same pop-up menu.

▼ Sharing Keywords

If you want to use your keywords in a copy of Lightroom on a different computer, or share them with friends or co-workers, go under the Metadata menu and choose Export Keywords to create a text file with all your keywords. To import these into another user's copy of Lightroom, go under the Metadata menu and choose Import Keywords, then locate that keyword file you exported earlier. Also, you can copy-and-paste keywords from text files directly into the Keywording panel.

Quickly Apply Keywords to Your Selected Photo

When you hover your cursor over a keyword in the Keyword List panel, a checkbox appears that lets you assign it to your selected photo.

▼ Quickly Create Sub-Keywords If you Right-click on a keyword in the Keyword List panel, there's a menu item called Put New Keywords Inside This Keyword and, until you turn it off (by choosing it again in the pop-up menu), all keywords you create are created as sub-keywords of this keyword.

▼ Auto Hide the Top Taskbar

As I mentioned, the first thing I do is turn the Auto Hide feature off (so the panels stop popping in/out all day long), and instead I show/hide them manually as needed. But you might consider turning on Auto Hide just for the top taskbar. It's

the most rarely used panel, but people do seem to like clicking to jump from module to module, rather than using the keyboard shortcuts. With Auto Hide turned on, it stays tucked out of sight until you click on the gray center triangle to reveal it. Then you can click on the module you want to jump to, and as soon as you move away from the top taskbar, it tucks away. Try it once, and I bet you'll totally dig it.

▼ Removing Unused Keywords

Any grayed-out keywords in the Keyword List panel are not being used by any photos in Lightroom, so you can delete these orphaned keywords (which makes your keyword list cleaner and shorter) by going under the Metadata menu and choosing Purge Unused Keywords.

▼ Making Your Panels Larger

If you want your panels to be wider (or thinner for that matter), just move your cursor right over the edge closest to the center Preview area and your cursor will change into a two-headed cursor. Now you can just click-and-drag your panels out wider (or drag them in to make them thinner). This also works for the Filmstrip at the bottom.

Lightroom Killer Tips > >

More Options for the Toolbar

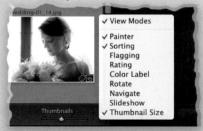

By default, Lightroom displays a number of different tools and options on the toolbar below the center Preview area, but you can choose which ones you want (including some you may not have realized were available) by clicking on the little triangle at the toolbar's far-right side. A menu will pop up with a list of toolbar items. The ones with checks beside them will be visible—to add one, just choose it.

▼ Zooming In/Out

You can use the same keyboard shortcuts used by Photoshop to zoom in and out of your image when it's in Loupe view. Just press Command-+ (PC: Ctrl-+) to zoom in, and Command-- (PC: Ctrl--) to zoom back out.

▼ Finding Out Which Collection a Particular Photo Is In

If you're scrolling through your entire Lightroom catalog (you've clicked on All Photographs in the Catalog panel), and you see a photo and want to know which collection it lives in, just Right-click on the photo, and from the pop-up menu that

appears, choose Go to Collection. If it's not in any collection, it will tell you so in the submenu.

▼ The "Flag and Move" Trick If you want to speed up the flaggingof-Picks process, try this: instead of just pressing P to flag a photo, and then using the Arrow key to move to the next photo, press Shift-P. This flags the photo as a Pick, but then automatically moves to the next photo for you.

▼ Turning Your Filters On/Off Just press Command-L (PC: Ctrl-L) to turn your filters (flags, ratings, metadata, etc., in the Library Filter bar) on/off.

▼ Filter Your Picks from the Filmstrip

Back in the original version of Lightroom, there wasn't a Library Filter bar at the top; instead, you showed your Picks and Rejects by clicking on little flag icons on the right side of the Filmstrip. Well, if you miss that way of doing things, Adobe left those filters there. So, you have your choice: do it from the top (which offers more features than just filtering by flags. stars, or colors), or the Filmstrip version. However, here's a tip within a tip: you're better off Right-clicking directly on the Filmstrip flags and making your choice from the pop-up menu, than you are trying to click on them, because they toggle back and forth, and it can get real confusing as to what you're actually seeing, real fast.

▼ How Much Space Is Left on Your Hard Drive for More Photos

If you're using one or more external hard drives to store your Lightroom photos, you can quickly find out exactly how much storage space you have left on those drives without leaving Lightroom. Just go to the Folders panel (in the left side Panels area), and in the Volume Browser, you'll see a volume for each drive that you have Lightroom managing photos on (including your internal hard drive), and beside each name, it displays how much space is still available, followed by how much total space there is. If you hover your cursor over a volume, a message will pop up telling you exactly how many photos are stored on that drive that are managed by Lightroom.

▼ Add Metadata to Multiple Photos at Once

If you manually entered some IPTC metadata for a photo, and you want to apply that same metadata to other photos, you don't have to type it all in again—you can copy that metadata and paste it onto other photos. Click on the photo that has the metadata you want, then Command-click (PC: Ctrl-click) on the other photos you want to add the metadata to, to select them. Now, click the Sync Metadata button (at the bottom of the right side Panels area), which brings up the Synchronize Metadata dialog. Click the Synchronize button to update those other photos with this metadata.

Sync Metadata N Sync Settings

Lightroom Killer Tips > >

▼ Switching to the Painter Tool You can switch to the Painter tool by pressing Command-Option-K (PC: Ctrl-Alt-K). When you're done, either click it back on its gray circular home in the toolbar or just press the same keyboard shortcut again.

Saving a Collection as a Favorite

If you find yourself using a particular collection fairly often (maybe your portfolio collection, or a client proofs collection), you can save it so it's always just one click away: Start by clicking on that collection in the Collections panel, then from the pop-up menu at the top left of the Filmstrip, choose **Add to Favorites**. That collection will appear in this pop-up menu from now on. To remove

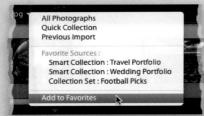

a favorite, click on the collection, then chose **Remove From Favorites** from that same menu.

▼ Removing Photos from Survey View

There's a little-known shortcut for removing a selected photo from contention when you're looking at them in Survey view: just press the / (forward slash) key on your keyboard.

▼ Locking In a Filter

In previous versions of Lightroom, when you turned on a filter in the Library Filter bar (let's say you turned on the filter to show just your 5-star photos), that filter was only turned on for the current collection or folder you were in. When

you changed collections or folders, it stopped filtering. Now, if you want to move from collection to collection and only see your 5-star images, just click on the padlock icon at the right end of

the Library Filter (at the top of the Grid view; if you don't see the Library Filter, press the / [backslash] key).

▼ Backing Up Your Presets

If you've created your own presets (anything from Import presets to Develop or Print module presets), you need to back these up at some point, too. If your hard drive crashes, or you lose your laptop, you'll have to create them all from scratch (if you can even remember what all the settings were). To find the folder where all the presets are on your computer, go to Lightroom's Preferences (under the Lightroom menu on a Mac or the Edit menu on a PC), click on the Presets tab, and then click the Show Lightroom Presets

Folder button in the middle. Now copy that entire folder onto a separate hard drive (or a DVD) to back it up. That way, if things go horribly wrong, you can just drag-and-drop the contents of this backup folder into your new presets folder.

▼ The Auto Advance Advantage You can have Lightroom automatically advance to the next image when you're adding a Pick flag, or star rating to a photo—just go under the Photo menu and choose Auto Advance.

▼ Making Collections in a Set

The quickest way to create a collection inside an existing collection set is to Right-click on the set (in the Collections panel) and choose **Create Collection**.

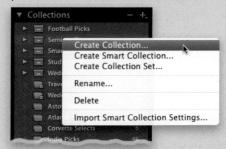

This automatically chooses that collection set when you turn on the Inside a Collection Set checkbox, so then all you have to do is name your new collection and click Create.

▼ Use Keyword Suggestions

When you click on a photo and Lightroom sees you've tagged it with a keyword, it instantly looks to see if you've tagged any other photos with that keyword. If you did, it lists the other keywords you applied to those photos as Keyword Suggestions (in the middle of the Keywording panel) figuring you're likely to use some of these same keywords again for the current photo. To add these suggested keywords, just click on'em (it even adds the comma for you).

▼ Create Search Presets

At the far-right end of the Library Filter is a pop-up menu with handy filtering presets. If you find yourself using a particular type of search often, you can save your own custom search presets here, too, by choosing **Save Current Settings** as **New Preset** from this same menu.

Photo by Scott Kelby | Exposure: 1/15 sec | Focal Length: 28mm | Aperture Value: f/5

CUSTOMIZING how to set things up your way

A great name for this chapter would have been "Pimp My Ride" (after the popular MTV show of the same name), seeing as this chapter is all about customizing Lightroom 5 to your own personal tastes. Kids these days call this "pimping" (by the way, I just checked with a nearby kid to confirm this and apparently that is correct. I said, "Hey, what does it mean if something is pimped?" and he said, "It means it has been customized." But then I called my older brother Jeff, who spent a number of years in the U.S. Navy, and asked him what it means if something is pimped and, surprisingly enough, he had an entirely different answer, but I'm not so sure our mom would be pleased with him for telling this to his impressionable younger brother). So, at this point, I wasn't sure if using the word "pimped" would be really appropriate, so I did a Google

search for the word "pimped" and it returned (I'm not making this up) more than 2,500,000 pages that reference the word "pimped." I thought I would go ahead and randomly click on one of those search result links, and I was pleasantly surprised to see that it took me to a page of totally customized cars. So, at that point, I felt pretty safe, but I realized that using the term "pimped" was kind of "past tense," so I removed the "ed" and got a totally different result, which led me to a webpage with a "Pimp Name Generator" and, of course, I couldn't leave without finding out what my pimp name would be (just in case I ever wrote a book about customizing cars or my brother's life), and it turned out to be "Silver Tongue Scott Slither" (though personally I was hoping for something more like "Snoop Scotty Scott").

Choosing What You See in Loupe View

When you're in Loupe view (the zoomed-in view of your photo), besides just displaying your photo really big, you can display as little (or as much) information about your photo as you'd like as text overlays, which appear in the top-left corner of the Preview area. You'll be spending a lot of time working in Loupe view, so let's set up a custom Loupe view that works for you.

Step One:

In the Library module's Grid view, click on a thumbnail and press **E** on your keyboard to jump to the Loupe view (in the example shown here, I hid everything but the right side Panels area, so the photo would show up larger in Loupe view).

Step Two:

Press **Command-J (PC: Ctrl-J)** to bring up the Library View Options dialog and then click on the Loupe View tab. At the top of the dialog, turn on the Show Info Overlay checkbox. The pop-up menu to the right lets you choose from two different info overlays: Info 1 overlays the filename of your photo (in larger letters) in the upperleft corner of the Preview area (as seen here). Below the filename, in smaller type, is the photo's capture date and time, and its cropped dimensions. Info 2 also displays the filename, but underneath, it displays the exposure, ISO, and lens settings.

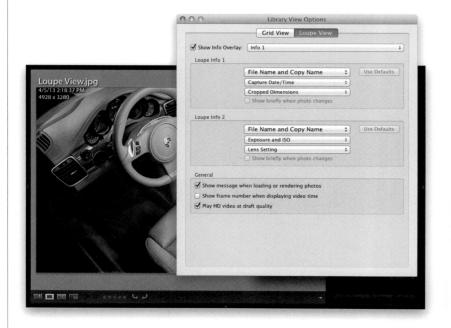

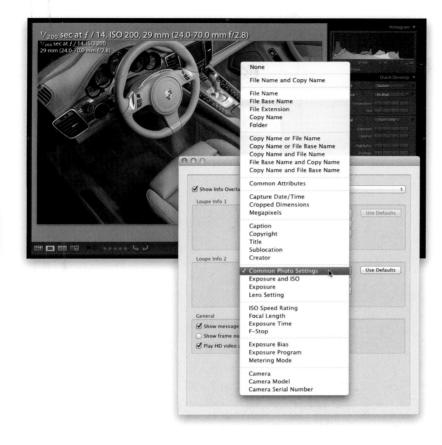

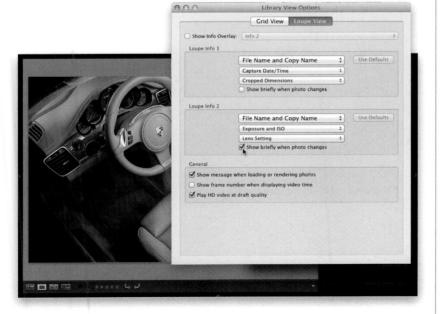

Step Three:

Luckily, you can choose which info is displayed for both info overlays using the pop-up menus in this dialog. So, for example, instead of having the filename show up in huge letters, here for Loupe Info 2, you could choose something like **Common Photo Settings** from the pop-up menu (as shown here). By choosing this, instead of getting the filename in huge letters, you'd get the same info that's displayed under the histogram (like the shutter speed, f-stop, ISO, and lens setting) found in the top panel in the right side Panels area. You can customize both info overlays separately by simply making choices from these pop-up menus. (Remember: The top pop-up menu in each section is the one that will appear in really large letters.)

Step Four:

Any time you want to start over, just click the Use Defaults button to the right and the default Loupe Info settings will appear. Personally, I find this text appearing over my photos really, really distracting most of the time. The key part of that is "most of the time." The other times, it's handy. So, if you think this might be handy, too, here's what I recommend: (a) Turn off the Show Info Overlay checkbox and turn on the Show Briefly When Photo Changes checkbox below the Loupe Info pop-up menus, which makes the overlay temporary—when you first open a photo in Loupe view, it appears on the photo for around four seconds and then hides itself. Or, you can do what I do: (b) leave those off, and when you want to see that overlay info, press the letter I to toggle through Info 1, Info 2, and Show Info Overlay off. At the bottom of the dialog, there's also a checkbox that lets you turn off those little messages that appear onscreen, like "Loading" or "Assigned Keyword," etc., along with some video option checkboxes.

Choosing What You See in Grid View

Those little cells that surround your thumbnails in Grid view can either be a wealth of information or really distracting (depending on how you feel about text and symbols surrounding your photos), but luckily you get to totally customize not only how much info is visible, but in some cases, exactly which type of info is displayed (of course, you learned in Chapter 1 that you can toggle the cell info on/off by pressing the letter **J** on your keyboard). At least now when that info is visible, it'll be just the info you care about.

Step One:

Press **G** to jump to the Library module's Grid view, then press **Command-J** (**PC: Ctrl-J**) to bring up the Library View Options dialog (shown here), and click on the Grid View tab at the top (seen highlighted here). At the top of the dialog, there's a pop-up menu where you can choose the options for what's visible in either the Expanded Cells view or the Compact Cells view. The difference between the two is that you can view more info in the Expanded Cells view.

Step Two:

We'll start at the top, in the Options section. You can add a Pick flag and left/right rotation arrows to your cell, and if you turn on the Show Clickable Items on Mouse Over Only checkbox, it means they'll stay hidden until you move your mouse over a cell, then they appear so you can click on them. If you leave it unchecked, you'll see them all the time. The Tint Grid Cells with Label Colors checkbox only kicks in if you've applied a color label to a photo. If you have, turning this on tints the gray area around the photo's thumbnail the same color as the label, and you can set how dark the tint is with the pop-up menu. With the Show Image Info Tooltips checkbox turned on, when you hover your cursor over an icon within a cell (like a Pick flag or a badge), it'll show you a description of that item. Hover your cursor over an image thumbnail, and it'll give you a guick look at its EXIF data.

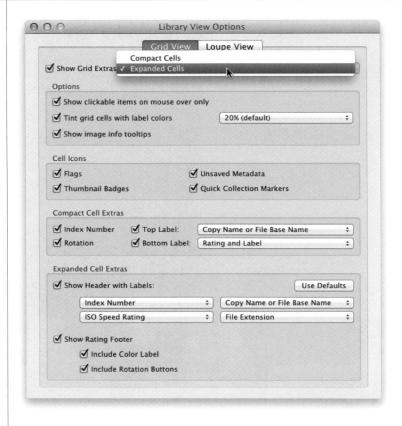

The thumbnail badges show you (from L to R) that a keyword has been applied, the photo has GPS info, it has been added to a collection, it has been cropped, and edited

The black circle in the upper-right corner is actually a button click on it to add this photo to your Quick Collection

Click the flag icon to mark it as a Pick

Click the Unsaved Metadata icon to save the changes

Step Three:

The next section down, Cell Icons, has two options for things that appear right over your photo's thumbnail image, and two that appear just in the cell. Thumbnail badges appear in the bottom-right corner of a thumbnail to let you see if: (a) the photo has GPS info, (b) the photo has had keywords added, (c) the photo has been cropped, (d) the photo has been added to a collection, or (e) the photo has been edited in Lightroom (color correction, sharpening, etc.). These tiny badges are actually clickable shortcuts, so for example, if you wanted to add a keyword, you could click the Keyword badge (whose icon looks like a tag), and it opens the Keywording panel and highlights the keyword field, so you can just type in a new keyword. The other option on the thumbnail, Quick Collection Markers, adds a black circle (that's actually a button) to the top-right corner of your photo when you mouse over the cell. Click on it to add the photo to (or remove it from) your Quick Collection (it becomes a gray dot).

Step Four:

The other two options don't put anything over the thumbnails—they add icons in the cell area itself. When you turn on the Flags checkbox, it adds a Pick flag to the top-left side of the cell, and you can then click on this flag to mark this photo as a Pick (shown here on the left). The last checkbox in this section, Unsaved Metadata, adds a little icon in the top-right corner of the cell (shown here on the right), but only if the photo's metadata has been updated in Lightroom (since the last time the photo was saved), and these changes haven't been saved to the file itself yet (this sometimes happens if you import a photo, like a JPEG, which already has keywords, ratings, etc., applied to it, and then in Lightroom you added keywords, or changed the rating). If you see this icon, you can click on it to bring up a dialog that asks if you want to save the changes to the file (as shown here).

Step Five:

We're going to jump down to the bottom of the dialog to the Expanded Cell Extras section, where you choose which info gets displayed in the area at the top of each cell in Expanded Cells view. By default, it displays four different bits of info (as shown here): It's going to show the index number (which is the number of the cell, so if you imported 63 photos, the first photo's index number is 1, followed by 2, 3, 4, and so on, until you reach 63) in the top left, then below that will be the pixel dimensions of your photo (if the photo's cropped, it shows the final cropped size). Then in the top right, it shows the file's name, and below that, it shows the file's type (JPEG, RAW, TIFF, etc.). To change any one of these info labels, just click on the label pop-up menu you want to change and a long list of info to choose from appears (as seen in the next step). By the way, you don't have to display all four labels of info, just choose None from the pop-up menu for any of the four you don't want visible.

Step Six:

Although you can use the pop-up menus here in the Library View Options dialog to choose which type of information gets displayed, check this out: you can actually do the same thing from right within the cell itself. Just click on any one of those existing info labels, right in the cell itself, and the same exact pop-up menu that appears in the dialog appears here. Just choose the label you want from the list (I chose ISO Speed Rating here), and from then on it will be displayed in that spot (as shown here on the right, where you can see this shot was taken at an ISO of 1600).

Step Seven:

At the bottom of the Expanded Cell Extras section is a checkbox, which is on by default. This option adds an area to the bottom of the cell called the Rating Footer, which shows the photo's star rating, and if you keep both checkboxes beneath Show Rating Footer turned on, it will also display the color label and the rotation buttons (which are clickable).

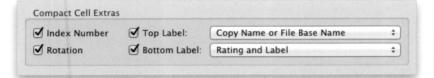

Step Eight:

The middle section we skipped over is the Compact Cell Extras section. The reason I skipped over these options is that they work pretty much like the Expanded Cell Extras, but with the Compact Cell Extras, you have only two fields you can customize (rather than four, like in the Expanded Cell Extras): the filename (which appears on the top left of the thumbnail), and the rating (which appears beneath the bottom left of the thumbnail). To change the info displayed there, click on the label pop-up menus and make your choices. The other two checkboxes on the left hide/show the index number (in this case, it's that huge gray number that appears along the top-left side of the cell) and the rotation arrows at the bottom of the cell (which you'll see when you move your cursor over the cell). One last thing: you can turn all these extras off permanently by turning off the Show Grid Extras checkbox at the top of the dialog.

Make Working with Panels Faster & Easier

Lightroom has an awful lot of panels, and you can waste a lot of time scrolling up and down in these panels just searching for what you want (especially if you have to scroll past panels you never use). This is why, in my live Lightroom seminars, I recommend: (a) hiding panels you find you don't use, and (b) turning on Solo mode, so when you click on a panel, it displays only that one panel and tucks the rest out of the way. Here's how to use these somewhat hidden features:

Step One:

Start by going to any side panel, then Right-click on the panel header and a pop-up menu will appear with a list of all the panels on that side. Each panel with a checkmark beside it is visible, so if you want to hide a panel from view, just choose it from this list and it unchecks. For example, here in the Develop module's right side Panels area, I've hidden the Camera Calibration panel. Next, as I mentioned in the intro above, I always recommend turning on Solo mode (you choose it from this same menu, as seen here).

Step Two:

Take a look at the two sets of side panels shown here. The one on the left shows how the Develop module's panels look normally. I'm trying to make an adjustment in the Split Toning panel, but I have all those other panels open around it (which is distracting), and I have to scroll down past them just to get to the panel I want. However, look at the same set of panels on the right when Solo mode is turned on—all the other panels are collapsed out of the way, so I can just focus on the Split Toning panel. To work in a different panel, I just click on its name, and the Split Toning panel tucks itself away automatically.

The Develop module's right side Panels area with Solo mode turned off

The Develop module's right side Panels area with Solo mode turned on

Lightroom supports using two monitors, so you can work on your photo on one screen and also see a huge, full-screen version of your photo on another. But Adobe went beyond that in this Dual Display feature and there are some very cool things you can do with it, once it's set up (and here's how to set it up).

Using Two Monitors with Lightroom

Step One:

The Dual Display controls are found in the top-left corner of the Filmstrip (shown circled in red here), where you can see two buttons: one marked "1" for your main display, and one marked "2" for the second display. If you don't have a second monitor connected and you click the Second Window button, it just brings up what would be seen in the second display as a separate floating window (as seen here).

Step Two:

If you do have a second monitor connected to your computer, when you click on the Second Window button, the separate floating window appears in Full Screen mode, set to Loupe view, on the second display (as seen here). This is the default setup, which lets you see Lightroom's interface and controls on one display, and then the larger zoomed-in view on the second display.

Continued

Step Three:

You have complete control over what goes on the second display using the Secondary Window pop-up menu, shown here (just click-and-hold on the Second Window button and it appears). For example, you could have Survey view showing on the second display, and then you could be zoomed in tight, looking at one of those survey images in Loupe view on your main display (as shown at bottom). By the way, just add the Shift key and the Survey view, Compare view, Grid view, and Loupe view shortcuts are all the same (so, Shift-N puts your second display into Survey view, etc.).

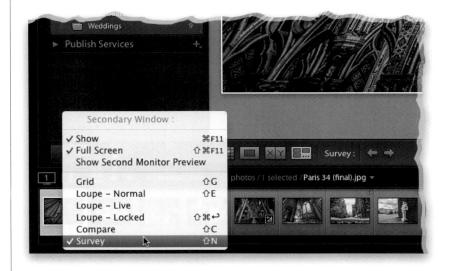

TIP: Swapping Screens

If you want to swap displays (where your main screen, panels, etc., appear on the second display and the Loupe view screen appears on your main display), if you're in Full Screen mode on your main display, press Shift-F to leave Full Screen mode, which lets you see the main display's title bar at the top. Now just drag-and-drop that title bar over to the right, right off the main display and onto the second display, and the two automatically swap positions.

Step Four:

Besides just seeing things larger with the Loupe view, there are some other pretty cool Second Window options. For example, click on the Second Window button and choose **Loupe – Live** from the Secondary Window pop-up menu, then just hover your cursor over the thumbnails in the Grid view (or Filmstrip) on your main display, and watch how the second display shows an instant Loupe view of any photo you pass over (here, you can see on my main display the third photo is selected, but the image you see on my second display is the one my cursor is hovering over—the fourth image).

Step Five:

Another Second Window Loupe view option is called **Loupe – Locked** and when you choose this from the Secondary Window pop-up menu, it locks whatever image is currently shown in Loupe view on the second display, so you can look at and edit other images on the main display (to return to where you left off, just turn Loupe – Locked off).

The Adobe Photoshop Lightroom 5 Book for Digital Photographers

Step Six:

The navigation bars at the top and bottom of your image area will be visible on the second display. If you want those hidden, click on the little gray arrows at the top and bottom of the screen to tuck them out of sight, and give you just the image onscreen.

Here's the second display default view, with the navigation bars at the top and bottom visible

Here's the second display with the navigation bars hidden, which gives a larger view

TIP: Show Second Monitor Preview There's a feature found under the Secondary Window pop-up menu called Show Second Monitor Preview, where a small floating Second Monitor window appears on your main display, showing you what's being seen on the second display. This is pretty handy for presentations, where the second display is actually a projector, and your work is being projected on a screen behind you (so you can face the audience), or in instances where you're showing a client some work on a second screen, and the screen is facing away from you (that way, they don't see all the controls, and panels, and other things that might distract them).

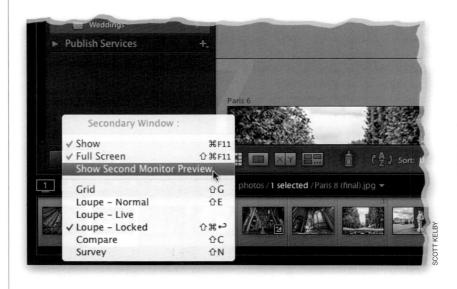

Just like you can choose what photo information is displayed in the Grid and Loupe views, you can also choose what info gets displayed in the Filmstrip, as well. Because the Filmstrip is pretty short in height, I think it's even more important to control what goes on here, or it starts to look like a cluttered mess. Although I'm going to show you how to turn on/off each line of info, my recommendation is to keep all the Filmstrip info turned off to help avoid "info overload" and visual clutter in an already busy interface. But, just in case, here's how to choose what's displayed down there:

Develop

Choosing What the Filmstrip Displays

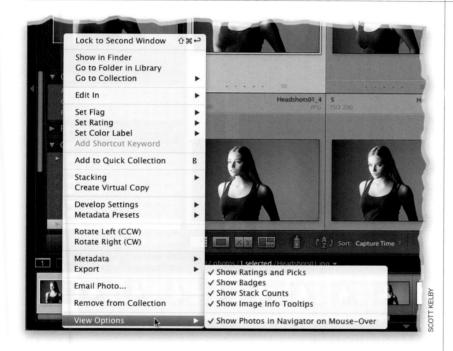

Step One:

Right-click on any thumbnail down in the Filmstrip and a pop-up menu will appear (seen here). At the bottom of this menu are the View Options for the Filmstrip. There are four options: Show Ratings and Picks will add tiny flags and star ratings to your Filmstrip cells. If you choose Show Badges, it adds mini-versions of the same thumbnail badges you can see in the Grid view (which show if the photo is in a collection, whether keywords have been applied, whether the photo has been cropped, or if the image has been adjusted in Lightroom). Show Stack Counts will add a stack icon with the number of images inside the stack. The last choice, Show Image Info Tooltips, kicks in when you hover your cursor over an image in the Filmstrip—a little window pops up showing you the info you have chosen in the View Options dialog for your Info Overlay 1.

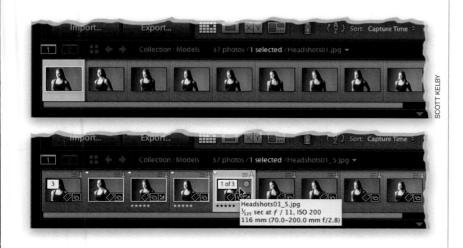

Step Two:

Here's what the Filmstrip looks like when these options are turned off (top) and with all of them turned on (bottom). You can see Pick flags, star ratings, and thumbnail badges (with unsaved metadata warnings), and I hovered my cursor over one of the thumbnails, so you can see the little pop-up window appear giving me info about the photo. The choice is yours—clean or cluttered.

Adding Your Studio's Name or Logo for a Custom Look

The first time I saw Lightroom, one of the features that really struck me as different was the ability to replace the Adobe Photoshop Lightroom logo (that appears in the upper-left corner of the interface) with either the name of your studio or your studio's logo. I have to say, when you're doing client presentations, it does add a nice custom look to the program (as if Adobe designed Lightroom just for you), but beyond that, the ability to create an Identity Plate goes farther than just giving Lightroom a custom look (but we'll start here, with the custom look).

Step One:

First, just so we have a frame of reference, here's a zoomed-in view of the top-left corner of Lightroom's interface, so you can clearly see the logo we're going to replace starting in Step Two. Now, you can either replace Lightroom's logo using text (and you can even have the text of the modules in the taskbar on the top right match), or you can replace the logo with a graphic of your logo (we'll look at how to do both).

Step Two:

Go under the Lightroom menu (the Edit menu on a PC) and choose Identity Plate **Setup** to bring up the Identity Plate Editor (shown here). By default, the name you registered your software in shows up highlighted in the large black text field in the middle of the dialog. To have your name replace the Adobe Photoshop Lightroom 5 logo seen above, turn on the Enable Identity Plate checkbox at the top left of the dialog. If you don't want your name as your Identity Plate, just type in whatever you'd like (the name of your company, studio, etc.), then while the type is still highlighted, choose a font, font style (bold, italic, condensed, etc.), and font size from the pop-up menus (directly below the text field).

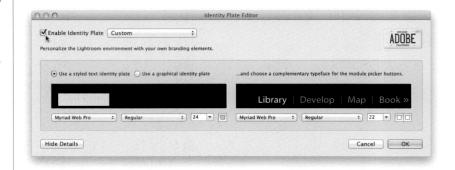

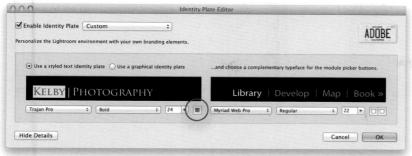

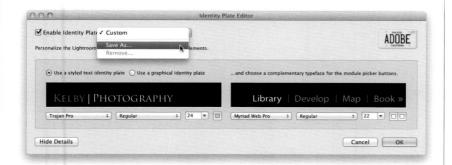

If you want to change only part of your text (for example, if you wanted to change the font of one of the words, or the font size or color of a word), just highlight the word you want to adjust before making the change. To change the color, click on the little square color swatch to the right of the Font Size pop-up menu (it's shown circled here). This brings up the Colors panel (you're seeing the Macintosh Colors panel here; the Windows Color panel will look somewhat different, but don't let that freak you out. Aw, what the heck go ahead and freak out!). Just choose the color you want your selected text to be, then close the Colors panel.

Step Four:

If you like the way your custom Identity Plate looks, you definitely should save it, because creating an Identity Plate does more than just replace the current Adobe Photoshop Lightroom 5 logo—you can add your new custom Identity Plate text (or logo) to any slide show, web gallery, or final print by choosing it from the Identity Plate pop-up menu in all three modules (see, you were dismissing it when you thought it was just a taskbar, feel good feature). To save your custom Identity Plate, from the Enable Identity Plate pop-up menu, choose Save As (as shown here). Give your Identity Plate a descriptive name, click OK, and now it's saved. From here on out, it will appear in the handy Identity Plate pop-up menu, where you can get that same custom text, font, and color with just one click.

Step Five:

Once you click the OK button, your new Identity Plate text replaces the Adobe Photoshop Lightroom 5 logo that was in the upper-left corner (as shown here).

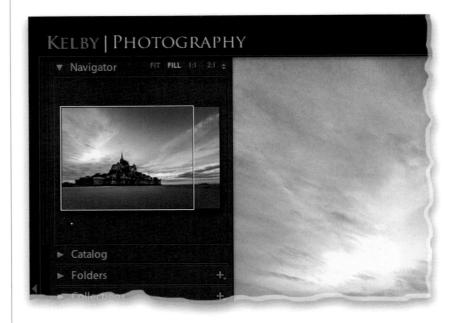

Step Six:

If you want to use a graphic (like your company's logo) instead, just go to the Identity Plate Editor again, but this time, click on the radio button for Use a Graphical Identity Plate (as shown here), instead of Use a Styled Text Identity Plate. Next, click on the Locate File button (found above the Hide/Show Details button near the lower-left corner) and find your logo file. You can put your logo on a black background so it blends in with the Lightroom background, or you can make your background transparent in Photoshop, and save the file in PNG format (which keeps the transparency intact). Now click the Choose button to make that graphic your Identity Plate.

Note: To keep the top and bottom of your graphic from clipping off, make sure your graphic isn't taller than 57 pixels.

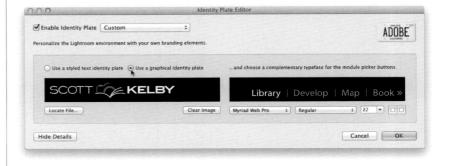

Step Seven:

When you click OK, the Adobe Photoshop Lightroom 5 logo (or your custom text—whichever was up there last) is replaced by the new graphic file of your logo (as shown here). If you like your new graphical logo file in Lightroom, don't forget to save this custom Identity Plate by choosing Save As from the Enable Identity Plate pop-up menu at the top of the dialog.

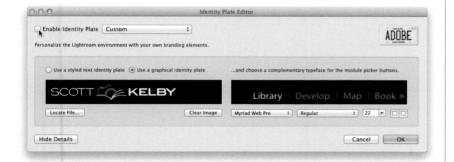

Step Eight:

If you decide, at some point, that you'd like the original Lightroom logo back instead, just go back to the Identity Plate Editor and turn off the Enable Identity Plate checkbox (as shown here). Remember, we'll do more with one of your new Identity Plates later in the book when we cover the modules that can use it.

Lightroom Killer Tips > >

▼ Spacebar Loupe Tricks

If you want to see your currently selected photo zoomed in to Loupe view, just press the Spacebar. Once it's zoomed in like that, press the Spacebar again, and it zooms in to whatever magnification (zoom factor) you chose last in the Navigator panel's header (by default, it zooms to 1:1, but if you click on a different zoom factor, it will toggle back and forth between the view you were in first and the zoom factor you clicked on). Once zoomed in, you can move around your image by just clicking-anddragging on it.

▼ Hiding the Render Messages If you chose Minimal or Embedded & Sidecar in the Render Previews pop-up menu in the Import window, Lightroom is only going to render higher-resolution previews when you look at a larger view, and while it's rendering these higher-res previews, it displays a little "Loading"

message. You'll see these messages a lot, and if they get on your nerves, you can turn them off by pressing Command-J (PC: Ctrl-J) and, in the View Options dialog that appears, click on the Loupe View tab (up top), then in that section, turn off the checkbox for Show Message When Loading or Rendering Photos.

▼ Opening All Panels at Once If you want every panel expanded in a particular side panel, just Right-click

on any panel's header, then choose Expand All from the pop-up menu.

▼ Jump to a 100% View

Any time you want to quickly see your image at a 100% full-size view, just press the letter **Z** on your keyboard.

Changing Where Lightroom Zooms

When you click to zoom in on a photo, Lightroom magnifies the photo, but if you want the area that you clicked on to appear centered on the screen, press Command-, (comma; PC: Ctrl-,) to bring up Lightroom's Preferences dialog,

then click on the Interface tab, and at the bottom, turn on the checkbox for Zoom Clicked Point to Center.

▼ Give Your Labels Names

You can change the default names Lightroom uses for its Color Label feature from the standard names of Red, Blue, Green, etc. (for example, you might want to name your Green label "Approved," and your Yellow label "Awaiting Client Approval," and so on). You do this by going under the Metadata menu, under Color Label Set, and choosing Edit to bring up the Edit Color Label Set dialog. Now, type in your new names (right over the old names). The numbers to the right of the first four color labels are the keyboard shortcuts for applying those labels (Purple doesn't have

a shortcut). When you're done, choose Save Current Settings as New Preset, from the Preset pop-up menu at the top of the dialog, and give your preset a name. Now, when you apply a label, onscreen you'll see "Approved" or "In Proofing" or whatever you choose (plus, the Set Color Label submenu [found under the Photo menu] updates to show your new names).

▼ How to Link Your Panels So They Close Simultaneously

If you set your side panels to Manual (you show and hide them by clicking on the little gray triangles), you can set them up to where if you close one side, the other side closes, too (or if you close the top, the bottom closes, too). To do this, Right-click on one of those little gray triangles, and from the pop-up menu that appears, choose Sync With Opposite Panel.

Lightroom Killer Tips > >

▼ You Can Add a Little Ornament Under the Last Panel

Lightroom used to have a little flourish thingy (called an end mark) at the bottom of the last panel in the side Panels areas that let you know you were at the last panel. It's gone, but you can add a built-in graphic or add your own. To add the built-in end mark, just Right-click below the last panel (you may have to collapse several panels first), and then from the pop-up menu, under Panel End Mark, pick **Small Flourish**. You can also create

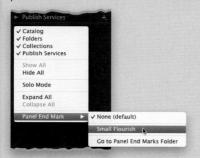

your own custom end marks (make sure they're on a transparent background, and saved in PNG format), then choose **Go to Panel End Marks Folder** from the Panel End Mark submenu. This is the folder you'll drop them in and where you'll choose them from.

■ Hiding Modules You Don't Use If there are some modules that you don't use at all (maybe you don't use the Web or Slideshow modules), you can actually hide those modules from view (after all, if you don't use 'em, why should you have to see them everyday, right?). Just Rightclick directly on any of the module names (Develop, for example) and a pop-up menu will appear. By default, they've all got a checkmark beside them, because they're all visible. So, just chose whichever one you want hidden and it's out of sight. Want to hide another module? Do the same thing, again.

▼ See Common Attributes

If you want to see if your image is flagged or has a star rating, there's a Common Attributes feature in the view pop-up menu (just Right-click at the top of a

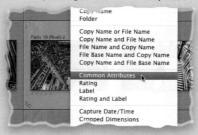

thumbnail cell), and if you choose it as one of your view criteria, it'll show those along the top of the image cell.

▼ Changing Lightroom's Background Color

You can change that medium gray background color that appears behind your photos by Right-clicking anywhere on that gray area, and from the pop-up menu that appears, you can choose

different background colors and/or a pinstripe texture.

▼ Delete Old Backups to Save Big Space

I usually back up my Lightroom catalog once a day (when I'm done for the day and am closing Lightroom; see Chapter 2 for more on this). The problem is that after a while, you've got a lot of backup copies—and before long you've got months of old, outdated copies taking up space on your hard drive (I really only

need one or two backup copies. After all, I'm not going to choose a backup from three months ago). So, go to your Lightroom folder from time to time and delete those outdated backups.

▼ The Secret Identity Plate Text Formatting Trick

It's surprisingly hard to format text inside the Identity Plate Editor window, especially if you want multiple lines of text (of course, the fact that you can have multiple lines of text is a tip unto itself). But, there's a better way: Create your text somewhere else that has nice typographic controls, then select and copy your text into memory. Then come back to the Identity Plate Editor and paste that already formatted text right into it, and it will maintain your font and layout attributes.

▼ Collection Badge

Lightroom has a Collection thumbnail badge (it looks like two overlapping rectangles), which, if you see it at the bottom-right corner of a thumbnail, lets you know the image is in a collection. Click on it, and a list of collections that photo appears within shows up, and you can click on any one to jump directly to that collection.

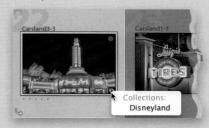

The Adobe Photoshop Lightroom 5 Book for Digital Photographers

Are You Seeing Different Sliders? Read This First!

Note: If you're upgrading from Lightroom 4, you can skip this altogether. Back in Lightroom 3, Adobe did a pretty sweeping update to how it processes your images, in regards to how it handles noise and sharpening (called the "process version," and before LR3, it was based on 2003 technology). In Lightroom 4, they did an even bigger update to the process version (with 2012 technology, improving the way your images look when tweaked in a big, big way). So, if you're bringing in images that you edited in Lightroom 2 or 3, there are some important things you'll want to know.

Step One:

If you're importing images from your camera's memory card, these are new images that haven't been edited in a previous version of Lightroom yet, so you'll get the benefit of the latest process version (mentioned above) right off the bat. However, if you're upgrading Lightroom and you have images that were edited in Lightroom 2 or 3 (or in Adobe Camera Raw 6 or earlier), vou'll have the choice of sticking with the old processing technology or updating to the new (and vastly improved) version from 2012 (do it, do it!!). So, how can you tell if your image is using the old or new process version? Well, you can find out in the Develop module by looking in the bottom-right corner of the Histogram panel. If you see a lightning bolt icon (circled in red), that's telling you you're using the old version.

Step Two:

The other way to tell is to just look in the Basic panel. If you see sliders from older versions of Lightroom, like Recovery and Fill Light (as seen in Step One), you know your image was edited using an old process version. To update to the new version, just click directly on that lightning bolt icon and it brings up the dialog you see here, explaining what the new processing technology may do and giving you the option of just updating this photo or all the photos currently selected or visible in your Filmstrip (totally your choice). If you want to see a before/after of your image after updating, just turn on the Review Changes Via Before/After checkbox, so you can see the difference.

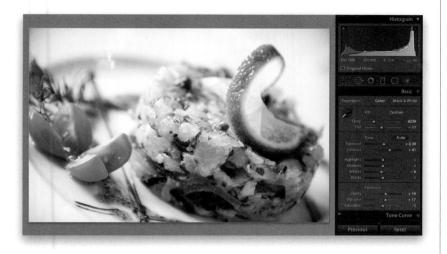

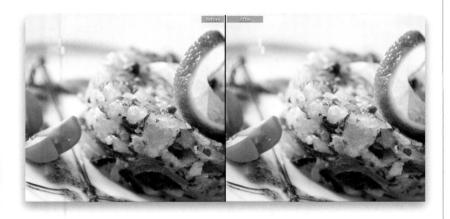

Basic Tone Exposure Contrast Highlights Shadows White Clipping Black Clipping Tone Curve Clarity Sharpening	Color Saturation Vibrance Color Adjustments Split Toning Local Adjustments Brush Graduated Filters Radial Filters Noise Reduction Luminance Color	Lens Profile Corrections Chromatic Abernation Upright Mode Upright Transforms Transform Lens Vignetting Effects Post-Crop Vignetting Grain Process Version Calibration	Crop Straighten Angle Aspect Ratio
---	---	---	------------------------------------

By the way, if you hit the Cancel button, no harm's done—it just leaves the image as is, using the old process version. So, just hit Cancel if you want to stick with the old version. But, for our purposes here, go ahead and click the Update button. Once you do that, take a look at the Basic panel and you'll see the sliders updated in Lightroom 4, including Highlights, Shadows, and Whites, but gone are Recovery and Fill Light (more on these sliders later in this chapter). If you look at your image now, and for any reason you don't like what the new processing technology has done, you can always adjust the sliders so it looks good to you, or you can just press Command-Z (PC: Ctrl-Z) to undo the update.

Step Four:

Here's a before and after for this photo, and I think the update was well worth it, with a much better-looking result from Clarity and Contrast, and the highlight reduction (although I'm not sure how much of that will even be visible when this is actually printed using a printing press to create this page in the book). I can tell you this, though: I haven't had a single image yet where I liked the old version better (yes, it's that much better). By the way, if you skip the updating for now, you can always update your photo later by going under the Settings menu, under Process, and choosing 2012 (Current). Just for fun, choose the 2003 or 2010 version for this file to see how far we've come.

TIP: Turn on Process Version When Syncing or Copying Settings

Whenever you synchronize or copy your settings, be sure to leave the Process Version checkbox turned on in the Synchronize Settings or Copy Settings dialog. With this off, you'll get different results when syncing or copying settings to images with a different process version.

Setting the White Balance

I always start editing my photos by setting the white balance first, because if you get the white balance right, the color is right, and your color correction problems pretty much go away. You adjust the white balance in the Basic panel, which is the most misnamed panel in Lightroom. It should be called the "Essentials" panel, because it contains the most important, and the most used, controls in the entire Develop module.

Step One:

In the Library module, click on the photo you want to edit, and then press the letter **D** on your keyboard to jump over to the Develop module. By the way, you're probably figuring that since you press D for the Develop module, it must be S for Slideshow, P for Print, W for Web, etc., right? Sadly, no—that would make things too easy. Nope, it's just Develop that uses the first letter. (Arrrrgggh!) Anyway, once you're in the Develop module, all the editing controls are in the right side Panels area, and the photo is displayed using whatever you had the white balance set on in your digital camera (called "As Shot").

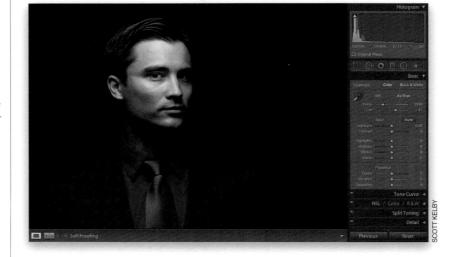

Step Two:

The white balance controls are near the top of the Basic panel, and there you'll see a White Balance (WB) pop-up menu where you can choose the same white balance presets you could have chosen in your camera, as seen here. (*Note*: The one big difference between processing JPEG and TIFF images, and those shot in RAW, is that you only get this full list of presets if you shoot in RAW. If you shoot in JPEG, you only get one preset choice—Auto—and that's it.)

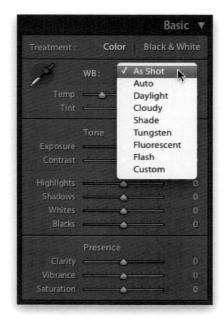

In our photo in Step One, his skin looks a bit reddish (well, magenta-ish if you want to be technical), and the whole tone of the photo looks kind of clammy, so it definitely needs a white balance adjustment. (Note: If you want to follow along using this same image, you're welcome to download it from http://kelbytraining.com/books/LR5.) We need to make it warmer, so choose Daylight from the White Balance pop-up menu and see how that looks (as you can see here, his skin actually looks somewhat better, but this looks pretty yellowish, so it's probably too much yellow for his skin tone). The next two White Balance presets down will both be even warmer (more yellow), with Cloudy being a bit warmer, and Shade being a lot warmer. Go ahead and choose Cloudy (just so you can see it), and now the whole photo is much too warm.

Step Four:

If you choose either of the next two down—Tungsten or Fluorescent—they're going to be way crazy blue, so you don't want either of those, and Flash is pretty close to Daylight, so it's out, too. Let's choose Auto white balance (shown here). While it's not perfect, it's probably the best of our built-in choices (take a moment and try each of those, just so you see how they affect the photo). By the way, the last preset isn't really a preset at all—Custom just means you're going to create the white balance manually using the two sliders beneath the pop-up menu. Now that you know what these presets look like, here's what I recommend: First, quickly run through all the presets and see if one of them happens to be "right on the money" (it happens more than you might think). If there isn't one that's right on the money, choose the preset that looks the closest to being right (in this case, I felt it was the Auto preset, but it's definitely not "on the money." He now looks a bit too blue [cool]).

The Adobe Photoshop Lightroom 5 Book for Digital Photographers

Step Five:

So now that you've chosen a preset that's kind of "in the ballpark," you can use the Temp and Tint sliders to dial in a better looking final White Balance setting. I zoomed in here on the Basic panel so you can get a nice close-up of the Temp and Tint sliders, because Adobe did something really great to help you out here—they colorized the slider bars, so you can see what will happen if you drag in a particular direction. See how the left side of the Temp slider is blue, and the right side graduates over to yellow? That tells you exactly what the slider does. So, without any further explanation, which way would you drag the Temp slider to make the photo more blue? To the left, of course. Which way would you drag the Tint slider to make the image more magenta? See, it's a little thing, but it's a big help.

Here's the White Balance temperature settings when you choose the Auto preset

To make his skin tone look less blue (cool), I dragged the Temp slider away from blue toward yellow and dragged the Tint slider away from green toward magenta (see Step Six)

Step Six:

Again, after choosing the Auto preset, his skin tone now looks a little too blue (or too cool in "white balance talk"), so click-and-drag the Temp slider slowly to the right (toward yellow), until the blue is removed (of course, don't drag too far to the right, or he'll turn yellow again). In the example you see here, I started with the temperature at 4550, and dragged to the right until it looked right. When I was done, the Temp reading was 5000, as seen in Step Five. That's all there is to it—use a White Balance preset as your starting place, then use the Temp slider to tweak it until it looks right. Now, if you feel the image is too magenta, then try dragging the Tint slider away from magenta, toward green (I started with the tint at 0 and dragged to +16. Again, drag slowly and don't go too far).

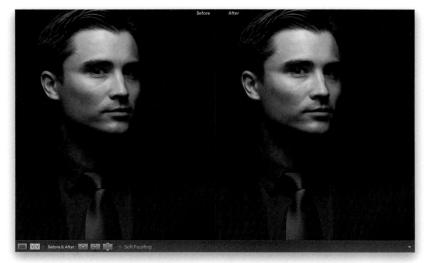

The Auto preset's temperature setting of 4550 makes his skin look a little bluish

After dragging a little bit toward yellow, to a temperature setting of 5000, and a little bit toward magenta, to a Tint setting of +16, the bluish skin turns warmer

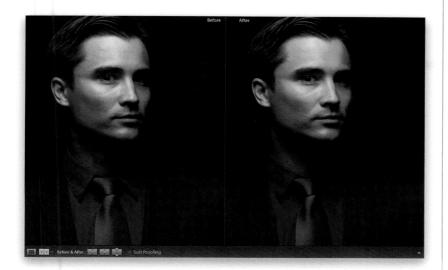

Develop

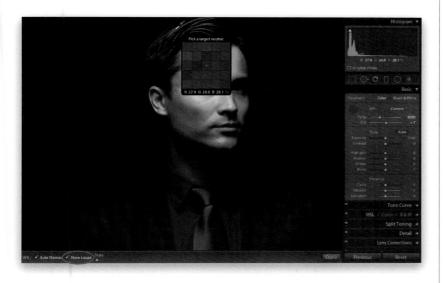

Step Seven:

Now that you've learned those two ways to adjust your white balance (the preset alone, and then the preset with Temp and Tint slider tweaks), I want to show you my personal favorite way, and the way I think you'll usually get the best, most accurate results, and that is to use the White Balance Selector tool (it's that huge eyedropper on the top-left side of the White Balance section, or press W). First, choose As Shot from the White Balance pop-up menu, so we're starting from scratch with this. Now click on the tool to get it, then ideally, you'd click it on something in your photo that's supposed to be light gray (that's right—don't click on something white, look for something light gray. Video cameras white balance on solid white, but digital still cameras need to white balance on a light gray instead). All you have to do for this image is click the White Balance Selector tool on the background (I clicked just to the right of his jacket collar) and the white balance is fixed (as seen here).

Step Eight:

Before we go any further, that big pixelated grid that appears while you're using the White Balance Selector tool is supposed to magnify the area your cursor is over to help you find a neutral gray area. To me, it just gets in the way, and if it drives you crazy (like it does me), you can get rid of it by turning off the Show Loupe checkbox down in the toolbar (I've circled it here in red, because my guess is you'll be searching for that checkbox pretty quickly). Now you get just the eyedropper (as shown in Step Nine), without the huge, annoying pixel Loupe (which I'm sure is fine for some people, so if that's you, replace "annoying" with the term "helpful").

Step Nine:

Although I'm not a fan of the "helpful" pixel Loupe, there is a feature that's a really big help when you use the White Balance Selector tool, and that's the Navigator panel on the top of the left side Panels area. What's cool about this is, as you hover the White Balance Selector tool over different parts of your photo, it gives you a live preview of what the white balance would look like if you clicked there. This is huge, and saves you lots of clicks, and lots of time, when finding a white balance that looks good to you. For example, set the White Balance to As Shot, then hover the White Balance Selector tool over the edge of his hair (as shown here), and then look at the Navigator panel to see how the white balance would look if you clicked there. Pretty sweet, eh? This live preview makes finding a white balance you like pretty easy (and you'll know if it looks wrong—look at the three I did here just by moving the White Balance tool around the photo).

Step 10:

A couple of last things you'll want to know about when setting your white balance: (1) In the toolbar, there's an Auto Dismiss checkbox. With this on, after you click the White Balance Selector tool once, it automatically returns to its home in the Basic panel. I leave this turned off, so I can easily just click in a different area without having to retrieve the tool each time. (2) If you turn off the Auto Dismiss checkbox, when you're finished using the tool, either click it back where you got it from (that round, dark gray circle in the Basic panel), or click the Done button down in the toolbar. (3) If you're in the Library module, and you know you want to use the White Balance Selector tool, you can press W, which will switch you over to the Develop module and give you the tool. (4) To return to the original As Shot white balance, just choose As Shot from the White Balance (WB) presets pop-up menu.

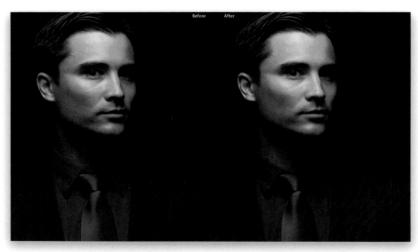

The original As Shot white balance setting, which looks too red and a little bluish overall

Here's the image after just one click with the White Balance Selector tool and his skin tone looks good

The fact that you can shoot tethered directly from your camera, straight into Lightroom, is one of my favorite features in Lightroom, but when I learned the trick of having the correct white balance applied automatically, as the images first come into Lightroom, it just put me over the top. So much so that I was able to include a free, perforated tear-out 18% gray card in the back of this book, so you can do the exact same thing (without having to go out and buy a gray card. A big thanks to my publisher, Peachpit Press, for letting me include this). You are going to love this!

Setting Your White Balance Live While Shooting Tethered

Step One:

Start by connecting your camera to your computer (or laptop) using a USB cable. then go under Lightroom's File menu, under Tethered Capture, and choose **Start Tethered Capture** (as shown here). This brings up the Tethered Capture Settings dialog, where you choose your preferences for how the images will be handled as they're imported into Lightroom (see page 24 in Chapter 1 for more details on this dialog and what to put in where).

Step Two:

Once you get your lighting set up the way you want it (or if you're shooting in natural light), place your subject into position, then go to the back of this book, and tear out the perforated 18% gray card. Hand the gray card to your subject and ask them to hold it while you take a test shot (if you're shooting a product instead, just lean the gray card on the product, or somewhere right near it in the same light). Now take your test shot with the gray card clearly visible in the shot (as shown here).

When the photo with the gray card appears in Lightroom, get the White Balance Selector tool (W) from the top of the Develop module's Basic panel, and click it once on the gray card in the photo (as shown here). That's it—your white balance is now properly set for this photo. Now, we're going to take that white balance setting and use it to automatically fix the rest of the photos as they're imported.

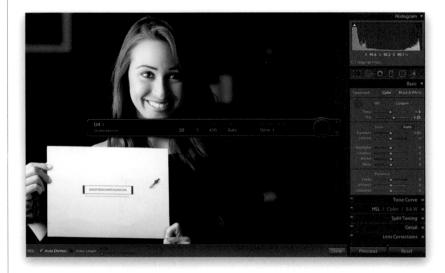

Step Four:

Go to the Tethered Capture window (press Command-T [PC: Ctrl-T] if it's no longer visible) and on the right side, from the Develop Settings pop-up menu, choose Same as Previous. That's it now you can take the gray card out of the scene (or get it back from your subject, who's probably tired of holding it by now), and you can go back to shooting. As the next photos you shoot come into Lightroom, they will have that custom white balance you set in the first image applied to the rest of them automatically. So, now not only will you see the proper white balance for the rest of the shoot, that's just another thing you don't have to mess with in post-production afterwards. Again, a big thanks to my publisher, Peachpit Press, for allowing me to include this gray card in the book for you.

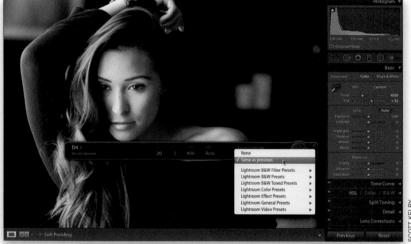

COTT KELBY

Here's a quick look at the sliders in the Basic panel (this isn't "official"—it's just how I think of them). By the way, although Adobe named this the "Basic" panel, I think it may be the most misnamed feature in all of Lightroom. It should have been called the "Essentials" panel, since this is precisely where you'll spend most of your time editing images. Also, something handy to know: dragging any of the sliders to the right brightens or increases its effect; dragging to the left darkens or decreases its effect.

My Editing Your Images Cheat Sheet

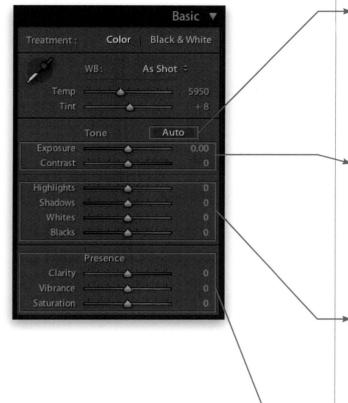

➤ Automatic Toning

Click the Auto button and Lightroom automatically tries to balance the image for you. Sometimes it's great; other times... well, not so much. If you have no idea where to start, click this button and see how it looks. It might be a good starting place. If not, just click the Reset button (at the bottom of the right side Panels area).

Overall Exposure

These two sliders, Exposure and Contrast, do most of the heavy lifting when it comes to editing your images. Exposure controls the overall brightness of your photo, so you'll almost always wind up using it, at least a bit. Once it's set the way you want it, then add contrast (I rarely, if ever, lower the contrast).

Problems

I use these four sliders when I have a problem. I use the Highlights slider when the brightest areas of my photo are too bright (or the sky is way too bright). The Shadows slider can open up the darkest parts of my image and make things "hidden in the shadows" suddenly appear—great for fixing backlit subjects (see page 236). The Whites and Blacks sliders are really for people used to setting white and black points in Photoshop's Levels feature. If that's not you, chances are you'll skip using these two.

► Finishing Effects

These are effects sliders that add tonal contrast and make your colors more vibrant (or take the color away).

How to Set Your Overall Exposure

Now that your white balance is set, the next thing we adjust is our overall exposure. Your basic exposure is set with just two sliders—Exposure and Contrast—and I wish all my images could be fixed with just these two. I usually have to reach for a few more, but this is where we start, so we'd better learn 'em up front.

Step One:

Here's our image opened in Light-room's Develop module. Seeing your image at a decent size is pretty important, so I recommend (at least at this point) that you close the left side Panels area because we're not going to need those panels right now (maybe later, but not now). So, just press **F7** on your keyboard, or just click on the little gray left-facing triangle (shown circled here in red) on the far left to collapse it and tuck it out of sight.

Step Two:

Look how much more room you have to see your image now that you've closed the left side Panels area—definitely worth doing while you're editing your photos. By the way, you can hide the top taskbar and get an even bigger image onscreen—just press **F5** on your keyboard to hide it—though I'm leaving it visible here, since we're just starting our work in the Develop module.

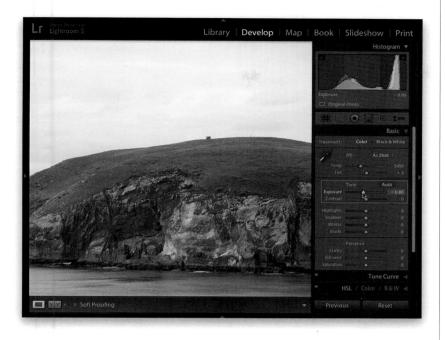

To set your overall exposure, you'll use the Tone section in the Basic panel (shown within a red rectangle here). The photo here looks pretty bright (overexposed). and it looks pretty flat contrast-wise, too. To make the overall photo darker, just click-and-drag the Exposure slider to the left (as shown here, where I dragged it down to -0.80). You can see by doing that it brought back some detail in the sky (you could hardly see the clouds in the original image; seen in Step Two). Keep this little tip in mind: to see more clouds, lower the Exposure (if it makes the image too dark, don't worry, you'll learn other techniques in this chapter to get it to look balanced again).

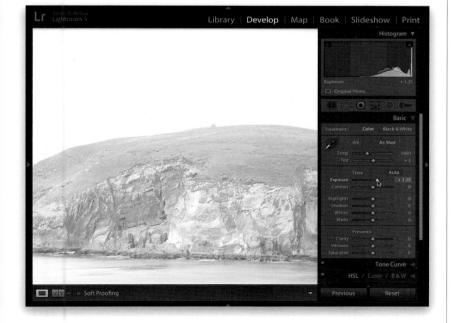

Step Four:

This photo was already too bright from the start, but I thought I'd show you what dragging the Exposure slider to the right does—it brightens the overall image (as seen here, where it's now way too bright). However, this really gives you an idea of how powerful this one slider is in choosing your overall exposure (this slider controls the midtones in your image, and part of the lower highlights, as well, so it's pretty important). One thing to remember (that I mentioned earlier in my Editing Cheat Sheet): dragging any of these sliders here to the right makes that adjustment brighter (or increases the effect) and dragging to the left makes it darker (or decreases the effect). Okay, that's what the Exposure slider does, and it's the first slider I set every time.

Step Five:

Now, let's set our Exposure back to -0.80, so it looks better, but even though the exposure now looks better (well, to me anyway), it still looks kinda flat (see the image back in Step Three and you'll see what I mean). So, let's add in some contrast. As I also mentioned earlier in my Editing Cheat Sheet, I rarely (if ever) lower the Contrast amount, but I almost always raise it a bit (of course, how high I raise it depends on the image). In this case, I dragged the Contrast slider over to the right to +62 (by the way, I'm not doing any of this "by the numbers." I do it based on how the image looks onscreen as I'm dragging a slider and, in this case, when I stopped dragging it was at +62).

Step Six:

The Contrast slider makes the brightest parts of the image brighter and the darkest parts darker, which makes the image look more contrasty overall. In this case, once I cranked up the Contrast, I thought the image looked a tiny bit too dark (remember, contrast makes the darkest parts darker), so after you add Contrast, don't be surprised if you have to go back to the Exposure slider and make a tiny adjustment to get things looking more balanced. Here, since the darks did get darker, I adjusted the Exposure slider so it wasn't so dark, moving it to the right from -0.80 to -0.65.

Note: If you're coming to Lightroom 5 from Lightroom version 3 or 2, you might be surprised to learn that the Contrast slider actually works now (we used to joke that the Contrast slider in those older versions wasn't actually connected to anything).

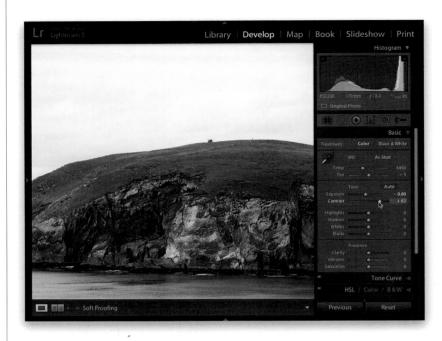

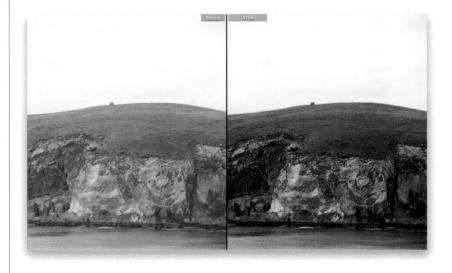

At the top of the right side Panels area is a histogram, which is basically what your image looks like if you charted the exposure on a graph. Reading a histogram is easier than it looks—the darkest parts (shadows) of your image appear on the left side of the graph, the midtones appear in the middle, and the brightest parts (highlights) are on the right side. If part of the graph is flat, there's nothing in your photo in that range (so if it's flat on the far right, that means your image doesn't have any highlights. Well, not yet anyway).

60 Seconds on the Histogram (& Which Slider **Controls Which Part)**

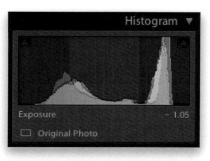

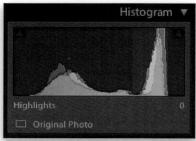

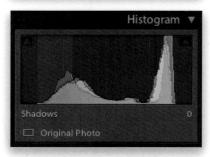

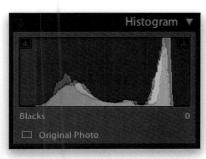

Exposure Slider: Midtones

Move your cursor over the Exposure slider and a light gray area appears over the part of the histogram that the Exposure slider affects. In this case, it's mostly the midtones (so the gray area is in the middle of the histogram), but it also affects some of the lower highlights, as well.

Highlights Slider: Highlights

The Highlights slider covers the next brightest areas above the midtones. If you look at the histogram shown here, it's flat right above that, which lets you know that this image doesn't have a full range of tones—it's missing the brightest parts. Moving the Highlights slider to the right can help fill in that gap, but there's actually a different slider that covers that range.

Shadows Slider: Shadows

This controls shadow areas. You can see it only controls a small area (but it's an important area because details can get lost in the shadows). Below that area is a flat area. and that means that this image is missing tone in the darkest part of the image.

Blacks & Whites Sliders

These two sliders control the very brightest (Whites) and darkest (Blacks) parts of your image. If your image looks washed out, drag the Blacks slider to the left to add in more black (and you'll see the Blacks expand over to the left in the histogram). Need more really bright areas? Drag the Whites slider to the right (and you'll see that area in the histogram slide over to fill in that missing gap).

Auto Tone (Having Lightroom Do the Work for You)

Like I mentioned in my Editing Cheat Sheet earlier in this chapter, the Auto Tone feature lets Lightroom take a crack at editing your photo (basically, it evaluates the image based on what it sees in the histogram) and it tries to balance things out. Sometimes it does a pretty darn good job, but if it doesn't, no worries just press Command-Z (PC: Ctrl-Z) to undo it.

Step One:

Here's an image with lots of problems mostly in the sky, where it's too bright (although the ground isn't properly exposed either—it's too dark). In short, if you have a shot like this, and you're not sure where to start, click on the Auto button (it's found to the right of the word "Tone" in the Basic panel and it's shown circled here in red).

Step Two:

Just one click and look at how much better the image looks. Well, actually, does it? The sky certainly looks a lot better (it's darker with more detail now), but our problem with the ground got even worse. That's the problem with any automatic fix—sometimes it works really well and other times it fixes part of the problem (like the sky here), but then creates a bigger problem (the ground is now darker than before here, and it was already too dark to begin with). Of course, since there are other tools in Lightroom we could use to fix the ground, we can just use the Auto Tone version of our image here as a starting place. So, it's worth clicking the Auto button just to see if it gives you a good starting place or not.

The next two sliders down are ones that I always think of as the "problem solvers." Sometimes the problems are caused by what I did in-camera (I took a shot where I let the highlights get clipped, or I took a shot where my subject is backlit and they are pretty much a silhouette), or these problems happen in Lightroom because of other changes I've made with other sliders.

Dealing With Exposure Problems (the Highlights and Shadows Sliders)

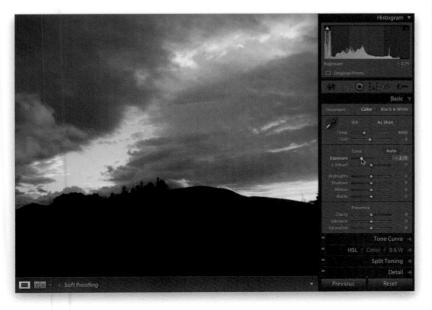

Step One:

Here, we'll use that same shot we just used for Auto Tone in the previous technique, since it has a number of exposure problems (I reset it here to the original version). When I took the shot, I let part of the sky clip (meaning, I let some of the highlights in the shot get so bright that there's actually no detail in those parts of the sky. No pixels whatsoever. Just blank nothing). You'll hear this problem referred to as having part of the photo "blown out" or "clipped" (short for clipped highlights). How do we know that part of this photo is clipping? Lightroom tells us with a white triangle-shaped highlight clipping warning, which appears in the upperright corner of the histogram (shown circled here in red).

Step Two:

As long as that highlight clipping warning triangle stays black, you're okay (there's no clipping). If it turns white, you're in trouble (that means there's some serious clipping). If it's red, yellow, or any other color, it's not as bad—you're only clipping in one of those color channels—but it's not ideal (you'd like it to be solid black). Of course, you could drag the Exposure slider to the left a bunch, until the highlight clipping warning eventually turns black, but in most cases, your overall exposure will now be way too dark (as seen here).

One thing that might help you in dealing with highlight clipping is to actually see which areas of your image are clipping. One reason you need to know this is so that you can decide if it really needs dealing with at all, because we only really sweat highlight clipping when it happens in an area where there's some important detail. For example, if the sun is visible in your shot, it's gonna clip. But, as far we know, there's no detail in the surface of the sun, so we can just ignore that. To see which parts of your image are clipping, just click directly on the white highlight clipping warning triangle itself (or press the letter J on your keyboard), and the areas in your image that are clipping will appear in red (as shown here).

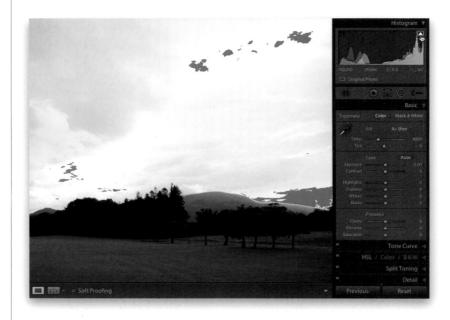

Step Four:

Clipping aside, the overall exposure of the sky looks too bright and (as I mentioned earlier) darkening the Exposure amount just a little makes the sky look better. In this case, it'll also remove some of the highlight clipping. So, I lowered the Exposure amount to –1.05 and you can see it did darken the sky and reduce the clipping a bit, but not nearly enough.

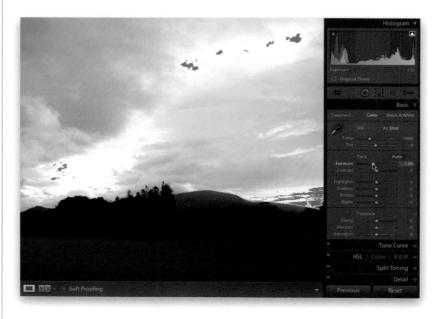

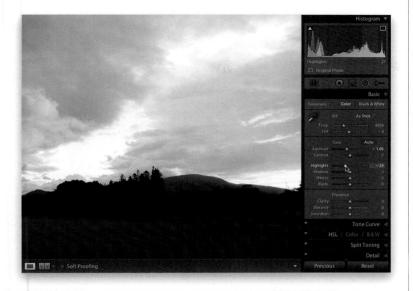

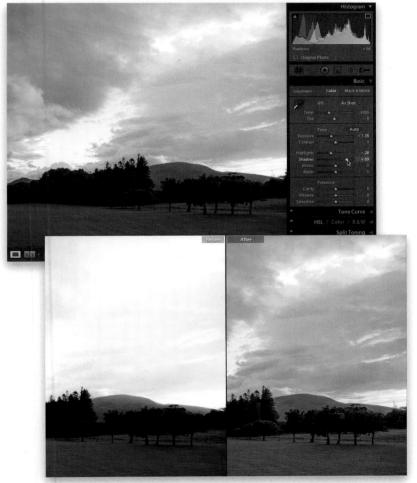

Step Five:

The slider that I use to reduce highlight clipping is the Highlights slider, and it does an amazing job of only affecting those really bright areas. If you drag it just a bit to the left (as shown here, where I dragged it to –28), you can see how it completely eliminated the red clipped areas (if you look up at the histogram, the triangle is now black). So, just remember: the Highlights slider is your secret weapon when it comes to highlight clipping.

Step Six:

Now, we still have the same problem we had in the previous technique, which is the trees are so dark in the foreground that it's hard to see any detail. This is where the Shadows slider comes in—it opens up detail and dimension in the shadows when you drag it to the right (as shown here, where I dragged it over to +69). Compare the trees and grass in this image to those in the last step and you'll see how much this helped, even though we darkened the overall exposure (I ended up decreasing the Exposure a bit here to -1.35). I also use this slider when I have a backlit subject (see page 236), where I add an extra step to the process to keep things balanced. Okay, so that's it. Those are the two main "problem solver" sliders.

Setting Your White Point and Black Point

The Whites and Blacks sliders are used most often by photographers who had a workflow where they always set the white and black points for their images using Photoshop's Levels command (which is the proper way to do it there), but missed that functionality here in Lightroom. Personally, I use these two sliders the least (well, the Whites anyway; I do drag the Blacks to the left when I have a photo that looks washed out. That fixes it fast!).

Step One:

The Whites and Blacks sliders control the very brightest and very darkest parts of your image (the two narrow ends of the histogram). Some folks like to start with these two sliders first, expanding the range of their image as far as they can, without clipping either the highlights or the shadows (turning them solid black, so there's no detail in those areas), before even touching the Exposure slider (I'm not that guy). You can do that by pressing-and-holding the Option (PC: Alt) key and dragging the Whites slider to the right to expand the very brightest whites. As you do, the screen turns black. Keep dragging until you see white areas appear (those areas are clipping), and then drag backward just a little until they're gone. That's as far as you can expand the Whites.

Step Two:

Now, press-and-hold the Option (PC: Alt) key, once again, and drag the Blacks slider to the left to expand the very darkest blacks. As you do, the screen turns white (as seen here). Keep dragging left until you see black areas appear (those areas are clipping in the shadows), so drag back to the right just a little until they're gone. That's as far as you can expand the blacks. Now, your white and black points are set. *Note:* I don't generally do this, but I thought you'd want to know it's possible, in case you're coming to Lightroom from years of using Photoshop and miss the ability to set your white and black points.

When Adobe was developing the Clarity control, they had actually considered calling the slider "Punch," because it adds midtone contrast to your photo, which makes it look, well...more punchy. It's great for bringing out detail and texture, and as of Lightroom 4, you can use a lot more Clarity than you could in the past. If you used a lot before, you'd often get little dark halos around edge areas, but now you can crank it up, bringing in detail galore, without the ugly halos. Plus, the Clarity effect just plain looks better now in Lightroom!

Adding "Punch" to Your Images **Using Clarity**

Here's the original photo, without any Clarity applied. This image is a perfect candidate for a lot of Clarity, because it works best on things that have a lot of texture and detail, and this image, with lots of detail in the building, is just begging for some Clarity. I apply between +25 and +50 Clarity to nearly every photo I process. For cityscapes, landscape photos, and anything with lots of detail, I crank it up even more. The only photos I don't add Clarity to are ones you wouldn't want to be punchy, or ones where you don't want to accentuate the detail or texture (so, for a portrait of a mother and baby, or a close-up portrait of a woman, I don't add any Clarity at all).

Step Two:

To add more punch and midtone contrast to our image here, drag the Clarity slider guite a bit to the right (here, I dragged it to +80, which is higher than I could usually get away with back in Lightroom 3. But, like I said up top, you can now get away with a lot more). You can really see the effect of Clarity in the example here. Look at the sky and the added detail in the clouds, then look at the building—the detail is pumped up in all those areas.

Note: The improved Clarity slider does have one side effect (which I happen to like) and that is that it tends to brighten the areas it affects a bit, as well as just enhancing the detail.

Making Your Colors More Vibrant

Photos that have rich, vibrant colors definitely have their appeal (that's why professional landscape photographers got so hooked on Velvia film and its trademark saturated color), and although Lightroom has a Saturation slider for increasing your photo's color saturation, the problem is it increases all the colors in your photo equally—while the dull colors do get more saturated, the colors that are already saturated get even more so, and well...things get pretty horsey, pretty fast. That's why Lightroom's Vibrance control may become your Velvia.

Step One:

In the Presence section (at the bottom of the Basic panel) are two controls that affect the color saturation. I avoid the Saturation slider because everything gets saturated at the same intensity (it's a very coarse adjustment). In fact, I only use it to remove colornever to add it. If you click-and-drag the Saturation slider to the right, your photo gets more colorful, but in a clownish, unrealistic way (the over-saturation won't show up as much here in the printed book because the photos get converted to CMYK for a printing press, so however clownish this looks here, double it for the web or a print). Go ahead and try it—drag the Saturation slider to the far right and you'll see what I mean. Now, return to 0.

Step Two:

Now try the Vibrance slider—it affects dull colors the most, and it affects already saturated colors the least, and lastly, if your photo has people in it, it does its best to avoid affecting flesh tones altogether, so as the color gets more vibrant, the skin tones on your people don't start to look weird (although that doesn't really come into play in this particular photo). This gives a much more realistic-looking color saturation across the board, which makes this a much more usable tool. Here's a before/after of the same photo using the Vibrance slider instead. The bases of the support posts, sky, and snow-covered trees look much more vibrant, but without looking "clowny" (I bet that word throws my spell checker for a loop).

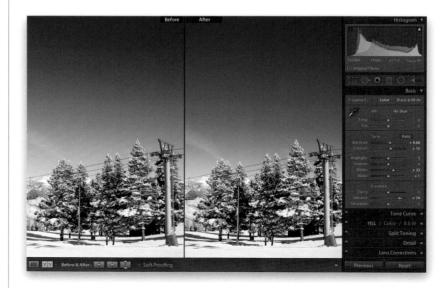

Once we've made our edits in the Basic panel, next we head down to the Tone Curve panel to adjust the overall contrast in our photos (I recommend doing your basic edits in the Basic panel, then using the tone curve to finish things off). We use this tone curve rather than the Contrast slider (in the Basic panel), because this gives us much more control, plus the tone curve (1) helps keep you from blowing out your highlights, (2) actually helps you see which areas to adjust, and (3) lets you adjust the contrast interactively.

Using the Tone Curve to Add Contrast

Step One:

If you scroll down past the Basic panel, you'll find the Tone Curve panel (shown here), which is where we apply contrast to our photo (rather than using the Contrast slider in the Basic panel, which seems too broad in some cases). As you can see, there's no Tone Curve contrast automatically applied (look at the bottom of the Tone Curve panel, and you'll see the word Linear [shown circled here in red], which just means the curve is flat—there's no contrast applied).

Step Two:

The fastest and easiest way to apply contrast is just to choose one of the presets from the Point Curve pop-up menu. For example, choose Strong Contrast and then look at the difference in your photo. Look how much more contrasty the photo now looks—the shadow areas are stronger, and the highlights are brighter, and all you had to do was choose this from a pop-up menu. You can see the contrast curve that was applied in the graph at the top of the panel.

If you think the Strong Contrast preset isn't strong enough (here, I think it needs a lot more contrast), you can edit this curve yourself, but it's helpful to know this rule: the steeper you make the S-shaped curve, the stronger the contrast. So to make this curve steeper, you'd move the point near the top of the curve (the highlights) upward and the bottom of the curve (the darks and shadows) downward. (Note: If you see sliders beneath your curve graph, you won't see the points on your curve. Click on the Point Curve button to the right of the Point Curve pop-up menu to hide the sliders and see the points.) To move your top point higher, move your cursor right over the top point, and a cursor with a two-headed arrow appears. Just clickand-drag it upward (shown here) and the image gets more contrasty in the highlights. By the way, if you start with the Linear curve, you'll have to add your own points: Click about 3/4 of the way up to add a Highlights point, then drag it upward. Add another about 1/4 of the way up to add a Shadows adjustment and drag down until you have a steep S-shaped curve.

Step Four:

Here, I've dragged the Shadow point down quite a bit (well, there are two, so I dragged them both down) to make the S-shaped curve steeper, and now I have more contrast in the highlight and shadow areas. (Remember: The steeper the curve, the more contrast you're applying.) Also, you can adjust the individual RGB (Red, Green, and Blue) channels by clicking on the Channel pop-up menu (shown circled here), choosing a channel to edit, and dragging the curve to add more contrast to that particular color channel.

TIP: Adding Mega-Contrast

If you did apply some Contrast in the Basic panel, using the Tone Curve actually adds more contrast on top of that contrast, so you get mega-contrast.

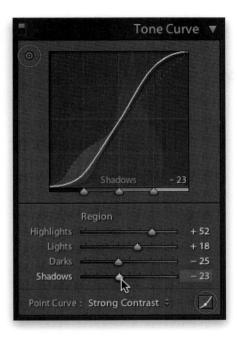

Step Five:

There's another way to adjust contrast using the tone curve, but before we get to that, click on the little Point Curve button (shown circled here) to reveal the curve sliders again. Each slider represents part of the curve, so if you don't like the idea of dragging the curve, you can drag the sliders instead (as shown here, where I'm adjusting the Shadows. More on this, though, in Step Seven). Besides using the sliders, you can also use the Targeted Adjustment tool (or TAT, for short). The TAT is that little round target-looking icon in the top-left corner of the Tone Curve panel (also shown circled here in red). It lets you click-and-drag (up or down) directly on your image, and adjusts the curve for the part you're clicking on. The crosshair part is actually where the tool is located (as shown on the left)—the target with the triangles is there just to remind you which way to drag the tool, which (as you can see from the triangles) is up and down.

Step Six:

Now, let's put it to use. First, reset the Point Curve pop-up menu to Strong Contrast. Then, take the TAT and move it over your photo (I put it over the building on the left, because I want that area to be darker). Look at the tone curve and you'll see two things: (1) there's a point on the curve where the tones you're hovering over are located, and (2) the name of the area you'll be adjusting appears at the bottom of the graph (in this case, it says Darks). Now, click-and-drag (as shown here) straight downward (if you drag straight upward, it brightens the building instead). You can move around your image and click-and-drag straight upward to adjust the curve to brighten those areas, and drag straight downward to have the curve darken those areas. When you're done, click the TAT back where you found it. By the way, the keyboard shortcut to get the TAT is Command-Option-Shift-T (PC: Ctrl-Alt-Shift-T).

The Adobe Photoshop Lightroom 5 Book for Digital Photographers

Step Seven:

The final method of adjusting the tone curve is to simply click-and-drag the four Region sliders (Highlights, Lights, Darks, and Shadows) near the bottom of the panel, and as you do, it adjusts the shape of the curve. Here, I dragged the Highlights slider to the far right to brighten the highlights. I dragged the Darks to the left to lower the midtones a bit, and I also dragged the Shadows slider to the left to keep everything from looking washed out. Finally, I moved the Lights slider quite a bit to the right to bring out some upper midtones and lower highlights. Also, if you look at the sliders themselves, they have the same little gradients behind them like in the Basic panel, so you know which way to drag (toward white to make that adjustment lighter, or toward black to make it darker). By the way, when you adjust a curve point (no matter which method you choose), a gray shaded area appears in the graph showing you the curve's boundary (how far you can drag the curve in either direction).

Step Eight:

So, that's the scoop. To adjust your photo's contrast, you're going to either: (a) use a preset contrast curve from the Point Curve pop-up menu, (b) use the TAT and click-and-drag up/down in your photo to adjust the curve, (c) use either one of those two, then move the point up/down using the Arrow keys on your keyboard, or (d) manually adjust the curve using the Region sliders. Note: If you find that you're not using the sliders, you can save space by hiding them from view (like I mentioned earlier): click on the Point Curve button to the right of the Point Curve pop-up menu (shown circled here in red). If you decide you want them back one day, click that same button again.

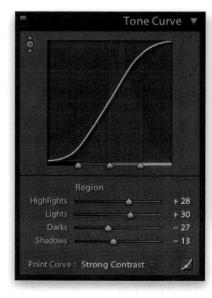

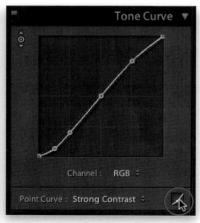

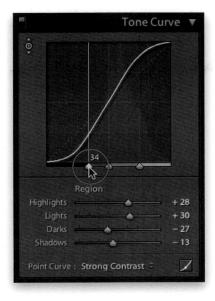

Step Nine:

There are three more things you'll need to know about the Tone Curve panel, and then we're set: The first is how to use the three slider knobs that appear at the bottom of the graph. Those are called Range sliders, and essentially they let you choose where the black, white, and midpoint ranges are that the tone curve will adjust (you determine what's a shadow, what's a midtone, and what's a highlight by where you place them). For example, the Range slider on the left (shown circled here in red) represents the shadow areas, and the area that appears to the left of that knob will be affected by the Shadows slider. If you want to expand the range of what the Shadows slider controls, click-anddrag the left Range slider to the right (as shown here). Now your Shadows slider adjustments affect a larger range of your photo. The middle Range slider covers the midtones. Clicking-and-dragging that midtones Range slider to the right decreases the space between the midtone and highlight areas, so your Lights slider now controls less of a range, and your Darks slider controls more of a range. To reset any of these sliders to their default position, just double-click directly on the one you want to reset.

Step 10:

The second thing you'll want to know is how to reset your tone curve and start over. Just double-click directly on the word Region and it resets all four sliders to 0. Lastly, the third thing is how to see a before/after of just the contrast you've added with the Tone Curve panel. You can toggle the Tone Curve adjustments off/on by using the little switch on the left side of the panel header (shown circled here). Just click it on or off. As we finish this off, here's a before/after with no adjustments whatsoever except for the Tone Curve. It's more powerful than it looks.

Two Really Handy Uses for RGB Curves

Although Curves have been in Lightroom for a while now, Lightroom 4 was the first version to let you adjust the individual Red, Green, and Blue channels (just like Photoshop does), which can come in really handy for things like fixing sticky white balance problems by adjusting an individual color channel, or for creating cross processing effects (which are very popular in fashion and fine art photography). Here's how to do both:

Step One:

You choose which RGB color channel you want to adjust by going to the Tone Curve panel, and then choosing the individual color channel from the Channel pop-up menu (as shown here, where I'm choosing the Blue channel to help me remove a color cast from her skin and hair—she isn't supposed to be "bluish"). So, now that you have just the Blue channel selected, notice that the Curve readout is tinted blue, as well, to give you a visual cue that you're adjusting just this one channel.

Step Two:

So, how do you know which part of the curve to adjust to remove this blue tint problem? Well, Lightroom can actually tell you exactly which part to adjust. Get the TAT (Targeted Adjustment tool) from the top-left corner of the panel and then move it over the area you want to affect (in this case, her hair), and you'll see a point appear on the curve as you move your cursor. Just click once while you're over her hair and it adds a point to the curve that corresponds to the area you want to adjust. Take that new curve point and drag at a 45° angle down toward the bottom-right corner and it removes the blue from her skin and hair (as seen here). Of course, since you have the TAT, you can use it, instead—click it directly on her hair and drag your cursor downward, and it edits that part of the curve for you.

SCOTT KELBY

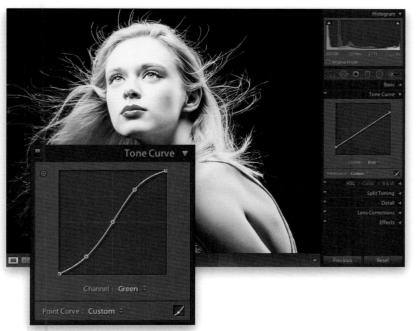

If you want to use these RGB curves to create a cross processing effect (a classic darkroom technique from the film days), it's actually fairly easy. There are dozens of different combinations, but here's one I use: Start by choosing **Red** from the Channel pop-up menu. Create kind of a steep S-curve by clicking three times along the diagonal curve—once in the center, once at the next major grid line above, and once at the next major grid line below, so they're evenly spaced along the line. Leave the center point where it is, and click-and-drag the top point upward and the bottom point downward to create the curve you see here. By the way, I put the original image, without any RGB curves applied, at the bottom here, just so you can see our original starting point.

Step Four:

Then, switch to the Green channel and make another three-point S-curve, but one that's not as steep (as seen here at the bottom). Lastly, go to the Blue channel. Don't add any points—just drag the bottom-left point straight upward along the left edge (as shown here). Then, drag the top-right point down along the right edge, as well. Of course, based on the particular image you use, you might have to tweak these settings (usually it's the amount you drag in the Blue channel, but again, it depends on the photo). By the way, if you come up with a setting you like, don't forget to save it as a Develop module preset (click the + [plus sign] button in the right side of the Presets panel header. When the New Develop Preset dialog appears, click Check None, then just turn on the checkbox for Tone Curve).

Adjusting Individual Colors Using HSL

Anytime you have just one color you want to adjust in an image (for example, let's say you want all the reds to be redder, or the blue in the sky to be bluer, or you want to change a color altogether), one place to do that would be in the HSL panel (HSL stands for Hue, Saturation, Luminance). This panel is incredible handy (I use it fairly often) and luckily, because it has a TAT (Targeted Adjustment tool), using it is really easy. Here's how this works:

Step One:

When you want to adjust an area of color, scroll down to the HSL panel in the right side Panels area (by the way, those words in the panel header, HSL/Color/B&W, are not just names, they're buttons, and if you click on any one of them, the controls for that panel will appear). Go ahead and click on HSL (since this is where we'll be working for now), and four buttons appear in the panel: Hue, Saturation, Luminance, and All. The Hue panel lets you change an existing color to a different color by using the sliders. Just so you can see what it does, click-anddrag the Red slider all the way to the left and the Orange slider to -71, and you'll see it changes the red scooters to magenta.

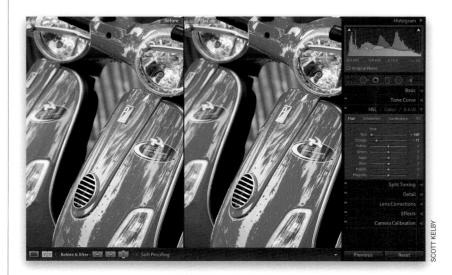

Step Two:

If you dragged the Red slider all the way to the right, and left the Orange slider at –71, it would change the color on the red scooters to more of an orangeish color. This is a perfect task for the Hue sliders of the HSL panel. Now, what if you wanted to make the orange color more orange, but you've pushed the sliders just about as far as they can go? Well, you'd start by clicking on the word "Saturation" at the top of the panel.

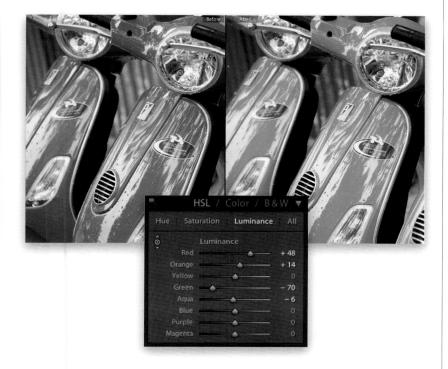

Now, these eight sliders control just the saturation of colors in your image. Drag the Orange slider way over to the right, and the Red not quite as far, and the orange in the scooters becomes much more vibrant (as seen here). If you know exactly which color you want to affect, you can just drag the sliders. But if you're not sure exactly which colors make up the area you want to adjust, then you can use the TAT (the same Targeted Adjustment tool you used in the Tone Curve panel). So, if you want to make the background on the left greener, click on the TAT, then click it on the green area of the background (as I did here near the top left), and drag it upward to make it greener (downward to make it less green). You'll notice that it doesn't just move the Green slider, but it also increases the Aqua Saturation slider, as well. You probably wouldn't have realized that there was any agua in that green area of the background, and this is exactly why this tool is so handy here. In fact, I rarely use the HSL panel without using the TAT!

Step Four:

To change the brightness of the colors, click on Luminance at the top of the panel. To darken the green color in the background, take the TAT and click-anddrag straight downward on it, and its color gets deeper and richer (the Luminance for both Green and Aqua decreased). Now, click-and-drag the TAT upward on one of the orange scooters to make them brighter (and notice that it moves the Red up, along with the Orange). Two last things: Clicking the All button (at the top of the panel) puts all three panels in one scrolling list and the Color panel breaks them all into sets of three for each color—a layout more like Photoshop's Hue/Saturation. But, regardless of which layout you choose, they all work the same way. A before/after is shown here, after we changed and brightened the scooters and darkened the background area and made it more green.

How to Add Vignette Effects

An edge vignette effect (where you darken all the edges around your image to focus the attention on the center of the photo) is one of those effects you either love or that drives you crazy (I, for one, love 'em). Here we're going to look at how to apply a simple vignette; one where you crop the photo and the vignette still appears (called a "post-crop" vignette); and how to use the other vignetting options.

Step One:

To add an edge vignette effect, go to the right side Panels area and scroll down to the Lens Corrections panel (the reason it's in the Lens Corrections panel is this: some particular lenses darken the corners of your photo, even when you don't want them to. In that case, it's a problem, and you'd go to the Lens Corrections panel to fix a lens problem, right? There you would brighten the corners using the controls in this panel. So, basically, a little edge darkening is bad, but if you add a lot intentionally, then it's cool. Hey, I don't make the rules—I just pass them on). Here's the original image without any vignetting (by the way, we'll talk about how to get rid of "bad vignetting" in Chapter 7—the chapter on how to fix problems).

Step Two:

We'll start with regular full-image vignetting, so click on Manual at the top of the panel, then drag the Lens Vignetting Amount slider all the way to the left. This slider controls how dark the edges of your photo are going to get (the further to the left you drag, the darker they get). The Midpoint slider controls how far in the dark edges get to the center of your photo. So, try dragging it over quite a bit, too (as I have here), and it kind of creates a nice, soft spotlight effect, where the edges are dark, your subject looks nicely lit, and your eye is drawn right where you want it to look.

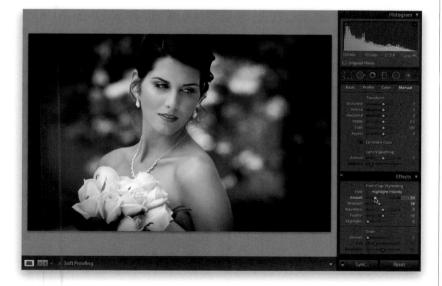

Now, this works just fine, until you wind up having to crop the photo, because cropping will crop away the edge vignette. To get around that problem, Adobe added a control called "Post-Crop Vignetting," which lets you add vignetting effects after you've cropped. I'm cropping that same photo in tight here, and now most of the edge vignetting I added earlier will be cropped away. So, scroll down to the Effects panel and at the top you'll see Post-Crop Vignetting. Before we try that, reset your Lens Vignetting Amount slider to 0 (zero), so we don't add the post-crop vignetting on top of the little bit of original vignetting still in our photo.

Step Four:

Before we get to the sliders, let's talk about the Style pop-up menu. You have three choices: (1) Highlight Priority, (2) Color Priority, and (3) Paint Overlay (though the only one that really looks good is Highlight Priority, so it's the only one I ever use. The results are more like what you get with the regular vignette. The edges get darker, but the color may shift a bit, and I'm totally okay with the edges looking more saturated. This choice gets its name from the fact that it tries to keep as much of the highlights intact, so if you have some bright areas around the edges, it'll try to make sure they stay bright). I made the edges pretty darn dark here—darker than I would make mine, but I wanted you to really see the effect on the cropped image (just for example purposes). The Color Priority style is more concerned with keeping your color accurate around the edges, so the edges do get a bit darker, but the colors don't get more saturated, and it's not as dark (or nice) as the Highlight Priority style. Finally, Paint Overlay gives you the look we had back in Lightroom 2 for post-crop vignetting, which just painted the edges dark gray (yeech!).

Step Five:

The next two sliders were added to give you more control to make your vignettes look more realistic. For example, the Roundness setting controls how round the vignette is. Just so you know exactly what this does, try this: leave the Roundness set at 0, but then drag the Feather amount (which we'll talk about in a moment) all the way to the left. You see how it creates a very defined oval shape? Of course, you wouldn't really use this look (well, I hope not), but it does help in understanding exactly what this slider does. Well, the Roundness setting controls how round that oval gets (drag the slider back and forth a couple of times and you'll instantly get it). Okay, reset it to zero (and stop playing with that slider).;-)

Step Six:

The Feather slider controls the amount of softness of the oval's edge, so dragging this slider to the right makes the vignette softer and more natural looking. Here I clicked-and-dragged the Feather amount to 57, and you can see how it softened the edges of the hard oval you saw in the previous step. So, in short, the farther you drag, the softer the edges of the oval get. The bottom slider, Highlights, helps you to maintain highlights in the edge areas you're darkening with your vignette. The farther to the right you drag it, the more the highlights are protected. The Highlights slider is only available if your Style is set to either Highlight Priority or Color Priority (but you're not going to set it to Color Priority, because it looks kind of yucky, right?). So there ya have it—how to add an edge vignette to focus the viewer's attention on the center of your image by darkening the edges all the way around.

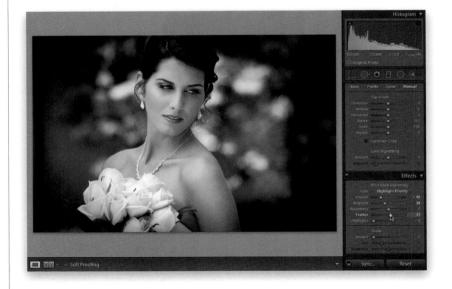

Book

There's a Photoshop effect that started making the rounds a couple years ago, and now it's one of the hottest and most requested looks out there—you see it everywhere from big magazine covers to websites to celebrity portraits to album covers. Anyway, you can get pretty darn close to that look right within Lightroom itself. Now, before I show you the effect, I have to tell you, this is one of those effects that you'll either absolutely love (and you'll wind up over-using it), or you'll hate it with a passion that knows no bounds. There's no in-between.

Develop

Getting That Trendy High-Contrast Look

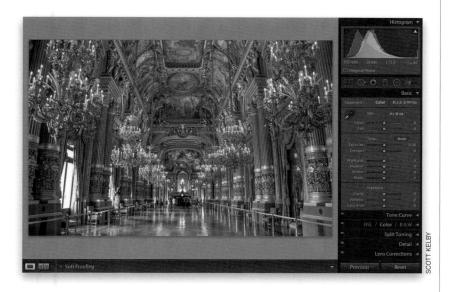

Step One:

Before we apply this effect, I have a disclaimer: this effect doesn't look good on every photo. It looks best on photos that have lots of detail and texture, so it looks great on city shots, landscapes, industrial shots, and even people (especially guys)—anything you want to be gritty and texture-y (if that's even a word). So, you're usually not going to apply this effect to anything you want to look soft and/or glamorous. Here's a shot with lots of detail—it's a shot of the Paris Opera House, which has lots of textures. It's just screaming for this type of treatment.

Step Two:

You're going to really crank up four sliders in the Develop module's Basic panel: (1) drag the Contrast slider all the way over to +100, (2) drag the Highlights slider all the way to -100, (3) drag the Shadows slider all the way to +100 (that opens up the shadows), and (4) drag the Clarity slider all the way to the right to +100. Now, the whole image has that high-contrast look already, but we're not done yet.

Continued

Now, at this point, depending on the photo you applied this effect to, you might have to drag the Exposure slider to the right a bit, if the entire image is too dark (that can happen when you set the Contrast at +100), or if the photo looks washed out a bit (from cranking the Shadows slider to +100), then you might need to drag the Blacks slider to the left to bring back the color saturation and overall balance. Outside of those potential tweaks, the next step is to desaturate the photo a little bit by dragging the Vibrance slider to the left (here, I dragged it over to -45). This desaturation is a trademark of this "look," which kind of gives the feel of an HDR image without combining multiple exposures.

Step Four:

The final step is to add an edge vignette to darken the edges of your photo, and put the focus on your subject. So, go to the Lens Corrections panel (in the right side Panels area), click on Manual at the top, and drag the Lens Vignetting Amount slider to the left (making the edges really dark). Then drag the Midpoint slider pretty far to the left, as well (the Midpoint slider controls how far the darkened edges extend in toward the middle of your photo. The farther you drag this slider to the left, the farther in they go). This made the whole photo look a little too dark, so I had to go back to the Basic panel and increase the Exposure amount a little bit (to +0.25) to bring back the original brightness before the vignette. I included a few befores and afters on the next page just to give you an idea of how it affects different images. Hey, don't forget to save this as a preset (see page 194), so you don't have to do this manually every time you want to apply this look.

SCOTT KELBY

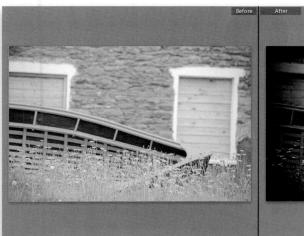

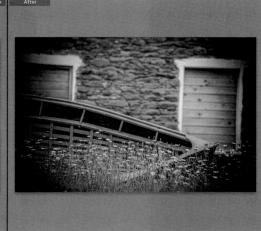

SCOTT KELBY

Creating Blackand-White Images

There are two auto conversion methods for converting your images from color to black and white (one in the Basic panel and another in the HSL/Color/B&W panel), and no matter where you choose to do it from, the results are the same. Now, to me they just look really flat, and I honestly think you can do much better by doing it yourself. We'll start with my preferred method for most color-to-black-and-white conversions, which lets you build on what you've already learned in this chapter.

Step One:

In the Library module, find the photo you want to convert to black and white, and first make a virtual copy of it by going under the Photo menu and choosing **Create**Virtual Copy, as shown here (the only reason you do this is so when you're done, you can compare your do-it-yourself method with Lightroom's auto-conversion method side by side. By the way, once you learn to do the conversion yourself, I doubt you'll ever want to use the auto method again). Press Command-D (PC: Ctrl-D) to deselect the virtual copy, and then go down to the Filmstrip and click on the original photo.

Step Two:

Now press **D** to jump to the Develop module and, in the right side Panels area, scroll down to the HSL/Color/B&W panel, then click directly on B&W on the far right of the panel header (as shown here). This applies an automatic conversion from color to black and white, but sadly it usually gives you the flat-looking B&W conversion you see here (consider this your "before" photo). The idea here is that you adjust the B&W auto conversion by moving the color sliders. The thing that makes this so tricky, though, is that your photo isn't color anymore. Go ahead and move the sliders all you want, and you'll see how little they do by themselves. By the way, if you toggle the panel on/off button (circled here in red), you can see how bad this black-and-white would have looked if Lightroom had done the auto conversion for you without using the default conversion settings.

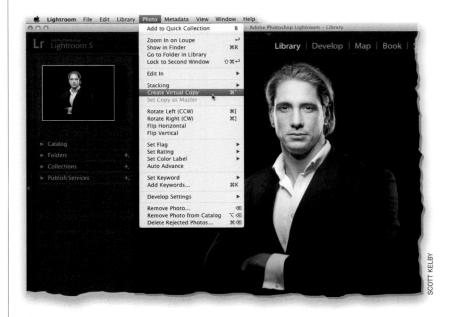

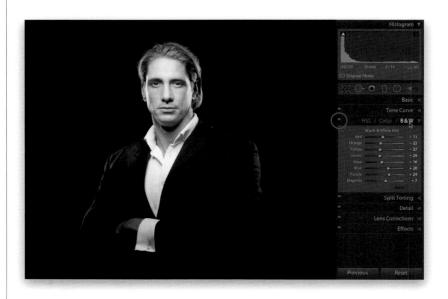

Now, press the **Right Arrow key** on your keyboard to switch to that virtual copy you made, and I'll show you my preferred do-it-yourself method. Go to the Basic panel (at the top of the right side Panels area), and in the Treatment section at the top, click on Black & White, and you get another flat-looking image (but that's about to change). Most photographers want to create a really rich, high-contrast B&W image, so the first thing to do is make sure we've gotten all we can out of the highlights in the photo, so drag the Whites slider over to the right until the moment the "white triangle of death" (in the upper-right corner of the histogram) appears, then stop. Next, drag the Highlights slider just a tiny bit to the left until that white triangle turns dark gray again. Now you know you've gotten the maximum amount of highlights without clipping any of them away.

Step Four:

Next, drag the Blacks slider over to the left a little until the photo doesn't look so flat and washed out, and then increase the Contrast guite a bit. Now, there are those who believe that you should never let any part of your photo turn solid black, even if it's a non-essential, low-detail area like a shadow under a rock. I'm not one of those people. I want the entire photo to have "pop" to it, and in my years of creating B&W prints, I've found that your average person reacts much more positively to photos with high-contrast conversions than to the flatter conversions that retain 100% detail in the shadows. If you get a chance, try both versions, show your friends, and see which one they choose. Once you increase the Contrast, his suit is going to be a little too dark, so increase the Shadows until you get some detail back. Overall, the photo seemed a little too bright, so I also decreased the Exposure a little.

Step Five:

We're going for a high-contrast black and white, so we can add even more contrast by clicking-and-dragging the Clarity slider quite a bit to the right (here I dragged to +49), which gives the midtones much more contrast and makes the overall photo have more punch and crispness.

TIP: Finding Out Which Shots Make Great B&W Images

Go to a collection, press **Command-A** (**PC: Ctrl-A**) to select all of the photos, then press the letter **V** to temporarily convert them all to black and white, and now you can see which ones (if any) would make great B&W images. Press **Command-D** (**PC: Ctrl-D**) to Deselect all the photos. When you see a great B&W candidate, click on it, then press **P** to flag it as a Pick. When you're done, select all of the photos again and press V to return them to full color. Now all the photos that you think would make great B&W images are tagged with a Picks flag. Pretty handy.

Step Six:

The final step is to add some sharpening. Since this is a portrait, the easiest thing to do is to go over to the left side Panels area, and in the Presets panel, under the Lightroom General Presets, choose Sharpen – Faces (as shown here) to apply a nice amount of sharpening for portraits. By the way, if that's not enough sharpening, try the next preset down (which is really for landscape shots, and is called Sharpen – Scenic, but it's worth trying). So that's it. It's not that much different from adjusting a color photo, is it? Now, I didn't want to tell you this earlier, because I wanted you to learn this technique, but there's a built-in preset that pretty much does all this for you. Click on the Reset button at the bottom right to reset your photo to the original color image, then go to the Presets panel, and under Lightroom B&W Presets, click on B&W Look 5. Don't hate the playa. Hate the game.

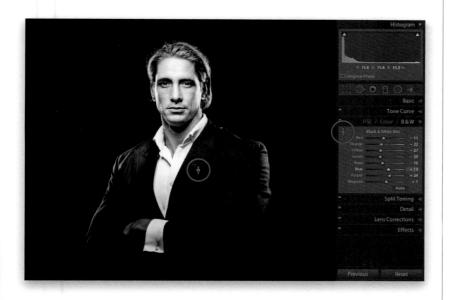

Step Seven:

Okay, we're done with our conversion, but there's one other thing you'll want to know about, and that's how to tweak an individual area of your B&W photo. For example, let's say you wanted his suit to be brighter. You'd just go to the B&W panel again, click on the TAT (Targeted Adjustment tool—shown circled here), then click it on the part of his suit you want to be lighter, and drag straight upward. Even though the photo is now a black and white, it knows which underlying colors make up that area, and it moves the sliders for you to brighten that area (as shown here). The next time you need to brighten or darken (you'd drag down instead) a particular area, try using the TAT and let it do the work for you.

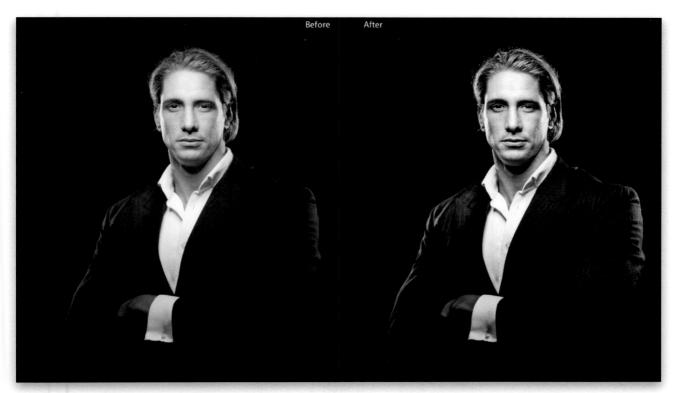

The auto conversion to black and white

Doing the black-and-white conversion yourself

Getting Great Duotones (and Split Tones)

Okay, I need to clarify here a bit: This trick is for getting great duotones, but I also cover how to do a split-tone effect, since it kind of uses the same controls. A duotone generally starts with a B&W photo, then you expand the visual depth of the image with a deep color tint. Split toning is where you apply one color tint to the highlights and another to the shadow areas. We'll cover duotones first, because not only are you more likely to do a duotone, they just look better (I'm not a big split-toning fan myself, but hey, I'm still happy to show ya how to do one, just in case).

Step One:

Although the actual duotone or split tone is created in the Split Toning panel (in the right side Panels area), you should convert the photo to black and white first. (I say "should" because you can apply a split-toning effect on top of your color photo, but...well...yeech!) In the Develop module's Presets panel, under Lightroom B&W Presets, click on B&W Look 5 to convert the photo. Then, in the Basic panel, increase the Clarity a bit more, and decrease the Exposure a little.

Step Two:

The trick to creating duotones is actually incredibly simple: you only add the color tint in the shadows, and you leave the highlights untouched. So, go to the Split Toning panel, in the right side Panels area, and start by dragging the Shadows Saturation slider to around 25, so you can see some of the tint color (as soon as you start dragging the Saturation slider, the tint appears, but, by default, the hue is a reddish color). Now, drag the Shadows Hue slider over to 41 to get more of a traditional duotone look (while you're there, increase the Saturation amount to 35, as shown here). That's it. Couldn't be simpler. Of course, you can choose any hue you want (this one just happens to be my favorite for duotones).

TIP: Reset Your Settings

If you want to start over, press-and-hold the Option (PC: Alt) key, and the word "Shadows" in the Split Toning panel changes to "Reset Shadows." Click on it to reset the settings to their defaults.

Now, on to split tones. To create a splittone effect, start with a good-looking B&W photo (you know how to convert from color to black and white now), then you're going to do the same thing you did to create a duotone, but you're going to choose one hue for the highlights and a different hue for the shadows. That's all there is to it (I told you this was easy). Here, I set the Highlights Hue to 45 and the Shadows Hue to 214. I then set the Shadows Saturation slider to 27 and the Highlights Saturation slider to 50 (a little bit higher than usual, just to add more color).

TIP: See a Tint Color Preview
To make it easier to see which color tint you're choosing, press-and-hold the Option (PC: Alt) key and drag the Hue slider, and it will give you a temporary preview of your color tint as if you bumped up the Saturation amount to 100%.

Step Four:

You can also choose your colors from a color picker: click on the color swatch next to Highlights to bring up the Highlights color picker. Along the top are some common split-tone highlight colors. For example, click on the beige swatch (the third from the left) to apply a beige tint to the highlights (you can see the result in the Preview area). To close the color picker, click on the X in the upper-left corner. The Balance slider (found between the Highlights and Shadows sections) does just what you'd think it would—it lets you balance the color mix between the highlights and shadows. For example, if you want the balance in your image more toward the beige highlights, you'd just click-anddrag the Balance slider to the right. Now, if you've created a particular duotone or split-tone combination that you like, save it as a preset by going to the Presets panel and clicking the little + (plus sign) button on the right side of the panel header.

Lightroom Killer Tips > >

▼ Resetting the White Balance

To reset both the Temp and Tint White Balance sliders to their original As Shot settings, just double-click directly on the letters WB in the Basic panel.

▼ Picking Zooms in the Detail Panel If you Right-click inside the little preview window in the Detail panel, a pop-up menu will appear where you can choose

between two zoom ratios for the preview—1:1 or 2:1—which kick in when you click your cursor inside the Preview area.

▼ Hiding the Clipping Warning Triangles

If you don't use the two little clipping warning triangles in the top corners of the histogram (or you want them turned off when you're not using them), then just

Right-click anywhere on the histogram itself and choose **Show Clipping Indicators** from the pop-up menu to turn it off, and they'll be tucked out of sight. If you want them back, go back to that same pop-up menu, and choose Show Clipping Indicators again.

▼ Separating Your Virtual Black & Whites from the Real Black & Whites

To see just your virtual B&W copies, go up to the Library Filter bar (if it's not visible, press the \ [backslash] key), and then click on Attribute. When the Attribute options pop down, click on the little curled page icon at the far right of the bar

to show just the virtual copies. To see the real original "master" B&W files, click the filmstrip icon just to the left of it. To see everything again (both the virtual and original masters), click the None button.

▼ Getting a Before/After of Your B&W Tweaking

You can't just press the \ (backslash) key to see your before image after you've done the edits to your B&W image, because you're starting with a color photo (so pressing \ just gives you the color original again). There are two ways to get around this: (1) As soon

as you convert to black and white, press Command-N (PC: Ctrl-N) to save the conversion as a snapshot. Now you can get back to your B&W original anytime by clicking on that snapshot in the Snapshots panel. Or, (2) after you convert to black and white, press Command-' (PC: Ctrl-') to make a virtual copy, and then do your editing to the copy. That way you can use \ to compare the original conversion with any tweaks you've been making.

▼ Tip for Using the Targeted Adjustment Tool (TAT)

If you're using the HSL/Color/B&W panel's TAT to tweak your B&W image, you already know that you click-and-drag the TAT within your image and it moves the sliders that control the colors underneath it. However, you might find it easier to move the TAT over the area you want to adjust, and instead of dragging the TAT up/down, use the **Up/Down Arrow keys** on your keyboard, and it will move the sliders for you. If you press-and-hold the Shift key while using the Up/Down Arrow keys, the sliders move in larger increments.

▼ Painting Duotones

Another way to create a duotone effect from your B&W photo is to click on the Adjustment Brush, and then in the

Lightroom Killer Tips > >

options that pop down, choose **Color** from the Effect pop-up menu. Now, click on the Color swatch to bring up the color picker, choose the color you want, and close the picker. Then, turn off the Auto

Mask checkbox and paint over the photo, and as you do, it will retain all the detail and just apply the duotone color.

▼ B&W Conversion Tip

Clicking on B&W in the HSL/Color/B&W panel converts your photo to black and white—kind of a flat-looking conversion, but the idea is that you'll use those color

sliders to adjust the conversion. However, it's hard to know which color sliders to move when the photo is in black and white. Try this: once you've done your conversion and it's time to tweak those color sliders, press **Shift-Y** to enter the Before & After split-screen view (if it shows a sideby-side view instead, just press Shift-Y again). Now you can see the color image on the left side of the screen, and black and white on the right, which makes it easier to see which color does what.

▼ Using the HSL/Color/B&W Panel? Color Correct Your Photo First

If you're going to be using the B&W panel to make your B&W conversion, before you go there, start by making

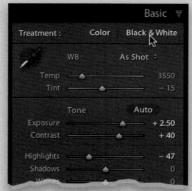

the color image look right first (balance the exposure, blacks, contrast, etc., first, then you'll get better results from the B&W panel).

▼ The Subtle Change in the Default Curve for RAW Images

In previous versions of Lightroom, if you opened a RAW photo, by default it had a slight S-curve already applied to it (in the Tone Curve panel, the Point Curve popup menu was set to Medium Contrast). For JPEGs (which have contrast added in-camera) the curve was flat (Linear) by default. This made applying presets that

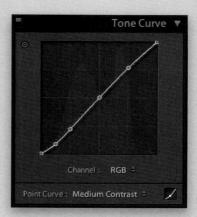

used a Curve kind of messy, because the amount of contrast would be different if you applied the same preset to a RAW photo than if you applied it to a JPEG. So, as of Lightroom 4, the Tone Curve is now flat (Linear) for both RAW and JPEG photos, but just so you know, Lightroom is still applying that medium S-curve to your RAW photo behind the scenes, but at least now your presets that have a Tone Curve in them will apply consistently for both RAW and JPEG images.

▼ Quickly Flatten Your Curve

If you've created a Tone Curve adjustment (in the Develop module) and you want to quickly reset the curve to a flat (Linear) curve, just Right-click anywhere inside the curve grid and choose **Flatten Curve**.

DJ DEVELOP (PART DEUX) more ways to tweak your images

This all used to be one giant chapter, but Adobe keeps adding new Develop module features in every version of Lightroom, and I realized that keeping it as one humongous chapter wasn't doing anybody any good, so I split it into two distinct chapters, with the most essential stuff in the first chapter, and everything else in this chapter. Now, I don't want you to think for one instant that the techniques in this chapter are not essential, just because they are, in fact, not essential, but there comes a time in every man's life when he needs to grow. We (as men) do this by taking a simple adjective and adding the letters "DJ" in front of it because, for some reason yet to be scientifically disproven, it attracts women faster than wearing a necklace made of hundred dollar bills. Seriously, try it yourself: Pick any adjective (like "shy") and you become "DJ Shy," and women will

literally pass out when you enter the room. And forget about using touch/taste adjectives like "hot," "icy," "fresh," "delicious," and so on. Add DJ in front of any of those, and you'll never be alone again. So, you have to imagine the guy that chose DJ Develop has to be a Lightroom user, and was trying to attract female photographers with his song "Banoodles" (available on iTunes for 99¢. I listened to the 90-second preview and it gave me suicidal thoughts). Anyway, I did a little digging and found out that there's a female equivalent to the prefix "DJ" that will cause any man to follow you anywhere, including a wedding chapel. That prefix is "HDTV." However, instead of using adjectives, add HDTV before the first name of any of the Spice Girls (i.e. HDTV Sporty or HDTV Baby), and you'll be married before sundown. It's a proven fact.

Making Your RAW Photos Look More Like JPEGs

The #1 complaint I hear at my Lightroom seminars is "When my RAW photos first appear in Lightroom, they look great, but then they change and look terrible." What's happening is when you shoot in JPEG, your camera adds contrast, sharpening, etc., right in the camera. When you shoot in RAW, you're telling the camera to turn all that contrast, sharpening, and stuff off. So, when your RAW image first comes into Lightroom, you're seeing a sharp, contrasty preview first, but then it draws the real preview and you see the actual RAW image. Here's how to get a more JPEG-like starting place:

Step One:

To get a more JPEG-like starting place for your RAW images, here's what to do: Go to the Develop module and scroll down to the Camera Calibration panel. There's a Profile pop-up menu near the top of this panel, where you'll find a number of profiles based on your camera's make and model (it reads the image file's embedded EXIF data to find this. Not all camera brands or models are supported, but most recent Nikon and Canon DSLRs are, along with some Pentax, Sony, Olympus, Leica, and Kodak models). These profiles mimic camera presets you could have applied to your JPEG images in-camera (but are ignored when you shoot in RAW). The default profile is Adobe Standard, which looks pretty average (well, if you ask me).

Step Two:

Now all you have to do is try out each of the different profiles, and see which one looks good to you (which to me is which one looks the most like a JPEG—a profile that looks more contrasty, with richer looking colors). I usually start by looking at the one called Camera Standard (rather than the default Adobe Standard). I rarely see a photo using Camera Standard that I don't like better than using the default Adobe Standard setting, so this is usually my preferred starting place.

Note: If you're shooting Canon, or Pentax, etc., you'll see a different list of profiles, as they're based on the names the camera manufacturer gives to their in-camera picture styles.

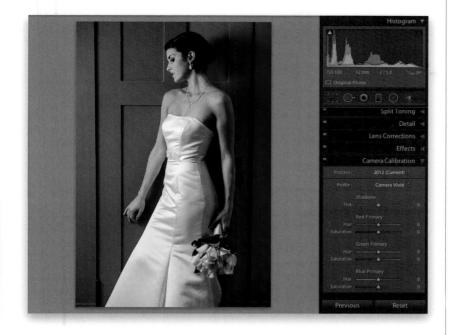

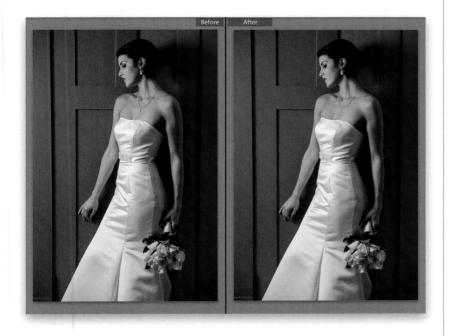

If you're shooting landscapes (and you want that Fuji Velvia film look), or you just have a subject where you really want vivid colors, try the Camera Vivid profile, which mimics the Vivid color preset you could have chosen in your camera. I love this one for landscapes, but I'll also try the Camera Landscape profile and compare the two, to see which one looks best for the particular photo I'm looking at, because I've learned that it really depends on the photo as to which profile looks best. That's why I recommend trying a few different profiles to find the one that's right for the photo you're working with. Note: Don't forget, you only get a choice of these camera profiles if you shot in RAW. If you shot in JPEG mode, you'll only see one profile: Embedded.

TIP: Create Your Own Profiles You can create your own custom profiles using Adobe's free DNG Profile Editor, available from Adobe at www.adobe.com/ products/photoshop/extend.display Tab2.html (look under Resources).

Step Four:

Here's a before/after, where the only thing I did was choose the Camera Vivid profile. By the way, Adobe doesn't claim that these profiles will give you the look of a JPEG image, but in my opinion, they surely can get you fairly close. I use these profiles anytime I want my starting point to be closer to the JPEG-like image I saw on the back of my camera.

TIP: Apply Profiles Automatically If you find that you like a particular profile, and you always want it applied to your RAW images, you can go to the Develop module, choose the profile (don't do anything else in the Develop module), and create a Develop preset with that name. Now, you can apply that look automatically to every photo you import by choosing that preset from the Develop Settings pop-up menu in Lightroom's Import window. (For more on creating presets, see page 194.)

Seeing Befores and Afters

In the first white balance project in Chapter 4, I ended with a before and after, but I didn't get a chance to show you how. I love the way Lightroom handles the whole before and after process because it gives you a lot of flexibility to see these the way you want to see them. Here's how:

Step One:

Any time you're working in the Develop module and you want to see what your image looked like before you started tweaking it (the "before" image), just press the \ (backslash) key on your keyboard. You'll see the word "Before" appear in the upper-right corner of your image, as seen here. In this image, you're seeing the overly cool original image. This is probably the Before view I use the most in my own workflow. To return to your After image, press the \ key again (it doesn't say "After;" the Before just goes away).

Step Two:

To see a side-by-side Before and After view (shown here on top), press the letter Y on your keyboard. If you prefer a split screen view, then click the little Before and After Views button in the bottom-left corner of the toolbar under your preview (as shown here on the bottom. If you don't see the toolbar for some reason, press the letter T to make it visible). If you click the Y button again, instead of a side-by-side before and after, you get a top/bottom before and after. Click it again, and you get a top/bottom split screen before and after. To return to Loupe view, just press the letter **D** on your keyboard.

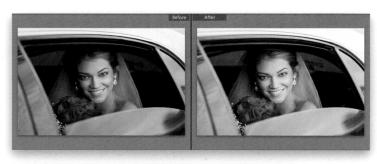

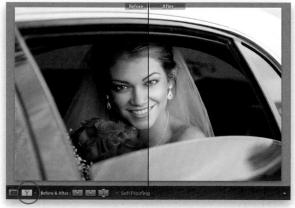

This is where your workflow starts to get some legs, because once you've edited one photo, you can apply those exact same edits to other photos. For example, in Chapter 4, we fixed the white balance for that one photo. But what if you shot 260 photos during one shoot? Well, now you can make your adjustments (edits) to one of those photos, then apply those same adjustments to as many of the other photos as you'd like. Once you've selected which photos need those adjustments, the rest is pretty much automated.

Applying Changes Made to One Photo to Other Photos

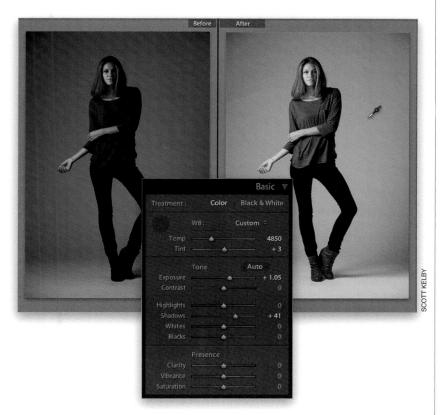

White Balance	Treatment (Color)	Lens Corrections Lens Profile Corrections	Spot Removal
Basic Tone Exposure Contrast Highlights Shadows White Clipping Black Clipping	Color Saturation Vibrance Color Adjustments Split Toning Local Adjustments Brush Graduated Filters	Chromatic Aberration Upright Mode Upright Transforms Transform Lens Vignetting Effects Post-Crop Vignetting Grain	Crop Straighten Angle Aspect Ratio
Clarity	Radial Filters	✓ Process Version	
Sharpening	Noise Reduction Luminance Color	☐ Calibration	

Step One:

Let's start by fixing the exposure (the shot is way underexposed) and the white balance for this catalog shoot. In the Library module, click on a photo, then press **D** to jump over to the Develop module. In the Basic panel, drag the Exposure slider and the Shadows slider to the right until they look about right (see the overlay here). Now, get the White Balance Selector tool (W) and click on something light gray in the photo (I pressed Shift-Y twice, so you could see a before/after sideby-side view here). So, those are the first steps—fix the exposure and white balance. Now press D to return to the regular view. (Just a reminder, you can download this photo and follow along at http:// kelbytraining.com/books/LR5.)

Step Two:

Now click the Copy button at the bottom of the left side Panels area. This brings up the Copy Settings dialog (shown here), which lets you choose which settings you want to copy from the photo you just edited. By default, it wants to copy a bunch of settings (several checkboxes are turned on), but since we only want to copy a few adjustments, click on the Check None button at the bottom of the dialog, then turn on just the checkboxes for White Balance, Exposure, and Shadows and click the Copy button. (Note: Be sure to also turn on the Process Version checkbox if you're copying settings to images that are using an old process version.)

Now press **G** to return to the Grid view, and select the photos you want to apply these changes to. If you want to apply the correction to all your photos from the shoot at once, you can just press **Command-A (PC: Ctrl-A)** to select all your photos (as shown here). It doesn't matter if your original gets selected again—won't hurt a thing. If you look in the bottom row of the grid here, you can see that the last photo is the one I corrected.

TIP: Choosing Other Adjustments Although, here, we're just copying-and-pasting a couple settings, you can use this function to copy-and-paste as many attributes as you want. If I've made a few edits in an area, I would just turn on the checkbox for that entire area in the Copy Settings dialog (in other words, I'd turn on the Basic Tone checkbox for my Basic panel edits, which automatically turns on all the tonal edit checkboxes. It just saves time).

Step Four:

Now go under the Photo menu, under Develop Settings, and choose **Paste Settings**, or use the keyboard shortcut **Command-Shift-V (PC: Ctrl-Shift-V)**, and the settings you copied earlier will be applied to all your selected photos (as seen here, where the white balance, exposure, and shadows have been corrected on all those selected photos).

TIP: Fixing Just One or Two Photos If I'm in the Develop module, fixing just one or two photos, I fix the first photo, then in the Filmstrip, I move to the other photo I want to have the same edits and I click the Previous button at the bottom of the right side Panels area, and all the changes I made to the previously selected photo are now applied to that photo.

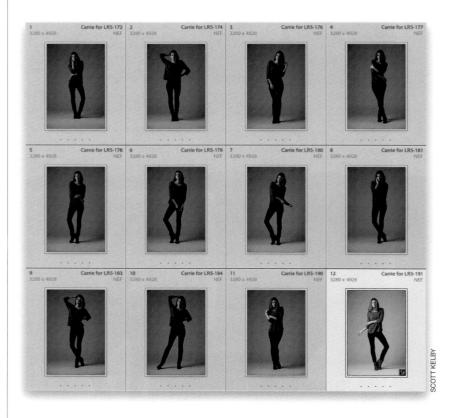

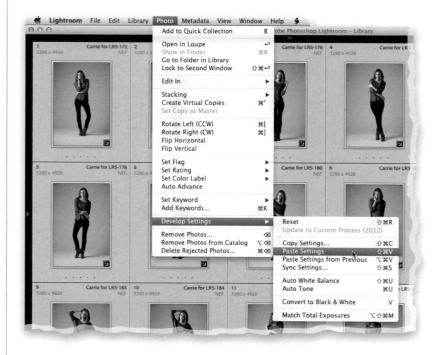

Develop

Remember the bridal shot we added a vignette to in Chapter 4? What if you wanted to see a version in black and white, and a version with a color tint, and then a real contrasty version, and then maybe a version that was cropped differently? Well, what might keep you from doing that is having to duplicate a high-resolution file each time you wanted to try a different look, because it would eat up hard drive space and RAM like nobody's business. But luckily, you can create virtual copies, which don't take up space and allow you to try different looks without the overhead.

Virtual Copies— The "No Risk" Way to Experiment

Step One:

You create a virtual copy by just Rightclicking on the original photo and then choosing **Create Virtual Copy** from the pop-up menu (as shown here), or using the keyboard shortcut **Command-'** (apostrophe; **PC: Ctrl-'**). These virtual copies look and act the same as your original photo, and you can edit them just as you would your original, but here's the difference: it's not a real file, it's just a set of instructions, so it doesn't add any real file size. That way, you can have as many of these virtual copies as you want, and experiment to your heart's content without filling up your hard disk.

Step Two:

When you create a virtual copy, you'll know which version is the copy because the virtual copies have a curled page icon in the lower-left corner of the image thumbnail (circled in red here) in both the Grid view and in the Filmstrip. So now, go ahead and tweak this virtual copy in the Develop module any way you want (here, I increased the Clarity and Vibrance and added more of an edge vignette using the Effects panel. See page 170 in Chapter 4 for how to add a vignette), and when you return to the Grid view, you'll see the original and the edited virtual copy (as seen here).

Continued

Now you can experiment away with multiple virtual copies of your original photo, at no risk to your original photo or your hard drive space. So, click on your first virtual copy, then press Command-' (PC: Ctrl-') to make another virtual copy (that's right—you can make virtual copies of your virtual copy), and then head over to the Develop module, and make some adjustments (here, I made changes to the White Balance, adding lots more yellow [I took the Temp to 50000 and set my Tint at +33], and left the Vibrance at +77to give this late sunset look. I also decreased the Exposure a little). Now, make some more copies to experiment with (I made a few more copies and made some more White Balance and Vibrance setting changes). Note: When you make a copy, you can hit the Reset button at the bottom of the right side Panels area to return the virtual copy to its original unedited look. Also, you don't have to jump back to the Grid view each time to make a virtual copy—that keyboard shortcut works in the Develop module, too.

Step Four:

Now, if you want to compare all your experimental versions side by side, go back to the Grid view, select your original photo and all the virtual copies, then press the letter N on your keyboard to enter Survey view (as shown here). If there's a version you really like, of course you can just leave it alone, and then delete the other virtual copies you don't like. (Note: To delete a virtual copy, click on it and press the Delete [PC: Backspace] key, and then click Remove in the dialog that appears.) If you choose to take this virtual copy over to Photoshop or export it as a JPEG or TIFF, at that point, Lightroom creates a real copy using the settings you applied to the virtual copy.

So you learned earlier how to edit one photo, copy those edits, and then paste those edits onto other photos, but there's a "live-batch editing" feature called Auto Sync that you might like better (well, I like it better, anyway). Here's what it is: you select a bunch of similar photos, and then any edit you make to one photo is automatically applied to the other selected photos, live, while you're editing (no copying-and-pasting necessary). Each time you move a slider, or make an adjustment, all the other selected photos update right along with it.

Editing a Bunch of Photos at Once Using Auto Sync

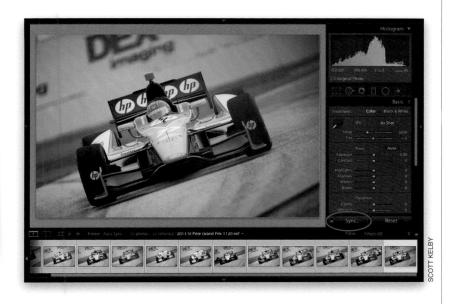

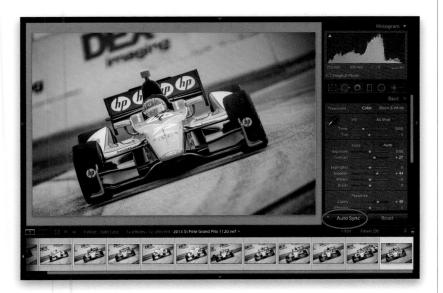

Step One:

In the Library module, click on the photo you want to edit, then in the Filmstrip, Command-click (PC: Ctrl-click) on all the other photos you want to have the same adjustments as the first one (here, I've selected 12 photos that all need the shadows opened up, and need more contrast and clarity). You see the first photo you clicked on in the center Preview area (Adobe calls this the "most selected" photo). Now, go to the Develop module and look at the button on the left at the bottom of the right side Panels area. It used to say "Previous," but when you select multiple photos, it changes to "Sync..." (shown circled here).

Step Two:

To turn on Auto Sync, click on that little switch to the left of the Sync button (you can see here the button now says "Auto Sync"). Now that it's on, I increased the Contrast amount to +27 (which makes the shadow areas darker and the highlight areas brighter), and I increased the Shadows to +44 and the Clarity to +49. As you make these changes, look at the selected photos in the Filmstrip—they all get the exact same adjustments, but without any copying-and-pasting, or dialogs, or anything. By the way, Auto Sync stays on until you turn off that little switch. To use this feature temporarily, press-and-hold the Command (PC: Ctrl) key, and Sync changes to Auto Sync. (Note: Remember, you won't see the Sync or Auto Sync buttons until you select multiple photos. Otherwise, it will say Previous.)

Using One-Click Presets (and Making Your Own!)

Lightroom comes with a number of built-in Develop module presets that you can apply to any photo with just one click. These are found in the Presets panel over in the left side Panels area, where you'll find eight different collections of presets: seven built-in collections put there by Adobe and a User Presets collection (that one's empty for now, because this is where you store the ones you create on your own). These are huge time savers, so take just minute or two and learn how to put them to use (and how to create your own).

Step One:

We'll start by looking at how to use the built-in presets, then we'll create one of our own, and apply it in two different places. First, let's look at the built-in presets by going to the Presets panel (found in the left side Panels area). There are seven built-in Lightroom collections (and a User Presets collection, where you can save and store your own presets). When you look inside each collection, you'll see that Adobe named these built-in presets by starting each name with the type of preset it is (for example, within the Lightroom Effect presets, you'll find Grain. That's the type of preset, then it says, "Heavy," "Light," or "Medium").

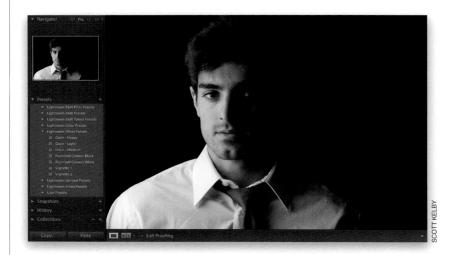

Step Two:

You can see a preview of how any of these presets will look, even before you apply them, by simply hovering your cursor over the presets in the Presets panel. A preview will appear above the Presets panel in the Navigator panel (as shown here, where I'm hovering over a Color preset called Cross Process 3, and you can see a preview of how that color effect would look applied to my photo, up in the Navigator panel, at the top of the left side Panels area).

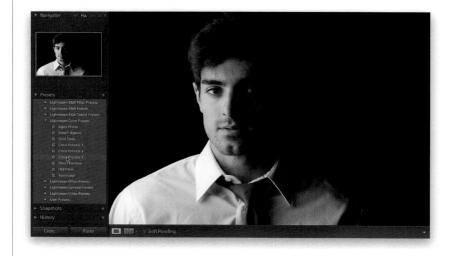

To actually apply one of these presets, all you have to do is click on it. In the example shown here, I clicked on the Color preset, Bleach Bypass, which gives the washed-out desaturated effect you see here. The nice thing is if you want to tweak things after the preset has been applied, you can just grab the sliders in the Basic panel and go to town!

TIP: Renaming Presets

To rename any preset you created (a user preset), just Right-click on the preset and choose **Rename** from the pop-up menu.

Step Four:

For example, here I increased the Clarity amount to +27 and the Contrast to +31. but then the colors started to look too desaturated, so Lincreased the Vibrance to -5. Also, once you've applied a preset, you can apply more presets and those changes are added right on top of your current settings, as long as the new preset you chose doesn't use the same settings as the one you just applied. So, if you applied a preset that set the Exposure, White Balance, and Highlights, but didn't use vignetting, if you then chose a preset that just uses vignetting, it adds this on top of your current preset. Otherwise, if the new preset uses Exposure, White Balance, or Highlights, it just moves those sliders to new settings, so it might cancel the look of the original preset. For example, after I applied the Bleach Bypass preset, and tweaked the settings I mentioned above, I went to the Effect Presets collection and applied the preset called "Vignette 1" (as shown here) to add a dark edge effect and darken his shirt a little. The Bleach Bypass didn't have a vignette, so it added it on top.

Step Five:

Now, of course you can use any built-in preset as a starting place to build your own preset, but let's just start from scratch here. Click the Reset button at the bottom of the right side Panels area (shown circled here in red) to reset our photo to how it looked when we started. Now we'll create our own saturated, contrasty look preset from scratch: Increase the Contrast amount to +31, increase the Shadows to +100, and then set the Clarity to +100. We're not finished yet ('cause this looks kinda lame).

Step Six:

Now go the Tone Curve panel (in the right side Panels area), choose Strong **Contrast** from the Point Curve pop-up menu, then go to the Effects panel, and drag the Post-Crop Vignetting Amount slider to -16 to darken the edges and complete the effect (that looks better. Kind of contrasty, with snappy color). Okay, now that we've got our look, let's save it as a preset. Go back to the Presets panel and click on the + (plus sign) button on the right side of the Presets panel header to bring up the New Develop Preset dialog (shown here). Give your new preset a name (I named mine "Saturated Contrast Look"), click the Check None button at the bottom of the dialog (to turn off all the checkboxes), then turn on the checkboxes beside all the settings you edited to create this preset (as seen here). Now, click the Create button to save all the edits you just made as your own custom preset, which will appear under the User Presets collection in the Presets panel.

Note: To delete a user preset, just click on the preset, then click on the – (minus sign) button, which will appear to the left of the + button on the right side of the Presets panel header.

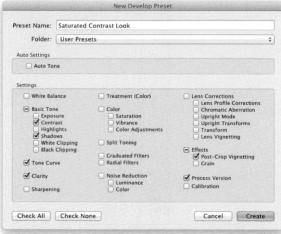

Step Seven:

Now click on a different photo in the Filmstrip, then hover your cursor over your new preset (I'm hovering over my Saturated Contrast Look preset). Look up at the Navigator panel, and you'll see a preview of the preset (as seen here, where you're seeing what the current color photo would look like if you applied the custom preset we just made). Seeing these instant live previews is a huge time saver, because you'll know in a split second whether your photo will look good with the preset applied or not, before you actually apply it.

Step Eight:

You can even put these presets (the built-in ones that come with Lightroom, and the ones you create yourself) to use from right within the Import window. For example, if you knew you wanted to apply the Saturated Contrast Look preset to a group of photos you were about to import, inside the Import window, over in the Apply During Import panel, you'd choose this preset from the Develop Settings pop-up menu (as shown here), and that preset would automatically be applied to each photo as it's imported. There's one more place you can apply these Develop presets, and that's in the Saved Preset popup menu, at the top of the Quick Develop panel, in the Library module (more about the Quick Develop panel on the next page).

TIP: Importing Presets

There are lots of places online where you can download free Develop module presets (like from this book's companion website [see Chapter 14] and from my buddy, Matt Kloskowski's LightroomKillerTips.com). Once you've downloaded some, to get them into Lightroom, go to the Presets panel, then Right-click on User Presets, and choose Import from the pop-up menu. Locate the preset you downloaded and click the Import button, and that preset will now appear in your User Presets list.

Using the Library Module's Ouick **Develop Panel**

There's a version of the Develop module's Basic panel right within the Library module, called the Quick Develop panel, and the idea here is that you'd be able to make some quick, simple edits right there in the Library module, without having to jump over to the Develop module. The problem is, the Quick Develop panel stinks. Okay, it doesn't necessarily stink, it's just hard to use, because there are no sliders—there are buttons you click instead (which makes it frustrating to get just the right amount)—but for just a quick edit, it's okay (you can see I'm biting my tongue here, right?)

Step One:

The Quick Develop panel (shown here) is found in the Library module, under the Histogram panel at the top of the right side Panels area. Although it doesn't have the White Balance Selector tool, it has pretty much the same controls as the Develop module's Basic panel (like Highlights, Shadows, Clarity, etc.; if you don't see all the controls, click on the triangle to the right of the Auto Tone button). Also, if you pressand-hold the Option (PC: Alt) key, the Clarity and Vibrance controls change into the Sharpening and Saturation controls (as seen on the right). Instead of sliders (which give us precise control over our adjustments), the Quick Develop panel uses one-click buttons. If you click a single-arrow button, it moves that control a little. If you click a double-arrow button, it moves it a lot.

Step Two:

There are two situations where I use the Quick Develop panel: (1) Where I can see, with just the thumbnail showing, that I have a photo that needs an adjustment (like some of the photos here that are underexposed), and I want to see if it can easily be fixed, before I invest any time into it in the Develop module. In the Grid view, click on an underexposed photo, then in the Quick Develop panel, click the Exposure double-right-arrow button two times (to increase it 2 full stops; the single arrow just does 1/3 stop per click) to get it closer to being properly exposed. Now you can make a better decision without having to pause your sorting process by jumping over to the Develop module.

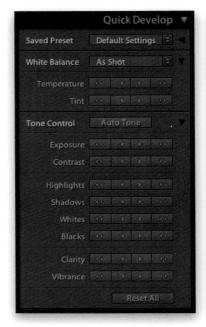

White Balance	☐ Treatment (Color)	Lens Corrections	Spot Removal
Basic Tone Exposure Contrast Highlights Shadows White Clipping Black Clipping Tone Curve	Color Saturation Vibrance Color Adjustments Split Toning Local Adjustments Brush Graduated Filters Radial Filters	Lens Profile Corrections Chromatic Aberration Upright Mode Upright Transforms Transform Lens Vignetting Effects Post-Crop Vignetting Grain	Crop Straighten Angle Aspect Ratio
☐ Sharpening	Noise Reduction Luminance Color	▼ Process Version ☐ Calibration	

The other time I use the Quick Develop panel is (2) when I'm in Compare or Survey view (as shown here), because you can apply Quick Develop edits while in these side-by-side views (just be sure to click on the photo you want to edit first, and make sure Auto Sync is turned off at the bottom of the right side Panels area). For example, these photos have a blue color cast, so while in Survey mode, I clicked on the topright photo. To make it warmer, I had to click the Temperature double-right-arrow button twice. Now that I know the adjustments I need, I could return to Grid view, select all those similar photos, and fix them all at once with just those two clicks. Also, when you're correcting multiple photos using Quick Develop, every image gets the exact same amount of correction (so if you increase the exposure by 2/3 of a stop, all the selected photos go up by $\frac{2}{3}$ of a stop, regardless of what their current exposure is). But, it's not that way when you do the same thing in the Develop module using Auto Sync. There, if you set the exposure of one photo to +0.50, every selected photo's exposure is also set to +0.50.

Step Four:

If you've selected a bunch of photos, but only want certain edits you made applied to them (rather than all your Quick Develop edits), then click the Sync Settings button at the bottom of the right side Panels area. This brings up a dialog (shown here) where you can choose which Quick Develop settings get applied to the rest of the selected photos. Just turn on the checkboxes beside those settings you want applied, and then click the Synchronize button.

TIP: Undo Quick Develop Changes You can undo any individual change in the Quick Develop panel by double-clicking on that control's name.

Using Soft Proofing to Make Your Images Look Good in Print and on the Web

Soft Proofing, for a lot of folks, was the #1 most-wanted feature in Lightroom. Basically, it gives you a preview of how your image will look when it's outside of Lightroom (it was designed to give you a print preview, but there's a web feature there, too). That way, if something's way off (or even just a little off), you can fix it now, while it's still in Lightroom, so it looks as good as possible in print or on the web (I say "as good as possible," because not every rich, vibrant color can be printed on today's printers). Here's how it works:

Step One:

While you might not want to take the time to soft proof every image you print (I sure don't), in a case like this—a photo with really vibrant colors—you should probably take a look and see what's going to happen when you output this to make a print or post on the web. One thing that I think surprises a lot of people at first is that the Soft Proofing feature is in the Develop module, rather than the Print (or Web) module. But, it makes sense when you realize that if you do find a problem, you wouldn't be able to fix it in the Print module—you'd have to jump back to the Develop module, so you may as well start there. To turn on Soft Proofing, just turn on its checkbox in the toolbar below the Preview area (circled here in red) or just press the letter S on your keyboard.

Step Two:

It's pretty easy to tell when you've entered Soft Proofing mode because the gray background surrounding your image changes to Paper White to simulate the color of paper (or a webpage, for that matter). If that bright white gets on your nerves, just Right-click anywhere in that white background area and choose a different background color from the pop-up menu (as shown here. The regular background color is 50% Gray, if you want to change it back). Another way to know that you're in Soft Proofing mode is that the Histogram panel header now says "Soft Proofing" and some proofing options appear below the histogram, as well. Also, in the upper-right corner of your Preview area it says "Proof Preview."

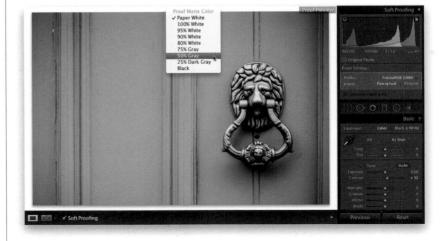

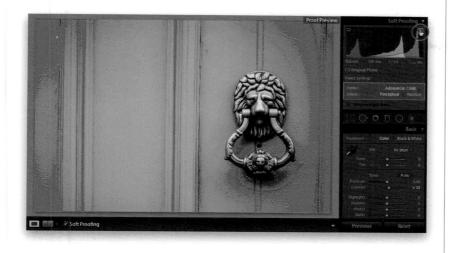

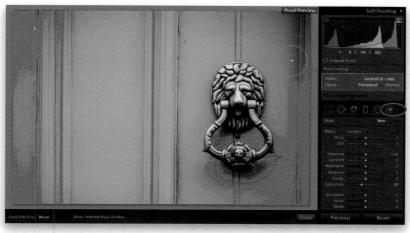

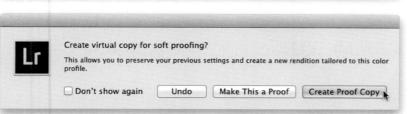

Now that you're in Soft Proofing mode, how do you know if some colors in your image are going to be printable (colors that can't be printed by your printer are technically called "out-of-gamut" colors)? Well, if you look up at the histogram, there are icons in the upper corners. The one on the right looks like a curled page (that's the print gamut warning), and if you click on it, it highlights in red any areas that are too vibrant to be printed by your printer (these are the colors that are out of gamut). Here, you can see a lot of the rich blue colors in the door are outside what my printer can print. You choose your printer profile from the Profile pop-up menu below the histogram or you can choose Adobe RGB (Adobe's recommended color space for printing, which you'd use if you don't have a printer profile installed. See Chapter 13 for more on printer profiles). By the way, the icon in the top left of the histogram (which looks like a monitor) is the web gamut warning, and we'll talk about this a little more in a minute.

Step Four:

Okay, so we see we have a problem here, and we can do one of three things: (1) We can desaturate the entire image by lowering the Vibrance in the Basic panel, but that will make all the colors in the image desaturated (not a good choice). What I'd do instead is (2) use the Adjustment Brush to desaturate just those colors in the door that are out of gamut. So, click on the Adjustment Brush (below the Soft Proofing panel; shown circled here), double-click on the word "Effect" to reset all the sliders to zero, then drag the Saturation slider to the left (I dragged it to -25 here). As soon as you do this, a dialog will appear asking if you want to make a virtual copy (a soft proof) of the image first (I sure would that way the original stays untouched). Now, start painting over the door. If the red out-of-gamut warning goes away as you paint, you've desaturated enough.

Step Five:

Once you've painted over all the main areas and they're back into gamut (colors that will print on your printer), then you need to drag that Saturation slider back to the right as much as possible, so you desaturate the colors no more than necessary. Here, I was able to drag the slider all the way back to just –9 (from –25). If I drag any farther, parts of my door turn red again (you can see a couple of really tiny areas here just starting to turn red—they're not big enough, though, to worry about. If I take it to –7 or –8, then you see more red, so –9 was as far as I could go. But, that's a lot better than desaturating by –25, right?).

TIP: Intent Previews Are Here, Too! You can also see a preview of how your image looks, using different Rendering Intents (see Chapter 13 for more on these). Click on Perceptual or Relative to see a preview of each. Try this with your gamut warning on, and you'll see if one is better than the other when it comes to gamut issues.

Step Six:

Another way to bring colors back into gamut is (3) to use the HSL panel sliders. But, first, while we still have the Adjustment Brush, drag the Saturation slider back to zero (so we have our gamut problem again) and then close the brush (click on its icon). Now, head down to the HSL panel and click on Saturation. The easiest way to do this is to take the TAT (Targeted Adjustment tool; circled here) and, with the gamut warning turned on, click on a red warning area and drag downward. It automatically grabs any Saturation color sliders that represent that area and drags them to the left to desaturate that area (here it moved the Blue slider). Again, you want to desaturate as little as possible, so drag back upward until you start to see red, then drag back down just a tiny bit.

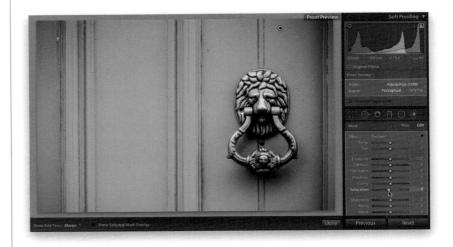

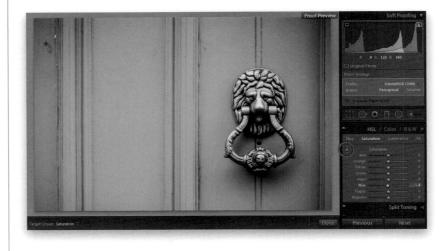

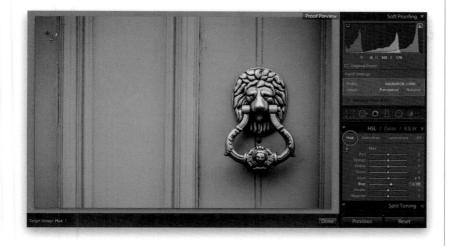

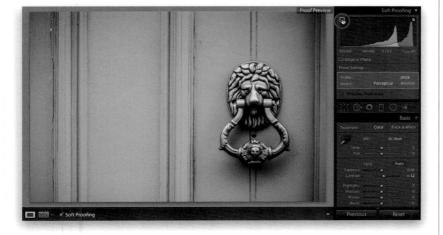

Step Seven:

So, if you're thinking the HSL version of desaturating is pretty much like the Adjustment Brush version, you're right it's just another way of desaturating the colors enough to where they're back in gamut. However, there is an advantage to using the HSL sliders and that's when, instead of desaturating the colors, you're willing to change their hues to colors that are actually in gamut. You do that by clicking on Hue at the top of the HSL panel (shown circled here in red), then get the TAT, put it over a red area (just like before), and drag up until the hue has changed enough that the gamut warning goes away. Now, just realize that you're actually changing the colors a bit (the door looks a bit more purple to me now, even though we didn't move the Purple slider), so if you're willing to be flexible with the color a little bit, you might be able to keep the same amount of saturation in your image.

Step Eight:

Now, if you're sending your image to the web, you'll first need to change your color profile to **sRGB** from the Profile pop-up menu (the default color space for most web browsers). Then, click the web gamut warning icon in the upper-left corner of the histogram (shown circled here) and the areas that aren't likely to appear as vivid or saturated on most regular monitors will appear in blue (if it's still on, click on the print gamut warning icon to turn it off). In our case here, when we switched to sRGB, all the colors were fine—they were within the gamut of what most web browsers and email programs can display, so there was no warning. If an area had turned blue, you would have done the same routine we did when we got our outof-gamut warning for print—we would use the Adjustment Brush (or the TAT in the HSL panel) to slightly desaturate those colors until they fell back into gamut. To see a before/after of your original and soft proof, press Y on your keyboard.

The "Previous" Button (and Why It Rocks!)

You reach for the Previous button when you have a bunch of similar images, but you don't want them all to have the same exact settings—instead you want to edit one of these and apply those changes to just the few out of the group you choose (otherwise, you'd use Auto Sync, right?). This is an incredibly handy feature. In fact, Matt Kloskowski (the guy behind our Lightroom Killer Tips website) called the Develop module's Previous button, "...the most important button in Lightroom," and I gotta tell ya, he may be right on the money!

Step One:

Here's an image I took of my book editor Ted Waitt (you get extra royalties if you work a photo of your editor into one of your books—a true, yet little known, book publishing fact. If you fix the white balance, you get an extra half-point kicker on the back end. I digress). Ted looks pretty blue here (probably depressed because I turned the book in a little late), and the image needs to be cropped in tighter, and we could probably lower the highlights a bit so the sky looks a little darker. Overall, Ted needs some help (that cost me a half-point. It was worth it).

Step Two:

In the Develop module, grab the Crop Overlay tool **(R)** and crop the image so it's tighter on Ted (I'm not losing another point, so I'll just let that one slide by), and then warm up the image a bit by dragging the Temp slider to the right (I dragged it to 7937). We could also open up the shadows a bit (so drag the Shadows slider over to +40) and decrease the highlights in the clouds (drag the Highlights slider to –94). Lastly, increase the Clarity just a little bit to give the overall image some punch (I dragged it to the right to +33).

When you're done with the Crop Overlay tool, click the Done button (on the far right of the toolbar directly below the image you can see it in Step Two), and your crop and changes are applied (as you see here). Let's pause for just a moment to ponder why Ted is standing very stationary in the Nevada desert with a tripod over his shoulder, yet we don't see a camera strap over his shoulder or a camera bag. Hmmmmm. Okay, that's enough pondering. Back to our project.

Step Four:

Go to the Filmstrip and, when you see another photo you want to have those exact same changes (cropping and all), just click on it, then click the Previous button, and (as you see here) it gets the exact same edits and cropping, all in one click. Now, you can scroll to another photo somewhere in the Filmstrip and do the same thing to any single selected photo. Note: If you click on a photo and, once you see it onscreen, you decide not to apply the changes, you'll have to go and click on any one of the photos you've already applied the changes to, so when you click the Previous button, it applies those changes.

Lightroom Killer Tips > >

Get Different Versions of Photos Without Making Virtual Copies

Think of snapshots as another way to have one-click access to multiple versions of your photo. When you're working in the Develop module and see a version of your photo you like, just press Command-N (PC: Ctrl-N) and how your photo looks at that moment is saved to your Snapshots panel (you just have to give it a name). So, that way, you could have a B&W version as a snapshot, one version as a duotone, one version in color, one with an effect, and see any of those in one click, without having to scroll through the History panel to try to figure out where each look is.

▼ Create White Balance Presets for JPEG and TIFF Images

I mentioned in Chapter 4 that with JPEG or TIFF images the only White Balance preset available to you is Auto. However, here's a cool workaround to get you more choices: Open a RAW image and only make one edit—choose the White Balance preset Daylight, Now, save just that change as a preset and name it White Balance Daylight. Then do that for each of the White Balance presets, and save them as presets. When you now open a JPEG or TIFF image, you'll have these one-click White Balance presets you can use to get a similar look.

▼ Updating Your Presets

If you start your editing by using a Develop module User Preset, and you like the new changes, you can update your preset by Right-clicking on the old preset and choosing Update with Current Settings from the pop-up menu.

▼ Getting a Film Grain Look

If you want to simulate the look of film grain, there's a feature that does just that in the Effects panel (to really see the grain, you'll first want to zoom in to a 100% [1:1] view). The higher you drag the Grain Amount, the more grain is added to your photo (I don't generally go over 40 as a maximum, and I usually try to stay between 15 and 30). The Size slider lets you choose how large the grain appears (I think it looks more realistic at a fairly small size) and the Roughness slider lets you vary the consistency of the grain (the farther to the right you drag the Roughness slider, the more it's varied). Lastly, Grain tends to disappear a bit when you make a print, so while the amount may look right onscreen, don't be surprised if it's barely visible in print. So, if your final output is print, you might have to use a little more grain than you think you should.

▼ Fix Underexposed Photos Fast with Match Exposure

If you see a series of photos of the same subject, and some of these photos are underexposed, try this quick trick to fix those fast: Click on a properly exposed

photo from that series, then while it's selected, also select the underexposed photos, then go under the Settings menu and choose Match Total Exposures. It will evaluate the overall exposure from your "most-selected" photo (your properly exposed photo) and use that to fix the underexposed photos.

▼ Copy What You Last Copied

When you click the Copy button in the Develop module (at the bottom of the left side Panels area), it brings up a Copy Settings dialog asking which edits you want to copy. However, if you know you want to copy the same edits as you had

previously (maybe you always copy everything), then you can skip having that Copy Settings dialog pop up completely by pressing-and-holding the Option (PC: Alt) key, then clicking the Copy button (it will change from Copy... to Copy).

▼ Make It Easier to Choose Camera Profiles

To make things easier when choosing your Camera Calibration panel profiles, try this: Set your DSLR to shoot RAW+JPEG Fine, so when you press the shutter button

Lightroom Killer Tips > >

it takes two photos— one in RAW and one in JPEG. When you import these into Lightroom, you'll have the RAW and JPEG photos side-by-side, making it easier to pick the profile for your RAW photo that matches the JPEG your camera produces.

Choosing What Will Be Your Before and After

By default, if you press the \ (backslash) key in the Develop module, it toggles you back and forth between the original untouched image (the Before view) and the photo as it looks now with your edits. However, what if you don't want your Before photo to be the original? For example, let's say you did some Basic panel edits on a portrait, and then you used the Adjustment Brush to do some portrait retouching. Maybe you'd like to see the Before photo showing the Basic panel edits after they were applied, but before you started retouching. To do that, go to the History panel (in the left side Panels area), and scroll down until you find the step right before you started using the Adjustment Brush. Right-click on that history state and choose Copy History Step Settings to Before. That now becomes your new Before photo when you press the \ key. I knowthat's totally cool.

▼ Making Your Current Settings the New Defaults for That Camera

When you open a photo, Lightroom applies a default set of corrections based on the photo's file format and the make and model of the camera used to take the shot (it reads this from the built-in

EXIF data). If you want to use your own custom settings (maybe you think it makes the shadows too black, or the highlights too bright), go ahead and get the settings the way you want them in Lightroom, then press-and-hold the Option (PC: Alt) key and the Reset button at the bottom of the right side Panels area changes into a Set Default button. Click on it and it brings up a dialog showing you the file format or the camera make and model of the current image. When you click Update to Current Settings, from now on, your current settings will be your new starting place for all images taken with that camera, or in that file format. To return to Adobe's default settings for that camera, go back to that same dialog, but this time click on the Restore Adobe Default Settings button.

▼ How the RGB Readouts Change When You Turn on Soft Proofing

In the Develop module, when you move your cursor out over your image, the red, green, and blue (RGB) values of what's under your cursor are displayed directly under the histogram, in the top of the right side Panels area, and they're displayed from 0% (black) to 100% (solid white). However, when you turn on Soft Proofing, these values change to a more traditional printing read scale, which measures 256 shades, ranging from 0 (solid black) to 255 (solid white) depending on which color profile you have selected. A lot of photographers who are into printing and have moved to Lightroom from Photoshop (which has always used the 0-255 readout

scale) are cheering this subtle, but important change.

▼ The Soft Proofing Histogram Updates Live

By default, the histogram shows you the readout of Lightroom's default ProPhoto RGB color space. But, if you want to see how the color profile you've chosen for your soft proofing affects your histogram, you'll be happy to know that once you turn on Soft Proofing, it now not only changes the histogram to display your currently selected printer (or output) profile, but these update live as you choose different color or printer profiles.

▼ Skip the Soft Proofing Copy Question Dialog

When you turn on the Soft Proofing feature, as soon as you start to make any changes to your image, a dialog appears asking if you want to create a virtual proof copy. If you don't, well, you can't tweak anything, so you're pretty much going to have to say "Yes" to creating one. If you want to skip this annoying dialog altogether (since you're going to have to make a proof copy anyway), just click the Create Proof Copy button right below the histogram.

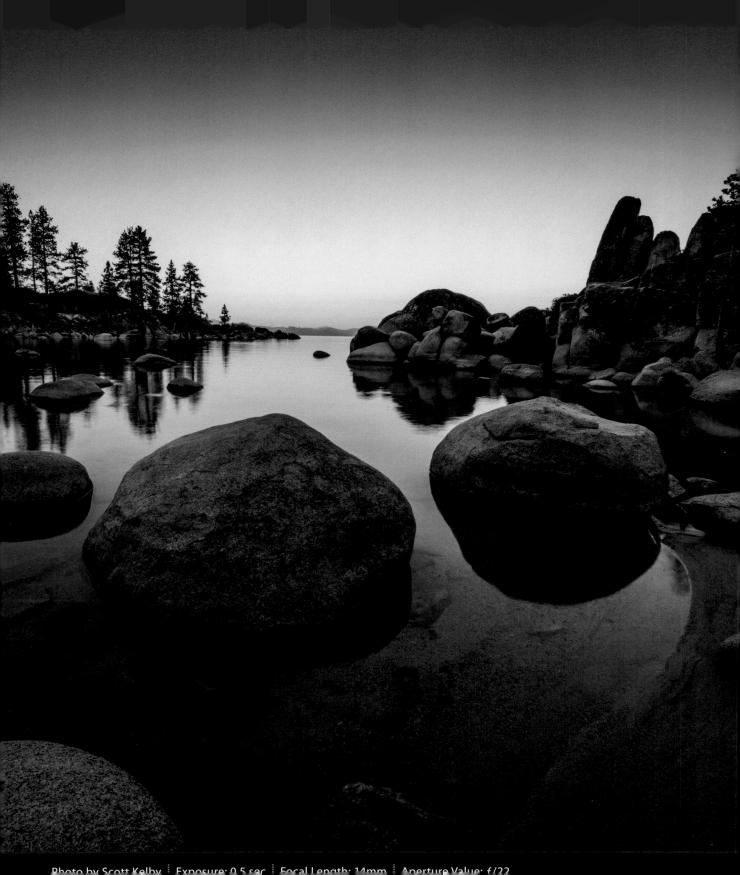

I'll be the first to admit that "Local Adjustments" isn't a great name for a chapter on using the Adjustment Brush (and the other local adjustment tools), but it's an "Adobe-ism" for editing just one section of your image. Here's how they describe it: Everything you do in Lightroom is a global adjustment. It affects your entire image globally. So, if you're affecting just one part of your image, it's not global. It's local. So what you're making is a local adjustment. This would all make perfect sense if anyone in the world actually thought that way, but of course nobody does (not even the engineer who thought up this term). You see, we regular non-software-engineer people refer to adjustments that affect the entire photo as "adjustments that affect the entire photo" and we refer to adjustments that affect just one part as "adjustments that

affect just one part." But, of course, Adobe can't actually name functions with those names, because then we'd clearly understand what they do. Nope, when it comes to stuff like this, it has to go before the official Adobe Council of Obscure Naming Conventions (known internally as ACONC, which is a powerful naming body whose members all wear flowing robes, carry torches, and sing solemn chants with their heads bowed). The ACONC types a simple, understandable phrase into the "Pimp Name Generator" (see page 119), and out comes an overly technical name that their sacred emissary (brother Jeff Schewe) will carry forward into the world (after which there is a great celebration where they sacrifice an intern from the marketing department, and a temp from accounting). And that's how I met your mother.

Dodging, Burning, and Adjusting Individual Areas of Your Photo

Everything we've done in the Develop module so far affected the entire image. For example, if you drag the Temp slider, it changes the white balance for the entire image (Adobe calls this a "global adjustment"). But what if you want to adjust one particular area (a "local" adjustment)? You'd use the Adjustment Brush, which lets you paint changes just where you want them, so you can do things like dodging and burning (lightening and darkening different parts of your photo), but Adobe added more to this than just lightening and darkening. Here's how it works:

Step One:

In the Develop module, in the toolbox right above the Basic panel, click on the Adjustment Brush icon (shown circled here), or just press the letter **K** on your keyboard. An options panel will pop down below the toolbox with all the controls for using the Adjustment Brush (as seen here). Take a look in this panel and you'll see that you can paint using nearly all the same controls you have in the Basic panel. One notable exception, though, is Vibrance. (Rats!) But, at least we have other cool stuff, like noise reduction and moiré removal, so it kinda makes up for not having Vibrance. Kinda.

Step Two:

With the Adjustment Brush, you choose which effect you want to paint with by dragging a slider, and then you just start painting on your photo. You can also choose an effect from the Effect pop-up menu (as seen here). The advantage of choosing from this menu is that when you choose an effect here, it increases the amount of that particular effect, and then it resets all the other sliders to zero, so you're not accidentally painting with some settings you used earlier. Plus, Adobe put some other presets at the bottom of this menu for specific tasks, like softening skin, whitening teeth, and so on.

TIP: Slider Reset Shortcut

The quickest way to reset all your sliders to zero is to double-click directly on the word "Effect" near the top-left corner of the panel.

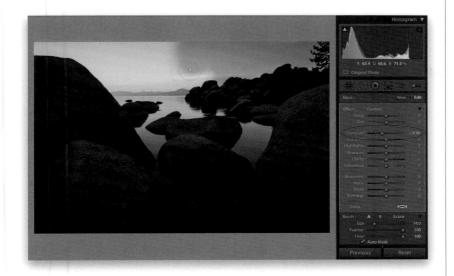

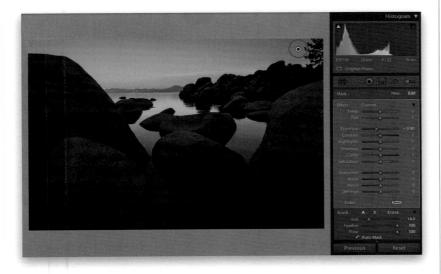

Now, this is going to sound weird at first, but this is how the Adjustment Brush works: (1) you pick a starting amount (literally, just a blind guess at how much you might want of a particular effect), then (2) you paint over the area you want to adjust, and then (3) you go back to the slider and tweak the amount for the area you painted over until it looks right. So, I guess the good part is you get to make your final decision after you've painted over the area, so you can get it right on the money. For example, here we want to darken the sky a bit, so (1) drag the Exposure slider over to the left a little (take a look at the gradient behind each slider to know which way to drag; I want the sky darker, so I'll drag over to the left). Then, (2) paint over the sky and, as you do, it darkens that area. If it looks too dark or not dark enough, it really doesn't matter at this point, because once you're done painting over the sky, you'll (3) tweak the Exposure amount until it's just right.

Step Four:

Now, you see that little black dot that appears on your image? (If you don't see it, make sure Auto, Always, or Selected appears after Show Edit Pins beneath the bottom left of the Preview area.) That's called an "Edit Pin" and it represents the change you just made to the sky. Each time you make an entirely new edit with the Adjustment Brush, it leaves a pin where you started painting. So, for instance, if you paint a different effect on the water (let's say you painted with Saturation to make the water more colorful), it would add a second pin that represents the changes you just made to the water. If you look at the photo and decide you want to go back and adjust the sky again, you'd just click directly on the sky adjustment's pin to make that adjustment active, and now you can tweak it. Want to go back to the water adjustment now? Click on that pin and tweak away.

Step Five:

Let's go ahead and paint over that water in the foreground (in front of the rock in the center) with Clarity to give it a little more depth. However, you can't just increase the Clarity amount and start painting that will just add Clarity to your sky, because the sky's pin is selected. So, before you paint a different area with different settings, you need to click the New button near the top-right corner of the panel (before I did this, though, I bumped up the Contrast amount in the sky a bit). Then, choose Clarity from the Effect pop-up menu (this resets all the other sliders to zero) and it'll increase the Clarity amount to 50 (just so you have a starting place), but we'll probably want to crank that up a bit more (here, I dragged it over to +65). Now, paint over the water.

TIP: Deleting Edit Pins
To delete an Edit Pin, click on it then press
the Delete (PC: Backspace) key.

Step Six:

Okay, we're able to make the floor of the lake up front a little more visible by painting Clarity over it, but here's where things get interesting: you can add more than one effect to that area you just painted. By dragging any one of the other sliders, it stacks other effects on that same area you just painted. So, let's increase the Exposure amount a bit to lighten it up (drag the slider to the right), and drag the Shadows slider to the right, until the sandy floor looks good (as seen here). Now you've applied multiple adjustments to the same area. Of course, you could continue adding effects to this one area—anything from Sharpness to White Balance—but before we totally trash this water, let's move on to a different area.

TIP: Working with Edit Pins
If you see a pin filled with black, it's currently active (gray pins are inactive). So, if you move any sliders, it will affect the area you painted with that currently active pin.

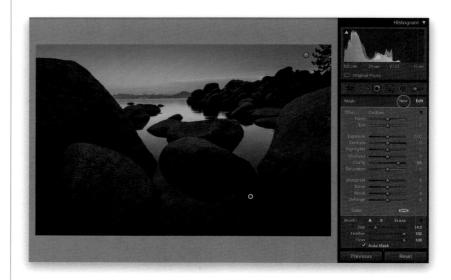

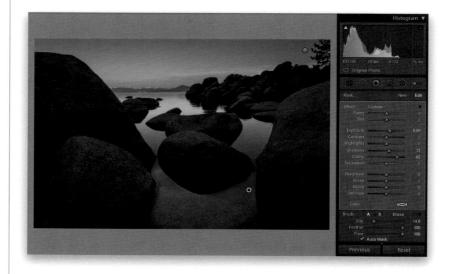

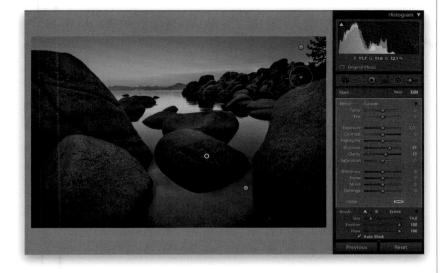

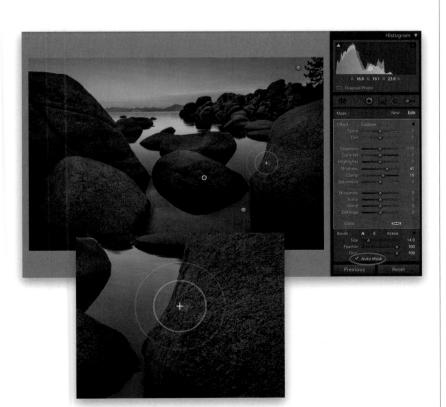

Step Seven:

Click the New button again, so we can work on a different area without disturbing the areas we've already worked on. Let's open up the shadows and add some clarity to the rocks, so choose **Shadows** from the Effect pop-up menu, and then paint over the rocks (be sure to paint over them on both sides of the photo). Now, increase the Shadows amount to 45 and drag the Clarity slider over to the right a bit, too (here, I increased it to 19).

TIP: Changing Brush Sizes
To change your brush size, you can
use the **Left and Right Bracket keys**(they're to the right of the letter P on
your keyboard). Pressing the Left Bracket
key makes your brush smaller; the Right
Bracket key makes it bigger.

Step Eight:

If you're worried about adding Clarity and opening up the shadows in the water, too, you really don't have to worry about it that much thanks to the Auto Mask feature (found near the bottom of the panel). It kind of senses where the edges of things are and it keeps you from accidentally painting where you don't want to paint. It's off by default, but I usually turn it on and leave it that way almost all the time, because it does a really amazing job. The trick to it is knowing how it works: You see that little + (plus sign) in the center of the brush (shown in the overlay here)? That's what determines what's getting painted, and any area that + travels over gets painted, so as long as that + doesn't go over the water, it won't paint it—even if the round outer rim of the brush extends way over onto the water (as shown here). Remember, if the + strays over the water, it figures it's okay to paint over it, so as long as you keep that off the water, it leaves that area alone.

Step Nine:

So, how do you know if you've actually painted over an entire area? How do you know whether you've missed a spot? In the toolbar at the bottom of the Preview area (if you don't see the toolbar, press the **T key**), you'll find a checkbox for Show Selected Mask Overlay. Turn that on and it shows a red mask over the area you painted (as seen here. You can toggle this on/off by pressing the letter **O**). This is incredibly handy for making sure you didn't miss any areas. If you did miss an area, just paint over it. If you painted outside of where you wanted, press-andhold the Option (PC: Alt) key and paint over that area to remove it (the red mask will go away where you paint). If you just want a guick look at the mask, move your cursor directly over a pin and it shows the mask overlay for that adjustment.

TIP: When to Turn Auto Mask Off When painting a large background area (like the sky), if you turn Auto Mask off temporarily (press the **A key** to toggle it on/off), the brush moves faster when it's not detecting edges as it goes.

Step 10:

There are brush options at the bottom of the panel. The Size slider changes the brush size (but it's faster to use the Bracket key shortcuts mentioned earlier). The Feather slider controls how soft the brush edges are—the higher the number, the softer the brush (I paint with a soft brush about 90% of the time). For a hard-edged brush, lower the Feather slider to 0. The Flow slider controls the amount of paint that comes out of the brush (I usually leave the Flow set at 100). Also, you get two custom brush settings—Brush A and Brush B—so you could set one up to be a large, soft-edged brush (shown at the top), and the other to be a small, hard-edged brush (shown at the bottom). Click on the letter, choose your settings, and it remembers them, so next time you can just click on the letter.

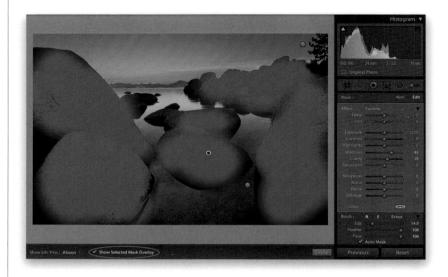

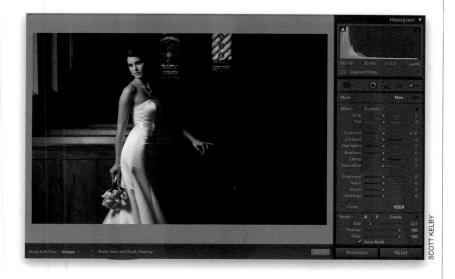

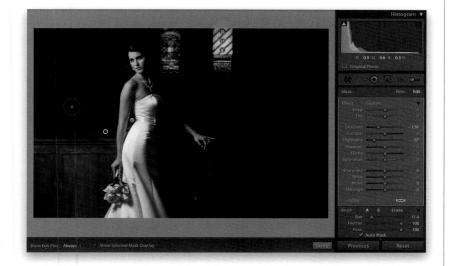

Step 11:

Let's switch gears and look at a different type of image to see how you'd use the Adjustment Brush for traditional dodging and burning (darkening and lightening individual areas). In this shot, I let some of the light from the flash spill over onto the pews and wall on the left, and that spillover just shouldn't be there (totally my fault). Luckily, we can use the Adjustment Brush to darken (burn) those areas, so you don't see that spill. First, let's set all the sliders to zero by double-clicking on the word "Effect" in the top-left corner of the Adjustment Brush panel.

TIP: Interactive Adjustments

You can make onscreen interactive adjustments with the Adjustment Brush, kind of like you do with the Targeted Adjustment tool (see Chapter 4). Just move your cursor directly over any Edit Pin and your cursor changes into a two-headed arrow. Clickand-drag left or right to make changes, and it drags the sliders for you. The advantage is: if you used multiple sliders (like we'll do here), it moves them all at once.

Step 12:

Now, lower the Exposure and Highlights amounts (the light I want to pull back is mostly highlights) and paint over those pews and the wall on the left to darken (burn) those areas (as seen here). Unfortunately, they look a little "gray" now, so move your Temp slider toward yellow and Tint slider toward magenta. Now the light is on the bride where it should be (I left a little light on the front of the pew, so you have a visual reference of where she is). Click the New button, shrink your brush size, and paint below her arm to darken the pews right behind her. Click New again, reset all the sliders to zero once again, and this time increase the Exposure amount a little bit and paint over the stained glass windows in the back to brighten (dodge) them. You can see a before/after, along with our original image, on the next page.

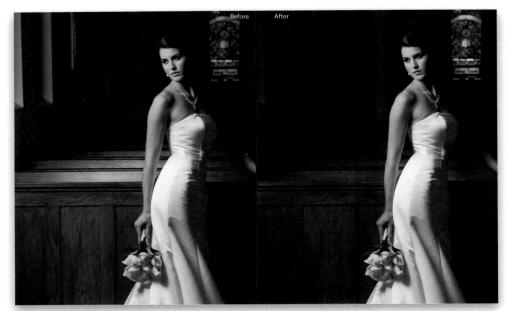

Here's a before/after of our bride shot, and you can see on the right how we've been able to burn away the spill of light from the flash, and increase the brightness of the stained glass windows

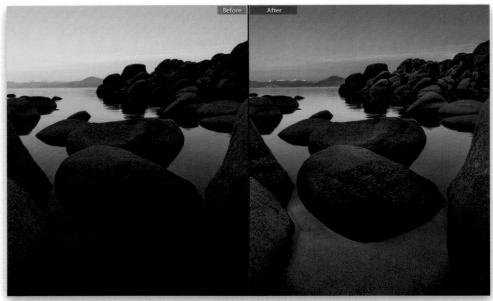

Here's a before/after of our landscape shot, and you can see how we've darkened (burned) the sky, and brightened and added more detail to the water in front and the rocks

There are a few other things you need to know that will help you get more comfortable with the Adjustment Brush, and once you learn these (along with the rest of the stuff in this chapter), you'll find yourself making fewer trips over to Photoshop, because you can do so much right here in Lightroom.

Five More Things You Should Know About Lightroom's Adjustment Brush

#1: You have a choice of how Lightroom displays the Edit Pins, and you make that choice from the Show Edit Pins pop-up menu down in the toolbar beneath the Preview area (as shown here). Choosing Auto means when you move your cursor outside the image area, the pins are hidden. Always means they're always visible and Never means you never see them. Selected means you only see the currently active pin.

#2: To see your image without the edits you've made with the Adjustment Brush, click the little switch on the bottom left of the panel (circled below in red).

#3: If you press the letter **O**, the red mask overlay stays onscreen, so you can easily see, and fix, areas you've missed.

#4: If you click on the little down-facing triangle to the far right of the Effect popup menu, it hides the Effect sliders, and instead gives you an Amount slider (as shown here) that provides a single, overall control over all the changes you make to the currently active Edit Pin.

#5: Below the Auto Mask checkbox is the Density slider, which kind of simulates the way Photoshop's Airbrush feature works, but honestly, the effect is so subtle when painting on a mask, that I don't ever change it from its default setting of 100.

Selectively Fixing White Balance, Dark Shadows, and Noise Issues

Fixing problems that only appear in certain parts of your image is where the Adjustment Brush comes up big, because you can paint away the problems in these areas. Things like white balance problems, when, for example, part of your image is in daylight and part is in the shade. Or painting away noise that just appears in the shadow areas, leaving the rest of the photo untouched (and saving it from the blurring that comes with noise reduction). Incredibly handy.

Step One:

Let's start with painting white balance. Take a look at the image here, where the bride is inside a limo, so while her face is lit with natural light coming in through the window, her veil is in the shade, and that's causing it to have a blue tint (as seen here). You can try warming up the overall white balance to see if that helps, like I did here, where I went to the Basic panel and dragged the Temp slider over to the right a bit. It helped the overall photo, but as you can see, the veil is still tinted blue (and most brides won't be happy with a blue veil). This is where the ability to paint white balance in just certain areas is incredibly helpful.

Step Two:

Click on the Adjustment Brush in the toolbox near the top of the right side Panels area (or just press the letter K), and doubleclick directly on the word "Effect" to reset all the sliders to zero. Then, drag the Temp slider over to the right quite a bit and start painting over her veil. As you do, the yellow white balance you're painting neutralizes the blue in her veil, and you wind up with a white veil (as seen here). Once you paint over that area, go back to the Temp slider and tweak the amount until the veil looks nice and white (here, that was +37). In this case, I also increased the Exposure amount just a little bit to make it look even whiter and brighter.

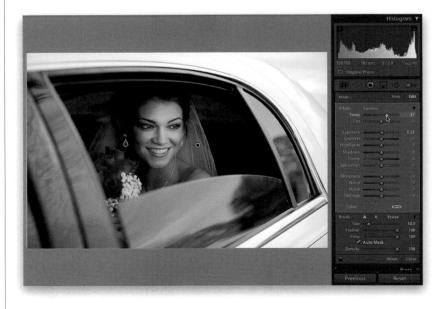

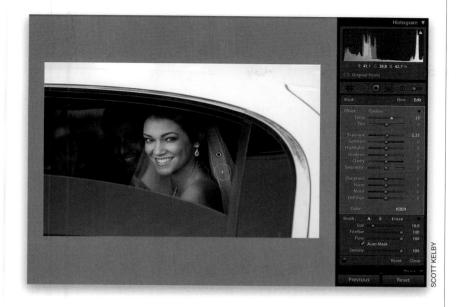

Another thing you can do is paint to open up the shadow areas using the Shadows slider. Here's another shot with the bride and groom in the limo, but the groom is kind of lost in the shadows, so we want to open up that area to make him more visible. But, before we do that, you can see the blue veil problem exists here, too, so go ahead and fix that first (using the same technique you just learned). Here, I've just started painting white balance over her veil on the right side (but, of course, make sure you paint over both sides—you'll see the veil looking better in the next step). Now, on to the groom. Click the New button at the top of the panel, and then double-click on the word "Effect" to reset all the sliders to zero.

Step Four:

Drag the Shadows slider to the right a bit and then start painting over the groom to bring him out of the shadows (don't forget to paint over his hand, too). Of course, don't make him as bright as the bride. The downside of opening up shadow areas like we just did pretty much comes down to one thing: noise. If there's noise in a photo, it lives in the shadows, and a lot of the time, since it's so dark, you really can't see it. However, when you brighten up those shadow areas like we did here, any noise that was there starts to become really obvious. If that happens to you, then just drag the Noise slider to the right and it suppresses the noise just in those shadow areas you painted over. Of course, you don't have to open the shadows up to use the Noise slider here. It's just that, in this case, since we created the noise problem, at least now we can reduce it. Plus, since the shadow areas are already painted in for us, the noise reduction just appears in those areas.

Getting Creative Effects Using the Adjustment Brush

Now that we know how the Adjustment Brush works, we can use it for more than just dodging and burning or fixing selected parts of our images—we can use it for creative effects. We'll start with a technique that is very popular in wedding photo albums, and that is the classic "bride's in black and white, but her bouquet stays in color" effect (which, as lame as it may sound, clients absolutely love).

Step One:

In the Develop module, start by clicking on the Adjustment Brush in the toolbox near the top of the right side Panels area, then from the Effect pop-up menu, choose Saturation, set the Saturation slider to -100 (as seen here), and begin painting over the areas you want to be black and white (here, we're painting over everything but the bouquet). This is one instance (painting over a large background area with different colors) where I recommend turning the Auto Mask checkbox off (at the bottom of the Brush section). Otherwise, it will try to detect changes in color and that not only slows down the brush quite a bit, it can leave little gaps, as well.

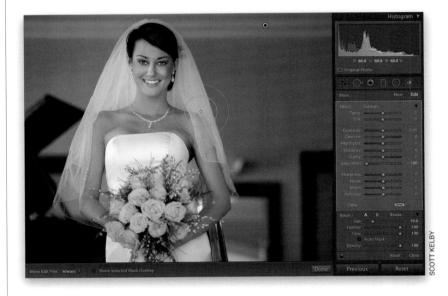

Step Two:

So, paint over the entire image (except for the bouquet), but when you do get close to the bouquet, that's when I'd do two things: (1) lower the size of your brush (you can use the Size slider in the Brush section or the **Bracket keys** on your keyboard), and (2) turn the Auto Mask checkbox back on. That way, it will try to keep your brush from painting on the flowers, because their colors will be much different than the white dress color and fleshtone colors you'll be painting over. The final effect is shown here, but on the next page, we'll try another effect.

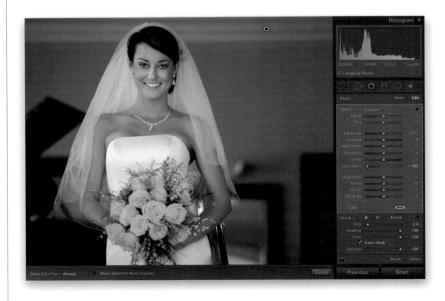

Click the Reset button in the bottom-right corner of the right side Panels area to reset the photo to its original full-color look. Now, let's use the Adjustment Brush to create a soft spotlight effect. Choose **Exposure** from the Effect pop-up menu, then drag the Exposure slider to the left to –2.08. Turn off the Auto Mask checkbox, and then paint over the entire image, which darkens the overall exposure (as seen here).

Step Four:

Now, press-and-hold the **Option (PC: Alt) key** to switch to the Erase tool. Increase the size of the brush big time (make the brush really huge), make sure the Feather and Flow amounts are both set to 100 (as seen here), and then paint over just the area of the photo where you want the spotlight to appear. Here, we're just going to paint over the bride's head, the top of her shoulders, and most of the bouquet to create our spotlight effect.

Retouching Portraits

When it comes to detailed retouching, I generally jump over to Adobe Photoshop, but if you just need to do a quick retouch, it's amazing how many things you can do right here in Lightroom using the Adjustment Brush and the Spot Removal tool, with its new healing power. Here's a quick retouch using just those two tools:

Step One:

Here's the image we're going to retouch, and here are the things we're going to do: (1) remove any major blemishes and wrinkles, (2) soften her skin, (3) brighten the whites of her eyes, (4) add contrast to her eyes and sharpen them, and (5) do some dodging and burning to sculpt her face. Although we're seeing the full image here, for retouching, it's best to zoom in quite a bit. So, in the next step, go ahead and zoom in nice and tight to start our retouch. (*Note:* Because this model is quite fair, I'm decreasing the Blacks here, so we can see what we're working with a bit better.)

Step Two:

Here, I've zoomed in to a 1:1 view, so we can really see what we're doing (just click on 1:1 at the top right of the Navigator panel, at the top of the left side Panels area). Click on the Spot Removal tool (in the toolbox near the top of the right side Panels area or just press the letter Q). This tool works with just a single click, but you don't want to retouch any more than is necessary, so make the brush Size of the Spot Removal tool just a little bit larger than the blemish you're going to remove. Move your brush cursor over the blemish and then just click once. A second circle will appear showing you from where it sampled a clean skin texture. Of course, it's not always 100% right, and if for some reason it chose a bad area of skin to sample from, just click on that second circle, drag it to a clean patch, and it will update your blemish removal. Go ahead and remove any blemishes now using this tool (as shown here).

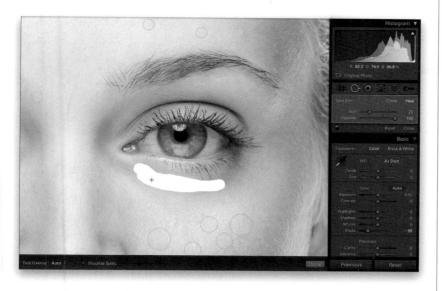

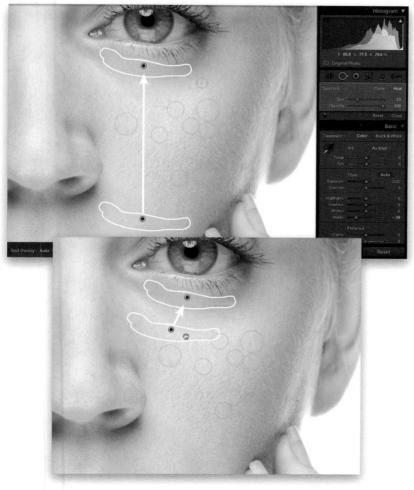

Now, let's try something we couldn't have done before Lightroom 5—remove wrinkles. Zoom in tighter (this is a 2:1 view), then take the same Spot Removal tool we've been using (make sure it's set to Heal) and paint a stroke over the wrinkles under her eye on the right (as shown here). The area you've painted over turns white (as seen here), so you can see the area you're affecting.

Step Four:

Lightroom analyzes the area and picks a spot somewhere else in the image to use to repair those wrinkles. It usually picks something nearby, but in this case it chose an area down below her nose (in fact, I had to scroll down just to see where it sampled from, as seen here). It actually did a pretty decent job, but the direction and texture of skin on a person's face varies quite a bit as you move around the face, and I'd prefer to have the sampled area be closer to her eye. Luckily, if you don't like where Lightroom chose to sample from, you can simply have it sample somewhere else by clicking on that second outline (the thinner one of the two) and dragging it somewhere on her face where you think the texture and tone will match better (here, I moved it right up under the original area where the wrinkles used to be, as shown in the overlay). Also, don't forget to remove the wrinkles from beneath the other eye (it's easier to forget than you'd think). By the way, while you're here, take this same tool and paint away any stray eyebrow hair, and then zoom in tighter (3:1), make your brush size really, really small, and get rid of those red eye veins, as well. Note: If your subject is at an age where fully removing the wrinkles would be unrealistic, we would instead need to "reduce" the wrinkles, so we would decrease the Opacity slider to lower the strength of the removal, bringing back some of the original wrinkles.

Step Five:

Now that the blemishes and wrinkles are removed, let's do some skin softening. Switch to the Adjustment Brush (also in the toolbox near the top of the right side Panels area, or just press the letter **K**), then choose **Soften Skin** from the Effect pop-up menu. Now paint over her face, but be careful to avoid any areas that you don't want softened, like her eyelashes, eyebrows, lips, nostrils, hair, the edges of her face, and so on. This softens the skin by giving you a negative Clarity setting (it's set at –100). Here, I've only painted over the right side of her face, so you can see the difference.

Step Six:

Next, let's work on her eyes, and we'll start by making the whites brighter. First, click the New button in the top right of the panel (so we're telling Lightroom to keep what we've already painted, but now we're going to paint on a new area), then double-click on the word "Effect" to reset all the sliders to zero. Now, drag the Exposure slider to the right a little bit (here, I dragged it over to +0.40) and paint over the whites of her eyes. If you accidentally paint outside the whites, just press-andhold the Option (PC: Alt) key to switch to the Erase tool and erase away any spillover. You can also paint a little over her irises to brighten them, as well. When you're done, adjust the Exposure slider, as needed, to where the whitening looks natural. Once again, click the New button, and then double-click on the word "Effect" to reset all the sliders to zero. Increase the Contrast amount to +72 and then paint over both irises and pupils to add more contrast. Also, increase the Sharpness amount a little bit (I dragged it to +13).

TIP: Keep from Seeing Too Many Pins
To see just the currently selected Edit Pin,
choose **Selected** from the Show Edit Pins
pop-up menu in the Preview area toolbar.

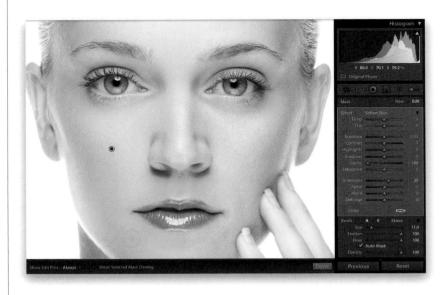

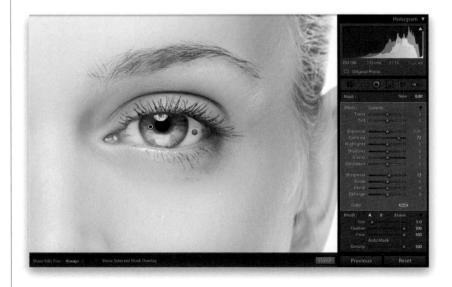

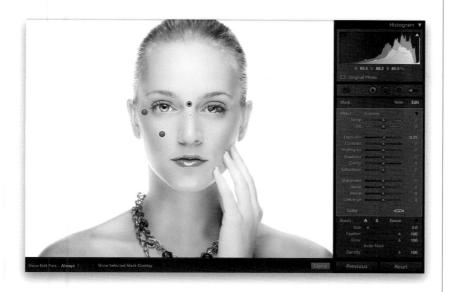

Step Seven:

Now, click the New button once again, and let's do some dodging and burning to sculpt her face. Start by resetting your sliders to zero, then drag the Exposure slider to the left a little bit (I dragged mine to -0.25), and then paint over areas that recede on her face—the shadow areas (like her cheekbones, the sides of her nose, the area right under her lip, the ridgeline of her hair, etc.). Then, click the New button one last time, increase the Exposure slider to around +0.25, and paint over the areas that protrude from her face (for example, paint a highlight down the bridge of her nose, then on the front of her chin, and on the frontmost areas of her cheeks). Basically, you're making the highlights on her face brighter and the shadow areas darker. A before/after is shown below.

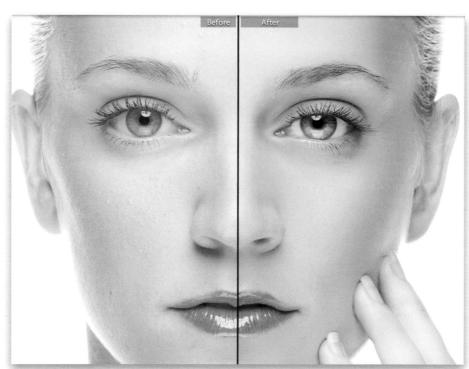

The After photo has clearer and smoother skin, the eyes are brighter and have more contrast, the eyebrows are trimmed, and dodging and burning has nicely sculpted her face

Fixing Skies (and Other Stuff) with a Gradient Filter

The Graduated Filter (which is actually a tool) lets you recreate the look of a traditional neutral density gradient filter (these are glass or plastic filters that are dark on the top and then graduate down to fully transparent). They're popular with landscape photographers because you're either going to get a perfectly exposed foreground or a perfectly exposed sky, but not both. However, the way Adobe implemented this feature, you can use it for much more than just neutral density gradient filter effects (though that probably will still be its number one use).

Step One:

Start by clicking on the Graduated Filter tool in the toolbox (it's the second icon to the left of the Adjustment Brush, or press M), near the top of the right side Panels area. When you click on it, a set of options pops down that are similar to the effects options of the Adjustment Brush (shown here). Here, we're going to replicate the look of a traditional neutral density gradient filter and darken the sky. Start by choosing **Exposure** from the Effect pop-up menu and then drag the Exposure slider to the left to -1.22 (as shown here). Just like with the Adjustment Brush, at this point we're just kind of guessing how dark we're going to want our gradient, but we can darken or lighten it later.

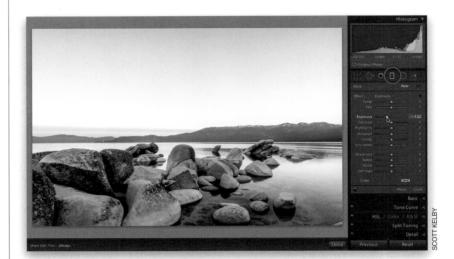

Step Two:

Press-and-hold the Shift key, click on the top center of your image, and drag straight down until you reach the middle of the photo (the horizon line. You can see the darkening effect it has on the sky, and the photo already looks more balanced). You might need to stop dragging the gradient before it reaches the horizon line, if it starts to darken your properly exposed foreground. By the way, the reason we held the Shift key down was to keep our gradient straight as we dragged. Not holding the Shift key down will let you drag the gradient in any direction.

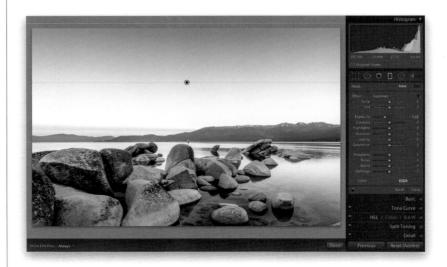

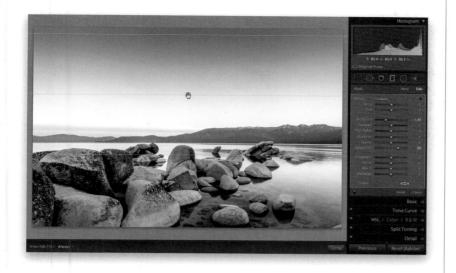

The Edit Pin shows where the center of your gradient is, and here, I think the darkening of the sky stopped a little short. Luckily, you can reposition your gradient after the fact—just click-anddrag that pin downward to move the whole gradient down (as shown here). Now, we can add other effects to that same area. For example, increase the Saturation to 50 (to make it more punchy), then decrease the Exposure to -1.44 (a before and after is shown below). Also, if you have a gray sky, you can add some blue by clicking on the Color swatch at the bottom of the panel and choosing a blue tint. Note: You can have more than one gradient (click the New button), and to delete a gradient, click on its pin and press the Delete (PC: Backspace) key.

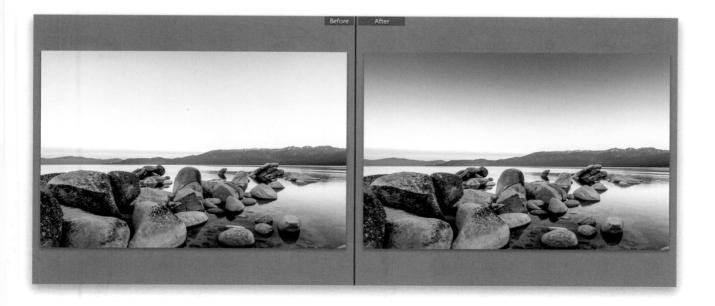

Custom Vignettes & Spotlight Effects Using the Radial Filter

Vignettes (where you darken the outside edges all the way around your image) have become very popular in the past couple of years. Normally, we would apply them using the Effects panel, and it works great—as long as your subject is right in the middle of the frame (which, hopefully, isn't always the case). Now, not only can you create vignettes in any location within your image, but you can do more than just darken, and you can have more than one vignette, so you can also use it to re-light your image after the fact.

Step One:

The viewer's eye is drawn to the brightest part of the image first, but unfortunately, in this shot (taken outside in natural light) the lighting is fairly even, so we're going to use the Radial Filter tool to "re-light the scene" and focus the viewer's attention on our bride. So, click on the Radial Filter tool in the toolbox near the top of the right side Panels area (it's shown circled here in red; or press **Shift-M**). This tool creates an oval or a circle and you get to decide what happens inside or outside this shape.

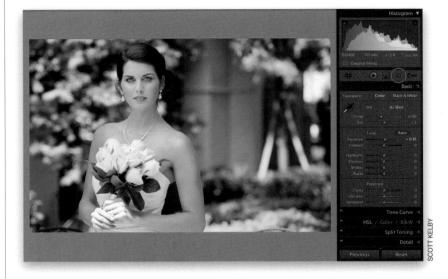

Step Two:

Click-and-drag out the tool in the direction you want your oval (or circular) pool of light to appear (here, I dragged it out over the bride). If it's not in the exact spot you want it, just click inside the oval and drag it wherever you want, just like I'm doing here (you can see my cursor has changed to the grabber hand cursor as soon as I started to drag the oval). Note: If you need to create a circle using the Radial Filter tool, pressand-hold the Shift key and it constrains the shape to a circle. Also, if you press-and-hold the Command (PC: Ctrl) key and doubleclick anywhere in your image, it creates an oval as large as it possibly can (you'd use this when you want to create one that affects nearly the entire image).

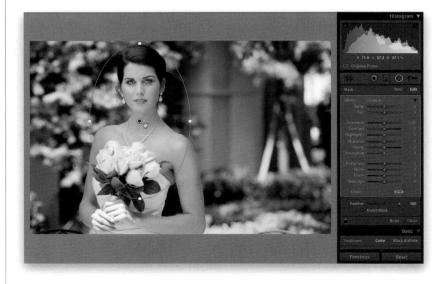

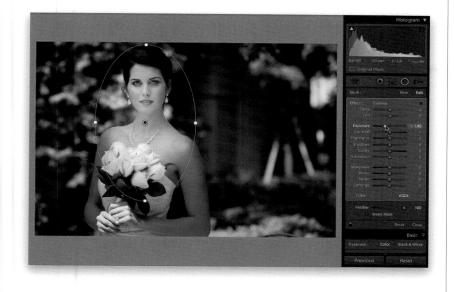

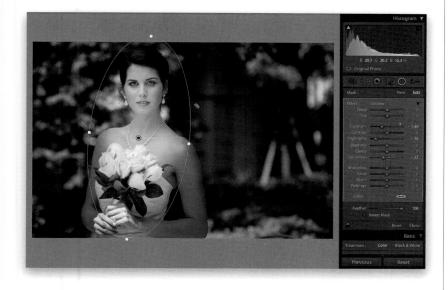

Here, we want to focus the attention on the bride, so we're going to make the area around her much darker. Drag the Exposure slider over to the left (as shown here, where I dragged it to -1.40), and you can see it darkens the entire area outside the oval (the area inside the oval stays the same as it was, and what's nice about this is that it kind of creates a spotlight effect on our bride). The transition between the brighter area and the darker area is nice and smooth because the edges of the oval have been feathered (softened), by default, to create that smooth transition (the Feather amount is set to 100. If you want a harder or more abrupt transition, just lower the amount using the Feather slider at the bottom of the panel).

TIP: Removing Ovals

If you want to remove an oval you've created, click on it and then just hit the Delete (PC: Backspace) key.

Step Four:

Once your oval is in place, you can rotate it by moving your cursor just outside the oval (as seen here, where my cursor is just outside the right side of the oval, just above its center, and I'm rotating it a little to the right. The area where you can rotate is really small, so make sure you stay pretty darn close to the edges of the oval, and make sure you have the double-headed arrow cursor before you start dragging to rotate or it will create another oval. If that happens, just press Command-Z [PC: Ctrl-Z] to remove that extra oval). To resize the oval, just grab any one of the four little handles on the oval and drag out or in (here, I dragged it out to cover more of our bride). The nice thing about this filter is that you can do more than just adjust the exposure. Here, let's also decrease the Highlights to -76 and the Saturation to -22.

Step Five:

Now, let's create another oval—this time to help hide that bright area over on the right side. Just move your Radial Filter tool over there and click-and-drag out an oval about the size you see here. By default, it's going to affect what's outside the oval, but you can switch it to have the sliders control what happens inside the oval instead. You do that by turning on the Invert Mask checkbox at the bottom of the panel (shown circled here in red). Now, when you move the sliders, it affects what's inside the oval and the area outside it remains unchanged.

TIP: Swapping to the Inside/Outside Pressing the '(apostrophe) key turns the Invert Mask checkbox on/off, swapping the effect to the inside/outside.

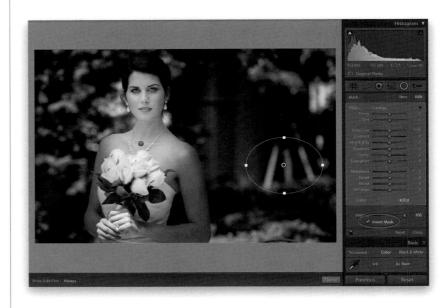

Step Six:

Drag the Exposure slider over to the left a bit (here, I dragged it to -1.43), until that area inside the oval gets dark enough to make it kind of blend in (instead of sticking out and drawing our eyes over there). Again, if you need to move the oval, just click inside it and drag, and if you need to rotate it, just click-and-drag in a circular motion right outside the oval. If you look at our bride now, you'll see a gray pin in the center of her necklace—that's an Edit Pin showing the first oval we placed there (the one that darkened the background). If you want to make any adjustments to that oval, just click on that gray pin and it becomes the active one.

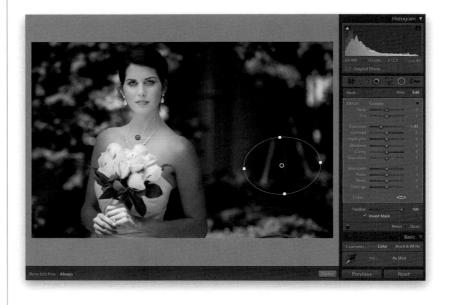

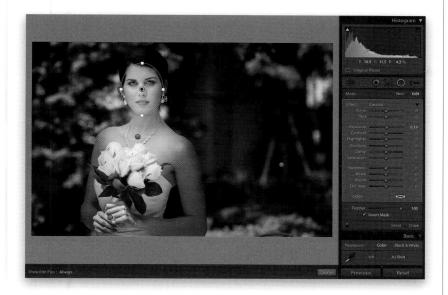

Step Seven:

You can also add an oval inside another oval. Since, here, we want one that's inverted (so the center of the oval gets affected), let's drag a copy of the one we just made. Press-and-hold Command-Option (PC: Ctrl-Alt), and then just clickand-drag on the center of the second oval you created and a third oval appears (it's a duplicate of your second one). Place this one right over her face (as shown here), shrink the size way down, and rotate it back up straight. Now, to make her face just a little bit brighter, drag the Exposure slider a little bit to the right (here, I dragged to 0.19) and it just affects her face. Next, press Command-Option once again, this time on this third oval, and then move this new one down over her hands (which are getting direct sunlight). For this one, drag the Highlights slider to the left to around -76, drag the Contrast down to -82, and then drag the Exposure slider down to -0.56 to darken that area a bit. A before/after is shown below.

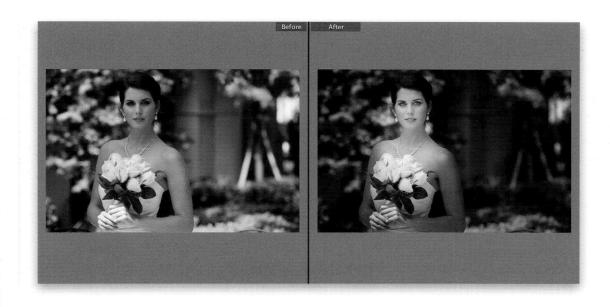

Lightroom Killer Tips > >

▼ Hiding Your Pins

You can hide the Adjustment Brush, Radial Filter, and Graduated Filter pins anytime by pressing the letter H on your keyboard. To bring them back, press Hagain.

▼ Shortcut for Adding New Edits When you're making a local adjustment, if you want to quickly add a new pin (without going back to the panel to click on the New button), just press the Return (PC: Enter) key on your keyboard.

▼ Shrinking the Brush Options

Once you've set up your A/B brushes, you can hide the rest of the brush options by clicking on the little downward-facing triangle to the right of the Erase button.

▼ Scroll Wheel Trick

If you have a mouse with a scroll wheel, you can use the scroll wheel to change the Size amount of your brush.

▼ Controlling Flow

The numbers 1 through 0 on your keyboard control the amount of brush Flow (3 for 30%, 4 for 40%, and so on).

The Erase Button

The Erase button (in the Brush section), doesn't erase your image, it just changes your brush, so if you paint with it selected, it erases your mask instead of painting one.

▼ Choosing Tint Colors

If you want to paint with a color that appears in your current photo, first choose Color as your Effect, then click on the Color swatch, and when the color picker appears, click-and-hold the eyedropper cursor and move out over your photo. As you do, any color you move over in your photo is targeted in your color picker. When you find a color you like, just release the mouse button.

To save this color as a color swatch. just Right-click on one of the existing swatches and choose Set this Swatch to Current Color.

▼ Seeing/Hiding the Adjustment Mask

By default, if you put your cursor over a pin, it shows the mask, but if you'd prefer to have it stay on while you're painting (especially handy when you're filling in spots you've missed), you can toggle the mask visibility on/off by pressing the letter O on your keyboard.

▼ Changing the Color of Your Mask

When your mask is visible (you've got your cursor over a pin), you can change the color of your mask by pressing Shift-O on your keyboard (this toggles you through the four choices: red, green, white, and gray).

▼ Scaling the Graduated Filter from the Center

By default, your gradient starts where you click (so it starts from the top or the bottom, etc.). However, if you pressand-hold the Option (PC: Alt) key as you drag the gradient, it draws from the center outward instead.

▼ Inverting Your Gradient

Once you've added a Graduated Filter to your image, you can invert that gradient by pressing the '(apostrophe) key on your keyboard.

▼ Changing the Intensity of the Effects

Once you've applied a Graduated Filter, you can control the amount of the lastadjusted effect by using the Left and Right Arrow keys on your keyboard. With an Adjustment Brush effect, use the Up and Down Arrow keys.

▼ Switching Between the A and B Brushes

The A and B buttons are actually brush presets (so you can have a hard brush and

a soft brush already set up, if you like, or any other combination of two brushes, like small and large). To switch between these two brush presets, press the / (Forward Slash) key on your keyboard.

▼ Increasing/Decreasing Softness
To change the softness (Feather) of your
brush, don't head over to the panel—
just press Shift-] (Right Bracket key) to
make the brush softer, or Shift-[(Left
Bracket key) to make it harder.

▼ Auto Mask Tip

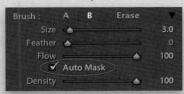

When you have the Auto Mask check-box turned on, and you're painting along an edge to mask it (for example, you're painting over a sky in a mountain land-scape to darken it), when you're done, you'll probably see a small glow right along the edges of the mountain. To get rid of that, just use a small brush and paint right over those areas. The Auto Mask feature will keep what you're painting from spilling over onto the mountains.

▼ Auto Mask Shortcut

Pressing the letter **A** toggles the Auto Mask feature on/off.

▼ Painting in a Straight Line

Just like in Photoshop, if you click once with the Adjustment Brush, then pressand-hold the **Shift key** and paint somewhere else, it will paint in a straight line between those two points.

▼ The Reset Button Really Means "Start Over"

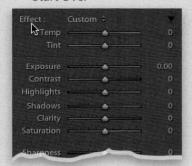

This one surprises a lot of folks because if you click the Reset button at the bottom of an adjustment panel, it doesn't reset your sliders, it deletes *all* the adjustments you've created like you're totally starting over from scratch. If you do just want to reset the sliders for your currently selected edit pin, just double-click directly on the word "Effect" at the top left of the panel, right above the sliders.

▼ A Gaussian Blur in Lightroom?

If you need a subtle blurring effect, kind of like a light amount of Gaussian Blur (well, probably more like a subtle version of the Lens Blur filter), just get the Adjustment Brush, choose **Sharpness** from the Effect pop-up menu (to reset the sliders),

then drag the Sharpness slider all the way to the left (to –100), and now you're painting with a little blur. Great for creating a quick shallow-depth-of-field look.

▼ Doubling the Effect

To double the effect of an adjustment, **Command-Option-click (PC: Ctrl-Alt-click)** on an active Edit Pin and drag just a tiny bit away from the original to make a duplicate of your original, then drag it right back on top of the original. This duplicate "doubles" the effect (like stacking effects one on top of the other). If you need to adjust the bottom Edit Pin, just drag the top one a tiny bit to the side, and then click on the bottom one, make your changes, and then drag that other pin back on top.

▼ Deleting Adjustments

If you want to delete any adjustment you've made, click on the pin to select that adjustment (the center of the pin turns black), then press the Delete (PC: Backspace) key on your keyboard.

fixing common problems

Of all the chapter names, this one is probably the most obvious, because what else could this chapter be about, right? I mean, you wouldn't name it "Problem Photos" and then have it be about creating problems with your photos, or the book would never sell. Well, the book might sell, but this chapter certainly wouldn't help sales. You know what does help sales? Using the word "pimp" not just once, but three times (in three chapter intros). Here's why: Google started this thing a few years back where they index all the pages to printed books, and then add that information to their search database (deep inside Chevenne Mountain), so if what you're searching for only appears within the pages of a printed book (rather than a webpage), it would still appear as a Google search result, and it would lead you directly to that book. Of course, you'd have to buy the book, but as an author, I can tell you that's not the worst outcome of a search. Anyway, now when

people search for the word "pimp," this book will appear as one of Google's search results. Of course, people looking for a pimp will see that this is, in fact, a Lightroom 5 book, which will probably initially dissuade them from buying it, but what I'm hoping is that they'll start to wonder why a book about Lightroom contains the word "pimp" at all, and that curiosity will start to eat at them. They'll be dying to know the mystery that lies deep within its crumpled pages, so they'll wind up buying the book anyway to unearth it's hidden pimpy agenda, but then of course, they'll realize that's not the way I was using the word "pimp," and while they'll still be somewhat disappointed, we know from more than a fiftieth of a century's research that approximately 6.7% of those people will start learning Lightroom. Hey, serves the rest right for trying to find a pimp using Google. They should have tried Craigslist.

Fixing Backlit Photos

One of the most common digital photography problems is photos where the subject is backlit, so it is almost a black silhouette. I think it's so common because the human eye adjusts for backlit situations so well that, to our naked eye, everything looks great, but the camera exposes much differently and that shot that looked very balanced when you took it, really looks like what you see below. The Shadows slider (which replaced the Fill Light slider in the Basic panel), does the best job of fixing this problem of anything I've ever seen, but there is one little thing you need to add.

Step One:

In this image, the sky looks properly exposed, but the building is totally in the shadows. While I was looking at the scene, everything looked fine because our eyes instantly balance the exposure of the scene, but unfortunately, our camera doesn't—it exposed for just the sky, leaving the building in shadows. Before we fix the backlit problem, increase the Exposure a little to see if that helps (I dragged it over to +0.45 without blowing out the highlights), then drag the Highlights slider to the left to –49 to lower the brightest highlights in the overly bright sky (hey, it helps).

Step Two:

To open up the foreground, click-and-drag the Shadows slider to the right (here, I dragged to around +79). Back in Light-room 3, you didn't want to drag the Fill Light slider (the Shadows slider's lesser-quality LR3 counterpart) that far, because it made the image look funky. Luckily, you don't get that same heavy-handed look in Lightroom 5. If you do crank up the Shadows slider pretty high (like I did here), then the photo may start to look washed out (as seen here), but in the next step, we'll fix that with just one simple move.

TIP: Watch Out for Noise

If an image has noise in it, it's usually in the shadow areas, so if you do open the shadows a lot, any noise gets amplified. Keep an eye out for it as you drag, and if you do see a lot, go to the Detail panel to reduce the luminance and color noise (see the next project for more on this).

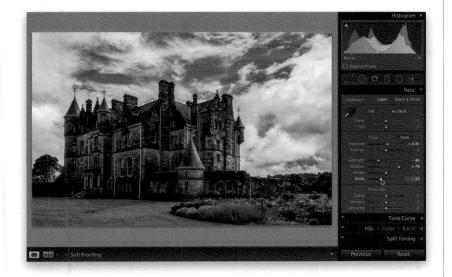

The way to get rid of that washed-out look is simply to push a little bit of blacks into the image by clicking-and-dragging the Blacks slider to the left just a little bit (here, I dragged it to –34). Luckily, this washed-out look doesn't happen nearly as often now as it did back in Lightroom 3, thanks to the new process version. In most cases, you'll be able to move it just a little bit to bring back the blacks.

Step Four:

Here, I used Lightroom's Before/After view (press **Y**) to show what a big difference this technique (using Shadows, then bringing back the deep shadows by increasing the Blacks slider) can do for our backlit photos.

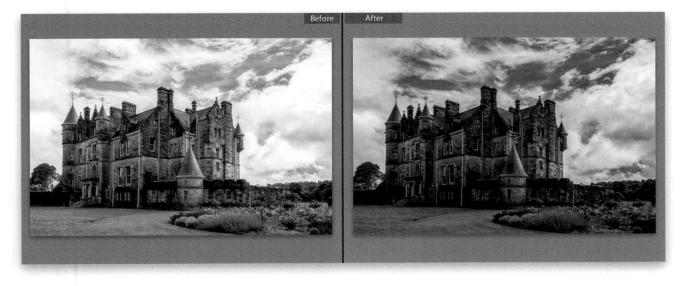

Reducing Noise

If you wind up shooting at a high ISO or in very low light, chances are your image is going to have some noise—either luminance noise (a visible graininess throughout the photo, particularly in shadow areas) or color noise (those annoying red, green, and blue spots). Although the noise reduction in previous versions of Lightroom was kind of weak, in Lightroom 3 Adobe completely reworked the Noise Reduction feature, so now it's not just good, it absolutely rocks. Not only is it more powerful, but it maintains more sharpness and detail than ever before.

Step One:

To reduce the noise in a "noisy" image like this (shot at 25,600 ISO, handheld, at night), go to the Develop module's Detail panel, to the Noise Reduction section. To really see the noise, zoom in to at least a 1:1 view. (Here, the light on the crowd was so bright, I reduced the Highlights first.)

Step Two:

I usually reduce the color noise first, because it's so distracting (if you shoot in RAW, it automatically applies some noise reduction, but I dragged the Color slider back to 0 [zero] so you could see how this works). So, start with the Color slider at 0, and slowly drag it to the right. As soon as the color goes away, stop, because once it's gone, it doesn't get "more gone." Here, there's no visible improvement between a Color setting of 14 (where the color first went away) and 100. The Detail slider controls how the edges in your image are affected. If you drag it way over to the right, it does a good job of protecting color details in edge areas, but you run the risk of having color speckles. If you keep this setting really low, you avoid the speckles, but you might get some colors bleeding (expanding, like they're glowing a bit). So, where do you set it? Look at a colorful area of your image, and try both extremes. I tend to stay at 50 or below for most of my images, but you may find an image where 70 or 80 works best, so don't be afraid to try both ends. Luckily, the Color slider itself makes the most visible difference.

Now that the color noise has been dealt with, chances are your image looks grainy. So to reduce this type of noise (called luminance noise), drag the Luminance slider to the right until the noise is greatly reduced (as shown here). I gotta tell you, this baby works wonders all by itself, but you have additional control with the other two sliders beneath it. The "catch" is this: your image can look clean, or it can have lots of sharp detail, but it's kinda tricky to have both. The Detail slider (in Adobe speak, the "luminance noise threshold") really helps with seriously blurry images. So, if you think your image looks a little blurry now, drag the Detail slider to the right—just know this may make your image a little more noisy. If, instead, you want a cleaner looking image, drag the Detail slider to the left—just know that you'll now be sacrificing a little detail to get that smooth, clean look (there's always a trade-off, right?).

Step Four:

The other slider under Luminance is the Contrast slider. Again, this one really makes a difference on seriously noisy images. Of course, it has its own set of trade-offs. Dragging the Contrast slider to the right protects the photo's contrast, but it might give you some blotchy-looking areas (the key word here is "might"). You get smoother results dragging the slider to the left, but you'll be giving up some contrast. I know, I know, why can't you have detail and smooth results? That's coming in Lightroom 9. The real key here is to try to find that balance, and the only way to do that is experiment on the image you have onscreen. For this particular image, most of the luminance noise was gone after dragging the Luminance slider to around 45 (dragging much higher didn't yield better results). I wanted to keep more detail, so I increased the Detail amount to around 67. I left the Contrast slider as is. The before/after is shown here.

Undoing Changes Made in Lightroom

Lightroom keeps track of every edit you make to your photo and it displays them as a running list, in the order they were applied, in the Develop module's History panel. So if you want to go back and undo any step, and return your photo to how it looked at any stage during your editing session, you can do that with just one click. Now, unfortunately, you can't just pull out one single step and leave the rest, but you can jump back in time to undo any mistake, and then pick up from that point with new changes. Here's how it's done:

Step One:

Before we look at the History panel, I just wanted to mention that you can undo anything by pressing Command-Z (PC: Ctrl-Z). Each time you press it, it undoes another step, so you can keep pressing it and pressing it until you get back to the very first edit you ever made to the photo in Lightroom, so it's possible you won't need the History panel at all (just so you know). If you want to see a list of all your edits to a particular photo, click on the photo, then go to the History panel in the left side Panels area (shown here). The most recent changes appear at the top. (Note: A separate history list is kept for each individual photo.)

Step Two:

If you hover your cursor over one of the history states, the small Navigator panel preview (which appears at the top of the left side Panels area) shows what your photo looked like at that point in history. Here, I'm hovering my cursor over the point a few steps back where I had converted this photo to black and white, but since then I changed my mind and switched back to color.

If you actually want to jump back to what your photo looked like at a particular stage, then instead of hovering over the state, you'd click once on it and your photo reverts to that state. By the way, if you use the keyboard shortcut for your undos (instead of using the History panel), the edit you're undoing is displayed in very large letters over your photo (as seen here). This is handy because you can see what you're undoing, without having to keep the History panel open all the time.

TIP: Undos Last Forever

Photoshop's History panel only lets you have 20 undos, and if you close the file, they go away. However, in Lightroom, every single change you make to your photo inside Lightroom is tracked and when you change images, or close Lightroom, your unlimited undos are saved. So even if you come back to that photo a year later, you'll always be able to undo what you did.

Step Four:

If you come to a point where you really like what you see and you want the option of quickly jumping back to that point, go to the Snapshots panel (right above the History panel), and click on the + (plus sign) button on the right side of the panel header (as shown here). That moment in time is saved to the Snapshots panel, and it appears with its name field highlighted, so you can give it a name that makes sense to you (I named mine "Duotone with Vignette," so I'd know that if I clicked on that snapshot, that's what I'd get—a duotone with a vignette. You can see my snapshot highlighted in the Snapshots panel shown here). By the way, you don't have to actually click on a previous step in the History panel to save it as a snapshot. Instead, you can just Right-click on any step and choose Create Snapshot from the pop-up menu. Pretty handy.

Cropping Photos

When I first used the cropping feature in Lightroom, I thought it was weird and awkward—probably because I was so used to the Crop tool in older versions of Photoshop—but once I got used to it, I realized that it's probably the best cropping feature I've ever seen. This might throw you for a loop at first, but if you try it with an open mind, I think you'll wind up falling in love with it. If you try it and don't like it, make sure you read Step Six for how to crop more like you used to in Photoshop (but don't forget that whole "open mind" thing).

Step One:

Here's the original photo. The shot is so wide the action kind of gets lost, so we're going to crop in tight to isolate the action. Go to the Develop module and click on the Crop Overlay tool (circled here in red) in the toolbox above the Basic panel, and the Crop & Straighten options will pop down below it. This puts a "rule of thirds" grid overlay on your image (to help with cropping composition), and vou'll see four cropping corner handles. To lock your aspect ratio (so your crop is constrained to your photo's original proportion), or unlock it if you want a non-constrained freeform crop, click on the lock icon near the top right of the panel (as shown here).

Step Two:

To crop the photo, grab a corner handle and drag inward to resize your Crop Overlay border. Here, I grabbed the bottom-left corner handle and dragged diagonally inward and I stopped just before I cut off the bottom of the player's shadow.

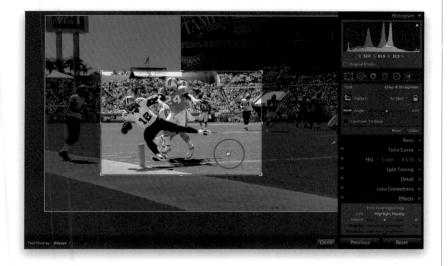

Previous Reading of the Color Flow Split Toning Previous Read Previous R

Step Three:

Now the top-right corner needs to be tucked in a bit to get us nice and tight in on the action and remove most of those players on the right (you did download this photo, right? The URL for the downloads is in the book's introduction). So, grab the top-right corner and drag it diagonally inward to eliminate those distracting players for a nice, tight crop (as seen here). If you need to reposition the photo inside the cropping border, just click-and-hold inside the Crop Overlay border. Your cursor will change into the "grabber hand" (shown here), and now you can drag it where you want it.

TIP: Hiding the Grid

If you want to hide the rule-of-thirds grid that appears over your Crop Overlay border, press **Command-Shift-H** (**PC: Ctrl-Shift-H**). Or, you can have it only appear when you're actually moving the crop border itself, by choosing **Auto** from the Tool Overlay pop-up menu in the toolbar beneath the Preview area. Also, there's not just a rule of thirds grid, there are other grids—just press the letter **O** to toggle through the different ones.

Step Four:

When the crop looks good to you, press the letter **R** on your keyboard to lock it in, remove the Crop Overlay border, and show the final cropped version of the photo (as seen here). But there are two other choices for cropping we haven't looked at yet.

Step Five:

If you know you want a particular size ratio for your image, you can do that from the Aspect pop-up menu in the Crop & Straighten options. Go ahead and click the Reset button, below the right side Panels area, so we return to our original image, and then click on the Crop Overlay tool, again. Click on the Aspect pop-up menu at the top-right side of the Crop & Straighten options, and a list of preset sizes appears (seen here). Choose 4x5/8x10 from the popup menu, and you'll see the left and right sides of the Crop Overlay border move in to show the ratio of what a 4x5" or 8x10" crop would be. Now you can resize the cropping rectangle and be sure that it will maintain that 4x5/8x10 aspect ratio.

The other, more "Photoshop-like," way to crop is to click on the Crop Overlay tool, then click on the Crop Frame tool (shown circled here in red) to release it from its home near the top left of the Crop & Straighten options. Now you can just click-and-drag out a cropping border in the size and position you'd like it. Don't let it freak you out that the original cropping border stays in place while you're dragging out your new crop, as seen here—that's just the way it works. Once you've dragged out your cropping border, it works just like before (grab the corner handles to resize, and reposition it by clicking inside the cropping border and dragging. When you're done, press R to lock in your changes). So, which way is the right way to crop? The one you're most comfortable with.

TIP: Canceling Your Crop
If, at any time, you want to cancel your
cropping, just click on the Reset button
at the bottom-right side of the Crop &
Straighten options panel.

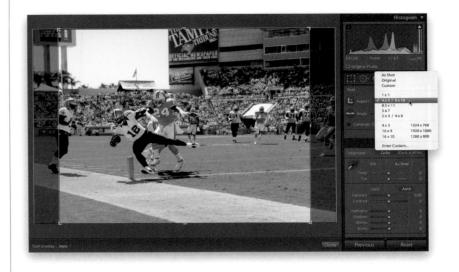

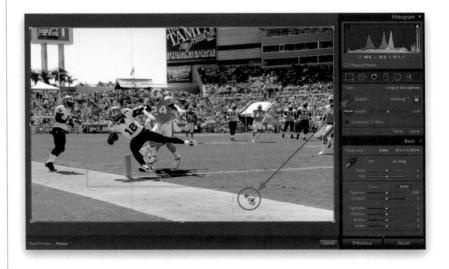

When you crop a photo using the Crop Overlay tool in the Develop module, the area that will get cropped away is automatically dimmed to give you a better idea of how your photo is going to look when you apply the final crop. That's not bad, but if you want the ultimate cropping experience, where you really see what your cropped photo is going to look like, then do your cropping in Lights Out mode. You'll never want to crop any other way.

Lights Out Cropping Rocks!

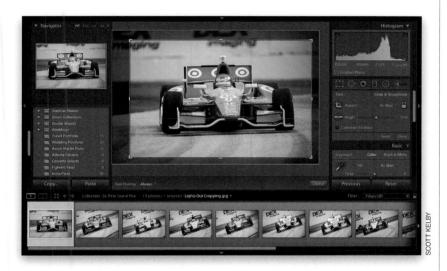

Step One:

To really appreciate this technique, first take a look at what things look like when we normally crop an image—lots of panels and distractions, and the area we're actually cropping away appears dimmed (but it still appears). Now let's try Lights Out cropping: First, click on the Crop Overlay tool to enter cropping mode. Now press Shift-Tab to hide all your panels.

Step Two:

Press the letter L twice to enter Lights Out mode, where every distraction is hidden, and your photo is centered on a black background, but your cropping border is still in place. Now, try grabbing a corner handle and dragging inward, then clicking-and-dragging outside your cropping border to rotate it, and watch the difference—you see what your cropped image looks like live as you're dragging the cropping border. It's the ultimate way to crop (it's hard to tell from the static graphic here, so you'll have to try this one for yourself—you'll never go "dim" again!).

Straightening Crooked Photos

If you've got a crooked photo, Lightroom's got three great ways to straighten it. One of them is pretty precise, and with the other two you're pretty much just "eveing it," but with some photos that's the best you can do.

Step One:

The photo shown here has a crooked horizon line, which is pretty much instant death for a landscape shot. To straighten the photo, start by getting the Crop Overlay tool (R), found in the toolbox, right under the histogram in the Develop module's right side Panels area (shown here). This brings up the Crop Overlay grid around your photo, and while this grid might be helpful when you're cropping to recompose your image, it's really distracting when you're trying to straighten one, so I press Command-Shift-H (PC: Ctrl-Shift-H) to hide that grid.

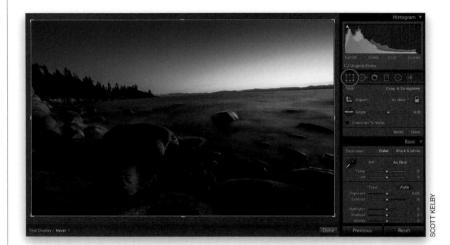

Step Two:

As I mentioned above, there are three different ways to straighten your photo and we'll start with my favorite, which uses the Straighten tool. I think it's the fastest and most accurate way to straighten photos. Click on the Straighten tool, found in the Crop & Straighten options (it looks like a level), then click-and-drag it left to right along something that's supposed to be level in the image (as shown here, where I've dragged it along the horizon line of the lake). See why I like straightening like this? However, there is one catch: you have to have something in the photo that's supposed to be level—like a horizon, or a wall, or a window frame, etc.

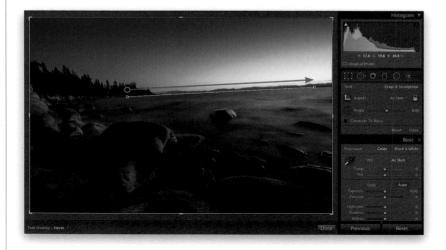

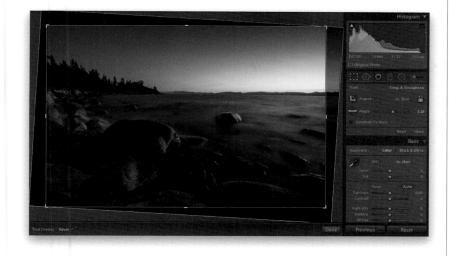

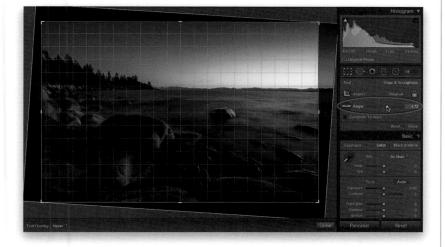

When you drag that tool, it shrinks and rotates the cropping border to the exact angle you'd need to straighten the photo (without leaving any white gaps in the corners). The exact angle of your correction is displayed in the Crop & Straighten options next to the Angle slider. Now all you have to do is press **R** to lock in your straightening. If you decide you don't like your first attempt at straightening, just click the Reset button at the bottom of the options, and it resets the photo to its unstraightened and uncropped state. So, to try again, grab the Straighten tool and start dragging.

Step Four:

To try the two other methods, we need to undo what we just did, so click the Reset button at the bottom of the right side Panels area, then click on the Crop Overlay tool again (if you locked in your crop after the last step). The first of the two methods is to just drag the Angle slider (shown circled here in red)—dragging it to the right rotates the image clockwise; dragging left, counterclockwise. As soon as you start to drag, a rotation grid appears to help you line things up (seen here). Unfortunately, the slider moves in pretty large increments, making it hard to get just the right amount of rotation, but you can make smaller, more precise rotations by clicking-and-dragging left or right directly over the Angle amount field (on the far right of the slider). The second method is to just move your cursor outside the Crop Overlay border (onto the gray background), and your cursor changes into a two-headed arrow. Now, just click-and-drag up/down to rotate your image until it looks straight.

Finding Spots and Specks the Easy Way

There is nothing worse than printing a nice big image, and then seeing all sorts of sensor dust, spots, and specks in your image. If you shoot landscapes or travel shots, it is so hard to see these spots in a blue or grayish sky, and if you shoot in a studio on seamless paper, it's just as bad (maybe worse). I guess I should say, it used to be bad—now it's absolutely a breeze thanks to a new feature in Lightroom 5 that makes every little spot and speck really stand out so you can remove them fast!

Step One:

Here's an image taken out in Lake Tahoe, Nevada, and you can see a few spots and specks in the sky pretty clearly (but it's the spots that you can't see clearly at this size, or against this flat sky, that "Getcha!"). Of course, you eventually do see them like after you've printed the image on expensive paper, or when a client asks, "Are these spots supposed to be there?"

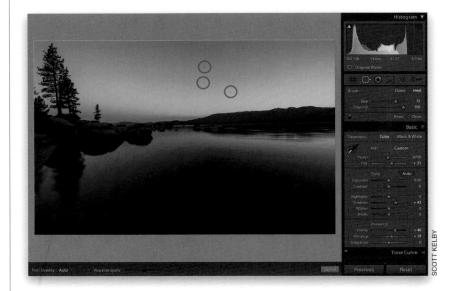

Step Two:

To find any spots, specks, dust, or junk in your image, click on the Spot Removal tool (**Q**; it's shown here circled in red) in the toolbox near the top of the right side Panels area. Down in the toolbar, directly below the main Preview area, is a Visualize Spots checkbox (also circled here). Turn this checkbox on and you get an inverted view of your image, where you can instantly see some more spots now.

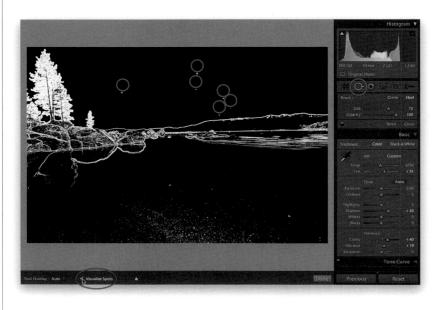

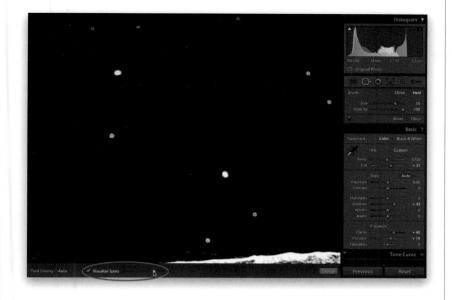

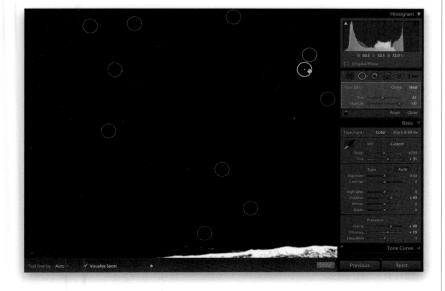

I zoomed in a bit here, so you can see the spots better, but another reason why they stand out so amazingly is because I increased the Visualize Spots threshold level (drag the Visualize Spots slider to the right, and now if there are any spots, specks, dust, etc., still hiding, you'll see them in an instant). I drag this slider to the right until I find that point where the spots stand out, but without the threshold overwhelming everything by bringing out what, if you drag too far, looks like snow or noise.

TIP: Choosing Brush Size

When using the Spot Removal tool, you can press-and-hold Command-Option (PC: Ctrl-Alt) and click-and-drag out a selection around your spot (start by clicking just to the upper left of the spot, then drag across the spot at a 45° angle). As you do, it lays down a starting point and then your circle drags right over the spot.

Step Four:

Now that the spots are so easily visible, you can take the Spot Removal tool and just click it once, right over each spot, to remove them (as shown here, where I've removed most of the visible spots). Use the Size slider or the **Left and Right** Bracket keys to make the tool a little larger than the spot you want to remove. When you're done, turn the Visualize Spots checkbox off and make sure the Spot Removal tool sampled from matching areas. If you see a spot where it didn't, just click on that circle to make it active, then click inside the sampling circle and drag it to a matching area (as shown here, where I still have Visualize Spots on and am moving the sampling circle).

Step Five:

Often, it's dust on your camera's sensor that creates these annoying spots and they'll be in the exact same position in every shot from that shoot. If that's the case, then once you've removed all the spots, make sure the photo you fixed is still selected in the Filmstrip, and select all the similar photos from that shoot, then click the Sync button at the bottom of the right side Panels area. This brings up the Synchronize Settings dialog, shown here. First, click the Check None button, so everything it would sync from your photo is unchecked. Then, turn on the checkboxes for Process Version and Spot Removal (shown here), and click the Synchronize button.

Step Six:

Now, it applies that same spot removal you did to the first photo, to all these other selected photos—all at once (as you can see it did here). To see these fixes applied, click on the Spot Removal tool again. I also recommend you take a quick look at the fixed photos, because depending on the subject of your other shots, the fixes could look more obvious than on the photo you just fixed. If you see a photo with a spot repair problem, just click on that particular circle, hit the **Delete (PC: Backspace) key** on your keyboard to remove it, then use the Spot Removal tool to redo that one spot repair manually.

TIP: When to Use Clone

There are two choices for how this tool fixes your spots—Clone or Heal. The only reason ever to switch it to Clone is if the spot you're trying to remove is on or near the edge of an object in your image, or near the edge of the image itself. In these cases, Heal often smudges the image.

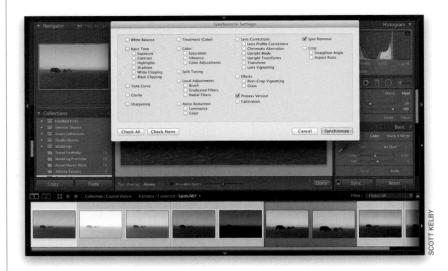

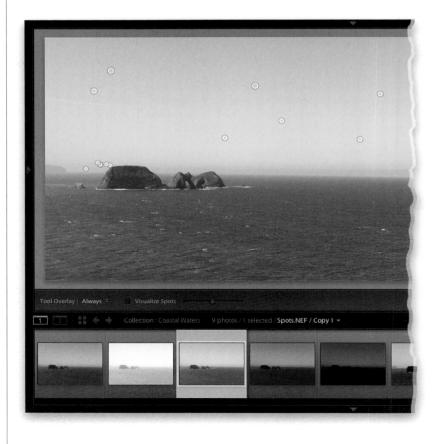

One thing we had to always go to Photoshop for was to use the Healing Brush. Sure, if you wanted to remove a spot or a blemish, you could use Lightroom's Spot Removal tool, but since it did "circular healing," you couldn't paint a stroke to remove a wrinkle, or a power line, or well...much of anything other than a spot—all you could do was create more circles. Well, finally (finally!), we have a tool that lets us paint a stroke and heal those problems away right here in Lightroom.

Oh Hallelujah, It's a Regular Healing Brush! (Finally!)

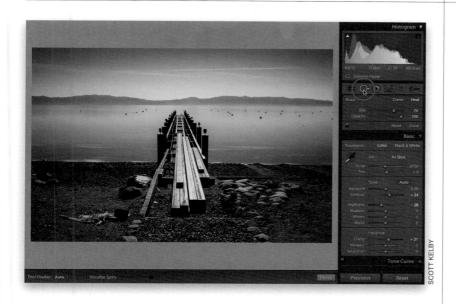

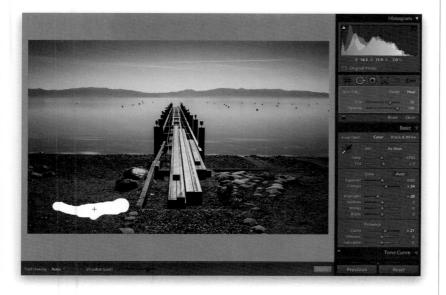

Step One:

Here's the image we want to retouch, because nothing says "beautiful land-scape shot" more than yellow caution tape lying on the beach (and removing that yellow caution tape would have been really tough to do in previous versions of Lightroom). So, click on the Spot Removal tool (**Q**: it's shown circled here in red) in the toolbox near the top of the right side Panels area. By the way, I think they totally should rename this tool now that it works more like Photoshop's Healing Brush and it does more than just remove spots.

TIP: Drawing Straight Lines with the Healing Brush

If you want to remove something distracting from your image that's in a straight line, like a telephone wire, start by clicking once on one end of the wire. Then, press-and-hold the Shift key, go to the other end of the wire, and just click once to have it paint a straight brush stroke between those two points, and remove the wire completely.

Step Two:

Take the Spot Removal tool and just paint a stroke over the yellow caution tape, along with the rock to its right (as seen here). As you do, you'll see a white area appear showing the area you're "healing" as you paint.

When you finish your stroke, you'll see two outlined areas: (1) the one with the slightly thicker outline is the one showing the area you're healing, and (2) the other one (the thinner one) is showing you the area that the Spot Removal tool chose to sample the texture it's going to use to remove the yellow caution tape. Usually, this sample area is pretty close to the area you're trying to fix, but sometimes it does what it did hereit chose an area far enough away that it doesn't actually create a perfect match (in this case, for reasons I can't begin to understand, it decided to sample the lake water). That's okay, though, because we can easily have the Spot Removal tool choose a different area to sample from.

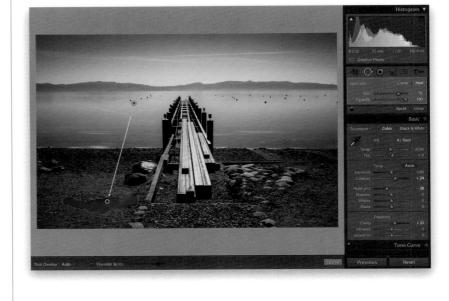

Step Four:

Just take your cursor, click inside the thinner outlined sample area, and drag it somewhere else in the image that's a better match (I picked an area of sand right there on the beach). Once you drag it over a new area, let go of the mouse button and it draws a preview of how this new sample area looks (that way you can see if moving it actually helped or not). If it still doesn't look good, just drag the sample outline somewhere else and release the mouse for a quick preview of how it looks now. It looks a lot better here, for sure, but it's not quite there yet.

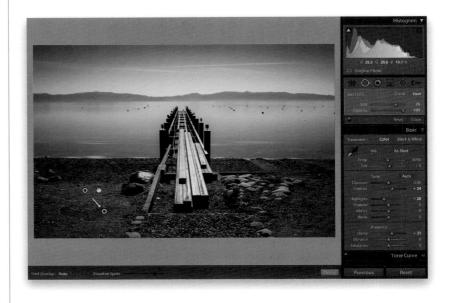

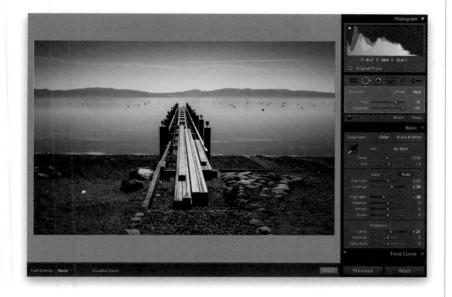

Step Five:

One thing you can do to make finding just the right sample area easier is to press the **H key** on your keyboard. This hides the outline borders around your sample area and the area you're trying to heal (it's great for a quick peek at how it looks without having those distracting borders in the way). Here's how I use it: I first move my cursor over the thinner outline (the "where it's sampling from" outline), then I press H. My cursor has changed into the grabber hand (as seen here), so now I can drag the "sampling from" outline around and see the results instantly as I drag. Getting those distracting outline borders out of the way while you drag makes a big difference in how quickly you'll find just the right spot.

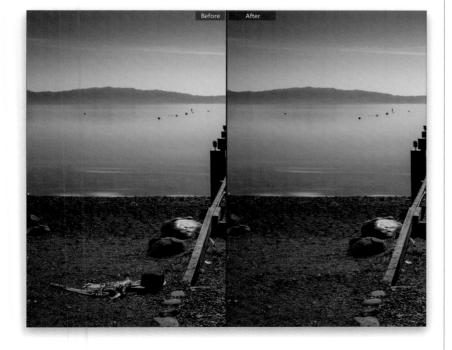

Step Six:

Here's a before/after, with the yellow caution tape and after removing it in Lightroom (we can see where it was because we know it was there—nobody else looking at this photo would have a clue. At least nobody I've ever shown it to has). Again, this is something we almost surely would have had to jump to Photoshop to do, but now we can do it here in Lightroom.

Removing Red Eye

If you wind up with red eye in your photos (point-and-shoots are notorious red-eye generators thanks to the flash being mounted so close to the lens), Lightroom can easily get rid of it. This is really handy because it saves you from having to jump over to Photoshop just to remove red eye from a photo of your neighbor's six-year-old crawling through a giant hamster tube at Chuck E. Cheese. Here's how it works:

Step One:

Go to the Develop module and click on the Red Eye Correction tool, found in the toolbox right under the Histogram panel (its icon looks like an eye, and it's circled here in red). Click the tool in the center of one of the red eyes and drag down and to the side to make a selection around the eye (I used the term "selection," but it's not really a selection in the Photoshop sense it's more an oval with crosshairs). When vou release the mouse button, it removes the red eye. If it doesn't fully remove all the red, you can expand how far out it removes it by going to the Red Eye Correction tool's options (they appear in the panel once you've released the mouse button), and dragging the Pupil Size slider to the right (as shown here).

Step Two:

Now do the same thing to the other eye (the first eye you did stays selected, but it's "less selected" than your new eye selection—if that makes any sense). As soon as you click-and-drag out the selection and release your mouse button, this eye is fixed, too. If the repair makes it look too gray, you can make the eye look darker by dragging the Darken slider to the right (as shown here). The nice thing is that these sliders (Pupil Size and Darken) are live, so as you drag, you see the results right there onscreen—you don't have to drag a slider and then reapply the tool to see how it looks. If you make a mistake and want to start over, just click the Reset button at the bottom right of the tool's options.

Ever shoot some buildings downtown and they look like they're leaning back? Or maybe the top of the building looks wider than the bottom. These types of lens distortions are really pretty common, but in early versions of Lightroom, to fix these types of problems you had to jump over to Photoshop and manually try to tweak your image there. Luckily, Lightroom 5 can not only fix your lens distortion problem, it can often do it automatically (but of course, you can do it manually if you want to, or if your lens isn't supported).

Fixing Lens Distortion Problems

Step One:

Open an image that has a lens distortion problem (this feature also automatically corrects edge vignetting problems and chromatic aberrations, as well, which I'll cover later. Here, we're just focusing on geometric distortion). Here's a photo taken with a 15mm fisheve lens, and while there are third-party plug-ins you can buy to address the fisheve distortion caused by the lens, since it's now built into Lightroom, we don't have to use them (wild cheers ensue!). Take a look at the image shown here, and the rounding of the stadium (and the lights).

Step Two:

In the Lens Corrections panel, you have four options: Basic (which we'll learn about next), Profile (it fixes the problem automatically), Color (it fixes chromatic aberrations and fringing), or Manual (you fix it yourself). We'll start with the auto method, so click on Profile, then turn on the Enable Profile Corrections checkbox. Bam!—your image is fixed (look at how it straightened out this image). It pulls off this mini-miracle because it reads the EXIF data embedded into the photo, so it knows which lens make and model you used to take the image (Adobe included lots of camera and lens profiles for popular Nikon, Canon, Tamron, and Sigma lenses. Look under the Lens Profile section and you'll see your lens' make and model, and the type of lens profile applied). This is pretty amazing stuff, and it happens all in a split second.

Continued

The Adobe Photoshop Lightroom 5 Book for Digital Photographers

Step Three:

You can tweak the automatic correction a bit by using the Amount sliders at the bottom of the panel. For example, if you thought it removed too much of the distortion, you can drag the Distortion slider to the left a little (as shown here), and it lessens the amount of rectilinear correction it applied to the photo (notice how the foreground area has a little bit of curve back in it, and there's less distortion around the far-left and far-right sides?). Having this simple slider to tweak the automatic result is pretty handy (and you'll probably use it more than you think).

Step Four:

Now, let's look at another photo. In this case, the image looks bloated (look at the buildings and how they look bowed out), and and even the yellow line on the road looks curved when it should be straight. When you turn on the checkbox for Enable Profile Corrections, you'll find out that nothing happens, and on the Profile tab, where it would normally list my lens' make and model, it reads "None." That's because, for whatever reason, this image doesn't have any embedded EXIF data (maybe the image was copied-andpasted into a blank document, or maybe when it was exported from Lightroom, the Minimize Embedded Metadata checkbox was turned on, so it stripped out that EXIF data, or maybe Lightroom just doesn't have this lens profile in its database). Whatever the reason, you need to help it out and tell it which brand of lens was used, and which lens it was taken with, and then it can apply an automatic correction.

Step Five:

In the Lens Profile section of the panel, from the Make pop-up menu, choose the brand of lens you shot with (in this case, it was a Nikon, so I chose Nikon). Then, choose the type of lens it was shot with from the Model pop-up menu (this was shot with a 28mm f/3.5–5.6 lens, but for whatever reason, there's not a profile for this particular lens. So, I chose the closest wide-angle lens I could find, a 24–70mm f/2.8, which really isn't close at all, but I tried them all and it seemed to be the best of the worst choices).

TIP: If There's No Profile, Don't Give Up

If Lightroom doesn't have a profile for your exact lens, try the closest match you can find. Often, it does a pretty decent job of fixing the distortion in the image.

Step Six:

While, in this case, there was no profile, if it does find one (like it did with the fisheye photo earlier), it usually does a pretty darn good job. Choosing the closet choice available in this case, it didn't do much more here than remove a bit of the edge vignetting. If your profile gets you close, but it's not right on the money, you can use the two sliders at the bottom of the panel to tweak the automatic fix. Here, I tried dragging the Amount Distortion slider to the right, but it didn't really do anything (honestly, it usually works better than it's doing on this image). If it only helps a little (or none at all), then click on Manual (at the top of the panel) to reveal the Transform sliders.

Step Seven:

I wound up having to drag the Distortion slider to +18 to remove the bend and bloating from the buildings (look at the yellow line on the ground now). Another thing that needed adjusting was the angle. The whole image looked a little bit crooked, so I went to the Rotate slider and rotated it just a bit (to -0.5) so it looked straight. We're not done yet, because there's still another lens problem we have to deal with.

TIP: Using the Adjustable Grid When you're trying to straighten things out like this, you might find it helpful to have a grid appear as you're rotating. To do that, go under the View menu, under Loupe Overlay, and choose Grid. Once it appears, you can change its Size and Opacity by pressing-and-holding the Command (PC: Ctrl) key and clickingand-dragging left/right on the two controls that appear at the top of the Preview area.

Step Eight:

Before we go any farther, lets have Lightroom crop the photo automatically so we don't see the white areas surrounding the image. Turn on the Constrain Crop checkbox (as seen here). Once this is done, let's re-evaluate the image and see how it looks. Now that it's cropped, I think I might have overdone the Distortion amount, so I backed it off to just +15. I also rotated it a little more (I moved it to -0.8). These are just little changes, but doing this manually is kind of a dance, with a little movement here and there making a big difference. Okay, we have one big lens problem left to deal with. Look at the image. See how the buildings are smaller on the left and then grow taller as they move to the right? That's a horizontal perspective problem, but one that's easy enough to fix.

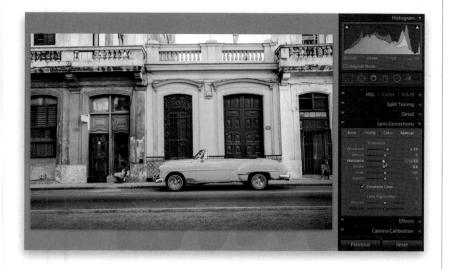

Step Nine:

To fix this horizontal perspective problem, just drag the Horizontal slider to the left (as shown here) and the buildings (and the whole scene) straighten out (here, I dragged over to –11). The image is looking much better, but we still need one last tweak to get this flat and straight. Take a look at the car. It looks like if you took the parking brake off it would roll downhill right out of the frame.

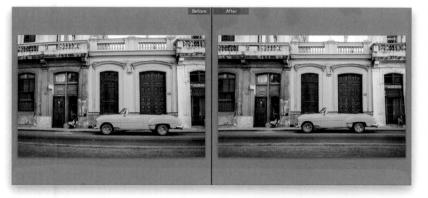

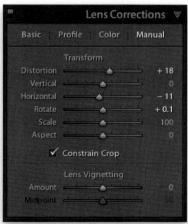

Step 10:

Our final tweaks are to rotate it a tiny bit so it looks flat, so grab the Rotate slider and bring it back to +0.1. Look at the image now, it looks like the Distortion amount I chose earlier (+18) was the right amount after all (as you make these changes, you have to re-evaluate how the image looks and tweak things as you go, so don't feel bad if a change you made earlier has to be tweaked a bit. The goal is to remove the distortion and perspective problems and if it takes a tweak or two along the way, that's to be expected). Here's a before and after. Look at the buildings, the yellow line, and the street now—the lens problems are gone.

TIP: Upright for Lens Corrections
There is a big new feature for lens
correction issues in Lightroom 5 called
"Upright" on the Basic tab. Although it
didn't work at all for these problems
(I tried it), it often works wonders, so
we'll cover it next.

Auto Correcting Perspective and Other Lens Problems Using Upright

Adobe has been working on better ways to correct lens problems (like when you see buildings tipping back or have distortion problems) for a while now with things like built-in profile corrections, which are actually pretty good. But, when you see the new Upright feature in action, you'll wonder how we ever lived without it. It puts a real automated fix just one or maybe two clicks away.

Step One:

Here's the original image, taken with a wide-angle lens, up really close, and you can immediately see the problems: the image is crooked, the pipe organ is leaning way back (it's larger at the bottom and narrower at the top), and well, it's all kind of a mess. I'm going to take you through the different Upright automatic fixes to get this to where it's a usable image.

Step Two:

Start by going to the Lens Corrections panel and click on the word "Basic" at the top of the panel (if it's not already selected), and then turn on the Enable Profile Corrections checkbox (as shown here; the Upright feature works better with this turned on first). The auto profile correction is fairly subtle, but it did help the two things it usually helps with: (1) it removed the lens distortion that makes the pipe organ look like it's bowing out a bit (it basically flattens out the bowing), and (2) it removed most of the dark edge vignetting in the corners of the image. But, that's pretty much usually the extent of what it does. Of course, depending on the image (and the amount of distortion), this can really help an image. In this case, like in many cases, it did fix those two things, but overall the change is fairly subtle.

Now, let's add the Upright auto corrections (they're in the middle of the Basic tab of the Lens Corrections panel). Since the image is crooked, let's try the Level auto correction. Click the Level button (as shown here) and it straightens out the image (as seen here).

TIP: Upright Loves a Crooked Horizon Line

Next time you've got a landscape shot, or a sunset shot with a crooked horizon line, now you know where to go.

Step Four:

Although you can just click the individual buttons for individual problems, I think the most useful feature of Upright is the Auto button—it corrects whatever it sees wrong with the image (well, lens-wise anyway), but it does it in a pretty evenhanded, balanced way (try clicking on the Vertical button by itself right now, and you'll see what I mean. Vertical works great if that's the only lens problem you have. But, if you've got more than one problem, Auto seems to handle the job much better). Here's the result of clicking the Auto button—it applies the Level auto-correction to straighten out the image, and it removes a good bit of the "leaning back" perspective problem at the same time. Now, anytime you do a pretty extreme fix like this, you're going to have to re-crop the image (to get rid of those white areas that are left over after fixing the perspective, but Upright can help with that, too).

The Adobe Photoshop Lightroom 5 Book for Digital Photographers

Step Five:

Right above the Upright corrections, you'll see the Constrain Crop checkbox. Turn it on, and it automatically crops the image down to where those white areas left over from the perspective fix are gone (as seen here, after I turned the checkbox on). This is really handy, since you're going to have to crop this image down anyway, so you might as well have Lightroom do it for you, eh?

Step Six:

While the Upright fixes are pretty darn amazing, they're not always perfect (for example, if you ask me, it's still a tiny bit crooked, and when you do any type of vertical perspective fix like this, it has to stretch the image a bit. So, sometimes the subject of the image—in this case, the pipe organ—looks like it's taller than it was. You can see this pretty clearly if you compare the images in Step Three and Step Four). You can fix both problems in the Manual tab of the Lens Corrections panel. So, just click on Manual at the top of the panel, and then drag the Rotate slider a little bit to the left to rotate the image, so it's really straight (I dragged it over to -0.8).

Step Seven:

To get rid of the stretched look, there's a new Aspect slider in Lightroom 5 that lets you adjust the image by making it wider or taller. In our case, we need it a little wider, so drag the Aspect slider over to the left to –57, and it looks more like it did before the correction (also, note that it brought back the top of the organ which was cut off [see the image in Step Six], which is a nice bonus). Take a look at the before/after below.

Step Eight:

Now, I don't want you to think the Vertical Upright auto fix is one of those "never touch" buttons because of how it looked on the pipe organ photo, so let's move on to this ugly photo (it's okay, I know it's ugly, and even after we fix it, it'll still be ugly, which proves once again what I always say, "Photoshop can make a good photo great, but it can't make a bad photo good"). This building looks like it's falling back, and that's exactly when you'd use the Vertical button (it levels and fixes the vertical perspective, which will hopefully make that leaning wall on the left straight).

Step Nine:

So, click back on the Basic tab at the top of the Lens Corrections panel, but before you click the Vertical button, be sure to turn on the Enable Profile Corrections checkbox first (once again, it helps the Upright stuff work better). Now, go ahead and click the Vertical button and it instantly straightens out the wall on the left and fixes most of the perspective problem (and creates those white triangle-shaped spaces on either side, but that's what happens when you fix perspective. You can either: [a] crop it down to size by turning on the Constrain Crop checkbox, or [b] jump over to Photoshop and use Content-Aware Fill to fix the problem). While the Vertical auto fix does try to level the image and fix the perspective, once again, the leveling seems to need a slight tweak to make that left wall look really straight, which we'll do next.

Step 10:

Click on the Manual tab and let's tweak a few things: First, the rotation. I had to rotate it to -2.1 to get it looking straight, but it still wasn't spot-on because the building was "bowing out." So, I went to the Distortion slider and dragged it over to +12 to get rid of that. Lastly, to keep the whole image from looking too stretched, I dragged the Aspect slider over to +31 (as shown here). The image looks pretty straight now, but of course, we either have some cropping to do or we need to head over to Photoshop and try Content-Aware Fill to fill in those white triangles on either side. Note: You won't always have to tweak things when you apply the Vertical Upright fix—it's just that this image was so extreme it needed a little extra tweaking. A lot of times Vertical literally is a one-click fix.

Step 11:

There's one more button we haven't tried yet, and that's the Full Upright correction (back in the Basic tab). Click on the Reset button (at the bottom of the Panels area) and when you click the Full button, it literally flattens the building out (as seen here). Once again, it's pretty amazing (but also, it's just pretty close—we'll need a little tweaking in the Manual tab to finish this one off).

Step 12:

Click back on the Manual tab and drag the Distortion slider over to +14 to get rid of the bowing-out lens distortion, and to keep the image from looking stretched, then drag the Aspect slider over to +34 (as seen here). Finally, drag the Vertical slider a bit to -18, then turn on the Constrain Crop checkbox, and now the image is looking normal. I put the original, Vertical correction and Full correction below.

Original image

Vertical Auto Correction

Full Auto Correction

Fixing Edge Vignetting

Vignetting is a lens problem that causes the corners of your photo to appear darker than the rest of the photo. This problem is usually more pronounced when you're using a wide-angle lens, but can also be caused by a whole host of other lens issues. Now, a little darkness in the edges is considered a problem, but many photographers (myself included) like to exaggerate this edge darkening and employ it as a lighting effect in portraits, which we covered in Chapter 4. Here's how to fix it if it happens to you:

Step One:

In the photo shown here, you can see how the corner areas look darkened and shadowed. This is the bad vignetting that I mentioned above.

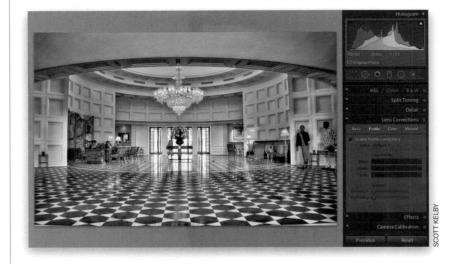

Step Two:

Scroll down to the Lens Corrections panel in the Develop module's right side Panels area, click on Profile at the top, then turn on the Enable Profile Corrections checkbox, and Lightroom will try to automatically remove the edge vignetting, based on the make and model of the lens you used (it learns all this from the EXIF data embedded in your image. See page 255 for more on how it reads this data). Since this image has no lens information, we have to tell it what make of lens it was (in this case, Nikon) in the Make pop-up menu. Then, choose the lens model, or one close to it. In this case, the profile for the 14–24mm lens (in the Model pop-up menu) works the best. If the image still needs a little correction (as this one does), you can try the Vignetting slider under Amount.

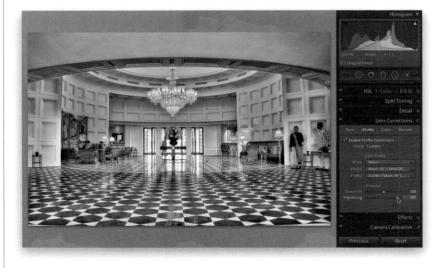

If you still think the automatic way isn't working well enough, you can do it manually by clicking on the Manual tab, and you'll see a section for Lens Vignetting at the bottom. There are two vignetting sliders here: the first controls the amount of brightening in the edge areas, and the second slider lets you adjust how far in toward the center of your photo the corners will be brightened. In this photo, the edge vignetting is pretty much contained in the corners, and doesn't spread too far into the center of the photo. So, start to slowly click-and-drag the Amount slider to the right, and as you do, keep an eye on the corners of your image. As you drag, the corners get brighter, and your job is to stop when the brightness of the corners matches the rest of the photo (as shown here). If the vignetting extends toward the center of the photo, drag the Midpoint slider to the left to make your brightening cover a larger area (as I did here). That's how easy removing this problem is.

Sharpening Your Photos

There are two types of sharpening you can do in Lightroom: The first is called capture sharpening (covered here), which is sharpening that would normally happen in your camera if you're shooting JPEG. If you shoot RAW, the sharpening in your camera is turned off, so we apply it in Lightroom instead (by default, all RAW photos have sharpening applied in Lightroom, but if you want more sharpening, or if you want to control which type of sharpening is applied, and how, then you definitely want to read this).

Step One:

In early versions of Lightroom, you had to view your image at a 1:1 (100%) view to be able to see the effects of sharpening, but now, not only can you view it at other magnifications, they've also improved the sharpening technology itself, so you can apply more sharpening without damaging your image. To sharpen your image, go to the Detail panel in the Develop module. There's a preview window in this panel that lets you zoom in tight on one area of the image, while you see the normal-size image in the main Preview area (if you don't see the preview window, click on the left-facing triangle to the right of Sharpening at the top of the panel).

Step Two:

To zoom in on an area in the preview window, just click your cursor on the spot you want to zoom in on. Once you've zoomed in, you can navigate around by clickingand-dragging inside the preview window. Although I use just the default 1:1 zoom, if you want to zoom in even tighter, you can Right-click inside the preview window, and choose a 2:1 view from the pop-up menu (shown here). Also, if you click the little icon in the upper-left corner of the panel (shown circled here in red), you can move your cursor over your main image in the center Preview area, and that area will appear zoomed in the preview window (to keep the preview on that area, just click on the area in the main image). To turn this off, click that icon again.

The Amount slider does just what you think it would—it controls the amount of sharpening applied to your photo. Here I increased the Amount to 90, and while the photo in the main Preview area doesn't look that much different, the Detail panel's preview looks much sharper (which is why it's so important to use this zoomed in preview). The Radius slider determines how many pixels out from the edge the sharpening will affect, and personally I leave this set at 1 (as seen here), but if I really need some mega sharpening I'll bump it up to 2.

TIP: Toggling Off the Sharpening If you want to temporarily toggle off the changes you've made in the Detail panel, just click on the little switch on the far left of the Detail panel's header.

Step Four:

One of the downsides of traditional sharpening in Photoshop is that if you apply a lot of sharpening, you'll start to get little halos around the edge areas within your photos (it looks like somebody traced around the edges with a small marker), but luckily, here in Lightroom, the Detail slider acts as kind of a halo prevention control. At its default setting of 25, it's doing quite a bit of halo prevention, which works well for most photos (and is why it's the default setting), but for images that can take a lot of sharpening (like sweeping landscape shots, architectural images, and images with lots of sharply defined edges, like the one you see here), you would raise the Detail slider up to around 75, as shown here (which kind of takes the protection off quite a bit and gives you a more punchy sharpening). If you raise the Detail slider to 100, it makes your sharpening appear very much like the Unsharp Mask filter in Photoshop (that's not a bad thing, but it has no halo avoidance, so you can't apply as much sharpening).

Step Five

The last sharpening slider, Masking, is to me the most amazing one of all, because what it lets you do is control exactly where the sharpening is applied. For example, some of the toughest things to sharpen are things that are supposed to be soft, like a child's skin, or a woman's skin in a portrait, because sharpening accentuates texture, which is exactly what you don't want. But, at the same time, you need detail areas to be sharp like their eyes, hair, eyebrows, lips, clothes, etc. Well, this Masking slider lets you do just that—it kind of masks away the skin areas, so it's mostly the detail areas that get sharpened. To show how this works, we're going to switch to a portrait.

Step Six:

First, press-and-hold the Option (PC: Alt) key and then click-and-hold on the Masking slider, and your image area will turn solid white (as shown here). What this solid white screen is telling you is that the sharpening is being applied evenly to every part of the image, so basically, everything's getting sharpened.

As you click-and-drag the Masking slider to the right, parts of your photo will start to turn black, and those black areas are now not getting sharpened, which is our goal. At first, you'll see little speckles of black area, but the farther you drag that slider, the more non-edge areas will become black—as seen here, where I've dragged the Masking slider over to 76, which pretty much has the skin areas in all black (so they're not being sharpened), but the detail edge areas, like the eyes, lips, hair, nostrils, and outline, are being fully sharpened (which are the areas still appearing in white). So, in reality, those soft skin areas are being automatically masked away for you, which is really pretty darn slick if you ask me.

Step Eight:

When you release the Option (PC: Alt) key, you see the effects of the sharpening, and here you can see the detail areas are nice and crisp, but it's as if her skin was never sharpened. Now, just a reminder: I only use this Masking slider when the subject is supposed to be of a softer nature, where we don't want to exaggerate texture. Okay, on the next page, we're going to switch back to the engine photo and finish up our sharpening there.

TIP: Sharpening a Smart Preview If you apply sharpening (or noise reduction) to a low-res smart preview of an image, the amount you apply might look just right. But, when you reconnect your hard drive, and it links to the original high-res file, that amount of sharpening (or noise reduction) will actually have much less of an effect. So, you might want to leave the sharpening (and noise reduction) for when you're working on the original file.

Step Nine:

Here, I reopened the engine photo and, at this point, you know what all four sliders do, so now it's down to you coming up with the settings you like. But if you're not comfortable with that guite yet, then take advantage of the excellent sharpening presets that are found in the Presets panel in the left side Panels area. If you look under the Lightroom Presets (the built-in ones), you'll find two sharpening presets: one called Sharpen - Scenic and one called Sharpen - Faces. Clicking the Scenic preset sets your Amount at 40, Radius at 0.8, Detail at 35, and Masking at 0 (see how it raised the detail level because the subject matter can take punchier sharpening?). The Faces one is much more subtle—it sets vour Amount at 35, Radius at 1.4, Detail at 15, and Masking at 60.

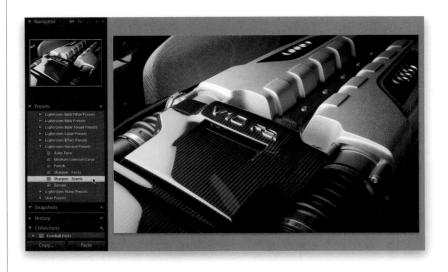

Step 10:

Here's the final before/after image. I started by clicking on the Sharpen - Scenic preset, then I increased the Amount to 125 (which is more than I usually use, but I pumped it up so you could see the results more easily here in the book). I set the Radius at 1.0 (which is pretty standard for me), the Detail at 75 (because a detailed photo like this can really take that punchy sharpening), and I left the Masking at 0 (because I want all the areas of the photo sharpened evenly—there are no areas that I want to remain soft and unsharpened). Now, at this point I'd save this setting as my own personal "Sharpening - High" preset, so it's always just one click away. (You learned how to do that back in Chapter 5.)

Sooner or later, you're going to run into a situation where some of the more contrasty edges around your subject have either a red, green, or more likely, a purple color halo or fringe around them (these are known as "chromatic aberrations"). You'll find these sooner (probably later today, in fact) if you have a really cheap digital camera (or a nice camera with a really cheap wide-angle lens), but even good cameras (and good lenses) can fall prey to this problem now and again. Luckily, it's easy enough to fix in Lightroom.

Fixing Chromatic Aberrations (a.k.a. That Annoying Color Fringe)

Step One:

Here I've zoomed in tight on the top of London's Victoria Tower. If you look at the close-up of that image here, it looks like someone traced around the left side with a thin purple marker and the right side with a pale green marker. If this is happening to one of your images, first go to the Lens Corrections panel and click on Basic at the top, then zoom in on an edge area with the color fringe (I zoomed in to 2:1), so you can see how your adjustments affect the edge.

Step Two:

At the top of the panel, turn on the Remove Chromatic Aberrations checkbox. If this doesn't fully do the trick, then try clicking on Color at the top of the panel. Under Defringe, drag the top Amount slider to the right a little to remove the purple fringe. Then, move the Purple Hue sliders, so any color left is between the two slider knobs. Do the same thing with the Green Hue and Amount sliders to get the results shown here.

Basic Camera Calibration in Lightroom

Some cameras seem to put their own color signature on your photos, and if yours is one of those, you might notice that all your photos seem a little red, or have a slight green tint in the shadows, etc. Even if your camera produces accurate color, you still might want to tweak how Lightroom interprets the color of your RAW images. The process for doing a full, accurate camera calibration is kinda complex and well beyond the scope of this book, but I did want to show you what the Camera Calibration panel is used for, and give you a resource to take things to the next level.

Step One:

Before we start, I don't want you to think that camera calibration is something everybody must do. In fact, I imagine most people will never even try a basic calibration, because they don't notice a big enough consistent color problem to worry about it (and that's a good thing. However, in every crowd there's always one, right?). So, here's a quick project on the very basics of how the Camera Calibration panel works: Open a photo, then go to the Develop module's Camera Calibration panel, found at the very bottom of the right side Panels area, as shown here (see, if Adobe thought you'd use this a lot, it would be near the top, right?).

Step Two:

The topmost slider is for adjusting any tint that your camera might be adding to the shadow areas of your photos. If it did add a tint, it's normally green or magenta—look at the color bar that appears inside the Tint slider itself. By looking at the color bar, you'll know which way to drag (for example, here I'm dragging the Tint slider away from green, toward magenta, to reduce any greenish color cast in the shadow areas, but the change in this particular photo is very subtle).

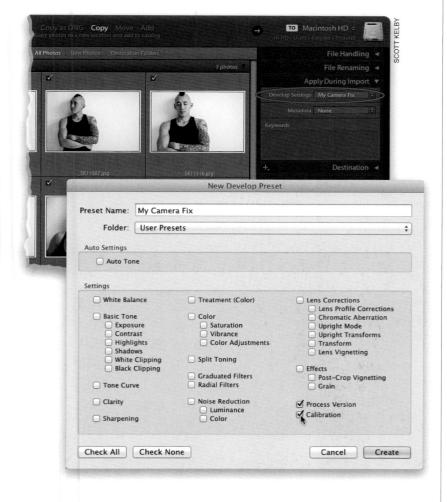

Step Three:

If your color problems don't seem to be in the shadows, then you'll use the Red, Green, and Blue Primary sliders to adjust the Hue and Saturation (the sliders that appear below each color). Let's say your camera produces photos that have a bit of a red cast to them. You'd drag the Red Primary Hue slider away from red, and if you needed to reduce the overall saturation of red in your photo, you'd drag the Red Primary Saturation slider to the left until the color looked neutral (by neutral, I mean the grays should look really gray, not reddish gray).

Step Four:

When you're happy with your changes, press **Command-Shift-N** (**PC: Ctrl-Shift-N**) to bring up the New Develop Preset dialog. Name your preset, click the Check None button, then turn on the Calibration and Process Version checkboxes, and click Create. Now, not only can you apply this preset in the Develop module and Quick Develop panel, you can have it applied to all the photos you import from that camera by choosing it from the Develop Settings pop-up menu in the Import window (also shown here).

Note: If you want to tackle the full camera calibration process (which is not for wusses by the way, as it's got quite a few steps and hoops you have to jump through), go to www.LightroomKillerTips.com and in the search field, enter "Camera Calibration" and you'll find a link to Matt Kloskowski's video (which he created for me as a supplement to this book), which covers the entire process in detail.

Lightroom Killer Tips > >

Using the Detail Panel's Preview for Cleaning Up Spots

The Detail panel's preview window was designed to give you a 100% (1:1) view of your image, so you can really see the effects of your sharpening and noise adjustments. But it's also great to keep it open when you're removing spots, because you leave the main image at Fit in Window size, and still see the area you're fixing up close in the Detail panel's preview window.

▼ You Can Always Start Over— Even with Virtual Copies

Since none of your edits in Lightroom are applied to the real photo, until you actually leave Lightroom (by jumping over to Photoshop, or exporting as a JPEG or TIFF), you can always start over by pressing the Reset button at the bottom

of the right side Panels area. Better yet, if you've been working on a photo and make a virtual copy, you can even reset the virtual copy to how the image looked when you first brought it into Lightroom.

▼ Another Noise Reduction Strategy

The Noise Reduction section, in the Detail panel, does a pretty good job, but if you're not happy with it or it's not

working for you, try what I've done in previous versions of Lightroom: jump over to Photoshop and use a plug-in called Noiseware, which does just an amazing job. You can download a trial copy from their website at www.imagenomic.com and install it in Photoshop (so, you'd jump from Lightroom to Photoshop, run the Noiseware plug-in using their excellent built-in presets, and then save the file to come back into Lightroom).

▼ What to Do If You Can't See Your Adjustment Brush

If you start painting and can't see the brush or the pins it creates, go under the Tools menu, under Tool Overlay, and choose **Auto Show**. That way, the pins

disappear when you move the cursor outside your photo, but then if you move your cursor back over it again to start painting, they reappear.

▼ How I Use the Upright Feature in Real Life

Although I described here in the book what each of the Upright automated corrections do so you can choose the right one, in real life, it's just easier to click on each of the four buttons and choose the one that looks best. It takes like all of four seconds to try all four, so rather than trying to logically decide

which of the four would make the proper correction, just try each of them and choose the one that looks best to you. Simple enough.

▼ The Constrain Crop Gotcha in Upright

I love the Constrain Crop feature because when I turn it on, it automatically crops away any white border areas left over from Upright's automated correction. However, there's a little gotcha: If I decide I don't like the way it cropped the image (or I want to see more of the top or sides of my image), just turning off the Constrain Crop checkbox won't let me do that. In fact, turning it off (once it was on) doesn't do anything at all. You have to turn it off, then click on the Crop Overlay tool up in the toolbox, and only then does it show you the entire pre-cropped image with the cropping border, so you can crop it yourself. Thought you'd want to know that one.

▼ Auto Upright Auto Crops for You

When you click the Upright Auto button for correcting a perspective problem, you're basically saying, "Do it all for me," so it usually will automatically crop the image down to size, as though you had Constrain Crop turned on (even if you don't). By the way, you noticed I said it "usually" will automatically crop. Sometimes, depending the image, it doesn't. One more thing: if it does auto crop, you

Develop

Rook

can no longer adjust the cropping at all—even if you click on the Crop Overlay tool, it won't show you the original uncropped image. You can only crop what's left tighter, unless you go back to Upright and either turn it off or choose a different Upright Auto correction, like Vertical or Full. It's weird. I know.

▼ Keeping Your Own Cropping in Place and Still Using Upright

This tip actually appears in the Upright panel itself, but I talk to so many people who have missed it there that I thought it was worth mentioning. If you've cropped an image already, and then you use

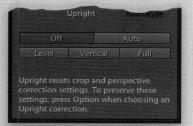

Upright, it automatically removes your cropping. If you want to keep your cropping in place and still use Upright, pressand-hold the Option (PC: Alt) key, and then click on one of the Upright buttons.

▼ New Common Print Sizes Cropping Overlay

Lightroom has had different cropping overlays, like a grid, the rule of thirds, the golden spiral, and so on, but in Lightroom 5, there's an important new one that shows you print aspect overlays (like a 5x7 crop, a 2x3, etc.). To get to

this Aspect Ratios overlay, get the Crop Overlay tool, then press the letter **O** until you see the overlay with the ratios appearing.

▼ Customizing the Crop Overlay Tool's Aspect Ratio

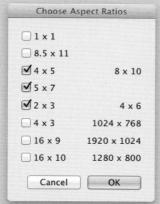

You're not stuck with the print size ratios Adobe chose for the Crop Overlay tool's new Aspect Ratios overlay. Choose the ratios you want to see by going under the Tools menu (in the Develop module), under Crop Guide Overlay, and selecting **Choose Aspect Ratios** to bring up a dialog where you can choose which of the preset sizes you'd like displayed.

▼ Hiding Crop Overlays You Don't Use

If you have the Crop Overlay tool active, each time you press the letter O, it toggles you through another one of the crop overlays (Thirds, Golden Spiral, the new Aspect Ratios overlay, and so on), but if you find there are some of them you don't ever use, you can hide them (that way, it takes less time to toggle through them to get to the one you actually want, right?). Just go under the Tools menu, under Crop Guide Overlay, and select **Choose Overlays to Cycle** to bring up a dialog where you can choose which of the Overlays you want to hide.

▼ Deleting Multiple Spot Repairs at the Same Time

If you've repaired multiple areas of your photo using the Spot Removal tool (maybe you used it to remove sensor dust on your image, or a spot or speck on your lens that now shows up on your image), you can remove any individual spot repair by pressing-and-holding the Option (PC: Alt) key and clicking on that individual spot. To remove multiple edits at once, press-and-hold the Option key, but then click-and-drag out a selection around the repairs you want to remove, and it instantly removes all those edits inside that selected area. If you want to remove all your repairs at once, just hit the Reset button at the bottom of the Spot Removal tool panel.

▼ Have Lightroom Remember Your Zoom Position

If you want Lightroom to remember the amount of zoom and the zoom location between images, go under the View menu and choose **Lock Zoom Position**. Now, as you swap between images and click to zoom, it will zoom to the same amount and position automatically. Helpful when you're comparing the same area between multiple images.

View	Window	Help	7
Hide Toolbar			Т
	e Loupe Vi gle Zoom \		Z
Zoom In			₩=
Zoom Out			೫
✓ Lock	Zoom Pos	ition 🖟	û#=
∠Loui	ne _		_ D

The Adobe Photoshop Lightroom 5 Book for Digital Photographers

Photo by Scott Kelby Exposure: 1/5 sec Focal Length: 28mm Aperture Value: f/7.1

EXPORTING IMAGES saving JPEGs, TIFFs, and more

Man, if there's a more exciting chapter than one on how to save a JPEG. I can't wait to see it, because this has to be some really meaty stuff. Okay, I'll be the first to admit that while this may not seem like an incredibly exciting chapter, it's about much, much more than saving JPEGs. That's right—it's also about saving TIFFs. Okay, I gotcha on that one (come on—you know I did), but in reality there is more to this process than you might think, so if you spend just a few minutes now reading this short chapter, I promise you it will pay off in saved time and increased productivity in the future. Now, at this point you might be thinking, "Hey Scott, that last part was actually somewhat helpful. What's that doing in a chapter intro?" I honestly don't know how that snuck in here, but I can tell you this (and I'm being

totally truthful here), it's really late at night as I write this, and sometimes if I'm not really paying attention, some actual useful information winds up sneaking into one of these chapter intros, rendering them totally useless. I do my best to make sure that these chapter intros are completely unfettered (I can't tell you how few times I've been able to use the word "unfettered" in a sentence, so I'm pretty psyched right now), but sometimes, against my better judgment, everything just starts to make sense, and before you know it—something useful happens. I try to catch these in the editing process by copying-and-pasting the entire chapter intro into the Pimp Name Generator (that's four times in one book. Cha-ching!), and then those results get copied-and-pasted back here as the final edited version for print. See, I do care. Pimp!

Saving Your Photos as JPEGs

Since there is no Save command for Lightroom (like there is in Photoshop), one of the questions I get asked most is, "How do you save a photo as a JPEG?" Well, in Lightroom, you don't save it as a JPEG, you export it as a JPEG (or a TIFF, or a DNG, or a Photoshop PSD). It's a simple process, and Lightroom has added some automation features that can kick in once your photo is exported.

Step One:

You start by selecting which photo(s) you want to export as a JPEG (or a TIFF, PSD, or DNG). You can do this in either the Library module's Grid view or down in the Filmstrip in any other module by Command-clicking (PC: Ctrl-clicking) on all the photos you want to export (as shown here).

Step Two:

If you're in the Library module, click on the Export button at the bottom of the left side Panels area (circled here in red). If you're in a different module and using the Filmstrip to select your photos for export, then use the keyboard shortcut Command-Shift-E (PC: Ctrl-Shift-E). Whichever method you choose, it brings up the Export dialog (shown in the next step).

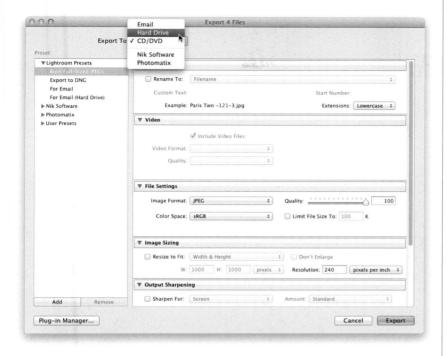

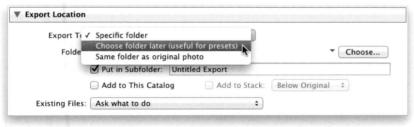

Choose where to save your exported images from the Export To pop-up menu

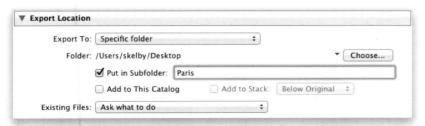

Turn on the Put in Subfolder checkbox to save your images in a separate subfolder

Step Three:

Along the left side of the Export dialog. Adobe put some Export presets, which are basically designed to keep you from having to fill out this entire dialog every time from scratch. It ships with a few presets from Adobe, but the real power of this is when you create your own (those will appear under the User Presets header). The built-in Lightroom Presets are at least a good starting place to build your own, so for now click on Burn Full-Sized JPEGs, and it fills in some typical settings someone might use to export their photos as JPEGs and burn them to a disc. However, we'll customize these settings so our files are exported where and how we want them, then we'll save our custom settings as a preset, so we don't have to go through all this every time. If, instead of burning these images to disc, you just want to save these JPEGs in a folder on your computer, go to the top of the dialog, and from the Export To pop-up menu, choose Hard Drive, as shown here.

Step Four:

Let's start at the top of the dialog: First, you need to tell Lightroom where to save these files in the Export Location section. If you click on the Export To pop-up menu (as shown here, at top), it brings up a list of likely places you might choose to save your files. The second choice (Choose Folder Later) is great if you're making presets, because it lets you choose the folder as you go. If you want to choose a folder that's not in this list, choose Specific Folder, then click the Choose button to navigate to the folder you want. You also have the option of saving them into a separate subfolder, like I did here, at the bottom. So, now my images will appear in a folder named "Paris" on my desktop. If these are RAW files and you want the exported JPEGs added into Lightroom, turn on the Add to This Catalog checkbox.

Step Five:

The next section down, File Naming, is like the file naming feature you learned about back in the Importing chapter. If you don't want to rename the files you're exporting, but want to keep their current names, leave the Rename To checkbox turned off, or turn it on and choose Filename from the pop-up menu. If you do want to rename the files, choose one of the built-in templates, or if you created a custom file naming template (we learned this back in Chapter 1), it will appear in this list, too. In our example, I chose Custom Name - Sequence (which automatically adds a sequential number, starting at 1, to the end of my custom name). Then, I simply named these shots "Paris," so the photos will wind up being named Paris-1, Paris-2, and so on. There's also a pop-up menu for choosing whether the file extension appears in all uppercase (.JPG) or lowercase (.jpg).

Step Six:

Let's say you're exporting an entire collection of images, and inside that collection are some video clips that were shot with your DSLR. If you want them included in your export, in the Video section, turn on the Include Video Files checkbox (shown here). Below that checkbox, you'll choose the video format (H.264 is really compressed, and is for playing on a mobile device; DPX is usually for visual effects). Next, choose your video Quality: Max will keep the quality as close to your original video as possible, and High is still good, but may be slower. Choose Medium if you're going to post it to the web, or if you're planning to view it on a high-end tablet. Choose Low for viewing on all other mobile devices. You can see the differences between your format and quality choices by watching the Target size and speed listed to the right of the Quality pop-up menu. Of course, if you don't have any videos chosen when you export, this section will be grayed out.

File Naming				
✓ Rename To:	Custom Name - Sequence	namentalis and a second second		÷
Custom Text:	Paris	Start Number:	1	
Example:	Paris-1.jpg	Extensions:	Lowercase	;

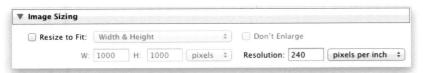

You can skip the Image Sizing section altogether, unless you need to make the image you're saving smaller than its original size

Step Seven:

Under File Settings, you choose which file format to save your photos in from the Image Format pop-up menu (since we chose the Burn Full-Sized JPEGs preset, JPEG is already chosen here, but you could choose TIFF, PSD, DNG, or if you have RAW files, you could choose Original to export the original RAW photo). Since we're saving as a JPEG, there's a Quality slider (the higher the quality, the larger the file size), and I generally choose a Quality setting of 80, which I think gives a good balance between quality and file size. If I'm sending these files to someone without Photoshop, I choose sRGB as my color space. If you chose a PSD, TIFF, or DNG format, their options will appear (you get to choose things like the color space, bit depth, and compression settings).

Step Eight:

By default, Lightroom assumes that you want to export your photos at their full size. If you want to make them smaller, in the Image Sizing section, turn on the Resize to Fit checkbox, then type in the Width, Height, and Resolution you want. Or you can choose to resize by pixel dimensions, the long edge of your image, the short edge of your image, or the number of megapixels in your image from the top pop-up menu.

Step Nine:

Also, if these images are for printing in another application, or will be posted on the web, you can add sharpening by turning on the Sharpen For checkbox in the Output Sharpening section. This applies the right amount of sharpening based on whether they're going to be seen only onscreen (in which case, you'll choose Screen) or printed (in which case, you'll choose the type of paper they'll be printed on—glossy or matte). For inkjet printing, I usually choose High for the Amount, which onscreen looks like it's too much sharpening, but on paper looks just right (for the web, I choose Standard).

Step 10:

In the Metadata section, you start by choosing what metadata you want to be exported with your images: everything, everything but your camera and Camera Raw data (this hides all your exposure settings, your camera's serial numbers, and other stuff your clients probably don't need to know), just your copyright and contact info (if you're including your copyright, you probably want to include a way for people to contact you if they want to use your photo), or just your copyright. If you choose All Metadata or All Except Camera & Camera Raw Info, you can still have Lightroom remove any GPS data by turning on the Remove Location Info checkbox.

The next section down lets you add a visible watermark to the images you're exporting (watermarking is covered in detail in the next project), and to add your watermark to each image you're exporting, turn on the Watermark checkbox, then choose a simple copyright or your saved watermark from the pop-up menu.

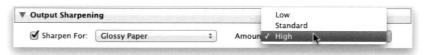

You can add Output Sharpening for wherever these images will be viewed, either onscreen (on the web or in a slide show), or on a print

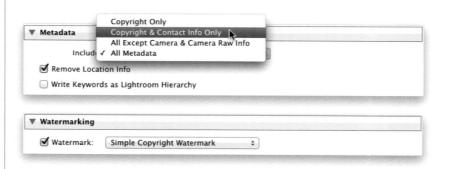

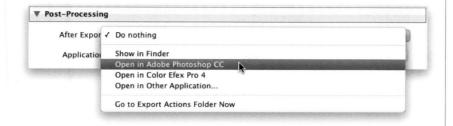

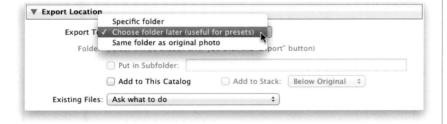

Step 11:

The final section, Post-Processing, is where you decide what happens after the files are exported from Lightroom. If you choose Do Nothing (from the After Export pop-up menu), they just get saved into that folder you chose back in the beginning. If you choose Open in Adobe Photoshop, they'll automatically be opened in Photoshop after they're exported. You can also choose to open them in another application or in a Lightroom plug-in. Go to Export Actions Folder Now opens the folder where Lightroom stores your export actions. So, if you want to run a batch action from Photoshop, you could create a droplet and place it in this folder. That droplet would then show up in the After Export pop-up menu, and choosing it would open Photoshop and run your batch action on all the photos you were exporting from Lightroom. (Note: I show you how to create a batch action in Chapter 9 on page 318.)

Step 12:

Now that you've customized things the way you want, let's save these settings as your own custom preset. That way, the next time you want to export a JPEG, you don't have to go through these steps again. Now, there are some changes I would suggest that would make your preset more effective. For example, if you saved this as a preset right now, when you use it to export other photos as JPEGs, they'll be saved in that same Paris folder. Instead, this is where it's a good idea to select Choose Folder Later (in the Export Location section, as shown here), like we discussed back in Step Four.

Step 13:

If you know you always want your exported JPEGs saved in a specific folder, then in the Export Location section, click the Choose button, and choose that folder. Now, what happens if you go to export a photo as a JPEG into that folder, and there's already a photo with the same name in it (maybe from a previous export)? Should Lightroom just automatically overwrite this existing file with the new one you're exporting now, or do you want to give this new file a different name, so it doesn't delete the file already in that folder? You get to choose how Lightroom handles this problem using the Existing Files pop-up menu (shown here). I pick

Choose a New Name for the Exported File (as seen here). That way, I don't accidentally overwrite a file I meant to keep. By the way, when you choose Skip, if it sees a file already in that folder with the same name, it doesn't export the JPEG image—instead, it just skips it.

TIP: Rename Files When Using a Preset

Before you export your photos, make sure you give your files a new custom name, or the shots from your hockey game will be named Paris-1.jpg, Paris-2.jpg, and so on.

Step 14:

Now you can save your custom settings as a preset: click the Add button at the bottom-left corner of the dialog (shown circled here in red), and then give your new preset a name (in this case, I used Hi-Res JPEGs/Save to Hard Drive. That name lets me know exactly what I'm exporting, and where they're going).

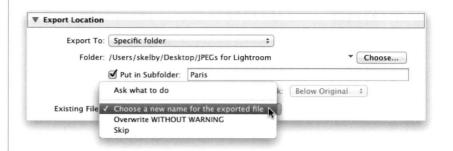

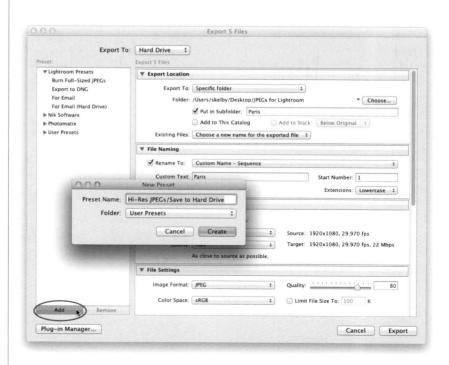

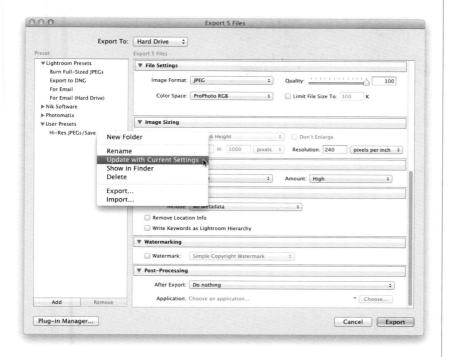

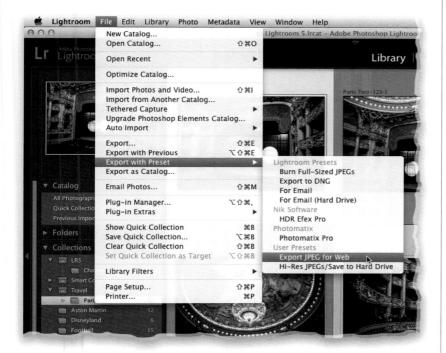

Step 15:

Once you click the Create button, your preset is added to the Preset section (on the left side of the dialog, under User Presets), and from now on you're just one click away from exporting JPEGs your way. If you decide you want to make a change to your preset (as I did in this case, where I changed the Color Space to ProPhoto RGB, and I turned the Watermark checkbox off), you can update it with your current settings by Right-clicking on your preset, and from the pop-up menu that appears, choosing **Update** with Current Settings (as shown here).

While you're here, you might want to create a second custom preset—one for exporting JPEGs for use in online web galleries. To do that, you might lower the Image Sizing Resolution setting to 72 ppi, change your sharpening to Screen, set Amount to Standard, and you might want to turn the Watermark checkbox back on to help prevent misuse of your images. Then you'd click the Add button to create a new preset named something like Export JPEG for Web.

Step 16:

Now that you've created your own presets, you can save time and skip the whole Export dialog thing altogether by just selecting the photos you want to export, then going under Lightroom's File menu, under **Export with Preset**, and choosing the export preset you want (in this example, I'm choosing the Export JPEG for Web preset). When you choose it this way, it just goes and exports the photos with no further input from you. Sweet!

Adding a Watermark to Your Images

If your images are going on the web, there's not much to keep folks from taking your images and using them in their own projects (sadly, it happens every day). One way to help limit unauthorized use of your images is to put a visible watermark on them. That way, if someone rips them off, it'll be pretty obvious to everyone that they've stolen someone else's work. Also, beyond protecting your images, many photographers are using a visible watermark as branding and marketing for their studio. Here's how to set yours up:

Step One:

To create your watermark, press **Command-Shift-E** (**PC: Ctrl-Shift-E**) to bring up the Export dialog, then scroll down to the Watermarking section, turn on the Watermark checkbox, and choose **Edit Watermarks** from the pop-up menu (as shown here). *Note:* I'm covering watermarking here in the Export chapter, because you can add your watermark when you're exporting your images as JPEGs, TIFFs, etc., but you can also add these watermarks when you print an image (in the Print module), or put it in a web gallery (in the Web module).

Step Two:

This brings up the Watermark Editor (seen here), and this is where you either (a) create a simple text watermark, or (b) import a graphic to use as your watermark (maybe your studio's logo, or some custom watermark layout you've created in Photoshop). You choose either Text or Graphic up in the top-right corner (shown circled here in red). By default, it displays the name from your user profile on your computer, so that's why it shows my copyright down in the text field at the bottom of the dialog. The text is also positioned right up against the bottom and left borders of your image, but luckily you can have it offset from the corners (I'll show you how in Step Four). We'll start by customizing our text.

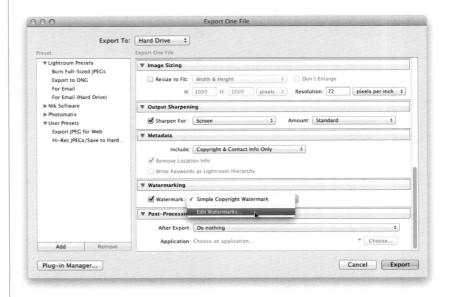

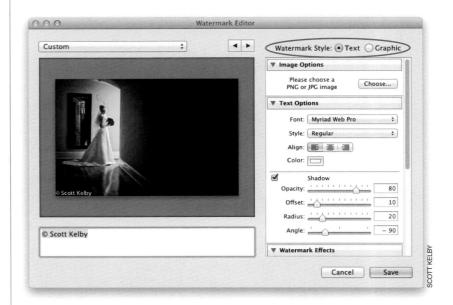

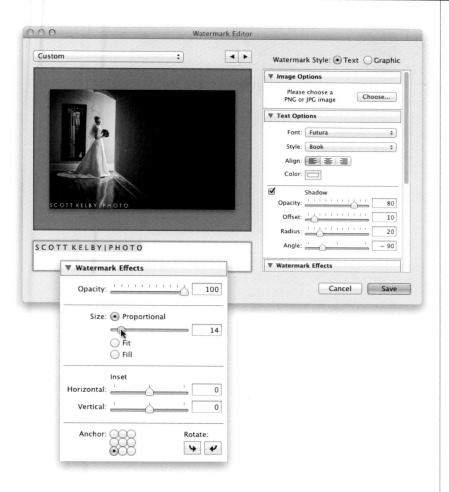

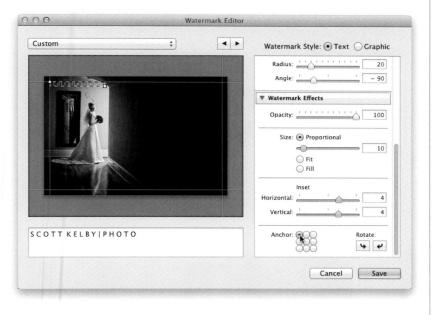

Step Three:

Type in the name of your studio in the text field at the bottom left, then choose your font in the Text Options section on the right side of the dialog. In this case, I chose Futura Book. (By the way, the little line that separates SCOTT KELBY from PHOTO is called a "pipe," and you create one by pressing Shift-Backslash.) Also, to put some space between the letters, I pressed the Spacebar after each one. You also can choose the text alignment (left justified, centered, or right justified) here, and you can click on the Color swatch to choose a font color. To change the size of your type, scroll down to the Watermark Effects section, where you'll find a Size slider (seen here) and radio buttons to Fit your watermark to the full width of your image, or Fill it at full size. You can also move your cursor over the type on the image preview and corner handles appear click-and-drag outward to scale the text up, and inward to shrink it down.

Step Four:

You get to choose the position of your watermark in the Watermark Effects section. At the bottom of the section, you'll see an Anchor grid, which shows where you can position your watermark. To move it to the upper-left corner, click the upper-left anchor point (as shown here). To move it to the center of your image, click the center anchor point, and so on. To the right of that are two Rotate buttons if you want to switch to a vertical watermark. Also, back in Step Two, I mentioned there's a way to offset your text from the sides of your image—just drag the Horizontal and Vertical Inset sliders (right above the Anchor grid). When you move them, little positioning guides will appear in the preview window, so you can easily see where your text will be positioned. Lastly, the Opacity slider at the top of the section controls how seethrough your watermark will be.

Continued

Step Five:

If your watermark is going over a lighter background, you can add a drop shadow using the Shadow controls in the Text Options section. The Opacity slider controls how dark the shadow will be. The Offset is how far from the text your shadow will appear (the farther you drag to the right, the farther away the shadow will be). The Radius is Adobe's secret code name for softness, so the higher you set the Radius, the softer your shadow will become. The Angle slider is for choosing where the shadow appears, so the default setting of -90 puts the shadow down and to the right. A setting of 145 puts it up and to the left, and so on. Just drag it, and you'll instantly see how it affects the position of your shadow. The best way to see if the shadow really looks better or not is to toggle the Shadow checkbox on/off a couple of times.

Step Six:

Now let's work with a graphic watermark, like your studio's logo. The Watermark Editor supports graphic images in either JPEG or PNG format, so make sure your logo is in one of those two formats. Scroll back up to the Image Options section, and where it says Please Choose a PNG or JPEG Image, click the Choose button, find your logo graphic, then click Choose, and your graphic appears (unfortunately, the white background behind the logo is visible, but we'll deal with that in the next step). It pretty much uses the same controls as when using text—go to the Watermark Effects section and drag the Opacity slider to the left to make your graphic see-through, and use the Size slider to change the size of your logo. The Inset sliders let you move your logo off the edges, and the Anchor grid lets you position the graphic in different locations on your image. The Text Options and Shadow controls are grayed out, since you're working with a graphic.

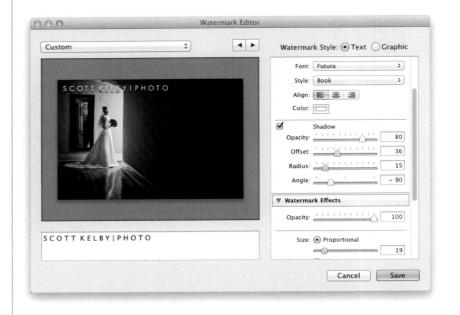

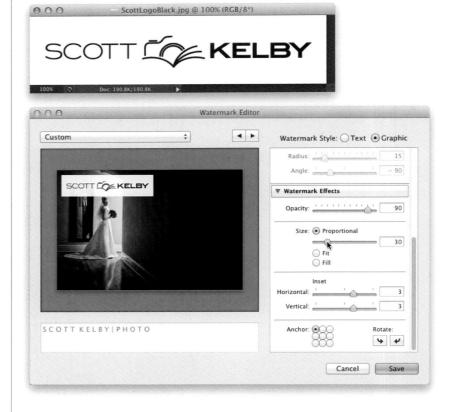

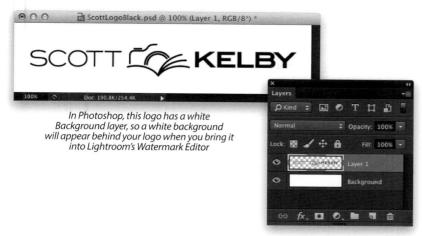

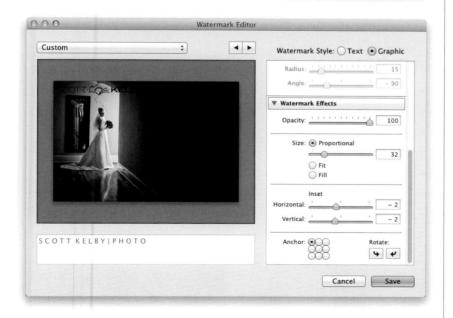

Step Seven:

To make that white background transparent, you have to open the layered file of your logo in Adobe Photoshop and do two things: (1) Delete the Background layer by dragging it onto the Trash icon at the bottom of the Layers panel, leaving just your graphics (and text) on their own transparent layers (as shown here at the bottom). Then, (2) save the Photoshop document in PNG format. This saves a separate file, and the file appears flattened, but the background behind your logo will be transparent.

Step Eight:

Now choose this new PNG logo file (in the Image Options section of the Watermark Editor), and when you import it, it appears over your image without the white background (as seen here). Now you can resize, reposition, and change the opacity of your logo graphic in the Watermark Effects section. Once you get it set up the way you want it, you should save it as a watermark preset (so you can use it again, and you can apply it from the Print and Web modules). You do that by clicking the Save button in the bottom right or choosing Save Current Settings as New Preset from the pop-up menu in the top-left corner of the dialog. Now your watermark is always just one click away.

Emailing Photos from Lightroom

Back in Lightroom 3 (and earlier versions), if you wanted to email images from Lightroom, it was...well...it was a workaround. You had to jump through a lot of hoops (creating aliases/shortcuts to your email program, and placing those inside one of Lightroom's folders, and on and on). It kinda worked, but it was kinda clunky. Luckily, now, it's built right in, and it couldn't be easier.

Step One:

In the Grid view, Command-click (PC: Ctrl-click) on the images you want to email. Now, go under the File menu and choose **Email Photos** (as shown here), or just press the shortcut **Command-Shift-M** (**PC: Ctrl-Shift-M**) to bring up Lightroom's email dialog (shown in the next step).

Step Two:

Here's where you enter the email address of the person you want to email the images to and type in the subject line of your email, and it chooses your default email application (but you can choose a different email application if you like from the From popup menu). You'll also see the thumbnails of the images you just selected in Lightroom's Grid view.

TIP: What If Your Email App Isn't Listed? Then, from the From pop-up menu, choose Go to Email Account Manager. There, click the Add button (in the bottom left) and when the New Account dialog appears, choose your email provider from the Service Provider pop-up menu (you'll see AOL, Gmail, Hotmail, etc.). If yours isn't listed there, then choose Other, and you'll have to add the server settings yourself. Now, add your email address and password in the Credential Settings section (it will verify that it's correct), and your email server will be added to your From pop-up menu.

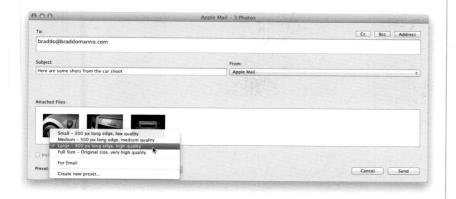

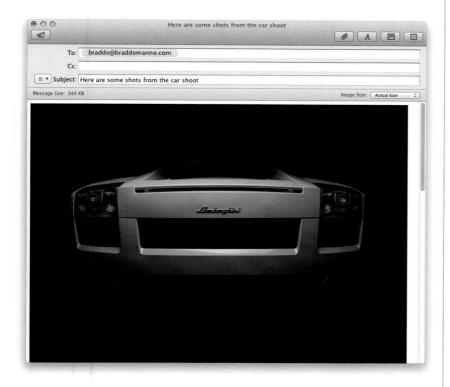

Step Three:

You also get to choose the physical size of the images you're emailing (after all, if you attach enough of them at their full resolution size, chances are your recipient's email will bounce them back for being too large). There are four builtin size presets you can choose from the pop-up menu in the bottom-left corner of the dialog (as shown here), where you can choose both the size and quality. If you've created any presets for emailing, those will appear here, too, or if you want to create one now, choose Create New Preset at the bottom of the menu, and it brings up the Standard Export dialog. Just enter the settings you want, save it as a preset (click the + [plus sign] button in the bottom-left corner of the Export dialog), and now that preset will appear in your email Preset pop-up menu.

Step Four:

When you click the Send button, it launches your email program, fills in all the info you entered in the Lightroom email dialog (address, subject, and so on), and then it attaches your images at the size and quality you selected. You have only one click to go—hit the Send button in your email program and off it goes.

TIP: Using the Two Email Presets Adobe has two email presets already included in Lightroom 5's Export dialog: one that just brings up the regular email dialog you just learned about (that one is called "For Email"), and the other simply saves your images to your hard drive for you to email later (manually). To save the images for emailing later, go under the File menu, under Export with Preset, and choose For Email (Hard Drive). It asks which folder you want to save your images into, you choose one, and then it literally just saves the images there as JPEGs at a small size (640x640 pixels at a quality setting of 50).

Exporting Your Original RAW Photo

So far, everything we've done in this chapter is based on us tweaking our photo in Lightroom and then exporting it as a JPEG, TIFF, etc. But what if you want to export the original RAW photo? Here's how it's done, and you'll have the option to include the keywords and metadata you added in Lightroom—or not.

Step One:

First, click on the RAW photo you want to export from Lightroom. When you export an original RAW photo, the changes you applied to it in Lightroom (including keywords, metadata, and even changes you made in the Develop module) are saved to a separate file called an XMP sidecar file, since you can't embed metadata directly into the RAW file itself (we talked about this in Chapter 2), so you need to treat the RAW file and its XMP sidecar file as a team. Now press Command-Shift-E (PC: Ctrl-Shift-E) to bring up the Export dialog (shown here). Click on Burn Full-Sized JPEGs just to get some basic settings. From the Export To pop-up menu up top, choose Hard Drive, then, in the Export Location section, choose where you want this original RAW file saved to (I chose my desktop). In the File Settings section, from the Image Format pop-up menu, choose Original (shown circled here in red). When you choose to export the original RAW file, most of your other choices are grayed out.

TIP: Saving Your RAW Photo as a DNG From the Image Format pop-up menu, choose **DNG** to bring up the DNG options. Embed Fast Load Data affects how fast the preview appears in the Develop module (it adds a little size to your file). Use Lossy Compression does to RAW images what JPEG compression does to other images—it tosses some info to give you files that are around 75% smaller in size (good for archiving the images the client didn't pick, but you don't want to delete).

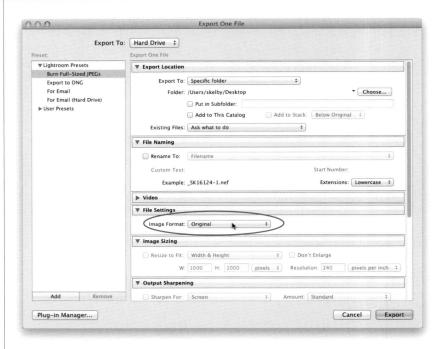

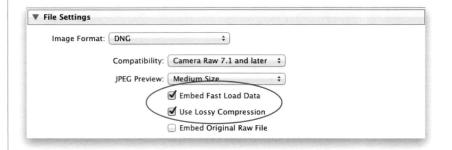

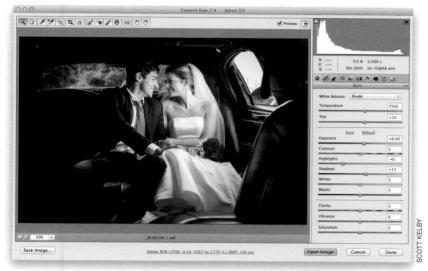

Here's the cropped image with white balance, exposure, highlights, and shadows adjustments, when you include the XMP sidecar file

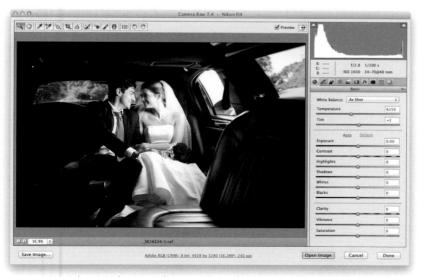

Here's the original uncropped image, without white balance, exposure, highlights, or shadows adjustments, when you don't include the XMP sidecar file

Step Two:

Now click Export, and since there's no processing to be done, in just a few seconds your file appears on your desktop (or wherever you chose to save it)—you'll see your file and its XMP sidecar (with the same exact name, but XMP as its file extension) right nearby (as seen here, on my desktop). As long as these two stay together, other programs that support XMP sidecar files (like Adobe Bridge and Adobe Camera Raw, for example) will use that metadata, so your photo will have all the changes you applied to it. If you send this file to someone (or burn it to disc). make sure you include both files. If you decide you want the file to not include your edits, just don't include the XMP file with it.

Step Three:

If you export the original RAW file and send it to someone with Photoshop, when they double-click on it, it will open in Camera Raw, and if you provided the XMP file, they'll see all the edits you made in Lightroom, as seen in the top image shown here, where the photo was cropped, and the white balance, exposure, highlights, and shadows were adjusted. The bottom image shown here is what they'll see in Camera Raw when you don't include the XMP file—it's the untouched original file with none of the changes I made in Lightroom.

Publish Your Images with Just Two Clicks

If you upload your images pretty regularly to sites like Flickr or Facebook, or maybe you just save them to other hard drives, or even to your iPhone, there's a drag-and-drop way to automate the process. Beyond that, it also helps you keep track of your published images, so the most recent versions of them are the ones that are published. This feature is called Publish Services, and if you take just a few minutes to set this up now, it'll save you a load of time whenever you want to post images online, or save images to your hard drive or external hard drive.

Step One:

The Publish Services panel is in the Library module's left side Panels area. By default, it has four templates you can set up: (1) your hard drive, (2) Behance, (3) Facebook, and (4) Flickr. Set these up by clicking on the Set Up button on the right side of each. Here, we'll start with the Flickr process, which is the most complicated, and at the end, we'll take a quick look at setting up your hard drive. The Behance and Facebook processes are pretty similar to Flickr's—click the Set Up button, authorize your account, and you're pretty much good to go. So, click on Set Up next to Flickr.

Step Two:

The main section of the Lightroom Publishing Manager dialog looks like the Export dialog, with two exceptions: (1) near the top, there are Publish Service, and Flickr Account and Title sections, and (2) at the bottom are Flickr's Privacy and Safety options. Start up top by clicking the Authorize button, and a dialog appears (shown on the bottom left) asking you to click another Authorize button to jump over to the Flickr website, so you can log in and give Flickr permission to work with Lightroom, so go ahead and click Authorize. Now the dialog changes to tell you that once you're done at Flickr.com, you need to come back to Lightroom to finish setting everything up (shown on the bottom right).

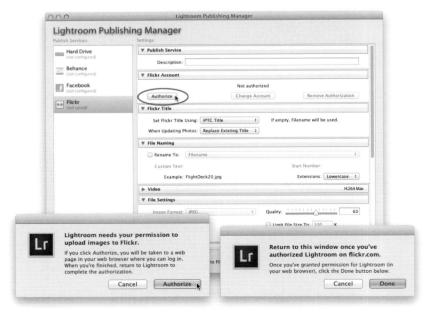

Develop

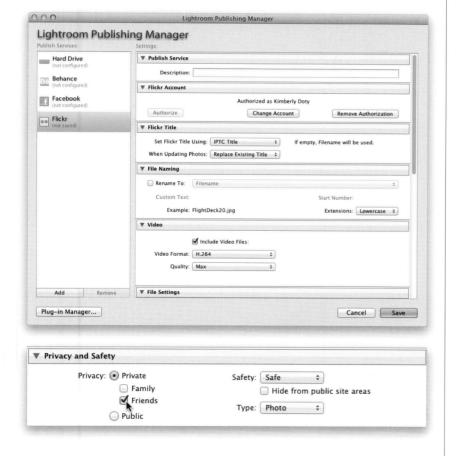

Step Three:

Once you log into your Yahoo account and get to Flickr (if you don't already have a Flickr account, and want to use this feature, go ahead and at least sign up for their free account through Yahoo), you'll find a page with something similar to what you see here, asking you to authorize Flickr to talk back and forth to Lightroom. Once you do, you'll get a confirmation page. Now, back to the Lightroom part.

Step Four:

Once you're done on the Flickr approval page, go back to Lightroom, and click Done in that dialog we saw in Step Two. Now all you have to do is set up the export options like usual (choosing your file format, whether you want sharpening added, watermarking added, etc.), but when you get to the bottom, you'll see options for Flickr's Privacy and Safety control (shown here at the bottom) for the images you're going to upload, so make your choices there now, then click the Save button to save this setup as your Flickr Publish Service.

TIP: Download More Plug-Ins from Adobe

You can add more Publish Services and Export plug-ins by clicking on the Find More Services Online button at the bottom of the Publish Services panel to take you to the Adobe Exchange website. Once downloaded and installed, a new Publish Service will show up below your others. To install an Export plug-in, in the Lightroom Plug-In Manager, click Add below the list on the left, locate your downloaded plug-in, and click the Add Plug-In button. You can access it in the Export To pop-up menu at the top of the Export dialog.

Step Five:

Now select the photos that you'd like to publish to Flickr, and drag-and-drop them onto the Flickr Photostream in the Publish Services panel (you'll see Photostream appear right underneath Flickr, shown here). Once you've dragged them into this collection (yup, it's a collection), click directly on Photostream (as shown here) and you'll see that the images you just dragged there are waiting to be published (they're not actually published to Flickr until you click the Publish button at the bottom of the left side Panels area or the top of the center Preview area). What's nice about this is it lets you gather up as many photos, from as many different collections as you'd like, and then publish them all at once with just one click. But for our example here, we'll assume that you just want to publish these four final images.

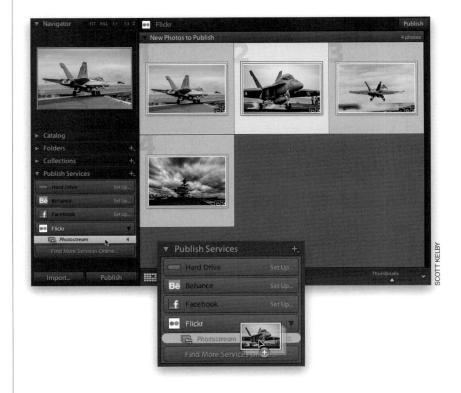

Step Six:

Click the Publish button now, and a split-screen appears in the Preview area, with the four New Photos to Publish appearing in the section on top first. One by one, they'll move down to the Published Photos section below (here, three of the four images have been published). Once all your photos have been published, the New Photos to Publish section disappears, because there are no photos waiting to be published. (By the way, while your photos are being published, a small status bar will appear at the top-left corner to let you know how things are moving along.)

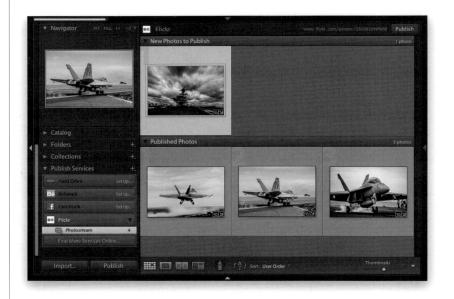

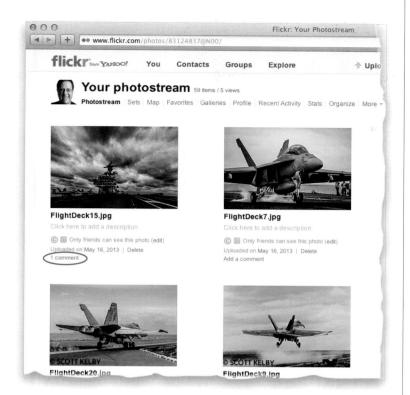

Step Seven::

Switch to your web browser, go to your Flickr photostream page, and you'll see your images have now been published there (as seen here). Now, you can take things a step further, because the comments that people post online about your published photos can be synced back to Lightroom, so you can read them right there in the Comments panel (in the right side Panels area). For example, on the Flickr website itself, I clicked on the comment field below the first image and wrote: "That watermark is really dark. It should be changed to white with the opacity lowered." (It's true, by the way.)

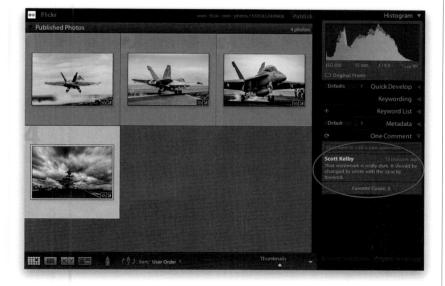

Step Eight:

To see the comments in Lightroom, go to the Publish Services panel, click on your Flickr Photostream, and it displays your published photos. Then, Right-click on your Photostream and choose Publish **Now** from the pop-up menu, and it goes and checks your Flickr account to see if any comments have been added, and downloads them into Lightroom. Now, click on a photo, and then look in the Comments panel (at the bottom of the right side Panels area), and any comments that were added to that image in Flickr will appear there. Also, it displays how many people have tagged that published photo as one of their favorites on Flickr.

Step Nine:

Okay, so far so good, but what if you make a change to one of those published photos in Lightroom? Here's what to do (and here's where this Publish Services thing works so well): First, click on the Flickr Photostream to display the photos you've already published to Flickr, then click on the photo you want to edit, and press **D** to jump over to the Develop module. In our case, we'll adjust two things here: (1) we'll drag the White Balance Temp slider to the left a little, so the photo is a little cooler, then (2) we'll bring up the Whites a bit to brighten the jet, as seen here. Now that our edits are done, it's time to get this edited version of the photo back up to our Flickr photostream. Note: If you have a standard Flickr account, rather than a pro account, this will delete all comments and ratings.

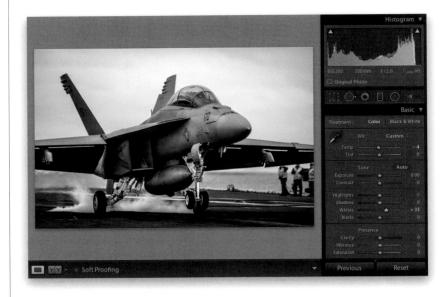

Step 10:

Go back to the Library module, to the Publish Services panel, and click on your Photostream (as shown here), and you'll see a split screen again, but this time it's showing your edited photo up top waiting to be republished. Click the Publish button and it updates the image on Flickr, so your most recent changes are reflected there. Of course, once you do this, the Modified Photos to Re-Publish section goes away, because now all your photos are published. Okay, so that's the Flickr Publish Services, and now that you've learned how that works, setting up your hard drive for drag-and-drop publishing is a cinch, so we'll do that next.

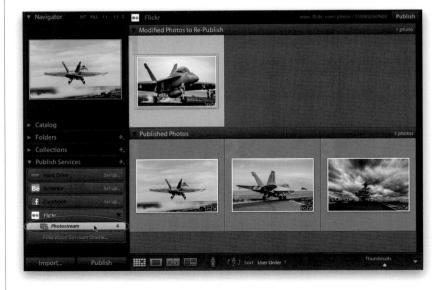

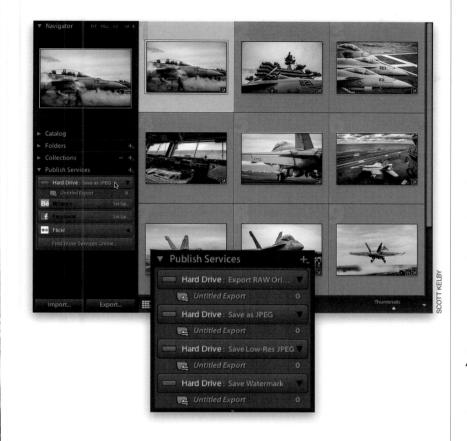

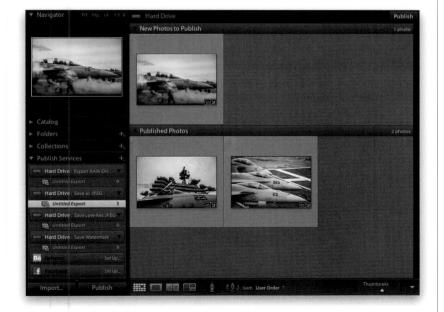

Step 11:

Start by clicking on the Set Up button next to Hard Drive in the Publish Services panel. We'll configure this one so it saves any files we drag onto it as high-resolution JPEGs to your hard drive (so think of this as a drag-and-drop shortcut to make JPEGs, rather than having to go through the whole Export dialog). Give this publish service a name now—call this one "Save as JPEG" (as shown here)—then fill out the rest just like you would for exporting a high-res JPEG to your hard disk (like we did back on page 292). When you click Save, it replaces Set Up with the name of your service (in this case, now it reads: "Hard Drive: Save as JPEG," so you know at a glance that it's going to save images you drag-and-drop on it to your hard drive as JPEGs). You can add as many of these as you'd like by Rightclicking next to Hard Drive and choosing **Create Another Publish Service via** "Hard Drive." That way, you can have some that export your images as originals, or some for emailing, or...well...you get the idea (look at the Publish Services panel here where I published a few extra setups, just so you can see what they'd look like).

Step 12:

Now that you've got at least one configured, let's put it to work. In the Library module, go ahead and select three RAW files you want saved as JPEGs (they don't have to be RAW files—they can already be JPEGs that you just want exported from Lightroom), and drag-and-drop those selected photos onto your Hard Drive: Save as JPEG publish service. From here, it's pretty much the same as you just learned with Flickr—the images appear in a New Photos to Publish section until you click the Publish button, then it writes them as JPEGs into whichever folder you chose when you set this publish service up (here, one of the three images being saved as JPEGs is in progress).

Lightroom Killer Tips > >

Exporting Your Catalog Shortcut

If, instead of just exporting a photo, you want to export an entire catalog of photos, press-and-hold the Option (PC: Alt) key, and the Export button in the Library module changes into the Export Catalog button.

▼ Using Your Last Export Settings If you want to export some photos and use the same export settings you used the last time, you can skip the whole Export dialog and, instead, just go under the File menu and choose Export with Previous, or use the keyboard shortcut

Command-Option-Shift-E (PC: Ctrl-Alt-Shift-E), and it will immediately export the photos with your last used settings.

▼ Using Export Presets Without Going to the Export Dialog

If you've created your own custom Export presets (or you want to use the built-in ones, as is), you can skip the Export dialog by Right-clicking on the photo, and from

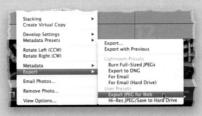

the pop-up menu, going under Export, and you'll see both the built-in and custom Export presets listed. Choose one from there, and off it goes.

▼ Lightroom's Built-In Address Book for Emailing

If you find yourself emailing from Lightroom a lot, you might want to create your own Lightroom email Address Book. You get to this from the main email dialogjust click on the Address button in the top right, and the Address Book appears.

Here, you can enter names and email addresses, and even create groups to organize your emails. To use an address from your Address Book, just click on the checkbox beside the name you want to use.

▼ Sharing Your Export Presets If you've come up with a really useful Export preset that you'd like to share with co-workers or friends (by the way, if you're sharing Export presets with friends, maybe you need some new friends), you can do that by pressing Command-Shift-E (PC: Ctrl-Shift-E) to bring up the Export dialog. Then, in

the list of presets on the left side, Rightclick on the preset you want to save as a file, then choose Export from the popup menu. When you give this Export preset to a co-worker, have them choose Import from this same pop-up menu.

▼ My "Testing Panos" Trick

If you shoot multi-photo panoramas, you know that once they get to Photoshop for stitching, it can take...well... forever (it feels like forever, anyway). And sometimes you wait all this time, see your finished pano, and think, "Ah, that's nothing special." So, if I shot a pano I'm not 100% sure is going to be a keeper, I don't use the direct Merge to Panorama in Photoshop command in Lightroom. Instead, I go to the Export dialog and use the For E-mail (Hard Drive) preset to export the files as small, low-resolution JPEGs, with a low Quality setting. Then, once they're exported, I open them in Photoshop, run the Photomerge feature, and because they're small, low-res files, they stitch together in just a couple of minutes. That way, I can see if it's going to be a good-looking pano (one worth waiting 20 or 30 minutes to stitch at high resolution). If it does look good, that's when I use the Merge to Panorama in Photoshop feature in the Photo menu in the Library, Develop, and Map modules, which sends over the full-size, full-resolution, full-quality images. Then I go get a cup of coffee. And maybe a sandwich.

Develop

Lightroom Killer Tips > >

Emailing or Posting Smart Previews Online

Smart previews of images actually have enough quality and resolution in them that you can export these as JPEGs. That way, you have a decent-sized JPEG you can email to someone as a proof, or post them online to Facebook, Twitter, and so on, all without having to access the original high-resolution file.

Exporting Directly to a Photo-Sharing Website

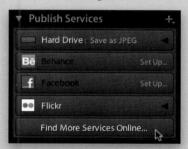

In this chapter, we talked about how you can publish images directly from Lightroom to Flickr.com, but there are now Export plug-ins available for most of the major photo-sharing sites (including Smugmug, Picasa Web Albums, and a dozen others) on Adobe's Exchange site. Click on the Find More Services Online button at the bottom of the Publish Services panel.

▼ Yes, You Sharpen Twice I get asked this question all the time, because, by default, Lightroom adds sharpening to your RAW photos. So, do you sharpen again when you export the photos? Absolutely!

▼ Installing Export Plug-Ins Although Adobe introduced Export plug-ins back in Lightroom 1.3, they've made the process of installing them much easier since then. Just go under the the File menu and choose **Plug-in**

Manager. When the dialog appears, click the Add button below the left column to add your Export plug-in (I told you it was easier).

■ Making Your Files Look Right on Somebody Else's Computer I get emails from people all the time who have exported their photos as JPEGs, emailed them to somebody, and when they see them on the other person's machine, they're shocked to find out the photos don't look anything like they did on their computer (they're washed out, dull looking, etc.). It's a color space problem, and that's why I recommend

that if you're emailing photos to someone, or that photo is going to be posted on a webpage, make sure you set your color space to **sRGB** in the File Settings section of the Export dialog.

▼ No XMP with DNG Files

If you convert your RAW image to DNG format before you export your original

(go under the Library menu and choose **Convert Photo to DNG**), your changes are embedded in the file, so you don't need an XMP file at all. There's more about DNG format in Chapter 1.

▼ Creating Flickr Photosets

If you want your published images to appear in their own Flickr Photoset or Smart Photoset, click on the + (plus sign) button on the right side of the Publish Services panel header and, in the pop-up menu, you'll see a Flickr section where you can choose **Create Photoset or Create Smart Photoset**. Choose one and it adds it underneath your Flickr collection, so you can drag-and-drop to publish to those sets directly.

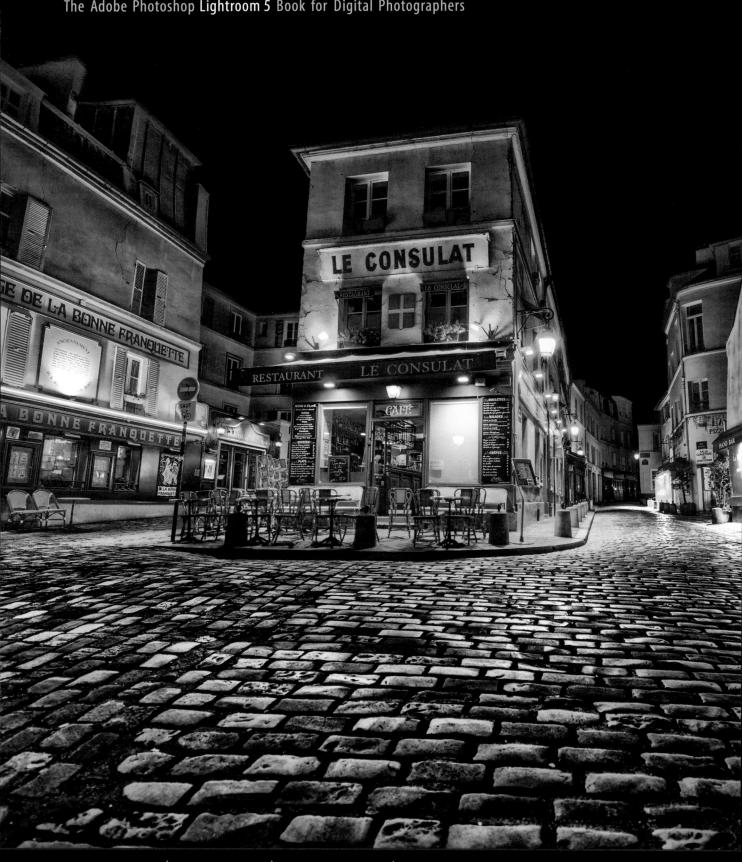

Photo by Scott Kelby | Exposure: 0.6 sec | Focal Length: 15mm | Aperture Value: f/2.8

JUMPING TO PHOTOSHOP how and when to do it

Even though this book was written so you can jump in anywhere, I can tell you right now that if this is the first chapter intro you're reading, you probably should turn back to the Chapter 1 intro and start by reading that first, then work your way back to here, just reading chapter intros (not the whole chapters). Actually, go back a page or two further (to the part where I tell you not to read these chapter intros if you're a Mr. Fussypants), and then you can determine if you should take the mental break imposed by these chapter intros or not. Now, the chapter you're about to embark upon is about using Adobe Photoshop with Lightroom, and there are still a bunch of reasons why we still need to use Photoshop (or Photoshop Elements) to get the job done. For example, Lightroom doesn't have things like layers, or filters, or blend modes, or

pro-level type control, or the Quick Selection tool, or HDR, or serious portrait retouching, or the ability to stitch panoramas (I could go on and on), so we still need it. We don't need Photoshop for every image, but you'll know when you need it, because you'll hit that moment when you realize what you want to do can't be done in Lightroom. Let's take creating counterfeit currency, for example. Lightroom kind of stinks for that, but if you're going to buy the full version of Photoshop (which runs around \$700 U.S.), you're just about going to need to be printing your own money. The Catch-22 is that you need counterfeit money to buy Photoshop, but you need Photoshop first to create realistic counterfeit money. It's this conundrum that has kept so many of us out of the Federal prison system.

Choosing How Your Files Are Sent to Photoshop

When you take a photo from Lightroom over to Photoshop for editing, by default, Lightroom makes a copy of the file (in TIFF format), embeds it with the ProPhoto RGB color profile, sets the bit depth to 16 bits, and sets the resolution to 240 ppi. But if you want something different, you can choose how you'd like your files sent over to Photoshop—you can choose to send them as PSDs (that's how I send mine) or TIFFs, and you can choose their bit depth (8 or 16 bits) and which color profile you want embedded when your image leaves Lightroom.

Step One:

Press Command-, (comma: PC: Ctrl-,) to bring up Lightroom's preferences, and then click on the External Editing tab up top (seen here). If you have Photoshop on your computer, it chooses it as your default External Editor, so in the top section, choose the file format you want for photos that get sent over to Photoshop (I set mine to PSD. because the files are much smaller than TIFFs), then from the Color Space pop-up menu, choose your file's color space (Adobe recommends ProPhoto RGB, and if you keep it at that, I'd change your Photoshop color space to ProPhoto RGB, as well whatever you do choose, just use the same color space in Photoshop so they're consistent). Adobe also recommends choosing a 16-bit depth for the best results (although, I personally use an 8-bit depth most of the time). You also get to choose the resolution (I leave mine set at the default of 240 ppi). If you want to use a second program to edit your photos, you can choose that in the Additional External Editor section.

Step Two:

Next, there's a Stack With Original checkbox. I recommend leaving this on, because it puts the edited copy of your image right beside your original file (more on this in the next project), so it's easy to find when you return to Lightroom. Lastly, you can choose the name applied to photos sent over to Photoshop. You choose this from the Edit Externally File Naming section at the bottom of the dialog, and you have pretty much the same naming choices as you do in the regular Import window.

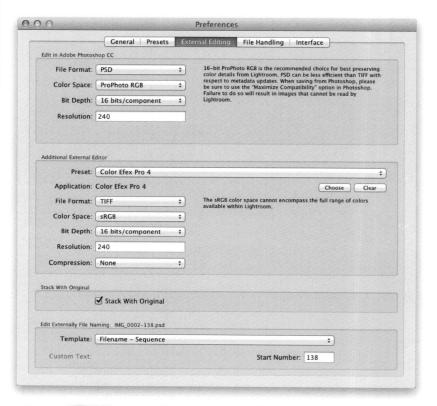

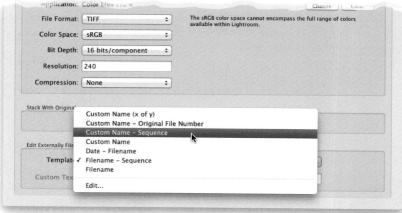

While Lightroom is great for organizing your photos, processing your images, making slide shows, and printing, it's not Photoshop. Lightroom doesn't do special effects or major photo retouching; there are no layers, no filters, or many of the bazillion (yes, bazillion) things that Photoshop does. So, there will be times during your workflow where you'll need to jump over to Photoshop to do some "Photoshop stuff" and then jump back to Lightroom for printing or presenting. Luckily, these two applications were born to work together.

How to Jump Over to Photoshop, and How to Jump Back

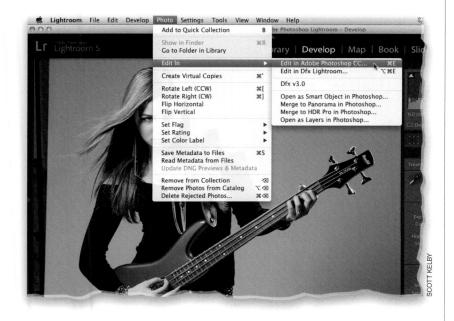

20-Second Tutorial:

To take the image you're working on over to Photoshop, go under the Photo menu, under Edit In, and choose **Edit in Adobe Photoshop** (as shown here), or just press **Command-E (PC: Ctrl-E)**, and Lightroom sends a copy of your image over to Photoshop. Do anything you want to it in Photoshop and then simply save the image, close the window, and it comes right back to Lightroom. However, the project below is much more fun (and you learn some cool Photoshop compositing stuff, too!).

Step One:

In this project, we're going to remove our bass player from this background and put her on a concert background, but I do as much as I can here in Lightroom first before I jump over to Photoshop. So, go to the Develop module and increase the Contrast to +20. She's wearing all black, so drag the Shadows slider over to +42 to bring out detail, and then increase the Clarity to +23 to accentuate the texture. I also ended up increasing the Exposure, here, just a bit (to +0.20).

Step Two:

Now, press Command-E (PC: Ctrl-E) to open the image in Photoshop. If you took the shot in RAW, it just "loans" Photoshop a copy of the image and opens it. However, if you shot in JPEG or TIFF mode, this brings up the Edit Photo with Adobe Photoshop dialog, where you choose (1) to have a copy of your original photo sent to Photoshop, with all the changes and edits you made in Lightroom applied to it, (2) to have Lightroom make a copy of your original untouched photo and send that to Photoshop, or (3) to edit your original JPEG or TIFF in Photoshop without any of the changes you've made thus far in Lightroom. Since we're working with a JPEG here, we'll choose the first option.

Step Three:

The first thing we have to do is get our subject off the background and onto her own separate layer. So, get the Quick Selection tool (**W**) and paint over our subject with it (as seen here). As you paint, it detects the outline of your subject and it makes a selection as you go. Don't expect the selection to be perfect, but just kind of "in the ballpark" at this point. Also, don't bother trying to select the edges of her hair. We'll do that separately, so pretty much don't worry about trying to select any "flyaway" hair.

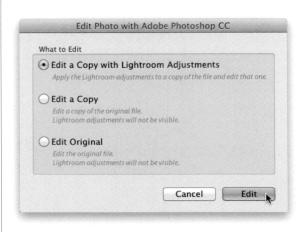

Step Four:

If you make a huge mistake (like you start selecting the gray background), you can deselect those areas by pressingand-holding the Option (PC: Alt) key and painting over them to remove them. However, this doesn't work nearly as well for small detail areas, like the small area between her arm and the bass guitar on the right. I've found it works much better to get the Magic Wand tool (Shift-W) at this point, press-and-hold the **Option** (PC: Alt) key and then just click once in those areas (as shown here) and it pretty much deselects them with just one click (I keep my Magic Wand's Tolerance setting [up in the Options Bar] at 20, so it doesn't deselect too much).

Step Five:

Ahhhh, now comes the magic. Selecting her clothes and bass guitar is easy, but making a selection where you keep her fan-blown hair intact is the tricky part. For stuff like this, we use Refine Edge. So, while your selection is still in place, click the Refine Edge button up in the Options Bar to bring up the Refine Edge dialog (shown here). At the top, you can choose how to view your selection, and I've found that the view that makes it the easiest to see which parts you've missed (like her fan-blown hair) is Overlay. With this view, everything that's not selected appears in a semi-transparent red tint (you can see some of her hair on the far left is still in red tint), and everything that actually is selected appears normal (as seen here).

Step Six:

Okay, now that our view is set, you'll need to turn on the Smart Radius checkbox (it helps us make a realistic selection by doing some crazy Adobe-math calculations), then drag the Radius slider a little to the right to soften and blend the edges (I dragged it over to 3.6). Now, click on the Refine Radius tool (it's on the left side of the dialog) and paint right over those fan-blown edges of her hair (as shown here). This lets Photoshop know which parts need to be included in your selection (and this brush does a pretty insane job of including them). Note: You can set the size of your Refine Radius brush using the Left and Right Bracket keys ([/]) on your keyboard (they're to the right of the letter P).

Step Seven:

Here you can see what an absolutely amazing job the Refine Edge brush does. So, that's the plan—go to any areas where her hair still appears in a red tint and paint over them to add them to your selection (when it's added, the red tint goes away and it looks normal). My next stop would be the hair under her arm on the left (shown at the top here). Okay, that sounds bad, but you know what I mean—the hair extending down below her armpit area. Anyway, you see that gray area between her armpit hairs (sorry, I couldn't resist)? Just paint over that (as shown at the bottom) and those gray areas will become transparent, leaving just the hair. Take a quick look around to see if there are any other missing areas and paint over them until you have most of her hair selected (you won't be able to get every tiny, fan-blown strand, but you can get most of it, no problem).

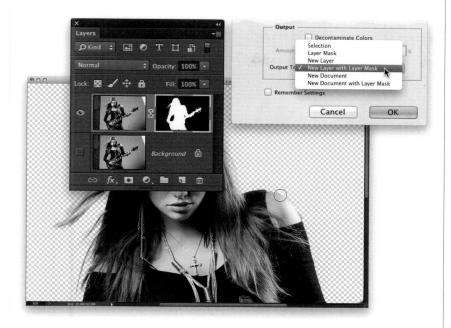

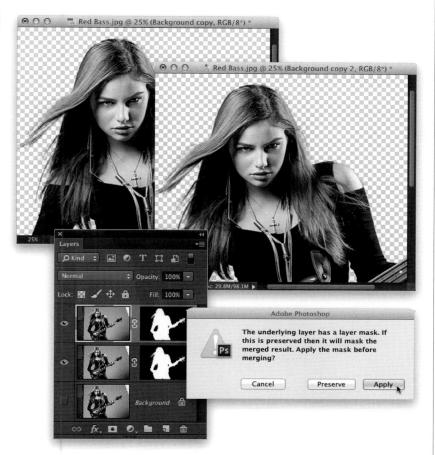

Step Eight:

When it looks pretty decent, in the Output section at the bottom of the dialog, choose New Layer with Layer Mask from the Output To pop-up menu, then click OK, and you get the image you see here—our subject on a transparent background (check out that hair selection!). Choosing New Layer with Layer Mask lets us tweak our mask after the fact if we need to (and if you look at her shoulder on the right, we'll need to do that a bit). So, just get the Brush tool (B), set its blend Mode to Overlay up in the Options Bar, and choose a small soft-edged brush from the Brush Picker. Then, click on the layer mask in the Layers panel to make it active, and paint in black over that area that's spilling over from her shoulder, and it's gone.

Step Nine:

Now, I'm going to share one of my all-time favorite compositing tricks, because it's so quick and easy and so effective. Ready? Here we go. Step One: Press Command-J (PC: Ctrl-J) to duplicate the layer. Okay, that's it. There is no Step Two. That's right just duplicating the layer actually has the effect of building up the hair and it makes it look fuller and better selected. I know. it sounds crazy, but it works like a charm (compare the left side of her fan-blown hair in the top photo to the one below). Now, press Command-E (PC-Ctrl-E) to merge these two layers into one. When you do this, since they both have layer masks applied, it's going to ask if you want to Preserve them (which keeps them intact), or if you choose Apply, it applies them (it keeps everything looking as is, but the layer masks are gone). In our case, we want to choose Apply because we're done tweaking the mask.

Step 10:

Now it's time to open our concert background image (this one was taken by my photo assistant, pro-concert photographer Brad Moore. It's a shot of the band Cage the Elephant. I kinda feel bad for the lead singer here, because he's about to get covered up by a bass guitar player, which is probably one of his deep-seated fears). Now we have two images open: the background image (shown here) and our subject image. Press **Command-A (PC: Ctrl-A)** to select the entire image, then press **Command-C (PC: Ctrl-C)** to Copy it into memory.

Step 11:

Switch back to our bass guitarist, then press Command-V (PC: Ctrl-V) to Paste the concert image into the document (it appears on its own layer). In the Layers panel, click-and-drag that layer down, so it appears below the bass guitarist's layer. Then, click back on the bass guitarist's layer, press Command-T (PC: Ctrl-T) to bring up Free Transform, press-and-hold the Shift key, and click-and-drag the top-right corner handle outward to make her a little bigger. Press Return (PC: Enter) to lock in your transformation. Next, get the Move tool (V), and position her so she completely covers the lead singer (sorry, mate). If you're thinking, "That doesn't look very realistic..." that's because we're not done. We haven't matched the color or any of that stuff yet, but first, we need to deal with any edge fringe (a thin white line that can appear around the outside edge of your subject). With the top layer (the bass player) active, go under the Layer menu, under Matting, and choose **Defringe**. When the dialog appears, leave it set at 1 pixel and click OK. This does an amazing job of removing that little bit of edge fringe. One other thing: since we no longer need it, you can clickand-drag the Background layer onto the Trash icon at the bottom of the Layers panel.

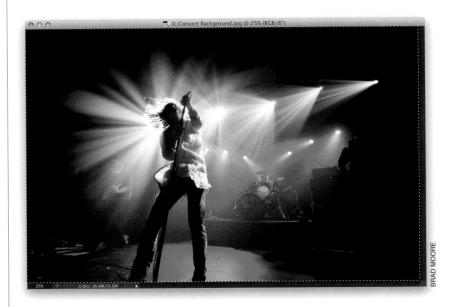

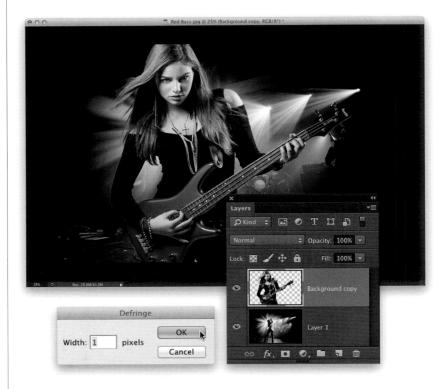

Hair Before: Single layer

Hair After: From duplicating layer

Step 12:

Let's try that little "duplicate the layer for fuller hair" trick once again. Make sure the bass player's layer is active, then press Command-J (PC: Ctrl-J) to duplicate the layer and take a look at how much more that helps (if it's a little hard to see here at this small size, you'll see it big time when you try it yourself with these practice files on your screen at full size). Press Command-E (PC: Ctrl-E) to merge these two layers.

Step 13:

Now, let's work on matching up the colors. There are a couple of different ways to do this, but this one is a little trickier because she's on stage with different colored lighting (it's greenish up top and orange/red down below), so we're going to have to do an extra step or two for this one. Start by pressing-and-holding the Command (PC: Ctrl) key, then click directly on the bass guitarist's thumbnail in the Layers panel. This puts a selection around the guitarist (wispy hair and all). Create a new blank layer by clicking on the Create a New Layer icon at the bottom of the Layers panel. Then, get the Eyedropper tool (I; which we use to steal colors from the image) and click it once on the light green lights behind her on the right (as shown here). That makes that greenish color your Foreground color (by the way, your selection should still be place, but don't do anything with it quite yet).

Step 14:

Press the letter **X** on your keyboard to swap your Foreground and Background colors, then click the Eyedropper tool on the orange/red background lighting (as seen here), and now that color becomes your Foreground color. So, at this point your Background color is greenish, and your Foreground color is orangish. We're now ready for the next part.

Get the Gradient tool (G) and, with the Foreground to Background gradient selected in the Gradient Picker in the Options Bar, drag it from the bottom of the bass upward a bit to fill your selected area with a gradient that kind of mimics the colors behind her on stage. Normally, you wouldn't have to do this gradient thing—you'd just click on one main color that stands out in the background, and you'd fill that selection with that color (you'd press Option-Shift-Delete [PC: Alt-Shift-Backspace], but don't do that now because we want that gradient we just created).

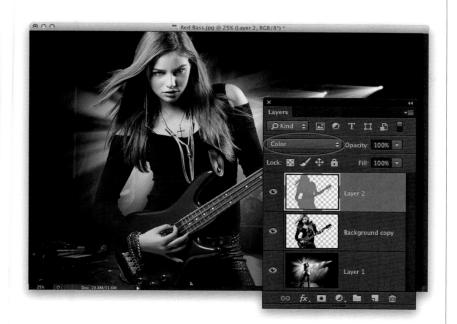

Step 16:

You can now press **Command-D** (**PC: Ctrl-D**) to Deselect. Then, to apply this color to your subject, go to the Layers panel and change the layer blend mode (from the pop-up menu up top—it's shown circled here in red) from Normal to **Color**, which lets the color come through to your bass player on the layer below it. This basically turns your bass player that color, but that's not what we want—we just want some of that color.

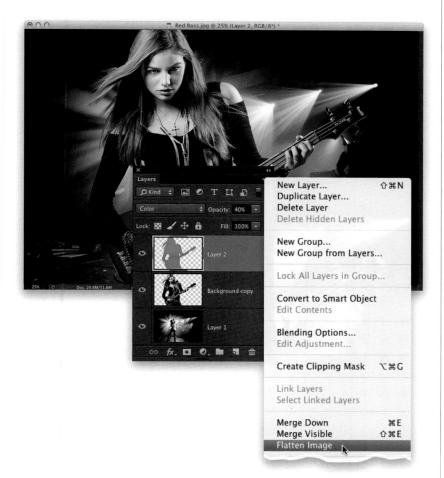

Step 17:

Using the Opacity slider (at the top-right corner of the panel), lower the amount until the bass player, color-wise, really looks like she was photographed in these surroundings with those lights (here, I lowered the Opacity of the Color layer to 40%). Okay, now we're starting to get closer, but we're not done yet. If you want to keep your layers intact when you take this file back to Lightroom, then just skip this next part (we'll talk more about layered files in Lightroom in just a moment). For those who don't need their layers intact (that'll be most of us), from the Layers panel's flyout menu, choose **Flatten** to merge the image layers down to just a single Background layer.

The Adobe Photoshop Lightroom 5 Book for Digital Photographers

Step 18:

Let's now take this image back to Lightroom for some finishing touches. To get it back to Lightroom, all you have to do at this point is simply two things: (1) save the file (press Command-S [PC Ctrl-S]), then (2) close the document (press Command-W [PC: Ctrl-W]). That's it. Don't rename it. Don't save it somewhere else. Don't overthink it. Just (1) save and (2) close. Save and close. That's it. Now, go back to Lightroom and you'll see the image you just created right beside the original image (as seen here).

Step 19:

One thing I always do to finish off my composites is apply a few changes to the entire composite (as one single flattened image) because applying it now, globally, unifies the image and makes it look and feel more real and less like a composite. So, click on your composite image, press **D** to jump over the Develop module, and we'll add a few little tweaks to finish this off. The main thing we'll do is add some clarity, so drag the Clarity slider to the right a bit (I dragged it over to +33), and then increase the Vibrance a little to accentuate the colors (I dragged it over to +27). Lastly, I think the overall image looks just a little too bright, so lower the Exposure to -0.60 and that should do the trick. A before/after of our original image and final composite is shown on the next page.

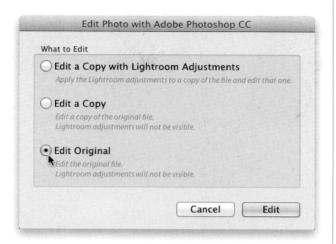

TIP: Saving Your Layers If you have multiple layers (like we did with this image), and you save and close the document without flattening it first, Lightroom keeps all those layers intact (Lightroom doesn't let you work in layers, though). What you see looks like a flattened image, but there is a trick that lets you reopen this image in Photoshop with all the layers still there. When you click on the layered image in Lightroom and press Command-E (PC: Ctrl-E) to open it in Photoshop, when that little dialog appears asking you if you want to edit a copy with your Lightroom changes, without, or edit the original, you need to choose Edit Original. It's the only time I ever open the original.

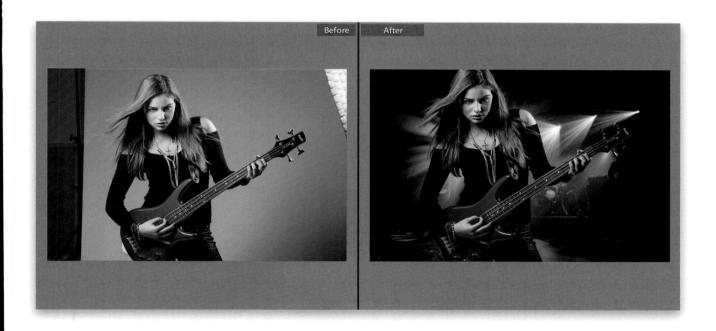

Adding Photoshop Automation to Your Lightroom Workflow

If there's a "finishing move" you like to do in Photoshop (after you're done tweaking the image in Lightroom), you can add some automation to the process, so once your photos are exported, Photoshop launches, applies your move, and then resaves the file. It's based on you creating an action in Photoshop (an action is a recording of something you've done in Photoshop, and once you've recorded it, Photoshop can repeat that process as many times as you'd like, really, really, fast). Here's how to create an action, and then hook that directly into Lightroom:

Step One:

We start this process in Photoshop, so go ahead and press Command-E (PC: Ctrl-E) to open an image in Photoshop (don't forget, you can follow along with the same photo I'm using here, if you like, by downloading it from the site I gave you back in the book's introduction). What we're going to do here is create a Photoshop action that adds a nice, simple softening effect to the image, and you can use it on everything from landscapes to portraits. (When I post a photo using this technique on my blog, I always get emails asking: "How is it that the image looks soft, but it still looks sharp?") Because this technique is repetitive (it uses the same steps in the same order every time), it makes it an ideal candidate for turning into an action, which you can apply to a different photo (or group of photos) much faster.

To create an action, go to the Window menu and choose Actions to make the Actions panel visible. Click on the Create New Action icon at the bottom of the panel (it looks just like the Create a New Layer icon in the Layers panel and is circled here). This brings up the New Action dialog (shown here). Go ahead and give your action a name (I named mine "Soften Finishing Effect") and click the Record button (notice the button doesn't say OK or Save, it says Record, because it's now recording your steps).

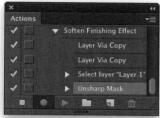

Step Three:

Make two duplicates of the Background layer by pressing Command-J (PC: Ctrl-J) twice. Then go to the Lavers panel and click on the center laver (shown highlighted here). Now go under the Filter menu, under Sharpen, and choose **Unsharp Mask**. This is a low-resolution image we're working on, so apply an Unsharp Mask with the Amount set to 85%, the Radius set to 1 pixel, and the Threshold set to 4 levels, and click OK to apply the sharpening. (Note: If this had been a full-resolution image from a digital camera, I would have used Unsharp Mask settings of Amount: 120, Radius: 1, and Threshold: 3.)

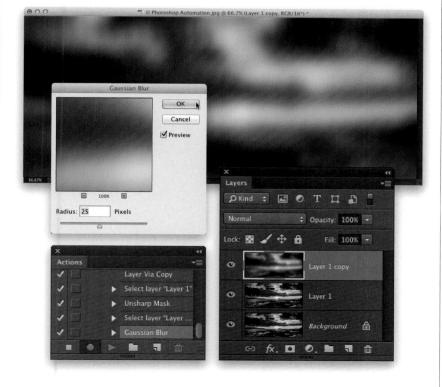

Step Four:

Now, after the sharpening, you're going to apply a huge blur to this image. So, click on the top layer in the Layers panel (Layer 1 copy). Go under the Filter menu, under Blur, choose **Gaussian Blur**, and enter 25 pixels as the Radius, so it's really blurry (like you see here).

Step Five:

In the Layers panel, lower the Opacity of this blurry layer to 20%, which gives us our final look (as seen here). Now, go to the Layers panel's flyout menu (near the top-right corner of the panel) and choose **Flatten Image** to flatten the layers down to just the Background layer. Next, save the file by pressing **Command-S (PC: Ctrl-S)** and close it by pressing **Command-W (PC: Ctrl-W)**.

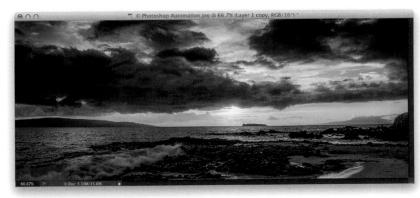

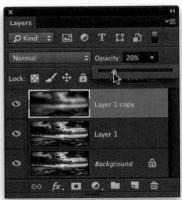

Step Six:

You may have forgotten by now, but we've been recording this process the whole time (remember that action we created a while back? Well, it's been recording our steps all along). So, go back to the Actions panel and click the Stop icon at the bottom left of the panel (as shown here). What you've recorded is an action that will apply the effect, then save the file, and then close that file. Now, I generally like to test my action at this point to make sure I wrote it correctly, so open a different photo, click on the Soften Finishing Effect action in the Actions panel, then click the Play Selection icon at the bottom of the panel. It should apply the effect, then save and close the document.

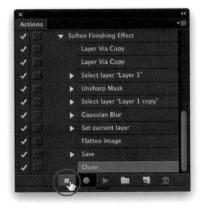

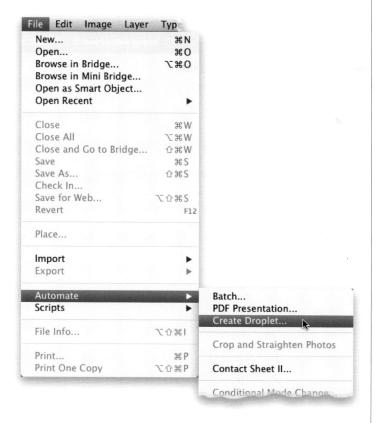

Step Seven:

Now we're going to turn that action into what's called a droplet. Here's what a droplet does: If you leave Photoshop and find a photo on your computer, and you drag-and-drop the photo right onto this droplet, the droplet automatically launches Photoshop, opens that photo, and applies that Soften Finishing Effect action to the photo you dropped on there. Then it saves and closes the photo automatically, because you recorded those two steps as part of the action. Pretty sweet. So, to make a droplet, go under Photoshop's File menu, under Automate, and choose Create Droplet (as shown here).

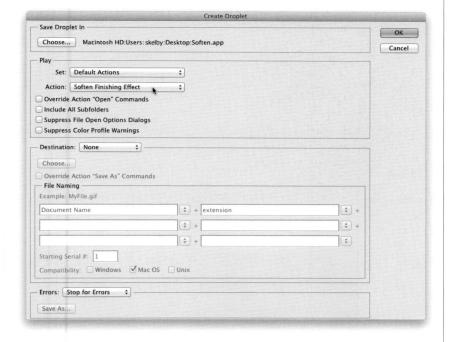

Step Eight:

This brings up the Create Droplet dialog (shown here). At the top of the dialog, click the Choose button, choose your desktop as the destination for saving your droplet, and then name your droplet "Soften." Now, in the Play section of this dialog, make sure to choose **Soften Finishing Effect** (that's what we named our action earlier) from the Action popup menu (as shown here). That's it—you can ignore the rest of the dialog, and just click OK.

The Adobe Photoshop Lightroom 5 Book for Digital Photographers

Step Nine:

If you look on your computer's desktop, you'll see an icon that is a large arrow, and the arrow is aiming at the name of the droplet (as shown here).

Step 10:

Now that we've built our Soften droplet in Photoshop, we're going to add that to our Lightroom workflow. Back in Lightroom, go under the File menu and choose **Export**. When the Export dialog appears, go down to the Post-Processing section, and from the After Export pop-up menu, choose Go to Export Actions Folder Now (as shown here).

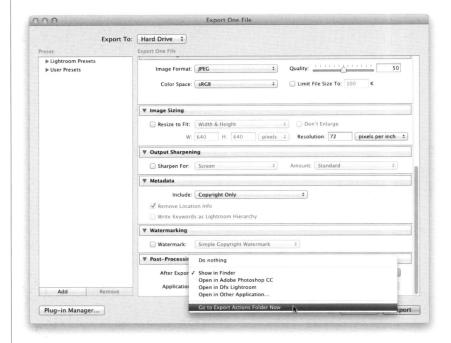

Export One File Export To: Hard Drive \$ ▶ Lightroom Presets **₩ User Presets** Export JPEGs for Web **▼** File Settings Hi-Res JPEG/Save to Hard Drive Image Format: Original **▼ Image Sizing** Resize to Fit: Width & Height Don't Enlarge W: 1000 H: 1000 pixels \$ Resolution: 240 pixels per inch ± **▼** Output Sharpening Sharpen For: Screen Amount: Standard Include: All Metadata Remove Location Info Write Keywords as Lightroom Hierarchy Do nothing **▼** Watermarking Show in Finder Watermark Open in Adobe Photoshop CC Open in Dfx Lightroom W Post-Processir Open in Other Application. After Expor ✓ Soften Go to Export Actions Folder Nov Plug-in Manager... Cancel Export

Step 11:

This takes you to the folder on your computer where Lightroom stores Export Actions (and more importantly, where you can store any you create). All you have to do is click-and-drag that Soften droplet right into that Export Actions folder to add it into Lightroom. Now you can close this folder, head back to Lightroom, and click Cancel to close the Export dialog (you only needed it open at this point to get you to that Export Actions folder, so you could drag that droplet in there).

Step 12:

Okay, now let's put it to work: In Lightroom's Grid view, select the photo (or photos) you want to have that effect applied to, then press Command-Shift-E (PC: Ctrl-Shift-E) to bring back the Export dialog. From the Preset section on the left, click on the right-facing triangle to the left of User Presets, and then click on the Export JPEGs for Web preset we talked about creating at the beginning of Chapter 8 (if you didn't create that one, go ahead and do it now). In the Export Location section, click on the Choose button and select the destination folder for your saved JPEG(s) (if you want to change it). Then, in the File Naming section, you can give your photo(s) a new name, if you like. Now, in the Post-Processing section at the bottom, from the After Export pop-up menu, you'll see Soften (your droplet) has been added, so choose it (as shown here). When you click Export, your photo(s) will be saved as a JPEG, then Photoshop will automatically launch, open your photo(s), apply your Soften Finishing Effect, then save and close the photo(s). Pretty slick stuff!

Stitching Panoramas Using Photoshop

One of my favorite features in Lightroom makes it easy to use one of my favorite features in Photoshop—the Photomerge feature, which automatically and seamlessly stitches panoramas together.

Step One:

In Lightroom's Grid view, select the photos you want to stitch together (the images shown here are of the Olympic Stadium in Barcelona, Spain). Here I've selected a series of 16 photos, and when I shot these, I made sure each photo overlapped the next one by around 20%, because that's about how much overlap Photoshop needs between images to stitch these 16 photos into one single panoramic image. Once the photos are selected, go under the Photo menu, under Edit In, and choose **Merge to Panorama in Photoshop**.

Step Two:

The dialog that will appear is Photoshop's Photomerge dialog (shown here), and in the center of the dialog, you'll see the names of the 16 images you selected in Lightroom. In the Layout section on the left side, leave it set to Auto, so Photomerge will automatically try to align and blend the images together for you, then click the OK button in the upper-right corner of the dialog.

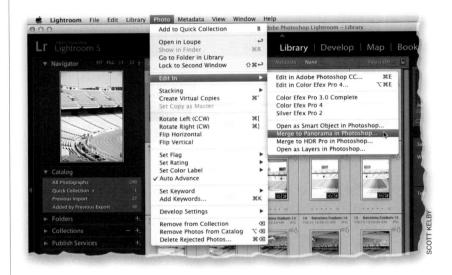

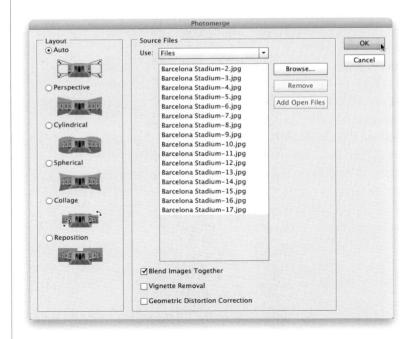

Step Three:

When Photoshop is done aligning and blending your photos, a new document will appear with your 16 images combined into a single panoramic image (as seen here). Parts of each photo wind up in this document as a separate layer (as seen in the Layers panel here), so if you wanted to tweak the masks created by Photomerge, you could (but we don't).

Step Four:

Let's go ahead and flatten the image by choosing **Flatten Image** from the Layers panel's flyout menu near the topright corner of the panel. Now that we've flattened the image, we'll need to crop it down to size to get rid of some of the big gaps that Photoshop left while stitching the image together (this pretty much always happens).

The Adobe Photoshop Lightroom 5 Book for Digital Photographers

Step Five:

Press C to get the Crop tool and clickand-drag the cropping points inward a bit, so most of those white gaps are gone (you don't have to crop it all away, though, because we can have

Photoshop fix some small gap areas for us). Once your cropping is in place (as seen here), press the Return (PC: Enter) key to apply the cropping to your pano.

Step Six:

To fill in the small gaps that remain along the top, bottom, and sides, we'll use Content-Aware Fill, which tries to fill in the gaps intelligently (and it actually does that pretty well most of the time). So, here's what ya do: Get the Magic Wand tool (press Shift-W until you have it) and click it once in one of the white gap areas. When there are multiple areas with gaps, just press-and-hold the Shift key and click on the other areas and it adds them to your current selection. If it selects areas where you didn't want it to (like, here, it selected some of the stadium seats), press

Shift-W to switch to the Ouick Selection tool, press-and-hold the Option (PC: Alt) key, and click on those areas to deselect them. Once your selection is in place (as shown here), we'll use a trick to make this work better: we'll expand it out by a few pixels. So, go under the Select menu, under Modify, and choose **Expand**. When the dialog appears, enter 4 pixels and click OK.

Step Seven:

Once you've expanded your selection by 4 pixels, go under the Edit menu and choose **Fill**. When the Fill dialog appears, choose **Content-Aware** from the Use pop-up menu (shown here) and click OK. As you can see here, it does a pretty amazing job, except it did duplicate two lights and leave one cut off up in the top-left corner. Easy enough to fix, though.

Step Eight:

Just grab the Clone Stamp tool (S) from the Toolbox, Option-click (PC: Alt-click) to sample a nearby area, and then paint right over the duplicates and they're gone. Then, just Option-click on the pole on the far left and extend it (as seen here). Now, let's take that image back to Lightroom for some finishing. Note: If you're shooting your panos in RAW, it actually works better to start in Lightroom by selecting all the images, then go to the Develop module and tweak the images (exposure, contrast, clarity, and so on), before you jump to Photoshop to stitch it together, because RAW images have a greater dynamic range.

Step Nine:

To take the pano back to Lightroom, you do just two things: (1) save the file, and (2) close it. So, press Command-S (PC: Ctrl-S) to save it, then press Command-W (PC: Ctrl-W) to close the image widow. Now, when you go back to Lightroom, you'll see the pano appear in Grid view, right after the images you used to create it. Take it over to the Develop module and lower the Exposure (the whole pano looks pretty overexposed). Also, let's pull back the Highlights (to darken the sky a bit) and increase the Contrast a bit. Then, grab the Adjustment Brush (K), lower the Exposure slider (to around -0.50) and darken the field. To darken the center of the field just a little more, click the New button, lower the Exposure (to around -0.26), and paint over it. Finally, click the New button, once again, raise the Exposure a little bit (to around 0.48) and paint over the stands that are in the shade (just to balance things out a bit and finish the pano off). (Note: You may need to take the pano back into Photoshop and use the Clone Stamp tool again to touch up the sky a bit.)

HDR (High Dynamic Range) images (a series of shots of the same subject taken at different exposures to capture the full tonal range) have become really popular, and you can take the images you shot for HDR straight from Lightroom over to Photoshop's Merge to HDR Pro feature. You start by shooting bracketed on your camera. Here, I set up my camera to shoot three bracketed shots with two stops between each shot—one with the standard exposure, one 2 stops darker, and one 2 stops brighter (for three shots total).

Develop

Creating HDR Images in Photoshop

Step One:

In Lightroom, select your bracketed shots. Here, I selected the three bracketed shots in the Library module. Once you've selected them, go under the Photo menu, under Edit In, and choose Merge to HDR Pro in Photoshop.

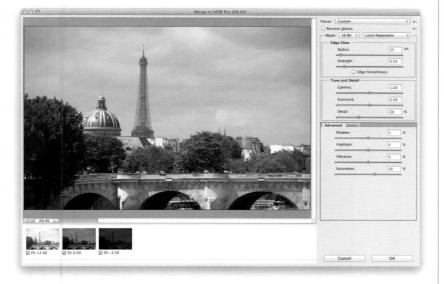

Step Two:

This launches Photoshop, brings up the Merge to HDR Pro dialog (shown here), and it compiles your three images (or five images, or seven images—it just depends on how many bracketed shots you took) into one boring-looking version of your image (as seen here). But, that's just reflecting the default settings (we'll tweak that next).

Step Three:

The Preset pop-up menu at the top-right corner of the dialog has a group of presets that are...well...most are just about unusable. Adobe must have gotten tired of hearing me whine about them because before they launched CS5, they asked if they could include one of my own presets. Of course, I was happy to have them include it, and it has been in HDR Pro ever since. It's called "Scott 5," and gives you that HDR-tone mapped look (I know, it looks horrible right now, but it'll get better in a moment.). Now, back in CS6, Adobe added an important new feature called "Edge Smoothing," but Scott 5 doesn't make use of that. We're going to fix that right now. So, start by choosing Scott 5 from the Preset pop-up menu, then drag the Strength slider a little bit to the right to add more tone mapping (I increased it to 0.65) and turn on the Edge Smoothing checkbox (it makes your HDR less harsh).

Step Four:

For now, let's save this as a preset by going to the flyout menu at the top-right corner of the dialog, choosing Save Preset (as shown in the overlay), and giving your preset a name. I named mine (wait for it...wait for it...) "Scott 6." Okay, this preset works well as a starting place for most images, but here it creates a common HDR problem—the bridge, trees, buildings, and Eiffel Tower look good, but the sky (with it's fakey-looking clouds and that awful white glow around the tower) is the very definition of "over-the-top" HDR, so we've got to fix that (we will in a moment). First, go down to the Advanced tab's Shadow slider. I usually drag this to the right to see if it adds any shadow detail back into the photo (here, I dragged it to 39, and it opened up the shadows in the tree on the far left). The Highlight slider controls the brightest whites, and I increased it just a tiny bit (I dragged it to -82). You can now click OK in the bottom right of the dialog.

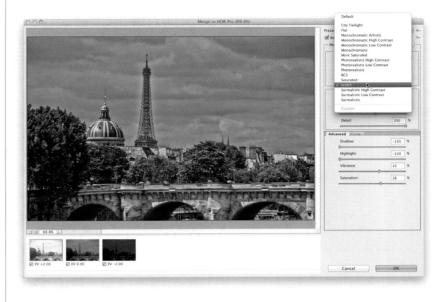

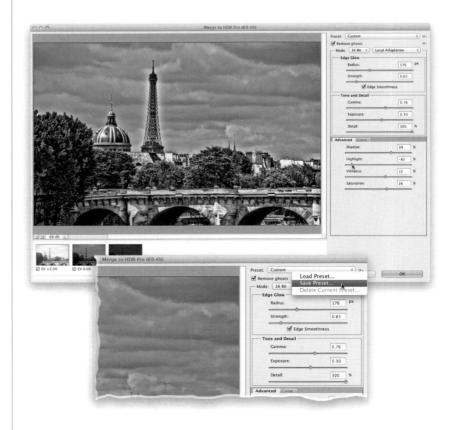

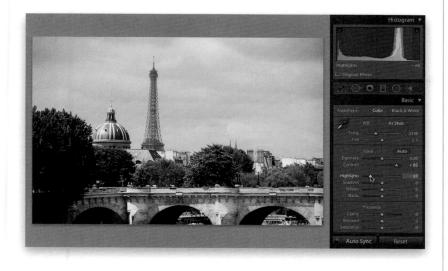

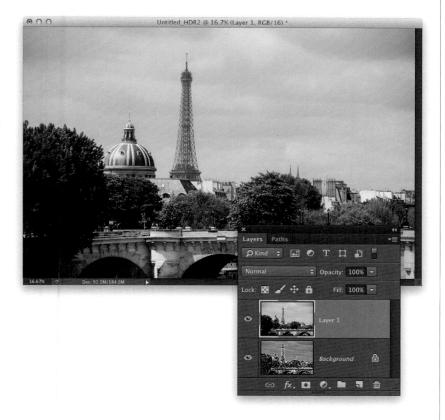

Step Five:

Now, go back to Lightroom for a moment. Remember, at the beginning, I mentioned I took three bracketed images—one normal exposure, one that's 2 stops underexposed, and one that's 2 stops overexposed? Okay, click on the one that is the normal exposure and then go to the Develop module. We're going to use this image to fix our sky and get rid of that awful white glow around the Eiffel Tower. At this point, let's just try to make the sky look a little better by increasing the contrast quite a bit (I dragged the Contrast slider over to +85) and pulling back the highlights (I dragged the Highlights slider to -69). This often helps the clouds look more defined. Okay, that's all we need to do there. So, press Command-E (PC: Ctrl-**E)** to open this slightly tweaked normal exposure image in Photoshop.

Step Six:

Once the image appears in Photoshop, press **Command-A** (**PC: Ctrl-A**) to put a selection around the entire image. Then, press **Command-C** (**PC: Ctrl-C**) to Copy the image into memory. Now, switch to your HDR image and press **Command-V** (**PC: Ctrl-V**) to Paste the normal exposure image right on top of your HDR image (it appears on its own separate layer, as seen here).

Step Seven:

In most cases, the two images will align absolutely perfectly, but in this case, it's off by a few pixels (due to how Photoshop processed the HDR shot, since I didn't shoot it on a tripod). Photoshop can fix the alignment problem for you, though. Start by going to the Layers panel and Command-clicking (PC: Ctrl-clicking) on the Background layer, so both layers are selected, then go under the Edit menu and choose Auto-Align Layers. Make sure Auto is selected in the Projection section of the Auto-Align Layers dialog, and then click OK. In just a few seconds, the images on your two layers are perfectly aligned. Note: When it does this aligning, you'll usually have to go and crop the image in just a tiny bit on all sides. Well, here I have to, anyway. Just so you know.

Step Eight:

In the Layers panel, click on the top layer (the normal exposure layer) to make it the active layer, then go to the bottom of the panel and click on the Add Layer Mask icon (it's the third one from the left). This allows us to control where we let the HDR image through (that'll make more sense in a moment). Here goes: with your Foreground color set to black, get the Brush tool (B), choose a medium-sized, soft-edged brush from the Brush Picker in the Options Bar, then just paint over the bridge, trees, and buildings to reveal those areas in all their HDR glory (as seen here). These were the good parts of the HDR image, and now they're added in to our normal exposure image. If you make a mistake, just press the letter X to switch your Foreground color to white and paint over those areas, then switch back to black to paint more HDR areas in.

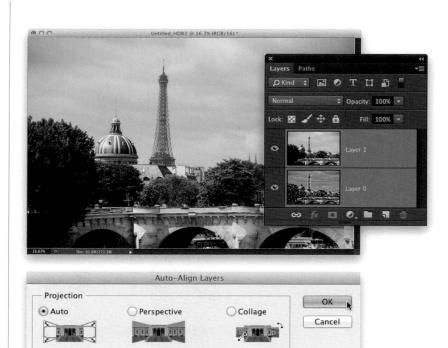

Reposition

O Cylindrical

Spherical

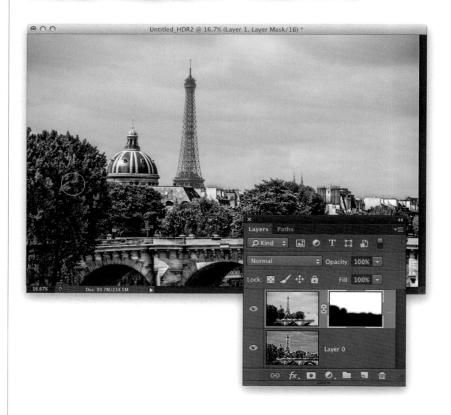

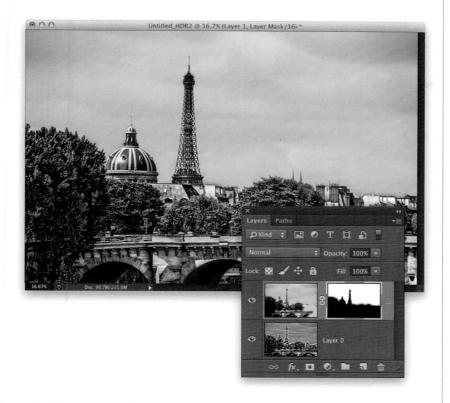

Layers Disc: 98:7M:235:8M Lock: Background Background Background Compactive: 100% | 10

Step Nine:

The Eiffel Tower needs painting in, too, so shrink your brush size way down (use the Left Bracket key on your keyboard to shrink it—it's immediately to the right of the letter P on your keyboard), and then carefully paint over the tower. As you paint up higher on it, you'll need to shrink your brush size even more, so hit that Left Bracket key again to make it smaller. Be careful not to "paint outside the lines" keep your brush inside the confines of the tower. If you need to, zoom in tight on the image. You also might want to make sure you fully painted in that dome on the building on the left and any other small detail areas you might have missed in the trees or the buildings.

Step 10:

Now, look—you've done it! You've got the good things from the HDR version (the bridge, trees, buildings, Eiffel Tower, etc.), but the sky looks natural and real (well, because it is), so you've got the best of both worlds in one shot (and this is what I usually do with HDR processing today— I blend parts of the two to make an image that makes folks wonder if it's an HDR or not). Anyway, at this point, we don't really need to do anything else in Photoshop we'll do our final tweaking in Lightroom itself. So, all we need to do now to get this image back over to Lightroom is to: (1) flatten the image, (2) save the file, and (3) close it. So, from the Layers panel's flyout menu, choose Flatten Image, then press Command-S (PC: Ctrl-S) to save it, and then press Command-W (PC: **Ctrl-W)** to close the image window.

Step 11:

Go back to Lightroom and you'll find that your new HDR file appears right next to the original image files you used to create it. Now, let's start tweaking it, so press D to take that image over to the Develop module. We're going to open up the shadows quite a bit and increase the contrast, pull back the highlights, and lower the overall exposure. So, start by increasing the Contrast to +16 to make the image more contrasty, then lower the Highlights to -38, and increase the Shadows to +54(which helps bring out detail in the trees, and well...pretty much everything dark). I thought the image looked a little washed out, so I increased the Blacks to +30, and lastly, I lowered the overall Exposure (using the Exposure slider) a tiny bit to -0.40. Now, we're done.

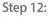

Here, you can see the progress in our image, from the original, to the over-the-top, awful sky and white glow HDR image, to the final image, which is a blend of the two.

Here's the normal exposure

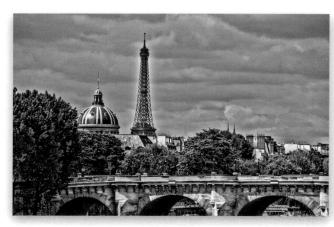

Here's the best of both worlds—a blend of the two

Lightroom Killer Tips > >

▼ Choosing the Name of Your Photoshop Edited Files

Back in Lightroom 1, it automatically added "Edit in CS3" to end of any photo you edited over there, but now you get to choose exactly what these edited files are named. Just go to Lightroom's preferences (press **Command-**, [comma; **PC: Ctrl-**,]), and then click on the External Editing tab, and at the bottom of the dialog, you'll see the Edit Externally File Naming section, where you can choose your own custom name or one of the preset file naming templates.

▼ Cutting Your File's Ties to Lightroom

When you move a file over to Photoshop for editing, and you save that file, the saved file comes right back to Lightroom. So, how do you break this chain? When you're done editing in Photoshop, just go under Photoshop's File menu and choose **Save As**, then give the file a new name. That's it, the chain is broken and the file won't go back to Lightroom.

File	Edit	Image	Layer	Туре
New				₩N
Open				#0
Browse in Bridge Browse in Mini Bridge Open as Smart Object				0#7
Open Recent				•
Close				₩W
Close All				WXJ
Close and Go to Bridge				Ω₩û
Sav	/e			ЖS
Save As Check In				企業S
_Say	e for V	Veb	_	2#17

▼ Get Rid of Those Old PSD Files If you upgraded from Lightroom 1, each time you jumped over to Photoshop, it created a copy of your photo and saved it alongside the original in PSD format, even if you never made a change to it in Photoshop. If you're like me, you probably had a hundred or more PSDs with no visible changes, just taking up space on your drive and in Lightroom. If you still haven't gotten rid of them, go to the Library module, and in the Catalog panel, click on All Photographs. Then, up in the

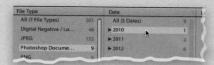

Library Filter, click on Metadata. In the first

field on the left, click on the header and

choose **File Type** from the pop-up menu, then click on Photoshop Document (PSD). Choose **Date** for the second field and click on the oldest dates, so you can see which ones you never used or don't need, and you can delete them so you get that space back.

▼ How to Get Photos Back Into Lightroom After Running an Export Action

If you created an action in Photoshop and saved it as an export action in Lightroom (earlier this chapter), when your photos leave Lightroom and go to Photoshop to run the action, that's the "end of the line" (the photos don't come back to Lightroom). If you want those processed photos to be automatically imported back into Lightroom, you can use Lightroom's Auto Import feature (under the File menu) to watch a folder, and when you write your Photoshop action, have it save your processed files to that folder. That way, as soon as the action is run, and the file is saved out of Photoshop, it will automatically be re-imported into Lightroom.

▼ Getting Consistent Color Between Lightroom and Photoshop

If you're going to be going back and forth between Lightroom and Photoshop, I'm sure you want consistency in your color between the two programs, which is why you might want to change your color space in Photoshop to match Lightroom's default color space of ProPhoto RGB. You do this under Photoshop's Edit menu: choose Color Settings, then under Working Spaces, for RGB, choose Pro-Photo RGB. If you prefer to work in the Adobe RGB (1998) color space in Photoshop, then just make sure you send your photo over to Photoshop in that color space: go to Lightroom's Preferences dialog, click on the External Editing tab up top, then under Edit in Photoshop, for Color Space, choose AdobeRGB (1998).

▼ Getting Much Better Looking High Dynamic Range Images

Although in this chapter I showed you how to jump from Lightroom to Photoshop to create High Dynamic Range (HDR) images, unfortunately if you're not using Photoshop CS5 or higher, Photoshop's built-in HDR feature isn't the greatest (and that's being kind). Every pro photographer I know who is into creating HDR images without CS5 or higher uses a program called Photomatix Pro (you can download a free trial version from their website at www.hdrsoft .com). Try it once, and I doubt you'll use Photoshop's old HDR feature again.

The Adobe Photoshop Lightroom 5 Book for Digital Photographers

BOOK OF LOVE creating photo books

The ability to create photo books has been on photographers' wish lists ever since Lightroom was first introduced back in the late 1800s by Grover Cleveland and the Sunshine Band. Before we get too far off topic, which is somewhat likely to happen, the title for this chapter ("Book of Love") is from the band called (in fact) Book of Love. I'm willing to set aside the fact that they really should be called something like The Book of Love, or perhaps James Buchanan and the Book of Love, but I find it really hard to separate their name (and their song of the same name—a bouncy synth-pop song recorded back in 1986 when people wore skinny ties and sport coats with the sleeves rolled up) from the original (and actually kind of good) song, "Who Wrote the Book of Love," which was recorded by The Monotones.

What is even more distressing is that I just made two references to past U.S. presidents that I doubt most American high school students would even pick up on, so those presidential references will probably be lost on most of the Norwegians and Thai folks that read the translations of this book. It won't be the first time I've actually heard from readers around the world that read the English-language version of the book first, and then the foreign translation, and who have told me my chapter intros don't make sense in translation. I always write back and remind them that they don't really make sense in English either, to which they usually reply, "Den hund er på kjøkkenet drive en båt gjort av bønner." See? When you read something like that, that's what makes it all worthwhile.

Before You Make Your First Book

Here are just a couple of quick things you'll want to know before you actually build your first book, including what kind of books, sizes, and covers are available through Adobe's partner in book building, Blurb (www.blurb.com).

Step One:

When you jump over to the Book module (up in the Module Picker, or just press **Command-Option-4** [**PC: Ctrl-Alt-4**]), a Book menu appears up top, and if you go under that menu, at the bottom of it, you'll find **Book Preferences**. Go ahead and choose that before we get rollin' here. Okay, let's start at the top: Just like in the Print, Slideshow, or Web modules, in the Book module, you get to choose whether the default setting for your frames is Zoom to Fill or Zoom to Fit (I leave it set at Zoom to Fill, simply because it usually looks better, but you can choose whichever you like best).

Step Two:

When we build our book project together (after these two pages), you'll have the option of having Lightroom automatically fill all the pages of your book with the photos you've chosen to be in the book (so you don't have to drag-and-drop them into the book one by one). So, with this preference turned on, as soon as you go to the Book module, it flows your Filmstrip photos into the photo frames on each page and—boom—you've got a book (of course, you can rearrange any pages or swap out photos after the fact, but it's a good starting place).

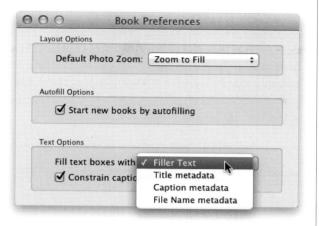

Step Three:

In the final section, there's a preference to help you visually see where you can add text. Some of the layouts have areas where you can put text, and it's easy to see in the thumbnail, but once you apply it to your actual page, unless there's some text already in place (Filler Text), then you wouldn't know there was a text box there at all. So, choosing Filler Text acts as a reminder (but don't worry—it's just for looks. It doesn't actually print until you erase it and start typing your own text, so you don't have to worry about it showing up in your final book—just like you don't have to worry about guides printing in your final book). Besides Filler Text, if you actually added captions or titles (in the Metadata panel fields in the Library module), you can choose to have Lightroom pull that text instead (which will definitely save you some time). Lastly, Constrain Captions to Text Safe Area just means it will keep your captions from extending into areas where it might get cut off, or extend into the page gutter between pages.

Step Four:

Before you turn the page and we start building a book together, I thought I'd show you the different sizes and types of books you can order directly from Lightroom through Blurb (an online photo book lab that's very popular with photographers, and Adobe's printing partner for Lightroom).

There are five different sizes: Small Square 7x7", Standard Portrait (tall) 8x10", Standard Landscape (wide) 10x8", Large Landscape 13x11", and Large Square 12x12". There are three different cover choices for each: a Softcover, a Hardcover Image Wrap (shown here, on the left and right), and a Hardcover Dust Jacket (you get to choose the inside flap covers and text if you want it, too!). Okay, let's build our book.

Building Your First Book from Scratch

Lightroom 4 was the first version of Lightroom to have a built-in book feature, and I have to say Adobe really did this one right! I thought the best way to learn this would be just to go ahead and build a book from scratch (it doesn't take long at all), and then when you're done with this one book, you'll totally have it down (yes, it's that easy). The hard part will be picking the images you want in the book—the actual building of the book is surprisingly easy, especially since Adobe included about 180 pre-designed page layout templates.

Step One:

In the Library module, create a new collection with just the photos you want in your book (as I did here). If you know the order in which you want your photos to appear in your book, go ahead and drag-and-drop them into that order. You can decide the order later, but if you have some idea now, it's handy to have them in order before the next step. Go to the Book module and, in the Book Settings panel (at the top of the right side Panels area), choose your book's size, paper type, and cover, and you'll get an estimated price (based on how many pages your book will be and in the currency you choose).

Step Two:

At this point, if you turned Autofill off in the Book preferences, all the pages are blank, but you can have Lightroom automatically fill them for you by clicking the Auto Layout button in the Auto Layout panel in the right side Panels area—it puts your photos in the book in the order they appear in your collection (ahhh, you see why it pays to put them into the order you want before you get here?). But, before you click the Auto Layout button, you can customize how it does the auto layout, from only putting one photo on each right page, with room for a caption, and leaving all the left pages blank, to the same layout without captions, to having one photo per page (that's what I generally do to start, and what we'll choose here). You choose which preset you want at the top of the Auto Layout panel.

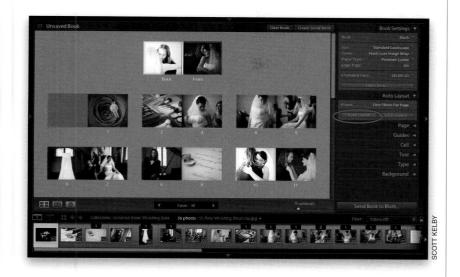

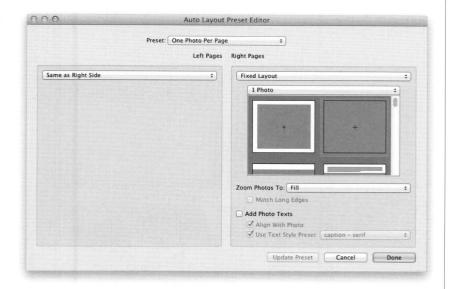

Step Three:

Now, so you have more room to see how your book is looking as you build it, I recommend hiding the left side and top panels (press **F5** on your keyboard to hide the top and **F7** to hide the left side) to make your Preview area much larger (as seen here). Click the Auto Layout button (shown circled here in red) and it automatically puts one photo on each page (as seen here). To see the rest of your pages, just scroll down. If you arranged them in the order you wanted them, then it's just a matter of choosing the right size for each image (if you don't want them all full-page). If they're not in the order you'd like, then drag-and-drop them on the book pages in the order you want.

Step Four:

Before we get to sorting, there is a very cool feature that can help you with your next book. Remember when you chose one of the built-in Auto Layout presets (back in Step Two)? Well, you can create your own custom presets and save them to that same pop-up menu. That way, you can have it auto fill exactly the way you want it (for example, let's say you want the entire book to have squareshaped images—you can set that up as a preset). To create a custom preset, from the Auto Layout panel's Preset pop-up menu, choose Edit Auto Layout Preset and the Auto Layout Preset Editor dialog appears. It's split into two parts: the left pages and the right pages. Right now it's set so whatever you choose on the right page, the left page will do the same (Same as Right Side), but let's create our own from scratch.

TIP: Adding More Pages

If you didn't do the Auto Layout thing, you can add more pages to your book by going to the Page panel (in the right side Panels area) and clicking the Add Page button.

Continued

The Adobe Photoshop Lightroom 5 Book for Digital Photographers

Step Five:

Let's set up a preset to make the left-page images square and the right-page images full page (like you see here). Here's what you do: In the Left Pages section, first choose Fixed Layout from the pop-up menu at the top, then choose 1 Photo from the pop-up menu below that. Now, scroll down to the square image page layout and click on it (as shown here), then just leave the right side at Fixed Layout, 1 Photo, and full page. Click the Save button, give your preset a name, and this layout will now be a preset choice for you. Sweet!

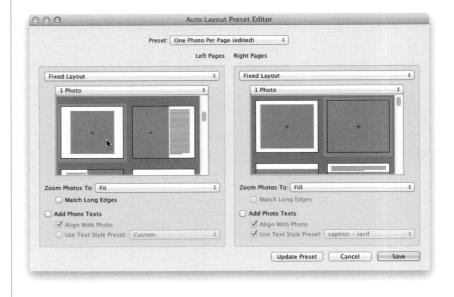

Step Six:

There's another option you need to know about with these custom layout presets: you get to choose how your image appears, once you drag it into place, using the Zoom Photos To pop-up menu in the Auto Layout Preset Editor dialog. If you choose Fit, it scales your image down to fit inside the frame. So, if you choose Fit with a square layout like we chose, the image will fit fully inside the square (like the image shown here on the top), but because it fits fully inside that square, your photo won't actually appear square. For that to happen, you'd have to choose Fill (like you see on the bottom). Luckily, you can always change this after the fact, on a per-page basis, by Rightclicking on a photo, and clicking on Zoom Photo to Fill Cell in the pop-up menu to turn it on or off.

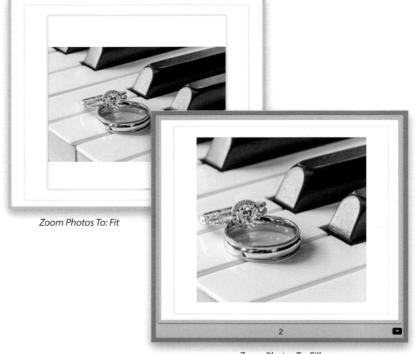

Zoom Photos To: Fill

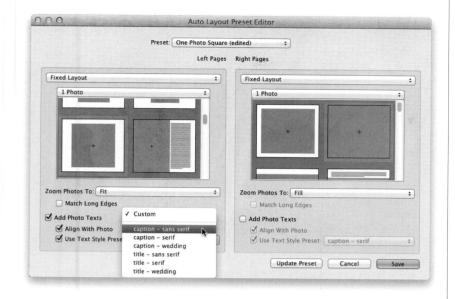

Step Seven:

If you know you're going to want to add a caption along with your photo, there's a checkbox for adding that, as well, and you can choose built-in text presets that work well for captioning.

TIP: If You Choose Fill, You Can Reposition Your Image in the Cell
Just click right on the image and drag it left or right, so the part you want to be visible appears within the frame.

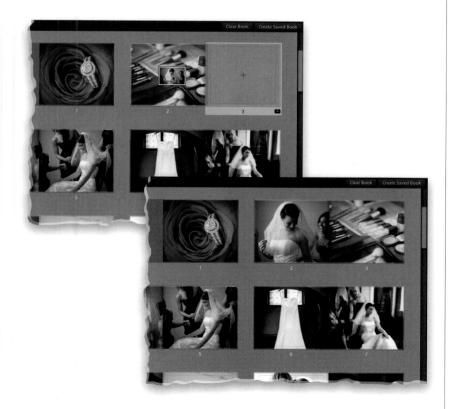

Step Eight:

Okay, now back to our layout. If you look back to Step Three, you'll see that the images on pages 2 and 3 probably need to be swapped (for design purposes, you generally don't want people looking off the page. It's more pleasing, and has less tension for the viewer, if they're looking in toward the spine, so let's swap those two pictures with each other). Click on the photo on page 3 and drag it over on top of page 2 (as shown here, top). When you release your mouse button, the two photos swap places (as shown here, bottom). Now she's kind of facing in toward the center of the book. I'd do the same thing on pages 6 and 7. She's looking off the page here, as well, but now you know how easy it is to swap these—just dragand-drop 'em.

Step Nine:

Thus far, we've been building our book in Multi-Page View mode, but I usually prefer to work in the two-page Spread View while I'm putting pages together. I only use the Multi-Page View near the end of the process, when I want to reorder the pages themselves (more on this in Step 20). To get to this two-page view, just click the Spread View button (second from the left) on the left side of the toolbar that appears right below the Preview area (as seen here). The button to its right is the Single Page View, and the button to its left is the Multi-Page View. So, to recap: I use this two-page Spread View most of the time while building my books, so you'll see a lot of this view from here on out. Once you're in this Spread View, you can move through the book using the left/right arrows in the center of the toolbar, but I just use the Left/ Right Arrow keys on my keyboard to move through the book.

Step 10:

You can choose how many photos you want on a particular page, and then the layout of that page, by clicking on the little black button in the bottom-right corner of the currently selected page (if you don't see this button, click on the page first to select it—your page will appear highlighted in yellow—then you'll see the button). Once you click the Change Page Layout button, the Modify Page menu appears (shown here). First, choose how many photos you want on your page (in this case, we'll stick with one for now), and then a list of page layout thumbnails will appear at the bottom of the menu (notice that scroll bar to their right? That's right—there are a whole bunch of them!). The currently selected layout appears highlighted in gold. Layouts with lines of text show where you can add stories, captions, and headlines. They also show where that text will be positioned (to the left, right, top, bottom, etc.).

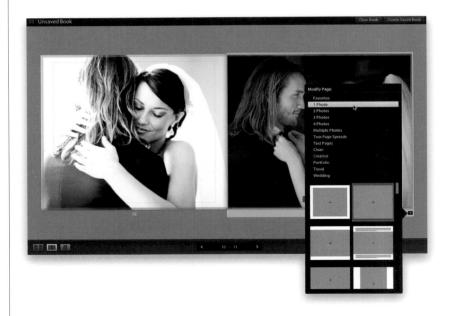

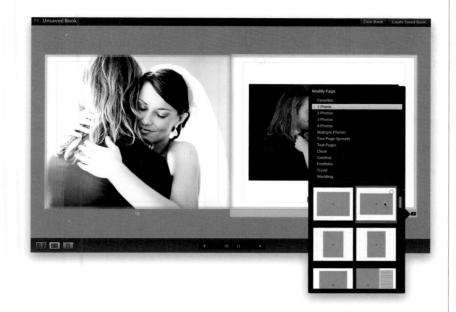

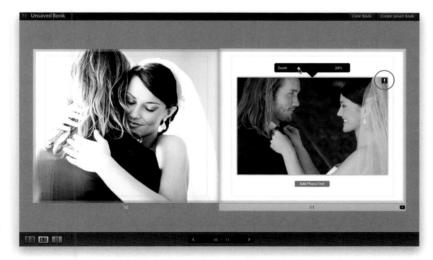

Step 11:

Let's go ahead and change the right page to have a smaller photo size, so scroll down the list until you come to a horizontal gray photo box and click on it (as seen here) to make that your new page layout. One of the things I love about Lightroom's Book module is that you can have a custom layout for every single page, rather than just applying a theme for the entire book. That way, you can mix and match pages from any themed layout you like (for example, you could pick the left page from the Travel theme, and the right page from the Portfolio theme).

Step 12:

Now that you've created a new page layout, you still have lots of control. Click on the image and a Zoom slider appears above it, so you can zoom in/out on your image (this is kind of like cropping the image, because as you zoom in, the image stays within the "cell"). Here, I've zoomed the image way in to add more drama. However, if you zoom in too tight, you won't have enough resolution to print the image, and if that happens, Lightroom gives you a warning (see that "!" in the upper-right corner of the photo?), letting you know you've zoomed in too close and now your image won't print as crisply or will look pixelated (or both).

DESIGN TIP: Make One Photo Larger When putting together a photo book in two-page layouts, try to make one photo larger, so it becomes the focal point—the main attraction on that spread, which draws the viewer's eye. Not only does it create a more pleasing layout, it also lets the viewer know which photo to look at first, since people generally feel like the most important object on a page is the largest, like a newspaper headline.

Step 13:

If you want more white space around your photo, you can shrink the size of its cell by clicking on the photo, and then grabbing the top, bottom, or side of it (as your cursor gets near the edges, it will change to a double-headed arrow) and dragging inward (as shown here). Another way to do this is to go to the Cell panel (in the right side Panels area) and drag the Padding Amount slider. As you drag it to the right, it shrinks the size of the photo in the cell. If you click on the black, left-facing triangle, it'll reveal four sliders, so you can individually adjust the top, bottom, left, and right margins. They are linked together by default, so to move an individual slider, click on Link All to turn that feature off. Note: If you chose a layout with multiple photos right up against each other, you can also add space between them this way.

TIP: Removing a Photo

To remove a photo from a cell, click on it and hit the **Delete (PC: Backspace) key**. It doesn't delete it from your collection, so you can still find it down in your Filmstrip and drop it onto another a page.

Step 14:

Before we move on, I zoomed back out a bit until the resolution warning went away. Now, if you want to change the background color of your page, go to the Background panel (in the right side Panels area) and turn on the Background Color checkbox. Choose a new color by clicking on the color swatch to the right to bring up the Background Color picker, and click on any of the preset color swatches at the top, or choose any shade from the gradient bar below. To access full colors, click-and-drag the little horizontal bar on the gradient bar on the right upward to at least the middle of the bar to reveal the colors. Now, you can choose any color you'd like for your background.

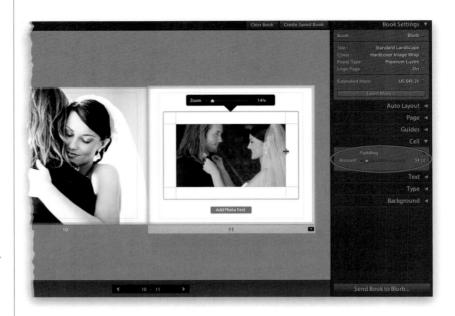

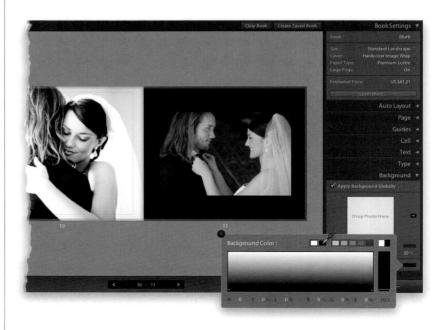

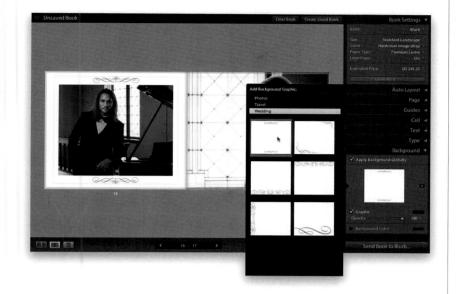

Clear Book Create Saved Book Blob 2 State Standard Landscape 7 State Standard Landscape 7 Faper Type Premian Lutter 1 Scorn More: US \$41.21 Corn More: W\$ 41.21 Corn More: Auto Layout 4 Rage 6 Guides 4 Cell 6 Cell 7 Text 7 Type 8 Background 7 Apply Background Globaly

Step 15:

Okay, I am seriously sick of seeing this same two-page spread (I'm sure you are, too), so for the sake of variety (and our mutual sanity), I'm changing pages for the rest of this Background panel stuff (and resizing the photo on the left page). Besides just a solid color for your background, you can also choose from a collection of built-in background graphics, including one for travel with things like maps and page borders, and one for weddings with elegant little page ornaments. To get to these, turn on the Graphic checkbox in the Background panel, then to the right of the square background graphic well in the center of the Background panel, click the little black button to bring up the Add Background Graphic menu, with a thumbnail list of built-in backgrounds (as seen here). Just click on the category at the top, then scroll down to the graphic you want to use, click on it, and it appears behind your photo (as seen here). You can control how light/dark the graphic appears using the Opacity slider near the bottom of the panel.

Step 16:

If you want a pattern, rather than ornaments, you can add vertical lines, and better yet, you get to choose their color. (By the way, I switched to the Single-Page View here, so you can see what's going on a little better.) First, go to the Travel category and choose the lines background from the pop-up menu, set its Opacity (lightness or darkness), then click on the color swatch to the right of the Graphic checkbox to bring up the Graphic color picker (seen here). Choose any color you'd like for your graphic (I chose a purple color here, and I increased the Opacity to 53% to make it more visible).

Step 17:

There is one more Background option, but before we get to that, look up at the top of the Background panel and you'll find a checkbox that repeats your current background throughout the entire book (if that's what you want. It saves you the time of adding a background manually to every single page). Okay, now on to the last option: using a photo as a background (very popular in wedding albums). Start by turning off the Graphic checkbox, then in the Filmstrip, find the photo you want to use as a background, and drag-and-drop it onto the square background graphic well in the center of the Background panel (as shown here) and that photo becomes your page background. I usually like this background photo to be very light behind my main photo (so it doesn't compete with it), so I lower the Opacity quite a bit usually to between 10% and 20%. By the way, to remove your background image altogether, Right-click on the background graphic well and choose Remove Photo.

Step 18:

Okay, now I want to show you another of my favorite book features—having one photo appear all the way across a two-page spread. This really adds a lot of impact to a book, and I usually include at least two or three two-page spreads like this per photo book. To create one, click on the photo page that you want to make a two-page spread, then click the Change Page Layout button in the bottom-right corner of the page to get the Modify Page menu, and choose Two-Page Spreads. This brings up a scrolling list of different layouts (the top one is a full-bleed—all the way to the edges—the next puts a small border around it, and the rest are really cool, as well. Some cover 2/3 of the two pages, leaving room for text). For this project, we'll choose the full-bleed template.

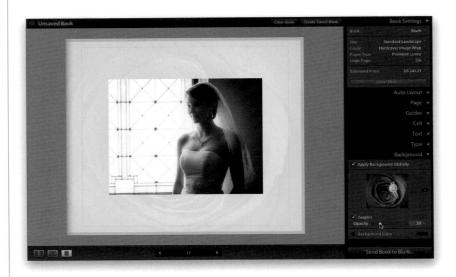

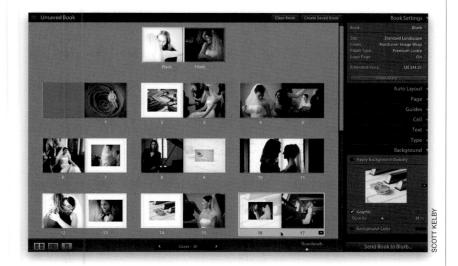

Step 19:

Once you make your two-page spread template choice, the photo on the second page moves to the next page and your photo now extends across two pages, and Lightroom simulates where the page break will appear in the center of the two-page spread. If you want to be able to reposition your photo on the two pages, you may have to zoom in a bit, so click on the photo to bring up the Zoom slider. Drag the slider to zoom it until the photo size looks good to you (don't forget to keep an eye out for the resolution warning in the upper-right corner of the photo, which you get if you zoom in too far). Once you zoom in, you can position your photo by just clicking-and-dragging directly on the photo (as I did here, where I clicked-and-dragged downward to center the image. I also dragged it a little bit to the left, so their noses weren't right in the page break). Note: I know we haven't covered text yet. I thought it needed its own separate pages, so that's coming shortly in the next technique.

Step 20:

At this point, I work on getting everything into the final order I want, moving spreads around in the Multi-Page View, so the book flows in the order I want (by the way, the shortcut to get to this Multi-Page View is Command-E [PC: Ctrl-E]). To move a two-page layout, click on the first page (the left page), press-and-hold the Shift key, and then click on the right page to select it, as well. Now (this is important), click on the bottom of the two selected pages—where the page numbers are then drag-and-drop the two-page spread anywhere you want in the book. If you don't click in that lower page-number area, it will think you want to move an individual photo. So, at this point, it's time to put the spreads in the final order you want them by dragging-and-dropping them into place.

Step 21:

Before we actually buy our book, I wanted to let you know about one more layout feature, even though I don't use it (it makes things look too cluttered to me, but you might find it useful): turning on/off visual guides. You turn on/off these non-printing guides in the Guides panel in the right side Panels area. There are four types of guides: (1) Page Bleed, so you see the small area on the very outside edge of your page that will be cropped off if you choose to have a photo fill the page. It's perfectly fine, and they only crop off around 1/8", so you won't even notice it. (2) The Text Safe Area guide shows the area where you can add text without it getting lost in the gutter between spreads or being too close to the outside edges. (3) The Photo Cells guide is the one that appears when you click on a photo anyway, so I leave that off for sure, and lastly, (4) the Filler Text guide only appears if you choose a layout with text, and it puts a word(s) in place so you know where to type.

Step 22:

When everything looks just the way you want it (make sure to check for typos), it's time to: (a) send the book to Blurb, or (b) save the book as a PDF or JPEG and have it printed wherever you'd like. You do all of this in the topmost panel—Book Settings. At the top, you choose either to print to Blurb, or make a PDF or JPEG (it creates an individual JPEG of each page). If you choose Blurb, you then choose your Paper Type and whether you'll let them add a Blurb logo page to the end of the book (if you do, they give you a discount). Below that, it gives you the estimated price for your book. If you choose PDF or JPEG, instead you choose the quality of the photos (I use 80), the color profile (many photo labs recommend sRGB), the resolution (I set mine to 240 ppi), the sharpening strength, and the type of paper (I use High and Glossy).

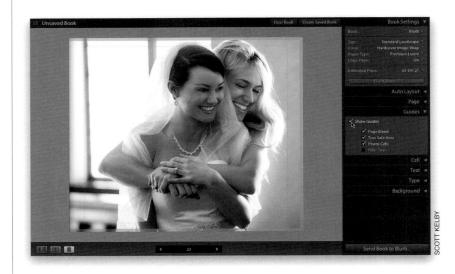

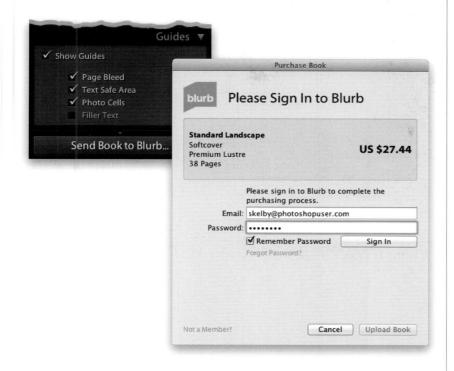

Step 23:

If you choose to have your book printed directly from Lightroom to Blurb, then you've got one more step: go to the bottom of the right side Panels area and click the Send Book to Blurb button (shown at left). This brings up the Purchase Book dialog, where you sign into your Blurb account (if you don't have one, you can set one up for free—click the Not a Member button in the bottom left). Once you log in, choose a Book Title, Book Subtitle (if any), and add the author's name (you, presumably), then click the Upload Book button. In a few days, your book will arrive (as shown below-my Blurb-printed version of the book).

TIP: The Numbers Above the Filmstrip Thumbnails

If you see a number (like 1 or 2) above an image in the Filmstrip, that's letting you know that photo has been placed into the book and how many times it has been used.

Step 24:

Now, before you do anything else, let's save your book (in case you want to make more of these later) by clicking on the Create Saved Book button at the top right of the Preview area. This saves your book layout to the Collections panel, so it's saved and just one click away. Okay, that's it—you've created your first book. If you noticed that we didn't go into adding text to your photo book, that's because there are a number of type features, so I thought we should go in-depth into them, and we do—starting on the next page.

Adding Text and Captions to Your Photo Book

If you've been using Lightroom for a while, you know the text capabilities have been really limited. But, when it came to books, Adobe added their full-featured type engine right into the Book module, so you have a surprising amount of control over how your type looks and where you can put it. Now, if we can only get them to put a copy of the Book module's type feature over into the Slideshow and Print modules (don't get me started).

Step One:

There are two ways to add text to your photo book: (1) Choose a page layout that has a text area already in place, so all you have to do is click in the text box and start typing. Or, (2) you can add a text caption to any page by going to the Text panel (in the right side Panels area) and turning on the Photo Text checkbox, as shown here. Now you'll see a yellow horizontal text box appear across the bottom of your image. To add your caption, just click and start typing.

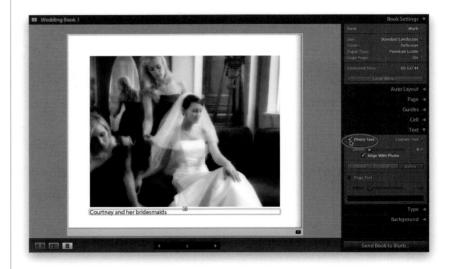

Step Two:

The Align with Photo checkbox keeps your caption aligned with your photo when you add padding to the photo's cell. So, as you shrink your photo within the cell, your caption will shrink within its cell, too. You can tweak exactly how far away your caption is from your photo using the Offset slider—the farther you drag it to the right, the farther away the text moves from your image (as seen here). Note: If you want to have Lightroom select a text box for you, go under the Edit menu and choose Select All Text Cells (this is handy if you have a page with three photos and three captions, and you want to turn all the captions offjust choose Select All Text Cells and then turn the Photo Text checkbox off to hide them from view).

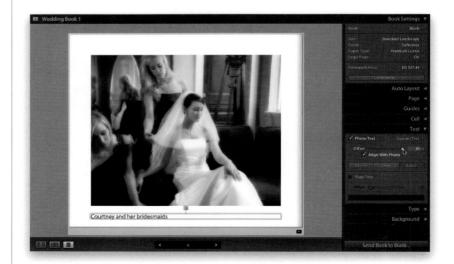

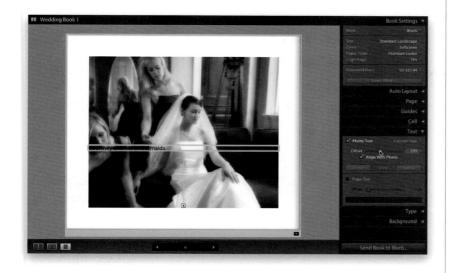

You also have the choice to move your caption above your photo, or to put your caption right over the photo itself (as seen here) using the three buttons below the Offset slider: Above, Over, and Below. Click the Over button and your text box now appears right over the photo, and the Offset slider controls how high your caption appears over it (as you slide it back and forth, you'll see your caption move up and down the photo). *Note:* If you choose to add a caption to a full-page photo layout, the only option you'll have for placement is Over, since there's no white space above or below the photo to fit a caption.

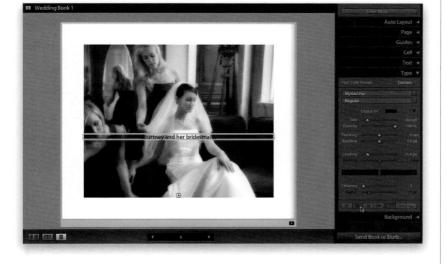

Step Four:

By default, your text is aligned with the left side of your photo, but if you go to the bottom of the next panel down, the Type panel, you'll see alignment buttons—you can choose Align Left, Align Center (as shown here), or Align Right (the fourth choice is Justification, which only comes into play if you're using columns of text). Note: If your Type panel doesn't look like this one (you see a lot fewer sliders), then you just need to click on the little black left-facing triangle to the far right of the word "Character" and this expands the panel down to show more options.

Step Five:

While we're in the Type panel, let's go ahead and highlight our text so we can change the color to white (easier to read over this particular photo) by clicking on the black Character color swatch, and when the Character color picker appears, clicking on the white swatch. Now, click on the Align Left button at the bottom of the Type panel. Look how close the text is to the left edge (it's right on it). If you want to offset that text (scoot it out a little from the edge), there isn't a slider for that. Instead, click off the photo (in that white area around it), then hover your cursor over the left end of the text box and it will change to a two-headed arrow. Now you can click-and-drag your text over to the right a bit (as shown here). Note: I have to warn you: getting this two-headed arrow cursor to actually appear may take a few tries. It's, shall we say, "finicky." You can also use it to drag the text box up/down by moving it over the top/bottom of the text box. Again, finicky though.

Step Six:

All the other standard controls that you'd expect for working with type are here (like Size, Opacity, and Leading [the space between two lines of text]), but there are also some more advanced type controls that I didn't expect (like Tracking [the space between all the letters in a word], Kerning [the space between two individual letters], and Baseline [shifting a letter or number above or below the line the text sits on—helpful for writing things like H₂O]). And, of course, you can choose your Font and Style (bold, italic, and so on) from the menus near the top. But, at the top is a very handy thing—Text Style presets, which are already set up using popular fonts and styles. So, if you're working on a wedding book and choose Caption - Wedding, you get a font style that's appropriate for wedding photo books. A nice time saver.

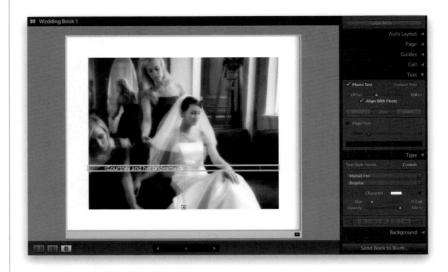

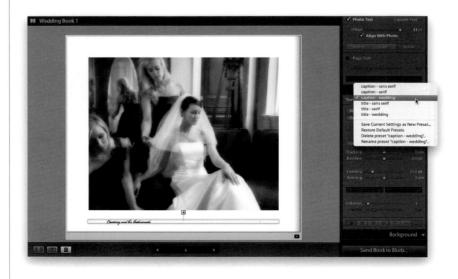

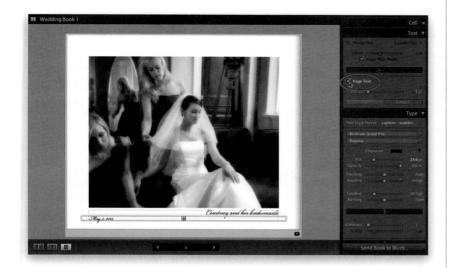

Step Seven:

While we're talking presets: if you tweak your text and like it, you can save the settings as a preset (choose **Save Current Settings as New Preset from** the Text Style Preset pop-up menu). That way, next time you don't have to start from scratch. If you'd like to add another line of text (besides your caption), go back to the Text panel and turn on Page Text (as shown here). This adds another line of text, lower down the page (you can control how far below the photo it appears using the Offset slider, just like the Photo Text). Of course, you can use the Type panel to choose your font, alignment, and all that stuff just like usual, but remember to highlight your text first.

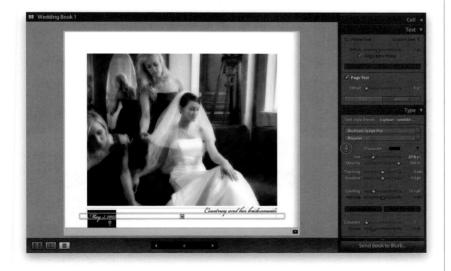

Step Eight:

If you'd like a more visual approach to your type tweaks (rather than dragging sliders or choosing numbers), then click on the Targeted Adjustment tool (TAT, for short—it's circled in red here). Now you can click-and-drag on your highlighted text to change the Size or Leading. Just move your cursor directly over your text, and click-and-drag up/down to control the space between two lines of text (Leading) or drag left/right to control the Size of your type (that's what I'm doing here). Honestly, I don't find myself using the TAT for Type tasks—it seems easier and faster to just move the sliders, but hey, that's just me. So, that's the scoop on adding captions and text to your photo book. Note: If you chose a layout where you can add a lot of text, you can split that text into multiple columns using the Columns slider at the bottom of the Type panel. The Gutter slider controls the amount of space between your columns—dragging to the right increases the amount of space between them.

Adding and Customizing Page Numbers

Another nice Book module feature added in Lightroom 5 is automatic page numbering. You have the ability to control the position, the formatting (font, size, etc.), and even which page the numbering starts on (along with how to hide the page numbers on blank pages if you want).

Step One:

To turn on page numbering, go to the Page panel and turn on the Page Numbers checkbox (shown circled here in red). By default, it places page numbers in the bottom-left corner of left pages and bottom-right of right pages.

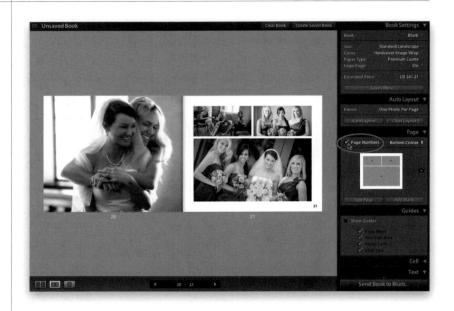

Step Two:

You can choose where you'd like them to appear using the pop-up menu to the right of the Page Numbers checkbox. The Top and Bottom options center the page number at the top or bottom of the page (respectively; as shown here, where I moved them to the bottom center). Choosing Side places the page number at the outside center of the page and, obviously, choosing Top Corner will move it to the top corner of the page.

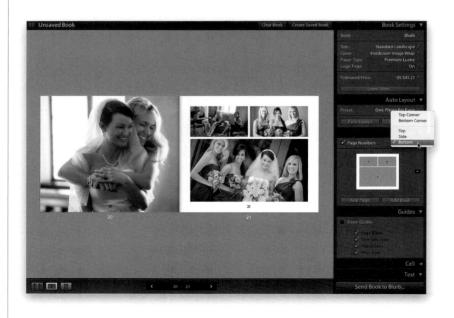

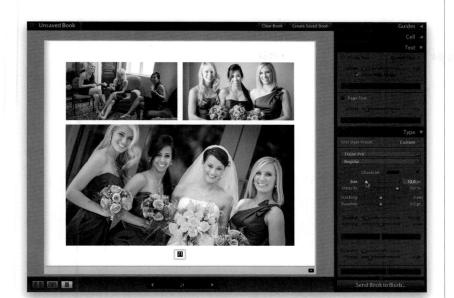

Once your numbers are visible, you can format them (choosing a custom font, size, etc.) by clicking on any page number, then going to the Type panel and choosing how you want them to appear (here, I changed the font to Trajan Pro and I lowered the Size to 12 pt).

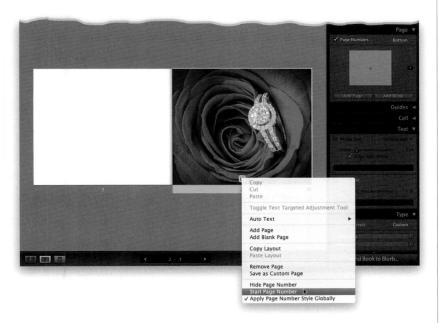

Step Four:

Besides just customizing their look, you can also choose which page the numbering starts on. For example, if the first page of your photo book is blank (so the images or opening story start on a right page), you can have that right page become page 1 by Rightclicking directly on the page number itself on the right page and, from the pop-up menu that appears, choosing Start Page Number (as shown here). Lastly, if you have a blank page(s) in your book (maybe all the left pages), and you don't want it to have a printed page number, just Right-click on the number on the blank page, and from the pop-up menu that appears choose Hide Page Number.

Four Things You'll Want to Know About Layout Templates

There are a few things about making books in Lightroom that aren't really obvious, so I thought I'd put them all together here so you don't have to go digging for them. It's all easy stuff, but since Adobe likes to sneak some features in "under the radar," or give them names that only Stephen Hawking can figure out, I thought this might keep you from reaching for a pistol. Ya know, metaphorically speaking.;-)

One: The Advantage of Match Long Edges (and How to Do It Manually) If you create an Auto Layout preset (see page 341) and choose Zoom Photos to Fit, there's a checkbox for Match Long Edges. With that turned off, if you put a wide photo and a tall photo on the same page, the tall photo will be much larger than the wide photo (as shown here, left). If you turn on Match Long Edges, then it balances the size, even though the two photos have different orientations (as shown here, right). If you didn't use Auto Layout, and you still want that balanced look, just hover your cursor over the corner of the tall image and it changes into a two-headed arrow. Click-and-drag inward to visually shrink the photo until it balances the size.

Two: Saving Your Favorite Layouts If you see a layout you like and want to use again (without having to remember where to find it), you can save it to your Favorites at the top of the Modify Page pop-up menu by hovering your cursor over it, then clicking on the little circle that looks like a Quick Collection marker (as shown here). If you change your mind, go to your Favorites, and click on the now-gray circle to turn it off. Also, once you've set up some favorites, if you create an Auto Layout preset, one of the page choices in the Editor will be Random from Favorites—it pulls the layout from ones you like. You even get to choose how many photos per page it includes (that way, if you only want 1- or 2-photo favorites, it'll only use those). Cool!

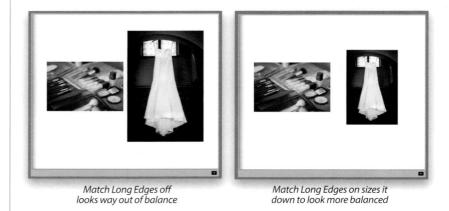

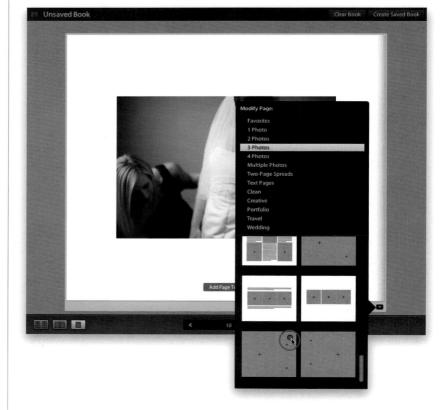

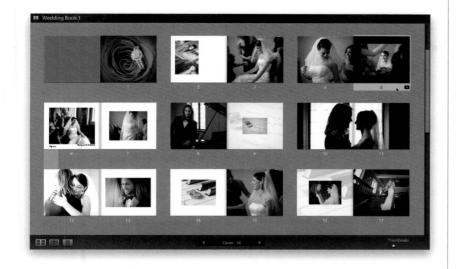

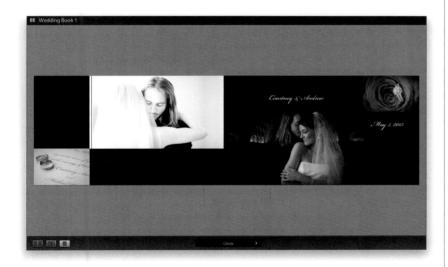

Book Settings	₹
Blurb	
Standard Landscape	
Softcover	÷
Premium Lustre	
None	
US \$33.34	
am More	
	Blurb Standard Landscape Softcover Premium Lustre None US \$33.34

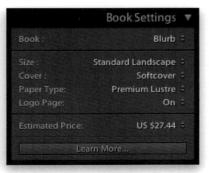

Three: Sorting Pages

You sort pages in Multi-Page View by clicking on the page you want to move to select it, then you click directly on the vellow bar at the bottom where the page number is (as shown here, where I've clicked on page 5), and then you just drag-and-drop that page where you want it in your book. If you want to move a two-page spread, click on the first page to select it, Shift-click on the second page to select it, and then click on either page number area to drag-and-drop the spread to a new location. You can even move groups of pages at once (like pages 10 through 15) by Shift-clicking on those pages to select them, then clicking on any one of the selected page's yellow bar at the bottom, and dragging them where you want them. By the way, you can swap photos from page to page when you're in the Multi-Page View by just clicking-anddragging them.

Four: The Front & Back Covers Change If You Choose Dust Jacket

If you choose the Hardcover Dust Jacket cover option for your book, you get to add two extra images on the flaps that fold inside the covers to keep your dust jacket in place (as seen here). You'll only see these side flaps appear if you choose the dust jacket option.

Five: I Know, I Said There Were Only Four, But...

There's one more page you might want to consider in your book: Blurb's logo page, which is the last page in the book. If you let them put their logo at the bottom of the last page, they give you a discount on the price of your book. How much? Well, on this book, the regular price was \$33.34 without the logo page. If you turn on the option to allow a logo page (in the Book Settings panel), then the price comes down to \$27.44 (that's around a 20% discount for giving them a logo on a page that was going to be blank anyway. Definitely worth considering).

Creating & Saving Your Own Custom Layouts

Back in Lightroom 4, the one Book module feature I really felt was missing was the ability to save your own custom layouts. I mean, technically you could *create* a custom layout, like we did earlier in this chapter (it wasn't really obvious—still isn't), but there was no way to save it to use it again. Sure you could mark some of the ones Adobe created as your favorites, but not ones you created from scratch. Well, until now anyway (whoo hooo!).

Step One:

Start by clicking on an image in your book layout, then click on the Change Page Layout button at the bottom-right corner of the page, and choose 1 Image, then the full bleed (edge-to-edge) layout preset. The reason we choose this one is because it's the preset that gives us the most flexibility in customizing. Now, click on the outside edge of the page and drag inward a bit, so you can see all the sides of the cell (as shown here).

Step Two:

Go to the Cell panel (in the right side Panels area) and make sure the Link All checkbox is turned off (as seen in the overlay below), so that you can move the cell borders anywhere you'd like, independently of each other. For this page, we want to create more of a panoramic crop for our images, so start by grabbing the bottom cell border and dragging upward (as shown here).

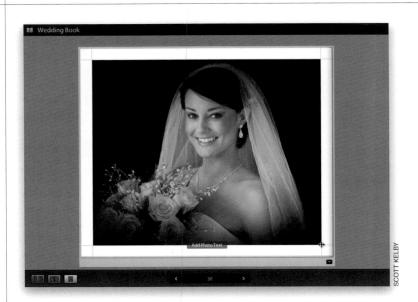

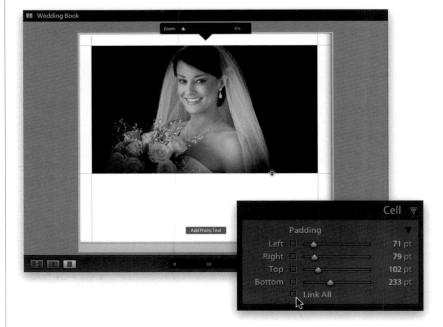

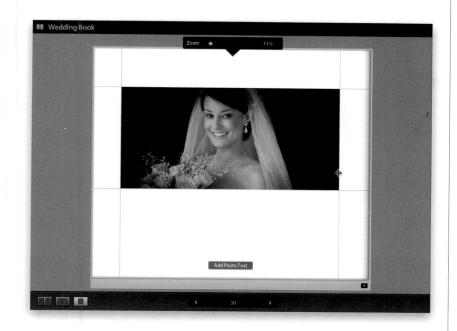

Now tuck in the sides of the cell, and adjust the top and bottom, until the photo layout looks like the pano-like crop you see here.

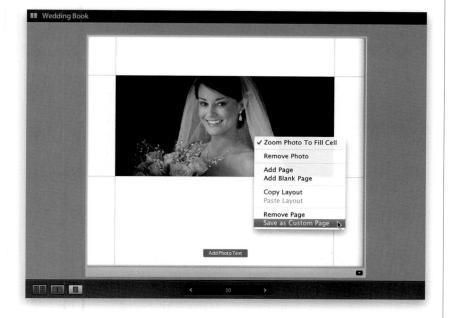

Step Four:

Once you have the page laid out the way you'd like it, Right-click anywhere on the page and from the pop-up menu that appears, choose **Save as Custom Page**. That's all there is to it! Now, on the next page, we'll look at where these custom pages are (and how to use them).

Step Five:

Click on the Change Page Layout button at the bottom-right corner of your page, and in the Modify Page pop-up menu, near the top, right under Favorites, will be your Custom Pages preset option. Click on it and it shows thumbnails of the custom layouts you've saved (in this case, I've saved three different layouts, the last one being the one we just created).

Step Six:

Now, to apply your custom layout to an existing book page, first go to that page (here, I'm going to change the layout of the photo of the groom on page 4). Click on the page and then, from the Modify Page pop-menu, click on Custom Pages to see your layout thumbnails at the bottom of the menu, then click on the layout you want to use (as seen here), and that layout is applied to that page (as shown at the bottom here).

Note: Depending on how the original page was laid out (i.e., whether it was set to Fit or Fill), you might have to increase the zoom amount (using the Zoom slider that appears above the image when you click on it), so the image now fills the cell (that's what I had to do here, because the Adobe layout I had used on page 4 was set to Fit inside the cells, not Fill it. Just so you know.

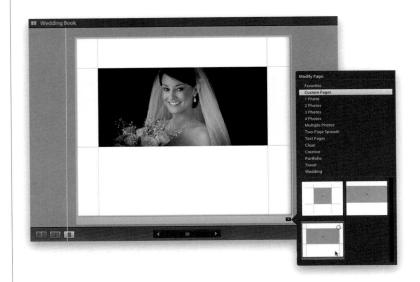

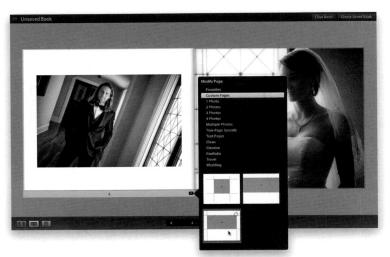

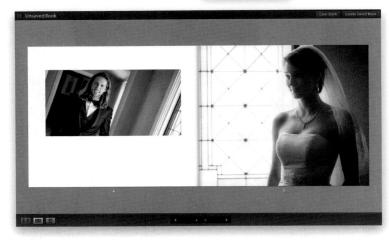

If you want to create your cover text here in Lightroom's Book module, you're in luck, because it's more powerful and flexible than you might think. You can create multiple lines on the cover, different text blocks with different typefaces, and you can even add text to the spine for hardcover wrap layouts.

Creating Cover Text

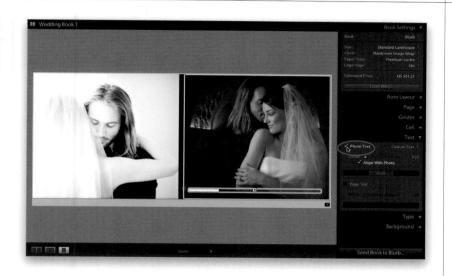

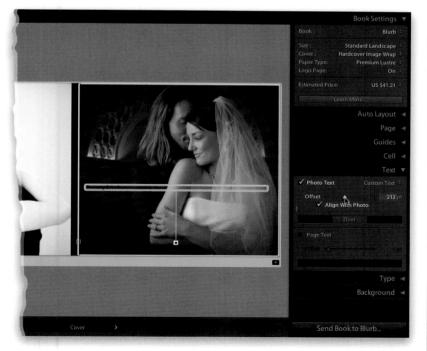

Step One:

Click on the Front Cover page to make it active, and you'll see "Add Photo Text" appear over the bottom center of the image. Click on that and a text block appears at the bottom of your image. Any text you enter in this text block will appear over your image. By the way, if for any reason you don't see the Add Photo Text button, go to the Text panel (in the right side Panels area) and turn on the Photo Text checkbox (as seen circled here) and it will appear. In our case, I typed in "Courtney & Andrew," but it's hard to see because the default type color is black (don't worry, we'll change that type color in a few moments).

Step Two:

Like I mentioned, by default your text block appears near the bottom of the image, but you can choose how high on the page this text block appears using the Offset slider in the Photo Text section of the Text panel (as shown here). The farther you drag the Offset slider, the farther up that text block moves (as seen here, where I stopped so I could put my text in the open dark area to the left of the groom).

Once you have your text block positioned where you want it, you can control everything from the color of the text to the size, leading (space between two or more lines of type), tracking (the space between all the letters in your text), and even the justification (left, center, right, justified) in the Type panel. This is a pretty darn surprisingly powerful panel, with lots of nice options to make your type look great. We'll start by making our type white (so we can actually see it). So, click-and-drag over your text to select it, then in the Type panel, click on the black Character color swatch to bring up the Character color picker and click on the white color swatch (as shown here). Now your type is white.

Step Four:

If you're creating a wedding book (like we are here), you can actually make use of a "wedding type" look that Adobe created for you. Just go to the top of the Type panel and you'll see a Type Style Preset pop-up menu. From that menu, choose **Title - Wedding** and it picks a nice wedding-style font for you. Now all you have to do is adjust the color and placement, as needed (as seen here, where I changed the color to white and clicked on the Align Left button at the bottom of the panel).

TIP: Getting a Second Text Block
If you go back to the Text panel and turn
on the Page Text checkbox, you can add a
second block of text that you can position
and style just like we've done here.

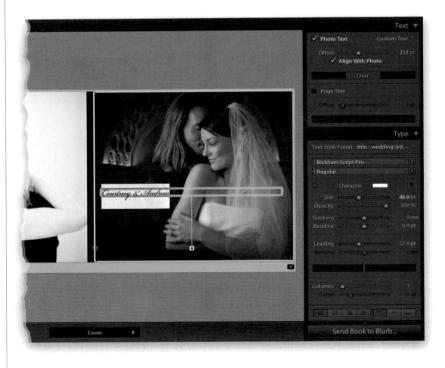

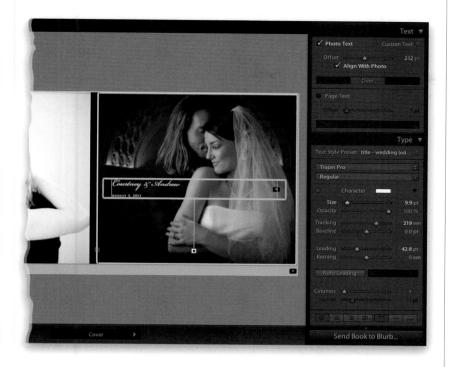

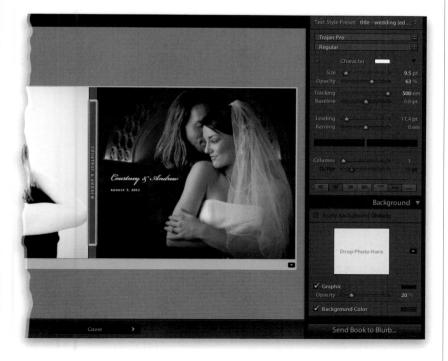

Step Five:

If you want a second line of type in the same text block, just put your cursor after the last letter and hit the Return (PC: Enter) key on your keyboard. The nice thing is this second line can be edited completely separately from the first line, so you can type in your text, select it, then choose a different font (I chose Trajan Pro), change the size (I made it real small— 9.9 points), and you can control the space between the letters (I increased the tracking to 219 to make the text look more elegant). Also, since the two lines of type were so close to each other (they were literally touching), I used the Leading slider (it controls the distance between two lines of text) to add lots more space between them (here, I increased it to 42.8). Finally, I clicked on the left side of the text box and dragged it in to the right a bit.

Step Six:

If you're printing a hardcover image wrap book, you also have the option of adding type to the spine. Just move your cursor over the spine (between the front and back cover) and a vertical text block will appear. Click inside it and start typing to add your text sideways down the spine (as seen here). You can edit the font, color, position, etc., just like you would any other text block.

TIP: Choosing a Color for the Spine
Go to the Background panel, turn on the
Background Color checkbox, then click on
its color swatch and choose a new color
(I chose a brown color in the last step).
Even better tip: when the Background
Color picker appears, click-and-hold your
mouse button down anywhere in the
picker and, while still holding down the
mouse, move the Eyedropper tool out
over your cover photo and steal a color.

Custom Template Workaround

If you want a layout for your photo book that is more ambitious than the simple Custom Page layouts you just learned about, then you can do a pretty slick little workaround (which I learned from Adobe's own Lightroom Evangelist, Julieanne Kost), which is to go to the Print module, design any custom page layout you want (at the same size as your book) with the photos you want, save it as a JPEG file, and import that finished layout into Lightroom as if it was just one photo. It's not actually a template, but it looks like you used one.

Step One:

First, jump over to Lightroom's Print module, and click on the Page Setup button in the lower-left corner. When the Page Setup (PC: Print Setup) dialog appears, from the Paper Size pop-up menu, choose Manage Custom Sizes to bring up the dialog you see here (on a PC, click the Properties button, then in the Paper Options section, click the Custom button). You're going to create a new preset size (so you don't have to go through this again). Click the + (plus sign) button (shown circled here in red), and enter 7 in for both Width and Height (PC: Length), for Blurb's Small Square 7x7" book. On a Mac, you'll need to set all your margins (left, top, right, bottom) to 0 in, then click OK twice. Now this template is one click away in the future. While you're here, though, you might want to create presets for all the Blurb sizes (like 10x8", 8x10", 13x10", and 13x13").

Step Two:

Now design any layout you'd like in the Print module. For this layout, I used one of the built-in presets that comes with Lightroom called 4 Wide (found in the Template Browser panel in the left side Panels area). Once the template appeared, I selected the four photos I wanted in this layout, then I turned the Identity Plate checkbox off in the Page panel in the right side Panels area. I only changed two small settings in the Layout panel, so it all fits nicely in the 7x7 square we're using. I set the bottom and top margins to 0.44 in and left the sides at 0.50 in, which gives you the layout you see here (there isn't a layout exactly like this in the Book module's templates).

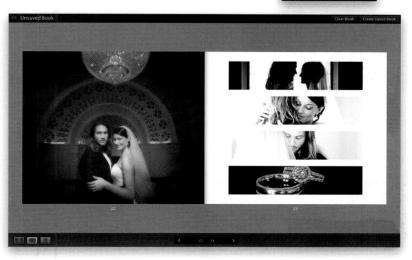

Although I used a built-in print template here, you can use the Print module's Custom Package feature (found up in the Layout Style panel at the top of the right side Panels area) to start with a blank page and create any type of layout you want (see page 426). Okay, once you've got your page set up the way you want it to look here in the Print module, scroll down to the Print Job panel and, where it says Print To, go ahead and choose JPEG File (as shown here). Set your Print Sharpening and Media Type to whichever settings you use (see Chapter 13 for more on this), then turn on the checkbox for Custom File Dimensions (so it uses the 7x7" custom size you created). Click the Print to File button to save this single 7x7" page as a JPEG file.

Step Four:

Now go to the Library module, and press Command-Shift-I (PC: Ctrl-Shift-I) to bring up the Import window. Find that JPEG file you just created and import it into Lightroom. Once it comes in, drag it into the collection you created for your photo book, then jump back to the Book module. Go to the page in your book where you want this 4 Wide image to appear. Right-click on the image on that page and choose Remove Photo, so it's just an empty page. From the Modify Page pop-up menu, choose a layout where the photo will fill the entire page (as shown at the top here). Then, simply find your 4 Wide image in the Filmstrip and drag it onto this empty page to get the layout you see here. The downside is that it's not a template—it's a fixed page (a flattened JPEG like any other photo). The upside is that you've got a page in your book where you created the layout from scratch exactly the way you wanted it.

Lightroom Killer Tips > >

▼ Zooming In/Out on Pages You can use Photoshop's keyboard shortcuts for zooming in/out on your pages: press Command-+ (PC: Ctrl-+) to zoom in tighter on your page, or Command-- (PC: Ctrl--) to zoom back out.

▼ Zoom Multiple Photos

If you're working with more than one photo on a page, and you want to zoom all those photos in tighter, just select the first photo, press-and-hold the Shift

key, select any other photos you want zoomed on the page, and then drag the Zoom slider, and all the selected photos will zoom at the same time.

▼ Lightroom Converts Your Book to sRGB for Printing

Most photo labs ask that images sent to their lab for printing be converted to the sRGB format, but when printing your book, you won't have to worry about this because the images in your book are automatically converted to sRGB when the book is sent to Blurb.

▼ Tweaking an Image on a Page If you're looking at an image in your book and you feel like it needs to be lighter, darker, more contrasty, etc., just click on the image, then press the letter D to take that image over to the Develop module. Make your tweaks there, and then press Command-Option-4 (PC: Ctrl-Alt-4) to jump back to the Book module and pick up right where you left off.

▼ Getting Larger Multi-Page Views

One thing a lot of folks miss when they're in Multi-Page View mode (the mode where you can see the two-page spreads in your book) is that you can change the size of your thumbnails, so you can either see more pages in the same space, or have a larger view of your spreads. You do this on the far-right side of the toolbar (right under the Preview area)—you'll see a Thumbnails slider. This works particularly well when you use the next tip (pressing Shift-Tab before you enter Multi-Page View mode).

A Bigger View for Sorting Your Pages in Multi-Page View

When you start to do your page sorting (sorting the order of two-page spreads in your book), try this: press Shift-Tab to hide all your panels, which gives you a much larger view of your book, and it's easier to move spreads around when you have more space like this.

▼ Four Keyboard Shortcuts That Save a Lot of Time

You don't have to learn a bunch of shortcuts for making books, but these four will make the process that much faster

for you: (1) Command-E (PC: Ctrl-E) switches you to the Multi-Page View; (2) Command-R (PC: Ctrl-R) switches you to the Spread View; (3) Command-T (PC: Ctrl-T) switches you to Single Page View; and (4) Command-U (PC: Ctrl-U) switches you to Zoomed Page View

(zoomed in really tight), which is particularly handy when you need to quickly check some caption text for a typo.

Adding Pages

If you click the Add Page button in the Pages panel, it adds a new blank page to the end of your book, but more likely you're going to want to add a page at

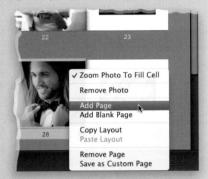

the spot you're currently working on in your book. To do that (add a page in front of the page you're on, rather than at the end), just Right-click on the page and choose Add Page, and it adds it right there.

▼ Why You Should Try Auto Lavout Before You Put Your Photos in Order

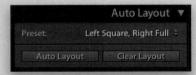

One big benefit of letting Lightroom do an Auto Layout of your book pages with your photos in a random order is that you'll generally find a couple of twopage layouts that look fantastic together, but they're photos that you might never have put together yourself. I find this happens every time I try this—I come up with at least three or four two-page layouts that look fantastic, just out of sheer luck of the pairing. Try it once and you'll see what I mean.

Lightroom Killer Tips > >

Custom Page Save "Gotcha!"

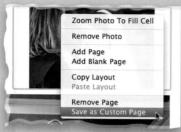

When you create a custom page design and save it as one of your own custom pages, it remembers how many cells you had and what their positions were, and it even remembers if you had a text field, along with its position. The "gotcha" is what it doesn't remember. It doesn't remember whether you had these cells set to Zoom Photo to Fill and it doesn't remember your text formatting (font, size, etc.), or whether your text had multiple columns. Hey, they have to have something to fix in Lightroom 6, right?

Changing the Format of a Page Number for Just One Page

By default, page numbers automatically added to your book using the Page Numbers feature in the Page panel all share the same formatting (they all use whichever font, size, and other formatting choice you make). But, what if you have a full-page image that's dark, and you need to have that one page have its page number appear in white? Or what if there are a handful of pages where the font is either too dark, too light, or the wrong size? In that case, you can Rightclick directly on the page number itself on the page where you need to change the color (size, etc.), and from the popup menu that appears, choose Apply Page Number Style Globally to turn

it off. Now, you can highlight the page number on that page, go to the Type panel, and choose white for its color (and now all the other page numbers can be edited individually, as well).

Adding Captions Under Multiple Photos

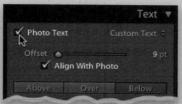

If you have a page with multiple images (let's say a page with three cells), and you want a caption to appear under each individual image (rather than just one caption for the entire page), start by clicking on the first photo, then press-and-hold the Command (PC: Ctrl) key and click on the other two images to select all three. Now, go to the Text panel and turn on the Photo Text checkbox and now each of the selected images will have their own separate caption field right under them.

▼ Automatic Captions from Your Image's Metadata

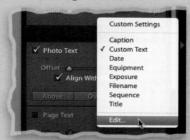

If you turn on the Photo Text checkbox (in the Text panel), just to the right of that checkbox is a pop-up menu of automated captions, including new choices in Lightroom 5 like the ability to pull info from the image metadata—stuff like Exposure or Equipment (camera make and model). Or you can totally customize your caption

by choosing Edit, which brings up the Text Template Editor, where you can pretty much have it generate whatever you want. By the way, you can format the font, size, and specs for this caption text in the Type panel.

▼ Locking a Text Caption's Position If you've positioned a text caption somewhere on your page and you want to make sure it doesn't get moved accidentally (when you're swapping out images or moving cells), just click on the square with a small black square inside that appears on the edge of the caption

field. It will fill with yellow, showing that its position is now locked. To unlock it, click on that same little square again.

▼ Money-Saving Paper Option If you want to save a few bucks on your photo book, in Lightroom 5, Blurb added a new paper option called "Standard," which uses a lesser-quality paper (perfect if you're just creating a small proof book before you print the larger, more expensive final book). For example, for a Standard Landscape size book, with a Hardcover Image Wrap, switching from Premium Luster to this new Standard paper equaled around a 13% savings for me. Definitely worth considering (even though the pages won't be as thick, so you might see some bleed-through if you print images on both sides of the page).

▼ Jump to a Single-Page View Double-click on any page to jump to a large Single Page View of that page.

The Adobe Photoshop Lightroom 5 Book for Digital Photographers

SLIDESHOW creating presentations of your work

You know what's harder than creating a compelling screen presentation of your work, coupled with a moving and emotionallycharged background music track? It's finding a song, TV show, or movie title that uses the word "Slideshow." By the way, I can't tell you the amount of angst the word "slideshow" has caused my beloved editor, Kim Doty, because, really, the word slideshow is two words (slide show), but in Lightroom, Adobe chose to name the module with just one word—Slideshow. Well, when the previous version of this book came out, I noticed that Kim had taken all uses of the word "slideshow" and changed it to "slide show," except when it referred to the actual module name itself. So, in this edition, I asked Kim to make it consistent and always refer to it as one word—slideshow. This didn't go over very well with Kim, which troubled me because Kim, by nature, has the happiest,

bubbliest demeanor of not only any editor in the editing world, but of most people on the entire planet. So, I thought I could kind of joke around about it and Kim would change it all back to one word, and she begrudgingly said "Okay" and went back to her office. But then, as we were wrapping up the book, Kim came to my office, sat down, and I could tell something was wrong. This is a rare moment indeed, so I gave her my full attention. She went on to let me know how much the single-word thing was bothering her, and we went back and forth for about 10 minutes, until she pulled out a knife. I clearly didn't realize how much this meant to Kim, so of course, I relented and the chapter has been adjusted so the two-word "slide show" appears where appropriate. Also, the other good news is: the doctor says my stitches should be out within two weeks.

Creating a Quick, Basic Slide Show

Here's how to create a quick slide show using the built-in slide show templates that come with Lightroom. You'll probably be surprised at how easy this process is, but the real power of the Slideshow module doesn't really kick in until you start customizing and creating your own slide show templates (which we cover after this, but you have to learn this first, so start here and you'll have no problems when we get to customizing).

Step One:

Start by jumping over to the Slideshow module by pressing Command-Option-5 (PC: Ctrl-Alt-5). There's a Collections panel in the left side Panels area, just like there is in the Library module, so you have direct access to the photos in any collection. First, click on the collection that has the photos you want to appear in your slide show, as shown here. (Note: If the photos you want in your slide show aren't in a collection, it will make your life a lot easier if they are, so head back to the Library module [press the letter G1, and make a new collection with the photos you want in your slide show, then jump back over to the Slideshow module, and click on that collection in the Collections panel.)

Step Two:

By default, it's going to play the slides in the order they appear down in the Filmstrip (the first photo from the left appears first, the second photo appears next, and so on), with a brief dissolve transition between slides. If you only want certain photos in your collection to appear in your slide show, then go to the Filmstrip, select just those photos, and choose **Selected Photos** from the Use pop-up menu in the toolbar below the center Preview area (as shown here). As you can see, you can also choose to have just flagged photos in your slide show.

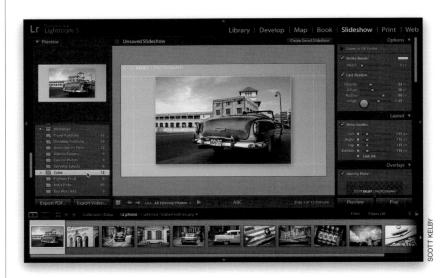

If you want to change the order of your slides, just click-and-drag them into the order you want them. (In the example shown here, I clicked on the third photo and dragged it over so it was the first photo in the Filmstrip.) So, go ahead and do that now—click-and-drag the photos into the order you'd like them to appear in your slide show. (*Note:* You can always change your mind on the order any time by clicking-and-dragging right within the Filmstrip.)

Step Four:

When you first switch to the Slideshow module, it displays your photos in the default slide show template, which has a light gray gradient background and your Main Identity Plate in the upper-left corner in white letters (now this is not to be confused with the Default template in the Template Browser, and yes, it usually looks pretty bad, as seen here, but we'll deal with that later on). Click on any other photo in the Filmstrip to see how that slide will look in the current slide show layout.

Step Five:

If you want to try a different look for your slide show, you can use any of the built-in slide show templates that come with Lightroom (they're in the Template Browser in the left side Panels area). Before you start clicking on them, however, you can get a preview of how they'll look by just hovering your cursor over their names in the Template Browser. Here, I'm hovering over the Caption and Rating template, and the Preview panel shows that template has a light gray gradient background, and the images have a thin white stroke and a drop shadow. While this is similar to the default template, with this template, if you've added a star rating to your photo, the stars appear over the top-left corner of your image, and if you added a caption in the Library module's Metadata panel, it appears at the bottom of the slide. Let's go ahead and try this one.

Step Six:

To see a quick preview of how your slide show will look, go to the toolbar below the center Preview area, and click the Preview button (it's a right-facing triangle—just like the Play button on a DVD player). This plays a preview of your slide show within that center Preview area, and although the slide show is the exact same size in that window, you're now seeing it without guides, with transitions, and with music (if you chose to add music, which we haven't covered yet, so you probably haven't, but hey, ya never know). To stop your preview, press the square Stop button on the left side of the toolbar; to pause it, press the two vertical lines where the Play button used to be (as shown here).

TIP: Life Is Random

Your slides play in the order that they appear in the Filmstrip, but if you want your slides to appear in a completely random order, go to the Playback panel in the right side Panels area and turn on the Random Order checkbox.

Step Seven:

If you want to remove a photo from your slide show, just remove the photo from your collection by clicking on it in the Filmstrip and pressing the Delete (PC: Backspace) key on your keyboard (or choose Selected Photos from the Use pop-up menu in the toolbar and just make sure you don't select that photo). Here, I removed that photo shown in Step Six from the slide show by hitting the Delete key, so the next photo in the Filmstrip is now displayed. By the way, this is another advantage of collections vs. folders. If you were working with a folder here, instead of a collection, and you deleted a photo, it would actually remove it from Lightroom and from your computer. Yikes!

Step Eight:

When you're done tweaking things, it's time to see the full-screen final version. Click the Play button at the bottom of the right side Panels area, and your slide show plays at full-screen size (as shown here). To exit full-screen mode and return to the Slideshow module, press the Esc key on your keyboard. Okay, you've created a basic slide show. Next, you'll learn how to customize and create your own custom slide shows.

TIP: Creating an Instant Slide Show I mentioned this in an earlier chapter, but you can create an impromptu slide show anytime without even going to the Slideshow module. Whichever module you're in, just go to the Filmstrip, select the photos you want in your slide show, then press Command-Return (PC: Ctrl-Enter), and it starts—full screen.

Customizing the Look of Your Slide Show

The built-in templates are okay, but after you create a slide show or two with them, you're going to be saying stuff like, "I wish I could change the background color" or "I wish I could add some text at the bottom" or "I wish my slide show looked better." Well, this is where you start to create your own custom look for your slides, so not only does it look just the way you want it, your custom look is just one click away from now on.

Step One:

Although you might not be wild about Lightroom's predesigned slide show templates, they make great starting points for creating your own custom look. Here, we're going to create a vacation slide show, so start by going to the Slideshow module's Collections panel (in the left side Panels area) and click on the vacation collection you want to use. Then, go up to the Template Browser and click on Exif Metadata to load that template (seen here, which puts your photos over a black background with a thin white border, info about your photo in the top right, bottom right, and below your photo, and your Identity Plate in the upper-left corner).

Step Two:

Now that we've got our template loaded, we don't need the left-side panels anymore, so press F7 (or Fn F7) on your keyboard to hide them. The first thing I do is get rid of all the EXIF info (after all, people viewing your vacation slide show probably won't care what your ISO or exposure settings were), so go to the right side Panels area, to the Overlays panel, and turn off the Text Overlays checkbox (as shown here). Your Identity Plate is still visible, but the info in the upper- and lower-right corners and below the photo is now hidden.

TIP: Resizing Custom Text Once you create custom text, you can change the size by clicking-and-dragging

the corner points outward (to make it larger), and inward (to make it smaller).

Now let's choose how big your photos are going to appear on the slide. For this design, we're going to shrink the size of the photos a bit, and then move them up toward the top of the slide, so we can add our studio's name below them. Your photo is positioned inside four page margins (left, right, top, and bottom), and you can control how big/small these margins are in the Layout panel found in the right side Panels area. To see the margins, turn on the Show Guides checkbox. By default, all four margin guides are linked together, so if you increase the left margin to 81 pixels, all of the other margins adjust so they're 81 pixels, as well. In our case, we want to adjust the top and bottom separately, so first click on Link All to unlink the margins (the little "lights" beside each margin go out). Now, click-and-drag the Bottom margin slider to the right to 216 px and the Top margin slider to 144 px, and you'll see the photo scale down in size inward, leaving a larger margin below the photo (as shown here).

TIP: Moving Guides

You don't actually resize the photos on your slide—you move the margin guides and your photo resizes within the margins you create. You can do this visually (rather than in the Layout panel) by moving your cursor over a guide, and you'll see it change into a "moving bar" cursor (by the way, I have no idea if "moving bar" is its official name, but it is a double-headed arrow), and now you can click-and-drag the margins to resize the photo. If you move your cursor over a corner (where two guides intersect), you can drag diagonally to resize those two guides at the same time.

Step Four:

Now that our photo is in position, let's move our studio name Identity Plate below the photo. Click on it (up in the topleft corner of your slide) and drag it so it appears under your photo (when you drag it, it does this weird Spiderman thing of clinging to the edges. This is supposed to help you center your text by having it snap to the edges. At least, that's the theory).

TIP: Zoom to Fill Frame

If you see a gap between the edges of your photo and the margin guides, you can fill that gap instantly with a very cool feature called Zoom to Fill Frame. Turning on this checkbox (found in the Options panel at the very top of the right side Panels area) increases the size of your photos proportionally until they completely fill the area inside the margins. Give this a try—you'll probably use it more than you'd think.

Step Five:

To customize your Identity Plate text, go to the Overlays panel, click on the little triangle in the bottom-right corner of the Identity Plate preview, and choose Edit to bring up the Identity Plate Editor (seen here). Type in the name you want to appear below each photo (in my case, I'm using one of my studio Identity Plates, where I typed in Scott Kelby | Photography in the font Myriad Web Pro at 24 points you get that little bar by typing Shift-\ [backslash] on your keyboard. I clicked on the color swatch here and changed the font color temporarily to black, to make it easier to see), and click OK. Choosing the right point size isn't so critical, because you can change the size of your Identity Plate by either using the Scale slider (in the Overlays panel), or by clicking on your Identity Plate text on the slide and then clicking-and-dragging any corner point outward (which scales the text up).

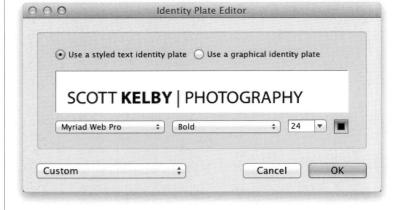

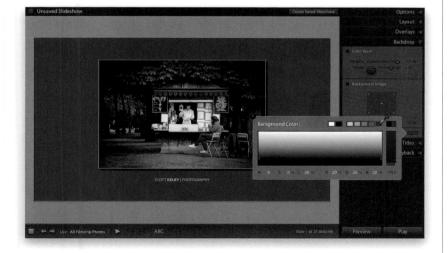

Step Six:

Let's take a look at how our custom slide layout is coming together by hiding the margin guides—press Command-Shift-H (PC: Ctrl-Shift-H), or you could go to the Layout panel and turn off the checkbox for Show Guides. If you look at the text below the photo, you can see it's not bright white—it's actually a very light gray (I like that better, because it doesn't draw the eye as much if it's not solid white), and to get this more subtle light gray look, you just lower the Opacity amount up in the Identity Plate section of the Overlays panel (here you can see I've got the Identity Plate Opacity lowered to just 60%). Also, if you want to rotate your Identity Plate text, click on it first, then use the two Rotate arrows found down in the toolbar (I've circled them here in red for you).

Step Seven:

You can change the background color of your slide to any color you'd like, so let's change it to a dark gray. Go down to the Backdrop panel, and to the right of the Background Color checkbox, you'll see a color swatch. Click on that swatch and the color picker appears, where you can choose any color you'd like (I chose a dark gray from the swatches at the top of the picker, as seen here). For more on customizing your background, go to the next project.

TIP: Add a Shadow to Your Identity Plate Text

If your slide has a lighter background color, you can add a drop shadow to your Identity Plate text. Just go to the bottom of the Overlays panel and turn the Shadow checkbox on. You can now control the opacity, how far offset your shadow is from your text, the radius (softness) of your shadow, and the angle (direction) of the shadow. *Note:* As of the writing of this book, this feature is not available in the PC version of Lightroom.

e Auobe Filt

Step Eight:

Now that we're on a gray background, rather than black, you can see that this Exif Metadata template actually has a drop shadow on the image included in the design, but of course you can't see it when you're on a solid black background (which makes you wonder why Adobe had that feature turned on in the first place, eh?). Anyway, you can control the size, opacity, and direction of the drop shadow (see page 390 for more on drop shadows) in the Options panel, but for now we'll just increase the Radius to soften the shadow and increase the Opacity a bit to give us the look you see here.

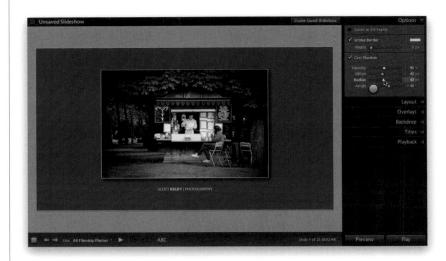

Step Nine:

Let's give this layout a little more of a fine art slide show feel by making the image area square. It's not real obvious how to do this, but luckily it's fairly easy. You start by moving the guides (press Command-Shift-H [PC: Ctrl-Shift-H] to turn them back on), so they make a square. This makes perfect sense at first, but once you see that it just resizes your photo, at the same aspect ratio, inside that square cell (rather than cropping it to square), you start scratching your head (well, I did anyway, but it was only because my head was itchy. That was pretty bad. I know). The trick is to go up to the Options panel and turn on the checkbox for Zoom to Fill Frame. That fills the square cell with your image, and now you get the square look you see here. While we're here, let's go and add a thicker stroke around the image using the Stroke Border Width slider in that same panel (more on adding a stroke on page 390).

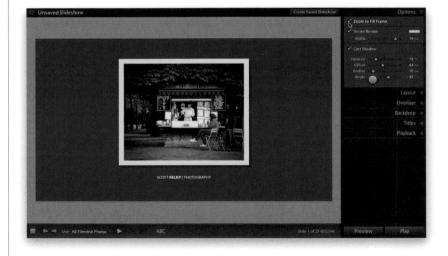

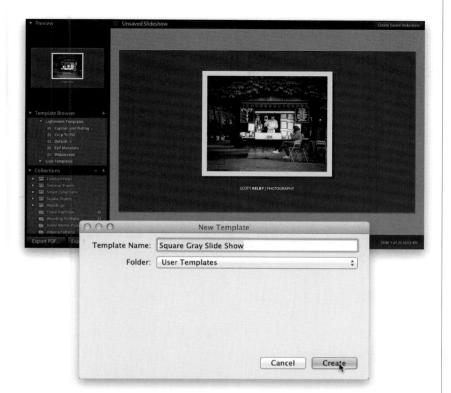

Step 10:

Now we're going to save our template, so in the future we can apply it with just one click in the Template Browser (it remembers everything: the text, the background color, the opening and closing title slides [more on those on page 392]—you name it). To do this, press **F7** to make the left side Panels area visible again, then go to the Template Browser and click on the + (plus sign) button on the far right of the panel header. This brings up the New Template dialog (shown here), where you can name your template and choose where you want to save it (I save mine in the User Templates folder, as shown here, but you can create your own folders and choose to save into one of them by choosing it from the Folder pop-up menu).

Step 11:

Now that you've saved your custom slide design as a template, you can apply this same exact look to a totally different set of images by going to the Slideshow module, and in the Collections panel, clicking on a different collection. Then, in the Template Browser, under User Templates, click on Square Gray Slide Show, and this look will be instantly applied to your collection of photos (as shown here).

Adding Video To Your Slide Show

Adobe didn't add a bunch of new features to the Slideshow module in Lightroom 5, but the one they did add is a biggie: the ability to have video clips and stills together in the same slide show. This expands what we can do in a big way. If you're a wedding photographer, or if you want to make a promo video for your business, or for behind-the-scenes videos, or even your family vacation, you no longer need to learn a dedicated video program to make a simple movie.

Step One:

Start in the Library module by creating a collection with the videos and stills you want in your slide show (in our example, we've got video clips of the wedding party and some still images). Now, press **Command-Option-5 (PC: Ctrl-Alt-5)** to switch to the Slideshow module.

Step Two:

The order that you see the images down in the Filmstrip is the order your videos and still photos will appear, so go ahead and arrange them in the order you want them. (*Note*: I generally find it looks better if you start with a video clip and then put a similar-looking still right after it.) Choose the Crop To Fill or Widescreen preset in the Template Browser on the left. Now, there are a few things I would definitely add to make this slide show more like a short movie, and we'll cover that next.

TIP: Editing Video Clips

If you want to learn how to trim clips and choose the opening frame for your video and stuff like that, turn to page 401 here in the book for my chapter on using DSLR video in Lightroom.

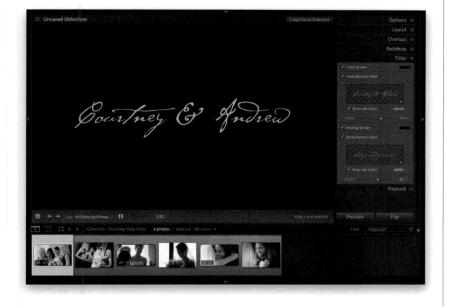

Step Three:

First, I'd start with an intro screen (see page 392 in this chapter) with the name of the bride and groom (in our case, Courtney & Andrew), and an ending screen (but I'd avoid writing "The End," unless you want a really awkward moment for everyone watching). Of course, for a wedding video like this, you need a background music track (see page 394). However, in Lightroom 5, since you're mixing video and stills, there's an important slider in the Playback panel. It's the Audio Balance slider and it lets you control the balance between the background music and any audio that was recorded by your camera when you shot the video. If you drag this slider all the way to the right, you'll only hear the background music. Drag it all the way to the left and you'll hear nothing but the audio in the video file. Put it in the middle, and you hear equal amounts of both, and you can drag it left or right to balance the two any way you want.

Step Four:

To see a preview of your slideshow, click the Preview button at the bottom of the right side Panels area. When you click that button, the slide show starts (with the intro screen, as seen here), and then moves through the videos and stills in order, with a dissolve between each one (controlled by the Fades slider in the Playback panel). That's all there is to it!

Getting Creative with Photo Backgrounds

Besides a solid color and a gradient fill, you can choose a photo as your slide background, and you can control the opacity of this background photo, so you can create a backscreened effect. The only downside is that the same background appears on every slide (except the title slides, of course), so you can't vary the background effect from slide to slide. Here, we're going to look at a simple photo background, then take it up a notch, and then finally pull a few tricks that will let you create some very creative slide show layouts.

Step One:

First a little setup: go to the Template Browser and click on the template named Caption and Rating. Now, let's simplify the layout: In the Options panel (at the top of the right side Panels area), turn off the checkboxes for Stroke Border and Cast Shadow, then click on the top-left corner of the guides and drag inward until your photo is smaller and closer to the bottomright corner (like the one shown here. After I did this, I turned off the Show Guides checkbox in the Layout panel). Now go down to the Overlays panel and turn off both the Text Overlays checkbox and the Rating Stars checkbox (so we don't see stars over our photo).

Step Two:

Go to the Backdrop panel, and turn the Color Wash checkbox off, so you no longer have a gradient over the background. Now, go to the Filmstrip and drag-and-drop the photo you want to use as a background image onto the Background Image well in the Backdrop panel (as shown here; you may have to turn the Background Image checkbox on first), and that image now appears as the background behind your currently selected photo. The background photo appears at 100% opacity, which usually means it's going to compete with your foreground photo, and for that reason we usually create a "backscreened" effect for the background photo, so it appears washed out and more subtle, and your main image stands out again.

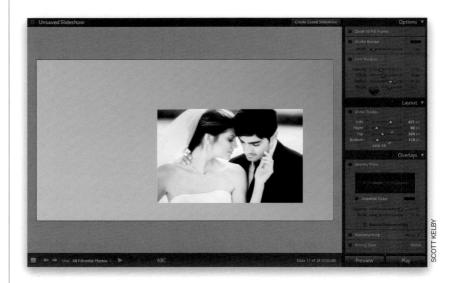

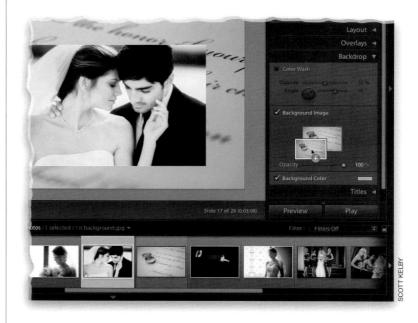

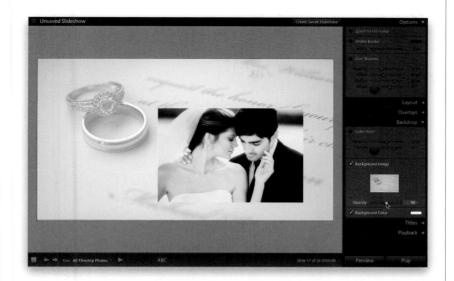

Step Three:

To create that backscreened effect, lower the Background Image Opacity to 50% (this will vary, depending on your image), and the photo fades to gray. If you prefer to have a white backscreened look, set your Background Color to white (click on the color swatch, then choose white in the color picker, as I did here), or if you want a black backscreened look (rather than gray or white), set the Background Color to black (which color looks best kind of depends on the photo you choose).

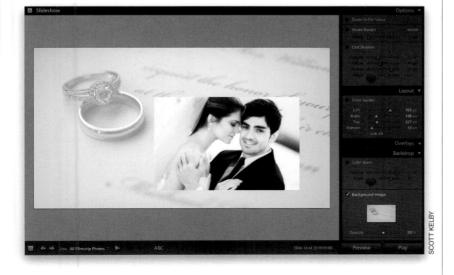

Step Four:

When you click the Preview button, or the Play button, you'll see the slides play with the photo you chose as the background image (as I mentioned in the intro, this same background will appear behind each photo).

The Adobe Photoshop Lightroom 5 Book for Digital Photographers

Step Five:

Now, thus far, we've just used one of our regular photos from the shoot as our background image, but if you use images that were designed to be backgrounds, you get an entirely different look. For example, the image shown here is a background image I bought from iStockphoto. I just went to their site (www.istockphoto.com), did a search for "photo frames," and this came up as one of the results. So I bought it, then imported it into Lightroom. Once it appeared in Lightroom, I dragged it into the collection where I wanted to use it, then I dragged it onto the Background Image well in the Backdrop panel for the effect you see here. (Note: I buy royaltyfree stuff like this from either iStockphoto or Fotolia [www.fotolia.com], but almost every microstock site has lots of frames and borders you can buy for just a few bucks.)

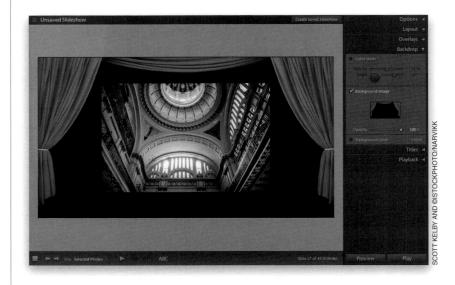

Step Six:

Here's another example of the kind of simple backgrounds you can download for your slide shows. Once you've imported the background image into Lightroom, remember to drag that image into the collection where you want to use it, then drag it onto the Background Image well in the Backdrop panel. Now, as your slide show plays, the images will appear inside the iPad. The only tricky part of this is getting the image to fit right inside the iPad. The trick is to (1) go to the Options panel and turn on the Zoom to Fill Frame checkbox. Then, (2) go to the Layout panel, click on Link All to turn this off, make your guides visible, and move them so they're just about the same size (on all sides) as the iPad's screen. It's easier than it sounds, since you can just drag the guides around right in the Preview area.

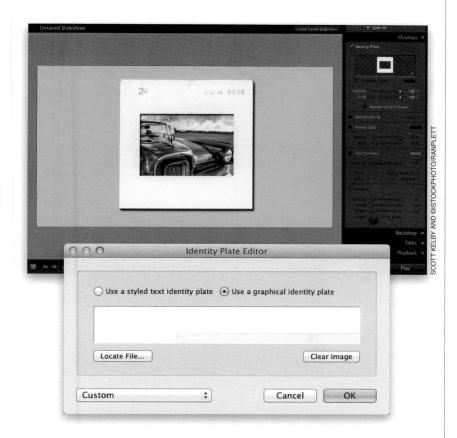

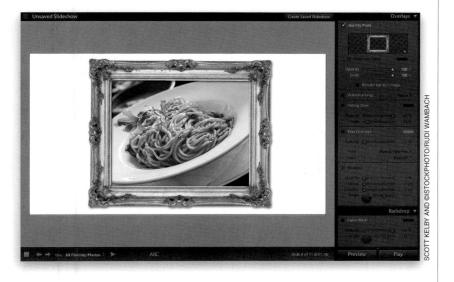

Step Seven:

Here's a workaround background trick that lets you put a photo inside your background (complete with a shadow): instead of using a graphic as a background image, use it as an Identity Plate. That way, you can have the background image appear in front of (or over) your photo rather than behind it. Here's a slide mount image I bought from iStockphoto. I took it into Photoshop, selected the slide and put it on its own layer, then selected the box in the center, and deleted it (to make the slide opening see-through). Next, I added a drop shadow in the opening, deleted the Background layer, and saved the file as a PNG to maintain its transparency when I bring it into Lightroom as a graphical Identity Plate. To bring it in, go to the Overlays panel, turn on the Identity Plate checkbox, click on the triangle at the bottom right of the Identity Plate preview, and choose Edit from the pop-up menu. When the Identity Plate Editor appears (shown here), click on the Use a Graphical Identity Plate radio button, then click on Locate File to find your slide file, and click OK. Once it appears in the Preview area, resize both the Identity Plate (by dragging the corner points) and the image (by dragging the margin guides). Also, be sure to have the Zoom to Fill Frame checkbox turned on in the Options panel.

BONUS VIDEO:

I did a bonus video for you, to show you step by step how to create Identity Plate graphics with transparency like you see here. You'll find it at http://kelbytraining.com/books/LR5.

Step Eight:

Here's another variation using a picture frame I bought from iStockphoto. The only difference is that I changed the Background Color (in the Backdrop panel) from gray to white. Now that you're seeing the potential of these backgrounds and Identity Plates, let's put the two together for some really creative layouts.

Continued

The Adobe Photoshop Lightroom 5 Book for Digital Photographers

Step Nine:

For this layout, let's start from scratch. Go to the Template Browser and click on the Caption and Rating template, then go to the Overlays panel and turn off the checkboxes for Rating Stars and Text Overlays, and be sure the Identity Plate checkbox is turned off, as well. Go to the Backdrop panel and turn off Color Wash, then go up to the Options panel and turn off the Cast Shadow and Stroke Border checkboxes. Now, use the margin guides to resize your image to give us the simple, clean look you see here.

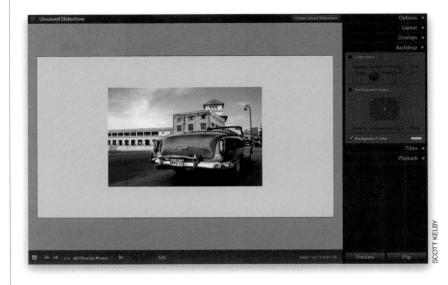

Step 10:

I went and downloaded an old map from iStockphoto (believe it or not, I searched for "old map" and this is what came up as the first result. Perfect!). Import that old map image into Lightroom, then drag it into the collection you're working with. Once it's there, drag that old map image into the Background Image well in the Backdrop panel (as seen here) to make the map the background for the slide. So far, so good.

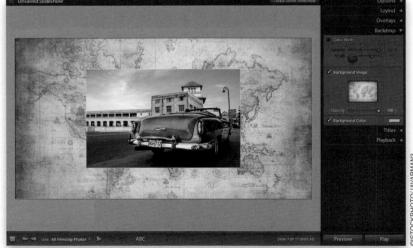

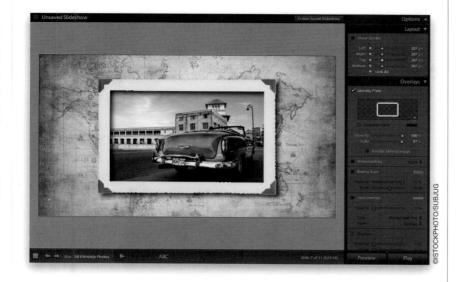

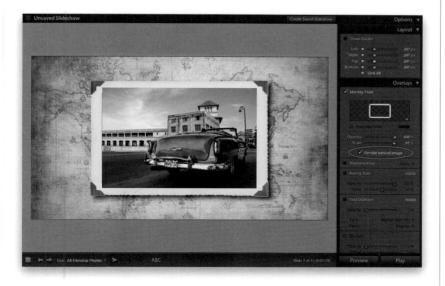

Step 11:

When I searched "photo frame" in iStockphoto earlier, I found this antique-looking photo frame. We're going to use this as a graphical Identity Plate, but before we do that, you'll need to use the same Photoshop technique I mentioned in Step Seven (and showed you in the bonus video), to make the center and surrounding area transparent (if we don't do that, you'd see a white box inside and around your frame, instead of the background around the frame, and inside being transparent, so it would totally wreck the look). Also notice how a slight drop shadow appears inside the frame, so it appears the photo is actually inside the frame. Anyway, once you've done the Photoshop transparency trick, go to the Overlays panel, turn on the Identity Plate checkbox, click on the triangle in the bottom-right corner of the Identity Plate preview, and choose Edit from the pop-up menu. When the Identity Plate Editor appears, click on the Use a Graphical Identity Plate radio button, then find your frame file, and click OK. Once it appears in the Preview area, resize both the Identity Plate and the image for the look you see here.

Step 12:

Make sure you have the Render Behind Image checkbox turned off, if you want the photo frame to appear in front of your image (like it does in Step 11), or for a slightly different look, turn it on (as seen here), so the image appears on top of the frame—you won't get the drop shadow appearing on the inside of your image, adding depth. The final layout is shown here (or in Step 11, depending on whether you turned the Render Behind Image checkbox on or off). I hope these few pages spark some ideas for you of what can be done with background images, Identity Plates, and using both together.

Working with Drop **Shadows and Strokes**

If you're building a slide show on a light background, or on a photo background, you can add a drop shadow behind your image to help it stand out from the background. You also have the option of adding a stroke to your images. While most of the built-in templates already have these features turned on, here we'll look at how to add them and how to make adjustments to both.

Step One:

To add a drop shadow, go the Options panel in the right side Panels area, and turn on the Cast Shadow checkbox. Most of the built-in templates, like Caption and Rating (shown here), already have the drop shadow feature turned on. The two controls you'll probably use the most are Opacity (how dark your drop shadow appears), and Radius (which controls how soft your drop shadow is. Why don't they call it "Softness?" Because that would be too obvious and easy [wink]). The Offset setting controls how far the shadow appears from the photo, so if you want it to look like your photo is higher off the background, increase the Offset amount. The Angle setting determines where the light is coming from, and by default, it positions your shadow down and to the right.

Step Two:

Let's tweak the drop shadow a bit: lower the Opacity amount to 18%, so it's lighter, then increase the Offset amount to 100%, so it looks like the photo is an inch or two off the background. Next, lower the Radius to 48%, so it's not quite as soft, and lastly, set the Angle to -41°, just to tweak its position a bit. Turning on the Stroke Border checkbox (at the top of the Options panel) puts a color stroke around your image. In this built-in template (and a couple of the others), the stroke is already on, but it's white and only 1-pixel thick, so you can hardly see it. To change the color, click on the color swatch, then choose a new color from the color picker (I chose black here). To make the stroke thicker, drag the Width slider to the right (I dragged mine to 12 px).

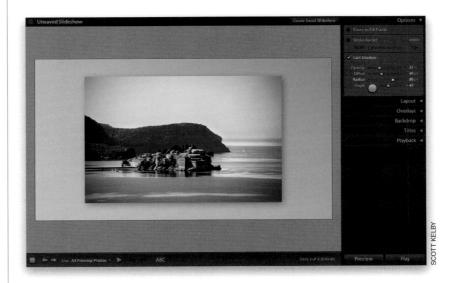

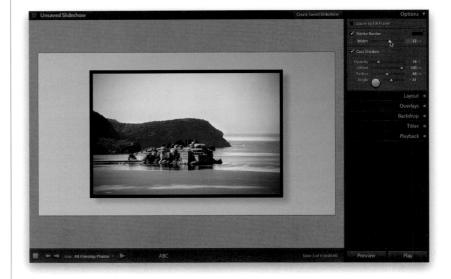

Besides adding text using the Identity Plate, you can add other lines of text to your photo (either custom text that you type in, or info that Lightroom pulls from the photo's EXIF data, or any metadata you added when you imported the photos, like your copyright info). You can also add a watermark to your slide show images, in case you're sending this slide show to a client or posting it on the web.

Develop

Adding Additional Lines of Text and Watermarking

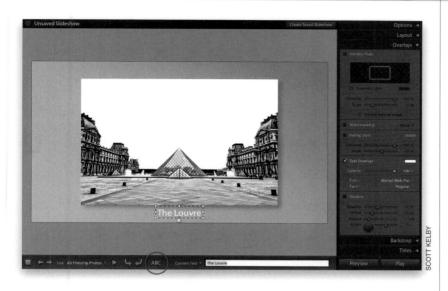

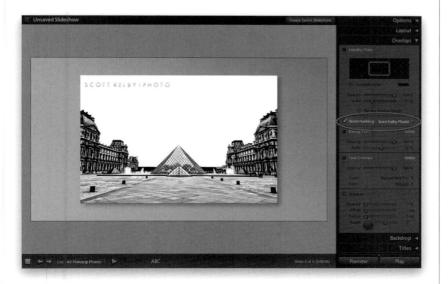

Step One:

To add text, click on the ABC button down in the toolbar (shown circled here in red). and a pop-up menu and text field will appear to the right of it. The default setting is Custom Text, and you can simply type the text you want in the text field, and then press the Return (PC: Enter) key. Your text appears on your slide with a resizing border around it. To resize your text, click-anddrag on any corner point. To move the text, just click right on it and drag it where you want it. If you click-and-hold on the words Custom Text in the toolbar, a pop-up menu appears that lets you choose text that may be embedded into your photo's metadata. For example, if you choose Date, it displays the date the photo was taken. If you choose any of the other options, it only displays that info if it's in the file (in other words, if you didn't add caption info in the Metadata panel, choosing Caption here won't get you anything).

Step Two:

If you set up a watermark (see page 288), you can add that, as well (or instead of the additional text). Go to the Overlays panel and turn on the Watermarking checkbox, and then choose your watermark preset from the pop-up menu (you can see the watermark here at the top left). The advantage of using a watermark (rather than custom text) is that you can use pre-made templates, where you also can lower the opacity so it's see-through, and doesn't fully cover the image behind it.

Adding Opening and **Closing Title Slides**

One way to customize your slide show is to create your own custom opening and closing title slides (I usually only create an opening slide). Besides just looking nice, having an opening slide serves an important purpose—it conceals the first slide in your presentation, so your client doesn't see the first image until the show actually begins.

Step One:

You create opening/closing slides in the Titles panel (found in the right side Panels area). To turn this feature on, turn on the Intro Screen checkbox and your title screen appears for just a few seconds (as seen here), then the first photo appears again. (Arrrgh!!! It makes working with titles really frustrating, however, here's a cool trick I stumbled upon to make it stick around as long and whenever you want: just clickand-hold directly on the Scale slider [as shown here] and it assumes you're going to use it, so the title screen stays visible until you let go.) The little color swatch to the right lets you choose a background color (by default, the background color is black). To add text, you add your Identity Plate text (or graphic) by turning on the Add Identity Plate checkbox, and your current Identity Plate text appears (as seen here).

Step Two:

To customize your Identity Plate text, click on the little triangle in the bottom-right corner of the Identity Plate preview and choose **Edit** from the pop-up menu that appears to bring up the Identity Plate Editor, seen here. Now you can highlight the existing text, type in any text you'd like (in this case, I added the bride's name), and choose a different font from the Font pop-up menu (I used "Satisfaction" from MyFonts [www .myfonts.com]). Click OK to apply this text to your intro slide. Note: If you make your text white, it's impossible to see in this dialog, so I highlight it before I start typing and then again when I'm done, as seen here.

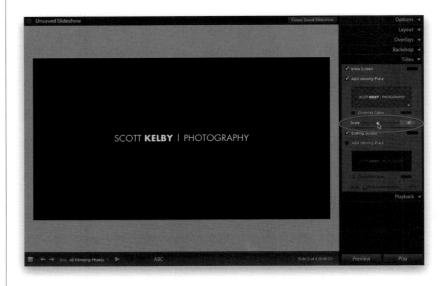

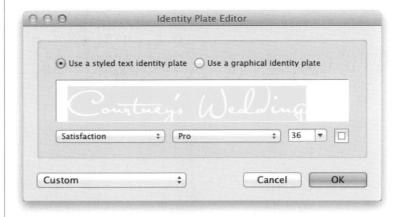

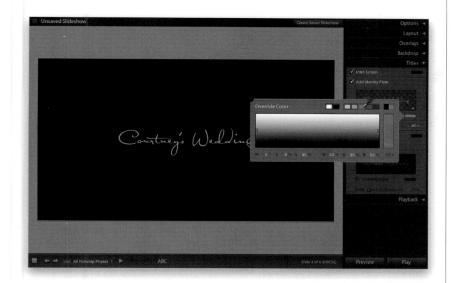

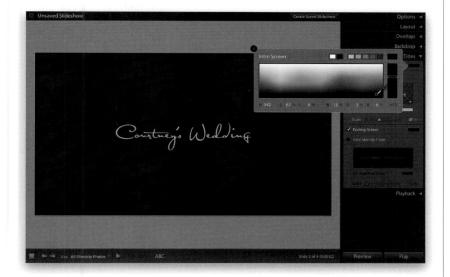

Step Three:

You can control the color of your Identity Plate text by turning on the Override Color checkbox (found under the Identity Plate preview). Once you turn that on, click once on the color swatch to its right and a color picker appears (shown here). At the top are some handy color swatches in white, black, and different shades of gray. You can choose one of those, or drag the bar up/down on the far right to choose a hue, and then you can choose your color's saturation from the large color picker gradient (here, I'm choosing a gray color, and you can see that color instantly reflected in the text). You can also control the size of your Identity Plate text by using the Scale slider at the bottom of the Intro Screen section.

Step Four:

To change the color of the intro screen's background, just click on the color swatch to the right of the Intro Screen checkbox. In this case, I changed the background to a maroon color just to show you what it looks like (I also changed the color of my Identity Plate to match the background). Once all your title text is formatted the way you want it (good luck on that, by the way, because editing text in the Identity Plate Editor is...well...it's clunky as heck, and I didn't want to say heck), you can preview the slide show in the Preview area. The ending screen works the same way: to turn it on, you turn on the Ending Screen checkbox in the Titles panel, and you can choose that screen's background color, Identity Plate size, etc., just like you did with the intro screen.

Adding **Background** Music

The right background music can make all the difference in a slide show presentation, and if you get a chance to see the pros show their work, you'll find they choose music that creates emotion and supports the images beautifully. Lightroom lets you add background music to your slide shows, and you can even embed that music into your slide shows and save them outside of Lightroom in multiple formats. More on that later, but for now, here's how to add background music to your slide shows.

Step One:

Go to the Playback panel at the bottom of the right side Panels area (shown here). Start by turning on the Audio checkbox shown circled here in red, then click the Select Music button (as shown). A standard Open dialog will appear, where you choose which music file you want to play behind your slide show, so find your song and click Choose (PC: Open).

Note: Lightroom requires that your music file be in MP3 or AAC format, so it won't recognize WAV files. If you have Apple's iTunes, it can convert a music file to AAC format for you. In your Music library, click on Songs at the top, then click on the song you want to convert. Next, go to iTunes' File menu, under Create New Version, and choose Create AAC Version, and you'll see the converted version of your song appear directly below the original (these files are located in your iTunes folder in your Music folder).

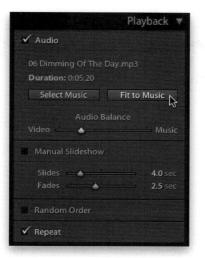

Step Two:

Now when you start your slide show (or even just preview it in the Preview area), the background music will play behind it. If you want to automatically have Lightroom adjust the length of your slide show so it matches the length of the song you chose, just click the Fit to Music button (as shown here). What this actually does is adjusts the duration and fade time of your slides, based on how long the song is (so basically, it does the math for you).

BONUS TIP: Background Music Ideas I know how hard it is to find great background music. I've been a fan of Triple Scoop Music (www.triplescoopmusic .com) ever since I heard some of the instructors at Photoshop World Conference & Expo using Triple Scoop's royaltyfree music tracks in their photo slide show presentations. As a musician myself, I am just so impressed with the quality of their tracks—their stuff is "the real deal." So, check out Triple Scoop Music for some ideas. They make it easy to find and license music for your slide show.

Choosing Your Slide Duration and **Fade Length**

Besides choosing your music, Lightroom's Playback panel in the Slideshow module is where you choose how long each slide stays onscreen and how long the transition (fade) between slides is. You can choose to play your slides in order or randomly, whether you want your slide show to repeat after your last slide or end at the last slide, and if you want your previews prepared in advance, so that your slide show doesn't get interrupted waiting for image data to render to the display.

Step One:

To choose how long your slides stay onscreen, go to the Playback panel and, below the Manual Slideshow checkbox, choose how many seconds each image should appear onscreen using the Slides slider. Then, choose how long the fade transition between images should last using the Fades slider. While Lightroom 5 still uses a dissolve transition, each photo no longer dissolves to black (or whatever color you chose) before bringing up the next photo, but simply dissolves one photo into the next. If you want to advance the slides yourself (for example, if you are using them to illustrate a talk or lecture), turn on the Manual Slideshow checkbox. Then, when you start your slide show, use the Right Arrow key to move to the next slide (this will be a hard transition, rather than a dissolve).

Step Two:

There are just a couple other controls to mention: (1) By default, your slides play in the order they appear in the Filmstrip, unless you turn on the Random Order checkbox. (2) Also by default, when you reach the last slide in the Filmstrip, your slide show will loop around and play the whole thing again (and again, and again), unless you turn off the Repeat checkbox.

If you want to show someone your slide show and they happen to be nearby, then no sweat—you can show it right within Lightroom. But if they're not standing nearby (perhaps it's a client across town or across the country), you can output your slide show in a number of different formats, like Windows Movie Format, QuickTime, Flash, and H.264, and these'll include your images, layout, background music, and transitions. Sweet! You can also save your slide show in PDF format, but if you do, sadly, it won't include your background music.

Sharing Your Slide Show

Step One:

To save your slide show in a video format (with background music), click on the Export Video button at the bottom of the left side Panels area (as shown here).

Step Two:

This brings up the Export Slideshow to Video dialog (shown here), where there's a Video Preset pop-up menu listing different sizes for your video. When you choose a preset size, it tells you right below the menu what that size works best for, and what type of devices (or software) will read the file. So, name your slide show, and then just choose the size you want, then click the Export (PC: Save) button and it creates the file for you, in the size you choose, and in a compatible format for that type of video.

Step Three:

The other export option is to save your slide show in PDF format. PDF is ideal for emailing because it compresses the file size big time, but of course the downside is that it doesn't include any background music you've added, which is a deal breaker for a lot of users. If that's not an issue for you, then it's worth considering. Just click the Export PDF button at the bottom of the left side Panels area, to bring up the Export Slideshow to PDF dialog (shown here). Go ahead and name your slide show, then at the bottom of the dialog, you'll see the Quality slider—the higher the quality, the larger the file size (which is a consideration when emailing). I usually use a Quality setting of 80 and I also always turn on the Automatically Show Full Screen checkbox, so the recipient can see the slide show without any other onscreen distractions. The width and height dimensions are automatically inserted in the Width and Height fields, but if you need the images to be smaller for emailing, you can enter smaller settings and Lightroom will automatically scale the photos down proportionally. When you're done, click the Export (PC: Save) button (as shown here).

Step Four:

When your client (friend, relative, parole officer, etc.) double-clicks on your PDF, it will launch their Adobe Reader, and when it opens, it will go into full-screen mode and start your slide show, complete with smooth transitions between slides.

TIP: Adding Filenames to a PDF If you're planning on sending this PDF slide show to a client for proofing purposes, be sure to make the filename text overlay visible before you make the PDF. That way, your client will be able to tell you the name of the photo(s) they've approved.

Lightroom Killer Tips > >

A Better Start to Your Slide Show

One of my biggest slide show complaints about Lightroom 1 was that when you started your slide show, the person viewing it always saw the first slide onscreen before the slide show even started (so, if you're showing a bride and groom the photos from their wedding, when they sit down, they see the first image onscreen, without any music, any drama, etc., which totally kills any emotional impact). You saw earlier in this chapter that you can have opening and closing title slides in Lightroom now, right? So, go ahead and set up a title slide (or just leave it black, but turn on the title slide feature in the Titles panel). Now, here's the tip: When you make a slide show presentation for a client, before the client is in front of your monitor, start the slide show, and as soon as it appears onscreen, press the Spacebar to pause it. Now when your client sits in front of your screen, they don't see your first photo—they see a black screen (or your title screen). When you're ready to begin your presentation, press the Spacebar again and your slide show starts.

▼ Detailed Slide Design

Although you can create your slide shows from scratch in Lightroom, there's nothing that says that you have to design your slides in Lightroom. If there are things you want to do that you can't do in Lightroom, just build the slides over in Photoshop, save them as JPEGs, then re-import the finished slides into Lightroom, and drop those into your slide show layout, add your background music, etc.

▼ Preview How Photos Will Look in Your Slide Show

On the far-right side of the toolbar that appears under the center Preview area, you'll see some text showing how many photos are in your current collection. If you move your cursor over that text, your cursor turns into a scrubby slider, and

you can click-and-drag left or right to see the other photos in your slide show appear in your current slide show layout (it's one of those things you have to try, and then you'll dig it).

▼ What Those Rotate Arrows Are For

If you look down in the toolbar, you'll see two rotation arrows, but they're always grayed out. That's because they're not for rotating photos, they're for rotating any custom text you create (you add custom text by clicking on the ABC button in the toolbar).

▼ Collections Remember Which Template You Used Last

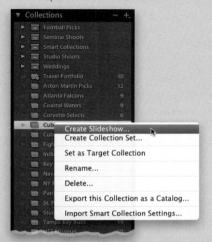

The Collections panel also appears in the Slideshow module (which you learned about in this chapter). If you click on a collection and select just a few photos in that collection for your slide show (and change the Use pop-up menu to Selected Photos in the toolbar at the bottom of the Preview area), and use them to set up a slide show, you probably want to be able to save that slide show so you don't have to go through all that again. Well, you can. Just Right-click on the collection, and choose Create Slideshow from the pop-up menu, or click on the Create Saved Slideshow button at the top right of the Preview area. This creates a new collection with just the photos you used in that particular slide show, in the right order, along with the template, so when you want that exact same slide show again (same look, same photos, same order), you're one click away.

The Adobe Photoshop Lightroom 5 Book for Digital Photographers

Photo by Scott Kelby Exposure: 1/1250 sec Focal Length: 85mm Aperture Value: f/1.4

DSLR: THE MOVIE working with video shot on your dslr

Here, I went with my longstanding tradition of naming chapter titles after a song title, movie, or TV show, and named this chapter after a movie. Well, sort of. Technically, this chapter title is mostly a movie title. Okay, the "DSLR" part isn't, but do you know how many movies have "The Movie" in their name? Remember Sex in the City: The Movie or Mama Mia: The Movie? And, believe it or not, there actually is a movie titled simply, The Movie. I am not making this up (although, I'm totally capable of doing so, but in this rare case, that movie actually does exist. However, since nobody that any of us knows actually saw The Movie, you probably aren't 100% sure that I didn't make it up in the first place, but that's what makes this whole thing so precarious). As it is, these chapter intros are held together by the thinnest thread and

things really start to fall apart if you do even 60 seconds of follow-up research on The Movie, because you'd find out that it is, in fact, only a 7-minute "movie short" and not really a movie at all (in the sense that a movie is long). But, one of the stars is Fiona Foulkes and, like you, I have no idea who she is, but there was a Princess Fiona in the movie Shrek. which was voiced by Cameron Diaz, who used to date Justin Timberlake, who was in the movie The Social Network, and it was Timberlake who recommended actor/dancer Kenny Wormald for the remake of the movie Footloose to play the lead role, which was originally played by (that's right) Kevin Bacon, which clearly supports the "Six Degrees of Separation" that the word DSLR is from the phrase "The Movie." Wow, this is holding up way better than I thought.

Working with Videos

In earlier versions of Lightroom, you could import video clips from DSLR cameras and...well...that was pretty much it. In Lightroom 5, you can do everything from trim a video to add special effects, like black and white, or split-tone looks, or well, basically, a lot of the stuff you can do to photos, you can now do to video (including applying curves, adding contrast, changing hues, or standard stuff like matching color across multiple videos). Here's whatcha need to do:

Step One:

You import a video into Lightroom just like you would a photo, but you'll know it's a video because you'll see a video camera icon in the lower-left corner of its thumbnail when it appears in the Import window (Lightroom 5 supports most major DSLR video formats, so chances are your video clips will import with no problem). Once it's in Lightroom, you can do all the organizational things you normally do with an image (like put it in a collection, add flags, metadata, and so on). Once the video(s) is imported, you won't see the little camera icon any more, though. Instead, you'll see the length of the video displayed in the bottom-left corner of the thumbnail (as seen here, where the length of the selected video clip is 12 seconds).

Step Two:

You can see a visual preview of what's on the video by moving your cursor over the thumbnail itself and dragging either left or right to quickly "scrub" through the video. Although you're not going to see all the frames in the video by doing this quick scrub, it comes in handy when you have two or three similar clips, and you want to find the one you're looking for. Let's say, for example, you've got a number of short clips of a bride and groom about to cut a wedding cake. Well, to find the one where they actually do the cutting (and not the cutting up), you can quickly scrub through each clip and find what you're looking for without having to actually open the video.

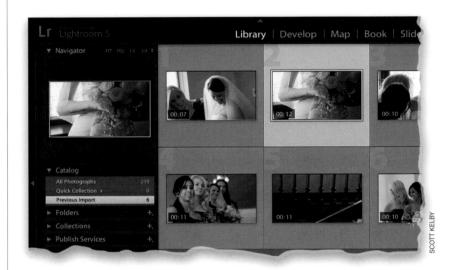

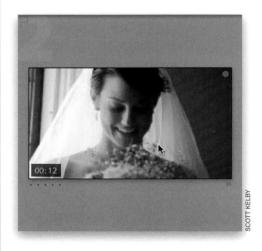

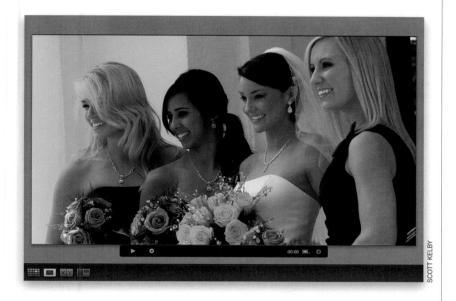

Step Three:

If you want to watch your video clip, just double-click on it and it opens in Loupe view (as seen here). To play the video, you can click the Play button (duh), in the control bar under the video, or just press the **Spacebar** on your keyboard to start/stop it. If, instead, you want to scrub through the video (kind of like manually fast-forwarding or rewinding), you can just drag the playhead in the control bar. When you play the video, it plays both the video and audio, but there's no volume control for the audio within Lightroom itself, so you'll have to control the audio volume using your computer's own volume control.

Step Four:

If your video needs to be trimmed down to size (maybe you need to cut off the end a bit, or crop the video so it starts after a few seconds or so), you can click on the Trim Video button (the little gear icon on the far-right side of the control bar) and the trim controls pop up (seen here). There are two ways to trim: One way is to just click on an end marker handle on either side of the video clip (they look like two little vertical bars) and drag inward to trim your clip (as shown here). The other way to trim is to set Trim Start and Trim End points (which basically means "start here" and "end here") by hitting the Spacebar to let the video play, then when you reach the point you want your video to actually start, press Shift-I to set the Trim Start point. When you reach the point in the video where you want the rest trimmed away, press Shift-O to set your Trim End point. Both methods (dragging the end markers or using the shortcuts) do exactly the same thing, so choose whichever you're most comfortable with.

Step Five:

There's something very cool you need to know about trimming your video clips: it doesn't permanently trim your video—it's non-destructive, so the original is always protected. The trimming is applied to a copy when you export the file (more on exporting later), so while that exported video will be trimmed (and what you see in Lightroom will be trimmed, as well), you can always come back to the original video clip anytime and pull those trim handles right back out (as shown here).

Step Six:

Okay, let's look at another handy feature: Have you ever had a friend upload a video they made to YouTube, and when you see the thumbnail for that video, you see them in mid-sentence with their mouth gaping open? Not the most flattering look, right? That's because the thumbnail is chosen randomly from a frame a few seconds into the video clip itself (if it chose the first frame, and the video faded in from black, the thumbnail would be black, which doesn't help identify the video clip, right?). Well, in Lightroom, you actually get to choose which individual frame becomes your thumbnail (called a "poster frame" in video speak). Being able to choose your poster frame is especially handy if you have four or five similar-looking clips—you can choose thumbnails that show which video has which important part in it (you don't just see it here in Lightroom, that thumbnail goes with it when you export it outside of Lightroom, too). To choose your custom thumbnail, first find the section of the video that has a frame you'd like as your thumbnail, then go to the control bar, click-and-hold on the Frame button (the little rectangle icon to the left of the Trim Video button) and choose Set Poster Frame (as shown here) and now your video clip will have that current image as your thumbnail.

Step Seven:

If you want to pull a single frame out of your video and actually make a still image from it, then you'd do the same thing you did in the previous step: find the part of the video where you'd like to pull a still image from, then click on the Frame button, but this time choose Capture Frame. This creates a second file (a JPEG image file just like any other photo) and puts it to the right of your selected video clip in the Filmstrip (as seen here). By the way, if you haven't added this video to a collection yet, instead, the JPEG image gets stacked with your video clip (see Chapter 2 for what stacking is and why it's handy). You'll know it worked if you see a "2" in the upper-left corner of your thumbnail (that's letting you know you have two images in your stack). Again, that's only if your video isn't in a collection (like mine is here).

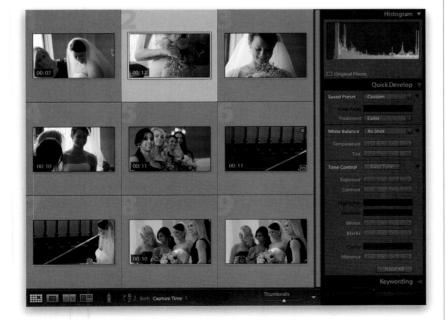

Step Eight:

Knowing how to create a still frame like we just did is really important, because now we're going to use that technique to get into the really fun stuff, which is applying effects to your video clips. Now, just for fun, click on your video clip, then press the letter **D** on your keyboard to jump over to the Develop module. You'll see "Video is not supported in Develop." appear in the center Preview area, but don't worry, you're not out of luck. Press **G** to jump back to the Library module's Grid view, and then look over in the right side Panels area. You see those Quick Develop controls? That's right, baby, we can use 'em on our video (well, not all of them, but some of the most important ones. I'll show you the trick to getting more editing controls in a moment).

Continued

Step Nine:

Let's try it out: double-click on your video clip, then click the Contrast double-right-arrow button three or four times and look at how contrasty the image onscreen looks. That's not just affecting the thumbnail—it applied that to the entire video (cool, right?). You'll also notice that a number of editing controls here are grayed out, and that's because you can't apply all the Quick Develop controls to video (for example, you can't apply Clarity or use the Highlights and Shadows controls), but again, I'll show you in a moment how to get at least some more controls than these.

Step 10:

So, while you can apply overall changes like changing the white balance for the entire video (how handy is that?!), or making your whole video clip brighter or darker using Exposure, or more vivid using the Vibrance controls, there probably are still a lot of things you wish you could do that are over in the Develop module, right? Right! But we just learned that the Develop module doesn't support video, right? Right. So what do we do? We cheat. There's a cool workaround that lets you use a lot more (but not all) of the controls in the Develop module by pulling a single frame from the video, taking that over to the Develop module, tweaking it there using everything from the Tone Curve to the HSL panel, and while you're applying these tweaks, the same edits are being applied to your entire video in real time. Totally sick. I know! :) Okay, let's try it: Click the Reset All button at the bottom of the Quick Develop panel, then grab a frame from somewhere inside your video (choose Capture Frame from the Frame pop-up menu), and then when the JPEG image appears next to your video clip in the Filmstrip at the bottom, press **D** to jump over to the Develop module.

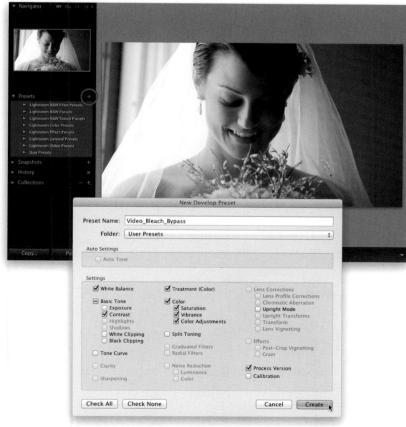

Step 11:

Now, what you're going to do is use Lightroom's Auto Sync feature, which takes whatever effects you apply to one image and applies them to any other selected images (or even a video clip, in our case). Give this is a try: Down in the Filmstrip, click on your still image, then Command-click (PC: Ctrl-click) on your video clip, so they're both selected. At the bottom of the right side Panels area, make sure the Auto Sync switch is turned on (it's shown circled here in red). Now, you can tweak the White Balance, Exposure, Contrast, Vibrance, etc. You can use the Camera Calibration panel, make it black and white, add a duotone or splittone effect, use the Tone Curve—basically, have a ball—and those changes are automatically applied to your selected video, as well. Not too shabby, eh? Here, I decreased the Temp and Tint to -40, decreased the Contrast to -20, and decreased the Vibrance and Saturation to -30. Then, I went to the Color panel (in the HSL/Color/B&W panel), decreased the Red Saturation to -40 and increased the Red Luminance to +10 to get this type of bleach bypass look. (Note: It may take a minute or two to see the adjustments reflect in your video thumbnail in the Filmstrip.)

Step 12:

Okay, so what if you create a cool look and think you'll want to use this exact look again on another video clip? Save it as a preset, and then you can apply it with just one click from the Quick Develop panel in the Library module. To save a preset, go to the Presets panel (in the left side Panels area of the Develop module) and click the + (plus sign) button on the right side of the panel header. When the New Develop Preset dialog appears, start by clicking the Check None button, then turn on the checkboxes for the changes you just made, give your preset a descriptive name, and click the Create button (as shown here).

Step 13:

Okay, now that we've got our preset, let's put it to use. Click the Reset button at the bottom of the right side Panels area, then press **G** to jump back to the Library module's Grid view, and double-click on your video clip. Now, go to the Quick Develop panel's Saved Preset pop-up menu (at the top of the panel), go under User Presets, and you'll see the preset you just saved. Choose that preset and now that effect will be applied to your entire video (if you have the Trim Video bar visible, like I do here, you can see the effect has been applied to the entire video).

TIP: What You Can't Apply to Video You can't add Clarity, Highlights, or Shadows from the Basic panel in the Develop module, or anything in the Lens Corrections or Effects panels, and you can't use the Adjustment Brush. What might throw you off is that these sliders aren't grayed out, because at this point you're just working on a still image, so everything's fair game. So, how do you know if what you're doing can be applied to video as a preset or when you sync? One way is to look at your thumbnails down in the Filmstrip while you're editing. If you only see one thumbnail changing (the JPEG image file), then it's not being applied to the video. Another quick way to tell is when you go to save a preset. See all those things that are grayed out in the New Develop Preset dialog in Step 12? Those edits, even if you did them, won't be applied to video.

Step 14:

Remember, these are all "non-destructive" edits you're making here, so if you apply these effects to your video and you decide you don't like them (right now, or a year from now), you can remove all those effects by clicking the Reset All button at the bottom of the Quick Develop panel (shown circled here in red).

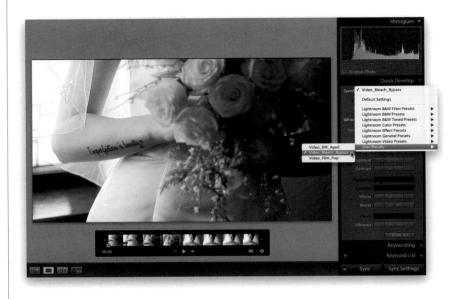

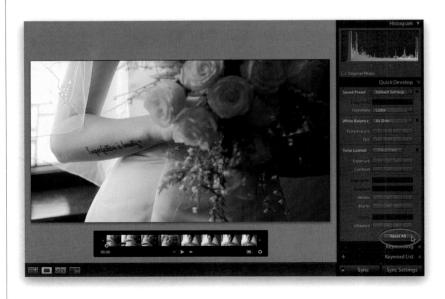

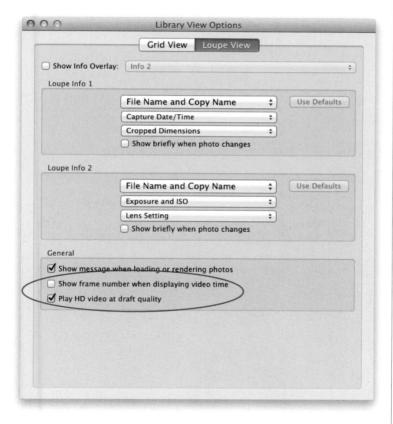

Step 15:

Once you've got your video just the way you want it, you're probably going to want to save it outside of Lightroom, so you can share it somewhere (or open it in a video editing program as part of a bigger video project). Although you can't email your video directly from Lightroom (most likely, the file size would be too large to email anyway), you can post the video directly to Facebook or Flickr using the Export presets or Publish Services (see Chapter 8 for more on how to use both, but I thought you'd want to know they do support posting your video directly from LR5). Otherwise, click on the video clip you want to export, then click the Export button at the bottom of the left side Panels area (as shown here).

TIP: Video Preferences

There are really only two video preferences and they're found in the Library View Options (press **Command-J [PC: Ctrl-J]**), on the Loupe View tab. In the General section, at the bottom, Show Frame Number When Displaying Video Time does just what it says—it adds the frame number beside the time (yawn). The option beneath that, Play HD Video at Draft Quality, is there to make sure the playback of your HD video is smooth if you don't have a super-fast computer—the lower-resolution draft-quality video takes less power to display the video in real time than the full HD version does.

Step 16:

When the Export dialog appears, if you scroll down a bit, you'll see an area dedicated to exporting video (seen here). Since you clicked on your video file to export it, the Include Video Files checkbox should already be turned on, so all you have to do is make two simple choices: (1) Which video format do vou want to save your clip in? I use H.264 as it's a widely supported format, and makes the file size smaller without losing much (if any) visible quality (kind of like JPEG does for image files), but of course, how much it's compressed is based on (2) the Quality setting you choose. If you're going to be sharing this somewhere on the web (YouTube, Animoto, etc.), then you'll probably want to consider a lower quality than Max (the physical size and fps will appear to the right when you choose a Quality size from the menu, so you know what each delivers). However, if you're taking this video over to a dedicated video editing application, that's when you'd want to choose Max quality. For the rest of the exporting features, see Chapter 8 (the exporting chapter).

Step 17:

Before you jump to the other sections of the book, I wanted to give you a few great examples of what kinds of things you can use Lightroom's video editing features for that might make your life easier. One I use a lot is to warm up skin tones. Although we set proper white balance for video by using a white card (rather than a gray card for still photos), that white balance, while being technically accurate, is a bit on the cool side, and people generally look better a little warmer. So, by capturing a still frame of the video, taking it into the Develop module, and dragging the Temp slider to the right, toward yellow, you can make the skin tones of people in your video look much more pleasing. Be sure you have Auto Sync turned on and have the video selected in the Filmstrip, along with the still frame.

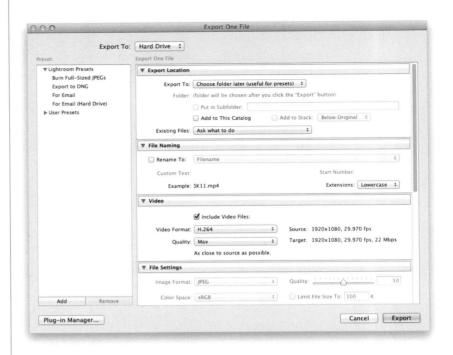

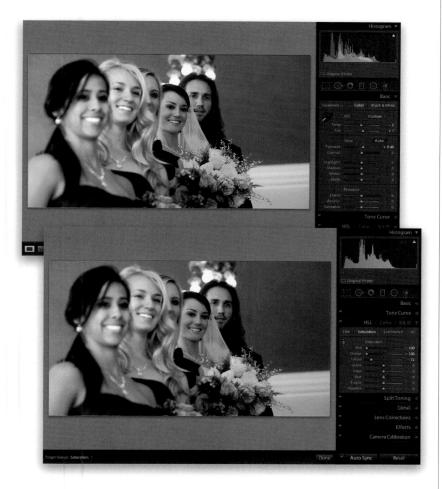

Step 18:

Another very important tweak is making sure the color is the same between multiple video clips—especially important if you're going to be putting these clips together in a video editing application. The quickest way to do this is to capture a still frame from one video, open it in Loupe view, then select that frame, along with all the video clips, and right there in the Library module, use the White Balance controls in the Quick Develop panel to tweak the still frame, and all the other selected video clips will now have the same white balance. Be sure, though, that the Auto Sync switch at the bottom of the right side Panels area is turned on.

Step 19:

If you want a more film-like look for your videos, you can increase the contrast by going to the Library module, clicking on the video clip, and clicking the Contrast double-right-arrow button once or twice. Do the same thing with the Vibrance to give your video a little more "pop." Those are "every day" types of edits, but of course, there are other things, like special effects, that are easy to do, too. For example, how about having your video look like it's black and white, but have one color that stays in color throughout the entire video. To do that, capture a still frame, then take that frame over to the Develop module. Pick one color to avoid (like red), then go to the HSL panel, click on Saturation at the top, take the Targeted Adjustment tool (near the top left of the panel), and click on any color but the one you want to keep. Now, drag straight down until everything else is black and white (this video isn't the perfect example for this trick, but here I desaturated the colors, and left some of the dresses and flowers in color). Then, go back and apply those changes to your video.

me Auone rnotosnop cignitioon 3 book for Digital rnotographers Au Ceatt Kalby : Type was 1/20 sec : Fesal Length: 14mm : Aperture Value: f/11

screen. Let's put this in perspective: It takes us 1/2000 of a second to take the shot, but then we spend 10 minutes in Lightroom processing the image, so the majority of our work takes place after the photo is taken. However, in real life, when we talk about a photo, your average person thinks of the 1/2000 of a second part of the photograph much more than they do the 10 minutes we spent on the computer balancing, sharpening, dodging and burning, etc., part. So, to them, the 1/2000 of a second part is the "real" part and the rest they (thankfully) don't really think that much about. So, when you show them a picture onscreen, it kind of reminds them that this is all software-based, because

"a cloud," so they aren't real. To most nonphotographers, an image becomes "real" when you make a print. Otherwise it's just some manipulated image on a computer. Think about it. So, you are kind of like a modern-day Dr. Frankenstein, in that you have created this thing, but you need to flip a switch (the printing switch), to give your creation life. Now, when you print, it's not entirely necessary to look toward the heavens, laugh an evil laugh, and yell, "It's alive!" but I can tell you that most of the pro photographers I know do exactly that (but you also should know that they generally wait to do all their printing on a dark, stormy night). Now you know.

Printing Individual **Photos**

If you really like everything else in Lightroom, it's the Print module where you'll fall deeply in love. It's really brilliantly designed (I've never worked with any program that had a better, easier, and more functional printing feature than this). The built-in templates make the printing process not only easy, but also fun (plus, they make a great starting point for customizing and saving your own templates).

Step One:

Before you do anything in the Print module, click on the Page Setup button at the bottom left, and choose your paper size (so you won't have to resize your layout once it's all in place). Now, start in the Template Browser (in the left side Panels area) by clicking on the Fine Art Mat template. The layout you see here should appear, displaying the first photo in your current collection (unless you have a photo selected—then it shows that one). There's a Collections panel here, too, so if you want to change collections, you can do so in the left side Panels area. A few lines of info appear over the top-left corner of your photo. It doesn't actually print on the photo itself, but if you find it distracting, you can turn this off by pressing the letter I, or going under the View menu and choosing Show Info Overlay.

Step Two:

If you want to print more than one photo using this same template, go down to the Filmstrip and Command-click (PC: Ctrl-click) on the photos you want to print, and it instantly adds as many pages as you need (here, I've only selected one photo, but if I had selected 26, you'd see Page 1 of 26 down in the toolbar). There are three Layout Styles (in the Layout Style panel at the top right), and this first one is called Single Image/Contact Sheet. This works by putting each photo in a cell you can resize. To see this photo's cell, go to the Guides panel and turn on the Show Guides checkbox. Now you can see the page margins (in light gray), and your image cell (outlined in black, as seen here).

Step Three:

If you look back at the layout in Step Two, did you notice that the image fit the cell side-to-side, but there was a gap on the top and bottom? That's because, by default, it tries to fit your image in that cell so the entire image is visible. If you want to fill the cell with your photo, go to the Image Settings panel and turn on the Zoom to Fill checkbox (as shown here), and now your image fills it up (as seen here). Now, of course, this crops the image a bit, too (well, at least with this layout it did). This Zoom to Fill feature was designed to help you make contact sheets, but as we go through this chapter, I bet you'll totally start to love this little checkbox, because with it you can create some really slick layouts—ones your clients will love. So, even though it does crop the photo a bit, don't dismiss this puppy yet—it's going to get really useful very soon.

Step Four:

Now, let's work on the whole cell concept, because if you "get" this, the rest is easy. First, because your image is inside a cell and you have the Zoom to Fill checkbox turned on, if you change the size of your cell, the size of your photo doesn't change. So, if you make the cell smaller, it crops off part of your image, which is really handy when you're making layouts. To see what I mean, go to the Layout panel, and at the bottom of the panel are the Cell Size sliders. Drag the Height slider to the left (down to 3.87 in), and look at how it starts to shrink the entire image size down right away, until it reaches its original unzoomed width, then the top and bottom of the cell move inward without changing the width further. This kind of gives you a "letter box" view of your image (HD movie buffs will totally get that analogy).

The Adobe Photoshop Lightroom 5 Book for Digital Photographers

Step Five:

Now drag the Height slider back to the right, kind of where it was before, then drag the Width slider to the left to shrink the width. This particular photo is wide (in landscape orientation), so while moving the top and bottom of the cell shrunk the image, and then the cell, dragging the Width slider like we are here, just shrinks the cell inward (this will all make sense in a minute). See how the left and right sides of your cell have moved in, creating the tall, thin cell you see here? This tall, thin layout is actually kind of cool on some level (well, it's one you don't see every day, right?), but the problem is that the stone structure is off the right side of the frame. We can fix that.

TIP: Print Module Shortcut

When you want to jump over to the Print module, you can use the same keyboard shortcut you do in almost any program that lets you print: it's the standard old **Command-P (PC: Ctrl-P)**.

Step Six:

One of my favorite things about using these cell layouts is that you can reposition your image inside the cell. Just move your cursor over the cell, and your cursor turns into the Hand tool. Now, just click-and-drag the image inside the cell to the position you want it. In this case, I just slid the photo over to the left a bit until part of the structure was in the center.

Step Seven:

At the bottom of the Cell Size section is a checkbox called "Keep Square." Go ahead and turn on this checkbox, which sets your Height and Width to the exact same size, and now they move together as one unit (since it's perfectly square). Let's try a different way of resizing the cell: click-and-drag the cell borders themselves, right on the lavout in the Preview area. You see those vertical and horizontal lines extending across and up/down the page showing the boundaries of your cell? You can clickand-drag directly on them, so go ahead and give it a try. Here, I'm clicking on the top horizontal guide (shown circled here in red), and dragging outward to enlarge my square cell (and the photo inside it). So, by now you've probably realized that the cell is like a window into your photo.

TIP: Rotating Images

If you have a tall photo in a wide cell (or on a wide page), you can make your photo fill as much of that page as possible by going to the Image Settings panel, and turning on the Rotate to Fit checkbox.

Step Eight:

Let's finish this one off with one of my favorite printing features in Lightroom: the ability to change the color of your page background. To do this, just go to the Page panel, turn on the Page Background Color checkbox, and click the color swatch to the right of it to bring up the Page Background Color picker (seen here). In this case, I'm choosing a dark gray, but you can choose any color you'd like (black, blue, red—you name it), then close the color picker. Also, you can put a stroke around your image cell by going up to the Image Settings panel, turning on the checkbox for Stroke Border, then choosing a color (just click on the color swatch), and choosing how thick you want your stroke using the Width slider.

Creating Multi-Photo Contact Sheets

The reason you jumped through all those hoops just to print one photo was because the whole Single Image/Contact Sheet was really designed for you to have quick access to multi-photo layouts and contact sheets, which is where this all gets really fun. We're picking up here, with another set of photos, to show you how easy it is to create really interesting multi-photo layouts that clients just love!

Step One:

Start by clicking on any of the multi-photo templates that come with Lightroom 5 (if you hover your cursor over any of the templates in the Template Browser, a preview of the layout will appear in the Preview panel at the top of the left side Panels area). For example, click on the 2x2 Cells template, and it puts your selected photos in two columns and two rows (as shown here). Here, I selected 10 photos, and if you look at the right end of the toolbar, you'll see Lightroom will make three prints, though only two will have four photos each—the last print will just have those two leftover photos. The layout you see here doesn't look that good, because we're mixing horizontal photos with a tall photo, but we can fix that.

Step Two:

Of course, just printing all your wide photos on a page with wide cells, and then creating a second template with tall cells, would fix this, but an easier way is to go to the Image Settings panel and turn on the Zoom to Fill checkbox (as shown here). This zooms all the images up to fill the cells, so the wide photos zoom in, and how they fill the cells looks uniform (as seen here). Plus, you can reposition the images in their cells by clicking-and-dragging them. However, turning on Zoom to Fill cropped a tiny bit off of the tall shot, and guite a bit off the wide shots, changing the whole look of the photos (luckily, there is a way around this, too).

Step Three:

What you need is a way to print the tall image and the wide images at nearly full size, without much cropping. The trick is to turn on the Rotate to Fit checkbox (shown circled here in red, in the Image Settings panel), which rotates the wide photos so they best fill the tall cells (as seen here at the top, where the wide photos are now turned sideways to fit in the cells as large as possible). When you turn on Rotate to Fit, it applies that to all your pages, so if you have other wide photos on other pages, it will rotate them, as well (as seen in the bottom graphic here, showing the second page of photos, and they're all rotated sideways. To see your other pages, click on the Right Arrow button on the left side of the toolbar).

Step Four:

If you want to print the same photo, at the same exact size, multiple times on the same page, then you can go to the Image Settings panel and turn on the checkbox for Repeat One Photo per Page, as shown here. If you want to print the same photo multiple times on the same page, but you want them to be different sizes (like one 5x7" and four wallet-size photos), then turn to page 432 for details on how to set that up.

Step Five:

If you click on a different multi-photo layout, like the 4x5 Contact Sheet (as shown here), your photos instantly adjust to the new layout. One nice feature of this template is that the names of your images appear directly below each image. If you want to turn this feature off, go to the Page panel and, near the bottom of the panel, turn off the Photo Info checkbox. By the way, when you have this checkbox turned on, you can choose other text to appear under your images from the popup menu to the right of the words Photo Info. Once again, because I was mixing tall and wide photos, the layout looked a little funky, so I turned on the Zoom to Fill checkbox, but of course, that's totally optional—if you don't want your images cropped, then you should leave Zoom to Fill turned off.

Step Six:

So far, we've been using Lightroom's built-in templates, but half the fun of this process is building your own, and it's surprisingly easy, as long as you don't mind having all your cells being the same exact size, which is the limitation of using the Single Image/Contact Sheet type of layout. You can't have one photo that's square, and two that are rectangular. They're either all square or all rectangular, but don't worry, we'll tackle how to create multiple photos at any size you want a little later. For now, we'll use this contact sheet power to create some cool layouts. Start by selecting some photos (eight or nine should be fine), then click on the template called "Maximize Size" (shown here; it's a decent starting place for building your own templates). Since we're going to be adding photos, I turned off the Rotate to Fit checkbox (it's on by default in this template) in the Image Settings panel.

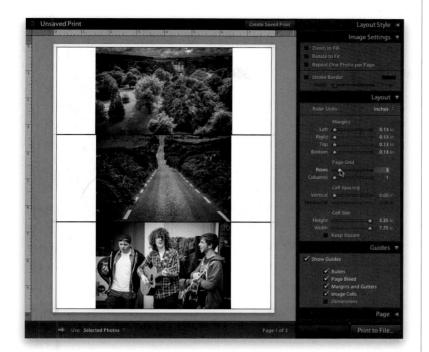

Step Seven:

You create custom multi-photo layouts in the Layout panel. There's a Page Grid section, which is where you pick how many rows and columns you want in your layout, so start by dragging the Rows slider over to 3, so you get three photos in a row (like you see here). You'll notice that the three photos are stacked one on top of another with no space between them. (Note: The black lines you see around the cells are just guides, so you can easily see where the cell borders are. You can get rid of these in the Guides panel by turning off the Image Cells checkbox. I usually leave these off, because you can still see the cell borders in light gray, as you'll see in the next step, where I have those black Image Cell borders turned off.)

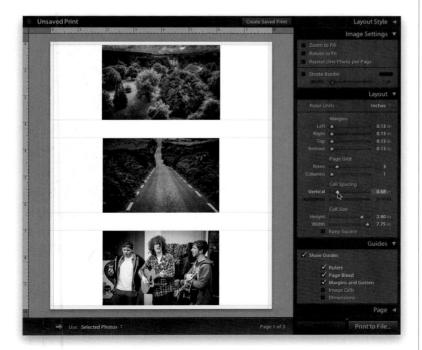

Step Eight:

To create some vertical space between your photos, go to the Cell Spacing section and click-and-drag the Vertical slider to the right (as shown here, where I dragged it over to 0.68 in to put a little more than a half-inch of space between the photos). Now let's take things up a notch.

The Adobe Photoshop Lightroom 5 Book for Digital Photographers

Step Nine:

Now go to the Page Grid sliders and increase the Columns to 3, so now you have this layout of three columns wide by three rows deep. Of course, since the default setting is to not have any space between photos, the columns of photos don't have any space between them horizontally.

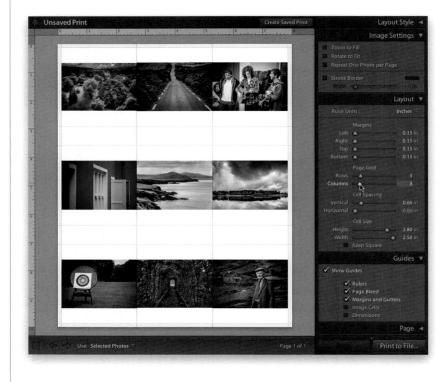

Step 10:

You add space between the photos in columns by going to the Cell Spacing section, and clicking-and-dragging the Horizontal slider to the right (as shown here). Now that you've got space between your columns, take a look at the page margins. There's lots of space at the top and bottom, and just a little bit of space on the sides of the page.

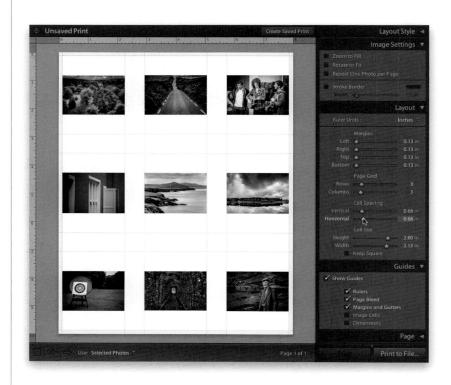

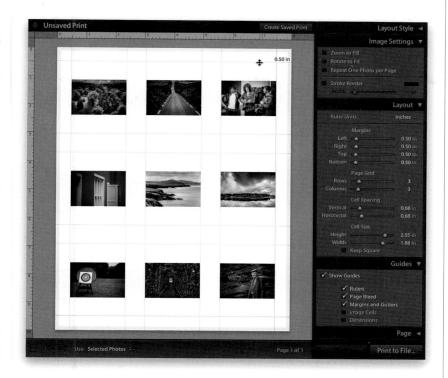

Step 11:

Although you can drag the Margins sliders to adjust the page margins (right there in the Layout panel), you can also just click directly on the margins themselves and drag them (as shown here). Here, I clicked-and-dragged the top, bottom, and side margins in to where they were about a half-inch from the edge of the page.

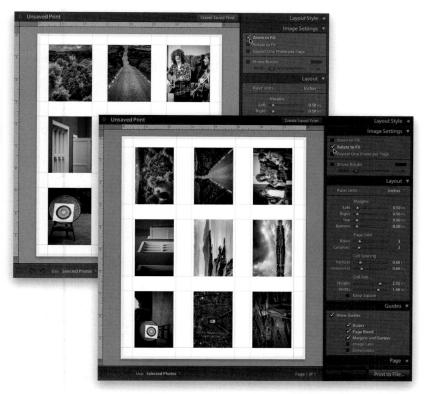

Step 12:

If you look back in the image shown in Step 11, you can see the images are all wide, but they're in tall cells. To get the images larger, you can go back up to the Image Settings panel and either:
(a) turn on the Zoom to Fill checkbox (as shown here at the top) to fill the cells with the images (don't forget, you can reposition your images inside those cells by just clicking-and-dragging on them), or (b) turn on the Rotate to Fit checkbox, in which case, all the photos would be turned on their sides so they fit larger in the cells you've created (seen here at the bottom).

Step 13:

Let's wrap this section up with a few examples of cool layouts you can create using these Contact Sheet style layouts (all based on a borderless 8.5x11" page size, which you can choose by clicking the Page Setup button at the bottom of the left side Panels area). Start by going up to the Image Settings panel and turning on the Zoom to Fill checkbox. Now, go to the Layout panel, under Page Grid, then change the number of Rows to 1 and the number of Columns to 3. Under Cell Size, turn off the Keep Square checkbox. Drag the Left, Right, and Top Margins sliders to around 0.75 in, and the Bottom Margins slider to around 2.75 (to leave lots of room for your Identity Plate). Jump down to the Cell Size, and for the Height, drag it to around 7.50 in, and set the Width at only around 2.20 in, which gives you very tall, narrow cells (as shown here). Now, select three photos and turn on the Identity Plate feature (in the Page panel), make it larger, and click-and-drag it so it's centered below your images, giving you the look you see here (I also turned off the Show Guides checkbox to get rid of the distracting guides).

Step 14:

Now let's create four panorama layouts in one photo (you don't need to use real panos—this creates fake panos instantly from any photo you select). Start by setting your Rows to 4 and Columns to 1. Then set your Left and Right Margins to 0.50 in, and set the Top to around 0.75 in or 0.80 in. Set your Bottom margin to 1.50 in. Make sure the Keep Square checkbox is turned off (under Cell Size), then increase your Cell Size Width to 7.33 in, and your Cell Size Height to 1.81 in to give you thin, wide cells. Now, set the space between your fake panos using the Vertical slider (set it to around 0.50) to give you the layout you see here. I went and clicked on four travel photos, and got the instant pano layout you see here.

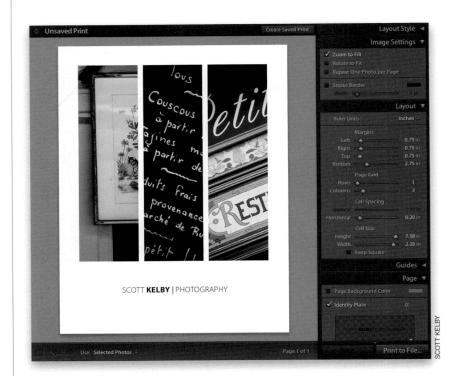

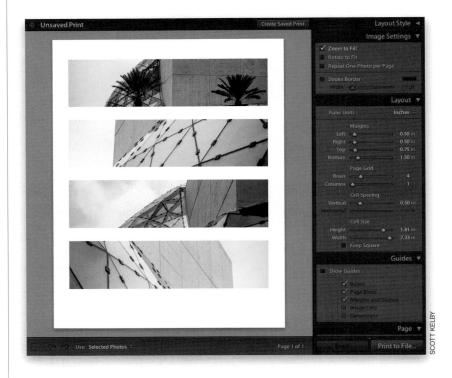

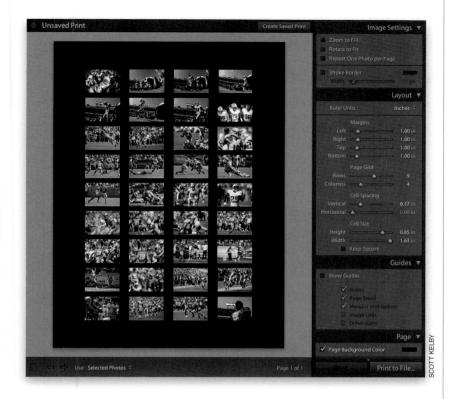

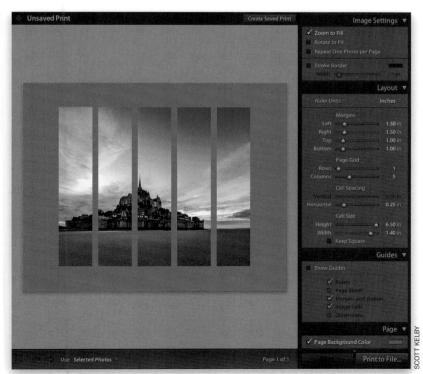

Step 15:

How about a poster, on black, with 36 wide images? Easy. Start by creating a collection made up of only wide images. Then go to the Image Settings panel and turn off the Zoom to Fill checkbox. Go to the Layout panel and set a 1-inch margin all the way around the page, using the Margins sliders. Now, set your Page Grid to 9 Rows, and 4 Columns. Keep your Horizontal Cell Spacing at 0 in, then put just enough Vertical Cell Spacing to make the space between the photos about half the size of the horizontal spacing (I set it at 0.17). Lastly, in the Page panel, turn on the Page Background Color checkbox, then click on the color swatch to the right of it, and choose black for your background color. If you have a white border, click on Page Setup and choose borderless printing.

Step 16:

Okay, this one's kinda wild—one photo split into five separate thin vertical cells. Here's how it's done: You start by clicking the Page Setup button (at the bottom left), and set your page to be Landscape orientation. Then Right-click on a photo in the Filmstrip and choose **Create Virtual** Copy. You need to do this three more times, so you have a total of five copies of your photo. Now, in the Image Settings panel, turn on Zoom to Fill, then in the Layout panel, set your Margins to 1.50 in on the sides, and 1.00 in for the Top and Bottom. For your Page Grid, choose 1 Rows and 5 Columns. Add a little Horizontal Cell Spacing—around 0.25 in. Then set your Cell Size Height to 6.50 in, and the Width to only 1.40 in. In the Page panel, turn on the Page Background Color checkbox, click on the color swatch, and change your background color to dark gray. Select all five photos in the Filmstrip, then you'll click-and-drag each of the five images around inside their cells—dragging left and right—until they appear to be one single image (like you see here).

Creating Custom Layouts Any Way You Want Them

In Lightroom 5, Adobe gives you the option to break away from the structured cell layouts of earlier versions to create your own custom cell layouts in any size, shape, and placement, using a Print layout style called "Custom Package." Here's where you can create photos in any size and any layout you want, without being tied into a grid.

Step One:

Start in the Layout Style panel by clicking on Custom Package (we want to start from scratch, so if you see any cells already in place, go to the Cells panel and click the Clear Layout button). There are two ways to get photos onto your page: The first is to go down to the Filmstrip and simply to drag-and-drop images right onto your page (as seen here). The image appears inside its own fully resizable cell, so you can just drag one of the corner handles to resize the image (this image came in pretty small, so I resized it to nearly fill the bottom of the page). It will resize proportionally by default, but if you turn off the Lock to Photo Aspect Ratio checkbox (at the bottom of the Cells panel), then it acts like a regular cell with Zoom to Fill turned on, in that you can crop the photo using the cell. More on that in a minute.

Step Two:

Go ahead and hit the Clear Layout button, so you can try the other way to get your images into your layout, which is to create the cells first, arrange them where you want, then drag-and-drop your images into those cells. You do this by going to the Cells panel, and in the Add to Package section, just click on the size you want. For example, if you wanted to add a 3x7"cell, you'd just click on the 3x7 button (as shown here) and it creates an empty cell that size on the page. Now you can just click inside the cell and drag it anywhere you'd like on the page. Once it's where you like it, you can drag-and-drop a photo into that cell from the Filmstrip.

Step Three:

Let's create a layout using these cell buttons, so hit the Clear Layout button to start from scratch again. Click the 3x7 button to add a long, thin cell to your layout, but then click the Rotate Cell button to make this a tall, thin cell. This cell is actually pretty large on the page, but you can resize it by grabbing any of the handles, or using the Adjust Selected Cell sliders to choose any size you'd like (here, shrink your Height to 5.00 in). Now, we need to make two more cells just like this one. The quickest way to do that is to press-and-hold the Option (PC: Alt) key, then click inside the cell and drag to the right to make a copy. Do this twice until you have three cells, like you see here, and arrange them side by side, as shown (as you drag these cells, you'll feel a little snap. That's it snapping to an invisible alignment grid that's there to simply help you line things up. You can see the grid by going to the Rulers, Grid & Guides panel and turning on the checkboxes for Show Guides and Page Grid).

Step Four:

Next, let's add a larger photo to the bottom of our layout. Click the 4x6 button and it adds a larger cell to the layout, but it's not guite as wide as our three thin cells above. You'll need to first turn off the Lock to Photo Aspect Ratio checkbox, and then just grab any point and drag until this cell is as wide as the three at the top of the page (as seen here). The layout's done, but before you start dragging-and-dropping images, there are two things you need to change first: (1) Because the cells at the top are tall and thin, the checkbox for Lock to Photo Aspect Ratio must be off (we already did this). Otherwise, when you drag-anddrop photos into those thin cells, they will just expand to the full size of the photo. (2) You'll also need to turn off the Rotate to Fit checkbox at the top of the Image Settings panel, so wide images won't rotate to fit the cell.

Step Five:

Now you're ready to start dragging-and-dropping photos into your layout. If you drag one that doesn't look good in your layout, just drag another right over it. You can reposition your photo inside a smaller cell by pressing-and-holding the Command (PC: Ctrl) key, then just dragging the image left/right (or up/down), so just the part you want is showing.

Step Six:

You can stack images so they overlap, almost like they're Photoshop layers. Let's start from scratch again, but first click the Page Setup button (at the bottom left), and turn your page orientation to Landscape. Now go back to the Cells panel, click the Clear Layout button, then click the 8x10 button, resize it, and position it so it takes up most of the page (as shown here). Now, click the 2x2.5 button three times, make each cell a little wider (like the ones seen here), and position them so they overlap the main photo, as shown. Drag-and-drop photos on each cell. You can move the photos in front or behind each other by Right-clicking on the photo, and from the pop-up menu, choosing to send the photo back/forward one level or all the way to the bottom/top of the stack. To add a white photo border around your images (like I did here), in the Image Settings panel, turn on the Photo Border checkbox (turn on the Guides to see this better). Also, try switching your Page Orientation to Portrait and see how that looks. For example, I thought it might make a good wedding book layout, so I swapped out the photos, rotated the small cells, made the main photo a little wider, turned off the Photo Border, then turned on the Inner Stroke checkbox, and added a 3-pt black stroke (as shown on the bottom right). It only took about 30 seconds. I also tried just rotating the three small cells, making the main photo fill the page, and adding a white stroke (as shown on the bottom left).

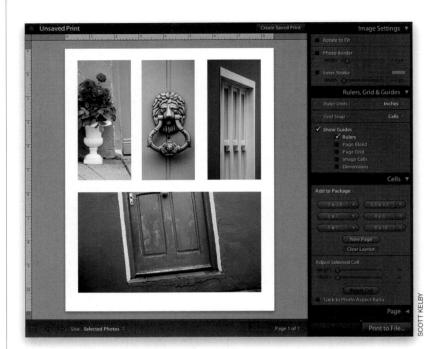

COTT KEL

Step Seven:

Okay, let's start from scratch again and shoot for something pretty ambitious (well, as far as layouts go anyway). Clear your layout again, then go to the Page panel, turn on the checkbox for Page Background Color, click on the color swatch, and choose black as your background color. Now, make sure the Lock to Photo Aspect Ratio checkbox is turned off, then just go to the Cells panel and click the buttons to add a bunch of cells, and resize them so your layout looks kinda like what I have here, with a gap between the top and bottom set of images (so you can add your Identity Plate).

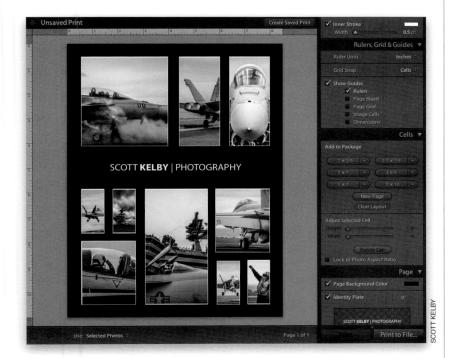

Step Eight:

Now, go ahead and drag-and-drop your photos into these cells. By the way, the thin white border you see around your cells is just there to show you where the cell borders are—those don't actually print in the final image. If you want a white stroke around your images, go up to the Image Settings panel and turn on the checkbox for Inner Stroke, then click on the color swatch to the right and set the color to white. For the image shown here, I switched to a collection of shots from an aircraft carrier, then I dragged some of those images into the cells. Lastly, to have your studio name appear between the images, go to the Page panel and turn on the checkbox for Identity Plate, then turn on the Override Color checkbox, click on the color swatch and choose white as your Identity Plate color. You can drag your Identity Plate anywhere on the page, but for this layout, just drag it to the center and you're done.

Adding Text to Your Print Layouts

If you want to add text to your print layouts, it's pretty easy, as well, and like the Web and Slideshow modules, you can have Lightroom automatically pull metadata info from your photos and have it appear on the photo print, or you can add your own custom text (and/or Identity Plate) just as easily. Here's what you can add, and how you can add it:

Step One:

Select a photo, then choose the Fine Art Mat template in the Template Browser and turn on the Zoom to Fill checkbox. The easiest way to add text is to go to the Page panel and turn on the Identity Plate checkbox (see Chapter 4 for how to set it up). Once it's there, you can click-and-drag it right where you want it (in this case, drag it down and position it in the center of the space below the photo, as shown here). Here's how I got two lines of text with different fonts (Trajan Pro on top; Minion Pro Italic on the bottom): Once you set the top row of text (I hit the spacebar once between each letter), then press Option-Return twice to move down two lines. (Note: This doesn't work on a PC, but you can create it in Photoshop as a graphical Identity Plate.) Then, hit the Spacebar 20 times (to center the text) and type the second line. Then highlight everything under the first line, and change the font. It's a workaround, but it works.

Step Two:

Besides adding your Identity Plate, Lightroom can also pull text from your metadata (things like exposure settings, camera make and model, filename, or caption info you added in the Library module's Metadata panel). You do this in the Page panel by turning on the Photo Info checkbox and choosing which type of info you want displayed at the bottom of your cell from the pop-up menu on the right (as shown here). You can change the size of your text right below it, but the largest size is 16 points, and on a large print, it's pretty tiny.

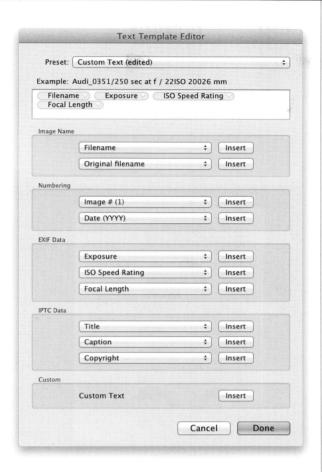

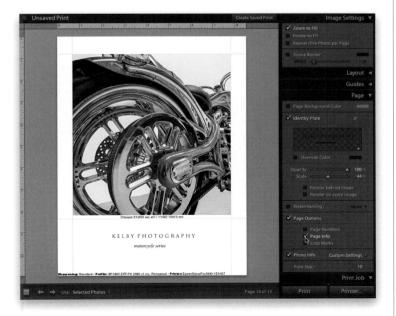

Step Three:

Now, besides just pulling the filename and metadata stuff, you can also create your own custom text (but it's going to show up at the bottom of the cell and this text is stuck there—you can't reposition it like you can the Identity Plate text, which is why I usually use that instead). If you choose Custom Text from the Photo Info pop-up menu, a field appears below it, so you can type in your custom text. You can also choose Edit from that same pop-up menu to bring up the Text Template Editor (shown here), where you can create your own custom list of data that Lightroom will pull from each photo's metadata and print under that photo. In this case, I chose to add text showing the filename, exposure, ISO, and the focal length of the lens by clicking the Insert button beside each of these fields in the Editor or choosing them from the pop-up menus. I can't imagine why anyone would want that type of information printed beneath the photo. But you know, and I know, there's somebody out there right now reading this and thinking, "All right! Now I can put the EXIF camera data right on the print!" The world needs these people.

Step Four:

If you're printing pages for a photo book, you can have Lightroom automatically number those pages. In the Page panel, turn on the Page Options checkbox, then turn on the checkbox for Page Numbers. Lastly, if you're doing a series of test prints, you can have your print settings (including your level of sharpening, your color management profile, and your selected printer) appear on the bottom-left side of the print (as seen here) by turning on the Page Info checkbox.

Printing Multiple Photos on One Page

You saw earlier in this chapter how to print the same photo, at the same exact size, multiple times on the same print. But what if you want to print the same photo at different sizes (like a 5x7" and four wallet sizes)? That's when you want to use Lightroom's Picture Package feature.

Step One:

Start by clicking on the photo you want to have appear multiple times, in multiple sizes, on the same page. Go to the Template Browser in the left side Panels area and click on the built-in template named (1) 4x6, (6) 2x3, which gives you the layout you see here. If you look over in the Layout Style panel at the top of the right side Panels area, you'll see that the selected style is Picture Package (as seen circled here in red).

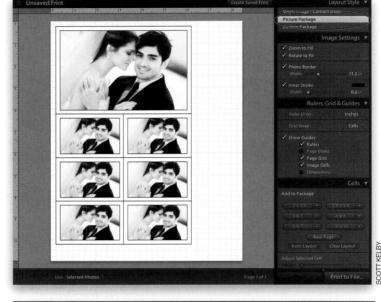

Step Two: If you look

If you look at the Preview area in Step One, you can see that, by default, it puts a little white border around each photo. If you don't want the white border, go to the Image Settings panel and turn off the Photo Border checkbox (as shown here). Also, by default, the Zoom to Fill checkbox is turned on, so your photo is cropped in a little bit. If you don't want your photo cropped like that, turn the Zoom to Fill checkbox off.

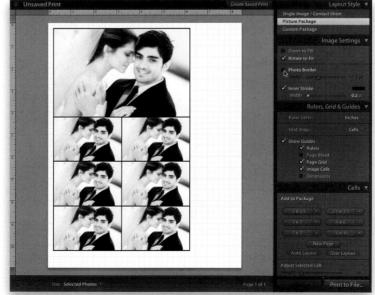

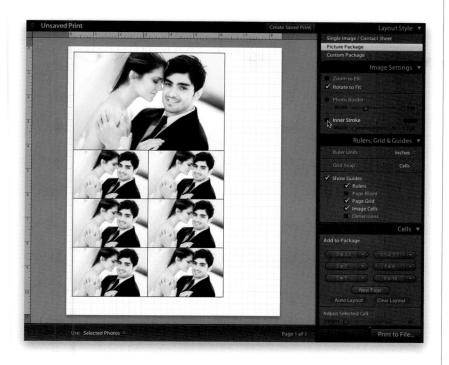

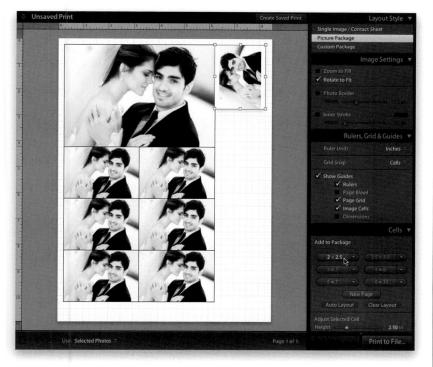

Step Three:

Another option it has on by default is that it puts a black stroke around each image (you can control the size of this stroke, using the Width slider right below the Inner Stroke checkbox). To remove this stroke, turn off the Inner Stroke checkbox (as shown here. You'll still see a thin stroke that separates the images, but does not print). Now your images are back to their original cropping, they're right up against each other (there's no extra white border), and you've removed the black stroke around the photos (by the way, if you like this layout, don't forget to save it as your own custom template by clicking on the + [plus sign] button on the right side of the Template Browser header).

Step Four:

Adding more photos is easy—just go to the Cells panel (in the right side Panels area) and you'll see a number of pill-shaped buttons marked with different sizes. Just click on any one of those to add a photo that size to your layout (I clicked on the 2x2.5 button, and it added the new cell you see selected here). So, that's the routine: you click on those buttons to add more photos to your Picture Package layout. To delete a cell, just click on it, then press the **Delete (PC: Backspace)** key on your keyboard.

Step Five:

If you want to create your own custom Picture Package layout from scratch, go to the Cells panels and click on the Clear Layout button (as shown here), which removes all the cells, so you can start from scratch.

Step Six:

Now you can just start clicking on sizes, and Lightroom will place them on the page each time you click one of those Add to Package buttons (as shown here). As you can see, it doesn't always place the photos in the optimum location for the page dimensions, but Lightroom can actually fix that for you.

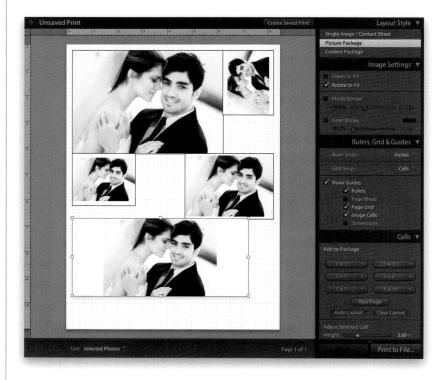

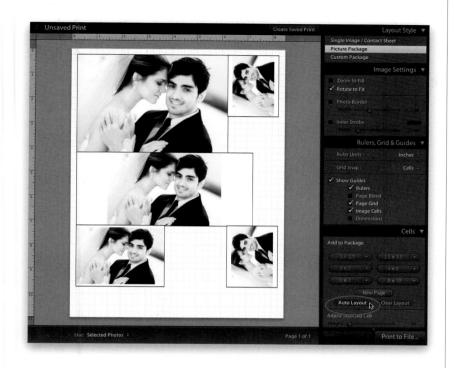

Step Seven:

If you click on the Auto Layout button, at the bottom of the Add to Package section (as shown here), it tries to automatically arrange the photos so they fit more logically, and gives you extra space to add more photos. Okay, hit the Clear Layout button and let's start from scratch again, so I can show you another handy feature.

TIP: Dragging-and-Copying
If you want to duplicate a cell, just press-and-hold the Option (PC: Alt) key, click-and-drag yourself a copy, and position it anywhere you'd like. If one of your photos overlaps another photo, you'll get a little warning icon up in the top-right corner of your page.

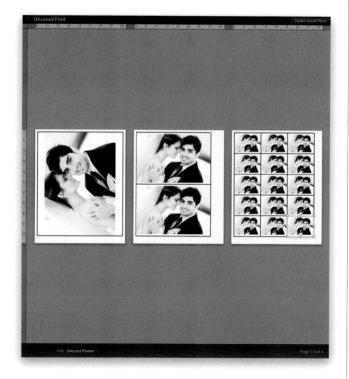

Step Eight:

If you add so many cells that they can't fit on one page, Lightroom automatically adds new pages to accommodate your extra cells. For example, start by adding an 8x10, then add a 5x7 (which can't fit on the same letter-sized page), and it automatically creates a new page for you with the 5x7. Now add another 5x7 (so you have two-up), then a 2x2.5 (which won't fit on the same page), and it will add yet another page. Pretty smart, eh? (By the way, I think this "automatically do the obvious thing" is a big step forward in software development. In the past, if something like this happened, wouldn't you have expected to see a dialog pop up that said, "This cell cannot fit on the page. Would you like to add an additional page?") Also, if you decide you want to add another blank page yourself, just click on the New Page button that appears below the Add to Package buttons.

Step Nine:

If you want to delete a page added by Lightroom, just hover your cursor over the page you want to delete, and a little X appears over the top-left corner (as seen here, on the third page). Click on that X and the page is deleted. Now, on the page with the two 5x7s, click on each of the 5x7s, press the **Delete (PC: Backspace) key** to remove them, and then go and turn on the Zoom to Fill checkbox up in the Image Settings panel.

TIP: Zooming In on One Page
Once you have multiple pages like this and you want to work on just one of these pages, you can zoom right in on the page by clicking on it, then clicking on Zoom Page on the right side of the Preview panel header (at the top of the left side Panels area).

Step 10:

You can also manually adjust the size of each cell (which is a handy way to crop your photos on the fly, if you have Zoom to Fill turned on). For example, go ahead and add two 3x7 cells on this second (now empty) page, which gives you a wide, thin, cropped image. Click on the bottom image (to bring up the adjustment handles around the cell), then click-and-drag the bottom handle upward to make the cell thinner (as seen here). You can get the same effect by clicking-and-dragging the Adjust Selected Cell sliders, at the bottom of the Cells panel (there are sliders for both Height and Width). There's only one real downside, and that is you can't have different photos at these different sizes—it has to be the same photo repeated for each different size (interestingly enough, this Picture Package feature was borrowed from Photoshop, but Photoshop actually does let you use different photos in your cells, not just one repeated).

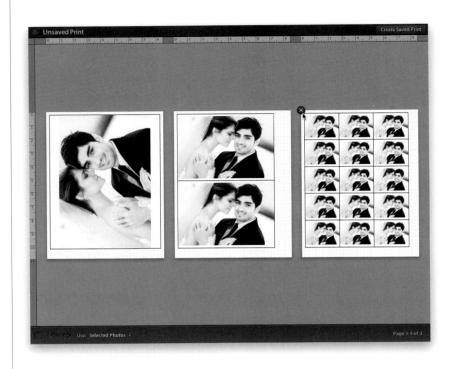

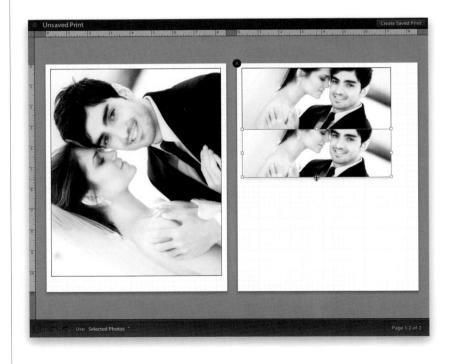

If you've come up with a layout you really like and want to be able to apply it at any time with just one click, you need to save it as a template. But beyond just saving your layout, print templates have extra power, because they can remember everything from your paper size to your printer name, color management settings, the kind of sharpening you want applied—the whole nine yards!

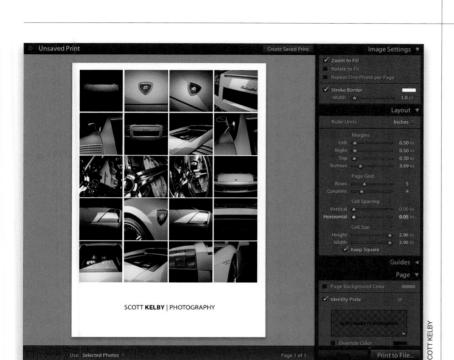

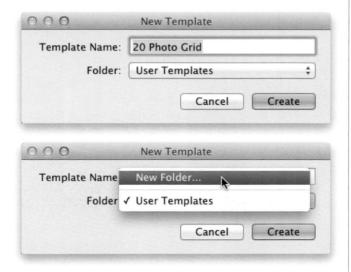

Saving Your Custom Layouts as Templates

Step One:

Go ahead and set up a page with a layout you like, so you can save it as a print template. The page layout here is based on a 13x19" page (you choose your page size by clicking the Page Setup button at the bottom of the left side Panels area). The layout uses a Page Grid of 5 Rows and 4 Columns. The cell sizes are square (around 3 inches each), and the page has a ½" margin on the left, right, and top, with a 3.69" margin at the bottom. I turned on the Stroke Border checkbox and changed the color to white, and turned on my Identity Plate. Also, make sure the Zoom to Fill checkbox (in the Image Settings panel) is turned on.

Step Two:

Once it's set up the way you like it, go to the Template Browser and click the plus sign (+) button on the right side of the header to bring up the New Template dialog (shown here). By default, it wants to save any templates you create into a folder called User Templates (you can have as many folders of print templates as you like to help you organize them. For example, you could have one set for letter-sized, one set for 13x19", one set for layouts that work with portraits, etc.). To create a new template folder, click on the Folder pop-up menu (shown here at bottom), and choose New Folder. Give your template a name, click Create, and now this template will appear in the folder you chose. When you hover your cursor over the template, a preview of the template will appear up in the Preview panel at the top of the left side Panels area.

Having Lightroom Remember Your Printing Layouts

Once you've gone through the trouble of creating a cool print layout, with the photos right where you want them on the page, you don't want to lose all that when you change collections, right? Right! Luckily, you can create a saved print, which keeps everything intact—from page size, to the exact layout, to which photos in your collection wound up on the page (and which ones didn't) and in which order. Here's how ya do it:

Step One:

Once you make a print, and you're happy with the final layout (and all your output settings and such, which we'll get into in a bit), click on the Create Saved Print button (shown circled here) that appears above the top-right corner of the center Preview area. This brings up the Create Print dialog (shown here). Here, you'll be saving a print collection. The key thing here, though, is to make sure the Include Only Used Photos checkbox is turned on. That way, when you save this new print collection, only the photos that are actually in this print are saved in it. Also, in the dialog, you'll have the option of including this new print collection inside an existing collection set if you want—just turn on the Inside checkbox and then choose the collection or collection set you want it to appear within.

Step Two:

Now click the Create button, and a new print collection is added to the Collections panel (you'll know at a glance that it's a print collection because it will have a printer icon right before the collection's name). Well, that's it! When you click on that print collection, you'll see the layout, just the way you designed it, with the images already in order ready to go, including all your output settings (like which printer you printed to, your sharpening and resolution settings—the works!), even if it's a year from now. Note: If all your images don't appear in the layout, just go to the Filmstrip and select them all—now they'll appear in your layout.

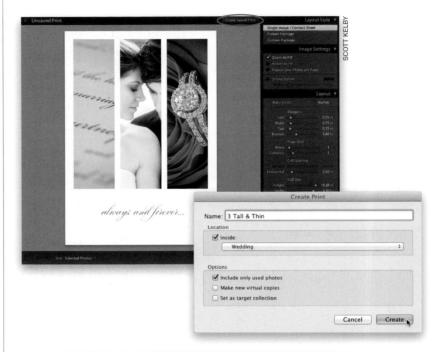

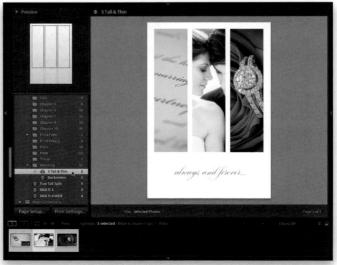

For all the wonderful things Lightroom's Print module does, one feature it doesn't have is one that lets you backscreen a photo (a staple in most wedding albums). So, I came up with a workaround, where we can use a backscreened image as our page background, and then put another non-backscreened image in front of it on the same page. It's easy, but not really obvious.

Develop

Creating Backscreened Prints

Step One:

Choose the photo you want to use as your backscreened image, then create a virtual copy of it by pressing **Command-'** (apostrophe; **PC: Ctrl-'**). We'll use this virtual copy to make our backscreened image, so our original stays intact. Once you've created your virtual copy, go to the Develop module's Tone Curve panel. Make sure the Point Curve is visible (if yours has more sliders below it, and doesn't look like the one you see here, just click on the little Point Curve icon at the bottom-right corner of the panel).

Step Two:

To create the backscreened look, clickand-drag the bottom-left corner point straight up along the left edge until it's about 3/4 or so of the way up to the top (as shown circled here in red).

The Adobe Photoshop Lightroom 5 Book for Digital Photographers

Step Three:

This is an optional step, but you see this often enough that you might want to consider converting the image you just backscreened to black and white. The advantage is it creates more contrast with the image you're going to put on top of it. To make it a black-and-white image, just go to the HSL/Color/B&W panel and click directly on B&W (as shown here). That's it—it's black and white. (Note: Because the image is backscreened, we can get away with this one-click black-and-white conversion. Otherwise, we'd use the technique for creating high-contrast black and whites found in Chapter 4) Now switch to the Print module. Click on the Page Setup button and choose a borderless 8.5 x 11" landscape page.

Step Four:

Then, click on Custom Package in the Layout Style panel at the top of the right side Panels area and scroll down to the Cells panel. Click the Clear Layout button, then make sure the Lock to Photo Aspect Ratio checkbox is turned off (turning this off allows you to drag a photo out larger than the page size if necessary). Now, click on your backscreened image, and drag it onto the page. To make your backscreened image fill the page, click-anddrag the image up to the top-left corner of the page, then grab the bottom-right corner point and just drag it out until it fills the entire page, edge to edge (as shown here). If your image won't stretch large enough to extend off the page, that's because you didn't turn off the Lock to Photo Aspect Ratio checkbox at the beginning of this step.

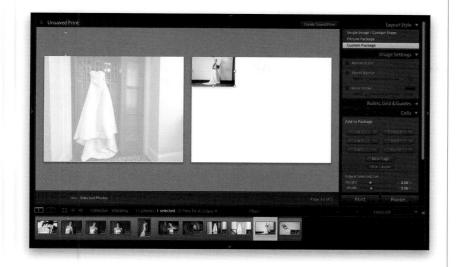

Step Five:

Getting another image to sit on top of this backscreened image is actually easy, but you kind of have to know a trick. The problem is if you add a new cell (like, for example, a 2.5 x 3.5 cell) it doesn't appear on the same page as your backscreened image. Instead, it creates a new page and adds the cell there. So, what you'll need to do is just click-and-drag your full-color photo into that new cell on the extra page (as seen here). Then, click-and-drag the cell onto the first page, and it appears over your backscreened image (as seen in the next step).

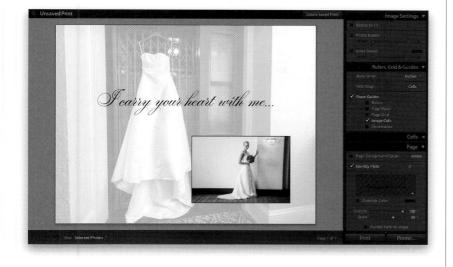

Step Six:

You can now position the image wherever you'd like (you'll see that now-blank additional page is still there, but to get rid of it, just click on the round X button in the top-left corner and it's gone). Here's the final page with the backscreened image and the second image on top of it. I also added a line of text (using the Identity Plate in the Page panel), using my favorite new wedding font, Parfumerie Script Regular (from MyFonts.com for around \$30).

The Final Print and Color Management Settings

Once you've got your page set up with the printing layout you want, you just need to make a few choices in the Print Job panel, so your photos look their best when printed. Here are which buttons to click, when, and why:

Step One:

Get your page layout the way you want it to look. In the capture shown here, I clicked on Page Setup at the bottom of the left side Panels area, chose a 17x22" page size, set my page to a wide [landscape] orientation, and then I went to the Template Browser and clicked on the Maximize Size template. I set my Left and Right Margins sliders to 2.04 in, my Top Margins slider to 2.75 in, and my Bottom Margins slider to 6.51 in. I also turned on the Zoom to Fill checkbox, Lastly, I added my Identity Plate below the photo (like the one we created earlier in this chapter). Once that's done, it's time to choose our printing options in the Print Job panel, at the bottom of the right side Panels area.

Step Two:

You have the choice of sending your image to your printer, or just creating a high-resolution JPEG file of your photo layout (that way, you could send this finished page to a photo lab for printing, or email it to a client as a high-res proof, or use the layout on a website, or...whatever). You choose whether it's going to output the image to a printer or save it as a JPEG from the Print To pop-up menu, at the top right of the Print Job panel (as seen here). If you want to choose the Print to JPEG File route, go to the next tutorial in this chapter for details on how to use the JPEG settings and export the file.

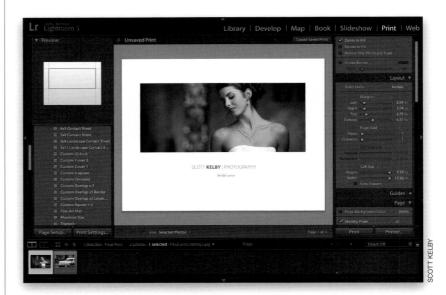

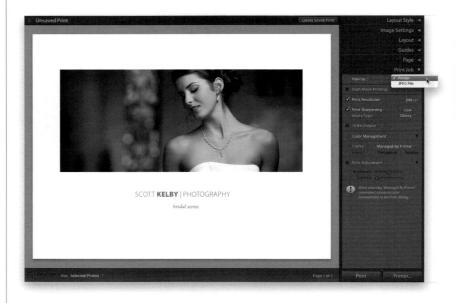

Step Three:

Since we've already started at the top, we'll just kind of work our way down. The next setting down in the panel is a checkbox for Draft Mode Printing, and when you turn this on, you're swapping quality for speed. That's because rather than rendering the full-resolution image, it just prints the low-res JPEG preview image that's embedded in the file, so the print comes out of your printer faster than a greased pig. I would only recommend using this if you're printing multi-photo contact sheets. In fact, I always turn this on when printing contact sheets, because for printing a page of small thumbnail images, it works beautifully—the small images look crisp and clear. Notice, though, that when you turn Draft Mode Printing on, all the other options are grayed out. So, for contact sheets, turn it on. Otherwise, leave this off.

Step Four:

Make sure the Draft Mode Printing checkbox is turned off, and now it's time to choose the resolution of your image. If you want to print at your file's native resolution, then turn the Print Resolution checkbox off. Otherwise, when you turn the checkbox on, the default resolution is 240 ppi (fine for most color inkjet printing). I use Epson printers, and I've found resolutions that work well for them at various sizes. For example, I use 360 ppi for letter-sized or smaller prints, 240 ppi for 13x19" prints, or just 180 ppi for a 16x20" or larger. (The larger the print size, the lower the resolution you can get away with.) In this instance, I'm printing to an Epson Stylus Pro 3880 on a 17x22" sheet, so I would highlight the Print Resolution field and type in 180 (as shown here), then press the Return (PC: Enter) key. Note: If printing at 180 ppi freaks you out, just leave it set to the default of 240 ppi, but at least try 180 ppi once on a big print, and see if you can tell a difference.

Step Five:

Next is the pop-up menu for Print Sharpening, and in Lightroom 2, Adobe really made this a powerful tool (the output sharpening in earlier versions was just too weak for most folks' tastes). Now when you tell Lightroom which type of paper you're printing on and which level of sharpening you'd like, it looks at those, along with the resolution you're printing at, and it applies the right amount of sharpening to give you the best results on that paper media at that resolution (sweet!). So, start by turning on the Print Sharpening checkbox (I always turn this on for every print, and every JPEG file), then choose either Glossy or Matte from the Media Type pop-up menu. Now choose the amount of sharpening you want from the Print Sharpening pop-up menu (I generally use High for glossy and Standard for matte paper, like Epson's Velvet Fine Art). That's all there is to it— Lightroom does all the work for you.

Step Six:

The next checkbox down reveals another feature: 16-bit printing, which gives you an expanded dynamic range on printers that support 16-bit printing. (Note: At the time this book was published, 16-bit printing in Lightroom 5 was only available for Mac OS X Leopard or higher users, but, of course, that is subject to change if Adobe releases an update for Windows.) So, if you're running Mac OS X Leopard or higher, and you have a 16-bit-capable printer, like some of the newer Canon printers (or if you've downloaded a 16-bit printer driver, like the ones Epson released in early 2008 that make your current printer 16-bit capable), then you should turn the 16 Bit Output checkbox on (as shown here).

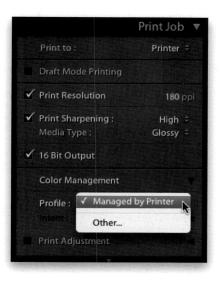

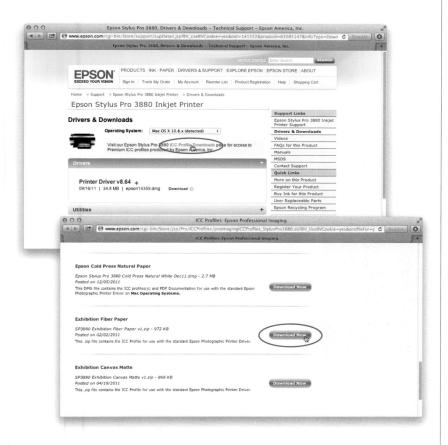

Step Seven:

Now it's time to set the Color Management options, so what you see onscreen and what comes out of the printer both match. (By the way, if you have any hope of this happening, you've first got to use a hardware monitor calibrator to calibrate your monitor. Without a calibrated monitor, all bets are off. More on this in a bit.) There are only two things you have to set here: (1) you have to choose your printer profile, and (2) you have to choose your rendering intent. For Profile, the default setting is Managed by Printer (as shown here), which means your printer is going to color manage your print job for you. This choice used to be out of the question, but today's printers have come so far that you'll actually now get decent results leaving it set to Managed by Printer (but if you want "better than decent," read on).

Step Eight:

You'll get better looking prints by assigning a custom printer/paper profile. To do that, first go to the website of the company that manufactures the paper you're going to be printing on. On their site, find the ICC color profiles they provide for free downloading that exactly match (a) the paper you're going to be printing on, and (b) the exact printer you're going to be printing to. In our case, I'm printing to an Epson Stylus Pro 3880 printer, and I'm printing on Epson's Exhibition Fiber Paper. So, I went to Epson's website and, under Drivers & Support for Printers & All in Ones, I found the 3880 downloads for a Macintosh. At the top of that page, I clicked on ICC Profile Downloads, then clicked on the Download Now button for Exhibition Fiber Paper under Stylus Pro 3880, and installed the free color profile for my printer. On a Mac, the unzipped file should be placed in your Library/Color Sync/Profiles folder. In Windows Vista or newer, Right-click on the unzipped file and choose Install Profile.

Step Nine:

Once your color profile is installed, clickand-hold on the Profile pop-up menu (right where it says Managed by Printer), and choose Other. This brings up a dialog (shown here) listing all the color profiles installed on your computer. Scroll through the list and find the paper profiles for your printer, then find the profile(s) for the paper(s) you normally print on (in my case, I'm looking for that Epson Exhibition Fiber Paper, or EFP for short, for the Epson Stylus Pro 3880), and then turn on the checkbox beside that paper (as shown here). Once you've found your profile(s), click OK to add it to your pop-up menu.

Return to that Profile pop-up menu in the Print Job panel, and you'll see the color profile for your printer is now available as one of the choices in this menu (as seen here). Choose your color profile from this pop-up menu (if it's not already chosen; in my case, I would choose the SP3880 EFP PK 2880v1.icc, as shown here, which is Epson's secret code for the Stylus Pro 3880, Exhibition Fiber Paper, PK, at 2880 dpi). Now you've set up Lightroom so it knows exactly how to handle the color for that printer on that particular type of paper. This step is really key to getting the quality prints we're all aiming for, because at the end of the day, it's all about the print.

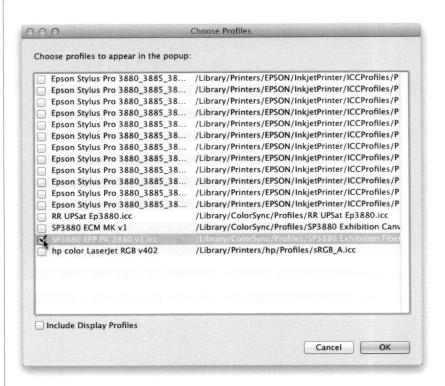

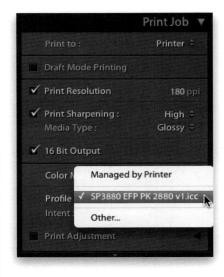

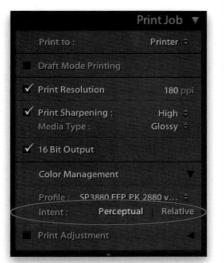

Print Printer: EpsonStylusPro3880-1E8107 \$ + Presets: Default Settings Copies: 1 Pages: (All OFrom: 1 to: 1 \$ Layout Pages per Sheet: 1 Layout Direction: Border: None Off Two-Sided: Reverse page orientation Flip horizontally (?) PDF * Hide Details Cancel Print

Step 11:

Next to Intent, you have two choices: (a) Perceptual, or (b) Relative. Theoretically, choosing Perceptual may give you a more pleasing print because it tries to maintain color relationships, but it's not necessarily accurate as to what you see tonally onscreen. Choosing Relative may provide a more accurate interpretation of the tone of the photo, but you may not like the final color as much. So, which one is right? The one that looks best on your own printer. Relative is probably the most popular choice, but personally, I usually use Perceptual because my style uses very rich, saturated colors, and it seems that Perceptual gives me better color on my particular printer. So, which one should you choose? The best way to know which one looks best for your printer is to print a few test prints for each photo—try one with Perceptual and one with Relative—when the prints come out, you'll know right away which one works best for your printer. We'll cover the last option, Print Adjustment, after you make your first print.

Step 12:

Now it's time to click the Printer button at the bottom of the right side Panels area. This will bring up the Print dialog (shown here. If you're using a Mac, and you see a small dialog with just two pop-up menus, rather than the larger one you see here, click the Show Details button to expand the dialog to its full size, more like the one shown here).

Step 13:

Click-and-hold on the dialog's main section pop-up menu, and choose Printer Settings (as shown here). By the way, the part of this dialog that controls printer color management, and your pop-up menu choices, may be different depending on your printer, so if it doesn't look exactly like this, don't freak out. On a PC, click on the Properties button next to the Printer Name popup menu to locate it instead.

Step 14:

When the Printer Settings options appear, under Color Mode, your printer's color management may be turned on. Since you're having Lightroom manage your color, you don't want the printer also trying to manage your color, because when the two color management systems start both trying to manage your color, nobody wins. So, if it's not already set that way, choose Off (No Color Management) from the pop-up menu (as seen here). On a PC (this may be different, depending on your printer), in the Media Settings section, under Mode, click the Custom radio button and choose Off (No Color Adjustment) from the pop-up menu. Here, mine was automatically turned off, and grayed out so I couldn't change it.

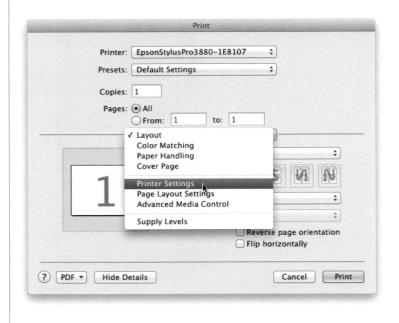

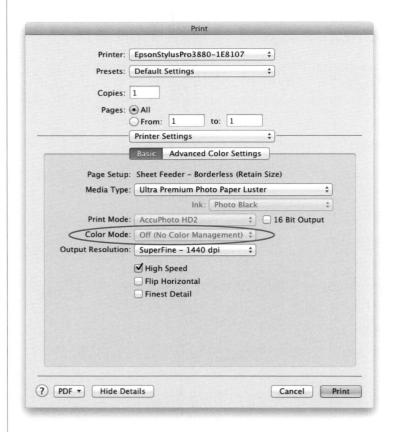

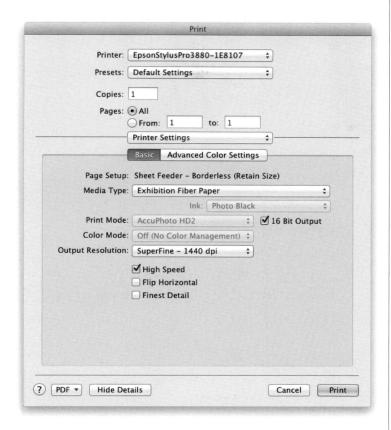

Step 15:

Now, also in the Printer Settings section (or Media Settings on a PC) of the Print dialog (again, your pop-up menus may be different, and on a PC, these will be in the Properties dialog for your printer), for Media Type, choose the exact paper you'll be printing to from the pop-up menu (as seen here, where I chose Exhibition Fiber Paper).

Step 16:

In that same Printer Settings section, for Output Resolution, choose SuperFine - 1440 dpi from the pop-up menu, and turn on the High Speed setting checkbox (if it's not already turned on; as seen in the previous step. Again, this is for printing to an Epson printer using Epson paper. If you don't have an Epson printer...why not? Just kidding—if you don't have an Epson printer, you're probably not using Epson paper, so for Print Quality, choose the one that most closely matches the paper you are printing to). Turn on the 16-Bit Output checkbox if you're doing 16-bit printing. On a PC, under Print Quality, choose Quality Options from the pop-up menu. In the resulting Quality Options dialog, you can turn on the High Speed checkbox and choose your Print Quality by setting the Speed slider. Now sit back and watch your glorious print(s) roll gently out of your printer. So far, so good.

Step 17:

Once your print comes out of the printer, now it's time to take a good look at the print to see if what we're holding in our hands actually matches what we saw onscreen. If you use a hardware-based monitor calibrator, and you followed all the instructions up to this point on downloading printer profiles and all that stuff, the color of your image should be pretty spot on. If your color is way off, my first guess would be you didn't use a hardware-based calibrator. The one I use is the Spyder4 Elite by Datacolor (shown here), and using it is seriously a no-brainer. You put it on your monitor, launch the software, choose "easy-youdo-it-all-automatically-for-me" mode (not it's actual name), and in about four minutes your monitor is calibrated. This is such a critical step in getting your color right that without hardware calibration of some sort, you really have little hope of the colors on your monitor and your print actually matching.

Step 18:

If you've used a hardware calibrator, and followed the instructions in this section of the book, your color should be pretty much spot on (and if it isn't, jump back to page 200 for the section on soft proofing), but there's another printing problem you're likely to run up against. Your color probably matches pretty darn well, but my guess is that the print you're holding in your hand right now is quite a bit darker than what you see on your screen. That's mostly because, up to this point, you've been seeing your image on a very bright, backlit monitor, but now your image isn't backlit—it's flat on a printed page (imagine how a backlit sign looks when you turn off the back lighting. Well, that's what you're holding). Luckily, in Lightroom 4, Adobe addressed this problem by adding a Print Adjustment option at the bottom of the Print Job panel (shown here).

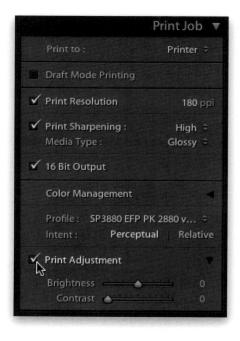

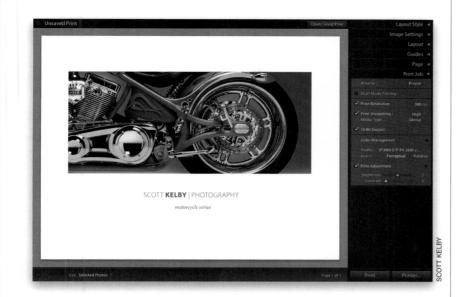

Step 19:

In earlier versions of Lightroom, we would intentionally bump up the Brightness slider (back when there was a Brightness slider) right before we would make a print, so when it came out, it would actually look as bright as it did on our monitor (I had to bump up mine by around 20% for my Epson printer). The problem with this was it actually made an adjustment to the image, so if you wanted to use the image somewhere else (like in a web gallery, or in a magazine), then you'd have to re-tweak the image every time. Now, if we need a little adjustment to the brightness or contrast at the printing stage, we can leave our image alone (in most cases) and use the new Print Adjustment sliders to have it just print brighter or with more contrast without actually changing our file.

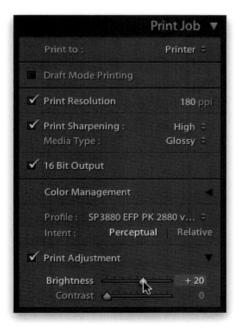

Step 20:

Let's start with the Brightness. How do you know how much to increase it? (I've never had to decrease it. Not once.) You do a test print. In fact, you kind of have to do a test print, since the changes you make with the Brightness and Contrast sliders aren't seen onscreen (they're only applied as the image is printed). Now, the good news is your test print doesn't have to be output on a big expensive 16x20" sheet of paper—it can be a small 4x6" print. Once you have your test print in hand, compare the brightness to what you see on your screen. If the image is too dark (my guess is that it will be), then try bumping up the Brightness slider to maybe 20 and do another test print, then see where you're at.

Step 21:

By the way, you may have to tweak that Brightness number up or down a little bit, but after just a few quick test prints, you'll know the amount you need for the paper profile and printer you chose, and you'll use that same setting every time when you print on that paper to that printer (unless you change paper types, as I've done here, because different papers display brightness differently, so you'll need to do a test for that paper, too). Luckily, you only have to do this once, because once you know where to set the Brightness...well...ya know.

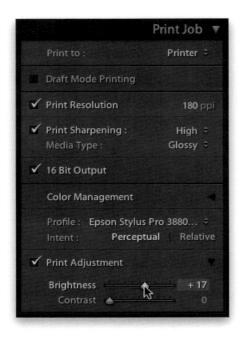

Step 22:

As for the Contrast slider, you use it the same way, but of course only if your image prints kind of flat looking and less contrasty. Drag it to the right to add contrast to the image, but again, you'll need a test print to see and test the effect, since there is no onscreen preview of this slider, either.

Note: These two sliders are for minor tweaks to just the contrast and brightness. If these two sliders aren't enough to get you a match (or if there's a color issue), go to page 200 for a more detailed way to prepare images for printing and using soft proofing (which saves paper and ink costs).

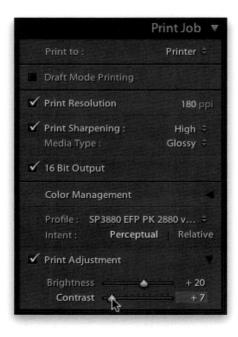

You can save any of these print layouts as JPEG files, so you can send them to a photo lab, or have someone else output your files, or email them to your client, or one of the dozen different things you want JPEGs of your layouts for. Here's how it's done:

Saving Your Page Layout as a JPEG

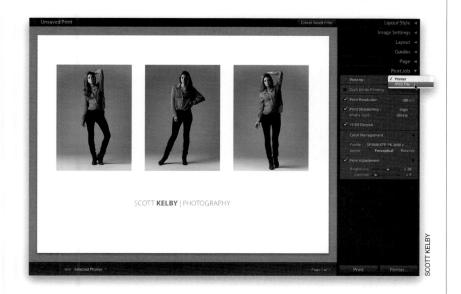

Step One:

Once your layout is all set, go to the Print Job panel (in the right side Panels area), and from the Print To pop-up menu (at the top right of the panel), choose **JPEG File** (as shown here).

Step Two:

When you choose to print to a JPEG, a new set of features appears. First, ignore the Draft Mode Printing checkbox (it's just for when you're actually printing contact sheets full of small thumbnails). For File Resolution, the default is 300 ppi, but if you want to change it, move your cursor directly over the File Resolution field (the 300), and your cursor will change into a "scrubby slider" (it's that hand with the two arrows, as seen here). Now you can click-and-drag left to lower the resolution amount, or click-and-drag right to increase it.

Step Three:

Next is the pop-up menu for Print Sharpening. What you do here is tell Lightroom which type of paper you'll be printing on (Matte or Glossy), and which level of sharpening you'd like applied (Low, Standard, or High). Lightroom looks at your choices (including resolution) and comes up with the optimum amount and type of sharpening to match your choices. So, start there (I apply this print sharpening to every photo I print or save as a JPEG). If you don't want this output sharpening applied to your exported JPEG, just turn off the Print Sharpening checkbox.

Step Four:

You've got a couple more choices to make before we're done. Next, is JPEG Quality (I usually use 80, because I think it gives a good balance between quality and compression of the file size, but you can choose anything you want, up to 100). Below that is the Custom File Dimensions section. If you leave the checkbox turned off, it will just use whatever page size you had chosen in the Page Setup dialog (in this case, it was a 22x17" page). If you want to change the size of your JPEG, turn on the Custom File Dimensions checkbox, then move your cursor over the size fields and use the scrubby slider to change sizes (shown here, where I changed it to 11x8½"). Lastly, you set your Color Management Profile (many labs require that you use sRGB as your profile, so ask your lab). If you want a custom color profile, go back to the last project for info on how to find those, and you can find info on the rendering Intent setting there, too. Now just click the Print to File button at the bottom of the right side Panels area to save your file.

I wish Lightroom had the built-in ability to add custom borders, edges, and frames around your photos, but unfortunately it just doesn't. However, you can do a little workaround that lets you use your Identity Plate, and a special option in the Identity Plate section, to get the same effect right within Lightroom itself. Here's how it's done:

Adding Custom Borders to Your Prints

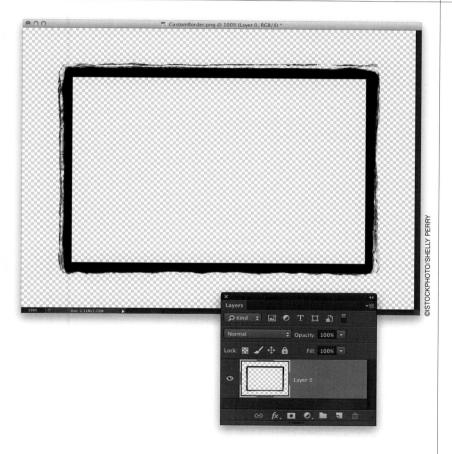

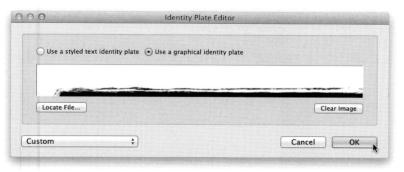

Step One:

We'll start in Photoshop with the edge border here (from iStockphoto.com; you can download it for free from this book's website, mentioned in the introduction). The edge comes flattened on the background, so select the entire black area. Then press Command-Shift-J (PC: Ctrl-**Shift-J)** to put it up on its own separate layer. Cut a rectangular hole out of the center (so our photo can show through) using the Rectangular Marquee tool (M), then press the Delete (PC: Backspace) key, Our file can't have a solid white background, or it will cover our photo in Lightroominstead it has to be transparent. So, go to the Layers panel and click-and-drag the Background layer into the Trash (at the bottom of the panel). Now, save the file in PNG format.

Step Two:

All right, that's all the prep work in Photoshop—back to Lightroom. Click on the photo you want to have an edge frame, then go to the Print module. In the Page panel, turn on the Identity Plate checkbox. Then, in the Identity Plate pop-up menu, choose **Edit** to bring up the Identity Plate Editor seen here. Click on the Use a Graphical Identity Plate radio button (because we're going to import a graphic, rather than using text), then click on the Locate File button, locate your saved PNG frame file, and click Choose (PC: Open) to load it into your Identity Plate Editor (you can see the top of our edge frame in the small preview window shown here).

BONUS VIDEO:

I did a little bonus video for you, to show you step by step how to create Identity Plate graphics with transparency. You'll find it at http://kelbytraining.com /books/LR5.

Step Three:

When you click OK, your edge frame will appear, hovering over your print (almost like it's on its own layer). The size and position won't be right, so that's the first thing you'll want to fix (which we'll do in the next step, but while we're here, notice how the center of our frame is transparent—you can see right through it to the photo below it. That's why we had to save this file without the Background layer, and as a PNG—to keep that transparency intact).

Step Four:

To resize your border, you can either click-and-drag a corner point outward (as shown here), or use the Scale slider in the Page panel. Once the size looks about right, you can reposition the frame edge by simply clicking-and-dragging inside its borders. You may need to resize your image, as well, using the Margins sliders in the Layout panel.

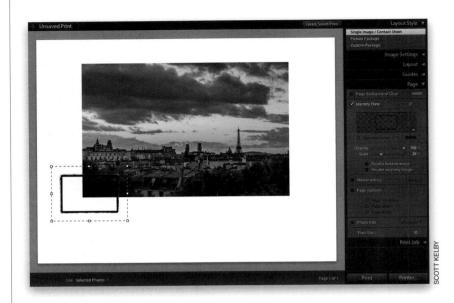

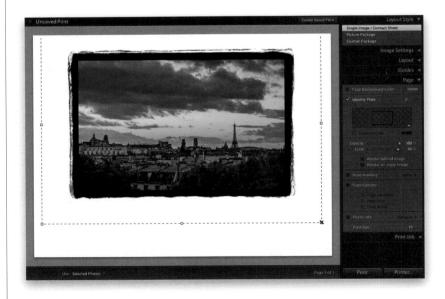

Step Five:

When it's right where you want it, just click your cursor outside the border and it will deselect. The final photo with the edge frame border is shown here. Now, if you decide you want to keep this border and use it in the future, go back to the Identity Plate Editor and from the Custom pop-up menu at the bottom-left corner of the dialog, choose **Save As** to save this frame border as an Identity Plate you can use anytime to add a quick border effect.

TIP: Frames for Multiple Photos
If you have more than one photo on
the page, you can have that Identity
Plate frame added to all the photos on
the page automatically by going to the
Page panel and turning on the Render
on Every Image checkbox.

Step Six:

We created a horizontal frame, but how do you add this frame edge to a vertical photo, like the one shown here? If you change your page setup to Portrait (by clicking on the Page Setup button at the bottom of the left side Panels area), the Identity Plate will rotate automatically. If you are printing a vertical photo in a Landscape setup, you can rotate the Identity Plate by clicking on the degree field that appears to the right of the Identity Plate checkbox in the Page panel and choosing the rotation angle (as shown here). You'll probably have to resize and reposition the frame (as I did here) to make it fit just right, but now your single frame edge is doing double duty.

Lightroom Killer Tips > >

▼ Can't See Your Rulers?

If you're pressing Command-R (PC: Ctrl-R) and you can't see your printing rulers (the ones that appear above the top of your photo, and along the left side), it's because you have to make your guides visible first. Press Command-Shift-H (PC: Ctrl-Shift-H) or just choose Show Guides from the View menu. Now when you use that shortcut, you'll be toggling the rulers on/off.

▼ Changing Your Ruler Units

To change the unit of measure for your rulers, just Right-click on either ruler, and a pop-up menu of measurements (Inches, Centimeters, Millimeters, Points, and Picas) will appear, so you can choose the one you'd like.

▼ Changing the Preview Area Background Color

You can change the color of the gray canvas area that surrounds your printed page. Just Right-click anywhere on that

gray background area and a pop-up menu will appear where you can choose different colors.

▼ Adding Photos to Your Printing Queue

Adding more photos to print couldn't be easier—just go to the Filmstrip and Command-click (PC: Ctrl-click) on any photo you want to add to your print queue, and Lightroom instantly creates another page for it in the queue. To remove a photo from the print queue, it's just as easy: go to the Filmstrip and Command-click (PC: Ctrl-click) on any already selected photo to deselect it (Lightroom removes the page from your queue automatically, so you don't print a blank sheet).

▼ Precise Margins Way Quicker Than Using the Margins Sliders

If you need to reposition your image on the page, you can adjust the Margins or Cell Size sliders. But if your guides are visible, it's easier just to click-and-drag a margin guide itself, because as soon as

you start dragging, the position of the guide (in inches) appears above the top of the guide, so it's easy to quickly set two side or top and bottom margins to the exact same amount.

▼ Sending Prints to a Lab?

If you use Lightroom's ability to save a page layout to JPEG, so you can send your prints to a lab for final printing, then here's a great tip: make a new template that has your usual page size, layout, etc.,

but make sure you set your color profile to the color space your lab prefers (which is usually sRGB for color labs). That way, when you save it as a JPEG, you won't forget to embed the right color space.

▼ Enabling 16-Bit Printing

If your inkjet printer was made in the last few years, it probably supports 16-bit printing, but to take advantage of it, make sure you have the latest printer driver (which can be downloaded for free from your printer manufacturer's website). *Note*: 16-bit printing currently only works for Mac users, and only those using Mac OS X Leopard or higher.

▼ Choosing How the Identity Plate Prints

There are two other options for how the Identity Plate is used in multi-photo layouts. If you choose Render on Every

Image, it puts your Identity Plate right smack dab in the middle of each photo, in each cell (so if you wanted to use your logo as a watermark by lowering the opacity of that Identity Plate, that would work). If you choose Render Behind Image, it prints on the background, as if it was a paper watermark (scale it up so it is slightly larger than your image).

▼ Nudging the Identity Plate

In the Print module, you can move the position of your Identity Plate graphic (or text) by small increments by using the **Arrow keys** on your keyboard.

THE LAYOUT creating cool layouts for web & print

Man, I just love it when you go searching for a song or movie title with the word "layout" in it, and the first album that pops up is "The Layout" by Frankie Jones. That's a lot better luck than I had when I searched for the chapter on Rendering Intents (ya know, if I actually had a chapter on that, and if I did, it would be an incredibly short chapter. About a page or two, and that's if I used a lot of big words, like Rendering and Intents). Anyway, some of these layouts were in the Lightroom 3 version of this book, buried in the Print chapter. I think that was a mistake. Mind you, I'm not saying I made this mistake. I learned long ago that, to be a successful author, a particular skill you need to master is the immediate and indiscriminate assigning of blame to your editor for anything that isn't 100% absolutely perfect. One reason this works so consistently, for authors across all genres of books, is that editors say so many messed up things during the

course of producing a book that they honestly have no idea what they really said or when they said it. I talked to my editor Ted Waitt about this, and he admitted what I had always suspected, which is that many editors today are hooked on steroids (that explains why Ted is so freakishly muscular). Anyway, most photographers today don't actually make prints their images go straight to the web (for the most part), so a lot of readers had no idea I put all these cool layouts in the book that work perfectly for the web, too (I use these on my blog, on Google+, in photo galleries, and at steroid conventions), so by putting these in their own separate chapter (along with 24 bad @\$! Lightroom presets created by Lightroom guru Matt Kloskowski), it distracts Olympic officials from administering their monthly mandatory drug tests for book editors. Well, at least that's what I've been told.

Here Are Some of My Layouts for You to Use

I wanted to share some of my most popular multi-photo print layouts with you (clients love these types of layouts), showing the panels needed for the layout, and an example of each. These all use a 13x19" final page size, so click the Page Setup button and set that first. Unless otherwise shown, they use the Single Image/Contact Sheet layout. Also, for a full-page bleed, set your page to borderless. I did a short video tutorial for you on how I created the Identity Plates I used in these examples at http://kelbytraining.com/books/LR5. Enjoy!

Note: The goal of this section is to teach you how easy it is to create your own layouts for the web or printing, and once you build a few, you'll have a blast building your own, but just so you know, I did save all these layouts as templates (once again, using the standard 13x19" size). So, if you don't want to recreate these layouts yourself, you can download them as templates by going to the book's companion webpage (the address is in that section up front you weren't supposed to skip), and load them into Lightroom 5.

SCOTT KELBY | PHOTOGRAPHY

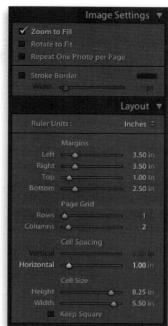

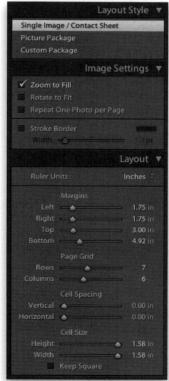

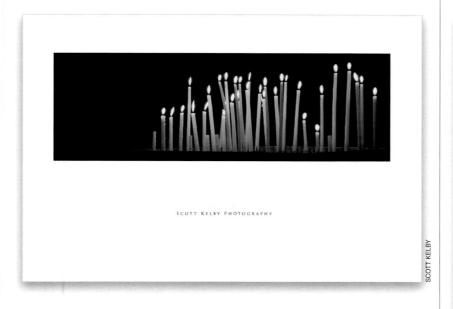

OTT KELBY

SCOTT KELBY PHOTOGRAPHY

Here, in the Cells panel, you're going to create a 4x6 cell, then grab one side and drag inward until it becomes a square 4x4 cell (turn off the Lock to Photo Aspect Ratio checkbox first).

Position that in the middle, above the center of the page. Now, create two more 4x6 cells and put them on either side of the square

SCOTT KELBY | PHOTOGRAPHY

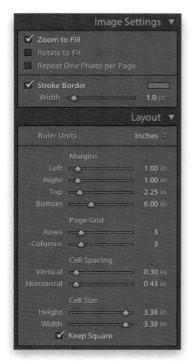

SCOTT KELBY

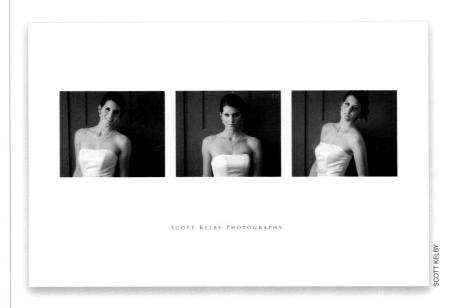

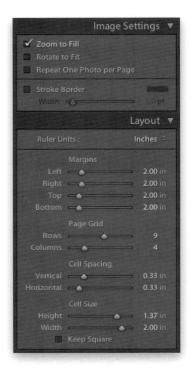

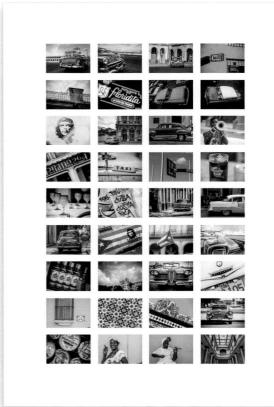

SCOTT KELBY

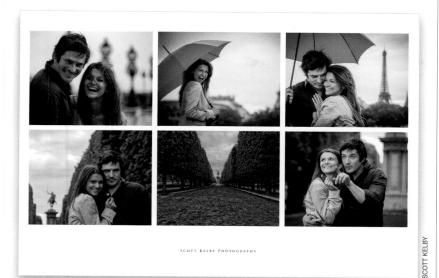

Image Settings ▼				
✓ Zoom to Fill				
Rotate to Fit				
Repeat One Photo per Page				
✓ Stroke Border				
Width 📤			0.2 pt	
		Lä	yout ▼	
Ruler Units :		Inches ÷		
Left	~	-,	0.75 in	
Right	<		0.75 in	
Тор	-		1.25 in	
Bottom	←		3.75 in	
Rows			3	
Columns	 		7	
	Cell Spacing			
Vertical			0.63 in	
Horizontal	<u>-</u>		0.30 in	
	Cell Size			
	Cell 3lze		2.25 in	
Width				
	Keep Square		2.23 (1)	
	nech oquare			

SCOTT KELBY | PHOTOGRAPHY

Click the Page Setup button and set your page to borderless so Lightroom will let you set your page margins to 0.00" all the way around for this full-page bleed look

Continued

Turn on the Zoom to Fill checkbox in the Image Settings panel. Click on the Page Background Color color swatch and change it to black in the Page panel, then turn on the Override Color checkbox for your Identity Plate and set the color to white

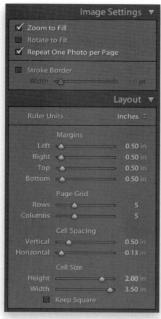

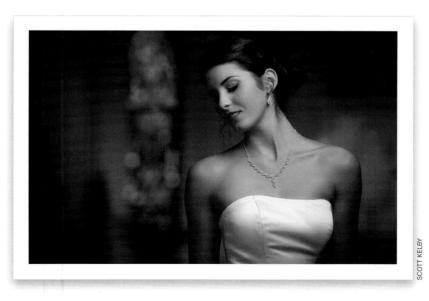

	Layout Style ▼			
Single Image / Contact Sheet				
Picture Package				
Custom Package				
Im	age Settings ▼			
☐ Rotate to Fit				
Photo Border				
Width & O	10.4 pt			
✓ Inner Stroke Width ▲	3.0 pt			
Rulers, Grid & Guides ◀				
	Cells ▼			
Add to Package				
(2×25 🔻 (2.5 × 3.5 🔻			
C 3×2 (2)	4×6 (▼)			
(5×7 v) (8 × 10 (~)			
New Page				
Clear La	yout			
Adjust Selected Cell				
Height O	in in			
Rotate				
Lock to Photo Asp	ect Ratio			

This is a do-it-yourself project, because you have to basically just start in the left-hand corner, create a series of 4x6 cells, and resize them one by one, until you have the layout you see here. That's the thing about using the Custom Package, it's up to you to create the custom layout yourself

Set your Page Background Color to light gray, then create four 5x7 cells and position them 2 across and 2 down. Then, press-and-hold the Option (PC: Alt) key, and click-and-drag one of the cells to make a copy, which you position in the center, on top of the original four.

Then, you turn on Inner Stroke and add about an 18-pt white stroke

Bonus: 24 Cool Lightroom 5 Develop Module Presets

I'll bet that's your favorite page headline in the book, right? Okay, so here's the scoop: my buddy and colleague is none other than Matt Kloskowski, who is the guy behind our Lightroom Killer Tips blog, and over the past few years, Matt has gained a reputation as the "Presets Ninja." So, I asked him if I could share a bunch of his best Lightroom 5 Develop module presets here in the book, and since he works for me, he was surprisingly willing to do this. ;-) My sincere thanks to Matt for letting me share these with you.

Step One:

First, you'll probably want to know where these presets actually are: They are on the book's companion website at http://kelbytraining.com/books/LR5. There are actually more than 24 presets on the website, though, because there are some sharpening presets, as well as alternate versions of some (like light, medium, and strong, or color variations). Besides Matt's Develop module presets, there is all sorts of other cool stuff there, too, like videos I recorded for you, and images to practice on, and layout templates, and stuff like that. So, start by downloading the presets from the website (pictured here).

Step Two:

Once they're downloaded, go to Lightroom's Develop module, to the Presets panel in the left side Panels area, and Right-click on the User Presets collection. This brings up a pop-up menu (shown here), and all you need to do now is choose **Import**, navigate to the presets you just downloaded from the book's site, and then click OK, and now these presets will appear in your User Presets collection. To see a preview of any preset, just hover your cursor over it in the collection, then look up at the Navigator panel at the top of the left side Panels area and you'll see what the currently selected photo would look like if you applied the preset. When you find one that looks good to you, you're just one click away from having that look. Enjoy!

▼ Black and White (Landscape)

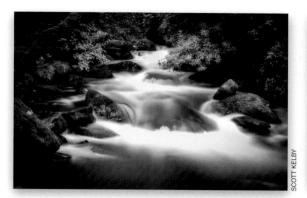

Before

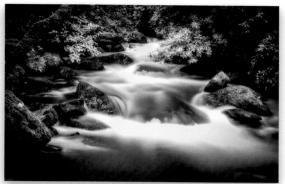

After

▼ Classic Black and White Tint

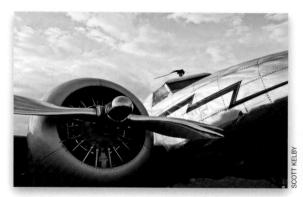

Before

After

▼ Colorize Red

Before

After

▼ Fall Foliage (Strong)

After

▼ Hawaii Five-O (Medium)

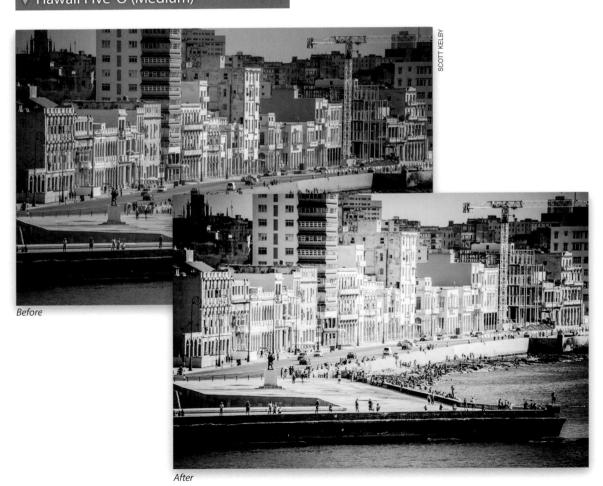

▼ Game Day

Before

After

▼ Hang Ten

Before

After

▼ The Hangover Movie Look

Before

After

▼ HDR Look (Strong)

Before

After

Library Develop Print

▼ Hazy Day

Before

After

▼ Lomo Effect

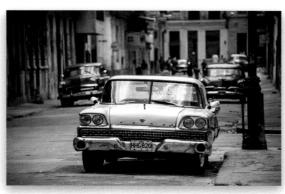

After

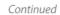

▼ Rounded Rectangle (White)

Before

After

▼ Lightroom Instagram Effect

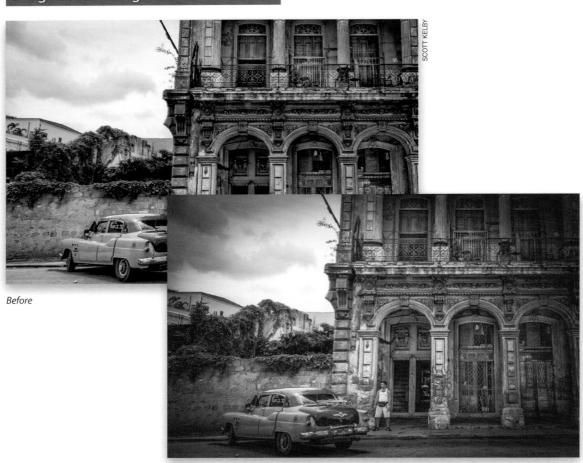

After

▼ Sin City (Light Red)

Before After

▼ Ultra Gritty Effect

Before

After

After

▼ Soft Focus Effect

Before

▼ Street Light Nights

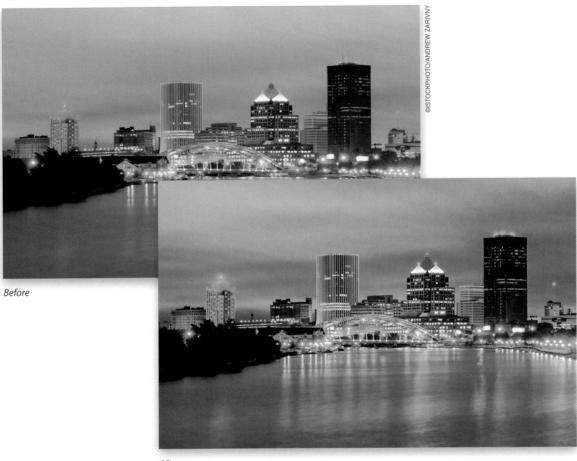

After

▼ The Ultimate Fighter (Medium)

Before After

▼ Summer Day

▼ That 70's Look

Before

After

▼ The 300 Look

Before

After

▼ Surreal Edgy Effect (Strong)

▼ Vintage Style

Before

After

▼ Wedding Fairytale (Medium)

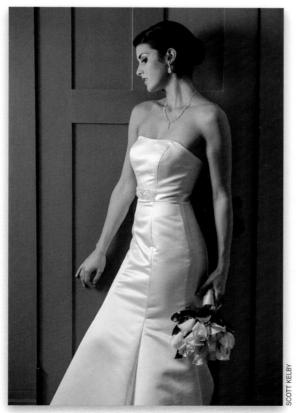

Before

After

The Adobe Photoshop Lightroom 5 Book for Digital Photographers

Photo by Scott Kelby | Exposure: 1/125 sec | Focal Length: 112mm | Aperture Value: f/13

MY PORTRAIT WORKFLOW

my step-by-step process from the shoot to the final print

If you've come to this chapter, you've either already invested a lot of time and energy in learning these techniques, or you just bought the book, and flipped right to this chapter, in which case you're one of those rabble-rousers who flaunt the time-honored tradition of book reading (where you start at Chapter 1 and work your way tirelessly through the book), and instead just jump to where the "good stuff" is hidden in the back. I'm going to assume you're not that person. Instead, I'll pretend you worked hard to get here, and therefore deserve a treat (Who's a good boy? Who's a good boy?). Thus far, the book has been one chapter on this topic, and another on that—one on importing, and another on editing; one on organizing, and another on printing. But I thought it would be helpful for you to see it all come

together—to see the entire process from beginning to end—and I thought I would even include the details of the photo shoot. Why? Because it takes up more pages, and publishers love that, because they think what readers want is more pages. In fact, if you tell them, "I'm going to add a page with just random words," they get absolutely giddy. If you tell them you're including a few pages that say "This page intentionally left blank," they black out for a few moments, and have to be revived with smelling salts—this is the Holy Grail of book publishing. Now, I have no idea if, when this book was printed, they added some blank pages, but I can tell you this: if they did, they added page numbers to them, then ran around their offices highfiving everybody in sight. Welcome to their world.

Workflow Step One: It All Starts with the Shoot

What you're about to learn is my typical day-in, day-out, workflow, and it doesn't matter if I'm doing a landscape shoot, portrait shoot, or a sports shoot, I pretty much use Lightroom the same way in the same order every time. For this particular example, I'm doing a studio shoot, so it actually starts with me shooting tethered (where I connect the camera to my laptop and shoot directly into Lightroom itself. I do this any chance I get, because you see your image at full-screen size rather than just on the tiny 3" LCD on the back of your camera). We're using a simple two-light setup here, so let's get to it!

Step One:

Before I set up the lighting, I use the USB cable that came with my camera to connect my Nikon DSLR to my laptop. Once connected, I launch Lightroom 5, then go under the File menu, under Tethered Capture, and choose **Start Tethered Capture**. I enter what I need to in the Tethered Capture Settings dialog (like where I want to save the images on my laptop), click OK, and it brings up the floating window you see here. Now, I'm ready to go (for details on setting up tethered capture, see Chapters 1 and 4).

Step Two:

The lighting setup I used is really simple: just a two-flash setup (the light with the softbox directly behind her isn't turned on—I'm just using it as a gray background. I had it turned on at first, but didn't like how the light looked coming through the scarf). The flash heads are Elinchrom BXRI 500s (a value-priced 500-watt studio strobe with a built-in wireless receiver). The top flash has a 17" beauty dish attached with a diffusion sock over the front (to make the light softer). The second flash (down below her, aiming up) has a 27" softbox attached. Camera settings: My lens is a 70–200mm f/2.8 lens. In the studio, I shoot in Manual mode, and leave my shutter speed set at 1/125 of a second, and then I can just adjust my f-stop (which for this shoot was f/13). Also, in the studio, I set my ISO at the lowest native ISO for my camera (which in my case is 100 ISO). That's it: a simple twolight setup.

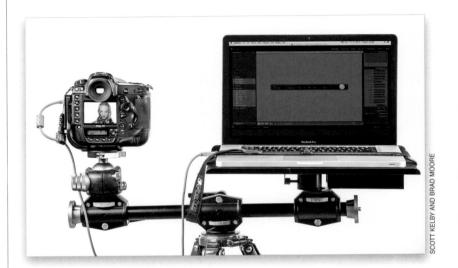

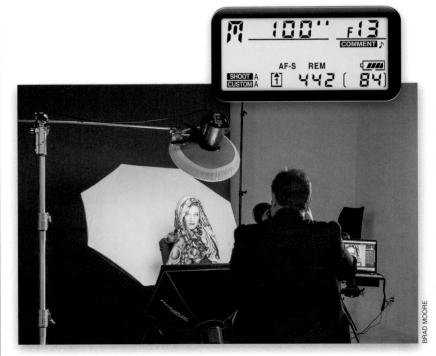

Develop

Book

Once the shoot is over, before you start the sorting/editing process in Lightroom and Photoshop, you've got some absolutely critical "first-things-first" stuff to do, and that is to back up your photos, right now, before anything else—I actually back up even when I'm on location shoots (using two OWC Mercury On-The-Go High-Speed 80-GB portable hard drives). Here's the step by step on backing up:

Workflow Step Two: Right After the Shoot, Do This First

Step One:

When you shoot tethered (directly from your camera to your laptop, like I did at this shoot), your photos are already in your computer, and they're already in Lightroom, but they're not backed up anywhere yet—the only copies of those photos are on that computer. If anything happens to your laptop, those photos are gone forever. So immediately after the shoot, I back up those photos. Although you can see the photos in Lightroom, you need to back up the photo files themselves. A quick way to find that folder is to go to Lightroom and Right-click on a photo from that shoot and choose **Show** in Finder (PC: Show in Explorer) from the pop-up menu, as shown here.

Step Two:

This opens a Finder (PC: Windows Explorer) window of the folder with your actual photo files inside, so click on that folder and drag the whole thing to your backup hard drive (this has to be a separate external hard drive—not just another partitioned disk on the same computer). If you don't have an external drive with you, then at the very least, burn that folder to a CD or DVD.

Collections

Workflow Step Three: Finding Your Picks & Making a Collection

Okay, your photos are in Lightroom, and they're backed up to a separate hard drive, so now it's time to make a collection of the keepers from the shoot, and get rid of the shots that are out of focus, the flash didn't fire for, or are just generally messed up (the Rejects). We're going to make our lives easy by creating a collection set right off the bat, and then we'll make other collections inside that set for our Picks and Selects (the final images we'll show to the client).

Create Collection...

Step One:

In the Library module, go to the Collections panel (in the left side Panels area), click on the + (plus sign) button on the right side of the panel header, and choose Create Collection Set from the pop-up menu. When the Create Collection Set dialog appears, name your new collection set "Scarf Studio Shoot," and then click the Create button. We've now got a set where we can save our Picks and our final images to show to the client (but we're not actually going to use this set right this minute we just set it up to use a step or two down the road).

Create Smart Collection.. reate Collection Set... Weddings Aircraft Carrier Sort by Name Banff Finals ✓ Sort by Kind Fighter Planes Final Model Shoots Create Collection Set Models Pano Name: Scarf Studio Shoot Paris Location Inside a Collection Set LR5 Create

Step Two:

Now I go through the process of finding just the Picks and the Rejects from the shoot. Press G to see your images in Grid view, then scroll up to the very top and double-click on the first photo (so it zooms in to Loupe view). Now use the Left/Right Arrow keys on your keyboard to view each image from the shoot. When you see a really good shot, press the letter P on your keyboard to flag it as a Pick, and when you see a Reject (shots that are out of focus, badly composed, messed up, etc.), press the letter X (to flag it as a Reject to be deleted). As you move through these images, remember: just Picks and Rejects—no star ratings, etc. If you make a mistake, press U to unflag it. For more on Picks and Rejects see page 60 in Chapter 2.

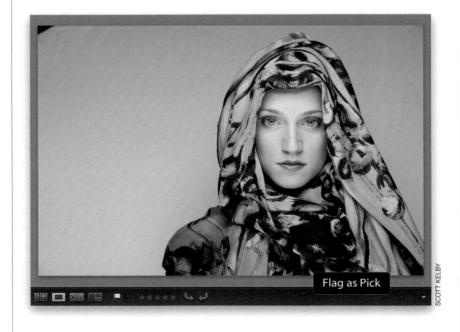

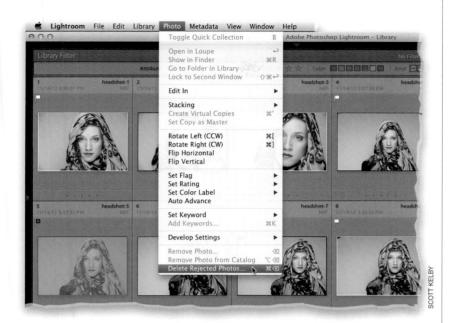

Step Three:

Once you've chosen your Picks and Rejects, let's get rid of those Rejects for good by choosing **Delete Rejected Photos** from the Photo menu (as shown here). By the way, when you flag an image as a Reject, its thumbnail actually dims to give you another visual cue (besides the black flag) that it's marked as a Reject: look at the first image in the second row and you can see the thumbnail is dimmed.

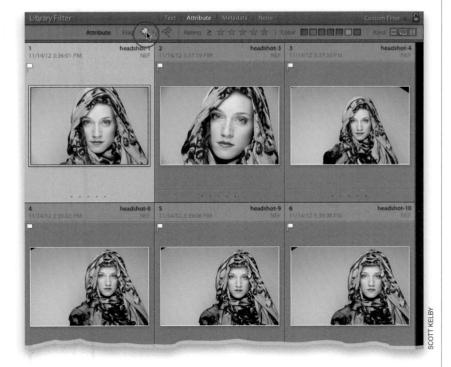

Step Four:

Now, let's turn on a filter that just shows our Picks (after all, this is what this is all about—separating our Picks from the rest of the shoot). Go up to the Library Filter above the Preview area, click on Attribute, and then click on the white Pick flag to filter your images so only the Picks are showing. *Note:* If you don't see the Library Filter bar at the top of your Preview area, press the backslash key (\) on your keyboard to make it visible.

Step Five:

Now, press Command-A (PC: Ctrl-A) to select all the Picks, and then press Command-N (PC: Ctrl-N) to create a new collection. When the dialog appears, name this collection "Picks," turn on the Inside a Collection Set checkbox, and from the pop-up menu, choose the Scarf Studio Shoot set we made back in Step One (see, I told you we'd wind up using this later on). Make sure the Include Selected Photos checkbox is turned on (so these selected photos wind up in this new collection automatically), and click the Create button. This saves your Picks into their own collection inside your Scarf Studio Shoot set (shown here at the bottom). At this point, all our Picks are still flagged, but since they're in their own collection now, we need to remove the flags for the next step. So, select them all, then press the letter U to unflag them. (For more on collections, see page 60 in Chapter 2).

Step Six:

It's time to narrow things down even further—to the images we'll send to the client for approval. To help with this, I select any images in this Picks collection with a similar pose and go into Survey view by pressing the letter N. The images show up together onscreen, and I keep removing my least favorite shot until I wind up with just one or two of a pose I like. I click on that image (as seen here, where I clicked on the center image), then I flag it as a Pick. Press G to return to the Grid view, select another set of images with the same pose, and narrow things down the same way (I wound up with three photos that are my Selects). Turn on the Pick flag filter up in the Library Filter, select all the images flagged as Picks, create a new collection, name it "Selects," and save it in your Scarf Studio Shoot set.

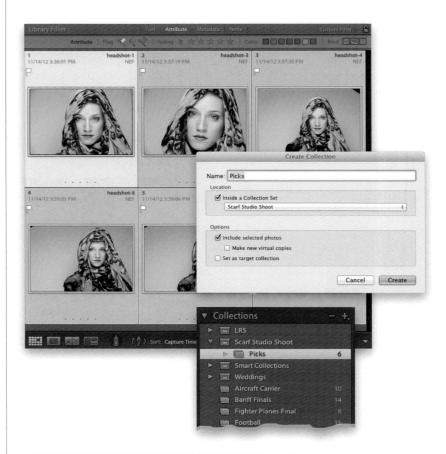

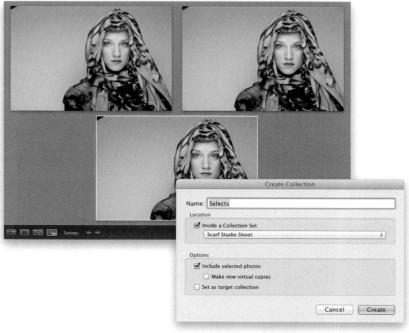

Now that you've whittled things down to the images you're going to show the client, it's decision time: are you going to let your client look at the proofs "as is," or do you want to tweak 'em a bit first in Lightroom's Develop module? If you're leaving them "as is," jump over to page 497. But, if you want to take a couple of minutes and tweak a few things, then stick with me here. By the way, these are just some quick tweaks—we don't want to invest a bunch of editing time now, because the client may only choose one (or none).

Workflow Step Four: A Quick Retouch for Your Selects

Step One:

Let's do some light tweaking on this Select image to get it ready to show the client. Of course, if the white balance or exposure is off, I would fix it in the Develop module before I did any retouching (in this case, both are okay already). Then it's time for a quick retouch. The first thing I notice is that the whites of her eyes are kind of grayish and her irises are kind of flat-looking, so get the Adjustment Brush (circled here). Drag the Exposure slider a little bit over to the right (here, I dragged it over to +0.68) and paint over the whites of her eyes to brighten them. Once you've painted them in, you can tweak the amount a bit (I took it up to +0.82, and that looks a little brighter). Let's add some contrast to her irises by first clicking on New and resetting all the sliders to zero (double-click on the word "Effect"). Then, increase the Contrast amount (I started at 25, then increased it to 62) and paint directly over her irises.

Step Two:

If you zoom in closer, you'll get a much better look at her skin, and you'll see a few blemishes we should probably get rid of (it only takes a few seconds). Get the Spot Removal tool (shown circled here), make your brush size a little larger than the blemishes you want to remove, then move your cursor over each blemish and just click once to remove the blemish. Go ahead and take a minute to remove the larger ones. Remember, this is just a tweak, not an in-depth retouch, so don't spend too long on this step—a minute or two, tops.

Continued

The Adobe Photoshop Lightroom 5 Book for Digital Photographers

Step Three:

The makeup artist applied her lip color before we put on this scarf and it looks like it might be a little too red to blend with the colors of her scarf. So, let's go to the HSL panel, click on Saturation at the top, then click on the Targeted Adjustment tool (that little target-looking thing in the top-left corner of the panel). Take the Targeted Adjustment tool (the TAT, for short), click it directly on her lips, drag downward, and it lowers the saturation of the reds (here, I dragged it down until the color seemed to match better, which, to me, was when the Red slider was at -31). Ahhh, that's better.

Step Four:

In the top-left corner of the image, you can see the edge of the softbox we're posing her against, and obviously we don't want that in the shot. So, go to the toolbar, get the Spot Removal tool again, and paint over that area to remove it (that's making great use of the new Healing Brush feature added in Lightroom 5). While you're there, you can see some wrinkles in the diffusion panel, so go ahead and paint over those to get rid of them, as well (that'll take you a couple of minutes because there are plenty of them, but hey, at least you can do it now right in Lightroom, eh?). Also, don't forget to apply these quick retouches to the other two images you're sending to your client for proofing.

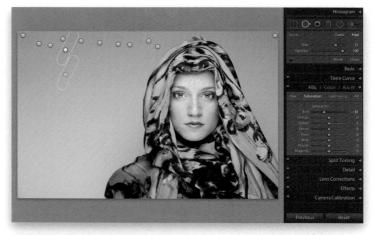

At this point, I want to get the proofs to the client as quickly and easily as possible, and for a small number of images like this, that means emailing them directly from Lightroom straight to the client. If I had a large number of images to send (15, 20, or more), at that point I'd create a web proofing page, and you can find out how to do exactly that in the bonus web chapter I included on this book's companion webpage (the address is in the intro of this book).

Workflow Step Five: Emailing Your Clients the Proofs

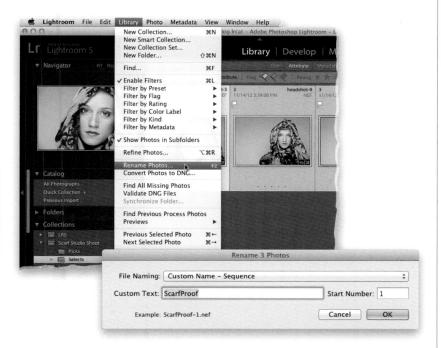

Step One:

Press **G** to jump back to the Grid view and click on your Selects collection. Select the three images you just gave the quick retouch to, as they're the one's we're going to send to the client. Now, go under the Library menu and choose **Rename Photos** (as shown here). When the Rename Photos dialog appears, change the name to something simple the client will be able to work with (I use the person's name or something specific to the shoot, then Proof, then a sequential number, so in this case, all the images will be renamed ScarfProof-1, ScarfProof-2, and so on).

Step Two:

Now, while your three Selects are still selected, go under the File menu and choose **Email Photos** (as shown here), although the keyboard shortcut for emailing from Lightroom 5 is really easy to remember—it's **Command-Shift-M** (**PC: Ctrl-Shift-M**).

Step Three:

This brings up Lightroom's email message dialog (shown here), where you enter your client's email address, the subject line of your email, and so on (more on emailing back on page 292). The one thing I do want to point out is the size you'll be sending these. You might want to send very small proofs if you're concerned about the client using the images before they're finished (or before you've been paid), in which case, not only should you send a smaller size (choose Small from the Preset pop-up menu in the bottom-left corner), but you also might want to add a visible watermark (see page 288 for how to do that). Once you've added your client's address, just click the Send button in the lower-right corner.

Step Four:

This opens your email application, creates a blank email, fills in all the info you just added, and attaches your photos. If you take a look here, I sent pretty decent-sized proofs to the client. I left the preset set to Large, so the long edge is 800 pixels long, and the quality was set to High, but even at that, these three JPEG files combined only added up to 616 KB. So, you can see that you could actually send quite a few via email (if each one is approximately just 205 KB in file size, with these settings, you could send around 25 JPEG proofs like this via email and still be under even the most conservative email attachment limit of 5 MB). Hit the Send button and off they go to the client. Now, we just keep our fingers crossed and hope they like 'em (don't worry, they'll like 'em).

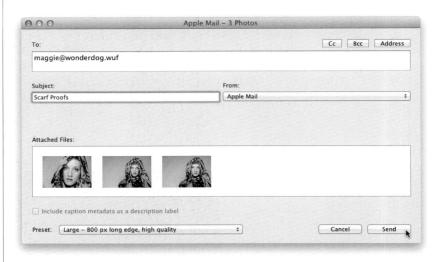

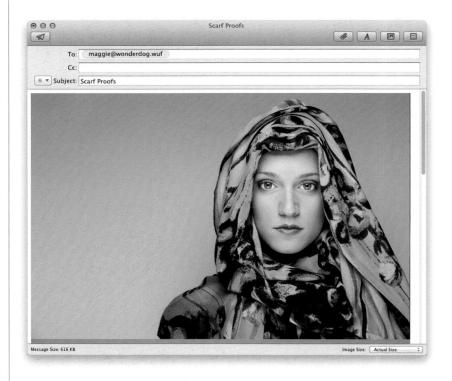

Once the client gets back to me with their pick(s), then I start working on the final image(s)—first in Lightroom, and then, if necessary, I jump over to Photoshop. In this case, since we'll be doing some more involved portrait retouching, we'll jump over to Photoshop for that stuff, but the process always starts here in Lightroom.

Workflow Step Six: Making the Final Tweaks & Working with Photoshop

Step One:

Once the client emails me their pick(s), I go back to the Selects collection in the Library module and I label it as Red by pressing the number **6** on my keyboard (I don't usually do this, but you could even make a separate collection with just their final picks and name it "Client Selects," but that's totally up to you). In this case, the client only chose one shot (which I marked with a Red label, as seen here).

Step Two:

Let's go ahead and crop the image here in Lightroom before heading over to Photoshop. So, go to the Develop module and click on the Crop Overlay tool in the toolbar. Click-and-drag in the corners of the cropping border until you have the nice tight crop you see here. Once you're done, hit **Return** (**PC: Enter**) to lock in your crop.

Step Three:

Now, let's head over to Photoshop. Press Command-E (PC: Ctrl-E) and in a few moments, your image will appear in Photoshop (as shown here). Of course, that's providing you have Photoshop (if you're using Photoshop Elements instead, it will open in Elements). We're going to make a few final retouches here for things we can't do in Lightroom—like fixing facial symmetry (getting the facial features to line up perfectly). For example, her eye and eyebrow on the right are lower than on the left (I dragged out some guides here, so you can see more easily). Same thing with her lips—the right side is lower than the left, so it doesn't look symmetrical. We're going to quickly fix both of those here in Photoshop, so let's zoom in tight on our image (press Command-+ [PC: Ctrl-+1 a couple of times to zoom in like vou see here).

Step Four:

We're going to put a selection around her eye and eyebrow, soften the edges, put them up on their own layer, and then literally nudge that area up 1/8" until the two eyes are perfectly in line. So, start by getting the Lasso tool (L) and make a selection all the way around her eye and eyebrow on the right, like you see here. Now, to soften the edges of our selected area (and to hide the fact that we did a retouch), go under the Select menu, under Modify, and choose **Feather**. When the Feather Selection dialog appears (shown here), enter 10 pixels (for a nice smooth edge transition), and click OK.

Step Five:

Now, press Command-J (PC: Ctrl-J) to put your selected area up on a separate layer. All you have to do now is switch to the Move tool (V) and use the Up Arrow **key** to nudge this whole area up a few pixels until the eyes on both sides look aligned (here, I pressed it 10 times). Why don't we see any hard lines or obvious edges from that area we selected? It's because we added that 10-pixel feather, which hides the hard edge by making it a smooth transition. Now, on to fixing the lips. We're actually going to do two quick fixes to her lips: we're going to lower the left side of her top lip, so it matches the right, and we're going to flatten out and extend the far-right corner of her mouth (where her lips meet), so it better matches the left side. But, before we do this, press Command-E (PC: Ctrl-E) to merge your layers.

Step Six:

Go under the Filter menu and choose **Liquify**, which brings up the Liquify dialog you see here. Zoom in tight on the lips (use the same keyboard shortcuts for zooming in we talked about a few steps ago), and then click on the first tool in the toolbox along the top left (it's called the Forward Warp tool). This tool moves your image around like it's made of a thick liquid (like molasses). Resize the brush, so it's a little bit bigger than the part of the lip you want to move (you can resize your brush using the Left and Right Bracket keys on your keyboard—they're just to the right of the letter P). Then, put the brush over the left side of her top lip (as shown here), click, and gently nudge it down until it lines up with the right side. Amazingly easy, right? Now, take the same tool, go over to the right corner of her mouth, and gently nudge it out so it's longer, and then push it up a bit so it looks flat like the left side. You might even push up the right side of her bottom lip, just to the right of center, a tiny bit.

The Adobe Photoshop Lightroom 5 Book for Digital Photographers

Step Seven:

Her nose certainly isn't big, but we're going to make it just a bit smaller using a tool that works perfectly for this type of retouch. It's called the Pucker tool and it shrinks whatever you click it on (or clickand-hold it over). So, switch to the Pucker tool (it's the third tool down in the toolbox) and click it a few times right over the main part of her nose (maybe five or six times), then move upward, over the bridge of her nose, and click three or four times. Lastly, click on each nostril two or three times (the reason I click these different areas, rather than using one big brush, is that I want to make sure all I affect is her nose, and not any surrounding areas. With too a big a brush, you'll pucker other areas). When you're done, click OK to apply your retouches.

Step Eight:

We can do our overall sharpening back over in Lightroom when we're done here in Photoshop, but while we're here, we can take advantage of a tool that lets us sharpen just one area and it does it using the most advanced sharpening algorithm in all of Photoshop—it's the Sharpen tool (Adobe updated the math for this tool back in Photoshop CS5 by adding a Protect Detail checkbox, which is on by default, and it's fantastic for things like sharpening eyes). So, zoom in really tight, get the Sharpen tool from the Toolbox (it's nested beneath the Blur tool), and make sure the Protect Detail checkbox is turned on in the Options Bar. Now, paint in a circular motion around her irises a few times and, man, it really makes those eye sparkle!

Step Nine:

The last thing I would do here in Photoshop is check over the image to see if you've missed any blemishes or stray hairs, and remove them with the Healing Brush tool (press **Shift-J** until you have it; it works similarly to the way the Spot Removal tool now works in Lightroom 5). Once all your retouching in Photoshop is done, you have two steps left: (1) Save the image by pressing **Command-S (PC: Ctrl-S)**. Don't rename it. Don't choose a new place to save it. Don't choose Save As. Just a simple Command-S is all you need. And, (2) close the image.

Before

After

Step 10:

That's it—do just those two things, and the edited image will appear in Lightroom right beside the original unedited image with "-Edit" at the end of its filename (as seen here). Below, I've put the two images side by side, so you can see a before and after. This isn't one of those hit-you-between-the-eyes type of retouches—it's all subtle stuff, and the end result is subtle too, but that's the idea.

By the way, if you'd like to see a little behind-the-scenes video of this shoot, Adobe did a Customer Story about me and my company. They taped part of it during the shoot for the photo you see here (which became the cover shot for this book). I talk a lot about Photoshop, but you see me using Lightroom, and I'm shooting tethered into Lightroom, as well. Here's the link to the video from Adobe: http://adobe.ly/13huxZT.

Workflow Step Seven: Delivering the Finished Image(s)

Once your image(s) has been retouched, it's time to deliver the final image(s) to the client, either via email or by delivering prints. The email part is the same as the emailing proofs part, so I won't put you through that again, but I do want to take you through making a print for the client.

Step One:

Click on the image you've fully retouched, then go to the Print module and, in the Template Browser, click on whichever template you want to use (I chose the Fine Art Mat template for the image you see here). The default page setup for this template is US Letter (8x11"), so if you need a different size, click the Page Setup button (at the bottom of the left side Panels area) and choose your size there. When the dialog appears, choose the printer, paper size, and orientation, then click OK to apply these settings. You might need to tweak the margins a bit after choosing a new page size, since it doesn't automatically adjust everything.

Step Two:

Now it's time to print the image (this is covered in-depth starting back on page 442 in Chapter 13). Scroll down to the Print Job panel (in the right side Panels area), and from the Print To pop-up menu at the top, choose **Printer**. Then, for Print Resolution, since I'm printing to a color inkjet printer, I can leave it at 240 ppi. Make sure the Print Sharpening checkbox is turned on, choose the amount of sharpening from the pop-up menu on the right (I generally choose High), and then choose the type of paper you'll be printing on from the Media Type pop-up menu (I chose Glossy here). If your printer supports 16-bit printing, then you can turn on the 16 Bit Output checkbox. Then, in the Color Management section, choose your Profile and set your rendering Intent (again, covered in Chapter 13). I chose Relative here.

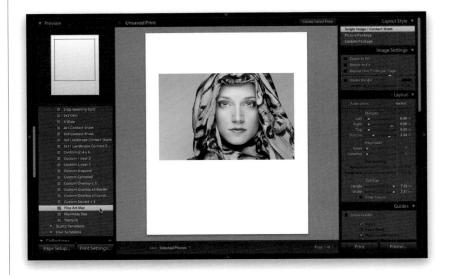

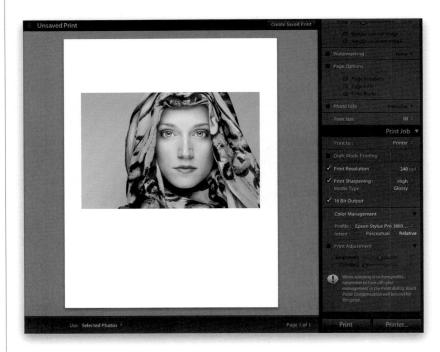

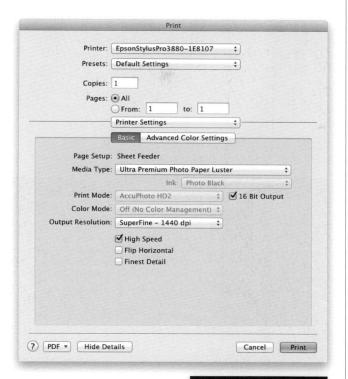

Develop

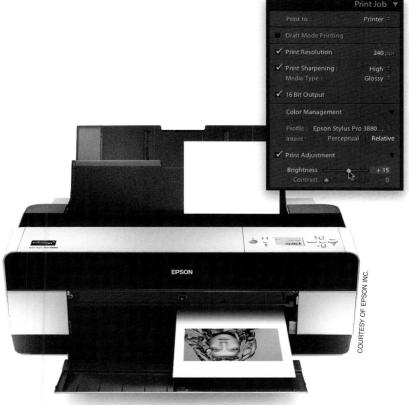

Step Three:

Now, click the Printer button at the bottom of the right side Panels area. and the Print dialog appears (the one shown here is from a Mac, but the Windows print dialog has the same basic features, just in a different layout). Your options will vary depending on your printer, but you'll want to choose the type of paper you're printing to from the Media Type pop-up menu, then under Output Resolution, I use Super-Fine-1440dpi with the High Speed checkbox turned on.

Step Four:

Let's print a proof: click the Print button, sit back, and wait for that puppy to roll out of the printer. Chances are your print is going to be darker than what you see on your super-bright, backlit computer screen. If so, turn on the Print Adjustment checkbox (at the bottom of the Print Job panel) and drag the Brightness slider to the right a bit, and then make another test print to compare to your screen. It might take a couple of test prints to get it right, but once you know how much brighter to make it, remember that setting for other prints on the same type of paper (you can adjust the contrast the same way). However, if there's a color problem, like the image looks too red, or too blue, etc., then you'll need to jump back to the Develop module, go to the HSL panel, and lower the Saturation for that color, then make another test print. There you have it: my workflow, from beginning to end. Remember, this workflow stuff is at the very end of the book for a reason: because it only makes sense after you've read the rest of the book. So, if anything didn't make sense, make sure you go back and reference the page numbers I gave you here, so you can learn about anything you might have skipped over or didn't think you'd need.

10 Important Bits of Advice for New Lightroom Users

Here are 10 things I wish somebody had told me when I first started using Lightroom. Of course, at this point, you might be wondering why I'm giving you this important advice this late in the book. It's because if you are a new Lightroom user, you needed to learn some of these Lightroom terms, features, and concepts first, so this advice would actually make sense. If you're reading this and thinking, "But Scott, I already knew these terms and features!" then you're probably not a beginner, now, are you? :) Anyway, here they are (in no particular order):

(1) Store all your photos inside one main folder.

You can have as many subfolders inside that one main folder as you want, but if you want to have peace, calm, and order in your Lightroom workflow, the key is not to import photos from all different locations on your computer (or on an external hard drive). Choose one main folder (like your Pictures folder on a Mac, or your My Pictures folder on a Windows PC), and put all your folders of photos inside that one main folder. Then, import them into Lightroom (or if you're importing from a memory card, have those images copied from the card into a folder within your main folder). Plus, this makes backing up your image library a breeze. Every time I run into someone whose Lightroom life is a mess, it's because they didn't follow this one simple rule. Also, if you're working on a laptop, it's totally fine to store your photos on an external drive, rather than on your laptop ('cause your laptop's drive is going to get full really quickly)!

(2) Use solo mode to make navigation easier and to cut clutter.

If you're tired of scrolling up and down the long list of open panels in Lightroom, I highly recommend turning on Solo Mode. That way, the only panel you'll see is the one you're working in (and the rest all automatically collapse). This not only cuts clutter, but it saves time and makes it easier to focus on just what you're working with. Turn this on by Right-clicking on the title of any panel and choosing **Solo Mode**. You will so love working like this.

Develop

(3) Use collections instead of folders. Folders are where all the actual photos you imported from a particular shoot are stored on your computer, or on an external hard drive. But once we import all those photos, all most of us really care about are the good ones, and that's why collections were invented. My buddy (and Lightroom expert) Matt Kloskowski and I always joke that "folders are where we go when we want to see our bad shots from a shoot," because we put all our good shots—our "keepers"—in a collection right away. It's kind of like we used to do with traditional film—we printed the good ones and put them in a photo album, and we kept the rest in the processing sleeve we got from the lab. Collections are like photo albums (in fact, I wish they had just called them albums). Plus, collections are safer because they'll help keep you from accidentally erasing images from your computer or hard drive.

(4) Do as much work in Lightroom as possible.

I do about 85% of my work in Lightroom itself, and I only go over to Photoshop to do something that Lightroom just can't do (like compositing images with layers, or creating professional-level type, or using the Pen tool, or advanced portrait retouching, etc.). You can do an amazing amount of your everyday work within Lightroom's Develop module (especially since the addition of a regular "Healing Brush" in Lightroom 5). So, take the time to learn these tools, and you will speed your workflow (and simplify your life) in ways you can't imagine, by staying in Lightroom as much as possible.

(5) Want to work really fast? Create presets and templates. The key to working efficiently in Lightroom is to make presets and templates for the things you do every day (even though a lot of users never take the few seconds it takes to create even one). If you find yourself making a particular edit more than just a couple of times, make a Develop module preset for it, so it's always just one click away. Have a printing setup you use pretty often? Save it as a printing template. How about when you're exporting files as JPEGs or TIFFs? Make an Export preset and save time. Or even an Import preset to save time there. The ability to make and use presets and templates is one of the big advantages of Lightroom, and once you start using them, your efficiency will go through the roof.

(6) Saving your images as JPEGs. I get asked this question again and again at my Lightroom seminars. It's because it's not totally obvious how to do it, because there is no "Save As" or even just a "Save" command under the File menu (like almost every other application on earth). If you do go under the File menu, you'll find four different Export commands, but none of them say "Export as JPEG," so again, it's not real obvious. However, you can just choose Export, and when the Export dialog appears, you'll have the option to save your selected image (or images) as a JPEG. By the way, since saving JPEGs is something you'll probably be doing a lot, you might as well create an Export preset, so you don't have to fill everything in every time. I'm just sayin'.

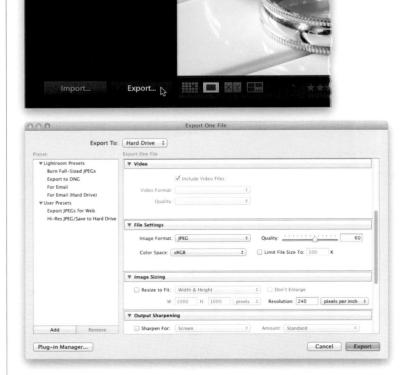

(7) Turn off Auto Hide & Show for panels.

I get more emails from new Lightroom users asking if there's a way to turn off this feature than you can shake a stick at. I have users literally begging me, "Please tell me there's a way to stop the panels from popping in and out on me all day long!"Thankfully, there is: Right-click on the little arrow on the center edge of each panel and a pop-up menu will appear, where you can just choose Manual and now the panels will only open when you actually click on that little arrow (or if you press the F-key keyboard shortcuts—F5 to show/hide the top Navigation panel; **F6** for the Filmstrip at the bottom; **F7** for the left side Panels area; and F8 for the right side Panels area—or if you press the **Tab key**, which will hide all the panels).

(8) Throw away your old backups. If you back up your catalogs on a regular basis (once a day or weekly), before long, you're going to have a whole bunch of backups stored on your computer. After a short while, if you've got a lot of photos, those old, outdated backups are going to start eating up a lot of space on your hard disk. So, go to your backups folder and delete the ones that are more than a couple of weeks old. After all, if your catalog got messed up, would you want to go back months in time, or to last week's backup? Right—those old ones are pretty much useless. Also, if you already back up your entire computer on a regular basis (like to the Cloud, or a wireless hard drive like Time Capsule, or Crash Plan, or whatever), you might not need to back up your catalog at all because you've already got a recent backup in those places.

(9) Stick with one single catalog as long as you can.

While you certainly can have multiple catalogs (it's a Lightroom feature), my advice to you would be to try to stick with just one single catalog as long as you possibly can. That's a long time these days, because Lightroom can now handle up to around 150,000 images with no problem (although, if things start to move slowly when you have over 100,000 or so images, make sure you run Optimize Catalog from the File menu). Having just one catalog will make your life so much easier, and you'll have all your images right in front of you without having to reload different catalogs to search through your personal image library. I hear the same advice from Adobe's Lightroom Product Manager, Tom Hogarty, when people ask him about multiple catalogs. His answer? Stick with one catalog. It's sage advice.

✓ Lightroom5.lrcat
Wedding Catalog.lrcat
Aston Martin Picks.lrcat
Lightroom 4 Catalog.lrcat
Family photos-2.lrcat
Studio Portraits Catalog.lrcat
Sports Catalog.lrcat

(10) Ask yourself if you really need to be adding keywords or not.

We were all originally taught to invest a reasonable amount of time adding global and specific keywords (search terms) to all the photos we import. If you're selling stock photography, or if you're a journalist, this is an absolute must, and if you have a client base that might call you up and ask, "Send me all your photos of red cars, and they need to all be in vertical orientation, and I only need ones where you can see the driver, and the driver has to be female," then you'll want to keyword like a pro. However, if you're just keeping track of the photos from your vacation to Paris last year, you might not need to go through all your photos and assign keywords. Ask yourself this question: "When was the last time I couldn't find the photos I needed by just going to my Collections panel?" For example, if I needed to find my photos from a family trip I took to Italy two years ago, I'd just go to my Collections panel, look under 2011, under Travel, and scroll down to Italy. If I went to Italy twice, I'd see two collections: one called "Italy" and one called "Italy 2." How hard is that? It's a no-brainer, right? So, if you're not having problems getting your hands on the photos you need in just a few seconds using collections with simple descriptive names (like Italy), you might be able to skip all the keywording stuff altogether (like I usually do). I'm not telling you not to keyword— I'm just asking you to consider whether you really need to spend the time adding a bunch of keywords or not, because most users probably don't need many (or any).

Want to Learn More?

If this way of learning Lightroom resonated with you, and now you want to learn more about Photoshop, or Elements, or even just how to take better photos, I've got you totally covered! Here's a little bit about some of the other books that I've written, using the same style and feel that I've written this book in (since that's the only style I know).

The Adobe Photoshop Book for Digital Photographers

This is pretty much the book that started it all for me, and the current edition covers both Photoshop CS6 and the Creative Cloud version of Photoshop (the book is actually based on CS6, but I added a large chapter that covers just the new Creative Cloud features for photographers). So, whether you have CS6 or the Cloud version, you're covered (the interface and layout are the same for both). It has the exact same layout, look, and feel as this book (since this book's layout, look, and feel was based on this Photoshop book). I think you'll dig it (I also have a version of this exact book for Elements users called The Photoshop Elements Book for Digital Photographers). It's published by New Riders Press.

Professional Portrait Retouching Techniques for Photographers Using Photoshop

It's my highest-rated book ever and it has become the retouching bible for a lot of photographers. I laid out the book based on the type of retouch. So, there's an entire chapter on retouching skin, one on retouching hair, one on retouching eyes (that chapter is 84 pages all by itself, and it covers everything you're likely to run into when retouching eyes), plus many more. (My only hope is that you never photograph anyone where you need all 84 pages of eye retouching. Kidding. I hope.) I also included three different start-to-finish projects (and you get all the files to practice along with)—a 5-minute, a 15-minute, and a 30-minute retouch—plus a really helpful list of what to retouch in the first place. It's published by New Riders Press.

Light It, Shoot It, Retouch It: Learn Step by Step How to Go from Empty Studio to Finished Image I have about every book on lighting out there, and I think the reason there are so many is because it's hard to really figure out where to put the lights, and why. So, with this book, I set out to do something different. There aren't any sketches or 3D models—you see the real lighting layout in a full-page photo, taken from above during the live shoot, so you can see exactly where everything's positioned (the subject, the photographer, the lighting, the background—you name it—you see it all). Plus, you'll see side, over-the-shoulder, and more behind-the-scenes views, so you can absolutely nail the lighting every time. I show all the camera settings, power settings, list each piece of gear, and then I take you through the entire start-to-finish retouch using Lightroom and Photoshop, so you see it, and learn it all. It has been translated into a bunch of different languages and I've heard from readers all over the world who tell me they're finally "getting

The Digital Photography Book, Parts 1, 2, 3 & 4

lighting." It's published by New Riders Press.

Man, am I ever glad I wrote these books. The first book, part 1, is the best-selling book on digital photography in history, and it spawned parts 2, 3, and 4 (each one picks up where the last left off). I think these books have been such a success because: (1) Each page covers only one single topic. It's just one picture, and then a paragraph that describes that one topic—short and sweet—and the chapters cover everything from how to get sharp photos to how the pros shoot everything from weddings to portraits to sports. And, (2) I leave out all the technical jargon and explain everything just like you and I are out shooting together. I give you the same plain-English explanations I would give a friend, and readers tell me that's exactly how they feel reading the books. I hope you will, too! The series is published by Peachpit Press. Hope you'll check 'em out.

(apostrophe) key, 230, 232 \ (backslash) key, 182, 188, 207 [] (bracket) keys, 213, 220, 233 1:1 previews, 11, 53 16-bit printing, 444, 458 18% gray card, 147–148 100% view, 10, 44, 136

Α

AAC file format, 394 A/B brushes, 214, 232, 233 about this book, xii–xiii actions (Photoshop), 318–323 droplets and, 321–323 recording, 318–320 testing, 320

Actions panel (Photoshop), 318, 320 Address Book for email, 302

Adjustment Brush, 210-225

Auto Mask feature, 213-214, 220, 233

Auto Show option, 276 brush options, 214, 232

Clarity adjustments, 212

creative effects using, 220–221

deleting adjustments in, 233

duotone effect and, 182–183

Edit Pins, 211, 212, 215, 217, 224, 232

Effect pop-up menu, 210, 220, 221, 224, 233

how it works, 210-216

interactive adjustments, 215

mask overlay preview, 214, 232

noise reduction using, 219

resetting, 233

resizing, 213, 214

retouching with, 224-225, 495

Saturation adjustments, 201–202, 220

Shadows adjustment, 213, 219

tips on using, 217, 232-233

white balance fix, 218

Adobe Photoshop. See Photoshop

Adobe Photoshop Book for Digital Photographers,

The (Kelby), 512

Adobe Photoshop Elements, 51, 500

Adobe Photoshop Lightroom. See Lightroom

Adobe Premiere Pro, 23

Adobe RGB color space, 201, 335

Adobe Standard profile, 186

After Export pop-up menu, 285, 322, 323

Amount slider

Adjustment Brush, 217

Detail panel, 269

Lens Corrections panel, 170, 267

Angle slider, 247

Apply During Import panel, 13-14, 19, 40

Arrow keys, 70

As Shot white balance, 145, 146

Aspect pop-up menu, 244

aspect ratios, 244, 277

Aspect Ratios overlay, 277

Aspect slider, 263, 264, 265

attributes

searching photos by, 101

sorting photos by, 63, 67, 71, 493

viewing common, 137

Audio Balance slider, 383

Auto Advance option, 53, 117

Auto button, Basic panel, 149, 154

Auto Dismiss checkbox, 146

Auto Hide & Show feature, 43, 115, 509

Auto Import feature, 335

Auto Layout panel, 340-341, 368

Auto Mask feature, 213-214, 220, 233

Auto Sync feature, 193, 407

Auto Tone feature, 154

Auto white balance, 143

Auto-Align Layers dialog, 332

automatic page numbering, 356

Auto-Stack feature, 79

Auto-Tag Selected Photos option, 98

В

B&W panel

automatic conversions, 176

Targeted Adjustment tool, 179

Back Up Catalog dialog, 109

Backdrop panel, 379, 384, 386, 388

Background layer

deleting, 28, 29

duplicating, 319

Background panel, 347-348, 365

backgrounds

book, 347-348

photos as, 384-389, 439-441

print, 417, 439-441, 458

slide show, 379-380, 384-389

Soft Proofing mode, 200

backing up	Book module
catalog database, 109–110	Auto Layout panel, 340–341, 368
deleting old backups, 137, 509	Background panel, 347–348, 365
improved features for, 52	Book Settings panel, 340, 350, 359
photos during import, 12, 51	Cell panel, 346, 360
presets, 117	Guides panel, 350
workflow for, 491	Page panel, 341, 356
backlit photos, 236-237	Preferences dialog, 338–339
backscreened effect, 384-385, 439-441	Text panel, 352, 355, 363
badges , thumbnail, 99, 123, 137	Type panel, 353–354, 357, 364
Balance slider, 181	books, 337–369
Basic panel, 142–160	adding pages to, 341, 368
Auto Tone feature, 154	Auto Layout for, 340–341, 368
B&W conversions, 177–178	backgrounds for, 347–348
Blacks slider, 158, 177, 237	Blurb service for, 351, 359, 369
Clarity slider, 159, 173, 178	captions for, 343, 352-355, 369
Contrast slider, 152, 161, 173	cover text for, 363–365
Exposure slider, 149, 150–152, 153, 156	creating new, 340–351
features overview, 149	custom layouts for, 360–362, 366–367, 369
Highlights slider, 157, 173	dust jacket option for, 359
Histogram panel, 153	editing images in, 368
Saturation slider, 160	guides used for, 350
Shadows slider, 149, 153, 157, 173, 236–237	keyboard shortcuts for, 368
Temp and Tint sliders, 144	killer tips on, 368–369
Vibrance slider, 160, 174	layout templates for, 358–359
white balance controls, 142–146	money-saving options for, 359, 369
Whites slider, 158, 177	numbering pages in, 356–357, 369
before-and-after views, 188	page layout for, 344–346
black-and-white conversions and, 182	preferences for, 338–339
selecting from History panel, 207	presets for, 341–342, 355
black point, 158	Print module layouts, 366–367
black-and-white conversions, 176–181	printing, 350–351, 368
auto conversion, 176	removing images from, 346, 348
backscreened effect and, 440	resolution warning, 345, 346
before-and-after views of, 182	saving layouts for, 351
do-it-yourself method, 177–179	sizes and types of, 339
duotones created from, 180, 182–183	sorting pages in, 349, 359, 368
presets for, 178, 477	spine color for, 365
	text added to, 352–355, 363–365
selecting images for, 178 split-tone effect and, 181	two-page spreads for, 348–349
	view modes for, 344, 368
tips on working with, 182, 183	zooming in/out of, 368
virtual copies for, 176, 182	_
blackout mode, 46–47	borderless prints, 462, 470 borders
Blacks slider, 149, 153, 158, 177, 237	
Bleach Bypass preset, 195	cell, 421, 429
blemish removal, 222, 495, 503	frame, 386, 389, 455–457
Blue channel adjustments, 166, 167	bracketed photos, 329, 331
blur effect, 233, 319	Brightness slider, 451–452
Blurb books, 351, 359, 369	

brushes	Checked State option, 7
flow controls, 232	chromatic aberrations, 273
size adjustments, 213, 214, 220, 232	circles, creating, 228
softness adjustments, 233	Clarity adjustments
Build Smart Previews checkbox, 16	Adjustment Brush, 212
	Basic panel, 159, 173, 178
C	Classic Black and White Tint preset, 477
	Clear Layout button, 426, 427
calibrating monitors, 445, 450	clipping warning, 155, 156, 182
Camera Calibration panel, 186–187, 274–275	Clone option, 250
Camera Landscape profile, 187	Clone Stamp tool (Photoshop), 327
Camera Standard profile, 186	Cloudy white balance, 143
Camera Vivid profile, 187	collapsing stacks, 77, 78
cameras	collection sets, 72–73, 492
default settings for, 207	collections, 63
fixing problems caused by, 273, 274–275	adding photos to, 115
importing photos from, 5–15	creating, 63–64, 68, 494
metadata embedded by, 89–90	deleting, 115
profiles for, 186–187, 206–207	exporting as catalogs, 106–108
searching photos by, 102	finding photos in, 100
shooting tethered from, 24–27	folders vs., 507
canceling imports, 5	locating for photos, 116
Candidate images, 69–70	making in a set, 117
Canon cameras, 26	naming/renaming, 68, 115
captions	playlists compared to, 64
book, 343, 352-355, 369	print layouts and, 438
metadata as, 90, 369	Quick Collections, 80–81
capture sharpening, 268	
capture time, stacking images by, 79	removing Pick flags in, 65
Cast Shadow checkbox, 390	saving as favorites, 117
Catalog panel, 50, 81	sets of, 72–73, 492
Catalog Settings dialog, 11, 38, 91, 109	slide show, 372, 399
catalogs, 104–110	smart collections, 23, 74–75, 115
backing up, 109–110	sorting photos using, 63–65, 67–68
creating, 104–105	stacking images in, 76–79
exporting, 106–108, 302	target collections, 82–83
importing, 51	thumbnail badge for, 137
optimizing, 110	video clip, 23
repairing corrupt, 113	Collections panel
, 3 , .	Library module, 64, 68, 492
restoring, 110, 113–114 selecting, 105	Print module, 414, 438
	Slideshow module, 372, 376, 399
single vs. multiple, 50, 510	Color blend mode, 315
syncing, 106–108	color fringe, 273
Cell panel, Book module, 346, 360	color gamut warning, 201, 203
cells	color labels, 60, 71, 75, 102, 136
book layout, 346, 352, 360–361	color management, 445–447, 448
print layout, 415–417, 421, 426–427, 433–436	color noise, 238
view options for, 45, 122	color picker, 181, 232
Cells panel, Print module, 426, 428, 433–434, 436, 467	Color Priority style, 171
Channel pop-up menu, 162, 166, 167	• •

color profiles, 445–446	Create Print dialog, 438
color space settings, 303, 306, 335	Create Proof Copy button, 207
color tints, 180–181, 232	Create Smart Collection dialog, 74
Color Wash checkbox, 384	Create Snapshot command, 241
Colorize Red preset, 477	Create Virtual Copy command, 191
colors	creative effects, 220–221
adjusting individual, 168–169	Crop Frame tool, 244
camera calibration for, 274–275	Crop Overlay tool, 204, 242–244, 246, 247, 276, 277
desaturating, 201–203	cropping photos, 242–245
out-of-gamut, 201	aspect ratio for, 244
vibrance added to, 160	and canceling crops, 244
Colors panel, 133	grid overlay for, 242, 243, 246, 277
Common Attributes feature, 137	lens distortion fixes and, 258, 261–262
Compact Cells view, 122	Lights Out mode for, 245
Compare view, 69–71	locking in crops, 243, 244
comparing photos	panorama cropping, 326
Compare view for, 69–71	perspective fixes and, 261–262, 264
Survey view for, 65–66	post-crop vignettes and, 170, 171
completion sounds, 37	Upright feature and, 276–277
composited images, 307–317	workflow process and, 499
computers	curves control. See Tone Curve panel
external hard drives for, 2, 12	custom layouts
importing photos already on, 18–19	for photo books, 360–362, 366–367, 369
recovering from crashed, 114	for printing images, 426–429, 474
Constrain Crop checkbox, 258, 262, 264, 265, 276	for slide shows, 376–381
contact information, 41	Custom Paner Sizes dialog 366
contact sheets, 418–425, 443	Custom Paper Sizes dialog, 366
Content-Aware Fill, 326–327	custom vignettes, 228–231 Custom white balance, 143
contiguous photo selections, 7 contrast adjustments	customizing Lightroom, 119–137
Contrast slider, 152, 161, 173, 452	customizing Lightroom, 119–137
Tone Curve panel, 161–167, 183	_
Contrast slider	D
Basic panel, 149, 152, 161, 173	Darken slider, 254
Detail panel, 239	darkening individual areas, 215, 216, 226-227
Print Job panel, 452	database backups, 109-110
Convert Photo to DNG option, 52	Date Format pop-up menu, 9
Copy as DNG option, 7, 52	date information
Copy Settings dialog, 141, 189, 206	choosing format for, 9
copying-and-pasting settings, 189–190	file naming with, 33–34
copyright information, 13, 41, 90	organizing photos by, 51
correcting problem photos. See fixing problem photos	searching for photos by, 102
corrupt catalogs, 113, 114	smart collections using, 74
cover text for books, 363–365	Daylight white balance, 143
Create Collection dialog, 64, 68, 83	Defringe options, 273
Create Collection Set dialog, 72, 492	deleting
Create Droplet dialog, 321	adjustments, 233
Create Folder with New Catalog dialog, 104	Background layer, 28, 29
3	collections, 115

edit pins, 212	local adjustments, 209–233
file naming tokens, 32	multiple photo editing, 189–190, 193, 205
keywords, 87, 115	Noise Reduction feature, 238–239
metadata presets, 41	presets, 13, 194-197, 476-487
old backups, 137, 509	Radial Filter tool, 228–231
presets, 196	Red Eye Correction tool, 254
PSD files, 335	Reset button, 149, 178, 192, 196
rejected photos, 62, 493	Smart Previews and, 17
Smart Previews, 17	Soft Proofing mode, 200–203, 207
virtual copies, 192	Split Toning panel, 180–181
See also removing	Spot Removal tool, 222–223, 248–253
Density slider, 217	Tone Curve panel, 161–167, 439
desaturating colors, 201–203	Vibrance adjustments, 160, 174
Deselect command, 178	video clip workaround, 406–407
desktop computers	virtual copies, 191–192
importing photos already on, 18–19	white balance settings, 142–146
storing photos on, 2	See also Quick Develop panel
Destination Folders view, 8	Develop Settings pop-up menu, 13, 275
Destination panel, 8, 9, 14	digital cameras. See cameras
Detail panel	Digital Photography Book series (Kelby), 513
Noise Reduction sliders, 238-239	disclosure triangles, 57
portrait sharpening, 270–272	distortion, lens, 255-259
preview zoom options, 182, 268	Distortion slider, 258, 264, 265
sharpening sliders, 269–270	DNG format
spot removal using, 276	advantages of, 39
Detail slider, 239, 269	converting photos into, 7, 52
Develop module, 139–207	exporting files in, 280
Adjustment Brush, 210–225	metadata info and, 39, 91, 303
Auto Sync feature, 193	preference settings, 39
Auto Tone feature, 154	saving RAW files in, 294
Basic panel, 142–160	DNG Profile Editor, 187
before-and-after views, 188	dodging and burning, 210, 215, 216, 225
black-and-white conversions, 176–181	Doty, Kim, 371
Camera Calibration panel, 186–187, 274–275	doubling effects, 233
Clarity adjustments, 159, 173, 178	downloading
contrast adjustments, 161–165	Develop module presets, 197, 476
copying-and-pasting settings, 189–190	images for this book, xii
Crop Overlay tool, 204, 242–244, 246, 247	Draft Mode Printing option, 443, 453
Detail panel, 238–239, 268–272	dragging-and-dropping
Effects panel, 206	keywords, 87
exposure adjustments, 150–158	photos, 50, 57
Graduated Filter tool, 226–227	drop shadows, 290, 379-380, 390
high-contrast effect, 173–175	droplets (Photoshop), 321-323
Histogram panel, 153	Dual Display feature, 127–130
History panel, 207, 240–241	duotone effect, 180–181, 182–183
HSL panel, 168–169, 202–203	duplicate photos, 12, 19, 50
killer tips on, 182–183, 206–207	
Lens Corrections panel, 170-172, 255-267, 273	

duplicating	emailing photos, 292-293, 302, 497-498
cells, 435	Embedded & Sidecar preview, 10, 53
layers, 311, 313	embedded metadata, 89-90
dust jacket for books, 359	Enable Identity Plate checkbox, 132, 135
dust spot removal, 248–250	end marks for panels, 137
	Ending Screen checkbox, 393
E	Erase button, 232
	Erase tool, 221, 224
edge vignetting	EXIF metadata, 89-90, 92, 255, 256
adding, 170–172, 174	Expanded Cells view, 122
fixing, 266–267	expanding stacks, 77, 78
Edit in Adobe Photoshop command, 307	Export Actions folder, 285, 323
Edit Metadata Presets dialog, 41	Export as Catalog dialog, 107
Edit Photo with Adobe Photoshop dialog, 308	Export dialog, 280-287, 322, 410
Edit Pins	exporting, 279–303
Adjustment Brush, 211, 212, 215, 217, 224	actions for, 323
Graduated Filter, 227	catalogs, 106–108, 302
Radial Filter, 230	emailing and, 292–293
shortcuts for working with, 232	images as JPEGs, 280–287, 508
Edit Smart Collection dialog, 75	keywords, 115
editing	killer tips on, 302–303
book images, 368	metadata with photos, 284
cheat sheet for, 149	naming/renaming files for, 282, 286
History feature for, 240–241	photos from Lightroom, 280-287
metadata presets, 41	plug-ins for, 297, 303
multiple photos, 189–190, 193, 205	presets for, 281, 285–287, 302, 323
offline images, 16–17	previous settings used for, 302
photos in Photoshop, 307–317, 335, 500–503 portrait workflow for, 495–496, 499–503	publishing and, 296–301, 303
smart collections, 75	quality settings for, 283
and undoing edits, 240–241	RAW photos, 294–295
Editing Cheat Sheet, 149	sharpening images for, 284, 303
Effect pop-up menu, 210, 220, 221, 224, 233	sizing images for, 283
effects	slide shows, 397–398
backscreened, 384–385, 439–441	smart collection settings, 115
blur, 233	video clips, 23, 282, 409–410
creative, 220–221	watermarking and, 284, 288–291
doubling, 233	exposure adjustments, 150–158
duotone, 182–183	Adjustment Brush and, 221, 224, 225
film grain, 206	Auto Tone feature and, 154
gradient filter, 226–227, 232	Blacks slider and, 158
high-contrast, 173–175	Contrast slider and, 152
skin softening, 224	Exposure slider and, 150–152, 153, 156
split-tone, 181	Graduated Filter and, 227
spotlight, 221, 229	Highlights slider and, 157
video, 411	Histogram panel and, 153
Effects panel, 206	Radial Filter tool, 229, 230, 231
ejecting memory cards, 53	Shadows slider and, 157
Elements, Photoshop, 51, 500	Whites slider and, 158

Library Develop Map Book Slideshow **Print** Web

Exposure slider metadata, 101-103 Adjustment Brush, 221, 224, 225 text search, 100 Basic panel, 149, 150-152, 153, 156 turning on/off, 116 Graduated Filter, 227 finding Radial Filter tool, 229, 230, 231 catalog files, 114 **External Editor options, 306** geographic locations, 95 external hard drives missing files/folders, 58, 111-112 photos by searching, 100-103 backing up photos to, 12, 51 Fit in Window view, 44 catalog backup to, 109 finding missing photos on, 111 fixing problem photos, 235-277 remaining space info for, 116 backlit subjects, 236-237 Smart Previews and, 16-17 camera calibration issues, 274-275 storing photos on, 2, 12 chromatic aberrations, 273 using multiple, 51 cropping images, 242-245 eye retouching, 224, 495, 500-501 dust spot removal, 248-250 eyedropper cursor, 232 edge vignetting, 266-267 Eyedropper tool (Photoshop), 313-314 killer tips about, 276-277 lens distortion problems, 255-259 noise reduction, 238-239 F perspective problems, 259, 261-265 Faces sharpening preset, 178, 272 red eye removal, 254 facial retouching, 222-225, 495-496, 500-503 retouching portraits, 222-225 Fall Foliage preset, 478 sharpening images, 268-272 favorites straightening images, 246-247 book layouts as, 358 undoing edits, 240-241 collections saved as, 117 unwanted object removal, 251-253 Feather Selection dialog (Photoshop), 500 flagging photos, 61-62, 116, 123 Feather slider, 172, 214 Flash white balance, 143 File Handling panel, 10-12, 19 Flatten Curve option, 183 file naming templates, 32-35 flattening images, 315, 320, 325, 333 File Renaming panel, 12, 32 Flickr website, 296-301, 303 Filename Template Editor, 32-35 Flow slider, 214 Fill Light slider, 236 Fluorescent white balance, 143 Filler Text for books, 339 folders Filler Text guide, 350 collections vs., 507 film grain effect, 206 creating, 14 **Filmstrip** dragging photos between, 57 customizing display of, 131 exporting as catalogs, 106 exporting photos from, 280 finding missing, 58, 111-112 filtering photos from, 63, 116 hiding unnecessary, 53 numbers above thumbnails in, 351 importing photos into, 8-9, 52 Previous button used in, 205 moving multiple, 58 shortcut for hiding, 43 naming/renaming, 9 slide show selections, 372 organizing photos in, 3-4, 9, 52 filters removing from Lightroom, 59 attribute, 63, 101, 493 for storing photos, 506 Filmstrip, 63, 116 subfolders in, 9 locking in, 117 synchronizing, 58-59 map location, 98 watched, 335

Folders panel, 56–59, 116	hard drives
Fotolia website, 386	storage space on, 2, 116
frame borders, 386, 389, 455-457	See also external hard drives
Full Upright correction, 265	hardcover books, 359, 365
full-screen slide show, 375, 398	Hawaii Five-O preset, 478
full-screen view, 48	Hazy Day preset, 481
	HDR images, 329–334
G	aligning layers for, 332
	bracketed exposures for, 329, 331
Game Day preset, 479	editing in Lightroom, 334
gamut warning, 201, 203	painting to reveal, 332–333
Gaussian Blur effect, 233, 319	Photomatix Pro for, 335
geographic locations, 95	presets for, 330, 480
global adjustments, 210	Heal option, 250
Google Maps, 94	Healing Brush tool (Photoshop), 503
GPS metadata, 92–99	hiding
embedded into photos, 92-93	clipping indicators, 182
map display of, 94–99	crop overlays, 277
thumbnail badge for, 99	Edit Pins, 232
tracklog of, 97–98	Filmstrip, 43
viewing data for, 99	folders, 53
Gradient tool (Photoshop), 314	panels, 42–43, 126
gradients, 226–227, 232	rule-of-thirds grid, 243
Graduated Filter tool, 226–227, 232	Tethered Capture window, 25
grain effects, 206	toolbar, 45, 47
graphics	unused modules, 137
Identity Plate, 134–135, 387, 389, 456	High Dynamic Range images. See HDR images
panel end mark, 137	high-contrast effect, 173-175
watermark, 290–291	Highlight Priority style, 171
gray card, 147–148	highlights
Green channel adjustments, 167	adjusting, 153, 155–157, 173
grid overlay	clipping warning for, 155, 156
image straightening, 258	split-tone effect, 181
non-printing, 49	Highlights slider, 149, 153, 157, 173
rule-of-thirds, 242, 243	histogram
Grid view, 45, 52, 122–125	exposure adjustments and, 153
guides	Soft Proofing mode and, 207
non-printing, 49	History panel, 207, 240-241
photo book, 350	horizon line, 261
viewing, 458	horizontal perspective fix, 259
Guides panel	HSL panel
Book module, 350	color gamut adjustments, 202–203
Print module, 321	individual color adjustments, 168–169
	Targeted Adjustment tool, 169, 202, 203, 496
H	HSL/Color/B&W panel, 168, 176, 183
halo prevention, 269	Hue sliders
Hang Ten preset, 479	Camera Calibration panel, 275
Hangover Movie Look preset, 479	HSL panel, 168, 203
J	Split Toning panel, 180, 181

I	Intro Screen checkbox, 392, 393
ICC color profiles, 445–446	Invert Mask checkbox, 230
Identity Plate Editor, 132–135, 378, 387, 392, 455	IPTC metadata, 41, 90
Identity Plates, 132–135	ISO information, 103
borders saved as, 457	iStockphoto website, 386, 387, 388
color background for, 472	
graphical, 134–135, 387, 389	J
printing, 424, 429, 430, 458	
rotating, 457	JPEGs
saving custom, 133, 135	camera profile for, 187
slide shows using, 378–379, 392–393	editing in Photoshop, 308
text for, 137, 378, 379, 392–393	exporting photos as, 280–287, 508
video tutorial on, xiii, 387, 456, 462	metadata embedded in, 90
image files for book, xii	printing to, 367, 453–454, 458
Image Overlay feature, 28–31	saving images as, 280–287, 508
Image Settings panel, 417, 419, 425, 432	tethered shots as, 26
Import button, 5, 15	white balance presets for, 206
Import from Catalog dialog, 108	
Import window, 5, 15, 18, 20, 50	K
importing photos, 2–53	kelbytraining.com website, xii
backup process, 12, 51	Keyword List panel, 86–87
canceling imports, 5	Keywording panel, 84–85
catalog synchronization, 108	keywords, 84–87
Develop settings for, 13	advice on choosing, 85
drag-and-drop for, 50	applying during import, 14
file handling options, 10–12, 19	assigning to images, 84–87, 115
folder organization for, 3–4, 9, 52	considering your need for, 511
Image Overlay feature, 28–31	creating sets of, 86
information displayed about, 53	dragging-and-dropping, 87
keyword assignments, 14	exporting, 115
killer tips about, 50–53	Painter tool, 85–86
located on your computer, 18–19	removing or deleting, 87, 115
metadata options, 13, 38, 40–41	smart collections using, 74
naming/renaming options, 12, 32–35	sub-keywords and, 87, 115
preference settings for, 36–38	suggested, 117
presets used for, 20–21	Kloskowski, Matt, 197, 204, 275, 461, 476, 507
previewing images before, 6, 8, 18	Kost, Julieanne, 366
rendering previews for, 10–11, 19, 53	11031, 24110411110, 300
selection process for, 7	ı
shooting tethered and, 24–27	L
Smart Preview creation and, 16–17	labels, color, 60, 71, 75, 102, 136
storage location for, 2, 8–9, 18	landscapes, sharpening, 178, 272
	laptop computers
viewing imported photos, 44–45	external hard drives for, 2
importing video clips, 22–23, 402	importing photos already on, 18–19
impromptu slide shows, 81, 375	Lasso tool (Photoshop), 500
info overlays, 120–121, 414	layers (Photoshop)
information resources, 512–513	duplicating, 311, 313
Inner Stroke checkbox, 433	flattening, 315, 320, 325, 333
Instagram Effect preset, 482	saving, 317
interactive adjustments, 215	

Layout Overlay feature, 28–31	stacking photos in, 76–79
Layout panel	Survey view, 65–67
Print module, 424, 425	viewing photos in, 44–45
Slideshow module, 377, 386	Library View Options dialog
Layout Style panel, 414, 426, 432	Grid view options, 122–125
layouts	Loupe View options, 120-121, 409
book, 358-362, 366-367	Light It, Shoot It, Retouch It (Kelby), 513
print, 414–438, 462–475	lightening individual areas, 215
slide show, 376–381	lightning bolt icon, 140
Lens Corrections panel, 255-267	Lightroom
chromatic aberration fixes, 273	advice for new users, 506–511
creating vignettes in, 170–172	background color options, 137
fixing vignettes in, 266-267	dual-monitor setup, 127–130
lens distortion fixes, 255–259	interface tips, 42–43
perspective fixes, 259, 261-265	Photoshop integration, 307–317, 500–503
Upright feature, 260–265, 276–277	process version updates, 140–141
lenses	Lightroom Instagram Effect preset, 482
chromatic aberrations from, 273	Lightroom Publishing Manager dialog, 296-297
correcting vignetting from, 266-267	LightroomKillerTips.com website, 275
EXIF metadata for, 255, 256	Lights Dim mode, 46
fixing distortion from, 255-259	Lights Out mode, 27, 46-47
profiles for, 255, 256–257	Compare view and, 69
searching photos by, 102	Crop Overlay tool and, 246
Level auto-correction, 261	Survey view and, 66
Library Filter, 63, 100–103, 117, 493	links
Library module, 55–117	folder, 58
catalogs, 104–110	panel, 136
collection sets, 72–73	photo, 111-112
collections, 63-65, 67-68, 72-75	Liquify filter (Photoshop), 501
Collections panel, 64, 68, 492	Load Tracklog option, 97
Compare view, 69–71	local adjustments, 209-233
database backup, 109–110	creative effects, 220–221
exporting photos from, 280	gradient filter effects, 226-227
Filmstrip, 63, 116, 131	how to make, 210–216
finding photos in, 100-103	noise reduction, 219
Folders panel, 56–59	portrait retouching, 222–225
GPS data in, 92–93	shadow lightening, 219
Grid view, 45, 52, 122–125	tips for making, 217, 232-233
keywords used in, 84–87	white balance fix, 218
killer tips about, 115–117	See also Adjustment Brush
Loupe view, 44, 45, 120–121	Locate photo dialog, 112
metadata options, 89–93	Location Filter, 98
Publish Services panel, 296, 298, 299, 300–301	Lock Zoom Position option, 277
Quick Collections, 80–81	logos, Identity Plate, 134–135
Quick Develop panel, 198–199, 405–406, 407, 408	Lomo Effect preset, 481
relinking missing photos in, 58, 111–112	Loupe view, 44, 45, 120–121, 136, 403
renaming photos in, 88	LRCAT files, 108, 110
smart collections, 74–75	luminance noise, 238, 239
sorting photos in, 60-71	

Luminance sliders	synchronizing, 116
Detail panel, 239	templates, 13, 40–41
HSL panel, 169	XMP sidecar files, 38, 39, 91
	Metadata panel, 89–90, 92
M	Midpoint slider, 170, 174, 267
	midtone adjustments
Magic Wand tool (Photoshop), 309, 326	Clarity slider and, 159
magnifying glass cursor, 45	Exposure slider and, 153
Make a Second Copy To checkbox, 12	Minimal preview, 10, 11, 53
Make Select button, 70	missing files/folders, 58, 111-112
Managed by Printer option, 445	Modify Page menu, 344
Map module, 94–99	modules
finding locations in, 95	hiding unused, 137
GPS-embedded images and, 94–95	navigating between, 42
Location Filter used in, 98	See also specific modules
map display options, 99	monitors
pin markers used in, 94–95, 99	calibration of, 445, 450
Saved Locations panel, 96	Dual Display feature, 127–130
tracklogs used in, 97–98	movie camera icon, 22
zooming locations in, 98	movies. See video clips
Map Style pop-up menu, 99	MP3 file format, 394
margins	Multi-Page View mode, 344, 349, 359, 368
print, 423, 458, 470	multi-photo print layouts, 462-475
slide show, 377	music in slide shows, 383, 394–395
Masking slider, 270, 271	My Lightroom Photos folder, 3–4, 9
Match Long Edges option, 358	My Pictures folder, 3, 506
Match Total Exposures option, 206	
Matte control, 31	N
McNally, Joe, 24	
measurement units, 458	naming/renaming
memory cards	collections, 68, 115
ejecting, 53	color labels, 136
importing photos from, 5-15	exported photos, 282, 286
numbering photos from multiple, 51	folders, 9
previewing photos on, 6, 8	imported photos, 12, 32, 50
menu bar, 47	photos in Lightroom, 88, 497
Merge to HDR Pro dialog, 329	Photoshop edited files, 335
message display options, 136	presets, 195
metadata	system for, 33–34
DNG file, 39, 91, 303	template for, 32–35
embedded, 89–90	Navigator panel
exporting with images, 284	history states in, 240
GPS data, 92–99	previewing presets in, 194, 197
lens info, 255, 256	viewing photos in, 44–45
preferences, 38	white balance adjustments and, 146
presets, 40–41, 90	New Action dialog (Photoshop), 318
printing photos with, 430	New Develop Preset dialog, 196, 275
RAW file, 38, 39, 91, 294, 295	New Metadata Preset dialog, 40
saving to a file, 38, 123	New Template dialog, 381, 437
searching photos by, 101–103	Nikon cameras, 26, 53

noise in images, 219, 236, 238	Р
Noise Reduction sliders, 238-239	Page Bleed guide, 350
Noise slider, Adjustment Brush, 219	Page Grid sliders, 421, 422
Noiseware plug-in, 276	page numbering, 356–357, 369
non-destructive edits, 408	Page panel
non-printing guides, 49	Book module, 341, 356
numbering	Print module, 425, 429, 430, 431
book pages, 356–357, 369	Page Setup dialog, 366, 414
photos, 34, 51	Paint Overlay style, 171
	Painter tool, 85–86, 117
0	panels
	end marks for, 137
Offset Time Zone dialog, 97	expanding all, 136
Opacity settings	hiding, 42–43, 126
background image, 385	linking, 136
composited image, 315	resizing, 115
drop shadow, 390	Solo mode, 126, 506
grid overlay, 49	See also specific panels
Identity Plate, 379	panoramas, 324–328
overlay image, 31	creating, 324–325
watermark, 289, 290	cropping edges of, 326
Optimize Catalog option, 110	editing in Lightroom, 328
Organize pop-up menu, 9 organizing photos	fake, in print layout, 424
collections for, 63–65, 67–68, 72–75	fixing gaps in, 326–327
date feature for, 51	testing, 302
folders for, 3–4, 9, 52, 56–59	paper selection options, 449
importing and, 9	Paper Size pop-up menu, 366
keywords for, 84–87	paper/printer profiles, 445–446
metadata info for, 89–93	Paste Settings command, 190
multiple catalogs for, 104–105	PDF slide shows, 398
Quick Collections for, 80–81	Perceptual rendering intent, 447
renaming process for, 88	perspective fixes
shooting tethered and, 25	horizontal perspective, 259
smart collections for, 74–75	vertical perspective, 261–265
stacks used for, 76–79	photo books. See books
See also sorting photos	Photo Cells guide, 350
organizing video clips, 23	Photo Text checkbox, 363
out-of-gamut warning, 201, 203	photography resources, 512-513
output sharpening, 284, 454	Photomatix Pro, 335
ovals for vignettes, 228–231	Photomerge feature, 302, 324–325
Overlay blend mode, 311	photo-sharing websites, 303
overlays	Photoshop
image overlays, 28–31	action creation, 318–320
non-printing grid/guide, 49	book resources about, 512
text/info overlays, 120–121, 376, 414	droplet creation/use, 321–323
Overlays panel, 376, 378, 379	edge border preparation, 455
5 terray 5 pariety 57 0, 57 0, 57 5	editing photos in, 307–317, 335, 500–503
	HDR image creation, 329–334, 335
	iumping to/from 307–317

killer tips on using, 335	built-in, 194–195
layout overlay preparation, 28–29	camera calibration, 275
naming photos edited in, 335	creating your own, 196–197
panorama creation, 324–328	deleting, 196
Photomerge feature, 302, 324–325	Develop module, 13, 194-197, 476-487
preparing files for, 306	downloading/importing, 197, 476
saving edits in, 316, 503	efficiency of using, 508
sharpening images in, 269, 319	email, 293
slide design in, 399	export, 281, 285-287, 302, 323
Photoshop Elements, 51, 500	file naming, 32–35, 88
Photoshop Elements Book for Digital Photographers,	HDR image, 330, 480
<i>The</i> (Kelby), 512	import, 15, 20-21
Photoshop Lightroom. See Lightroom	keyword, 86
Picks	metadata, 40–41, 90
collections from, 63-64, 494	previewing, 194, 197, 476
filtering, 63, 101, 116, 493	Quick Develop, 407–408
flagging photos as, 61-62, 67, 116, 123, 492	renaming, 195
removing flags from, 65	saving, 35, 196, 407
smart collections from, 75	search, 117
Picture Package feature, 432–436	sharing, 302
Pictures folder, 3, 506	sharpening, 178, 272
Play/Pause button, 23	updating, 206
Playback panel, 383, 394, 396	video clip, 407–408
playing	watermark, 291
slide shows, 375, 396	white balance, 142–143, 206
video clips, 403	Presets panel, 194, 196, 272, 476
playlists, 64	previews
Plug-in Manager, 303	1:1 (one-to-one), 11
plug-ins	B&W conversion, 178
export, 297, 303	imported photo, 6, 8
Noiseware, 276	mask overlay, 214
PNG file format, 28, 291	preset, 194, 197, 476
Point Curve button, 162, 163, 164	render options for, 10–11, 19, 53
Point Curve pop-up menu, 161, 163, 164	second monitor, 130
portraits	slide show, 374, 383, 399
retouching, 222–225, 495–496, 500–503	Smart, 16–17, 52, 303
sharpening, 178, 270–272	thumbnail, 6, 10–11
workflow for, 489-505	video clip, 23, 402
post-crop vignetting, 170, 171	zoom ratios for, 182
poster frames, 404	Previous button, 204–205
posters, multi-image, 425	Previous Import option, 50
Post-Processing options, 285	Previous/Next buttons, 70
Preferences dialog, 36–37	Print Adjustment sliders, 451-452
Premiere Pro, 23	Print dialog, 447-449, 505
presets	Print Job panel, 367, 442-447, 450-454
applying, 195	Print Adjustment option, 450–452
B&W conversion, 178, 477	Print To option, 367, 442, 453-454
backing up, 117	Print module, 414–458
Book module, 341–342, 355	book layouts, 366–367
brush, 233	Cells panel, 426, 428, 433-434, 436, 467

Image Settings panel, 417, 419, 425, 432 Layout panel, 424, 425 Layout Style panel, 414, 426, 432 Page panel, 425, 429, 430, 431 Page Setup dialog, 366, 414 Print Job panel, 367, 442–447, 450–454 Rulers, Grid & Guides panel, 427 Template Browser, 414, 418, 432, 437 print queue, 458 Print to File button, 454 printer/paper profiles, 445–446 printing, 413–458 16-bit, 444, 458 backgrounds for, 417, 458 backscreened effect, 439–441 books, 350–351, 368 collections for, 438 color profiles for, 445–446	Print module (continued)	proofing, soft, 200–203
Guides panel, 321 Image Settings panel, 417, 419, 425, 432 Layout panel, 424, 425 Layout Style panel, 414, 426, 432 Page panel, 425, 429, 430, 431 Page Setup dialog, 366, 414 Print Job panel, 367, 442–447, 450–454 Rulers, Grid & Guides panel, 427 Template Browser, 414, 418, 432, 437 print queue, 458 Print to File button, 454 printer/paper profiles, 445–446 printing, 413–458 16-bit, 444, 458 backgrounds for, 417, 458 backscreened effect, 439–441 books, 350–351, 368 collections for, 438 color profiles for, 445–446	Collections panel, 414, 438	ProPhoto RGB color space, 207, 306, 335
Image Settings panel, 417, 419, 425, 432 Layout panel, 424, 425 Layout Style panel, 414, 426, 432 Page panel, 425, 429, 430, 431 Page Setup dialog, 366, 414 Print Job panel, 367, 442–447, 450–454 Rulers, Grid & Guides panel, 427 Template Browser, 414, 418, 432, 437 print queue, 458 Print to File button, 454 printer/paper profiles, 445–446 printing, 413–458 16-bit, 444, 458 backgrounds for, 417, 458 backscreened effect, 439–441 books, 350–351, 368 collections for, 438 color profiles for, 445–446	Custom Package feature, 367	PSD files, 52, 90, 280, 306, 335
Layout panel, 424, 425 Layout Style panel, 414, 426, 432 Page panel, 425, 429, 430, 431 Page Setup dialog, 366, 414 Print Job panel, 367, 442–447, 450–454 Rulers, Grid & Guides panel, 427 Template Browser, 414, 418, 432, 437 print queue, 458 Print to File button, 454 printer/paper profiles, 445–446 printing, 413–458 16-bit, 444, 458 backgrounds for, 417, 458 backscreened effect, 439–441 books, 350–351, 368 collections for, 438 color profiles for, 445–446 Pucker tool (Photoshop), 502 punchy images, 159 Pupil Size slider, 254 Q Quality settings exported photo, 283 print, 449, 454 slide show, 398 video clip, 282, 410 Quality slider, 283 Quick Collections, 80–81, 123 Quick Develop panel, 198–199 presets saved to, 407–408 situations for using, 198–199 video clip options, 405–406, 408	Guides panel, 321	Publish Services panel, 296, 298, 299, 300-301
Layout Style panel, 414, 426, 432 Page panel, 425, 429, 430, 431 Page Setup dialog, 366, 414 Print Job panel, 367, 442–447, 450–454 Rulers, Grid & Guides panel, 427 Template Browser, 414, 418, 432, 437 print queue, 458 Print to File button, 454 printer/paper profiles, 445–446 printing, 413–458 backgrounds for, 417, 458 backscreened effect, 439–441 books, 350–351, 368 collections for, 438 color profiles for, 445–446 page Setup dialog, 366, 414 Pupil Size slider, 254 Q Q Quality settings exported photo, 283 print, 449, 454 slide show, 398 video clip, 282, 410 Quality slider, 283 Quick Collections, 80–81, 123 Quick Develop panel, 198–199 presets saved to, 407–408 situations for using, 198–199 video clip options, 405–406, 408	Image Settings panel, 417, 419, 425, 432	publishing photos, 296-301, 303
Page panel, 425, 429, 430, 431 Page Setup dialog, 366, 414 Print Job panel, 367, 442–447, 450–454 Rulers, Grid & Guides panel, 427 Template Browser, 414, 418, 432, 437 print queue, 458 Print to File button, 454 printer/paper profiles, 445–446 printing, 413–458 16-bit, 444, 458 backgrounds for, 417, 458 backscreened effect, 439–441 books, 350–351, 368 collections for, 438 color profiles for, 445–446 Pupil Size slider, 254 Q Q Quality settings exported photo, 283 print, 449, 454 slide show, 398 video clip, 282, 410 Quality slider, 283 Quick Collections, 80–81, 123 Quick Develop panel, 198–199 presets saved to, 407–408 situations for using, 198–199 video clip options, 405–406, 408	Layout panel, 424, 425	Pucker tool (Photoshop), 502
Page Setup dialog, 366, 414 Print Job panel, 367, 442–447, 450–454 Rulers, Grid & Guides panel, 427 Template Browser, 414, 418, 432, 437 print queue, 458 Print to File button, 454 printer/paper profiles, 445–446 printing, 413–458 16-bit, 444, 458 backgrounds for, 417, 458 backscreened effect, 439–441 books, 350–351, 368 collections for, 438 color profiles for, 445–446 Print Job panel, 367, 442–447 Quality settings exported photo, 283 print, 449, 454 slide show, 398 video clip, 282, 410 Quality slider, 283 Quick Collections, 80–81, 123 Quick Develop panel, 198–199 presets saved to, 407–408 situations for using, 198–199 video clip options, 405–406, 408		punchy images, 159
Print Job panel, 367, 442–447, 450–454 Rulers, Grid & Guides panel, 427 Template Browser, 414, 418, 432, 437 print queue, 458 Print to File button, 454 printer/paper profiles, 445–446 printing, 413–458 backgrounds for, 417, 458 backscreened effect, 439–441 books, 350–351, 368 collections for, 438 color profiles for, 445–446 Quality settings exported photo, 283 print, 449, 454 slide show, 398 video clip, 282, 410 Quality slider, 283 Quick Collections, 80–81, 123 Quick Develop panel, 198–199 presets saved to, 407–408 situations for using, 198–199 video clip options, 405–406, 408	Page panel, 425, 429, 430, 431	Pupil Size slider, 254
Rulers, Grid & Guides panel, 427 Template Browser, 414, 418, 432, 437 print queue, 458 Print to File button, 454 printer/paper profiles, 445–446 printing, 413–458 backgrounds for, 417, 458 backscreened effect, 439–441 books, 350–351, 368 collections for, 438 color profiles for, 445–446 Quality settings exported photo, 283 print, 449, 454 slide show, 398 video clip, 282, 410 Quality slider, 283 Quick Collections, 80–81, 123 Quick Develop panel, 198–199 presets saved to, 407–408 situations for using, 198–199 video clip options, 405–406, 408	Page Setup dialog, 366, 414	
Rulers, Grid & Guides panel, 427 Template Browser, 414, 418, 432, 437 print queue, 458 Print to File button, 454 printer/paper profiles, 445–446 printing, 413–458 16-bit, 444, 458 backgrounds for, 417, 458 backscreened effect, 439–441 books, 350–351, 368 collections for, 438 color profiles for, 445–446 Quality settings exported photo, 283 print, 449, 454 slide show, 398 video clip, 282, 410 Quality slider, 283 Quality slider, 283 Quality slider, 283 Quick Collections, 80–81, 123 Quick Develop panel, 198–199 presets saved to, 407–408 situations for using, 198–199 video clip options, 405–406, 408	Print Job panel, 367, 442–447, 450–454	\circ
print queue, 458 Print to File button, 454 printer/paper profiles, 445–446 printing, 413–458 backgrounds for, 417, 458 backscreened effect, 439–441 books, 350–351, 368 collections for, 438 color profiles for, 445–446 print to File button, 454 print, 449, 454 slide show, 398 video clip, 282, 410 Quality slider, 283 Quick Collections, 80–81, 123 Quick Develop panel, 198–199 presets saved to, 407–408 situations for using, 198–199 video clip options, 405–406, 408	Rulers, Grid & Guides panel, 427	
Print to File button, 454 printer/paper profiles, 445–446 printing, 413–458 16-bit, 444, 458 backgrounds for, 417, 458 backscreened effect, 439–441 books, 350–351, 368 collections for, 438 color profiles for, 445–446 print, 449, 454 slide show, 398 video clip, 282, 410 Quality slider, 283 Quick Collections, 80–81, 123 Quick Develop panel, 198–199 presets saved to, 407–408 situations for using, 198–199 video clip options, 405–406, 408	Template Browser, 414, 418, 432, 437	,
printer/paper profiles, 445–446 printing, 413–458 16-bit, 444, 458 backgrounds for, 417, 458 backscreened effect, 439–441 books, 350–351, 368 collections for, 438 color profiles for, 445–446 slide show, 398 video clip, 282, 410 Quality slider, 283 Quick Collections, 80–81, 123 Quick Develop panel, 198–199 presets saved to, 407–408 situations for using, 198–199 video clip options, 405–406, 408	print queue, 458	
printer/paper profiles, 443–446 printing, 413–458 16-bit, 444, 458 backgrounds for, 417, 458 backscreened effect, 439–441 books, 350–351, 368 collections for, 438 color profiles for, 445–446 video clip, 282, 410 Quality slider, 283 Quick Collections, 80–81, 123 Quick Develop panel, 198–199 presets saved to, 407–408 situations for using, 198–199 video clip options, 405–406, 408	Print to File button, 454	200 000 000 000 000 000
16-bit, 444, 458 backgrounds for, 417, 458 backscreened effect, 439–441 books, 350–351, 368 collections for, 438 color profiles for, 445–446 Quality slider, 283 Quick Collections, 80–81, 123 Quick Develop panel, 198–199 presets saved to, 407–408 situations for using, 198–199 video clip options, 405–406, 408	printer/paper profiles, 445–446	
backgrounds for, 417, 458 backscreened effect, 439–441 books, 350–351, 368 collections for, 438 color profiles for, 445–446 Quick Collections, 80–81, 123 Quick Develop panel, 198–199 presets saved to, 407–408 situations for using, 198–199 video clip options, 405–406, 408	printing, 413–458	
backgrounds fol, 417, 438 backscreened effect, 439–441 books, 350–351, 368 collections for, 438 color profiles for, 445–446 Quick Develop panel, 198–199 presets saved to, 407–408 situations for using, 198–199 video clip options, 405–406, 408	16-bit, 444, 458	
backscreened effect, 439–441 books, 350–351, 368 collections for, 438 color profiles for, 445–446 Quick Develop panel, 198–199 presets saved to, 407–408 situations for using, 198–199 video clip options, 405–406, 408	backgrounds for, 417, 458	
collections for, 438 situations for using, 198–199 color profiles for, 445–446 video clip options, 405–406, 408		
color profiles for, 445–446 video clip options, 405–406, 408	books, 350-351, 368	•
COIOI DIOIIIES IOI, 443–440	collections for, 438	-
C	color profiles for, 445–446	2 1
COHIGCE SHEELS, 4 10-423	contact sheets, 418–425	See also Develop module
custom layouts for, 426–429, 437, 474 Quick Selection tool (Photoshop), 308, 326	custom layouts for, 426–429, 437, 474	Quick Selection tool (Photoshop), 308, 326
draft mode option for, 443		
examples of layouts for, 462–475		R
frame borders for, 455–457 Radial Filter tool, 228–231		
gamut warning for, 201, 203 Radius slider, 269	gamut warning for, 201, 203	
Identity Plates, 424, 429, 430, 458 Range sliders, 165	Identity Plates, 424, 429, 430, 458	
individual photos, 414–417 Rating Footer, 125	individual photos, 414–417	-
to JPEG files, 367, 453–454, 458 rating rootel, 123		
killer tips on, 458 RAW photos	killer tips on, 458	
multiple photos per page, 418–425, 432–436 camera profiles for, 186–187	multiple photos per page, 418–425, 432–436	
Print Adjustment cliders for 451, 452		
quality settings for, 449, 454 converting to DNG format, 52 default tone curve for, 183		
resolution settings for 442, 452		
editing in rinotoshop, 500		
cotting options for 442, 452		
charponing photoc for 294 444 454		
templates for 414 418 420 427		
tout add of far 420, 421	·	
recording actions, 510–520		
Nectaligual Marquee tool (Flotoslop), 433		
ned Charmer adjustments, 107		
Ned Eye Correction 1001, 234		-
Using Photospan (Kalby) 512		
negion sinders, 104		
camora 196 197 206 207	The state of the second st	
long 255 254 257		
printer/paper, 445–446 flagging, 61–62, 492		11agging, 61–62, 492

Relative rendering intent, 447	Roundness setting, 172		
relinking	rule-of-thirds grid, 242, 243		
folders, 58	rulers, displaying, 458		
photos, 111–112	Rulers, Grid & Guides panel, 427		
removing			
book images, 346, 348	S		
facial blemishes, 222, 495, 503			
flags from Picks, 65	sampling image areas, 252–253		
folders from Lightroom, 59	Saturation sliders		
keywords from photos, 87, 115	Adjustment Brush, 201–202, 220		
photos from stacks, 78	Basic panel, 160		
red eye from photos, 254	Camera Calibration panel, 275		
slide show photos, 375	Graduated Filter, 227		
spots from photos, 248–250	HSL panel, 168–169, 202		
unwanted objects in photos, 251–253	Split Toning panel, 180, 181		
wrinkles from faces, 223	Saved Locations panel, 96		
See also deleting	saving		
Rename Files checkbox, 12, 32	book layouts, 351		
Rename Photos dialog, 88, 497	Identity Plates, 133, 135		
renaming. See naming/renaming	metadata to a file, 38, 123		
Render Behind Image checkbox, 389	photos as JPEGs, 280–287, 508		
Render Previews pop-up menu, 10–11, 19	Photoshop edits, 316, 503		
Rendering Intents	presets, 35, 196		
previewing images using, 202	print layouts, 437		
Print Job options for, 447	Quick Collections, 81		
Repair Catalog button, 113	templates, 35, 381		
Reset button, 149, 178, 192, 196, 233	See also exporting		
Resize to Fit checkbox, 283	Scale slider, 392, 393, 456		
resizing. See sizing/resizing	Scenic sharpening preset, 178, 272		
resolution settings, 306, 443, 453	scroll wheel tip, 232		
resources, photography, 512–513	scrubby slider, 399		
restoring catalogs, 110, 113–114	search presets, 117		
retouching photos	searching for photos, 100–103		
Adjustment Brush for, 224–225, 495	Second Window button, 127, 129		
portrait workflow for, 495–496, 499–503	Secondary Window pop-up menu, 128, 129, 130		
Spot Removal tool for, 222–223	Segment Photos By Shots feature, 24–25, 27		
See also fixing problem photos	Select Catalog dialog, 105		
RGB channel adjustments, 162, 166–167	Select images, 69–70		
RGB value readouts, 207	sets		
Rotate Cell button, 427	collection, 72–73		
Rotate slider, 258, 259, 262	keyword, 86		
Rotate to Fit checkbox, 419, 423, 427	Shade white balance, 143		
rotating	shadows		
Identity Plates, 457	duotone effect, 180		
images, 258, 259, 262, 417, 419	histogram showing, 153		
ovals for vignettes, 229	locally adjusting, 213, 219		
print layout cells, 427	noise in, 219, 236		
text, 379, 399	opening up detail in, 157		
Rounded Rectangle preset, 482	split-tone effect, 181		
nounded nectaligie preset, 402	See also drop shadows		

Shadows slider	full-screen, 375, 398			
Adjustment Brush, 213, 219	Identity Plates in, 378-379, 392-393			
Basic panel, 149, 153, 157, 173, 236–237	impromptu, 81, 375			
sharing	killer tips on, 399			
export presets, 302	music added to, 383, 394–395			
keywords, 115	ordering photos for, 373			
slide shows, 397–398	PDF format, 398			
smart collection settings, 115	Photoshop design of, 399			
Sharpen tool (Photoshop), 502	playing, 375, 396			
sharpening images, 268–272	previewing, 374, 383, 399			
B&W conversions and, 178	random order option, 374, 396			
exporting and, 284, 303	removing photos from, 375			
output sharpening, 284	resizing photos in, 377			
Photoshop used for, 269, 319	selecting photos for, 372			
portrait sharpening, 270–272	slide duration options, 396			
presets for, 178, 272	strokes used in, 390			
print settings for, 284, 444, 454	templates for, 374, 376, 381			
sliders for, 269–270	text used in, 376, 391–393			
Sharpness slider, 233	title slides for, 392–393, 399			
shooting tethered. See tethered shooting	transitions for, 396			
Shot Name dialog, 27	video clips in, 382–383			
Show Edit Pins pop-up menu, 224	video formats for, 397			
Show Fewer Options button, 21	watermarks in, 391			
Show Guides checkbox, 377, 379	sliders			
Show Image Info Tooltips checkbox, 122	process version and, 140–141			
Show Info Overlay checkbox, 120, 121, 414	resetting, 165, 182, 210, 233			
Show Loupe checkbox, 145	See also specific sliders			
Show More Options button, 21	Slideshow module, 371–399			
Show Second Monitor Preview option, 130	Backdrop panel, 379, 384, 386, 388			
Show Selected Mask Overlay checkbox, 214	Collections panel, 372, 376, 399			
Sin City (Light Red) preset, 483	Layout panel, 377, 386			
Single Image/Contact Sheet layout, 414	Options panel, 378, 380, 386, 390			
Single Page View mode, 344, 369	Overlays panel, 376, 378, 379			
Size slider, 214, 220	Playback panel, 383, 394, 396			
sizing/resizing	Preview area, 374, 399			
brushes, 213, 214, 220, 232	Template Browser, 374, 376, 381			
exported photos, 283	Titles panel, 392–393, 399			
frame borders, 456	smart collections, 23, 74–75			
ovals for vignettes, 229	sharing settings for, 115			
	video clips in, 23			
panels, 115	Smart Previews, 16–17, 52, 303			
slide show photos, 377	Smart Radius checkbox (Photoshop), 310			
thumbnails, 6, 18, 44, 52				
skin softening effect, 224	snapshots, 182, 206, 241			
sky darkening technique, 226–227	Snapshots panel, 182, 241			
slide shows, 371–399	Soft Focus Effect preset, 483			
backgrounds for, 379–380, 384–389	Soft Proofing mode, 200–203, 207			
collections for, 372, 399	soft spotlight effect, 221			
customizing the look of, 376–381	Soften Skin effect, 224			
drop shadows in, 379–380, 390	Solo mode, 126, 506			

exporting, 397–398

Sort pop-up menu, 7	Survey view, 65–67, 117, 494			
sorting photos, 60-71	Swap button, 70			
collections for, 63–65, 67–68	swapping			
color labels for, 60, 71	Compare view photos, 70			
Compare view for, 69–71	dual screen displays, 128			
flags used for, 61–62	Sync Settings button, 199			
star ratings for, 60–61	Synchronize Folder dialog, 59			
Survey view for, 65–67	Synchronize Settings dialog, 141, 199, 250			
workflow for, 492	synchronizing			
See also organizing photos	catalogs, 106–108			
sound settings, 37	folders, 58–59			
Spacebar zoom options, 136	metadata, 116			
Split Stack option, 79	Quick Develop edits, 199			
Split Toning panel, 180–181	spot removal, 250			
split-tone effect, 180, 181				
Spot Removal tool, 248–253	т			
dust spot removal with, 249–250	Т			
portrait retouching with, 222–223, 495, 496	tagging photos, 84-87			
removing multiple repairs in, 277	target collections, 82–83			
synchronizing settings for, 250	Targeted Adjustment tool (TAT)			
unwanted object removal with, 251–253	B&W panel, 179			
Visualize Spots feature, 248–249	HSL panel, 169, 202, 203, 496			
spotlight effect, 221, 229	tip for using, 182			
Spread View mode, 344	Tone Curve panel, 163, 166			
sRGB color space, 203, 303, 368, 454, 458	Type panel, 355			
S-shaped curve, 162, 183	taskbar, 42, 43, 115, 150			
stacks, 76–79	Temp slider, 144, 218			
Auto-Stack feature, 79	Template Browser			
changing top photo in, 77	Print module, 414, 418, 432, 437			
expanding/collapsing, 77, 78	Slideshow module, 374, 376, 381			
grouping photos into, 76	templates			
removing photos from, 78	book, 358-359			
splitting, 79	efficiency of using, 508			
Standard preview, 11, 53	file naming, 32–35			
star ratings, 60–61, 75, 101, 125	metadata, 13, 40-41			
stock photo websites, 386	print, 414, 418, 420, 437			
Straighten tool, 246–247	saving, 35, 381			
straightening photos, 246–247	slide show, 374, 376, 381			
Street Light Nights preset, 484	Tethered Capture Settings dialog, 24, 147			
Stroke Border checkbox, 390, 417	Tethered Capture window, 25–26, 148			
strokes in slide shows, 390	tethered shooting, 24-27, 490			
Strong Contrast preset, 161–162	camera functions and, 26			
Style pop-up menu, 171	equipment setup for, 24			
subfolders, 9	image advance options, 53			
sub-keywords, 87, 115	Layout Overlay feature and, 28–31			
suggested keywords, 117	Nikon USB settings for, 53			
Summer Day preset, 485	shortcut for triggering, 27			
	white balance settings and, 147–148			
Surreal Edgy Effect preset, 486				

text	type. See text
book, 352-355, 363-365	Type panel, 353–354, 357, 364
Identity Plate, 137, 378, 379, 392–393	
print layout, 430–431	U
rotating, 379, 399	U
searching by, 100	Ultimate Fighter preset, 484
slide show, 376, 391–393	Ultra Gritty Effect preset, 483
watermark, 288–290	Uncheck All button, 7
Text Overlays checkbox, 376	underexposed photos, 206
Text panel, Book module, 352, 355, 363	undoing edits, 199, 240–241
Text Safe Area guide, 350	unflagging photos, 62
Text Template Editor, 431	units of measure, 458
That 70's Look preset, 485	Unsharp Mask filter (Photoshop), 319
The 300 Look preset, 485	unwanted object removal, 251-253
thumbnails	Update Process Version dialog, 140-141
	Upright feature, 260-265, 276-277
badges in, 99, 123, 137	User Presets collection, 476
preview, 6, 10–11	
resizing, 6, 18, 44, 52	V
video clip, 404	V
Thumbnails slider, 6, 18, 44	vertical perspective fix, 261–265
TIFF files, 90, 206, 280, 306, 308	Vibrance slider, 160, 174
time zone setting, 97	video clips, 402–411
Tint slider	displaying only, 53
Basic panel, 144	editing in Develop module, 406-407
Camera Calibration panel, 274	effects applied to, 411
title bar, 47	exporting, 23, 282, 409-410
title slides, 392–393, 399	frame capture from, 405
Titles panel, 392–393, 399	icon indicating, 22, 402
tokens, file naming, 32, 33, 34	importing, 22-23, 402
Tone Curve panel, 161–167	organizing, 23
backscreened effect and, 439	playing, 403
contrast adjustments, 161–165	preferences for, 409
default tone curve in, 183	presets saved for, 407–408
Point Curve presets, 161	previewing, 23, 402
Range sliders, 165	Quick Develop options, 405–406, 407, 408
Region sliders, 164	slide shows including, 382–383
resetting sliders in, 165	thumbnail options, 404
RGB channel adjustments, 162, 166–167	trimming, 403–404
Targeted Adjustment tool, 163, 166	white balance adjustments, 410–411
tips for using, 183	video slide shows, 397
Tool Overlay pop-up menu, 243, 276	video tutorials
toolbar, 45, 47, 116	about this book, xii
tooltips, 122	on Identity Plates, xiii, 387, 456, 462
tracklogs, 97–98	viewing photos, 44–48
Trash icon, 28, 291	Compare view, 69–71
trimming video clips, 403–404	full-screen view, 48
Triple Scoop Music, 395	Grid view, 45, 52, 122–125
Tripod Accessory Arm, 24	Lights Dim mode, 46
Tungsten white balance, 143	Lights Oit mode, 46 Lights Out mode, 46–47
two-page spreads, 348–349	Lights out mode, 40-47

Loupe view, 44, 45, 120-121 Survey view, 65-67 vianettes adding to photos, 170-172, 174 creating custom, 228-231 fixing, 266-267 post-crop, 170, 171 Vintage Style preset, 487 virtual copies, 191–192 B&W conversions and, 176, 182 print layout using, 425 resetting, 192, 276 soft proofing and, 201, 207 Visualize Spots feature, 248-249 Volume Browser, 116 W Waitt, Ted, 204, 461 washed-out look, 237 watched folders, 335 Watermark Editor, 288-291 watermarks, 284, 288-291 graphic, 290-291 slide show, 391 text, 288-290 web gamut warning, 203 Web module, xiii website for book, 476 wedding books, 364-365 Wedding Fairytale preset, 487 white balance adjustment options, 142-146 gray card for setting, 147-148 local adjustments, 218 preset creation, 206 resetting, 182 tethered shooting and, 147-148 video editing for, 410-411 White Balance Selector tool, 145-146, 148 White Balance (WB) pop-up menu, 142 white point, 158 Whites slider, 149, 153, 158, 177

workflow process, 489–505
backing up the photos, 491
delivering the finished photos, 504–505
editing for initial presentation, 495–496
emailing proofs to client, 497–498
final editing process, 499–503
printing the photos, 504–505
shooting the photos, 490
sorting the photos, 492–494
world map, 94–99
wrinkle removal, 223

Χ

XMP sidecar files, 38, 39, 91, 294, 295 X|Y button, 70

Ζ

Zoom Clicked Point to Center option, 136
Zoom Position Lock option, 277
zoom ratios, 182, 268
Zoom to Fill Frame option, 378, 380, 386
Zoom to Fill option, 338, 415, 418, 423, 432
zooming in/out
of maps, 98
of pages, 368, 436
of photos, 116, 136, 368

APP announces full-length online FOR PL TOS IP SH DO GEAR STIO ALIE STIO ALIE STIO ALIE STIO ALIE STIO GEAR STIO SHOW ALIE STIO GEAR STIO SHOW ALIE STIO GEAR STIO SHOW ALIE STIO GEAR STIO ALIE ST

AS PART OF YOUR MEMBERSHIP

NAPP IS THE PLACE WHERE YOU TURN "ORDINARY" INTO "EXTRAORDINARY" WITH A BUNDLE OF CLASSES TO CHOOSE

- Sweeping online classes from Lightroom Basics to Lightroom 5 Killer Tips to Lightroom 5 In-Depth.
- Bold Lightroom Training with top-notch instructors eager to help you maximize your learning experience and let your Lightroom genius emerge!

Learning Lightoom is fun, easy and affordable with NAPP.

The World's Best Photoshop® Training!

Join/Renew NAPP today @ PhotoshopUser.com/24-Hour-Trial | 800.738.8513

Available Now

FIRST-EVER

LIGHTROOM® MAGAZINE FOR THE IPAD

DOWNLOAD THE LIGHTROOM® MAGAZINE APP TODAY

AVAILABLE AT THE APP STORE

Info at PhotoshopUser.com/lightroom-app-support

A HOW-TO APP MAGAZINE FOR LIGHTROOM® USERS

- Easiest Step-by-Step Tutorials
- Hottest Tips & Tricks
- Latest Plug-In News
- Issues Published 8x Annually